Moving Sites

Moving Sites ex... ...ecific dance practice through a combination of analytical essay... ...oner accounts of their working processes. In offering this j... ...of theory and practice, it aims to provide dance academics, stu... ...practitioners with a series of discussions that shed light both on... ...hes to making this type of dance practice, and evaluating andg on it.

This edited v... ...ines critical thinking from a range of perspectives including com... ...and observation from the fields of dance studies, human geogra... ...spatial theory in order to present interdisciplinary discourse and aof critical and practice-led lenses through which this type of workconsidered and explored. In so doing, this book addresses the f... ...g questions:

- How do ch... ...aphers make site-specific dance performance?
- What occ... ...en a moving body engages with site, place and environme...
- How might ... interpret, analyse and evaluate this type of dance practice through a range of theoretical lenses?
- How can th... type of practice inform wider discussions of embodiment, site, space, ...ce and environment?

This innovative and exciting book seeks to move beyond description and discussion of site-specific dance as a spectacle or novelty and considers site-dance as a valid and vital form of contemporary dance practice that explores, reflects, disrupts, contests and develops understandings and practices of inhabiting and engaging with a range of sites and environments.

Victoria Hunter is a Senior Lecturer in Dance at the University of Chichester, UK.

Moving Sites

Investigating site-specific dance performance

Edited by Victoria Hunter

Routledge
Taylor & Francis Group

LONDON AND NEW YORK

First published 2015
by Routledge
2 Park Square, Milton Park, Abingdon, Oxon OX14 4RN

and by Routledge
711 Third Avenue, New York, NY 10017

Routledge is an imprint of the Taylor & Francis Group, an informa business

British Library Cataloguing-in-Publication Data
A catalogue record for this book is available from the British Library

Library of Congress Cataloging-in-Publication Data
Hunter, Victoria (Senior lecturer in dance)
Moving sites : investigating site-specific dance performance / by
Victoria Hunter.
pages cm
Includes index.
1. Choreography. 2. Dance–Stage-setting and scenery. 3. Dance–
Social aspects. 4. Dance–Study and teaching. I. Title.
GV1782.5.H86 2015
792.8'2–dc23
2014034251

ISBN: 978-0-415-71017-6 (hbk)
ISBN: 978-0-415-71325-2 (pbk)
ISBN: 978-1-315-72495-9 (ebk)

Typeset in Baskerville
by Saxon Graphics Ltd, Derby

MIX
Paper from
responsible sources
FSC
www.fsc.org FSC® C013604

Printed and bound by CPI Group (UK) Ltd, Croydon, CR0 4YY

Contents

Acknowledgements

Chapter 1: 'Experiencing space' – V. Hunter – permission granted from Butterworth, J. and Wildschutt, L. (eds) (2009) *Contemporary Choreography: A Critical Reader*, London: Routledge.

Chapter 5: 'Embodying the Site' – V. Hunter – permission granted from *New Theatre Quarterly*.

Chapter 8: 'Video Space: A Site for Choreography' – D. Rosenberg – permission granted from *Leonardo* journal.

Chapter 10: 'Spatial Translation' – V. Hunter – permission granted from *New Theatre Quarterly*.

Chapter 13: 'Site-Specific Dance in a Corporate Landscape' – M. Kloetzel – permission granted from *New Theatre Quarterly*.

Chapter 22: 'Dancing in Place: Site-Specific Work' – Josie Metal-Corbin – permission granted from *Journal of Physical Education, Recreation & Dance*, Volume 83, Issue 4, pp. 31-37.

Chapter 25: 'Moving Sites' – V. Hunter – permission granted from *Contemporary Theatre Review*.

As with any project of this nature, the work results from a collaborative effort and I would like to firstly thank the book's contributors who have produced a wonderful collection of chapters in a generous and supportive manner. Thank you to all for demonstrating such commitment to the project and for sharing my enthusiasm and passion for site-specific dance in all its permutations.

I would like to thank a number of people who have offered encouragement, support and advice throughout the development of this project over a number of years. In particular my colleagues from the School of Performance and Cultural Industries at the University of Leeds where the idea for this publication was first proposed, and greatly supported by Sita Popat and Jonathan Pitches. A special thank you also to my colleague, mentor and friend Joanne Butterworth for her sage advice, encouragement and support. Thank you to my colleagues at the University of Chichester, in particular Cathy Childs and Jane Bacon, for their support and to external colleagues

Fiona Wilkie and Nigel Stewart for providing valuable feedback on the planning and development stages of the project.

Thank you to the many dancers, production crew, designers and collaborators who have contributed to the development of my own practice-based research over the years, the reflective accounts of which feature here in this volume.

Thank you also to the individuals and organisations who have been kind enough to allow certain materials to be reproduced herein. Particular thanks are due to *New Theatre Quarterly*, *Leonardo* and to the editors of *Contemporary Choreography: A Critical Reader* (Routledge 2009).

Finally, a huge thank you to Scott, Finlay, Molly, Maureen and Malcolm for their support, patience and encouragement.

Contributors

Carol Brown is a choreographer, performer, and Associate Professor at the University of Auckland, New Zealand, and a visiting Reader at Roehampton University, UK. Renowned for her trans-disciplinary collaborations with other artists, her work evolves through dialogue, experimentation and creative research in response to contemporary issues of space and becoming. After completing a practice-led PhD at the University of Surrey, Carol was invited to be Choreographer in Residence at the Place Theatre, London where she developed Carol Brown Dances. In 2009 she moved to New Zealand where she directs Choreographic Research Aotearoa whilst contributing as co-director to the international research platform, MAP (Music_Architecture_Performance). Her dance theatre and performance installation works have toured internationally with the British Council, and she has been commissioned to make place responsive dances for Barcelona (Park Guell), Perth (Perth Dancing City), Prague (PQ2003) and Auckland (Auckland Arts Festival). Her writings on dance, space, technology and sexuality are published widely.

Camilla Damkjaer is a Senior Lecturer in Dance Theory and head of research education at Stockholm University of the Arts, Sweden. Her research concerns the methodologies of artistic research, the articulation of embodied knowledge within the arts, and the modes of consciousness in circus and dance practices. Damkjaer's lecture-performances and publications have concerned the potential of Gilles Deleuze's philosophy in the study of movement, the relation between scholarly and artistic methodologies, and close analysis of the embodied knowledge in circus practices. Her PhD thesis (The Aesthetics of Movement – Variations on Gilles Deleuze and Merce Cunningham, 2005) addresses the meeting point between dance and philosophy with an interpretation of Gilles Deleuze's philosophy and the choreography of Merce Cunningham.

Natalie Garrett Brown is Principal Lecturer in Dance at Coventry University, UK, She is Associate Editor for the *Journal of Dance and Somatic Practices* and Vice Chair of Dance HE. She is a founding member of *enter & inhabit,*

collaborative site responsive project and the Corporeal Knowing Network; an exchange between theatre and dance artists and scholars interested in embodied writing practices and processes. Natalie undertook her Somatic Movement Educators Training in Body–Mind Centering with Embody Move Association, UK.

Victoria Hunter is a Practitioner-Researcher and Senior Lecturer in Dance at the University of Chichester, UK. Her research is practice-based and explores issues of presence, engagement and human interaction with the site and environment. Her work explores the body's phenomenological engagement with space and place through a consideration of the individual's corporeal, spatial and kinetic engagement with their environment. Victoria's work has been published in *Performance Research, New Theatre Quarterly* and *Contemporary Theatre Review.*

Jean Johnson-Jones is BA Programme Director of Dance Studies at the University of Surrey, UK. Her research interests include somatic practices and the application of Laban Analysis to the documentation of African Peoples' Dancing. Her PhD research examined the dancing of the Khoisan, the indigenous people of South Africa and merged Labanotation, Laban Movement Analysis and anthropological/ethnographic methodologies. Her current research *Processes of 'Reconstruction': Transcultural Transmission of Helen Tamiris Negro Spirituals (1928)* addresses issues surrounding the 'reconstruction' of dances from Labanotation scores.

Melanie Kloetzel is an associate professor of Dance at the University of Calgary, Canada. She is also the Artistic Director of kloetzel&co., a dance theatre company founded in New York in 1997 and now based in Calgary. Kloetzel's research focuses on performance, place, text, and characterisation and her creations have appeared in spaces as varied as an abandoned egg farm, a railroad depot, the Calgary Skywalk system, and in a rural churchyard, as well as in more conventional sites such as New York's Danspace at St. Mark's Church, Movement Research at Judson Church, On the Boards in Seattle, Dusk Dances in Toronto, and Southside Studios in Glasgow. Her research has been published in *New Theatre Quarterly, IJPADM,* and *Conversations Across the Field of Dance Studies;* her anthology with Carolyn Pavlik, *Site Dance: Choreographers and the Lure of Alternative Spaces* (2009), is now available in hard cover, paperback, and as an eBook from the University Press of Florida.

Kate Lawrence trained in dance at Thamesdown and Laban (1984–1989) and ran feminist dance company Nomads in the 1990s. She is currently a part-time Lecturer in Performance at Bangor University, following ten years as dance lecturer at University of Surrey. She specialises in vertical dance, using the equipment of rock climbing to suspend the dancing body against

walls of buildings, which become the dance floor. Her practice includes training dancers and choreographing and performing in vertical dance works. She has published articles on site-specific performance and, more recently, on vertical dance.

Derek P. McCormack is Associate Professor at the School of Geography and Environment at Oxford University, UK. He is the author of *Refrains for Moving Bodies: Experience and Experiment in Affective Spaces* (Duke University Press, 2013) and has written widely on non-representational theory, atmospheres, affective spaces and the body. He is currently working on a book project exploring atmospheric things by focusing on the balloon as an experimental device.

Josie Metal-Corbin has been teaching, choreographing and directing since 1967 and holds the Margaret Killian Diamond Professorship of Education at the University of Nebraska at Omaha (UNO), USA. She is the 2012 National Dance Association Artist/Scholar and the Director of UNO's modern dance company, The Moving Company. She has created choreography for the Joslyn Art Museum, The Durham Museum, Omaha Public Library, Omaha Performing Art's Holland Center, Lauritzen Botanical Gardens, Glacier Creek Prairie, Andrew Leicester's Castle of Perseverance and the Henry Doorly Zoo. Some of this work has been funded through grants from the Smithsonian, the American Democracy Project, the National Endowment for the Arts, Dana Foundation, Literacy in Nebraska and California, Sherwood Foundation and the Center for the Book/Library of Congress. Metal-Corbin has performed and given scholarly papers, workshops and presentations in the United Kingdom, Canada, Jamaica, Portugal, France, Italy and China.

April Nunes Tucker has a PhD in dance and phenomenology. She has lectured in dance at Trinity Laban, Roehampton University and helped launch the undergraduate dance degree at the University of Bedfordshire, UK. She publishes in the areas of dance and phenomenological inter-subjectivity and reflective practice in healthcare and performance. April performs and makes dances that take movement inspiration from Butoh and yoga and are usually site-specific structured improvisations. She is interested in the inter-subjective relationships that are formed between performer and audience and her practical and theoretical work reflects this interest.

Sita Popat is Professor of Performance and Technology at the University of Leeds, UK. Her interests centre on performance in digital and new media contexts. She has choreographed for humans, robots and digital 'sprites', and she is fascinated by the interrelationships between performers, operators and computers. Her research has been funded by the Arts and

Humanities Research Council, the Engineering and Physical Sciences Research Council, and the Joint Information Systems Committee. She is author of *Invisible Connections: Dance, Choreography and Internet Communities* (Routledge, 2006) and co-editor of *Performance Perspectives: A Critical Introduction* (Palgrave, 2011). She has been Associate Editor of the *International Journal of Performance Arts and Digital Media* (Taylor & Francis) since the journal was founded in 2004. She sits on the Board of Trustees for DV8 Physical Theatre. In her spare time, she plays *World of Warcraft* with her two grown-up sons.

Dr. Sandra Reeve is a movement artist, facilitator and teacher who lives in West Dorset. She teaches an annual programme of autobiographical and environmental movement workshops called Move into Life® and creates small-scale ecological performances. She is an Honorary Fellow at the University of Exeter, lecturing in Performance and Ecology, and a Movement Psychotherapist, currently offering therapy and supervision in private practice. She first studied with Suprapto Suryodarmo in Java in 1988 and subsequently worked with him intensively for 10 years, based in Java from 1995–98. Their practice together continues to evolve through workshop collaborations in the UK and in Java, 2011–2015.

Douglas Rosenberg is both an artist and a theorist. He is the author of *Screendance: Inscribing the Ephemeral Image*, published by Oxford Press and a founding editor of *The International Journal of Screendance*. His work for the screen has been exhibited internationally for over 25 years and he has been a long-time advocate of screendance as a curator of the International Screendance Festival at the American Dance Festival, as a speaker and organiser of symposia and international workshops. He is also Editor of the forthcoming *Oxford Handbook of Screendance Studies*. His most recent screendance is CIRCLING, a collaboration for the screen with Sally Gross, an original member of The Judson Dance Theater Group. He is currently finishing a documentary called, *Here Now* with Sally Gross which focuses on Ms Gross's teaching and site specific work.

Alice Sara is a dance artist with an extensive performance, choreographic and teaching portfolio. She has toured nationally and internationally in site-specific, dance theatre and film projects including work with Seven Sisters Group (a long-term member), Deborah Hay, Debbie Tiso, Tom Dale, Maresa Von Stockert. She graduated from London Contemporary Dance School, becoming a member of 4D (LCDS post-graduate performance company) and gaining an MA in 2000. She is a dance lecturer at Trinity Laban Conservatoire of Music and Dance, where she teaches release-based technique, improvisation and performance. She is currently working with Melanie Clarke, Debbie Tiso, and Lizzi Kew Ross & Co.

Rachel Sara is Director of the Architecture Research Group and Programme Leader for the Master of Architecture programme at the University of the West of England, Bristol, UK. Her research particularly explores 'other' forms of architecture, specifically examining architecture without architects through investigations of the performed architecture of the carnival, the relationship between architecture and dance, and the transient architecture of the campsite. She co-edited *Architectural Design: The Architecture of Transgression* (2013), and co-organised the tenth international conference of the AHRA on the subject of Transgression, Bristol 2013. She was co-curator of the *Transgression: Architecture without Architects* exhibition at the Bristol Architecture Centre in 2012, and co-authored the associated book *architecture + transgression*, for which she wrote the essay *Carnival: Performed Transgressions*. She co-edited the *Transgression: Body and Space* special issue of *Architecture and Culture* (November 2014) and has been collaborating with dance artist Alice Sara over the last ten years with whom she co-authored 'Between the Lines: Experiencing Space Through Dance', for *CEBE Transactions* (2006).

Malaika Sarco-Thomas is a dance artist and Lecturer in the new Dance Studies programme at the School of Performing Arts, University of Malta. Through performance and curatorial projects she investigates how performance practices can alter attention to site, physicality and place. Her collaborative 2006 peripatetic PhD research project TWIG: Together We Integrate Growth investigated links between 'ecological practice' and dance improvisation through an overland journey from England to China that included guerilla tree-planting and Twig Dances, solo performances with living plants. Since 2011 with Richard Sarco-Thomas she has co-organised Contact Festival Dartington and Conference, an annual platform for the development and exchange of CI practice, and co-teaches Aikicontact, or aikido and CI principles in movement. Since 2007 they have led weekly contact jams at Dartington College of Arts in Devon, Falmouth University in Cornwall, where Malaika was Senior Lecturer and course coordinator for Dance & Choreography at the Academy of Music and Theatre Arts, and now in San Gwann, Malta. With Misri Dey she recently co-edited issue 6.2 of the *Journal of Dance and Somatic Practices* 'on Contact [and] Improvisation' (2014).

Katrinka Somdahl-Sands is an Assistant Professor of Political Science at Rowan University and the Coordinator for the New Jersey Geographic Alliance. She is a political geographer with research interests in the spaces of political communication, mediated spaces of performance, and geographic education. Her teaching areas include geopolitics, globalisation, the politics of popular culture, and a number of regional courses on Africa, the Middle East and Europe.

Jen Southern is an artist and lecturer in Fine Art and New Media at Lancaster University, UK. She has a practice-based PhD in Sociology from the Centre for Mobilities Research, where she is now artistic director. Southern's collaborative artwork, exploring hybrid digital and physical spaces and practices has been exhibited at festivals and galleries in Europe, Canada, India, Japan and New Zealand since 1991. She currently works collaboratively with Chris Speed on *Comob Net*, exploring collaborative uses of GPS technology, and producing and making visible a sense of comobility, of being mobile with others at a distance. Her writing about comobility and locative art has been published internationally by *Transcript, The Canadian Journal of Communications, Second Nature: International journal of creative media,* and the *Fifth IEEE International Conference on e-Science*. She has produced work through residencies and commissions including: The Banff Centre; Mobile Media Studio, Montreal; FACT, Liverpool; The Pervasive Media Studio, Bristol.

Chris Speed is Chair of Design Informatics at the University of Edinburgh, UK, where his research focuses upon the Network Society, Digital Art and Technology, and The Internet of Things. Chris has sustained a critical enquiry into how network technology can engage with the fields of art, design and social experience through a variety of international digital art exhibitions, funded research projects, books, journals and conferences. At present Chris is working on funded projects that engage with the flow of food across cities, an internet of cars, turning printers into clocks and a persistent argument that chickens are actually robots. Chris is co-editor of the journal *Ubiquity* and leads the Design Informatics Research Centre that is home to a combination of researchers working across the fields of interaction design, temporal design, anthropology, software engineering and digital architecture, as well as the MA/MFA and MSc and Advanced MSc programmes.

Nigel Stewart is a dance artist and scholar. He is Senior Lecturer in the Institute for Contemporary Arts at Lancaster University, UK; the Artistic Director of Sap Dance (www.lancs.ac.uk/fass/projects/jackscout); and was Principal Investigator of the AHRC-funded project Re-enchantment and Reclamation: New Perceptions of Morecambe Bay Through Dance, Film and Sound (2006–8). He has published many essays on contemporary dance, dance phenomenology and environmental dance; and is co-editor of *Performing Nature: Explorations in Ecology and the Arts* (Peter Lang 2005). He has danced for various UK and European choreographers, including Thomas Lehmen, and as a solo artist. Apart from his choreography for Sap Dance, he has worked as a choreographer and director for Artevents, Louise Ann Wilson Company, National Theatre Wales, Theatre Nova, Theatreworks Ltd., Triangle and many other UK companies, and Odin Teatret in Denmark.

Cheryl Stock AM has a career spanning choreography, directing, education and research. Formerly Head of Dance and Director of Postgraduate Studies, Creative Industries Faculty, Queensland University of Technology, Cheryl has created over 50 dance works and was founding Artistic Director of Dance North. Her doctorate in intercultural performance engendered 20 collaborative exchanges in Asia and her publications encompass interdisciplinary and interactive site-specific performance, contemporary Australian and Asian dance, and practice-led research. Cheryl was the 2003 recipient for Lifetime Achievement at the Australian Dance Awards for outstanding contributions to dance practice and scholarship and in 2014 was made a Member of the Order of Australia 'for significant service to the performing arts as a choreographer, educator and administrator'. As Secretary General of World Dance Alliance, Cheryl co-convened and curated the 2008 (Brisbane) and 2014 (Angers, France) WDA Global Summits.

Caroline Walthall is Development Manager at ODC/Dance in San Francisco, USA. Prior to that she worked in Individual Giving at San Francisco Ballet. An advocate for dance and personal and professional development, she served as a 2013–2014 EAP Fellow and teaches Yoga Therapeutics. She graduated from Barnard College, Columbia University with a B.A. in Dance and American Studies. As a dancer, she has worked with renowned artists including Camille A. Brown, Nora Chipaumire, Faye Driscoll, Nicholas Leichter, and Colleen Young.

Fiona Wilkie is a Senior Lecturer in Drama, Theatre and Performance at the University of Roehampton, UK. She has published on various aspects of site-specific performance in journals including *Contemporary Theatre Review*, *New Theatre Quarterly* and *TDR*, as well as in Blackwell's *Concise Companion to Contemporary British and Irish Drama* (2008). Her recent work has been concerned with the 'mobility turn' in the social sciences, and she has drawn on this field in writing about a range of arts practices, including works by the Scottish playwright David Greig and the Turkish artist Kutluğ Ataman. Her book *Performance, Transport and Mobility: Making Passage* (Palgrave, 2015) considers the ways in which performances engage with and produce mobilities, reshaping existing models and engendering alternative possibilities for movement.

Introduction

Victoria Hunter

What intrigues and compels me to seek out and attend site-specific dance events is the promise of the unknown and the potential realisation and revelation of new-found realities in familiar and unfamiliar places. This book stems from my own fascination with site-specific dance performance as an event experience that rewards those intrepid and brave enough to engage with the genre with, an often revelatory experience, one that reveals to the experiencer not only something of the site in which it is housed but also exposes their own processes of being-in-the-world.

The title of this book, *Moving Sites*, alludes not only to the potential for this work to be moving and evocative in an experiential sense but also to the opportunity for it to reveal the site in which it occurs in a new light, as a place of performance. This temporary act of transformation challenges perceptions of familiar places by moving them 'forwards' into direct consciousness as sites of play, engagement and interaction as opposed to 'background' façades or statutory components of a common cityscape or rural scenery which we pass by or move through en route to somewhere else. Site-specific dance performance and dance sited in real-world locations holds the potential to create fractures of disruption to often assumed and comfortably familiar encounters with the urban and rural environment. In her discussion of site-specific art and locational identity Miwon Kwon (2004) observes that, through this process place becomes a 'phantom' (p. 165) as the site-specific event invokes a liberating 'deterritorialization' (p. 165) of site. In so doing, the fixed identity of a site, building or location becomes disrupted and problematised through the introduction of a performance work that might celebrate, contest or contradict the habitual function of a site.

Site-specific dance can be defined as dance performance created and performed in response to a specific site or location. The practice is wide-ranging and varied in terms of its aims, location and focus, from the rural to the urban, the political to the spectacle. This collection of chapters presents a series of discussions that shed light on practical approaches to making and producing site-specific choreography and theoretical and conceptual approaches to reflecting upon, evaluating and making sense of

this type of dance practice. The edited volume combines critical thinking from a range of perspectives including commentary and observation from site-dance practitioners and academics from the fields of dance and performance studies, human geography, architectural and spatial theory, dance anthropology and digital performance in order to present interdisciplinary discourse and a range of critical and practice-led lenses. This book questions: How do choreographers make site-specific dance performance? What occurs when a moving, dancing body engages with site, place and environment? How might we interpret, analyse and evaluate this type of dance practice through a range of theoretical 'lenses'? and How can this type of practice inform wider discussions of embodiment, site, space, place and environment – what does it reveal?

Site-specific dance performance is considered here as a well-established contemporary dance form possessing a discernable set of characteristics, practices and conventions. The genre is also considered as a distinct form of dance practice that, through its engagement with everyday rural and urban environments presents opportunities to explore space, place and environment through corporeal means. In this sense, the book moves beyond description and discussion of the genre as a spectacle or novelty and considers site-dance as a valid and vital form of dance practice that explores, disrupts, contests and develops understandings and practices of inhabiting and engaging with a range of sites and environments.

Through the contribution of scholars and practitioners researching encounters with space, place and location this book extends its remit to considerations of the body's movement and mobility in, across and through a range of real and virtual environments in a broader sense and challenges the reader to consider the role that dance knowledge and embodied understandings might bring to interdisciplinary discourses. Through this self-reflexive approach the book also exposes ambiguities, contradictions and conflicts that arise when attempting to pin down definitions of a dance form that, through its engagement with an ever-mobile world is itself in a constant state of flux. It questions some of the definitions, terminology and conceptual arguments often applied to discussions of site-specific dance practice and explores what the form can and might consist of and what it might tell us. For example, through a consideration of embodied engagements with architectural design, immersive performance and mobile technology as an extended form of site-specific 'dance' performance, what new knowledge and understandings of practices of engaging with the world emerge? In return, this process of questioning contributes to and extends ubiquitous questions of what constitutes 'dance' in this context, what is 'dance' here and where and when it can literally 'take place'?

While the wider fields of site-specific devised, visual and text-based performance are well documented (e.g. Hill and Paris 2006; Wrights and Sites 2000; Kaye 2000; Pearson 2010; Birch and Tompkins 2012), little academic research into site-specific dance performance and its creative

methods currently exists. A key development in the field emerged in 2009 with the publication of Melanie Kloetzel and Carolyn Pavlik's excellent volume *Site Dance: Choreographers and the lure of alternative spaces* in which the editors successfully capture the voices of a range of site dance artists making work in the United States and offer insights into the artistic motivations and contextual conditions informing this work. In the UK a number of dance practitioners and dance companies create and produce dance work for presentation in non-theatre locations,[1] but few appear to engage in articulating notions of specificity and site-specific choreographic processes in depth. Where there is evidence of artistic research and development being conducted by practitioners (Susanne Thomas, Lea Anderson, Paul-André Fortier and Rosemary Lee, for example) the knowledge often remains tacit and contained within the field of professional practice. As a result, site-specific dance performance, its creative practices and theoretical approaches remain under-explored within the wider field of choreographic and site-specific (performance-led) discourse. Accompanying discourses surrounding the practice have sought to define and articulate the nature of the work through the development of sub-category definitions such as site-generic, site-adaptive and site-sympathetic (see Wilkie's articulation of Wrights and Site's model, 2002).

Site-dance as an evolved terminology functions as an inclusive label that embraces a multitude of performative approaches. However, the term site-specific dance performance is retained in this publication as (in the UK in particular) it is commonly applied as an umbrella term that encompasses a broad range of practice. The term is also attached to the work of a number of well-established companies and dance artists and is used throughout many further and higher education dance and performance studies institutions worldwide to refer to a certain type of non-theatre based dance performance and, as such the nomenclature provides a useful point of reference.

This publication acknowledges the evolution of this field of practice through the incorporation of a varied range of chapters that address these concerns and perspectives from a range of angles. The chapters are arranged into five sections that address the following themes:

- Approaching the site: experiencing space and place.
- Experiencing site: locating the experience.
- Engaging with the built environment and urban practice.
- Environmental and rural practice.
- Sharing the site: community, impact and affect.

Some of the chapters address site-specific dance and its creation and reception in a very tangible sense through artist-researcher accounts of their own creative processes or through theoretical and analytical reflections on site-dance experiences. Other chapters, however, question notions of

what constitutes this field of practice and challenge the reader to consider what constitutes site-specific dance practice in the twenty-first century. The chapters therefore provide space for a range of 'voices' to appear in a number of ways from the subjective and (often) autobiographical registers of artist-practitioners for whom experiences of body–site and self are interwoven to the analytical and objective chapters presented by academics and theoreticians. These chapters cover a diverse range of practice including screen dance, mobile technologies and body–architecture relationships and through doing so raise questions regarding the 'location' of this work and our relationship to it as viewers and participants.

Historical influences

Dance in non-theatre locations can be found in many countries and in many contexts around the world. A wide range of folk, religious and indigenous dance practices take place both in specific sites (for example, in places of worship and sacred spaces) and more generic outdoor locations as a component in festival and ritual performance. The placing and presentation of dance in non-theatre locations as part of a celebratory or festival event or as a component within Western indigenous folk dance practices (i.e. Morris dancing, mystery plays, religious dance ceremonies and American pageants) can be viewed as potentially influential and resonant with contemporary incarnations of site-specific dance performance. Components such as promenade performance, folk dance informed group dance patterns and formations, audience interaction and performer–audience proximity, for example, are often included within site-dance performances that invoke and respond to a myriad of folk dance traditions.[2] While acknowledging these forms of (often) culturally specific dance practices and their alignment with some of the discourses presented in this volume, a deeper consideration of these forms lies beyond the scope of this work.

Contemporary discussions of site-specific dance performance are informed by a line of influence originating from early dance explorations that engaged dance practitioners with outdoor dance performance, through to the more formalised presentation of work in non-theatre locations by practitioners such as Isadora Duncan and Ruth St Denis, the Happenings of the late 1950s and the experiments of artists at Black Mountain College in the United States. Influences from the natural dance movement in England and continental Europe and explorations of the body's relationship to the environment within the development of the German modern dance tradition must also be acknowledged.

Developments in live art practice from the 1960s and early 1970s that called for a re-consideration of where art can be placed and performed, and its influence on the Judson Church post-modern choreographers' experiments with dance in non-theatre locations again provides a useful point of departure from which to consider the evolution of contemporary

site-specific dance performance. As with any attempt to provide a definitive and monolithic account of dance history, however, the aspiration to present a single-lineage account of the development of the form is essentially flawed.[3] Certain dance developments, practices and the work of particular dance artists are referred to here in an attempt to capture a range of influences that, through a process of historical evolution, can be considered as influential and potentially impressive upon practitioners interested in alternative modes of presenting dance performance.

Specific dance practices developed both in America and Europe from the early twentieth century that engaged choreographers and dance artists with explorations of the body, dance and the 'natural' environment can be viewed as highly influential on the development of contemporary dance practices that consider the body's relationship to the world as an intrinsic component within the dance-making process. In America, artists such as Isadora Duncan and Ruth St Denis explored notions of nature and beauty and a fundamental sense of connection between body, earth and environment through their work. In Europe, the development of a German modern dance genre that incorporated an interest in the body–environment relationship as a key component in developing a strong and healthy body was also beginning to emerge. This incorporated a form of dance practice evident in the work of practitioners such as Rudolph Laban, Jacques Dalcroze and Mary Wiedman that was often performed (and photographed) in the open air, reflecting an ethos that celebrated the life-enhancing, vital energies of the natural world. In the UK the 'natural dance' movement developed by Madge Atkinson and Ruby Ginner explored the rhythms, forms and energies of the natural world through embodied expression. This often overlooked period in British modern dance history is well documented in Alexandra Carter and Rachel Fensham's (2011) work, *Dancing Naturally: Nature, neo-classicism and modernity in early twentieth-century dance.* The volume considers how notions of nature and the natural were conceived and explored by dance artists and how their work was influenced by the concerns and performances of Isadora Duncan and other artists from the United States and Europe. Central to the development of this work was the simultaneous development of dance education and choreographic teaching practices that encouraged students to experiment with relationships between dance, location, space and time as such investigation was often housed within dance education or teacher training colleges such as Black Mountain College and Jacobs Pillow in the US. Through the establishment of Dartington College in the UK and subsequently Bretton Hall College in the North of England there evolved a rurally-based arts-college tradition where dance practice evolving out of and through the dancing body's response to the natural environment was explored, encouraged and given space to flourish.

Developments in European philosophy, psychoanalysis and experimental literary and performance practice in the early 1960s gave rise to new ways of

considering, experiencing and thinking about space, place and environment. Guy Debord's ideas and the emergence of the Situationist movement's practice of the *derivé* as a means of engaging in processes of psychogeography and the experimental, site-specific writing of George Perec, for example, presented novel and alternative approaches to engaging with urban environments. In the late 1960s and the early 1970s, through a questioning of modern art and its concepts, site-specific art works began to emerge as a reaction against modern sculpture and art with its emphasis on the artwork as 'autonomous and self referential' (Suderburg 2000: 38). Real places became the new places of art as opposed to the gallery space that served merely to house the artwork:

> Site-specific work in its earliest formation; then, focused on establishing an inextricable, indivisible relationship between the work and its site and demanded the physical presence of the viewer for the work's completion.
>
> (Suderburg 2000: 39)

This notion of the viewer or audience member being present with the artwork began to shift and develop conventional understandings regarding the role of the observer; in the emerging genre of site-work the audience became an integral part of the creative process implying a shift from the visual towards a more phenomenological appreciation of art:

> During the sixties, the idea of an artwork as 'environment' was elaborated beyond the basic fact that the spectator should, rather than looking at it, inhabit it as he or she inhabits the world. A key figure in this development was Robert Smithson, who formulated the distinction between a site, a particular place or location in the world at large and a non-site, a representation in the gallery of that place in the form of transported material photographs, maps and related documents.
>
> (De Oliveira *et al.* 1994: 34)

The emergence of land art practices in the late 1960s and early 1970s involved artists such as Robert Smithson and Dennis Oppenheim in the development of large-scale projects that created art interventions within a diverse range of landscape settings. Jane Rendell in her publication *Art and Architecture: A place between* (2006) provides a comprehensive overview and discussion of this work in her chapter 'site, non-site, off-site' (pp. 23–40). Smithson was a key figure in the development of site-specific art practice through which he encouraged his peers to take work out of the studio and engage in a more authentic manner with the subject matter and the world with which it conversed; in doing so he identified ten points of difference between sites and non-sites:

Site	Non-Site
Open limits	Closed limits
A series of points	An array of matter
Outdoor coordinates	Inner coordinates
Subtraction	Addition
Indeterminate creativity	Determinate creativity
Scattered information	Contained information
Reflection	Mirror
Edge	Centre
Some place (physical)	No place (abstraction)
Many	One

(De Oliveira *et al.* 1994: 38)

The mantras of authenticity, real-world engagement with subject matter and a questioning of what constituted art practice and where it could be situated was also explored by a number of conceptual and performance artists of the era who began to challenge the notion of site further still. Conceptual artist and author Sophie Calle extended the themes and philosophies of the early Situationists through her work *Suite Vénitiene* (1988) in which she (covertly) followed a man she met at a party in Paris to Venice and recorded her experiences of surveillance, subterfuge and getting lost as key elements in an experiential, living artwork-experience. 'Body Artists' such as Chris Burden and Vito Acconci questioned the viability of the artwork as a product and turned their attention to the 'body as site' creating a new sense of immediacy between the artist and the artwork, addressing questions such as: How do I move in real space? What makes me move and what are the possibilities of the body?[4]

In the fields of theatre and performance Richard Schechner's environmental theatre began to challenge the theatrical usage of space and sought to explore alternative spaces for performance, concerned with exploring spaces in their totality:

> The first scenic principle of environmental theatre is to create and use whole spaces. Literally, spheres of spaces, spaces within spaces, spaces which contain or envelope, or relate, or touch all the areas where the audience is and/or the performers perform.
>
> (Schechner 1994: 2)

Notions of play, participation and the materiality of everyday life informed the work of artist and performance practitioner Allan Kaprow, whose experimental 'Happenings' of the 1960s and 1970s paved the way for collaborative explorations of art and everyday life. Kloetzel and Pavlik observe:

The Happenings, in addition to minimalist efforts among visual artists, joined with developments among modern dancers to create the elemental stew for site-specific dance.

(2009: 8)

In the world of dance, Merce Cunningham began to challenge notions of space explored in the modernist era, famously adopting Einstein's mantra of 'there are no fixed points in space' and, through his collaboration with composer John Cage, pushed the boundaries of modernist compositional structures. Cunningham's employment of chance procedures and his interest in the incorporation of film and technology within his work produced dance performance work that challenged Euclidean notions of space in relation to both the situation of the audience and the siting/location of the performance work itself. His concern for the democratisation of stage space informed post-modernist concerns with space that highlighted issues of the body and representation and led to experimental approaches to producing dance work that challenged the audience–performer relationship. In New York, the Judson Church Group began to present work in non-theatre spaces. Trisha Brown's early works famously involved walking down walls, performing on rooftops and intimate performance events in private apartments. Judith Mackrell observes:

Cunningham's 'Events' took dance out of the theatre and into gyms and galleries; Trisha Brown had her dancers crawling up walls and over rooftops; and in Lucinda Child's *Street Dance* (1964) two dancers moved among pedestrians in the street while the audience watched from an upper storey window, listening to a commentary on the architecture and weather.

(1991: 40)

Lucinda Childs' work *Street Dance* (1964) is often cited as an example of early site-specific dance performance as it exposed the choreographer's overt questioning of space, place and human engagement with the built environment in a particular manner, dance historian Sally Banes describes the work in detail:

For *Street Dance,* Childs' placed herself and one other performer, James Byars, both dressed in black raincoats, in a very particular area on Broadway between 11th and 12th street. Watching from loft windows above and across the street, the audience observed the pair highlighting the details of the site, such as a display window and objects in it, as well as integrating seamlessly with the bustle of the street. During their observation, Childs' taped voice – emanating from a recorder inside the loft-reinforced the audience's perception of these details by providing them with exact verbal descriptions of the site's features.

(1987: 135–6)

This work and many others created by post-modern choreographers including Simone Forti, Douglas Dunn and Meredith Monk reflected the sentiments of Yvonne Rainer's famous 'no' statement[5] eschewing conventional proscenium-arch based presentation modes for dance and incorporating often mundane activities alongside surreal components in an act of eclectic collage:

> Meredith Monk's *Juice* (1969) roamed all round the Guggenheim museum and the island of Manhattan – taking in an exhibition of Roy Lichtenstein's paintings and later involving the dancers in the chanting of biographical recita-tives, the frying of chops and the dismantling of a log cabin to reveal a violinist surrounded by books, a quart of milk and a Lichtenstein print.
>
> (Mackrell 1991: 46)

Other movement practitioners such as Deborah Hay, Mary Fulkerson, Steve Paxton and Anna Halprin explored what might be referred to as more body-based approaches facilitated through dance improvisation and, in the case of Halprin's work, a return to exploring the natural environment through the placement of dance improvisation and performance in open air and landscape environments. These performances, experiments and improvised events, while not labelled as 'site-specific' at the time, can be considered as closest in resemblance to contemporary incarnations of the form and instigated practical methods and creative approaches that are reflected in the site-dance work of today. The legacy of this work in the US continues to inform the evolution of the form and its establishment as a distinct genre of dance practice supported in part through the many experimental art and site-specific dance festivals such as *Dancing in the Streets* (New York), *Bates Dance Festival* (Maine), *Westfest* (Wesbeth NYC) and *Jacob's Pillow* (Massachusetts) that either focus solely on site-dance performance or devote a significant part of their programming to the form.

The lineage of the early experiments with dance and site in America can be further traced through the development of the British New Dance scene that developed in the 1970s and early 1980s. This period of dance development in Britain was heavily influenced by the experimental nature of the American post-modern dance scene while also reflecting the changing and challenging socio-economic climate of the time. The work of the experimental X6 collective in particular challenged understandings of where dance could be presented and what themes and issues could be explored. Choreographers such as Emilyn Claid, Maddy Duprees, Fergus Early and Jackie Lansley, created work that challenged contemporary dance aesthetics through both content and form. Writing about the collective's performance work *by River and Wharf* (1976) Anastasia Kirillova observes:

Summer time provided further possibilities in the X6 quest to explore movement, space and their relationship to the audience. For an iconic event called *by River and Wharf,* that took place in the summer of 1976, the collective brought together hundreds of performers and organised an afternoon-long festival staged all around the Bermondsey docklands. Jacky [Lansley] was performing a version of the dying swan on a wooden pallet in the mud of the River Thames. Fergus [Early] was hidden inside a movable bush, performing alongside a Morris dancer in the grounds of the housing estates down river. Mary [Prestidge] joined ten other dance artists in a bicycle piece, riding in unison around the area. Spectators would gather at Tower Hill tube station and were led by tour guides over Tower Bridge to the north side, then back and around Butler's Wharf, into some of the inlets, where performances culminated.[6]

A key figure in the development of experimental dance in the UK at this time was the choreographer Rosemary Butcher whose work drew influence from visual and live art and explored the potential and possibilities of staging dance in non-theatre locations:

> She saw the stage as a live visual field in which bodies could be disposed in space, textures of movements contrasted. She was fascinated, too, by the effect of placing dance within different frames – creating works for non-theatrical spaces like Paternoster Square, galleries or open fields. In the 1980s this extended to working within sculpted installations such as Hans Dieter Pietch's grey ragged screens for Imprints (1983), which stood side by side in a pool of light.
>
> (Mackrell 1991: 48)

This period of British dance history is further documented in Judith Mackrell's publication *Out of Line* (1992) and Stephanie Jordan's work *Striding Out* (2000), both of which capture the experimental spirit of an emerging contemporary dance scene that paved the way for the emergence of small, avant-garde dance companies and independent dance artists who sought to develop their artistic voices outside of the mainstream.

Theatre and performance-derived site-specific work began to emerge as a recognisable genre in the UK in the late 1970s to early 1980s through the work of companies such as Brith Gof, Wrights and Sites, Welfare State, I.O.U. and Corridor Theatre Company. From the late 1980s and early 1990s, independent dance artists and choreographers such as Lea Anderson, Mark Murphy, Shobana Jeyasingh and Jacky Lansley began to experiment further with site-specific dance performance alongside the development of their work in proscenium arch environments. This type of work emerged alongside developments in video and 'screen dance' as dance artists began to experiment with new camera and editing techniques and played with ideas of placement and staging. In works such as Lea Anderson's *Flesh and*

Blood (1989) and *Perfect Moment* (1992) and VTOL's *Where Angels Fear to Tread* (1995) dancers interacted with urban locations and the built environment. In Jonathan Lunn's *Mosaic* (1992) the interior of an art gallery provided the place of performance. From this period onwards the term 'site-specific' dance began to emerge and was applied by practitioners and theorists to describe a form of work that very clearly concerned itself with attending to and exploring the particular non-theatre location in which it was created and performed. The work of Seven Sisters dance company and choreographers such as Rosemary Lee, Carolyn Deby, Rosie Kaye and Cscape dance company has contributed to the development of a clear and increasingly established ecology of site-specific dance practice in the UK that, over the past 20 years, has been enhanced further through the development of site-dance festivals such as the Greenwich and Docklands Festival in London and the coastally-based *Salt* festival in Cornwall. Most recently, increased funding availability arising from the hosting of the Olympics in London in 2012 provided opportunities for site-dance artists to present work as part of the UK's Cultural Olympiad programme. A number of these works focused on the spectacular and celebratory potential of site-dance such as Rosemary Lee's *Square Dances*, a large-scale community-based work that engaged intergenerational groups in dance performances within the communal squares and parkland lining the River Thames. Elizabeth Streb's spectacular work *One Extraordinary Day* (July 2012) celebrated the athleticism of the human body as her dancers abseiled down London's City Hall and bungee jumped from the Millennium Bridge. While these works focused on developing large-scale events and participatory opportunities, other events arising from the Cultural Olympiad focused on more specific explorations and interactions with their locations such as the Quay Brothers' *Overworld and Underworlds* (July 2012) project situated in the city of Leeds, an ambulatory performance that engaged audiences in a performance trail across the city. In this project the artists approached the whole city as a stage in which 'every person strolling through the city will contribute to the choreography'[7] achieved through the audience member's process of journeying through the city during which they encountered moments of dance performance in the streets, under bridges and in shop doorways.

Contemporary incarnations of site-specific dance can be found in various formats around the world, and, as the genre continues to evolve it has incorporated a wide variety of performance components including circus skills, aerial performance, walking, durational and immersive performance elements evidenced in the work of numerous companies and choreographers. International artists engaging in this practice either as the main focus of their work or as a development or alternative to their proscenium-based work include, in the US, Stephan Koplowitz, Jennifer Monson, Heidi Duckler and environmental dance artist Joanna Stone; in the Netherlands, Frank van de Ven, Company Bewth and Krisztina de Chatel; in New Zealand, practitioner-academics Karen Barbour and Sue Cheesman; in Australia

practitioner-academic Peter Snow and choreographer Paula Alexander Lay; Chinese dance and installation artist Shen Wei; French choreographer Noémie LaFrance and Paul-André Fortier in Canada.

Categories, approaches and contentions

Nick Kaye refers to site-specific practice as a form that 'invariably works to expose that which confines it' (2000: 218) and, in their own work Pearson and Shanks propose a 'theatre/archaeology' approach to making site-work through which the resulting performance material effectively 'recontextualises' (2001: 23) the site. Movement artists Miranda Tufnell and Chris Crickmay (1990, 2004) prefer an embodied approach to experiencing space and place resulting in 'place-specific events', an approach that chimes with the work of environmental movement artist Helen Poynor[8] involving a process of listening, waiting and responding corporeally to a kinaesthetically attuned 'sense' of place. Choreographer Rosemary Lee's (2006) discussion of her own approach to working in the site-specific context outlined in her essay 'Expectant Waiting'[9] describes her exploration of a 'profound connection between environment and character, and a sense of place'[10] invoked through stillness and attending to the energies and essences of site. A multitude of practices, models and approaches to making site-specific dance exist, emerge and converge at various moments in time.

The interdisciplinary nature of the theoretical frameworks running throughout this volume illuminate the depth and diversity of approaches to analysing and conceptualising site-specific dance and performance work and in doing so reveal the complex and problematic nature of categorisation. As opposed to pursuing fixed definitions of site-specificity it is perhaps useful here to consider how particular theoretical ideas might contribute to the development of a broader, more fluid understanding of site-specific dance performance.

Ideas drawn from the fields of spatial theory and human geography, for example, facilitate an awareness of the scope of spatial information contained within sites and the potential for developing performance material from these experiences. The so-called 'spatial turn' within the humanities and social sciences has facilitated the valorising of subjective experience, placing the body-self at the centre of debates and provoking theorists to consider further how individuals construct and encounter spatialised experiences of the world. Critical geographer, Edward Soja's (1996) work, for example, presents the notion of a 'third space' in which historicity, spatiality and sociality combine to inform ontological experience. In his publication *Environmental and Site-Specific Theatre*, Andrew Houston proposes that Soja's work is particularly significant to the study of site-specific performance as his theoretical attempts to 'develop a more thorough understanding of the world' (2007: xiv) share the same concerns reflected

in the practical explorations of site-specific dance and performance artists. Similarly, the work of spatial theorist Henri Lefebvre challenges artists to consider the rhythmic nature of space and spatial organisation alongside embodied notions of 'socially' and 'personally' constructed space (1974: 7). Michel De Certeau's discussion of walking through the city as an embodied practice and his definition of space as a '*practiced place*' (1984: 117) and Mildred and Edward T. Halls' (1975) discussion of the 'transaction' between humankind and their environment serve to further develop understandings of environmental engagement occurring at the point of interaction between individual and site. Yi Fu Tuan's discussion of 'Topophilia' (1974) pertaining to the human tendency to couple sentiment with place and environmental psychologists Proshansky and Krupat's (1983) discussion of 'place identity'[11] are useful concepts when considering how individuals might relate to places and develop individual constructions of 'located-ness'. An alternative perspective, however, is presented by French theorist Marc Augé (1992) who proposes that contemporary practices of 'super modernity' have resulted in the production of 'non-places' such as airport lounges and shopping malls in which individuals have no sense of a relationship with the places that they pass through, pass by or connect with through virtual media. From the field of human geography, Doreen Massey's ideas have been broadly adopted within the field of dance research, notions of 'co-evalness' and spatial simultaneity challenge the concept of a singular, fixed 'present' (2005) and she alternatively proposes a form of spatial existence that is in a constant state of production resulting in a simultaneity of 'here and nows'; while I am experiencing this place, another individual is simultaneously engaged in their own spatial experience next door, in the next street, or on the other side of the world. This notion of multiplicity is a potentially useful tool for expanding artistic approaches to engaging with space, place and site as it encourages us to consider the complexity of sites as they are made up of many factors co-existing at any one time. Similarly, ideas emerging from the work of Nigel Thrift (2002), John Wylie (2007), Tim Ingold (2011) and Peter Merriman (2012) within the field of human geography and non-representational theory have informed many site-dance researchers in their articulation of tacit knowledge contained within spatialised movement practices.

Phenomenological theory and, in particular Heidegger's (1962) concept of dwelling and 'being-in-the-world', informs the work of many dance practitioners and theorists featured in this volume. This philosophical approach places the body-self and its perception of the world at the centre of lived experience thereby valorising corporeal and sensorial knowledge. Merleau-Ponty's (1962) development of Heidegger's theories, in particular notions of the lived body and phenomenological explorations of the relationship between self and other inform a number of chapters in which practitioner-researchers consider in-depth relationships between themselves and the site-world. The writings of dance theorists informed by

phenomenological theory including Maxine Sheets-Johnstone (1979), Sondra Fraleigh (1987) and Jaana Parviainen (1998) develop (among others) notions of reversibility and bodily knowledge proposed by Heidegger and Merleau-Ponty, concepts that are re-examined here through their application within site-specific choreographic discourse. Similarly, a number of contributors to this volume refer to the work of French philosophers Gilles Deleuze and Félix Guattari (1987) whose non-hierarchical, multiplicitous considerations of engaging with the world have helped them to articulate their own work and theoretical concerns explored through practical inquiry. The list of theoretical frameworks presented here is by no means exhaustive; particular ideas emerging from the fields of psychology, science, mobility studies, geopolitics and geopoetics, ecology and gender studies, for example, do not feature explicitly in this brief introductory discussion yet can be found within a wide range of site-specific dance and performance discourses. Reflecting the ever-expanding and ever-curious nature of the genre this list continues to grow as the real-world nature of the practice demands a form of engagement with wider fields of discourse that enable practitioners and dance artists to make sense of their practice and the world in which it exists.

The approach to site-specific dance performance presented in this volume is, therefore, deliberately and necessarily inclusive. As opposed to a position of absoluteness, the definition of the genre presented here is intended as a point of departure informed by developments in the field that have seen the genre expand to encompass a wide and diverse range of practices. In essence, site-specific dance performance has, in many ways, departed from approaches informed by the pioneering mantras of the visual and live art movement of the 1960s and 1970s in which the quest for specificity dominated and, as sculptor Richard Serra (1994) later proposed; 'to move the work is to destroy the work' (in Kaye 2000: 2). From this perspective it has evolved to encompass a broader range of site-generic and site-adaptive, installation, walking practice, flash mob, intimate performance and digital art practices that are less concerned with absolute specificity *per se* as the primary driver and instead address and interrogate broader notions of mobility, presence, subjectivity, affect, disruption and resistance.

Attempts to categorise and 'fix' definitions of artistic genres, outputs and types of work are, by their very nature, contentious. However, it is perhaps useful here to acknowledge and explore some of these attempts as a means of identifying prospective 'ways in' to making site-specific dance performance and the potential application of category definitions as useful tools for analysing and evaluating the aims and outcomes of this work.

Fiona Wilkie (2002) conducted the first ever survey of site-specific performance in Britain and through doing so aimed to categorise a range of site-specific practices and identify some of their key characteristics. While containing some information gathered from dance companies, the survey predominantly referred to site-specific work derived from theatre and

performance disciplines. In her article *Mapping the Terrain*, she presented a model of 'specificity' proposed by the performance company Wrights and Sites as a continuum that includes distinctions between 'site-sympathetic', 'site-generic' and 'site-specific' work:

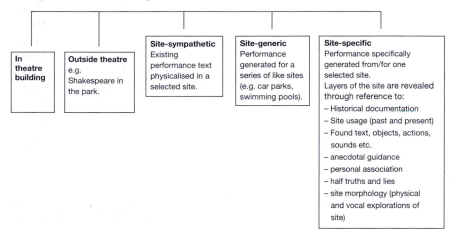

Figure 0.1 Model of site-specificity (Wrights and Sites cited in Wilkie 2002)

Reflecting on this model 13 years later it is clear to see that it represents a field of practice that, at the time of construction, was still in its infancy and grappling in some ways to capture and encapsulate the commonalities and differences between distinct creative approaches and performative outcomes. For example, at one end of the scale presenting a re-working of *Hamlet* on castle ramparts and, at the other end creating site-specific performance such as Mike Pearson's *Raindogs* sited in Cardiff in 2002 informed by a creative process defined as one of 'deep mapping' (p. 68) arising from the artist's engagement with complex layers of site information. In her accompanying description of the model, Wilkie observes that a qualifying component of the site-specific category is the notion of a 'sense of fit' whereby performance work situated in this category contains a sense that 'the performance "fit" the site and vice-versa' (Wilkie 2002: 149), working with the site rather than imposing itself upon it.

Site-dance practitioners and scholars Melanie Kloetzel and Carolyn Pavlik (2009) propose four categories or approaches to site dance making in their publication *Site Dance: Choreographers and the lure of alternative spaces* that allude to a practice-based approach to experiencing site and developing dance material into performance work. In their first category, *Excavating Place: Memory and Spectacle* they refer to creative processes that engage choreographers with researching historical site information in an attempt to 'unearth the memories linked to place, the details of bygone eras' (p. 27) and cite works by Meredith Monk and Joanna Haigood. Their second category; *Environmental Dialogues: Sensing site* explores interventions in

public sites that utilise the choreographer's and performers' sensory responses as a means of developing dance content. In this category they refer to the work of Olive Bieringa and Otto Ramstad's Body Cartography Project and the work of Leah Stein. The third category or approach is defined as *Revering Beauty: The Essence of Place*, one that draws on phenomenological and aesthetic explorations of site as a means of 'restor[ing] people's communication with place by enhancing their admiration of it' (p. 178), exemplified in the processes of Eiko Otake's *Breath* (1998) and *Tree Song* (2004). The final category *Civic Interventions: Accessing Community* refers to examples of the politically-driven work of the experienced and prolific site dance artists such as Martha Bowers and Jo Kreiter and, as a category it encapsulates applied site-dance work and its potential as a vehicle for community engagement with site and environment.

US based choreographer Stephan Koplowitz, a key figure in the development of site-specific dance, has been producing performances in a range of locations since the early 1980s. His own category definitions of site-dance echo those proposed by Wrights and Sites in many ways. Koplowitz proposes four categories of site-specificity arising from the choreographer's artistic intention; site-specific, site-adaptive, studio-site and reframing the known.[12] In the first category Koplowitz refers to the ephemeral and unique nature of site-specific dance performance arising from the choreographer's engagement in a process of dialogue with the site. Koplowitz's own work *Babel Index* (1998) performed in the British Library, London provides an example. The second category; site adaptive work, involves a process in which all artistic decisions are inspired by the site, its design, history, current use and community, however the site in question is generic and the work can be re-made and adapted to numerous sites. This aligns with Wrights and Sites' 'site-generic' category and is exemplified by Jacky Lansley's work *Standing Stones* (2008), a dance work that toured to a number of cathedrals in the North of England. In the third category, Koplowitz introduces the notion of 'reframing' in which a choreographer intentionally takes an existing dance work and places it in a specific location. In this process of reframing Koplowitz proposes that there is some degree of a relationship between the location and the work and, from this starting point the choreographer might alter or amend discrete elements in relation to the site's physical components; the site influences the work's presentation but not its thematic content. An example of this process can be seen in the reframing of DV8's work *The Cost of Living* (2000), a work originally created for stage and subsequently adapted for the screen. In 2003 this work was re-staged in London's Tate Modern gallery and re-titled *Living Costs*, audience members followed the work around the site in promenade format and experienced the physical re-staging of the work while the thematic content remained unaltered. Koplowitz's final category 'reframing the known' refers to a process of placing an existing performance work in a non-theatre venue, effectively reframing the work and presenting it in a

different context for a (potentially) different audience. The performance of Merce Cunningham's work in outdoor locations and the re-presentation of Trisha Brown's *Accumulation* (2010) in the Turbine Hall of Tate Modern, London provide examples of this kind of work. While this final category may appear somewhat sanitised and distanced from earlier, reactionary examples of site-specific dance practice, the notion of reframing is perhaps useful when considering the affect and impact of placing theatre-dance in real-world locations. This subtle infraction in a small yet significant way forces a shift of perspective regarding considerations of where dance can take place and where audience members might locate themselves physically and conceptually in relation to it.

These models and category definitions provide useful starting points for discussion when considering how to identify particular types of site-specific work and working methods in relation to artistic aims and objectives. However, in many ways they fail to capture the breadth and richness of many site-specific performance encounters. For example, Wrights and Sites' model (no doubt due to the era of its construction) does not reflect the current expansion of site-specific practice into digital and interactive domains. The model perhaps requires additional categories that can encompass works such as Sophia Lycouris' *City Glimpses* (2013) in which dancers performed simultaneously in three urban locations via live streaming and Anna McDonald's *This is For You* (2014) in which a single audience member situated in a shop window 'receives' a dance from a solo performer in the street. Similarly, Angela Woodhouse's dance installation work *Court* (2006),[13] a touring performance for two dancers and one audience member sited inside a temporary tented structure located in a gallery space creates an intimate performance 'space-within-a-space' in which the dance experience unfolds. The model could also perhaps expand to consider the proliferation of dance work appearing within festival events that prioritise spectacle and the spectacular by programming several dance works in quick succession within the same site. Melanie Kloetzel (2014)[14] observes that this work is often site-generic and unrelated to the contexts in which it appears and offers a consideration of this type of work as simply 'on site' and 'non-specific'. Reflecting positively on this work, however, she suggests that it potentially acts as a 'place magnifier, enabling new angles on a place to be witnessed as opposed to a singular vision presented by one choreographer', as the consumer-festival goer becomes the creator of their own event experience by selecting which works to view. She further argues, however, that without a sense of conscious curation there is a danger that festival work encourages us to slide into placeless-ness as site-dance events become commodified and effectively less site-specific.

In recent years there has also been an upsurge of non-theatre based performance 'events' involving durational components, audience choice and autonomy, for example Punchdrunk's *Sleep No More* (2011–12) performed in a disused New York hotel and *The Drowned Man* (2013–14), an

episodic, promenade performance work sited in a disused London warehouse. Both works enabled audience members to choose the duration of their 'visit' and the order in which performance episodes were viewed. Louise Ann-Wilson's *Fissure* (2011) involved walking and dance performance that unfolded over a three-day period in the Yorkshire Dales and performance company Duckie's work *Lullaby* (2011) invited audience members to spend the night at the Barbican theatre, London as the work lulled them to sleep. This type of performance work invites the audience/ experiencer to 'live' alongside the work as it unfolds and encounter aspects of site-performance making in real time and places the body-self at the centre of the experience. Similarly, the work of more 'self-specific' approaches practised by environmental movement artists such as Helen Poynor, Gretel Taylor, Tamara Ashley and Sandra Reeve in which the body's immersion in the landscape constitutes the central core of their dance practice and the movement outcomes may (or may not) be presented for sharing with others, does not appear to be fully aligned with any of the categories referred to above. These performance examples and practices, and many others, challenge category definitions presented in the models discussed here and introduce possibilities for a reconsideration of site works as multi-layered, mobile and unfixed.

Returning to Wilkie's discussion of 'fit' it is perhaps useful here to pursue further an observation posited (but not pursued) by Wilkie that 'the "fit" may not be a comfortable merging with the resonances of the site but might be a reaction against them' (2002: 149). The expanded range and scope of diverse performance work discussed in this volume and encompassed under the umbrella term 'site-specific' provokes a necessary re-examination of the notion of 'fit'. I would contend that the definition of a sense of fit could be many and varied, encompassing a range of practices encompassing *senses* of fit that range from the congruous to incongruous, respectful and irreverent, elaborate and incongruous, overt and covert. Furthermore, it would appear that the questions and complexities associated with exploring senses of fit have occupied the concerns of many site-dance and performance artists developing this type of work in the twenty-first century as they question and explore what constitutes a sense of fit between site and work, body and site, individual and world in a range of urban, rural, globalised and mediatised contexts.

These concerns illuminate the complexity of engaging with research into space and place, and attending to the minutiae of rhythm, materials, energies and essences that shift, change and develop both when we notice and when we look away. The perpetual motion of space and place and its dynamic affect, the ability for sites to change before our very eyes becomes illuminated, brought forward to consciousness through the site-specific research process. For the site-dance practitioner therefore, interdisciplinary dialogues present other ways 'in' to considering and experiencing space and enhance understandings of the mobility of space and place as unified

entities possessing fluid and permeable boundaries. In turn, these dialogues enable a 'freeing up' of category definitions and support a mobile conception of the genre that encompasses a myriad of practices, approaches and methods. From this perspective, dialogues from practitioners and academics from Australasia, Europe, Canada and America contained within this volume converge here to collectively develop understandings regarding the practices, challenges and potential of site-specific dance performance.

Notes

1 Dance practitioners and companies engaging in this type of work include Susanne Thomas, Rosemary Lee, Shobana Jeyasingh, Athina Vahla, Rosie Kaye, Gerry Turvey, Lea Anderson, Ascendance Rep, Coiscéim Dance Theatre, Motionhouse Dance Theatre. Not all of these practitioners engage exclusively in site-specific work and some are engaged with exploring notions of specificity more than others.

2 For further information regarding folk dance and anthropological perspectives, see Farnell, B. and Williams, D. (2004) *Anthropology and the Dance*, Illinois: University of Illinois Press; and Buckland, T. (2007) *Dancing from Past to Present*, Wisconsin: Wisconsin University Press.

3 For a discussion of re-defining dance history through a multi-layered approach, see Carter, A. (2003) *Re-defining Dance History*, London: Routledge.

4 Vito Acconci in conversation, *Lumen* lecture, University of Leeds, 5 November 2004.

5 For a detailed discussion of this statement, see Banes, S. (1987) *Terpischore in Sneakers*, Wesleyan: Wesleyan University Press.

6 www.bonnieparker.tv/writing/the-landing-of-the-x6-2/ accessed 29 October 2013.

7 The Quay brothers in interview with Joe Brean and Morishka van Steenbergen, *Guardian* Newspaper, 18 May 2012.

8 *Walk of Life* workshop Dorset, May 2007.

9 In Bannerman, Sofaer, Watt (eds) (2006) *Navigating the Unknown: The creative process in contemporary performing arts*, London: Middlesex University Press.

10 Rosemary Lee in conversation with Donald Hutera (2009). [online] [accessed 16 June 2009] Available from www.danceumbrella.co.uk

11 Referring to the individual's identification with place as an influencing factor upon the construction of self-identity.

12 Koplowitz, S. Lecture notes 'Creating Site-Specific Dance and Performance Works' online lecture, Coursera, Calarts, December 2013.

13 See: http://angelawoodhouse.co.uk/recent-past-work/court-2003-06/

14 Kloetzel, M. (2014) 'Site Work on Tour: Labor, Mobility and Critical Engagement', conference presentation, *Performing Place Symposium*, University of Chichester, June 2014.

References

Augé, M. (1992) *Non Places: An introduction to super-modernity*, London: Verso Publishing.

Banes, S. (1987) *Terpischore in Sneakers*, Wesleyan: Wesleyan University Press.

Bannerman, C., Sofaer, J. and Watt, J. (eds) (2006) *Navigating the Unknown: The creative process in contemporary performing arts*, London: Middlesex University Press.

Birch, A. and Tompkins, J. (eds) (2012) *Performing Site-Specific Theatre: Politics, places, practice*, Basingstoke: Palgrave.

Buckland, T. (2007) *Dancing from Past to Present*, Wisconsin: Wisconsin University Press.

Calle, S. (1988) *Suite Vénitienne: Please follow me*, Washington: Bay Press.

Carter, A., Fensham, R. (eds) (2011) *Dancing Naturally: Nature, neo-classicism and modernity in early twentieth century dance*, Basingstoke: Palgrave.

Cresswell, T. and Merriman, P. (2012) (eds) *Geographies of Mobilities: Practices, spaces, subjects*, London: Ashgate.

De Certeau, M. (1984) *The Practice Of Everyday Life*, California: University of California Press.

Deleuze, G. and Guattari, F. (1987) *A Thousand Plateaus: Capitalism and schizophrenia*, Minnesota: University of Minnesota Press.

De Oliveira, N., Oxley, N. and Petry, M. (1994) *Installation Art*, London: Thames and Hudson.

Farnell, B. and Williams, D. (2004) *Anthropology and the Dance*, Illinois: University of Illinois Press.

Fraleigh, S. (1987) *Dance and The Lived Body: A descriptive aesthetics*, Pittsburgh: University of Pittsburgh Press.

Hall, M. and Hall, E.T. (1975) *The Fourth Dimension In Architecture: The impact of building on behaviour*, Santa Fe, Mexico: Sunstone Press.

Heidegger, Ma. (1962) *Being and Time*, London: Blackwell Publishing.

Hill, L. and Paris, H. (2006) (eds), *Performance and Place*, Basingstoke and New York: Palgrave Macmillan.

Houston, A. (2007) (ed.) *Environmental and Site-Specific Theatre*, Toronto: Playwrights Canada Press.

Ingold, T. (2011) *Being Alive: Essays on movement, knowledge and description*, London: Routledge.

Jordan, S. (2000) *Striding Out: Aspects of contemporary and new dance in Britain*, London: Dance Books.

Kaye, N. (2000) *Site-Specific Art: Performance, place, and documentation*, London: Routledge.

Kloetzel, M. (2014) 'Site Work on Tour: Labor, Mobility and Critical Engagement', conference presentation, *Performing Place Symposium*, University of Chichester, June 2014.

Kloetzel, M. and Pavlik, C. (2009) (eds) *Site Dance: Choreographers and the lure of alternative spaces*, Gainesville, Florida: University Press of Florida.

Koplowitz, S. (2013) Lecture notes 'Creating Site-Specific Dance and Performance Works' online lecture, Coursera, Calarts, December 2013.

Kwon, M. (2004) *One Place After Another: Site-specific art and locational identity*, Massachusetts: MIT Press.

Lefebvre, H. (1974) (trans. Nicholson-Smith, 1991) *The Production Of Space*, Oxford: Blackwell.

Mackrell, J. (1991) 'Post Modern Dance in Britain', *Dance Research*, 19(1), Spring.

Mackrell, J. (1992) *Out of Line: The story of British new dance*, London: Dance Books.

Massey, D. (2005) *For Space*, London: Sage Publishing.

Merleau-Ponty, M. (1962) *The Phenomenology of Perception*, London: Routledge.

Merriman, P. and Cresswell, C. (2012) (eds) *Geographies of Mobilities: Practices, Spaces, Subjects*, London: Ashgate Press.

Parviainen, J. (1998) *Bodies Moving and Moved: A phenomenological analysis of the dancing subject and the cognitive and ethical values of dance art*, Finland: Tampere University Press.

Pearson, M. (2010) *Site Specific Performance*, Basingstoke: Palgrave.

Pearson, M. and Shanks, M. (2001) *Theatre/Archaeology: Disciplinary dialogues*, London: Routledge.

Proshansky, H.M., Fabian, A.K. and Kamino, R. (1983) 'Place-identity: Physical World Socialization of the Self', *Journal of Environmental Psychology*, 3, pp. 57–83.

Rendell, J. (2006) *Art and Architecture: A place between*, London: IB Tauris.

Schechner, R. (1994) *Environmental Theatre*, New York: Applause Books.

Sheets-Johnstone, M. (1979) *The Phenomenology Of Dance*, London: Dance Books.

Soja, E. (1996) *Thirdspace: Journeys to Los Angeles and other real-and-imagined places*, London: Wiley-Blackwell.

Suderberg, E. (ed.) (2000) *Space, Site, Intervention: Situating installation art*, Minnesota: University of Minnesota Press.

Thrift, N. and Grang, M. (2002) (eds) *Thinking Space*, London: Routledge.

Tuan, Y.F. (1974) *Topophilia: A study of environmental perception, attitudes, and values*, New Jersey: Prentice-Hall Inc.

Tufnell, M. and Crickmay, C. (1990) *Body, Space, Image: Notes towards improvisation and performance*, London: Dance Books.

Tufnell, M. and Crickmay, C. (2004) *A Widening Field: Journeys in body and imagination*, London: Dance Books.

Wilkie, F. (2002) 'Mapping the Terrain: a Survey of Site-Specific Performance in Britain', *New Theatre Quarterly*, xv(111) (Part 2, May 2002), pp. 140–160.

Wilkie, F. (2005) 'Hybrid Identities? Space and Spectatorship'. [Unpublished symposium paper] *Anywhere But The Stage Symposium*. University of Surrey, January 2005.

Wrights and Sites (eds) (2000) 'Site-Specific: The Quay Thing Documented,' *Studies In Theatre and Performance* (Supplement 5) August 2000.

Wylie, J. (2007) *Landscape*, London: Routledge.

Part I

Approaching the site

Experiencing space and place

Victoria Hunter

This section introduces the reader to a number of philosophical ideas and practical approaches to negotiating interactions with space and place. It combines theoretically driven essays with practitioner accounts of working practices that employ spatial and phenomenological theory and experiential methods to approaching site, engaging with space and place and making site-specific dance performance. This section is, essentially about beginnings, encounters and exploratory methods and, through the contributors' approaches it addresses questions such as: where to begin, what to respond to and how to react to spatial information and place-based experience.

The section begins with my own essay that presents a model for experiencing site and a framework for considering how site-based experiences and both formal and informal site responses might inform the making of a performance work. Following this, Fiona Wilkie's chapter presents interview material from two contemporary site-based artists in which they discuss their individual approaches to developing site performance. In this chapter dance artist Carolyn Deby and performance maker Stephen Hodge reflect on contemporary developments in site-based practice and consider how evolved considerations of site, mobility, environment and ecology have informed the development of their work. In the third chapter, architectural academic Rachel Sara explores relationships between the built environment and the moving body in which she presents an account of her movement–architecture workshop practice that aims to explore synergies between moving bodies and designed spaces. Through a discussion of atmosphere and the affective qualities of spaces presented in Chapter 4, human geographer Derek McCormack invites us to consider the often, ineffable qualities of spatial interactions and presents an engaging theoretical discussion that explores ideas of non-representational theory in relation to corporeal and sensory space–time encounters. The section concludes with the re-presentation of my essay *Embodying the Site* in which many of the theoretical ideas explored in the preceding chapters are exemplified through the account of the *Beneath* (2004) creative process. This chapter presents an account of my working processes when creating a site-specific dance work in a basement location. Informed by theoretical

ideas posited by the human geographer Doreen Massey, the chapter outlines a number of working methods and reflects on the implications of the work in terms of what this type of practice might reveal regarding understandings and experiences of space and place.

1 Experiencing space

The implications for site-specific dance performance

Victoria Hunter

This chapter considers how site elements might influence and affect creative dance practitioners.[1] It explores relationships between the spatial and experiential components of site and the choreographer and considers how these relationships might inform the creative process leading to performance.

Drawing upon the work of architectural and philosophical theorists concerned with the experiencing of space, including Henri Lefebvre (1974, 1991), Bryan Lawson (2001), Yi-Fu Tuan (1974, 1977) and Gaston Bachelard (1964), initial questions of how we experience, perceive, and interact with space are explored. These theories of space and spatial interaction are placed alongside those drawn from choreographic and performance theory offered by Valerie Briginshaw (2001) and Valerie Preston-Dunlop (1998) in an attempt to begin to draw parallels between the philosophical and practical areas of dance and space theory. Concepts of social and personal space, ways of constructing, experiencing, perceiving, and reading them and the implications for site-specific dance performance are considered here. The chapter focuses on architectural and constructed spaces and does not concern itself with landscaped or geographical environments. Though the existence of dance specific spatial components (Hunter 2007) implicit in choreographic creation is acknowledged, they are not scrutinised in depth here.

The chapter concludes with the presentation of a 'model of influence' as an illustration of how the various approaches upon the creative and interpretive process can be of influence.

Perceiving, constructing and experiencing space

The process of perceiving space can be defined as a form of absorbing and ordering information gained while experiencing and interacting with space. Perception can be seen as a process of 'making sense' of this information, a process that is particular to each individual. Further definitions are provided by Bryan Lawson (2001) and Christian Norberg-Schulz (1963),

Perception is an active process through which we make sense of the world around us. To do this of course we rely upon sensation but we normally integrate the experience of all our senses without conscious analysis.

(Lawson 2001: 85)

Our immediate awareness of the phenomenal world is given through perception.

(Norberg-Schulz 1963: 27)

These definitions imply that perception is distinct from analysis and is an active process, occurring subconsciously, almost instantaneously. The act of perception is a personal one, subject to many variables; space and spaces therefore can be experienced and perceived in many different ways by many individuals. Towns, cities and buildings, however, are constructed spaces, 'concrete' in dimensions and form, so how can such 'closed' structures produce a variety of responses and interpretations?

Lefebvre (1991) and Lawson (2001) suggest that environments and spaces are 'constructed' in a variety of ways. Lefebvre considers concepts of 'socially' and 'personally' constructed space, as 'real' or 'mental' space. Linked to this is the practice of architecture itself. While many architects are assigned or assign themselves to a particular architectural 'school' or movement, few provide a concise, generic definition of the term 'architecture'. For the purposes of this discussion therefore, an appropriate definition of architecture is provided by the dance scholar and architectural user and 'consumer' Valerie Briginshaw: 'spaces that are structured actually or conceptually according to ideas associated with building design' (2001: 183).

On first inspection, this definition appears straightforward enough. On closer inspection, however, it begins to raise questions regarding authorship and construction. Buildings do not simply appear; they are subject to complex processes of planning, designing and re-designing, eventually culminating in construction and realisation. Likewise, towns and cities evolve according to a number of factors including history, economic growth, social migration, and national and international policy. Buildings, towns and cities largely speaking are subject to rules and regulations regarding planning. They are constructed environments and, as such, dictate and influence how we experience and ultimately interpret them.

An examination of the use of scale in construction can serve to illustrate this point. Bryan Lawson (2001: 29) observes: 'Scale is one of the most important elements in the social language of space.' He then cites the example of the city of Prague dominated by the grand Hradčany castle built at the top of a hill overlooking the city. He describes how housing built at the foot of the hill is small and increases in size and stature towards the top of the hill nearest the castle, reflecting the social hierarchy in existence at

the time of construction (Lawson 2001: 50–1). This use of scale indicating wealth and status is still prevalent in Western society today. Large houses are deemed 'grand' and 'imposing' deferring social and economic status upon the occupants. Similarly, the size and scale of many civic buildings reflects the importance of the activities taking place within. Notions of power and control can also be associated with large civic and corporate buildings. Briginshaw (2001: 30) observes: 'As a social construct space is not transparent and innocent, it is imbued with power of different kinds.'

Briginshaw's observation highlights how particular elements of location, scale, construction, and design can be interpreted and imbued with meaning according to the dominant ideology of a particular society. Historically, in the UK for example, we associated the term 'inner city' with notions of poverty and deprivation, while 'the countryside' carried with it images of peace and tranquillity.[2] Social construction of space can be seen therefore to develop through associations and connotations assigned to particular environments and spaces. Through common usage these associations become part of the common psyche. Thus cities, spaces, and environments are 'constructed' on a number of levels including physical and social ones as influenced by ideology.

Such social and ideological factors can influence the way in which we interact with and experience spaces. However, the physical construction and design of spaces and buildings directly dictate the manner in which we physically engage with space. Road systems and one-way traffic management schemes dictate how we enter cities and towns. Entrances and corridors determine how we navigate our journey through buildings. Lawson describes architectural and urban spaces as:

> 'Containers to accommodate, separate, structure and organize, facilitate, heighten, and even celebrate human spatial behaviour'
>
> (2001: 4)

Here, Lawson is referring to a degree of architectural 'control' examined later. Constructed environments inevitably provide us with a wealth of formal and informal spatial information. While we may not consciously be aware of their impact upon our perception of space, Lawson explains how our brains prioritise these elements over others when later attempting to recreate a space in our 'mind's eye'. Lawson (2001: 62–8) identifies these elements as:

Verticality
Symmetry
Colour
Number (of windows, columns, doors, etc.)
Meaning (i.e. 'labels' church, gallery, etc.)
Context (our context when entering a space)

The first four elements listed here refer to an interaction with the more formal and structural elements with space, leading perhaps to an aesthetic response. The remaining two elements, meaning and context, both relate to the social and personal construction of space and require further examination.

The dominant ideology of any given society attaches labels of meaning to particular buildings and environments. These meanings are often constructed externally via architectural design and internally through conventions of use. This type of functional inside/outside interface is also facilitated via the internal design of the building serving to orchestrate and engineer the individual's interaction with the space and ultimately the institution it houses or represents. Lawson provides a pertinent illustration of this process when describing the conventions surrounding the construction of and interaction with church buildings:

> The Christian church not only organizes space for ritual, but also uniquely locates each of the roles in the special society of worship. The chair, the congregation, and the clergy each have their own place, and a Christian visiting a strange church will have little difficulty in knowing where to go and how to behave.
>
> (Lawson 2001: 26)

Lawson implies that the 'meaning' of the space refers not only to its external façade, but also indicates the building's function and the social norms employed when interacting with the space. These meanings and social norms attached to certain buildings can be culturally determined and are often identifiable only to those familiar with the conventions of usage. For example, an individual well versed in the conventions and social norms of a church building may be unfamiliar with the conventions employed within other places of worship. The individual's subjectivity and the context in which they experience a particular building or site may also impact upon their experience and perception of the space.

Personal, social, time-based, environmental, cultural, geographical, and political contexts can influence and impact upon our experience of place, to quote the Dutch architect Aldo Van Eyck: 'Whatever space and time mean, place and occasion mean more. For space in the image of man is place, and time in the image of man is occasion' (Van Eyck in Lawson 2001: 23).

Again, using the example of a church space, we can see how our experience and interaction with the space can be radically altered according to the context of the occasion occurring within the space. Weddings, funerals and christenings all elicit differing responses to and prescribe differing interactions with the space, while the internal and external architectural make up remains essentially the same.

Choreographers engaging in the creation of site-specific work need therefore to experientially research the site on a number of occasions and

from a range of social, cultural and contextual perspectives prior to embarking upon the creative process (see Hunter 2007).

While 'external' factors focus the experience of space, therefore, 'internal' elements add contextual meaning. Erving Goffman (1969) highlights how the 'performance of self' affects the way in which we interact with any given space and Gaston Bachelard (1964) emphasises the psychological associations we make with spaces, suggesting that attics, for example, relate to the 'super ego' (p. 19) while basements connect to 'the dark id' (p. 19); the home remains a haven, an 'ideal' space. Lefebvre, however, urges that both external and internal spatial factors operate upon our experience and perception of space: 'In actuality each of these two kinds of space involves, underpins and presupposes the other' (Lefebvre 1991: 14).

Thus both external and internal 'contexts' influence and inform our experiencing of space inferring a two-way interaction between individual/space and space/individual.

Notions of a passive, arbitrary interaction with spaces are further challenged when exploring Lawson's earlier reference to architectural 'control'. He argues that our experience of space is managed by architects, designers and town planners in particular ways. In this sense, space is both 'product and producer' (Lefebvre 1991: 142). It is both produced by the architect and planner and produces certain patterns of behaviour: 'Space commands bodies, prescribing or proscribing gestures, routes, and distances to be covered' (Lefebvre 1991: 143).

Lawson's example describes a pathway and a series of gates leading to a private house: '[As an architectural system which] symbolizes and controls the transition from public through semi-public and semi-private areas to the private domain. It signals changes of possession, of control, and of behaviour' (Lawson 2001: 12).

Architectural 'control' can be experienced in a vast number of buildings in the constructed environment. For example, when entering a hospital building we may walk down a directed footpath, through an external covered entrance porch, through automated sliding doors, into a reception area with signs indicating a stated direction. This process again indicates and controls a transition and change in status from the autonomous to the institutional. Equally, site-specific dance performance by its very nature has the potential to challenge and disrupt the site's conventional norms of usage, a factor which can effectively operate as a choreographic 'device' in its own right as the choreographer explores alternative approaches to moving through, on and around the site.

While recognising the concept of the 'architect as author' it is also important to avoid the intentionalist assumption that a 'closed' or 'fixed' reading of any particular space is achievable or indeed desirable. Lefebvre argues that spaces themselves construct meanings (albeit influenced by the

intentions of the architect/planner): 'a space is not a thing, but rather a set of relations between things (objects and products)' (Lefebvre 1991: 83).

This suggests that constructed environments are not simply empty, passive spaces; instead they actively engage with their contents, users, contexts, and environments to construct meanings. Through this process of interaction, according to Michel de Certeau, place (stable, positional) becomes space (mobile, temporal): 'In short, *space is a practiced place*. Thus the street geometrically defined by urban planning is transformed into a space by walkers' (de Certeau 1984: 117).

The meanings and associations encountered in sites and places then are not absolute but are open to the further processes of individual interaction and interpretation resulting in multi-'readings'.

Internal and external space

As the concern of this chapter is with the concepts of experiencing and perceiving space, the notion of 'architect as author' is limiting, as observed by Mildred and Edward T. Hall, 'Far from being passive, environment actually enters into a transaction with humans' (Hall and Hall 1975: 9).

This 'transaction' is key, as acknowledged by Hall and Lefebvre: both place the individual at the core. Lefebvre refers to the concept of 'internal and external space' (Lefebvre 1991: 82). In geographical terms this could relate to indoor and outdoor spaces. In human terms, however, this can refer to 'internal' mental, cognitive space, and 'external' physical and sensory space occupied by the individual. He adds: 'each living body *is* space and *has* its space; it produces itself in space and also it produces that space' (Lefebvre 1991: 170).

According to Lefebvre, therefore, the body *is* space – we consist of both internal (mental) and external (physical) space, we produce ourselves in the world while also physically constructing spaces and environments. This third stage, the production of space, can occur in several ways, the most literal of which is the architectural construction of towns, cities, and buildings. We can also produce space through our external physical interactions with space. For example, the process of travelling from point A to point B is constructed conceptually as 'a journey'. 'Journeys' can vary in size and duration including movements from room to room or from country to country, consisting of both micro- and macro-forms connecting through both time and space. Accordingly, site-specific choreography presents a unique form of spatial production emerging from the dancer's movement interventions in the site, described by choreographer Carol Brown (2003) as a form of 'ephemeral architecture'.

The inside/outside interface perhaps becomes more complex when considering our 'internal' (mental/cognitive) construction of space. This internal construction of space is also influenced by external factors and combines with elements such as our sensory, kinaesthetic, and emotional

responses to create a personal 'construction' of a particular space. In this sense we are referring to different ways of 'knowing' and experiencing a space, acknowledging the influence of sensory and 'other' forms of knowing upon the personal construction of space, in addition to the more formalised processes of experiencing such as the physical, visual and aural. Personal construction of space can be located as occurring at the point of interaction with environments and implies both an epistemological and physical approach to experiencing space.

Bloomer and Moore (1977) develop the discussion of 'inside' space by focusing on the more physical and anatomical elements of the experiencing process. They argue that our sense of internal space is created by a physical sense of space within the body. For example, in the common perception of the heart as the 'centre' of the body, referring to the heart and other major organs as 'landmarks': 'The heart, with its auditory and rhythmic presence, exemplifies the phenomenon of an internal landmark acquiring a universal spatial meaning in adult life' (Bloomer and Moore 1977: 30).

They discuss this type of 'knowing' in conjunction with the type of 'knowing' developed by the awareness of touch, the 'haptic' sense,

> To sense haptically is to experience objects in the environment by actually touching them (by climbing a mountain rather than staring at it)… and thus it includes all those aspects of sensual detection which involve physical contact both inside and outside the body.
>
> (Bloomer and Moore 1977: 34–5)

This suggests that the inside/outside interface becomes permeable, with the boundaries between body and space becoming 'fluid' (Briginshaw, 2001); sensations experienced on the outside of the body via the skin receptors are also experienced simultaneously on the inside of the body, often in a physical/sensorial manner such as shivering, excitement or revulsion. This further haptic information enables us then, as sensory beings, to locate and orient ourselves within general space. An internal 'grounding' provided by 'haptically perceived landmarks' (Bloomer and Moore 1977: 39) can serve to inform us of our own sense of internal space while processing 'external' spatial information. When combined with our 'internal' mental creation of space, these physical and 'haptic' influences can begin to contribute towards our perception of space.

Further to the methods of experiencing space already identified, perhaps the most illusive concept to examine and identify is the sensory experiencing of space. Upon entering a space our senses are immediately challenged and engaged; among many elements we react to sight, sound, smell, taste, temperature, and touch (our 'haptic' sense referred to previously). This notion of bodily 'knowing' and experiencing in relation to space is a concept, according to Lefebvre, which is often overlooked:

> When 'Ego' arrives in an unknown country or city, he first experiences
> it through every part of his body – through his senses of smell and taste,
> as (providing he does not limit this by remaining in his car) through his
> legs and feet.
>
> (Lefebvre 1991: 162)

Certainly, these sensory experiences can be seen to combine with those
spatial, aesthetic, and contextual images identified by Lawson when later
attempting to re-create a mental image of a space. Similarly, certain smells
and sounds can instantly evoke a recollection of place, highlighting the
power of the senses. In addition, certain theorists have identified a link
between space and the kinaesthetic sense, whereby an internal physical
sense of motion and engagement is created while interacting with a space.
Violet Paget, speaking of landscape in *The Beautiful* (1931) observes, 'You
always, in contemplating objects, especially systems of lines and shapes,
experience bodily tensions and impulses relative to the forms you
apprehend, the rising and sinking, rushing, colliding, reciprocal checking
… of shapes' (Paget 1931: 61).

This sense of motion can be linked to the physical aspects of scale and
the participation of the body in the appreciation of size. For example, the
kinaesthetic feeling induced when standing at the base of the Eiffel Tower
in Paris, looking up through the steel structure to its summit. A sense of
motion and bodily awareness is invoked, allowing comparison of the scale
of the structure with our own human form. Yi-Fu Tuan in *Topophilia* (1974)
argues that the very words we use to describe certain spaces and environments
imply a kinaesthetic relationship:

> The existence of a kinaesthetic relationship between certain physical
> forms and human feelings is implied in the verbs we use to describe
> them. For example, mountain peaks and man-made spires 'soar', ocean
> waves as well as architectural domes 'swell'.
>
> (Tuan 1974: 29)

Tuan's and Paget's acknowledgement of this type of kinaesthetic relationship
is important as it serves to underline the existence of these types of 'knowing'
with their reliance upon sensation and bodily awareness that challenge the
dominance of visual and formal factors. The kinaesthetic experience
therefore can be added to the list of elements (sensory, cognitive, spatial,
ideological and psychological) that combine and contribute towards our
experiencing of space and explain why individuals perceive spaces
differently through a 'process of experiencing'.

How all these contextual elements combine is the concern of the site-
specific choreographer.

Site-specific dance performance

Site-specific choreography is influenced by the choreographer's response to a particular space and/or location, which presupposes an implied awareness from the choreographer when selecting spaces for site-specific performance. The choreographer 'tunes in' to this awareness on a conscious level, while simultaneously reacting to the 'processes of experiencing' operating at a subconscious level. Tangible elements will have an immediate impact on the conscious level. These include formal and structural elements of the site, architectural design, historical and contextual information and also the practicalities of staging including site-lines and health and safety obstacles. At the same time, however, the other 'processes of experiencing', including personal aesthetic and artistic preferences will be informing the choreographer's choices and decisions. As Stephan Koplowitz observes:

> When creating a site-specific performance one is dealing with multiple levels at once: the architecture of the site, its history, its use, its accessibility. I'm interested in becoming a part of the design and rhythm of the site and amplifying that. This kind of work is not necessarily about big extensions and triple turns, but what is most appropriate for the site. The most virtuosic movements might simply be everyone raising their arms together.
>
> (Koplowitz, 1997)

Koplowitz captures here the essence of successful site-specific work, the creation of a carefully constructed balance between the performance and the site. The final performance outcome is at once a reflection of the site and its architecture and the choreographer's personal and artistic response to the site.

For the choreographer, the processes of experiencing and perceiving space and the subsequent interpretation of these responses combine with aesthetic and artistic concerns to inform the creative process by providing stimuli both conscious and subconscious for movement content and creation. This process can operate on a number of levels and is dependent upon the choreographer's working methods and experience. On a simplistic level, the choreographer may be inspired by the function or the architectural design of a space, the shape, form and number of columns and arches, for example. These formal elements may directly relate to the number of sections of a dance work, or may provide a starting point for an improvisational task, improvising around the theme of 'planes' or on the theme of reaching and dropping.

In addition to formal and structural site-related components, the individual's kinaesthetic empathy with a space can also influence the dynamic content of the choreography. In *Architecture, Form, Space and Order*, Francis Ching (1996) describes how 'rows of columns can provide a

rhythmic measure of space' (p. 16); this 'rhythmic' information could be interpreted to produce rhythmic, repetitive movements. In addition, the sheer size and scale of a building may influence both the content and the form of a work, causing the choreographer to investigate and explore the concept of size and scale in a choreographic sense, moving from experimenting with large to small movements and gestures. Even the practical concerns of staging can act as a stimulus for creative solutions leading to further performance development. The intangible 'processes of experiencing' and the phenomenological resonances of 'place' also influence the creation of movement material. For example, the subterranean location of a basement or cellar may influence the choreographer's 'processes of experiencing' and trigger contextual associations, to produce a work with an air of mystery or foreboding (see my discussion of the *Beneath* project in Chapter 5). Therefore, processes involved in the outside/inside interface combined with other sensory influences can combine and contribute to the underlying mood and 'feel' of a piece.

What then are the implications for the site? How does the site itself feature in such an interaction? Is its purpose merely to provide a stimulus and setting for a performance or does the interaction between the space and the performance develop further?

While the site > performance relationship is perhaps relatively easy to visualise, the performance > site relationship could be viewed as more complex. Essentially, the creative process can be viewed as a collaboration between site, choreographer and performer. Choreographer Carol Brown alludes to this process of interaction when discussing a dance–architecture workshop located in the Isadora and Raymond Duncan Centre for Dance in Athens:

> In responding to the architecture of the site, the performers uncovered layers of embedded history and new trace-forms. The centre became an ear for the body, listening to the movements of the dancers. Architecture and anatomy traded places. We passed messages between them. The walls spoke.
>
> (Brown 2003: 2)

Drawing upon theories offered in this discussion and considering the relationship or interface between site and choreographer as one which combines a socially constructed space with a personally constructed one, we can begin to see how the dance performance can serve to 're-inscribe' the space (Briginshaw 2001: 57), thus challenging the context, dominant ideology, and perception of a particular space or site. Site-specific dance performance situated within a church space, for example, can serve to challenge preconceptions concerning the form and function of the building as the audience use and view the building and its content from a different viewpoint, challenging the codes and conventions of usage. A pertinent

example of which is Gerry Turvey's site-specific dance work *Fallen Angels* (2004) performed in Holy Trinity church, Leeds (www.turveyworld.co.uk). In addition, the codes and conventions of performance spectatorship are also challenged. Gay McAuley discusses the conventions adopted in a traditional theatre setting:

> The behaviour of actors is marked; spectators know that it is to be interpreted differently from apparently identical behaviours occurring in other places. Spectators in the theatre both believe and disbelieve, they play a game in which they permit themselves to believe to a certain extent what is occurring.
>
> (McAuley 2001: 4)

This participation by the audience in a theatrical 'game' is challenged and heightened in site-specific performance as the rules are no longer defined according to the accepted conventions of theatre going; they become fluid and ill-defined, opening up the interpretive possibilities.

Pioneered by the post-modernists in the sixties and seventies, site-specific art and performance provided the ideal genre for the challenging of artistic convention:

> The conceptual focuses of sixties artists on the avant-garde use of site specific performance spaces which stretched audience perception, on a particular urban sensibility and on blurring boundaries, such as inside/ outside, private/public, and art/everyday life, paved the way for what was to follow.
>
> (Briginshaw 2001: 44)

Not only is the art form challenged and presented in a different format, but the nature and definition of the performance site itself is questioned, presented and transformed. Site-specific performance, with its lack of proscenium arch and auditoria seating, actively encourages the audience's participation both with the site and the performance. The audience becomes actively engaged in the construction of meanings and interpretation; they have a greater sense of participation and ownership over the performance as they are often responsible for placing themselves physically in the space as observers. Similarly, they are required to be more proactive in the interpretation of the work, as the conventions of the traditional theatre venue are abandoned, leaving the observer to respond to the work independently. In this sense, site-specific performance, with its frequent inclusion of elements such as promenade, can be seen to challenge traditional Euclidean theory implying 'a single viewpoint in space from which all points converge' (Briginshaw 2001: 89). Instead, a multitude of viewpoints is created, effectively 'de-centring' the performance space and fundamentally challenging notions of performance and spectatorship.

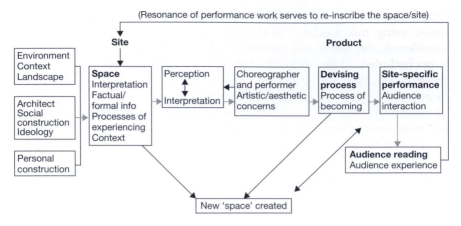

Figure 1.1 Hunter's model of influence, detailing the relationship between the site and the creative process.

Therefore, we can begin to see how the site influences the dance, which in turn influences the site, each component informing and defining the other; the choreographer essentially enters into a 'dialogue' with the space whereby the performance works *with* the site as opposed to becoming imposed upon it. In this sense, both the concept and definition of the dance and the space is constantly shifting, becoming a fluid entity with no 'fixed' meaning. During the site-specific dance performance, both the site and the performance piece exist in a state of 'becoming-ness'; the readings are never fixed. Clifford McLucas, co-artistic director of Welsh performance company Brith Gof observes, 'The real site-specific works that we do, are the ones where we create a piece of work which is a hybrid of the place, the public, and the performance' (McLucas in Kaye 2000: 55).

In a sense, this interaction between site, performance, and observer results in the creation of a new 'space', the conceptual space of performance that exists only temporarily yet brings a new dimension to the architectural location.

Conclusion – 'model of influence'

When considering the various elements involved in the creation of site-specific dance performance it is possible to identify a number of influencing factors involved in the production of a performance work. These factors are perhaps best illustrated via the presentation of a suggested 'model of influence', highlighting in linear form the relationship and interaction between the various components. The initial model shown in Figure 1.1 focuses on the 'site to product' relationship, following the creative journey from the individual choreographer's interaction with the space/site to the

creation of a final product/performance presented to an audience. When constructing this model, the various stages of spatial interaction were considered and the 'processes of experiencing' contained within these stages included. In this sense the 'through line' of influence from space to choreographer becomes affected and embellished by the various sensory, formal, psychological, and artistic elements collectively referred to here as 'processes of experiencing'.[3] The interplay between these processes may vary from space to space and from site to site. In some spaces, for example, formal and thematic elements may serve to influence the choreographer predominantly; in other spaces the sensory and personal construction of space may dominate. While recognising the existence and influence of these processes, the model does not suggest that all of these processes operate to influence the creative process at any one time. While this *may* occur, it is more likely that the various processes of experience will serve to influence the choreographer in a process of ebb and flow. Some processes will be more dominant at certain stages of the experiencing and creative process, while other factors will influence at other times. It is also necessary to acknowledge that the creative and devising process operates in a cyclical manner informed by the site–choreographer and site–performer relationship that develops and informs the creation of the final work. We recognise the existence of the choreographer and performers as living, breathing, and creative individuals, susceptible to a variety of factors that, in turn, will affect the processes of experiencing, perceiving and interacting with space and spaces.

In this model a continuous through line of influence can be witnessed, from the physical and social construction of space to the creation of a performance, and the audience's interaction with the performance. Prior to the presentation of the final performance product, however, a complex and creatively rich devising and creative exchange between the choreographer/performer and the space must occur; a process during which a temporary, new space of 'process' exists, inhabited by creative ideas and explorations which may or may not feature in the final performance outcome. Influencing factors, such as the various 'processes of experiencing' and the interpretive process together with aesthetic and artistic concerns, combine to contribute to the creation of performance material by the choreographer. This particular model reflects a devised approach to the creative process, thereby acknowledging the artistic and creative input of the performer. The active role played by the audience in the reading and interpretive process is also acknowledged in the model, a process which can carry resonances of the performance forward after the event, in turn serving to 're-inscribe' the original space with a variety of meanings. Finally, the creative potential presented by this type of interface between performance and space is alluded to via a reiteration of the suggestion that this type of interaction serves in itself to create a new type of 'space'. Preston-Dunlop captures the essence of this type of interaction:

The body-in-space
is the basic sculptural element of choreography.
Bodies enter and move through, in and with a space
turning the void into a place.

(Preston-Dunlop 1998: 121)

In site-specific terms, the type of 'place' created is the 'place' of performance, transforming the accepted and conventional properties ascribed to a particular space, while simultaneously creating a temporary place of performance. This interaction between the spatial and the performative is ephemeral in nature, existing only in the moment and can be identified perhaps as the 'true' and desired outcome of site-specific performance, a perfect synthesis between space, performance, and audience. In this sense, the role of choreographer can be viewed as that of an intermediary, providing a creative channel of communication between site and performance, informed and influenced by many varying factors that serve to enrich and enlighten the final performance outcome.

Notes

1 This chapter is a revised version of a previously published one 'Experiencing Space: The Implications for Site-Specific Dance Performance', in Butterworth, J. and Wildscutt, L. (2009) *Contemporary Choreography: A critical Reader*, London: Routledge. It is reproduced here with kind permission from the editors.
2 The idealised view of the countryside may be slowly eroding, however, following the wide-scale reporting of countryside flooding, erosion of farming traditions etc. in recent years in the UK.
 See: Appleton, J. (1975) *The Experience Of Landscape*, London: John Wiley & Sons.
 Bourassa, S.C. (1991) *The Aesthetics Of Landscape*, London: Belhaven Press.
 Brown, J. (1982) *The Everwhere Landscape*, London: Wildwood House Ltd.
3 In communication theory this concept is equitable to the concept of 'noise', the influencing or effecting factors at play during a communicative interaction between sender and receiver. See Fiske, J. (1982) *Introduction To Communication Studies*.

References

Appleton, J. (1975) *The Experience of Landscape*, London: John Wiley & Sons.
Bachelard, G. (1964) *The Poetics of Space*, New York: Orion Press.
Bloomer, K.C. and Moore, C.W. (1977) *Body, Memory, and Architecture*, New Haven: Yale University Press.
Bourassa, S.C. (1991) *The Aesthetics Of Landscape*, London: Belhaven Press.
Briginshaw, V. (2001) *Dance, Space, and Subjectivity*, New York: Palgrave.
Brown, C. (2003) *Dance–Architecture Workshop, Isadora and Raymond Duncan Centre for Dance*, www.Carolbrowndances.com (accessed 9 December 2005).
Brown, J. (1982) *The Everwhere Landscape*, London: Wildwood House Ltd.

Ching, F.D.K. (1996) *Architecture, Form, Space, and Order*, New York and Chichester: John Wiley & Sons.

De Certeau, M. (1984) *The Practice of Everyday Life*, trans. Steven Rendall. Berkeley, CA: University Of California Press.

Fiske, J. (1982) *Introduction To Communication Studies*, London: Taylor and Francis.

Goffman, E. (1969) *The Presentation of Self in Everyday Life*, London: Penguin.

Hall, M. and Edward, T. (1975) *The Fourth Dimension in Architecture: The impact of building on behavior*, Santa Fe, Mexico: Sunstone Press.

Hunter, V. (2007) 'Public space and site-specific dance performance: negotiating the relationship', *Research in Drama Education*, 12(1): 112–115.

Kaye, N. (2000) *Site-Specific Art: Performance, place, and documentation*, London and New York: Routledge.

Koplowitz, S. (1997) *Project Interview*. Available online at www.webbedfeats.org (accessed 9 December 2005).

Lawson, B. (2001) *The Language of Space*, Oxford: Architectural Press.

Lefebvre, H. (1974) *La Production de l'espace*, Paris: Anthropos.

—— (1991) *The Production of Space*, trans. D. Nicholson-Smith, Oxford: Blackwell.

McAuley, G. (2001) *Space in Performance: Making meaning in the theatre*, Ann Arbor: University of Michigan Press.

Norberg-Schultz, C. (1963) *Intentions in Architecture*, London: Allen & Unwin.

Paget, V. (1931) *The Beautiful: An introduction to psychological aesthetics*, Cambridge: Cambridge University Press.

Preston-Dunlop, V. (1998) *Looking at Dances: A choreological perspective on choreography*, London: Verve Publishing.

Tuan, Yi-Fu (1974) *Topophilia: A study of environmental perception, attitudes, and values*, Englewood Cliffs, NJ: Prentice-Hall.

Tuan, Yi-Fu (1977) *Space and Place: The perspective of experience*, Minneapolis and London: University of Minnesota Press.

2 Sited conversations

Fiona Wilkie, with Carolyn Deby and Stephen Hodge

This chapter consists of two interviews with site-specific practitioners; interviews that were themselves both site-based and mobile. The first is with Carolyn Deby of the London-based dance company sirenscrossing; the second subject is Stephen Hodge, of the Exeter-based performance collective Wrights & Sites. Both interviews followed the course of rivers and, along the way, both navigated questions of flow, ecology, urbanism and encounter in relation to performance. Both document a concern with site-based practice as a means of reconfiguring relationships to the city. But especially, both are concerned with method: with the choices that artists make when approaching sites for performance. It is significant that these conversations were situated at a mid-point of an ongoing process for both artists. For the most part, neither Carolyn nor Stephen were discussing finished works, but rather projects that they were immersed in at the time: respectively, *rivercities* and *Where to build the walls that protect us*. One result of this is that the reader is given a sense of practitioners reaching towards something as yet unknown – along with the negotiations and rethinkings that this involves – rather than a retrospective reflection on past work. Of course, the reader may wish to follow up on these conversations by visiting the websites listed at the end of the chapter and viewing documents recording the projects as they became.

In presenting these dialogues here, this chapter is not figured as an in-depth theoretical investigation; nor does it expound a particular argument about the current state of site-based practice. Rather, it aims to provide an insight into the working methods of two performance-makers and, in doing so, to raise wider questions about the kinds of enquiry that site-based performance might make and the encounters that it might generate. By way of introducing some of these wider questions, I wish to frame the interviews themselves with brief comments on three contexts for thinking about them: a survey of site-specific performance that I published in 2002, a concept of 'mobile methodologies', and a concern with the ways in which performance might productively engage with organisations and individuals beyond the arts.

Mapping the terrain

In the article 'Mapping the terrain' (2002), I presented the results of a survey of site-specific performance in Britain. It involved collating both statistical and discursive material from a questionnaire completed by 44 practitioners, including individuals and groups working in theatre, dance and live art. The article considered questions of location, terminology, logistics, localism, funding, audiences and the relationship between form and content. My aim was, perhaps naïvely, to create something of a 'map' of site-based practice, and responses I have received suggest that something in this approach was welcome to many working in the field at the time. But the article was restrained to some extent by the social science model that it employed. One drawback of the questionnaire method is that it limits the discursive opportunities available for teasing out the preoccupations, the processes, the problems and the possibilities of making work. In fact, the late Cliff McLucas, of the Wales-based site-specific pioneers Brith Gof, made this point to me at the time and, declining to complete the survey, invited me instead to meet and interview him. In conversation, of course, we were able to move beyond the fixed questions that I had prepared, and ranged instead across topics such as Welsh industrial heritage, the lure of the rural, the politics of articulating a cultural identity, and the use of documentation to trouble the presumed 'authenticity' of the original performance.

Another limitation of the survey is that it was concerned to a large extent with not just mapping but staking a claim to some kind of territory. This, I think, was coming not only from me, as an (over)eager PhD student, but also from an anxiety felt by many of the artists involved: there seemed to be a need to define the site-specific, to wrestle over those definitions, and to mark site work in relation to other practices that it was not. One element of the survey that has been picked up in many responses is Stephen Hodge's 'sketch for a continuum' (sometimes erroneously credited to me). The continuum proposed a series of categories for distinguishing different approaches to site, from performance in a theatre building to site-specific performance, with the latter label understood as 'performance specifically generated for/from one selected site' (Wilkie, 2002, p. 150). Along the continuum, sited performance might alternatively be understood as 'site-generic' or 'site-sympathetic'. The sketch was, as Stephen noted when we met, 'written in five minutes in a taxi!', and merely intended to begin a conversation at the conference where it was originally presented.[1] My feeling is that practitioners are now far less concerned with labelling the work and with issues of the 'purity' of site-specific performance than they were a decade ago, and this is reflected in the fact that questions of terminology were not at all on the agenda in my discussions with Carolyn and Stephen.

Mobile methodologies

In arranging these interviews, I invited Carolyn and Stephen to select a site for our meeting, one that meant something to their practice. Without my prompting, both chose to take me for a walk, and this choice reflected one of the methods that each had been using in her/his artistic practice. We might understand the use of 'sited conversations' as a research choice; a way of working, investigating and collaborating that is not merely incidental to the work that is created. In this respect, it is a method that can be traced through the practice of a range of writers and artists. In *The Old Ways*, for example, Robert Macfarlane writes that 'this book could not have been written by sitting still' (2012, p. xi); he envisages the book's content and the means of creating it as inextricably entwined. Similarly, Deirdre Heddon and Misha Myers talk of 'employing a research methodology on the move' in their *Walking Library* project (2014, p. 2), referencing an edited collection in the social sciences that explores 'mobile methodologies' (Fincham et al., 2010).

> Following anthropologist Tim Ingold, we recognize ourselves and our fellow walkers on this journey as wayfinders, knowing as we go. In place of 'factual' data and classifications, therefore, we offer stories – 'occurrences' or topics that are knots in the complex and always-in-process meshworks constructed as we move along them.
>
> (Heddon and Myers, 2014, pp. 2–3)

And in her study of Stonehenge, the archaeologist Barbara Bender positions a series of dialogues: discussions about the site with academics and others, many of which were conducted while walking through the Wiltshire landscape. Bender frames the discussions in terms of her wider concern with multivocality, and reflects on what they bring to her research:

> I wanted to use the dialogues to question and to open up discussion of matters raised in the different chapters. I found the dialogues exhilarating precisely because they were dialogues, the arguments could move backwards and forwards, they could be critical and constructive, could offer alternative ways of thinking about things, bring in other case-studies, and they could also – although the people involved could not appreciate this – play off each other.
>
> (Bender, 1998, p. 11)

I have borrowed her label of 'dialogues' rather than interviews to stage the discussions included in this chapter, and hope that they too connect in interesting ways with questions raised elsewhere in the book's contributions and speak to each other in ways that Carolyn and Stephen could not have anticipated. The question remains as to what, if anything, being on the move *does* as a methodology,[2] but it is one worth asking in relation to site and performance.

Encounters beyond performance

The 'sited conversations' of my title are, of course, those that I had with Carolyn and Stephen, but also those that their work facilitates with a range of participants: specifically, in Carolyn's case, with the organisation Thames 21 and with communities local to the rivers at which she is working, and, in Stephen's case, with experts from the Met Office and the University of Exeter and with the walkers who attended each of his excursions. When working in sites that are not framed as artistic spaces, and particularly when engaging with spatial concerns such as environment and regeneration, inevitably the artist faces some kind of encounter with others who may have different vested interests in these spaces and topics. What makes a performance enquiry different to other kinds of enquiry: what perspectives might performance bring to the discussion? Perhaps a more pressing question raised across these conversations (explicitly in Stephen's and implicitly in Carolyn's) is that of how performance might enter into a useful dialogue with other parties – town councils, environment agencies, businesses, etc. – without being put into the service of potentially competing agendas. It is a question raised too by Steve Bottoms in relation to his practice-as-research projects *Multi-Story Water* and *Towards Hydro-Citizenship*. In his blog, Bottoms discusses the way in which a *Guardian* article had positioned the latter project: the journalist had presented art as something that businesses might think of investing in as an alternative to 'corporate sustainability messaging', and thereby had upset some of the project's collaborators. While Bottoms acknowledges concerns over the use to which performance is put, he also advocates pursuing dialogue with people beyond performance: 'you never know what can arise from being part of a conversation.'[3] It is with this thought in mind that I move to my dialogues with Carolyn and Stephen.

Dialogue with Carolyn Deby – London, 19 February 2014

Carolyn Deby is a Canadian choreographer based in London. She creates collaborative performances under the name *sirenscrossing*, and participated in my 2002 survey with reference to the performance *Trace and Flight* (2000). We met at a café in east London, from where we walked a portion of the route of the underground River Fleet to the point where it meets the Thames. Along the way, we kept returning to Carolyn's current project, *rivercities*, which has had performances in Sweden and Canada, with a London manifestation currently in preparation.

We began by talking about *rivercities* in terms of the relationship between artistic practices and sustainability, though…

CD: I hate the word sustainability, I have to say, because it's such an overused political term. So I wouldn't choose to use that word in my

practice. On a very basic level my work is attempting to devise performance from everyday life. My core belief is that humans become disconnected from nature, from the natural world, especially in our increasingly urbanised lives. Urban is not just cities any more, of course. I'm interested in investigating the human connection to nature within the urban, whatever that is, and devising audience experiences that somehow travel through the urban. What I've realised in my performance work is to what degree everything else is important to the experience. You know, I've always had a light touch, I've always tried not to work in a theatrical way – not to impose a lot of props and structures and lights and sound and extraneous elements. But to rather just gently input things that will alter the experience and bring meaning into it, or to tilt meaning in the direction I want it to go.

FW: *The work seems very much focused on what happens to the spectator, rather than your own exploration of what's going on in a site.*

CD: Yes, and on the human and non-human actors.

FW: *So actually, although you say that you're resistant to the term sustainability, there's an ecology underpinning the work, a sense that everything is connected.*

CD: Yes, it's implicit in what I'm doing. The route that humanity is taking, where we increasingly build ourselves away from being a part of nature, is not sustainable, it can't work. If we deny every other aspect except the human-made aspects of the world, we're living on a rock with no oxygen.

FW: *And the river appears, then, as one of the more obvious places where nature and the urban meet.*

CD: Rivers for me became a metaphor for thinking about the flows within existence, you know, all the different systems of flow. In 2011/12 I was an artist-in-residence at UCL, at the Urban Laboratory, for a year. I was working with Matthew Gandy, a professor of urban geography. I was attracted to him in part because he had written about the city as a cyborg. The city as reconstituted nature. You know, this is a tree that we've got our drinks sitting on; this floor is a composite of petroleum products and… I'm not sure what else. The metal in the stand here comes from the ground. Virtually everything about the way the city is constructed is reconstituted nature in some way. So that's one sense. The other sense is that our bodies have extended into the infrastructure of the cities, so your circulation system, your waste-disposal system, your energy intake, is all connected into the distribution systems – sewage, water, pipes, food – everything about the way the city is structured to supply and take away things is part of our bodies in a very literal sense. That's something that we don't think about either. *Rivercities* set out to explore these ideas by making links between different parts of the world: the Yukon in the Canadian Arctic, a river that flows through Göteborg in Sweden, and the River Lea in London.

I live beside the River Lea. In east London we drink the River Lea, and it's the most polluted river in England. So put those two facts together!

FW: *I know you worked with local communities on the Yukon. Will there be a community focus to the work in London?*

CD: I know community work is a big thing in England, and I've always resisted applying that label. But because I'm interested in making work that engages with the real life of the place, inevitably you end up having conversations with people that you discover in the area, they ask about what you're doing, so there becomes a dialogue that's not formalised in a workshop sense. I don't call it community work but it is part of my process. Often there will be aspects of the work that come from engagements with people. There was a pivotal moment in Vancouver, in a neighbourhood that is one of the most troubled postcodes in North America: a woman along the route where we were working stopped me to ask what we were doing. This happens all the time. She was quite agitated. And I tried to explain that we were doing a piece about revealing the forest beneath the city. The next day we came by the same spot and she was working away with a pair of gardening shears, and she'd been clipping bits of foliage and attaching them to this chain link fence, creating a huge 'forest' installation. This was her response to our theme.

FW: *You're working with three rivers, in three different countries. How has that affected the work?*

CD: Overwhelmingly our feeling about the River Lea in London has been that there is a lack of flow. Conversely the Yukon is a huge river; there are no human barriers to its flow. The people in the town we stayed in, Dawson City, talked of how much they were affected by the Yukon river and its seasons. The town is dissected by the river, and there's no bridge. In the summer there's a ferry running 24 hours a day, so they can go back and forth at will. In the winter it freezes solid and they make an ice bridge, so they drive across. However, there are two parts of the year when they are unable to cross, and the town is divided. In the spring when the river is breaking up – it's quite dramatic – it takes maybe two weeks for it to become safe to take the boat across. During that period the city is divided. And in the autumn there's a period of two to three weeks where it's freezing up and it's not thick enough ice to cross. What the people talked about beyond that was that not only did it limit their mobility within their own town, but it affected profoundly the way they felt. In the early spring they begin to hear the river dramatically booming and cracking, and they start to feel their own pulses increasing. They start to get excited. People begin laying bets: what day is it going to break? They all come out and watch it. And then finally there's this one dramatic day when the ice cracks and the river is flowing. Once the ice has cleared, they can start using boats again. The effect of the accelerating river is married to the increasing

amount of light, moving from winter into spring. In the summer there's this mass of energy: the river is always flowing and the sun is always shining. And then in the autumn the light starts to go and the river starts to slow as it gets iced up.

FW: *So it's not just metaphorical – it actually has a physical effect on the body.*

CD: Yes, we heard that over and over from people. It's quite profound. In London we have these rivers where we control the flow. How does that make us feel? Do we feel stuck? Do we notice it? I will be collaborating with Thames 21, and in conversation they said that they've done workshops with children in schools that are maybe a block away from the river and the kids in school don't realise there's a river there. It's become so subsumed by the built environment of the city.

FW: *You were talking about working with people who live near these rivers, and then the Thames 21 collaboration. I'm wondering if that's been a deliberate move: to seek out different kinds of expertise in relation to these spaces. So in the case of the Yukon it's almost as if everyone in the community becomes an expert, because you have to be in order to organise your daily life. But actually here…*

CD: In a bigger city I start to look for people who already have an interest in the river. It's an indication, perhaps, of how disconnected people in London might be from the river that you look for people whose mandate is something to do with rivers. Whereas in the smaller place, out of necessity they have to pay attention to it because it affects their lives so profoundly. These are interesting times, because in the UK we've suddenly had to pay attention to the water.

FW: *And there's a lot of anger against organisations such as the Environment Agency – previously people wouldn't have even known what their remit is, but suddenly what they've been doing is perceived to be wrong and they should have been doing something different.*

CD: I know, and there are simplistic ideas about what should be done: more flood defences, more dredging.

FW: *So, one might then wonder why you've been drawn to make a London section of the* rivercities *project. Is it partly a plea to reconnect with the rivers here, or is it something else?*

CD: Well, rivers as a manifestation of a world that we've become disconnected from.

FW: *Has walking the hidden rivers been part of your process?*

CD: Yes.

FW: *What are you looking for when you do it?*

CD: Well, I guess… It's interesting to find the clues which show the presence of the underground rivers. Like when we discovered a waterfall in Sweden that humans turn on and off, discovering that these London rivers have been put underground and imprisoned in sewage pipes was astonishing. It's another sign of human arrogance towards the natural world. The thing that I find equally fascinating is that the River Fleet has been known to burst its pipes, and to intrude

into basements of buildings. So it's still there, it's not gone away, despite this feeling that it's all tidied away now. Many people have written about this. Gareth Rees in *Marshland* writes about how the Lea is one of the last tributaries of the Thames that hasn't been imprisoned underground, even though it's been chopped up, subdivided, made into a canal, had locks put on it, its flow has slowed. He describes it as a harpooned whale, slowly dying.

FW: *I know you're at the early stages of thinking of what will happen for an audience in the Lea version of* rivercities, *but is it in part going to be about enabling spectators to explore some of this history?*

CD: I think so. The format that my work has taken in the last 14 years has often been an audience journey. Their movement through space, their agency, the fact that they have to make decisions and act on information that we feed them in different ways, is part of the choreography. That's become a form that I'm quite familiar with using.

FW: *So actually the audience's movement is as of much interest to you as the performers' movement.*

CD: Absolutely. When I was at UCL, on a Leverhulme Trust residency, I was much more free to explore that – it didn't have to be about dance or performance at all. I was able to be much more experimental, I think, and I hope to carry that forward. I have to say that I don't come into my work as someone who wants to animate history. What's relevant is thinking about what the presence of these historical clues tells us about the evolution of the place we are now part of. Are there any invisible or visible manifestations in our daily lives of that? We were talking about the fact that the Fleet bursts its pipes sometimes and reminds people that it's there – the Lea at the moment is reminding people that it's there. It's been very close to the banks, and in fact last weekend we had a flood alert for the whole of the valley. It didn't make the news, but I certainly noticed it. According to the Environment Agency map my flat would have been under water. Mostly it's completely still. But in recent months, since Christmas, it's been boiling with current – it looks like a mountain river (being from Canada, I know what that looks like!). It's gone through an astonishing personality change, despite the fact that it's highly controlled.

FW: *It might seem that many of the concerns of your work are rooted more in the rural than the urban, and yet the city site has been central to your projects.*

CD: To be kind of mischievous, I feel that some people who live in a rural location have more of an urban life than I do. You know, they have to use a 4x4 to get from A–B, and they're on the internet and… I think what signifies urban now is totally dispersed and that's something that urban geographers have been writing about for a while (like Matthew Gandy in particular), so it's not a new idea. I'm quite curious to be in relatively rural places and reflect on the urban, and on human

intervention into flows. That's one way of talking about what I'm interested in: the intersection of different kinds of flows. Recently I've realised that there's another thing I need to incorporate into my work, if it's truly about everyday life and our everyday experience of being urbanised humans – and that's smart technology. I'm a refusenik in terms of the smartphone – it's a very deliberate position on my part – but the reality is that even I spend a lot of time in front of a laptop, increasingly on the internet. Almost everybody carries some kind of device, and that device is interwoven with our bodily experience of being alive. I think that I need to start addressing that thread. My experience of it is that it tends to encourage a shorter attention span: you're always channel-surfing between what's going on in the real world and what's happening on the screen.

FW: *Of course this affects that sense of movement between places that's at the heart of a lot of what we've been discussing: we're used to very different kinds of movement at different speeds, so the tempo of our movement shifts quite considerably.*

CD: Yes, that's right – I wonder what that does. Now, it's low tide, and there's an outflow pipe for the River Fleet somewhere around here…. Another large area of research interest for Matthew Gandy at UCL is urban wasteland. While I was there part of my project with him was looking at a patch of wild land behind the UCL building we were in. Its time is limited because it will eventually be built on. We got permission to use it and made a small performance that, in part, used that space.

FW: *There was a time, wasn't there, that site-specific performance seemed to be all about the derelict, and I've not seen a lot of that recently.*

CD: It's probably moved on, hasn't it, but there's been this romanticism about the derelict. For me, that's all about a confirmation that, although nature is conquered by the city, given a chance it comes back. And so our apparent dominance over the earth is only apparent.

FW: *The discourse of climate change is making us have to connect with some of this, isn't it?*

CD: Well you hope so, but there's a lot of denial amongst those who have power. I think that the fascination with dereliction is partly to do with our needing confirmation that nature will survive. Here, though, there's so much about the way we've structured our lives that allows us to ignore what's happening where we are.

FW: *By having the* rivercities *project positioned between these three cities, putting them into dialogue: ok, there are connections to be made and there are broad ideas that you might be interested in following around what's happening to urban life, but actually the differences are a large part of what's interesting there. The fact is that actually people aren't mobile or emplaced in the same way at all in these places. So perhaps we don't want to make broad statements about what place means now, what the river means now, because actually it means*

quite different things in each of these places. There was something that really struck me on reading some of your writing on your website, about your interest in those places where the city cracks open. It occurs to me that the points where the city cracks open…

CD: The wasteland idea is connected to that…

FW: *… they become a filter or lens through which the differences become apparent and that sort of gloss of flow and movement is revealed to be working in quite different ways.*

CD: I made a piece in 2006 in Deptford, commissioned by Laban, called *Palimpsest* (still using that word!) and it was trying to examine an area of derelict factories that was slated for demolition and rebuilding, part of which has now been rebuilt on. That place no longer exists. And there we very abruptly came up against issues of private/public ownership, permissions – it had the appearance of a place that was unconsidered and uncontrolled, but actually when we tried to inhabit it we were slammed down very quickly. We made a piece that ultimately had to be totally revisioned for a different adjacent site, not even remotely like the site we'd been on, but dealing with the same themes, and we managed it. The whole process of that making, which was about six weeks, was a daily struggle with the powers of permission and access. It was a shifting ground, things kept changing, and I had 20 student performers to keep on board.

FW: *Do you have an interest as a performer in pushing up against that, politically, or does it rather trouble you that it gets in the way of what you want to do?*

CD: No, I thought it was interesting. I mean, I did almost have a nervous breakdown making that piece! But in the end that struggle with permissions and control was what it became about. At one point we thought our audience would be allowed to be in the derelict factories area, and then it was decided that they could only be in the street looking in through the fence. I realised that we could make that meaningful, make the audience quite aware of the fact that they weren't allowed to go behind the fences. And then in the end not even the performers were allowed in there so we had to find different strategies. We still gave the audience vantage points that made them aware of the barriers between them and the areas that we inhabited, so it became an important idea to represent in the work somehow.

FW: *If we only work in the places that we're allowed to, where access is easy, then we're already limiting the kinds of conversation that we can have, and the people that we might be talking to.*

CD: There are always health and safety concerns with working in this way. I have a production manager that I worked with in Vancouver, who's lovely, but she's quite adamant about certain things like shepherding the audience, making sure they don't stray and things like that. And in Sweden I didn't have that person and I could dare to allow a higher degree of audience autonomy. So maybe they were going to get lost

– we risked that. We always work with test audiences initially, so we tried things out, and what I discovered is that people can be challenged a bit more than we'd done previously. I'm also really interested in asking them to respond with personal agency: you can work with groups, make them feel almost like a tribe and to take responsibility for each other – that's one thing we've done. I'm also interested in what happens if individuals are each more isolated within the experience. You might still be part of a larger group but you have to navigate the challenges we present you with on your own.

FW: *Who are these audiences? Do you have a sense that you attract a 'dance' audience?*

CD: I don't necessarily feel part of the so-called dance 'scene'. And I don't want to – it's a much too narrow world. I want those people to be interested, but not just them. I get annoyed with a narrow idea in England of what constitutes dance. I was a visual artist originally, and didn't train in dance until I was 27 [in Canada]. I'd been an audience member of contemporary dance, but when I initially became involved with dance I saw it as a world that seemed open to a variety of artistic languages. I saw it as a coming home – a place to which I could bring the visual, the auditory, the movement of body, text – you know, everything could live in that world, it didn't seem narrow. In western Europe dance felt equally open to a variety of languages, and also quite conceptually led, whereas here in England there was a greater interest in virtuosity and technical proficiency – to the exclusion sometimes of concept – and that is really not what I'm interested in.

FW: *So do you find yourself avoiding a dance frame for your work here, in terms of how you describe it?*

CD: Well, I'm at a point of re-entry, I suppose, into the scene here, and I would be afraid of that. I understand that *city:skinned* in King's Cross [2002] upset some dance people, because there wasn't enough dance in it. You know, why are we walking around? Why are there these long bits where there isn't a dancer in front of me? I heard that through the grapevine, despite the fact that the piece was a four-week, sold-out, critical success. That was 12 years ago so perhaps things have moved on.

FW: *It's interesting: we haven't talked about the movement vocabulary of your dancers at all – that's not something that we've discussed today. When we've talked about choreography you've talked about it in relation to the audience and how you imagine orchestrating their movements within a particular piece, much more than the dancers.*

CD: Yes exactly. It's interesting. The body in performance is still central. There are certain things that I feel continue in my work. I've always had a fascination with falling – with different gestures of falling. So there have been certain themes that have reappeared through the years. Control/lack of control. But I also think that it can be really

problematic if the audience are put in the position of just observing other people doing amazing things that they can't do. I don't want to go that way.

FW: *Particularly if the politics of human connection with a space is underpinning a lot of the process; that would be removed to some extent if the audience comes and only watches.*

CD: Yes, it's a delicate balance. What you hope is that there's some kind of kinaesthetic connection – so that even though this performer's doing a thing that they can't do themselves, that somehow they feel implicated, as another human body inside the experience.

Dialogue with Stephen Hodge – Exeter, 4 March 2014

Stephen Hodge is Head of Drama at the University of Exeter and a core member of the group of artist-researchers, Wrights & Sites.[4] As part of Wrights & Sites he participated in my 2002 survey, responding mostly with reference to the group's performance event *The Quay Thing* (1998). We met in Exeter on a clear March day, shortly after the railway from London to the south west of England had started running a full service again following disruption caused by severe flooding. Stephen met me at the station and we walked along the river Exe through the city. We spoke about a number of his projects with Wrights & Sites, but our primary focus was Stephen's ongoing solo project *Where to build the walls that protect us*.

SH: We're going to start up there, if that's all right?

FW: *Sounds great. Where are we walking to?*

SH: We've got the river here, and the flood relief channel here, and we're simply going to follow them.

FW: *There seems to be something interesting emerging in talking to Carolyn first and then you, in terms of rivers and their relationship to cities, and the kinds of approach that site-based work might take in this context.*

I want to start by asking you about the shift in focus in your work and that of Wrights & Sites. There's a tagline on your website that once described Wrights & Sites as 'a group of artist/researchers with a special relationship to place'. I'm sure it used to say that. And now it's 'a special relationship to site, city/landscape, and walking'. And I guess something of that shift is also involved in where your thinking might have gone since putting your 'continuum' together.[5]

SH: Well, at the point of that survey… What year was that?

FW: *It was published in 2002, so around that time.*

SH: So it was before our *Mis-Guides* were in print.

FW: *Yes.* The Quay Thing *was what you were really talking about then.*

SH: That's right. So Wrights & Sites was founded just over 17 years ago, and it was about a year before we actually did anything public. The other three in particular were very much rooted in theatre, and in fact

all very much writers, all playwrights. Whereas I was coming more from a live art angle. And that first project, *The Quay Thing* [1998], was configured in a way that meant we were very much making theatre. We made, largely, static pieces of work; initially we worked in sites where the audience could sit down and watch (even if they were on a moving boat). That project almost finished us, just as we were starting, and even though we had 30-something people working on it, we found ourselves becoming project managers, and at times that got in the way of making the work. So we started walking, really as a way of us being able to spend time together and to gently explore things without having any pressure on us. And we didn't formulate another public project for some time. The walking essentially became both a space for us to work together because we all have jobs in different academic theatre departments, and also a way of teasing out walking methods and outcomes for ourselves. That wasn't recognised in that initial statement, so it was amended. Whilst we have worked on projects that engage landscape beyond the city, almost all our work after a few years was clearly centring around cities. We were attending in particular this annual conference that's happened since 2000 called Walk21, which is hosted by major cities around the world. It's an interesting annual get-together – quite big – which mostly brings together politicians and city planners to think about walking in the city for urban planning purposes and health reasons, but also in terms of quality of life, getting the cars out of the city centres…

FW: *Creating a 'liveable city', that kind of approach.*

SH: It's very much about liveable cities, and sustainable cities. And it invited… for the first few years at least it certainly had a very positive engagement with artists and visionary creative thinkers.

Walk21 really embraced the slightly strange outliers, and I think Wrights & Sites was probably one of them. In Zürich in 2005 we gave a manifesto presentation about walking and the city.

FW: *That's the one that was published in* Performance Research, *wasn't it?*

SH: *Performance Research* and Nicolas Whybrow's cities book. That 15-minute manifesto was one of the most successful things we've ever done. And so through being involved in Walk21 we found other people to talk to, from very different disciplines, about the city and walking. They became more important than the site-specific…

FW: *Yes. I wonder if what was going on a decade ago was more around trying to claim a space, a validity, for this thing that was labelling itself 'site-specific', and actually there's not really the urge to do that any more. It feels that that's a given now, and we don't need to have those debates any more.*

SH: They're not really useful, are they?

FW: *Well, I don't think so, and so the focus on terminology and so on…. It did something at the time, I think. It indicated a set of concerns and a way of working that marked itself as different to works that simply plonked themselves*

on a location and then disappeared again. But actually I think that lots of people now are more interested in what gets enabled by different methods of being in place, moving through place, and so on.

SH: Yes. Our *Mis-Guides* very much work on the basis that you set up an open framework. A number of our projects have involved setting up these provocations that people then respond to, either sitting at home as thought-experiments or actually getting out there and working with them, or giving them to other people, for example students, to work on. It's fed through a number of projects. For instance, we worked on a public art commission for Weston-super-Mare in 2010: *Everything you need to build a town is here.*

FW: *Where did that phrase come from? I liked it: it sounded like something lifted from a drier document.*

SH: The title is lifted from the text on a sign I wrote for Weston Woods about building dens. We just couldn't find the right title so we looked through all our texts and picked one that made sense. The project was commissioned with money from CABE (Commission for Architecture and the Built Environment – axed as part of the 'bonfire of the quangos'), as one of six artworks for the town. And because we like to minimise the amount of bussing in and bussing out, we used walking there as a reconnaissance tool. On one trip we found this old sign that forbade cycling in a neighbouring village to Weston. We borrowed the sign's format: we made 41 new signs in various locations that referred to architecture. Each sign referred to a piece of architecture in its vicinity and then offered a provocation for people to either think or do something in relation to that. And the signs linked back to a website. They were arranged into eight different layers: so one focused on the main architect of the Victorian town; one referred to amateur builders, donkey railings and sheds, things like that. So in that project we were turning our minds back, after a period of walking, towards the fabric of the city, the architecture.

FW: *Your current project,* Where to build the walls that protect us, *is also embedded in a notion of architecture, isn't it? The kind of imagining and the method of modelling that you're moving towards, that you're proposing, seem to reference architectural approaches.*

SH: And I'm working with an architect. [Unfolds a newspaper.] This is a page from Exeter's *Express and Echo* newspaper from almost a year ago. Exeter flooded badly; the river Exe washed away the railway, and a pub that's right next to it was seriously damaged too. As you can see, I'm borrowing the title from this article's headline. The project was already commissioned at that point, by an organisation called Kaleider [kaleider.com]. Kaleider's vision is twofold. One is not to have a building, so it's sort of along the National Theatre Wales model. And the second concern has to do with future-facing issues, particularly in relation to resilience and sustainability. They're going to end their

first three years with a big, city-wide performance in about a year's time. But along the way they've initiated a lot of other activity, including a commissioning programme. So, my project began with a reconnaissance phase – I've been really using the term 'reconnaissance' ever since a piece of work about Erik Satie I made for the National Review of Live Art in 1994, so just a few years before Wrights & Sites formed.

FW: *Is it because, more than 'exploration', it seems to promise a future… something that's going to happen afterwards, something it's going to lead to?*

SH: I think it's because I prefer working in the field to sitting in the library.

FW: *Fair enough. Although there must have been a lot of that. I've been looking at the website – particularly the blog you did about the first walk – and it struck me that there must have been quite a lot of sitting in libraries going on.*

SH: For this project?

FW: *Well, before you got to it… There are certain things that you put on the table at the beginning, so to speak, for example about climate…*

SH: Yes, I suppose there were. The other thing that I put on the table is… [pauses to rummage in his bag before producing a book] … this, which has actually fed into a few projects now. So this is a book that…. After the war, a lot of cities and towns, whether or not they were bombed (and Exeter was severely damaged), produced these rather glossy plans for redevelopment. My current project is a sort of faux (although that makes it sound silly) public consultation – a charrette – and will continue to be right till the end. It's about imagination, it's about plans… not producing some kind of final plan that I'm pretending is going to really happen, but…

FW: *It's what happens in the process of imagining that becomes the 'stuff' of the project.*

SH: It is. So the project begins with this provocation – where to build the walls that will protect us – that comes from a newspaper headline about the flood defences, which is a fairly concrete thing, literally! But the phrase itself has a more poetic side to it, I think; when lifted from the newspaper article it could refer to the old city walls or it could refer to your house.

FW: *And also, suggests…. All right, the literal meaning is that we're being protected from the floods, from the water. But more metaphorically, what else are people within cities feeling a need to protect themselves from? What are the different versions of that? What kinds of protection might citizens understand themselves to need, together and separately? Is there, then, a kind of ethical drive to the whole conception of the project, in the terms of… you know, how do we live together? How should we live, side by side?*

SH: Yes, and that's partly embedded in the way that the project unfolds, I think, publicly. So, in terms of the reconnaissance phase, I set up four excursions. I called them 'excursions' rather than 'drifts', partly because they were mapped to a large extent before we went out, and

partly just to mark a slight break between the work I do with Wrights & Sites and what I'm doing here. And also, you know, it's a Dada term.

FW: *And of course then there's the tourist approach: the idea that you go on a trip, an excursion.… It frames a place in a particular way.*

SH: That's right. What I've been trying to do, rather than tackle everything at once, is to divide it into four themes that might mirror those a planner would consider in a major city overhaul. The first one – 'climate and terrain' – is probably the most important: because of the driver for Kaleider; because of the currency of the topic; because of the newspaper headline. So, I had these four themes.[6] And the notion was that we would go out as a group that was of a manageable size – just – but able to get as many people as possible along to them, and – I think this was quite challenging for Kaleider and also for possible attendees – that they would last four to six hours. Actually three of them lasted six and one five.

FW: *So there's quite a commitment being asked of the group.*

SH: A big commitment. The notion was that I would lead the participants on a route that would take in nodes with a bearing on the theme of the excursion, and that we would come across, at strategic points, experts. So for instance, on the first excursion we came across two planned experts. One was Mark McCarthy, science manager of the National Climate Information Centre at the Met Office. In terms of this project and others that are happening around it Exeter's in an interesting position, because it has, I think, the highest per capita number of climate scientists anywhere in the world (because the Met Office is here, and because we have several research centres at the university that look specifically at climate). Mark fed us material about air flow within the city; how climate affects buildings and buildings affect climate – so how temperatures might be affected depending on how close together you place buildings or how high they are or what materials they're made of; the importance of 'green', 'blue' and 'brown' spaces within the city. The Met Office are very good at public engagement, and they employ a number of tactics that reach towards performance. Mark used bubbles, to help illustrate air flow, and Lego, and samples of water that he'd collected in jars in his garden. He was very engaging – playful, yet serious – just what I was after. The other planned expert we encountered on this first excursion was a scientist from the university, Professor Tim Lenton, who works on tipping points – we met him towards the end of the day. So most of the day was led by me in terms of where we went – feeding in key information, providing stimuli for discussion, or facilitating exercises to feed the imagination. And then we encountered 'real, proper' experts along the route at certain points. As we walked I gave everybody a waterproof map case and a blank book and pencil, and the participants were charged with responding (verbally and visually) throughout the day in

their book. And so I have a stack of these books. There was a lot of space. There were certain things that I wanted to do, but if you compressed in total the time that that took within the six hours, it would probably be an hour. Essentially what I created were provocations for people to imagine shared futures, and a format within which the experts came out from behind their desks and lecterns. We would end back at the Kaleider office, where we would try to pull a few key ideas together, and I'd get people in small groups doing some model-making: in the first one I gave them clay, but people were reluctant because their hands got mucky so later we moved to Lego!

FW: *So this is a particular method, then, of working through conversation, through encounter – you broker certain kinds of encounter between participants and experts. What's driven you towards that sort of methodology in this work?*

SH: Er, a knowledge that I'm not an expert in any of these four fields. Neither am I a futurologist. And when you're talking about... I think it's quite easy for Wrights & Sites to play with heritage frameworks. I think it's much more difficult when you get into local politics, and planners and architects' circles, for us to have much authority. Almost from the moment that Wrights & Sites set off after *The Quay Thing*, we started inviting other people to walk with us, so that tactic of walking and talking around a certain theme was a model that has been used by Wrights & Sites since around 2000. Throwing in the experts filled a gap, I think. I mean, the two experts I gave you as examples were professional experts. As part of the second excursion, which focused on 'buildings and the life between them', we visited a new town – Cranbrook – that is currently being built butting up against Exeter; our experts there were the resident town minister and a parkour enthusiast.

FW: *Were the routes for all four excursions devised as completely different routes, or were there overlaps?*

SH: They were different. There were inevitably some overlaps, but I devised them so that we covered different areas of the city. The third one was very much focused on the centre and business, and also it was designed with ease of physical access in mind. So it was the shortest one as well. A city planner attended that one, from a London borough, which gave an interesting perspective. And we dealt a little bit with heritage there, visiting the tourist information centre at one point. And in the fourth one, we travelled on buses and trains, and we ended up at the motorway service station in an industrial estate where all the roads are named after birds, so that got us looking up – by accident a man who hang-glides had come on that one. So they each had different themes and functions, and I'm starting work on the second phase at the moment, trying to root through all the reconnaissance material that the excursions have generated and figure out what happens next.

FW: *You've said that the project will lead to some kind of final event, though you've not yet specified what that will be. Are you going to be creating a kind of archive of what's happened so far?*

SH: Ok, so now I come to the problem that I've set myself, which is that I said during the first phase that I'm going to make a model.[7] But of course a model is a finished thing, and it has the potential to close down the imaginative nature of the project, and also to be ridiculed as utopian or just not good enough!

FW: *But presumably you haven't said what you understand by the term model – it could be other things. I'm just thinking of the map: there was a period within site work where the map was an important document for many people, and some of the work that Mike Pearson and others were doing was about reenvisaging what the map might be. It might be a 'deep map', it might have layers, and so on. So there could be a parallel version in terms of thinking about what constitutes a model. Does a model have to be something you can see and touch, or can it exist between other things?*

SH: Well, I think there will be some kind of physical model, but it'll be quite abstracted. There are a number of problems, I think. One is scale: if you talk about Exeter you can't really exclude sections of it. You make a model of the whole of Exeter and you reduce the scale of a person to a pinhead. I think now what I'm working towards is some kind of abstracted, poetic model. I introduced different types of models during the excursions. There's this fascinating model that I looked at in the third one called the Phillips Machine, or Financephalograph, or MONIAC (Monetary National Income Analogue Computer), which was invented by Bill Phillips at LSE in the late 40s, and there are about 12 of them around the world now: there's one at the Science Museum and one at Cambridge, which is animated through a lecture once a year. In fact you can see the lecture online.[8] It's an abstracted model of the economy which is driven by water, and there are all these pipes and pumps and taps and things – you can turn a tap and turn interest rates up and see what happens to savings. It's a sort of working idealised model of the economy. So that's sort of in the mix. The problem to solve is how to keep the imagination open. I'm imagining feeding a lot of the material I currently hold through an audio commentary, so we might have this disembodied voice of someone who seems to know a lot about the city: maybe they're a planner; maybe they're an angel like in *Wings of Desire*.

FW: *I'm reminded of something that Jeremy Deller did when he was up for the Turner Prize (and won it). Each artist at the Turner Exhibition gets a room with their stuff in it: Deller's room just did something different than the other rooms there. I remember reading the* Guardian *art critic saying that the other artists present product, whereas Deller invites you into a conversation. So yes, there was stuff around the room – there were images of various things and there was video material playing – but there was a central table, kind of an old trestle table*

looking very out of place within the Tate Britain set-up, and there were documents and things on there. And there was a timetable: a sort of rota of experts who would come in and talk. Much of Deller's work involves conversations with groups – obviously the mining stuff is the most famous, but there was also a project he'd done with a cycling organisation, quite a low-key thing around commissioning a series of memorials or markers at spaces where cyclists had been killed in road traffic accidents. A representative from this organisation that's trying to get people to think differently about how road users negotiate with one other: he was there at a certain point to talk to visitors. So you could imagine a room, a model, that is also an ongoing conversation, that has that sort of feel to it.

SH: Yes, I find myself very much in tune with Deller and his body of work, and that's definitely the direction I'm heading in. So actually I'm not going to try to present something finished, but rather something that goes back to the *Mis-Guides* in a way: there's a framework that acts as a provocation, but is open enough to allow people into it. But unlike the *Mis-Guides*, which are generally used by individuals, the intentional gap in this work is a collective space. A very important part of it will be what happens in the discussions around the model. I will be inviting the experts back, perhaps to take little walks out into the city around their area of expertise. I'm trying at the moment to think of ways to keep the conversation going.

FW: *We were talking about why you're inviting other people into the dialogue and including experts in the process – because you feel that you're an amateur in some of the fields that you're engaging with. But obviously there's a framework in which you're absolutely an expert, in framing this as an art project and thinking about what the model of performance might be in relation to that. I mean, in your work with Wrights & Sites and here as well, there's a playful set of strategies running through. But then there's the question, particularly in terms of the problem of the model, of how to be taken seriously: how to do something that doesn't just look silly or as if it hasn't achieved anything. Almost as if it could be measured against criteria that weren't your criteria in the first place.*

SH: There are other measures as well, of course, because I'm supposed to be a researcher. So, is this research? And, more specifically, is this arts and humanities research? Where is my research in this? I am able to articulate answers to these questions, of course, but these answers are in flux, because I think this is a new direction for me that could develop beyond this project.

FW: *So in those terms this project is perhaps partly about a thinking through and a testing out of how performance and art frameworks and practices can productively engage with other dialogues, so it doesn't just become…*

SH: Rather than servicing them.

FW: *Yes, or touching on them but never actually doing anything useful. How can it be a reciprocal thing that becomes useful for both parties, and what happens to*

performance within that? So I guess, what I'm getting to in terms of a question is: why is it important that this is a performance project or an art project in that context? And how to be taken seriously: how does the playfulness of the art not become something that undermines it in conversation with others?

SH: One of the main reasons that I know it's serious at the moment is that the Met Office and others have taken it seriously. They don't seem to be tied down by inherited assumptions about what our discipline can and cannot hold.

FW: *And of course you're the Head of Drama, after all; the title itself invites assumptions that don't necessarily fit with your aims in this project. Are we ever going to be able to get past that? Well, I suppose through dialogues like this…*

SH: The engagement with the experts, some of those experts in particular, gives me great hope in relation to that. There are a number of people who seem to be operating in that kind of way within their current research: Carl Lavery and Steve Bottoms are both doing interesting work, for instance.

FW: *For both of them, an ecology is underpinning what they're doing. And that's running through this project as well. Is that partly because of where the funding's coming from, or is it something that you've found pressing in terms of thinking about cities and moving through cities?*

SH: I think lots of things are showing us that you can't ignore it, if you're thinking about cities or landscape.

FW: *Has anything happened within the excursions that has also thrown up social questions, questions of inequality within the city, or has that not really been something that's figured within there? I guess when you propose a project in that framework – that it's about imagining a future version – one thing that that throws up is that you could conceive of it as a set of existing problems to be solved. And the flood defences is part of that, isn't it? So social deprivation in particular areas, and problems around that, could be implicated in the project as well.*

SH: This is the Environment Agency's map, which shows the 'at risk' territories at the moment. We started here, near the pub that got flooded, on the outskirts of town, and we've walked from here down to here [shows the route on the map]. So you can see a lot of this area that's at risk… and that's why it's a no-man's land with very few populated structures. Now that we're down here you can see that there's one particular area, a poorer area of the city, that's at risk. One of the activities we undertook on the climate walk was to head off to the edge, out to the boundary of the 'at risk' area, just to show the scale of it, really. So, yes, in terms of where people live and their demographic in terms of flooding, it does include some of the poorer parts of the city.

FW: *So the realities of social inequality underpin some of the other issues that are central to the project. I guess the ethical question is part of that: how do we*

negotiate that? Have you been finding that people come along to the excursions with particular versions for themselves of what this project might be?*

SH: Probably more than half of them are coming along with overlaps with their job or their interests. And I've only really scratched the surface of what that means I'm afraid.

FW: *There's a set of narratives, as well, around regeneration, and I'm wondering how, for you, this sits in relation to those kind of narratives. I mean, I know it hasn't been framed in terms of regeneration, but even so, imagining a future version of a city has those kind of echoes, doesn't it?*

SH: It does. And the fact that a city councillor who is a very active Twitter user participated in one of the excursions would have clearly been noticed by those who hold any regeneration portfolio. But I don't have any pretence that I'm going to... or desire to get involved with the planning committee.

FW: *So the purpose of proposing the project as a planning project is to borrow some of those narratives to do something else?*

SH: Yes, just as Wrights & Sites borrowed heritage narratives in the work with *Mis-Guides.*

FW: *It becomes a framework through which various people can get engaged in an exploration.*

SH: Exactly. Increasingly as the project's gone along it's moved away from the notion of making a performance at the end of it. I had intended to animate the model through performance – that's what it says on the flyer! I had imagined there being some sort of 'Royal Institution Christmas Lecture'-type presentation which might bring it to life, but for a number of reasons I have chosen not to do that. I'm now going to work with this looped audio that will feed in much smaller, more manageable provocations within the wider work. The aim is to get people thinking on their own terms, rather than, you know, 'what are we going to build at the bus station complex'?

For further details of Carolyn Deby's work, including the current *rivercities* project, see the sirenscrossing website: www.sirenscrossing.com.

For details of Stephen Hodge's *Where to build the walls that protect us,* see the project website: www.wheretobuildthewallsthatprotectus.com. For more on his work with Wrights & Sites, see www.mis-guide.com.

Notes

1 Performance of Place conference, University of Birmingham, May 2001.
2 In a recent article, the geographer Peter Merriman challenges some assumptions that he finds in social science's apparent embrace of 'mobile methods', suggesting that we should be cautious about the claims to special insight that are sometimes made for such methods. Further, he argues that there remains much to be said for so-called traditional research methods (2014).

3 http://performancefootprint.co.uk/blog-2/ (accessed 12 August 2014). Bottoms' ongoing work in this field is mentioned in the dialogue with Stephen Hodge in this chapter.

4 The other three members are Simon Persighetti, Phil Smith and Cathy Turner.

5 See the 'Mapping the terrain' section, above, for details of Stephen's continuum of site-based practice that formed part of my earlier survey.

6 The four themes were 'climate and terrain', 'buildings and the life between them', 'industry and commerce' and 'mobility and communications'.

7 Later in the process, Stephen revised his plans for the final event of the project, presenting not one model of a future city but five 'possible Exeters' created (and erased) collaboratively over five days. In a document outlining phase two of *Where to build the walls that protect us*, which he sent to me following our interview, he writes: 'originally, I conceived of the first-phase reconnaissance excursions as tools for generating the material content of the work. Now, it is clear to me that these collective, conversational, relational practices are (at the centre of) the actual work.'

8 The 45-minute lecture, by Allan McRobie, can be seen at www.sms.cam.ac.uk/media/1094078.

References

Bender, B. (1998) *Stonehenge: Making Space*, Oxford and New York: Berg.

Fincham, B., M. McGuinness and L. Murray (eds) (2010) *Mobile Methodologies*, Basingstoke: Palgrave Macmillan.

Heddon, D. and M. Myers (2014) 'Stories from the Walking Library', *Cultural Geographies*, published online before print at http://cgj.sagepub.com/content/early/2014/02/12/1474474014521361

Hodge, S., S. Persighetti, P. Smith and C. Turner (2010) 'A Manifesto for a New Walking Culture: dealing with the city', in N. Whybrow, ed., *Performance and the Contemporary City: An Interdisciplinary Reader*, Basingstoke: Palgrave Macmillan, 69–86.

Macfarlane, R. (2012) *The Old Ways: A Journey on Foot*, London: Hamish Hamilton.

Merriman, P. (2014) 'Rethinking Mobile Methods', *Mobilities*, 9(2), 167–187.

Wilkie, F. (2002) 'Mapping the terrain: a survey of site-specific performance in Britain', *New Theatre Quarterly*, 18(70), 140–160.

3 Between dance and architecture

Rachel Sara in collaboration with Alice Sara

This chapter draws on a 12-year collaboration between an architecture educator and theorist, and a dance educator and artist. The collaboration resulted in a series of workshops, which use the processes of dance to develop an understanding that is located somewhere between the two disciplines. This chapter draws from architectural theory in conjunction with references to the collaborative work in order to theorize a relationship between architecture and dance. The workshop structure is presented and critically reflected upon as part of the output of the collaboration. The chapter concludes by locating architecture and dance, which are normally separated by distinct ontologies, as part of the same continuum. The collaboration is presented as an attempt to develop a new trans-ontology[1] that is between architecture and dance.

Architecture is not just about walls

> Architecture is defined by the actions it witnesses as much as by the enclosure of its walls. Murder in the Street differs from Murder in the Cathedral in the same way as love in the street differs from the Street of Love. Radically.
>
> (Bernard Tschumi 1978)

The events and activities of everyday life construct architecture as much as the architect-as-designer herself; Architecture is constructed by its use. From the everyday activities of walking, talking, flirting and sleeping, to the deliberate critical and political occupation of space, to the carnivalesque activities of illegal raves, street parties and zombie walks, *use* constructs the function, atmosphere and meaning of a place. When you change the function, atmosphere and meaning of a place then you construct architecture.

This relationship between the physical space and the actions that the space witnesses has been variously explored and interpreted by both architects and theorists who highlight the potential meaning (as well as the architectural potential) inherent in such a union. The twentieth-century

Dutch architect and writer Aldo van Eyck, whose work explored humanism in architecture, stated that he was not interested in space and time, but instead in place and event. This signified a shift in focus: from understanding buildings as merely physical objects, which might age with time (independent of human activity); to understanding buildings as emotionally and personally significant places determined as much by the events that go on in them, as by the demarcation of their walls. Fundamentally, we might see this as a shift in focus from the building (object) to the person (subject), from the (hard) walls to the (sentient) body and perhaps even from the designer to the user.

In the 1970s, architect, writer and educator Bernard Tschumi explored another similar duality, shifting the space/time versus place/event dialectic to explore the relationship between concept and event. In an essay entitled 'Architecture and Transgression', Tschumi investigated the notion that architecture inhabits an impossible location in which it transgresses the inevitable paradox of architecture as both a product of the mind, a dematerialized and conceptual undertaking, and 'architecture as the sensual experience of space and as a spatial praxis' (1996: 66). He argues that since both these elements do co-exist within built architectural projects, there is an inherent paradox, due to the 'impossibility of simultaneously questioning the nature of space and, at the same time, making or experiencing a real space' (1996: 67). For Tschumi, this implies that since the paradoxical oppositions are denied, architecture is inherently transgressive, meaning that architecture necessarily breaks or goes beyond accepted limits; in this case by contradicting a perceived paradox.[2]

More recently, this notion of architecture as occurring at the intersection between both place and event, concept and experience, was explored through the example of the Occupy movement by architect, educator and urban theorist Louis Rice. He argued that the Occupy events were fundamentally architectural events, declaring that 'architecture is the occupation of space' (Rice 2013: 75). Through this example, Rice proposes that the encampments demonstrate an 'inaesthetic'[3] form of architecture and urbanism in which 'the visual is immaterial, the processual qualities and relational assemblages are essential' (2013: 74). Through this essay, Rice implies that we might see physical spaces and the material world as having agency (or the ability to act upon others). In other words the shift from building (object) to person (subject) is completed, as both are treated as equals and place and event are elided as one. This is not to suggest that 'architectural design has a direct and *determinate* effect on the way people behave. [This] implies a one-way process in which the physical environment is the independent and human behaviour the dependent variable' (Broady 1966: 174). Instead the argument is that we should understand both the building *and* the people, the walls *and* the bodies, as mutually constitutive.

Dance is not just about event

The shift in focus from architecture as being concerned with the building, to the intersection between place and event therefore begins to imply a commonality with dance, as an activity that is concerned with constructing event and place. It sets up an understanding of architecture that has more in common with dance than might immediately be obvious and begins to suggest that there might be a value in exploring the domains of architecture and dance in conjunction. What can dance bring to architecture? Why should architecture be of any interest to dancers? What understanding might be gained by investigating dance through the lens of architecture and vice versa?

Reading these architectural critiques through the lens of dance, it is possible to apply much of the thinking to this other event-oriented discipline. Equally to architecture, we may see dance as both able to exist as an experiential spatial practice (product of the senses) and simultaneously explore concepts that critique the nature of space (product of the mind). Therefore, according to Tschumi's logic, dance could also be understood as inherently transgressive. It is also possible to understand dance (as event) as influenced (or acted upon) by the place in which it is both created, rehearsed and performed. Simultaneously, the place is also affected (or acted upon) by the dance (event) that goes on within it. This implies another elision; perhaps we should understand the building *and* the people, the walls *and* the bodies, the architecture *and* the dance as mutually constitutive.

Architecture and dance are about more than the frozen object

Simultaneously, contemporary architects are regularly criticized for focusing too much on the object (usually a building), and in particular the visual – the glossy image of the object that is pornographically reprinted in architectural journals and websites. 'Instead of being a situational bodily encounter, architecture has become an art of the printed image fixed by the hurried eyes of the camera' (Pallasmaa 2005: 30). Buildings that capture media attention are typically those which photograph well, and have a clear, visual concept. Therefore buildings like London's Gherkin (or 30 St Mary Axe, by Foster and Partners), the Bilbao Guggenheim (Museum of Contemporary Art by Frank Gehry) and the Shard, London (a skyscraper by Renzo Piano) are 'known' and recognized by many without the perceived need to actually visit and experience the buildings first-hand.

While attention to the visual is obviously necessary, relying primarily on sight has its limitations. 'More than other senses, the eye objectifies and masters. It sees at a distance and maintains a distance' (Irigaray, 1978 in Jay, 1994: 493). An over-emphasis on the eye denies the rest of the body, it denies the role of the user of the building in constructing its meaning; it denies the physical experiential understanding of a place and denies the potential for the building to change over time. We might therefore understand this kind

of architecture as prioritizing concept, space and time (embodied in the object), over meaning, place and event (embodied in the subject).

There are parallel arguments in the discipline of dance. Whether explicitly or implicitly, dance is always an exploration of the body's relationship with space, but it is also always an exploration of the body's relationship with time. Dance explores this relationship of space and time to the body, and this body is a living body. Every breath taken, every beat of the heart, is a passing of time, every gesture made and progression through space is a relationship with time. However dance is marketed through the fixed image of the bold, dramatic movement, usually this is a leap or a particular tableau, photographed against a neutral (often black) background.[4] In these images, gravity, time, and location are suspended, the body is a representation of the 'ideal' body, and the sounds, the smells and the vibrations of the live event are inevitably lost. This representation of dance can be seen as prioritizing that which is embodied in the object (in this case the dance/r/s), over that which is embodied in the subject (in this case the constructed meaning, the influence of the place and the event).

This objectification of both architecture and dance is damaging for both disciplines, since the root of all our understanding comes from our personal experiences. In architecture our understanding of spaces always refers back to those places that we have experienced most: 'our room, our house, our street, our village, our town, our landscape' (Zumthor 2006: 65). We experience architecture with our whole being – the feeling of light on our skin, the isolation of being in a large space alone, the texture of the floor surface, the warmth of the space and the smell of new timber, the muffled sound of a small, carpeted space, or the echoes in a large hard-surfaced room. The way in which these phenomenological,[5] close-up experiences combine is fundamental to the way that we feel about architecture and our relationship with it. Both the affect of event, or use, on architecture and the affect of architecture on its use, underline that a piece of architecture is never a finished or fixed object, but rather a relational, experiential, and contingent construct.

How might the relationship between architecture and dance be understood?

Figure 3.1 Architecture and Dance can be seen as locations on a shared continuum between space and event.

Conceiving of architecture in this way emphasizes the body in relation to architecture. If it is possible to construct architecture by affecting the function, atmosphere and meaning of a place through the way in which it is inhabited, through the events and activities that take place in it, and perhaps even through the way in which that space is experienced, then might we see dance as a form of architectural production? If this is the case, then what is the difference between architecture and dance? Is there a distinction between either discipline?

The easy answer is that of course architects are different to dancers, defining the role of each is simpler than defining the discipline. Both disciplines have accepted and distinct ontologies associated with distinct ways of knowing and approaches to practice. Architecture practice normatively involves drawing, whereas dance practice involves the use of the body. Each discipline has its own set of theories and ways of being. Architects might typically be seen to produce the spaces that dancers might dance in (often heavily inspired by the kinds of activities that they predict might go in that space). Dancers create events and activities within those spaces (often heavily inspired by the space for which they are creating those events).

However if, as Rice implies in relation to the Occupy movement, both place and event are considered as mutually constitutive then we begin to see each discipline less as distinct, distinguishable activities, and more as locations along a continuum between space and event (Figure 3.1).

Architecture can be seen as more typically concerned with the space end of the continuum, and dance more typically concerned at the event end of the continuum. However, as the continuum also implies, there are architects who are much more concerned with the creation of event, or in other words what the architecture does, than the space itself, just as there are dancers who are more concerned with the creation and reinterpretation of space, than the event itself. Dance can be seen as acting across most locations along the continuum from site independent work at the 'event' end of the continuum, to site-specific work, right through to work that is intended to shape and act upon the space in which it is performed/created.

What might happen between architecture and dance?

The combination of understanding space and event as mutually constitutive, and the perceived problems with contemporary architecture's overemphasis on the visual, highlights the opportunities for understanding, investigating and creating spaces through means outside of the norms of architectural production. Whereas traditionally we may have characterized architecture as being concerned with the creation of fixed spaces, designed in a studio at a distance from site and experience, dance suggests another way. In contrast to the experience of designing a building through drawing (mediated by pen or computer), dance allows a 'whole body' experiential

exploration and understanding of spaces and can prompt us to think through experience how space affects us, and how we can affect space.

In a parallel rejection of the separation between space and event, the French philosopher Maurice Merleau-Ponty (1945) rejected the separation between mind and body. He explored the idea of existentialism, locating the body at the centre of the experiential world. Through this argument he rejects Descarte's dualism in which the body and the mind are recognized as separate entities (the body is merely mechanical and the mind the intelligent element that enables the activity of the body). Instead, Merleau-Ponty argues that the mind and the body are unified; our bodies have their own intelligence.

This phenomenological argument implies a need to investigate and understand architecture through bodily experience. Returning to the critique of architecture as overly reliant on the image, this bias might be seen as a corollary of the emphasis of the role of the drawing (produced through either pencil or computer) on architectural education and production. Architectural theorist and educator Federica Goffi (2007: 88) writes:

> In today's practice of architecture, the problem of 'drawing' is the problem of 'building', both are seen as final ends... Prior to this contemporary understanding, the building was a perpetually unfinished entity, capable of being worked and reworked including through the media of drawing.

Once the drawing is the output, the experiential qualities of space are easily forgotten, for example, the way in which the building weathers and ages, how it might change its meaning with every continually changing use and the subjective interpretations that each visitor to the building brings. All are easily neglected, just as the fixed image of the marketing shot forgets the subjective meaning constructed through the live event.

Exploring somewhere between architecture and dance, between space and event, enables a different set of values to inform both disciplines. Sliding along the continuum between the two poles of space and event acknowledges the attempt to investigate somewhere between the concept and the sensual; between mind and body and between the object and the subject. It implies not solely a shift in the *focus* of attention, but also a shift in the *means* of investigation, from the output to the process, from the object to the method.

Dance workshops for architects/architecture workshops for dancers

In a series of workshops for architecture students and academics, we exploited this quality of being between architecture and dance. Designed

through a collaboration between architecture educator and theorist Rachel Sara, and dance artist and educator Alice Sara, as well as additional collaborations with dance artists and educators Clare Baker and Melanie Clarke, the workshops have been held over the past 12 years in both dance spaces and architecture spaces. Variously located at the Trinity Laban Conservatoire of Music and Dance in London, as well as at the architecture design studios at Sheffield University, Plymouth University and the University of the West of England, and as a part of an international architecture conference,[6] the workshops aimed to function between space and event, mind and body, object and subject, concept and experience.

The workshops were developed through discussion and aimed to heighten participants' focus on the experiential qualities of space, to prompt participants to affect the qualities of space solely with their bodies and to allow participants to communicate an understanding of a space to others using movement. Inspired by the work of social critic Walter Benjamin, the workshops allowed a creative engagement with the 'objective' world of architecture:

> The process was seen as a way of allowing participants to read themselves into architecture and feel themselves reflected in architecture, acknowledging the endowment of architectural space with a subjective psychical quality.
>
> (Nigianni, 2007: 256)

The intention was not to teach the architecture students and academics to dance or even to attempt to investigate architecture through dance, but rather to explicitly work between architecture and dance, between space and event. Although designed for architecture students, the workshop could as easily be delivered to dancers, without great need for adaptation, as our exploration of space is a shared concern. With this intention, the workshops loosely exploit the practice of dance, to investigate ideas from both disciplines.

Entitled 'Body Stories in a Peopled Space',[7] the workshops were structured over a two-hour period, which took participants on a journey from experiencing space, to affecting space, through to creating space using their bodies. The workshops comprised the following format:

1 Warm-up games (whole group, exercise 1).
2 Observing and experience space through the body (individual, exercise 2).
3 Use of the body to alter the environment (whole group, exercises 3–4).
4 Defining space and creating narrative (in small groups, exercise 5).
5 Communicating conceptual ideas through the body (in small groups).
6 Reflections (whole group).

1 Warm-up games

The warm-up games were developed to help the participants feel at ease in their engagement with an unfamiliar way of working. After some playful ice-breaking activities (playing zip–zap–boing[8] and passing around a movement to go with our names), we began by engaging deeply with the space, asking participants to be very aware of their own bodies and how their bodies inhabit the space. This prompts participants to understand space as it is experienced; in other words to see the space as a place with a meaning that is constructed through the relationship between the building (object) and the person (subject), between concept and experience, and between the walls and the body.

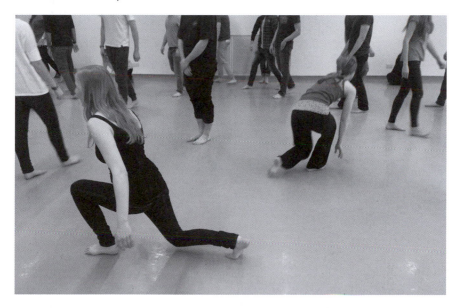

Figure 3.2 Participants are prompted to experience space at different levels, to notice each other, and notice how they alter one another's experience of the space. Image credit: Alice Sara.

Exercise 1

We start walking through the space inhabiting our bodies inhabiting the space.

Noticing our pathway's through space. Are we walking in a straight line or are we arcing through the space? Noticing other people in the space and the pathways they are making.

Seeing the patterns that emerge in the space.

Now we can introduce time, explore pace. How fast/slow are we moving?

What if we stop?

What impact does it have on the space? On the energy in the room?

We explore proximity to others: how near/far are we to other people? As we do this groups form and disband.

What about different levels?

How does it feel to move up high while others move

close to the floor?

What if you lie still?

Notice the whole space. Notice the people and how you and they alter your experience of the space.

2 Observing and experiencing space through the body

This stage of the workshop aimed to give participants a deep experiential understanding of the space in which they were working. It emphasized going beyond the image of the space, to really understand a space through the body. The exercises were designed to enable the participants to take their time, to get up close to the building and to reflect on the feelings that the place invokes.

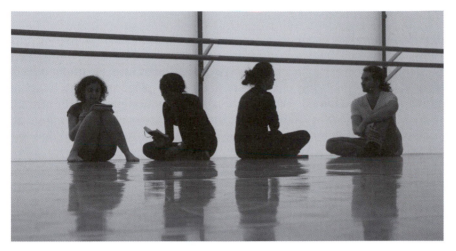

Figure 3.3 Participants share their experience of the space with a partner. Image credit: Elena Marco.

Exercise 2

Find a space, be in that space in whatever position is comfortable and use all your senses to experience it:

Touch – explore the texture and temperature with your hands as well as the whole body. Where would you lick? What might you stroke? Where would you like to lean or sit?
Sound – listen to the sounds outside the room, inside the room and inside yourself: how do they affect each other?
Smell – observe the smells and how they make you feel.
Sight – close your eyes – see the light source through your eyelids, then open your eyes and observe what can be seen of your space and its view.
Write a record of your experience.
Find a partner – take them to your space, tell them exactly where you were, whether you were standing/sitting/lying, which way you were facing, and swap over, then experience their space.
Write a record of this experience.
Read your notes and share your experiences with your partner.
You were both in the same room, but may have had very different experiences.
What was similar about your experiences?
What was different?

3 Use of the body to alter the environment (whole group)

The third workshop stage set a series of quick tasks, which ask participants to use solely their bodies to alter the environment. This stage introduced participants to the ways in which they, even without any expertise in dance, were able to dramatically change the nature of a place solely by changing the way in which it is used. The workshops were also designed to demonstrate to participants that they already have the tools with which to communicate via the ways in which they inhabit the space, and to help them to develop techniques to develop movement material for the next exercises.

Exercise 3

Without talking, take a moment to:

Link two points in the room.

Make a space within a space.

Make a dark space in the room.

Change the light of the space.

Emphasize the height.

Change the energy.

Change the sound.

Make the space unfriendly.

Make it softer.

Divide the space – a few times.

Figure 3.4 Participants take a moment to experience the space through touch, sound, smell and sight. Image credit: Elena Marco.

Exercise 4

Divide into two groups. Each group should make an entrance for the other group.

Enact or perform these entrances.

How is outside defined?

How do you know when you are 'in'?

What creates entrance?

4 Defining space and creating narrative (in small groups)

The fourth workshop stage was longer, and allowed participants to develop material to create a short narrative piece (or event) that explored ideas of space and place. It prompted architecture participants to move outside of their own ontological positions, not asking them to perform as dancers, but to inhabit a trans-ontological position in which they are neither operating as dancers, nor as architects, but instead are operating somewhere between. They were tasked with holding onto their architectural knowledge; how to create sequences of spaces, atmospheres and concept, while also being prompted to create and communicate using the language and constituents of dance.

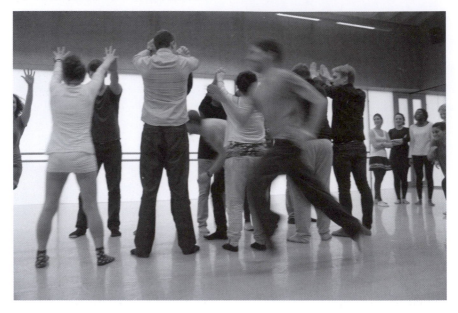

Figure 3.5 Experiencing an entrance (designed through exercise 4). Image credit: Elena Marco.

Exercise 5

Form a group of around five.

Create a sensorial journey for the rest of us to experience, an evolving environment – transform our experience of the space.

Are you inside or outside the space? Do you cross over its border?

How close are you to others within the group?

How close are you to the audience?

Consider the levels in space – sit/kneel/stand?

Think about energy, motion, directions in space.

Consider the timing/duration/rhythm of actions and events.

Are you making a series of spaces or a single space?

5 Communicating conceptual ideas through the body

The fifth stage of the workshop was a performance. This prompted architecture-disciplined participants to communicate their ideas in ways that are quite different to their usual practice. Whereas architecture designs are usually presented as fixed and finished images, the performance prompted participants to consider the relationship between the place and the body over time. It also prompted an understanding of the audience, who might be considered as analogous to the users of a building. Again, the performance reinforced the trans-ontological position. Participants are reminded that they are not expected to 'perform' solely as dancers, but somehow to use the techniques and constituents of dance as a way of creating meaning at the intersection between space and event.

6 Reflections

This final stage allowed all the participants to reflect on what they had learned from the process and to discuss what understanding might be gained by investigating architecture through the practice of dance. What emerged from the discussions was that the workshop brought to the fore often forgotten elements of architecture: sensory experience; emotion and meaning; the inter-relationship between the user and the space; between multiple users of space; between time and contingency. Each inter-relationship is continually affected by, as well as having an affect upon, the other.

Dance artist Alice Sara reflects:

> What became increasingly apparent to me in co-facilitating these sessions, and seeing how architects work, was this disparity in how the two disciplines consider time. Experiencing a space, altering a space with our bodies, unavoidably creates a conversation between time and space. While a dancer's response to the creative tasks would likely involve some element of development through time, the architecture students (and academics) have tended towards the tableau or a static formation of bodies in space. As we developed these workshops we increasingly included preparatory tasks and ways of introducing tasks that encouraged the consideration of time. For example we used to have as a final task, 'Explore a space, and as a group find a way of representing/altering this space with the body', and have since developed the final task to ask participants to 'create a sensorial journey for the rest of us to experience, an evolving environment'. We found this enabled the architecture students to allow their exploration of space to have a relationship with time.
>
> (Sara, in interview, 2013)

This broadened perceptions of the range of ways of communicating ideas, and the value of understanding architecture as a sequence of experiences, rather than a single object. The workshops construct an understanding that there is no fixed 'space' to be designed and represented, but rather an ongoing interaction between 'object' and 'subject', 'architecture' and 'user', space and event.

The workshops gave architecture students a deeper, empathetic and more holistic understanding of space; rooted in human experience rather than solely the formal arrangement or ordering of space. This might be seen through what Benjamin describes as a process of 'mimesis'. Architectural theorist Betty Nigianni reflects on his use of the term as:

> the psychoanalytic sense of a creative empathizing with the object. For Benjamin, the ability to identify with and assimilate to the environment refers to a constructive reinterpretation that goes beyond mere imitation and becomes a creative act in itself.
>
> (Nigianni 2007: 256)

Through this creatively empathetic understanding the workshops begin to explicate the relationship between architecture and dance and suggest not only that through inhabiting an ontological position somewhere between architecture and dance we can *understand* architecture, but that in this liminal place we might also be able to *create* architecture.

The knowledge that is constructed through the collaboration further develops the relationship between space and event, so that we might begin to see them not as two poles, at opposite ends of the same continuum, but rather as an ongoing interaction. Practicing between architecture and dance allows a creative empathizing that in itself resists separations: between mind and body, object and subject, fixed and contingent, concept and sensory, space and event. In doing so it implies a new way of inhabiting both domains of space and event, dance and architecture as continuously affecting and reinterpreting the other. This model is analogous to notions presented through the Möbius strip.

A Möbius strip is a surface that can easily be created by cutting a ribbon (for example a strip of paper), twisting it once and gluing together the ends (see Figure 3.6). It has one continuous surface; when you run your finger along this surface you can continuously travel from what at first glance looks like an 'inner' to the 'outer' surface without crossing over an 'edge'. Using this as a diagram, we can see that space and event at first reading seem to be on different sides of the ribbon. However, a closer investigation shows that if you follow the ribbon around, you find that both domains are infinitely connected.

Figure 3.6 A Möbius strip links space and event on a shared continuum.

Conclusions

Working between architecture and dance suggests a radical redefinition of the relationship between the two domains. It generates a knowledge and even a way of being that is itself 'between'; a knowledge that is between mind and body, space and event, object and subject. This is explored here as a trans-ontology, which implies not only a way of thinking that is across the two domains, but also implies an altered way of being. In turn this suggests the need to develop new approaches, by making connections across and between domains and dissolving the rigidly drawn boundaries delineating each discipline. The collaboration is itself a form of resistance to disciplinary boundaries, in the way that it interrupts the binary categorizations of each.

The collaboration forms a critical practice, in which the normative models of each domain are actively questioned, challenged, reformulated and rethought. Through investigating in this way we are able to question what both disciplines could, or even should be. Perhaps in working in this trans-ontological way we can allow ourselves a deeper and more nuanced exploration of space that we may not usually make time for, and in working with our bodies, a conversation can be developed between space and time; between place and event; between architecture and dance.

Notes

1 'Trans' is used to mean through, across or beyond, but also implies changing thoroughly, and 'ontology' is used to denote a theory of being, that is strongly linked to 'epistemology' or theory of knowing.

2 Jonathan Mosley and Rachel Sara, 'Architecture and Transgression: An Interview with Bernard Tschumi' in Mosley and Sara (eds), (2013) *The Architecture of Transgression AD*, London: Wiley, pp. 32–37.
3 I.e. Not concerned with beauty.
4 Ironically the dramatic forms captured in dance photography are often described as 'architectural' – which very much conforms to an understanding of both architecture and dancer as object.
5 Prof. David Seamon defines phenomenology in Phenomenology, Place, Environment and Architecture: a review of the literature, as *'the exploration and description of phenomena, where phenomena refers to things or experiences as human beings experience them. Any object, event, situation or experience that a person can see, hear, touch, smell, taste, feel, intuit, know, understand or live through is a legitimate topic for phenomenological understanding.'* Available at www.arch.ksu.edu/seamon/ articles/2000_phenomenology_review.htm, accessed 17 December 2013.
6 Transgression, The 10th International Conference of the Architectural Humanities Research Association (AHRA), University of the West of England, Bristol, 21–23 November 2013.
7 This workshop title was generated through collaboration with Clare Baker.
8 See, for example, http://dramagames.info/2011/07/03/zip-zap-boing/ accessed 18 December 2013.

References

Broady, M. (1966) 'Social Theory in Architectural Design', in Gutman, R., *People and Buildings*, New York: Basic Books.
Goffi, F. (2007) 'Architecture's twinned body: Building and Drawing', in Frascari, M., Hal. J. and Starkey, B. (eds) (2007) *From Models to Drawings, Critiques: Critical studies in architectural humanities*, London: Routledge.
Jay, M. (1994) *Downcast the Eyes: the Denigration of Vision in Twentieth-Century French Thought*, Berkeley, Los Angeles, London: University of California Press.
Merleau-Ponty, M. (1945) (2012 edition) *Phenomenology of Perception*, London: Taylor & Francis.
Mosley, J. and Sara, R. (2013) 'Architecture and Transgression: An Interview with Bernard Tschumi', in Mosley, J. and Sara, R. (eds) *The Architecture of Transgression AD*, London: Wiley.
Nigianni, B. (2007) 'Architecture as Image-space-text', in Frascari, M., Hal, J. and Starkey, B. (eds), *From Models to Drawings, Critiques: Critical studies in architectural humanities*, London: Routledge.
Pallasmaa, J. (2005) *The Eyes of the Skin: Architecture and the senses*, Chichester, UK: John Wiley and Sons Ltd.
Rice, L. (2013) 'Occupied Space', in Mosley, J. and Sara, R. (eds) *The Architecture of Transgression AD*, London: Wiley.
Sara, A. (2013) Personal diary extract, December.
Tschumi, B. (1978) *Advertisements for Architecture*, Cambridge, Mass: MIT Press.
Tschumi, B. (1996) *Architecture and Disjunction*, Cambridge, Mass: MIT Press.
Zumthor, P. (2006) *Thinking Architecture*, Germany: Birkhauser.

4 Atmospheric choreographies and air-conditioned bodies

Derek P. McCormack

One of the more important trajectories of thinking in the contemporary social sciences and humanities is the emergence of sustained attention to matters of air and atmosphere. Interest in such issues is clearly by no means new. However, where earlier work about these topics often tended to examine their cultural significance, and often did so in relation to representational processes, more recent writing and thinking has departed from this in a number of notable ways. Thus, there is greater emphasis on the affective materiality of different forms of "aerial life" as it is organized and experienced in relation to the contingencies of atmospheric phenomenon (Adey, 2010). There is also greater attention to the elemental geographies of what Tim Ingold (2006) calls "weatherworlds," and to the specific forms of experience associated with, for instance, different spacetimes of precipitation and condensation (Martin, 2011; Jackson and Fannin, 2011). Equally, there is a greater appreciation of how the technological fabrication and affective experience of different spheres of inhabitation are shaped and sustained by relations with the material properties of air and atmosphere as these properties are made explicit in different ways (Choy, 2011; Sloterdijk, 2011). And, relatedly, there is a growing effort to examine how the affective and meteorological senses of atmosphere become intertwined through experiments with different devices and experiences (McCormack, 2008).

Building upon these trajectories of thinking, in this chapter I ask how attention to matters of air and atmosphere shapes understandings of the relation between site, site-specificity, and moving bodies. Posing this question is an opportunity to reflect critically upon how the affective materiality and the ethico-aesthetics of both site and moving bodies are intertwined through processes of being and becoming airborne. It also requires us to develop ways of accounting for some sense of the specificity of things as they take shape as worldly presences, while also encouraging us to realize that this specificity may not be a function primarily of site as location. In what follows I develop this claim by examining choreographic experiments with moving bodies in, and in relation to, air and atmosphere. I understand choreographic experiments in a deliberately broad sense:

they involve the arrangement and organization of the relations between bodies, things, and their surroundings in order to explore new ways of going on in the world. Like others, I don't assume that bodies pre-exist these experiments, but I take them to be compositions that emerge in relational terms through movement (Manning, 2009). In this broadly Spinozist (1989) approach, bodies are defined in terms of their speeds and slowness, and in terms of their capacity to affect and be affected by other bodies. If we think in these terms, a body is not just a human form. It may also be a cloud or a gust of wind, or a "site." Moreover, the consistency of these "bodies" depends less on their actual position vis-à-vis some fixed point, but on their capacity to affect and be affected by other bodies.

The claim I develop in this chapter is twofold. First, attention to air and atmosphere encourages us to foreground what, following Robert Irwin (1985), we might call the site-conditioned, or more accurately, the *air-conditioned* qualities of choreographing moving bodies. The constraint of such choreographies is not so much provided by a grounded location but by the fluctuating contingencies of spacetimes composed of assemblages of relations not necessarily defined by a straightforward division between surface and air, earth and atmosphere. However, and second, this requires us to mobilize different conceptual resources for thinking through the relation-specific (Massumi, 2011) forms of aerial and atmospheric gatherings that take into account the materiality of particular sites without necessarily being site-specific. Following Irwin (1985), and Michel Serres (2008), I point to how we might understand choreographic experiments with moving bodies in terms of circumstantial gatherings that foreground the relations of speed and slowness of which atmospheres and air consist. Thinking in terms of a certain kind of circumstantial specificity does not mean becoming ungrounded through a dream of transcendence. Instead it involves cultivating responsiveness to the relation-specific affective materialities of moving bodies that become present in different ways as air-conditioned, atmospheric things.

On site

I have always had mixed feelings about site as a concept for thinking geographically. In part this is because I have found it so difficult to distinguish site from other, related, concepts. This difficulty goes a long way back. Part of the state geography exams I took midway through secondary school in Ireland involved a map interpretation exercise. Among the various questions asked was one concerning the site and situation of a given feature, usually a small town in a rural location. The first part of the question would ask exam candidates to describe the site of the town, while the second part would ask for a description of the situation. By site I understood the actual and immediate location of a feature, such as a town: it referred to the characteristics of the piece of ground upon which this town was sited,

characteristics such as altitude, gradient, etc. And situation, at least as far I understood it, described the relation between site and its surroundings. To describe these different aspects of a particular geographical feature seemed straightforward. Somehow, however, these terms never failed to frustrate me. I would begin my answer about site but quickly realize I was eating into the stock of things I could be using to describe situation. At some point I would split the difference between the two terms without really knowing what this difference was or indeed where it lay. And I hoped the examiner would fail to notice my uncertainty and indecision.

For me, then, site has been unsettling right from the outset of my encounter with the term: it has always been a term whose meaning has been complicated by its relation with that which is beyond its limits or edges. This sense was amplified further when, much later, I encountered the wide range of critical interrogations of the term by thinkers in the social sciences, humanities, and performance studies (see, for example Kaye, 2001; Hunter, 2005; Pearson, 2010). Much of this critique centered, of course, on the problem of presence, and on the risks of equating site-specificity with the promise of a relatively bounded form of spatiotemporal fullness or plenitude. As numerous figures across various disciplines have argued, the specificity of site is something constituted by absence as much as by presence, by what is beyond, in a spatial and temporal sense, the physical limit of site. Moreover, this is a critique that resonates with the affirmative interrogation within the social sciences and humanities of a repertoire of related concepts, including space, place, and location (see, for instance Massey, 2005; Thrift, 1999).

The force of this critique does not, of course, mean that site is no longer available as a concept for thinking-with in the context of different modes of performing and theorizing spacetimes (see, for example, Schatzki, 2003; Jones, Woodward, and Marston, 2007). And yet, there are other related reasons why we may wish to continue to unsettle site as a concept. Not least of these is the importance of refusing to allow an affirmation of site and site-specificity to become a way of grounding or tempering abstraction. There is something about the site-specific that seems to privilege a kind of grounded, if also unsettled, worldliness considered more authentically lived than abstraction, where abstraction is defined as a mode of thinking that takes us out of, or above, the world. However, rather than something that helps us to avoid abstraction, or to make abstraction more worldly, site, like world, can better be understood itself as an abstraction requiring explanation. This, in turn, means that the affirmation of site cannot, in any straightforward way, become a vehicle for defining embodiment against modes of thinking taken as abstract because they are considered to distance thought from moving bodies. Bodies, no less than sites, are abstract before we think too much about them: they have what Brian Massumi (2002) calls a kind of abstract virtuality that means they are always becoming more than they actually are (which does not necessarily imply a benign process).

Equally, the risk of thinking or doing things with site-specificity is that we fall back on what the philosopher Alfred North Whitehead (1978) calls a misplaced sense of concreteness: that is, on a sense of the immediacy of a kind of object-world that makes it more difficult to grasp the eventful processuality of things in passing. In short, rather than thinking about bodies and sites as discrete entities pre-existing the relations of which they are being composed, we are better understanding both as being produced together: the form and force of bodies and sites emerges through and as relation-specific events of what Alanna Thain (2008) calls "affective commotion." Both bodies and sites, in other words, are already moving, albeit at different speeds. The implications of this claim are manifold, but not least among them is that it becomes more difficult to think of site as something whose fixity is defined against the movement of lively, animated, bodies.

The point of unsettling in this way is not necessarily to dismiss the concept but to put it to work in ways that simultaneously agitate it while holding on to its potential to furnish a generative constraint for thinking. This of course is precisely what much theoretical and practice-based work in performance and performance studies has sought to do. And in some respects it is what work in social sciences such as geography has been endeavouring to do, and increasingly so through a range of collaborative aesthetic experiments with artists and performers (see, for instance Hawkins, 2013a, 2013b). Much of such work might be understood, following Robert Irwin (1985), as site-conditioned, insofar as it is developed in response to a set of surroundings while also being shaped by a range of experiential trajectories. Put another way, in site-conditioned work the qualities of a particular material assemblage can potentialize a relation-specific spacetime for thinking and doing whose contingencies are shaped in part by the qualities of a particular location at the same time as these spacetimes are shaped by movements beyond that location.

Air-conditioned moving bodies

But if we foreground air and atmosphere we may need to go even further than these necessary agitations of site. We may need to think about how the qualities and forms of choreographed, eventful gatherings can be as much *air-conditioned* as site-conditioned. By this I mean that as moving assemblages, gatherings of moving bodies are air-conditioned insofar as they are shaped as much by what is in the air and by how the air moves as they are by what is on the ground. In other words, the air-conditionality of choreographing moving bodies might take place as a form of being and becoming exposed to that which is excessive of site: that which is aerial, atmospheric.

There are various ways in which the relation between moving bodies and air-conditioned specificity is articulated through choreographic and dance practices. At the outset, and first, we should note the parallels between the

emergence of site-specific performance and forms of aerial dance. Certainly, with the emergence of site-specific dance in the 1960s, choreographers often began exploring different ways of working with verticality in a manner that was not framed so heavily by the ideals of lightness and weightlessness that had long circumscribed the moving body in ballet. Notable examples of this, for instance, were Trisha Brown's 1970s works *Walking on the Wall* and *Man Walking Down the Side of a Building*, in which dancers worked with ropes and harnesses in order to explore movement along vertical surfaces in different ways. Similar experiments with aerial choreography continue to be undertaken by a range of companies today. For instance the French company, Retouramont, led by Fabrice Guillot, produces aerial works designed to intervene in the sense and experience of urban public spaces. Such works, including for instance, *Danse Des Cariatides: Urban Vision*, performed on the walls of Oxford Castle in 2012, explore different relations of lightness, sound, and volume through the movement of bodies in particular urban contexts. In that sense, these works exemplify a choreographic ethico-aesthetics that is both site-conditioned and air-conditioned.

However, there are important ways of becoming aerial that pre-date the emergence of site-specific dance while anticipating forms of skilful movement and technical expertise performed by contemporary aerial choreographers. Here we might recall, for instance, the kinds of agility and corporeal expertise required by sailors as they clambered about on the rigging of sailing ships high above moving decks. Equally, we can point to the kind of bodily choreography required as part of the construction of increasingly monumental structures in the literal and metaphorical rise of modern cities. Take, for instance, large suspension bridges, such as the Brooklyn Bridge. The construction of these bridges required workers to work with wires and cables at great heights (see McCullough, 1972). And, as such, they mobilized skills that were also found in the performance of aerialists as popular theatre entertainers in the nineteenth century, and that can still be found in the work of contemporary wire-walkers (Tait, 2005). The important point here is that all of these skilled performances involve the choreographic arrangement of bodies, devices, and spaces, such that they are made mobile and aerial in distinctive ways according to the conditioning constraints of particular sites (see also Lawrence, 2010).

A second way in which the relation between air and site is articulated through the choreography of moving bodies is via the very effort to generate and modulate the distinctive qualities of atmospheres. By atmosphere here I mean a spacetime that is simultaneously affective and meteorological. Atmospheres in an affective sense are distributions of feeling across and between bodies (see, for instance, Brennan, 2004; McCormack, 2008; Anderson, 2009; Bissell, 2010; Stewart, 2011). Affective atmospheres are palpable as the sense of things happening (or not), while always remaining excessive of incorporation in an object or in the shape of a discrete thing.

Atmospheres name the affective qualities of gathering intensities of feeling while always escaping the recognizable form of that gathering. But atmospheres are also obviously meteorological or gaseous. They are composed of bodies of gas of different degrees of density, different temperatures, and different speeds. Atmospheres, in this sense are moving spacetimes characterized by different degrees of turbulence that can affect and be affected by bodies in a range of ways.

Clearly, regardless of their location, we can think of human bodies in terms of how they move in but also generate affective atmospheres, and moreover, about how these atmospheres can be and are modulated through different combinations of light, sound, and objects (see, for instance, McCormack, 2013; Edensor, 2014). There is a long and complex genealogy of efforts to choreograph relations between moving bodies and atmospheres. In dance and choreography these efforts have been characterized by various changes in emphasis, including, for instance, a shift away from the assumption of an inevitable and necessary relation between music and movement. In this respect, the emergence of site-specific dance marked another juncture in the relation between the problem of choreographing moving bodies and the generation and modulation of affective atmospherics through light and sound. Certainly, in many instances these processes become less tethered to the architectural surrounds of traditional performance venues. Instead, the atmospherics of site-specific dance emerges in relation to the constraints placed upon this dance by the architectural surrounds in which it takes place. This, however, is not unique to dance – it is at the heart of how a whole range of performance genres, from sports commentating to cinema, have had to come to terms with the logistical and aesthetic demands of working "on location."

Site-specific dance can also be about becoming more explicitly atmospheric in another obvious way however: about cultivating openness and exposure to the elemental qualities of air and atmosphere in different ways than dance that takes place in more traditional performance settings. In particular, site-based forms of what Nigel Stewart (2010) calls "environmental dance" engage directly with the relation between body and atmospheric phenomena, albeit often under the guise of encounters with "landscape." This engagement takes place through a modified form of witnessing, in which the dancer becomes a witness not just to the dance of other human bodies, but to the ebb and flow of different elemental movements. Equally, we can point here to how body weather training, developed by Min Tanaka from Butoh, is premised upon the possibility of cultivating a form of worldly moving in which "bodies are not conceived as fixed and separate entities but are – just like the weather – constantly changing through an infinite and complex system of processes occurring in- and outside of these bodies"[1] (for a discussion and critique, see Taylor 2010).

A third way the relation between site and air or atmosphere is articulated through moving bodies is via the use of particular objects as affective participants within choreographic experiments. Here, objects become devices for doing atmospheric things. By atmospheric things I mean first, relatively shaped forms that foreground the relations in which they are immersed and, second, and simultaneously, the sense that something atmospheric is taking place without forming as an object (see Stewart, 2011). A commonly used device for doing these kinds of atmospheric things is the balloon. Indeed, because of its obvious qualities of lightness and volume, the balloon has been used in a range of aesthetic and choreographic experiments that might be called atmospheric. One of these experiments had its origins in the collaboration, during the 1960s, between an engineer at Bell Labs, Billy Klüwer, and the artist Andy Warhol, under the aegis of the organization Experiments in Art and Technology (E.A.T.). Warhol initially had the idea of huge floating light bulbs. However, when it became clear that making such things would be impractical due to the size of the batteries required Warhol, began working instead with some lightweight foil packaging material being used at Bell Labs. Warhol used this material to produce pillow-shaped balloons that were then inflated with helium. The resulting piece was called *Silver Clouds*. When installed in a given space the result was a work in which visitors could move around and with the balloons, while small fans generated air currents that kept the balloons circulating gently around the room. Insofar as it is always installed in a particular space, and needs to be contained, *Silver Clouds* is a site-conditioned work: its volume and relational density depend upon the size of the room in which it is installed. But *Silver Clouds* is also air-conditioned: the shape and movement of the balloons depends upon the dynamic relation between different gases, and on the circulation of air in the space where it is installed.

The balloons used in *Silver Clouds* became participants in a more explicitly choreographic experiment when they were used in Merce Cunningham's 1968 work *RainForest*. In an interview in 2005, Cunningham outlined how the idea to use the balloon originated: "I was with Jasper Johns at an exhibition and Andy's pillows were just piled in a corner. I immediately thought they would be marvellous on stage because they moved, and they were light, and they took light. So I asked Andy and he said, "Oh sure." As he continued, dancers had to learn to work with these balloons in a particular way: "you had to push, not kick, to get them to float. When we first did *RainForest* they had only had one rehearsal with the pillows, and a lot went out into the audience" (Cunningham, in Mackrell, 2005). In effect, in *RainForest* balloons became free, "unmanageable," untethered participants that added a certain sense of uncontrolled spaciousness to a work of air-conditioned choreography. As Marcia Siegel writes: "the pillows behaved in their own fashion. They skittered along on end at the slightest disturbance of the air. They drifted about the floor or out into the wings" (2001: 263).

The participation of the balloons in pieces such as *Silver Clouds* and *RainForest* anticipates more recent choreographic works, perhaps most notably William Forsythe's *Scattered Crowd*, first installed in 2002. In this piece, hundreds of tethered pairs of balloons (one white, filled with helium, and the other translucent, filled with air) are suspended in a given space accompanied by the refrain of a looping, ambient soundtrack. Visitors can move around, touch, and move with the balloons. The effect is to generate an atmosphere of immersion in which the shifting volumes of a spacetime emerge between air, balloons, and bodies (see Manning, 2009).

Choreographing atmospheric circumstances

Choreographic works like *Scattered Crowd* and *Silver Clouds* remain site- and air-conditioned if not necessarily site-specific. They take place anew every time they are installed. However, even the term air-conditioned only goes so far in relation to the question of how to choreograph moving bodies with the dynamics of air and atmosphere. These works remain dependent upon a certain sense of groundedness, however expansive, however voluminous. What might it mean to think with and choreograph air and atmosphere in ways that try to take into account the affective potential of meteorological forces and processes to move things in distinctive ways? In posing this question I foreground deliberately the gaseous or meteorological associations of that term. In part this is because if we emphasize the affective dimensions of that term it remains comparatively easy to think of atmospheres in site-specific terms. We can refer to the atmosphere of this room, that hall, this open space, for instance. But if we emphasize the gaseous/meteorological sense of atmosphere then things becomes a little more difficult.

We might therefore begin to ask how, and in what sense, is the meteorological atmosphere site-specific? In a general sense, atmosphere might be an example of what Timothy Morton (2013) calls a "hyper-object." As a turbulent zone of gases surrounding Earth, the spatiotemporality of atmosphere exceeds any incorporation in a particular location or position, apart from its relation to Earth. This atmosphere is not undifferentiated, however. It is composed of variations in temperature, pressure, humidity and velocity that sometimes cross a threshold such that they become palpable as relatively discrete events: showers of rain, gusts of wind, clouds. But in what sense is a shower of rain or a gust of wind site-specific? Certainly not in the same sense that the atmosphere associated with a performance in a particular building is site-specific. We might of course say that a shower of rain or a gust of wind is site-specific because it is blowing here, in this place, at that location, for me or for someone else. A shower of rain is site-specific because it soaks me here, in this place. A gust of wind is site-specific because it blows with such force that it threatens to knock me over. But as atmospheric things, this shower or that gust is only a very local, surface expression of a

far more complex thing whose shape is not necessarily dependent upon a grounded location.

How then to grasp the spacetimes of these atmospheric things in ways that capture the form of a gathering without necessarily becoming grounded in the specificity of site? One way we can think of these things is in terms of what both Robert Irwin (1985) and Michel Serres (2008) call circumstances. For Irwin, circumstance "encompasses all of the conditions, qualities, and consequences making up the real context of your being *in* the world. There is embedded in any set of circumstances and your being in them the dynamic of a past and future, what was, how it came to be, what it is, and what it may come to be" (1985: 28). In a less obviously phenomenological vein, circumstance, for Serres, refers to the torus of relations that fringe a thing while also making it what it is through a myriad of deviations and fluctuations. So we might say that the spacetime of a shower of rain, or a gust of wind, is circumstantial, without necessarily being site-specific. More precisely, Serres tells us that circumstances have a threefold quality. They refer to the "imprecise surroundings of subjects, objects or substances," to "highly unpredictable chance occurrences," and to "a tricky history of stasis and equilibrium, disturbances and returns to the original state, deviations towards the fluctuating environment" (2008: 293). To take Serres seriously here is to understand circumstances in terms of a form of partial, moving consistency that is always being pulled into a new shape by the relations and forces in which it is immersed. So a cloud or a shower of rain has a circumstance-specific rather than site-specific quality.

It is possible to respond to these circumstantial gatherings in different ways, of course. One way, for instance, is through the kinds of witnessing associated with practices of environmental dance that may be site-specific (Stewart, 2010). But there are other ways of choreographing relations with air and with atmospheric processes that involve taking advantage of the circumstantial relations of atmospheric things by moving within the constraints of those relations or, more accurately, by allowing things to move within those constraints. Here I merely want to gesture briefly to three cases in which we might understand this kind of choreography to be taking place. As it happens, balloons and ballooning figure in each case.

First, we can find this kind of choreography in the non-human world. Choreographing the relations between moving bodies and air and atmosphere is not an activity specific to humans: instead, it can be found in the way in which non-human forms of life arrange their relations with their environmental surrounds. Take, for instance, the kind of "ballooning" undertaken by spiders, a technique of aerial dispersal recognized in the late seventeenth century (Parker and Harley, 1992; see also Blackwell, 1827) and frequently remarked upon since by various figures, including Charles Darwin. Elsewhere, in an article published in 1874 in *The American Naturalist*, G. Lincecum described the emigration, during November and December in Texas, of what he called "the Gossamer Spider." Lincecum's description

anthropomorphizes the spider, to be sure, but it is worth discussing here because it points to the existence of a kind of choreographic arrangement between spider, silk, and air. Lincecum describes in detail the process by which the Gossamer spider fashions its balloon, each of which is "furnished with two long lines at the forward end." These, he suggests, "aid in preserving the equable position of the light floating craft" (1874: 595). Lincecum notes how, on one occasion, he observed closely the activity of one such spider as it prepared for a journey, the details of which are worth quoting at length here:

> She finished up the body of the balloon; threw out the long bow lines, which were flapping and fluttering on the now gently increasing breeze, several minutes before she got all ready for the ascension. She seemed to be fixing the bottom and widening her hammock-shaped balloon. And now the breeze being suitable, she moved to the cable in the stern, severed it, and her craft bounded upwards and soaring away northwards, was soon beyond the scope of my observation. I was standing near when it was preparing to cast loose the cable; and had thought I would arrest its flight but it bounded away with such a sudden hop, that I missed and it was gone.
>
> (1874: 595)

Since this behaviour was first observed the conventional explanation has been that it is facilitated by the wind. It is often assumed that what is required is not a strong wind, but a wind blowing at under 3 metres per second in combination with some degree of thermal uplift (see Thomas *et al.*, 2003). A more recent study has explained the phenomenon via electrostatic forces that act both to separate the gossamer threads and which generate sufficient lift to allow the spider to undertake excursions even when wind conditions do not allow. Regardless of the merits of either explanation, what seems to be happening is that the spider is choreographing the act of release and ascension in such a way as to take advantage of sets of circumstances that emerge in the relations between the capacities of the spider, the affordances of the ground, and the dynamics of the air. All that can be choreographed here, of course, is the act of release. The eventual landing site is undetermined, at least as far as we know.

Second, we can find efforts to choreograph atmospheric circumstances in aesthetic experiments that try to allow objects and material devices to move independently of these circumstances, insofar as that is possible. Mirroring the act of speculative release undertaken by spiders, this kind of aesthetic work is premised on the possibility that after an initial input things become atmospheric according to their own devices. On one level here we can point to aesthetic works that use the act of release in order to generate site- and air-conditioned atmospheric things that once released move independently. A notable example here, for instance, is Alfredo Jaar's 2000

work *Cloud*. This work took place on the US–Mexican border and involved the performance of a concert combined with the release of a cloud of white helium-filled balloons memorializing the migrants who died in the act of trying to cross this border. Once released, the balloons drifted off. Even here, however, the act of release is a deliberately symbolic and meaningful one. And, while atmospheric, it remains relatively site-specific.

Others have tried to push further the possibility of atmospheric choreographies that are not framed so obviously by particular meanings and sites. Take the work of the artist Hans Haacke, for instance. During the 1960s Haacke began experimenting with artworks that foreground the dynamics of atmospheric processes. Some of these works used balloons. Among the works Haacke created during a period at MIT was *Sky Line*. Similar to an earlier work he had created in New York, *Sky Line* consisted of a nylon line to which were attached hundreds of white helium-filled balloons. The balloons functioned to keep the line aloft while the line kept the balloons together. While these aerial works were clearly experienced visually by spectators on the ground, for Haacke, however, they were intended to offer more than an aerial spectacle, and were planned to be more than aerial versions of conventional sculptures or compositions (see Jones, 2011). Influenced by ideas from systems theory, Haacke conceived of works like *Sky Line* to be primarily about the aesthetics of systems that operated, as far as was possible, beyond human influence and intervention, and independent of human perception. In Haacke's words, these pieces were "produced with the explicit intention of having their components physically communicate with each other, and the whole communicate physically with the environment… Changes are desired and are part of the program—they are not due to the shifting experience of the viewer" (cited in Jones, 2011). Here the goal was to allow simple devices like "balloons or whatever to become completely autonomous" but only insofar as they also became part of systems incorporating elements often invisible to art, such as air and wind (Haacke, in Jones, 2011). These works were designed, at least for their relatively short duration, to be quasi-autonomous affective systems that could be "witnessed" by the viewer without being dependent upon any empathetic relation with that viewer (see Burnham, 1968).

A third place we can find efforts to choreograph atmospheric circumstances is in experiments with directing the movement of things aloft by making use of the very conditions that are found at altitude. Here we can begin to discern the emergence of increasingly sophisticated efforts to choreograph relations with the circumstantial qualities of air and atmosphere as part of the imagining of new kinds of complex systems of connection and control. Such works are less explicitly aesthetic than, for instance, Haacke's works: rather, they aim towards devising new formations of atmospheric power through the generation of distributed connectivity facilitated by technological platforms that consist of assemblages of moving things. One of the most significant recent examples of this is the Google

Loon Project, which was first publicized in mid-2013. Consisting of a "network of balloons travelling on the edge of space," Project Loon is an experiment in providing a cost-effective and feasible technological solution to the problem of how to increase internet connectivity in relatively isolated areas. Antenna on the ground "talk" to solar-powered balloons floating 20 km high, which in turn talk to each other and to the base station of a local internet provider. These balloons are not dirigible in the conventional meaning of that term: they cannot be steered, in the sense that dirigible blimps can. Instead, their position can be modified by Project Loon "mission control" engineers who take advantage of winds moving in different directions and at various altitudes in the stratosphere.

Obviously dependent to some extent upon activities on the ground, the Loon Project can nevertheless be understood as an attempt to choreograph what is arguably a new kind of atmospheric thing, one specific to the technological assemblages of the anthropocene: a moving assemblage composed of different elements on the ground and in the air, the shape of which is determined as much by the direction of the wind as it is by human action. This thing is not so much site-specific: its consistency as a kind of assemblage is dependent upon the atmospheric circumstances in which it moves. It is a circumstance-specific thing whose movement, duration and extent are co-determined by both engineers and the elements with which they work.

Conclusion: towards a circumstantial atmospheric aesthetics

In an important and oft-cited statement Richard Serra has observed that if a given site-specific work is moved then it is destroyed (see Kaye, 2001). This claim is accurate in relation to certain kinds of work. And yet it has limits. Certainly, if we remain tethered too closely to the idea of site as relatively fixed location then it is more difficult to think about different kinds of relational specificity that may be site-conditioned without necessarily being site-specific. Things become even more difficult when we add questions of air and atmosphere into this mix, as I have tried to do in this chapter. Thus, while a certain site-conditioning might well remain important, choreographing moving bodies in relation to air and atmosphere is also about a responsiveness to the air conditions that shape these bodies. Beyond this, however, choreographing moving bodies can also involve the arrangement of the relations between these bodies as they are moved by a range of atmospheric forces and processes that are not necessarily dependent upon site conditions.[2]

In the future there are likely to be further experiments with choreographing moving bodies in relation to and as atmospheric things. Some of these works will be explicitly commercial, in the vein of the Google Loon Project. Thus, at the time of writing Facebook had just announced that it was exploring possibilities for using high altitude drones for

enhancing internet coverage.[3] Others' projects will be hybrid works involving corporations like Google and various artists as the former begins to become one of the major sources of new kinds of experiments with atmospheric aesthetics. In part this is because a corporation like Google is one of the few entities with enough money to undertake such experiments, but it is also because such experiments fit with the kinds of atmospheric power upon which Google trades. This power is about market share and connectivity, of course. But it also has a certain kind of aesthetic: one defined by the affective value of a kind of ambient atmospherics in relation to which different domains of life, technology and expertise are seen to be increasingly blurred. As a recent example we can point to *Skies Painted with Unnumbered Sparks*, a 2014 work by the artist Janet Echelman, developed in collaboration with Aaron Koblin, Creative Director of the Data Arts Team in Google Creative Lab. The work is over 700 feet long and consists of braided synthetic fibre knotted together between two major buildings in Vancouver. The work is site-conditioned insofar as it is designed for a particular location in downtown Vancouver, and installed to coincide with the 2014 TED conference. But it is also an air-conditioned atmospheric thing. Air-conditioned because its material form and construction are designed to take into account the speed and force of the wind. And it is atmospheric in the sense that its shape and movement unfold in response to local expressions of more general atmospheric phenomena, and because its affective qualities of lightness and illumination are shaped in response to the movements of those who connect wirelessly with it. As the publicity material accompanying the work put it, "at night the sculpture came to life as visitors were able to choreograph the lighting in real time using physical gestures on their mobile devices. Vivid beams of light were projected across a massive scale as the result of small movements on spectators' phones."[4] The project team is explicit about how the sculpture is not just a moving physical artifact, but a meshwork of synthetic fibre, moving with the wind, onto which is projected a "web browser. The lighting on the sculpture is actually a single fullscreen Google Chrome window over 10 million pixels in size."[5]

There are ways of choreographing air-conditioned atmospheric things in other, more modest ways, of course: experiments that involve such simple things as balloons albeit in a range of different guises. And yet, regardless of the form taken by these experiments there is something important at stake here. What is at stake is the way in which air and atmosphere become explicit as spacetimes of ethico-aesthetic concern. The way in which this process takes place matters as part of a more general effort to make sense of the complex entanglements of human forms of life and the other forms of life, geological forces, and elemental energies from which new worlds are taking shape. While it may well be that site-specific art and performance played an important part of making explicit the environment as a matter of social and political concern in the 1960s and since, new practices and new

vocabularies are required for us to grasp the qualities of the air-conditioned worlds in which we and others live and the many kinds of atmospheric things, choreographed and otherwise, that move within these worlds.

Notes

1 See http://www.google.com/loon/. Last accessed 1st February 2015.
2 See www.bodyweatheramsterdam.blogspot.co.uk. Last accessed 26 March 2014.
3 See http://internet.org/projects. Last accessed 30 March 2014.
4 See www.echelman.com/project/skies-painted-with-unnumbered-sparks/. Last accessed 26 March 2014.
5 See www.unnumberedsparks.com. Last accessed 26 March 2014.

References

Adey, P. (2010) *Aerial Life*, Oxford: Wiley Blackwell.
Anderson, B. (2009) "Affective atmospheres," *Emotion, Space, and Society*, 2(1), pp. 71–77.
Bissell, D. (2010) "Passenger mobilities: Affective atmospheres and the sociality of public transport," *Environment and Planning D: Society and Space*, 28(2), pp. 270–289.
Blackwell, J. (1827) "Observations and experiments, made with a view to ascertain the means by which the spiders that produce gossamer effect their aerial excursions," *Transactions of the Linnean Society of London*, 15, pp. 449–459.
Brennan, T. (2004) *The Transmission of Affect*, Ithaca: Cornell University Press.
Burnham, J. (1968) "Systems Esthetics," *Artforum*, September, 1968.
Choy, T. (2011) *Ecologies of Comparison*, Durham, NC: Duke University Press.
Edensor, T. (2014) "Producing atmospheres at the match: Fan cultures, commercialisation and mood management in English football," *Emotion, Space and Society*, Available online, January 10, 2014.
Hawkins, H. (2013a) *For Creative Geographies: Geography, visual arts and the making of worlds*, London: Routledge.
Hawkins, H. (2013b) "Geography and art: An expanding field," *Progress in Human Geography*, 37(1), pp. 52–71.
Hunter, V. (2005) "Embodying the site: The here and now in site-specific dance performance," *New Theatre Quarterly*, 21, pp. 367–381.
Ingold, T. (2006) "Earth, sky, wind, and weather," *Journal of the Royal Anthropological Institute*, 13(1), pp. 19–38.
Irwin, R. (1985) *Being and Circumstance: Notes Towards a Conditional Art*, San Francisco: Lapis Press.
Jackson, M. and Fannin, M. (2011) "Letting geography fall where it may – aerographies address the elemental," *Environment and Planning D: Society and Space*, 29(3), pp. 435–444.
Jones, C. (2011) *Hans Haacke 1967: Exhibition Catalogue*. Cambridge MA: List Visual Arts Centre.
Jones III, J.P., Woodward, K. and Marston, S. (2007) "Situating Flatness," *Transactions of the Institute of British Geographers*, 32(2), pp. 264–276.
Kaye, N. (2001) *Site-Specific Art: Performance, place and documentation*, London: Routledge.

Lawrence, K. (2010) "Hanging from knowledge: Vertical dance as spatial fieldwork," *Performance Research*, 15(4), pp. 49–58.

Lincecum, G. (1874) "The Gossamer Spider," *The American Naturalist*, 8(10), pp. 593–596.

Mackrell, J. (2005) "The Joy of Sets," *The Guardian*, available at www.theguardian.com/stage/2005/jun/06/dance.

Manning, E. (2006) *Politics of Touch: Movement, sense, sovereignty*, Minneapolis: University of Minnesota Press.

Martin, C. (2011) "Fog-bound: Aerial space and the elemental entanglements of body-with-world," *Environment and Planning D: Society and Space*, 29(3), pp. 454–468.

Massey, D. (2005) *For Space*, London: Sage.

Massumi, B. (2002) *Parables for the Virtual: Movement, affect, sensation*, Durham and London: Duke University Press.

Massumi, B. (2011) *Semblance and Event*, Cambridge, MA: MIT Press.

McCormack, D. (2008) "Engineering Affective Atmospheres: On the Moving Geographies of the 1897 Andrée Expedition," *Cultural Geographies*, 15, pp. 413–430.

McCormack, D. (2013) *Refrains for Moving Bodies: Experience and Experiment in Affective Spaces*, Durham and London, Duke University Press.

McCullough, D. (1972) *The Great Bridge: The epic story of the building of the Brooklyn Bridge*, New York: Simon Schuster.

Morton, T. (2013) *Hyper-objects*, Minneapolis: University of Minnesota Press.

Parker, J. and Harley, B. (eds) (1992) *Martin Lister's English spiders 1678*, Colchester: Harley Books.

Pearson, M. (2010) *Site-Specific Performance*, Basingstoke: Palgrave.

Schatzki, T. (2003) "A New Societist Social Ontology," *Philosophy of the Social Sciences*, 33(2): 174–202.

Serres, M. (2008) *The Five Senses: A Philosophy of Mingled Bodies*. Trans. by M. Sankey and P. Cowley. London: Athlone.

Siegel, M. (2001) "Dancing in the dust," *The Hudson Review*, 54(3), Autumn 2001, 455–463.

Sloterdijk, P. (2011) *Spheres: Volume 1*. Translated by W. Hoban. Cambridge, MA: MIT Press.

Spinoza, B. (1989) *Ethics*, London: Dent.

Stewart, K. (2011) "Atmospheric attunements," *Environment and Planning D: Society and Space*, 29, pp. 445–453.

Stewart, N. (2010) "Dancing the face of place: Environmental dance and eco-phenomenology," *Performance Research*, 15(4), pp. 32–39.

Tait, P. (2005) *Circus Bodies: Cultural identities in aerial performance*, London: Routledge.

Taylor, G. (2010) "Empty? A critique of the notion of 'emptiness' in Butoh and Body Weather training," *Theatre Dance and Performance Training*, 1(1), pp. 72–87.

Thain, A. (2008) "Affective commotion: Minding the gap in research," *Inflexions*, 1 (May 2008).

Thomas, C. F. G., Brain, P. and Jepson, P. C. (2003) "Aerial activity of linyphiid spiders: Modelling dispersal distances from meteorology and behavior," *Journal of Applied Ecology*, 40, 912–927.

Thrift, N. (1999) "Steps to an Ecology of Place," in Massey, D., Allen, J. and Sarre, P. (eds) *Human Geography Today*, Cambridge: Polity Press, pp. 295–323.

Whitehead, A. N. (1978) *Process and Reality*, Corrected Edition. New York: The Free Press.

5 Embodying the site

The here and now in site-specific dance performance[1]

Victoria Hunter

In the 2005 RESCEN seminar entitled 'Making Space' Doreen Massey challenged the concept of a singular, fixed 'present', suggesting instead that we exist in a constant process of producing 'here and nows' akin to 'being in the moment'. Throughout her address she referred to the concept of 'co-evalness' pertaining to a simultaneous experiencing of spaces and places coexisting in time. In this chapter I apply the concept of the 'here and now' to the creation of my site-specific dance performance, *Beneath* (2004). Throughout this chapter Massey's here and now is discussed in relation to the concept of dance embodiment informed by the phenomenological interaction with the *genius loci* or 'spirit of place'.[2] These concepts provide a framework for analysis of the various phases involved in the production of the performance work, exposing stages that I have called Experiencing the site, Expressing the site, Embodying the site and finally Receiving the site in the form of a performance work. These stages are discussed in a linear fashion representing a sense of progression 'through' the process while simultaneously reflecting a shift of focus from the choreographer-led early stages of the process through to the collaborative middle stages involving the performers leading to an analysis of the final audience/performance interface.

Beneath was performed in September 2004 in the basement of the Bretton Hall mansion building,[3] an area normally inaccessible to the general public. While involved in the creation of the work I became interested in the nature of the interactive relationship between the site, choreographer, performer, and audience. This chapter explores the concept of embodiment as a symptomatic component of site-specific dance performance informed by an awareness of 'being in the moment', resulting in a phenomenological exchange between site, choreographer, performer, performance, and audience. Merleau-Ponty defines phenomenology as a 'study of essences' (1962: 5). In relation to the generation and performance of dance material, it can be considered as a bodily process whereby the individual experiences the site-phenomenon corporeally in an immediate process of 'transaction' with the site borne of being 'in the moment'. This process constitutes a

conscious, 'present' interaction with space and the world at large. Maxine Sheets-Johnstone describes the process:

> Consciousness experiences its world and itself through its body. If we have conscious experiences, it is because our body moves within the environment as a spatial presence and intuitively knows the meaning of its spatiality.
>
> (1979: 24)

My research attempts to interrogate a conscious sense of connection with the site experienced by myself as choreographer and the performers throughout the creative process. This experience was informed and heightened by an awareness of being in the world comprising of an embodied experience derived from *being* in the space. As opposed to addressing any mystical notions or interpretations of space and place, this chapter considers phenomenology as an experiential phenomenon reliant upon the conscious presence of the individual in space resulting in a human *lived* experience of that space. Phenomenology then, is applied to this investigation to refer to the body's lived experiences and interactions with the site, these experiences are embodied by the individual and transformed and expressed through the medium of dance. Valerie Preston-Dunlop (2002) provides a succinct definition of dance embodiment: 'Embodying is a process which gives tangible form to ideas' (Preston-Dunlop, 2002: 7)

In site-specific dance performance then, the body gives form to ideas and responses to the site as experienced by the choreographers and performers[4] (and latterly by the audience as discussed later). This process occurs as a result of a heightened awareness of being in the moment during which the body becomes porous, open and receptive. In the analysis of the practice-as-research investigation discussed here the bodily experiencing and expressing of site is prioritised and placed at the centre of the investigation. As opposed to a dualistic approach, however, this discussion incorporates the notion of the thinking body. Space and place are experienced and expressed by a 'minded body, not a mind in command of something called body' (Fraleigh, 1987: 9).

The Basement Project: *Beneath*

> If site-specific work makes any departure from the usual premise of theatre it is made out of a desire to let PLACE speak louder than the human mediator or actor who enters the place.
>
> (Simon Persigetti, 2000: 9)

Persigetti's reference to the human 'mediator' between the site and the site-specific performance appears particularly relevant to an analysis of my own role as a choreographer in this particular creative process. From the outset it was my intention to create a work that would exist in sympathy with the site.

Figures 5.1a and 5.1b The Basement site.
Photography V. Hunter

The work was created and performed in a section of the building containing several rooms which pre-production research revealed to be a disused wine cellar fed by a long service corridor. Abandoned for many years, the space was unheated and covered in a thick layer of brick dust and had become a haven for mosquitoes. However, despite these aspects, the site remained attractive to me as a site-choreographer. While the site contained many interesting architectural features, such as a vaulted ceiling, partial dividing wall and a variety of doorways all of which serve to fuel the choreographic imagination, the site also appealed to me on a more fundamental, corporeal level. Like many site-specific practitioners[5] the site in a sense 'spoke' to me in a phenomenological sense informed by the *genius loci* or 'spirit of place' as defined by Norberg-Schulz (1980). In his work *Genius Loci: Towards A Phenomenology Of Architecture*, he refers to; '*Environmental Character* which is the essence of place' (p. 7). He asserts that this 'environmental character' combines with more formal spatial and architectural features to produce 'lived space' (1980: 11) experienced holistically by the individual. Place then becomes 'A qualitative, *total* phenomenon which we cannot reduce to any of its properties' (Norberg-Schulz, 1980: 7).

This notion of 'lived space' experienced phenomenologically implies by its very definition an awareness of 'being' or 'presence' on behalf of the individual. Through a process of existing in the space, becoming present and receptive to the phenomenological essences contained within the site the individual absorbs and intuits the site at a fundamental level. Disused or abandoned sites, however, inevitably carry with them a sense of the past pertaining to the lives of the previous occupants or the former usage of the site. These resonances may be informed by factual information discovered through pre-production research (as in the *Beneath* project) and by architectural and functional components remaining *in situ*.

The lived space of place then becomes informed by the individuals' awareness and presence in the space in the here and now combined and negotiated with an awareness of the past. This process then relates to Massey's notion of place as an 'event' informed by an 'intersection of trajectories'.[6] In the basement site the trajectories of past and present combined to create the *genius loci* or 'spirit of place'. If, according to De Certeau, 'space is a practised place' (1984: 117) then this particular space had been practised, performed, inhabited, and transformed many times over. Cathy Turner suggests that this process results in a 're-writing' of space,

> Each occupation, or traversal, or transgression of space offers a reinterpretation of it, even a rewriting. Thus space is often envisaged as an aggregation of layered writings – a palimpsest.
>
> (Turner, 2004)

The palimpsestic nature of the basement site then appeared to leave a resonance of past lives, narratives and less explicitly, energies equating to the *genius loci* or 'spirit of place' and began to inform my own subjective experiencing of the site in the here and now. While avoiding any literal anthropomorphising of the site, these qualities came to be referenced during the rehearsal process as the energies, resonances and past lives of the site resulting from my own phenomenological experiencing.

While seeking to expose the methodologies and approaches contained within the process, this particular observation serves to highlight the problematic nature of objectifying the subjective experience. The inadequacies of language as an expression of the phenomenological are exposed here through an attempt to verbalise and label a uniquely personal experience. The description of 'lives, energies, and resonances' contained within the site reflects only a fraction of the holistic, whole-body, sensorial interaction with the site experienced by myself, and subsequently the performers. The multitudinous nature of the phenomenological experience can often render these experiences unutterable in verbal form. Mike Pearson refers to this dichotomy when discussing the documentation of performance practices and experiences:

> Their embodiment in sensori raises the issue of the representation of phenomena which are partially at least, ineffable – beyond language.
>
> (Pearson and shanks, 2001: 57)

As a result, movement actions, imagery, sound utterances and physical demonstration were utilised as accompanying embellishments to verbal descriptions when attempting to communicate and share phenomenological responses between myself and the dancers and vice versa.

Experiencing the site

Figure 5.2 Choreographic Diary entry

14/7/2004
- Associations of abandonment, closed, shut-down, cold, empty shell.
- Main location – corridor leading to wine cellar, associations of usage, wine cellar, wine bottles, servants.
- Corridor, ante-room, main space implies a natural progression of form from solo – group material.
- Initial 'storyboard' suggested by the form of the space.

<div align="center">

Solo (corridor)
↓
Ante-room (installation)
↓
Wine Cellar

</div>

(Choreographic diary entry, 14 July 2004)

Akin to Mike Pearson's approach to Theatre/Archaeology (2002) the site-specific choreographer experiences and interacts with the site on a number of levels metaphorically digging beneath the surface to reveal a uniquely personal interaction with the site. On an immediate, practical level the site presents the choreographer with a range of spatial information. Elements of which may serve to inform the creation of movement material and choreographic form. Theories of experiencing space drawn from Lawson (2001), Lefebvre (1974), and Tuan (1974)[7] provided a theoretical framework for the practical investigations embedded in the project whilst simultaneously raising my awareness as a choreographer of the potential scope of spatial information contained within the site. My initial investigation into the site therefore adopted a formalistic approach addressing the architectural and spatial qualities of the site in the first instance. Pre-production research involved the collection of written and oral histories of the site, the study of floor plans and a guided tour of the site. This formal architectural and spatial information combined with historical and contextual information concerning the former inhabitants of the building and the past function of the site to suggest an immediate choreographic response. This response consisted of the imagined creation of an organisational structure for the dance commencing with a solo introduction to the space followed by a group dance section contained within the larger wine-cellar room. This resulted in the preparation of a 'storyboard' (see 'choreographic diary' entry) detailing the organisational form of the opening and initial section of the final performance work. On closer inspection however, whilst the site's formal qualities and sense of dynamic 'flow'[8] appeared to provide an indication of the final performance form and structure, ideas and suggestions for movement content remained illusive. An over-emphasis on the site's formal, spatial and factual components in the first instance had in fact resulted in an unintentional attempt effectively to colonise the site through the application of an imposed form lacking in substantive meaning. I had in fact pre-judged the site in an objective manner revealing perhaps the dichotomy of the practitioner/academic researcher. As a result, any attempt to generate movement content appeared futile and insubstantial. Through a negation of the corporeal and phenomenological experiencing of the site I was in danger of overlooking a vital component in the creation of site-specific dance performance. Clearly an embodied approach involving the body-in-space was required. In an attempt to experience the site in a less contrived manner I allowed myself time to simply enter the space alone and just 'be' in the space in a series of 'moments'. This involved me moving slowly through the space for example, touching, sensing and experiencing the space, or simply sitting quietly absorbing the atmosphere around me. Maxine Sheets-Johnstone situates this type of approach at the heart of the phenomenological experience:

The phenomenologist's attitude towards the phenomenon is neither objective or subjective, but rather an attitude of being present to the phenomenon, fully and wholly.

(1979: 12)

Undoubtedly, in this context I was entering the space with a heightened sense of awareness informed by the intention of the project and the intention of the exercise itself. However, the intention of the exercise remained to attempt to experience the site-phenomenon fully and wholly. The following journal extract records one of the responses to the site generated during this exercise:

Abandoned, cold, shut down, an empty shell. Flickering-light beneath the surface, resonances, energies.

(Choreographic Project, diary entry, 20 July 2004)

This exercise proved invaluable in the facilitation of a corporeal exchange between individual and site. Through simply 'being' in the site an inside/outside interface[9] began to occur, invoking an awareness of the site's phenomenological 'essences'. Through this investigation my developing awareness of the site equated to an initial process of tuning in prior to any form of interpretation or analysis enabling the body-self to absorb phenomenological experiences of the site and the *genius loci* in the moment. In light of these theories, is it possible to objectify and/or conceptualise what I was actually experiencing?

An interplay of responses

The outcome of the experiential exercise described here is referred to as an exchange or interface thereby implying a two-way interaction between the site and the individual. Indeed, simply by entering the site, the individual's presence constitutes an intervention within that site. This notion of intervention or disturbance becomes particularly pertinent when discussing the creation of work in disused or abandoned sites. As previously discussed, the site offers up a wealth of visual, spatial, historical and factual information for the explorer. But it is only through bodily interaction and intervention that the site's phenomenology and *genius loci* are revealed.

Norberg-Schulz's description of the *genius loci* as 'lived space' comprises two interrelated components of 'space' and 'character'. Space, according to Norberg-Schulz denotes the 'three dimensional organisation of the elements which make-up place' whilst 'character' refers to the 'general atmosphere which is the most comprehensive property of any place' (1980: 11). He proposes that these two elements are interrelated and operate in a co-operative manner to produce the 'spirit of place'. This identification of

the formally tangible and intangible aspects of place equate to my own investigation of the basement site.

As the project developed it became clear that my experiencing of the site and the subsequent generation of movement material was informed by a complex interplay of responses resulting from my interaction with both the formal/architectural and the intangible/atmospheric site components, the combination of which invoked a unique phenomenological response. These responses then combined with information gathered during the pre-production research period regarding the past usage, inhabitants and 'life' of the site and began to shape and influence my creative thinking.

Notions of past-lives, energies, and resonances of the past began to appear as key themes serving to provide a framework and conceptual structure in which to house the wealth of phenomenological responses generated by myself and the performers. Whilst these energies and resonances served to provide a structure and direction for the creative work, the intention was never to attempt to recreate a snapshot of the past akin to a modern-day costume drama. Instead, the theme and notions of the past were explored in relation to their impact upon the individual's experiencing of the site in the here and now.

Any likelihood of romanticised nostalgia became eradicated therefore as these resonances of the past became associated by myself and the performers with notions of abandonment, sadness, and neglect. The two trajectories then of past and present became located in the site creating a 'meaningful place' as defined by Norberg-Schulz (1980: 7).

Expressing the site

How then were these experiences transformed into dance performance?

Once the initial pre-production and experiential research stages had been completed the project was able to shift into a process of 'expressing the site' involving the formulation of research data into dance responses to express the performer's and choreographer's experiences of the site. The choreographic intention remained from the outset to create a work that revealed the site, retaining a sense of connectivity between the site and the emerging work at all times. To this end rehearsals took place on location with the intention that the work would develop in a process of negotiation and collaboration with the site. The work involved seven dancers (five female, two male), and the project adopted a devised creative approach involving collaboration between myself and the performers. The nature of the interplay between the phenomenological components of the site's 'space' and its 'character' and the generation of both dance form and content became apparent throughout the rehearsal process. For example, the opening and initial sections of the dance retained elements of the original 'storyboard' ideas suggested by the formal architectural and spatial relationships contained within the site (see 'choreographic diary' insert).

However, additional movement content and qualities contained within these episodes began to emerge in response to phenomenological information.

The dancers were asked to improvise movement in response to their sensory, phenomenological and kinaesthetic experiencing of the site. The purpose of this exercise was to reveal and explore the performers' corporeal responses, thereby focusing on the 'other-ness' of response as opposed to the visual or verbal. In addition, this type of devised, collective exploration of the site served to combine with my own responses, thereby broadening the resource of response to the site-stimuli. The following diary extract provides a description of some of the movement content generated during this initial improvisatory phase:

> Twisting, touching the body, touching the walls. High-arch movements beginning to appear, arms raised to the ceiling whilst body curves over. Sinking, curved body, curved arms. Sliding of feet, turning and dropping, suspending and dropping, delicate.
>
> (V. Hunter, *Beneath* choreographic diary entry, 9 September 2004)

These movements were observed and recorded during the opening moments of the exercise and can clearly be related to the dancers' response to the architectural components of the site's curved ceiling and arched brickwork (see Figure 5.3 below).

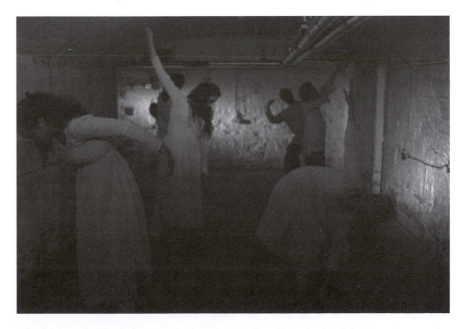

Figure 5.3 Beneath 2004.
Photography P. Davies

However, as the improvisation continued a selection of more recognisable, familiar movement material began to emerge, perhaps indicating a diminishing lack of concentration and associated connection between the dancers and the space. As a result, only a few of the most 'genuine' responses were retained, largely generated in the first moments of the exercise.[10] However, what interested me most as a choreographer was the dynamic quality contained within the dancers' movement responses and the commonality of these dynamic site-responses. These responses comprised a combination between soft, flowing, gentle qualities and more sudden, sustained moments. Somehow this level of response appeared to contain the most honest corporeal reaction to the site paralleling the energies, essences and dynamics of the site itself.[11] These responses felt spontaneous, unplanned and unencumbered by elements of the dancers' inherited codified dance technique and aesthetic considerations. In this sense, these responses could be equated to an embodied experiencing of the site manifested through movement evidencing a phenomenological response. Referring back to Sheets-Johnstone's consideration of 'presentness', these dynamic responses can be equated to a phenomenological response which is neither objective or subjective borne of being in the moment and open to the here and now of the site phenomenon. Could this very 'present' state of being comprising of a heightened state of phenomenological awareness be equated to a 'hyper-place' of 'presentness'? This particular place is 'practised'[12] in the moment, however, as opposed to implying an 'indication of stability' (a defining component of place according to De Certeau) it is reliant upon a degree of fluidity and flux. This conceptual place then moves above and beyond conventional definitions of place becoming a 'hyper-place' situated in the transitory 'here and now'.

Through a process of experiencing situated in this hyper-place, requiring the minded-body to respond honestly and unquestionably to the site-phenomenon, it could be suggested that the dancers had revealed the site's underlying energies and qualities creating an immediate and dynamic response in the body. The *Beneath* project then, began to call for a different movement approach, challenging my usual choreographic vocabulary applied more frequently to a traditional theatre context. 'Theatre'[13] dance vocabulary appeared incongruous in this site, artificial and unrelated to the *genius loci* or 'spirit of the place'.

The site as choreographer

This incongruity could perhaps be related to the concept of intention in site-specific performance. 'Theatre' dance vocabulary by its very definition is created for performance within a very specific environment encompassing a range of spatial and presentational codes and conventions. The performance material in this context is housed and framed within the theatrical environment but does not usually bear any conceptual relationship

to the theatre building in which it is housed. A very different intention and relationship between content and environment forms a key component in site-specific dance performance, Eileen Dillon observes:

> Movement that is borne out of a sensory response to environment draws an audience's attention as much to the environment as to the performer.
>
> (Dillon, 1988, in Wrights & Sites, 2000)

In accordance with my initial intention to 'reveal' the site, only movement content generated from a direct response to the site appeared to function effectively in this sense. Therefore, any suggestion of artifice or gratuitous embellishment of movement was eradicated from the final work. As a result the movement aesthetic began to develop an informal, pedestrian derived quality, devoid of any discernable reference to a codified technique.

One such movement phrase involved a reaching gesture whereby the dancer's hand touched the air and played with its texture between the fingers. This movement resulted from my direct response to the dusty, damp atmosphere contained within the site that, at times appeared 'tangible'. This arm gesture was developed by the dancers and later combined with a simple walking pattern allowing them to sample the atmospheres at different points in the space. This lack of 'theatricality' helped me to facilitate a sense of balance between the site and the work as the developing movement content began to reveal a through-line of connectivity with the site, thereby lessening any degree of incongruity.

The site in a sense had begun to choreograph the choreographer, calling for a particular movement approach and drawing my aesthetic and artistic attention towards particular architectural and spatial features that could not be ignored. These features included the presence of a central dividing wall which began to operate as a choreographic device in its own right, as movement sequences incorporating touching, leaning, running and rebounding into the wall began to develop. Similarly, linear floor patterns traversing the space began to develop in response to the shape of the site and the dynamic qualities that appeared to resonate in the space when inhabited by moving bodies.

Following a prolonged period of time spent in the space during the rehearsal and devising process a form of osmosis between the site, the choreographer and the emerging work appeared to develop largely due to the constant process of referral to and inclusion of the site-stimuli involved in this particular creative process. This process began to reveal that unlike traditional studio-based approaches to dance making, in site-specific choreography the ever present site-stimulus necessitates a constant process of review, and to a certain degree, self-censorship. In accordance with Pershigetti's consideration of the artist as 'mediator' in this context then the choreographer must remain mindful of maintaining a balance between

intention and aesthetic impulse, ensuring that the work develops in collaboration with the site as opposed to imposing itself upon it.

Embodying the site

If embodiment is used in this context to refer to a process whereby the human body gives 'tangible form to ideas',[14] then the intention of the dancers and the dance in the *Beneath* project was to give form to ideas and responses arising from an interaction with the site. As previously discussed, movement content, form and dynamic qualities began to emerge through an organic process of experiencing and communing with the site. Once captured both bodily and more formally through the use of video recording, these initial responses became formalised into structured movement sequences or episodes as referred to throughout the rehearsal process. Initial movement responses generated through devising episodes as previously described would be developed through the application of choreographic devices[15] and group relationship. In addition, movement sequences devised in response to my own experiencing of the site would be taught to the dancers and further modified or embellished in order to achieve an appropriate sense of 'fit' between the site and the developing work.

During rehearsals, the focus of the project began to shift from a process of collecting and collating experiences and responses to the site to a process of embodying these responses by giving form to them through the bodily medium of dance. The term embodiment is used to refer to the performer and the dance as the medium of expression and their capacity to embody the site's essences in a phenomenological sense. In conventional creative performance processes contained within a studio setting the rehearsal and refining process with its necessary shift of focus towards the concretisation of an end product can result in the performers becoming distanced from their initial response to a particular stimulus. However, in site-specific dance performance, the potential for this process of detachment is lessened due to the omnipresent nature of the surrounding site-stimulus.

Nevertheless, during the *Beneath* rehearsal process there remained the potential for the dancers to become over-familiar with the developing dance material during the rehearsal process resulting in a lack of connection with the site and the original choreographic intention. In an attempt to perfect the aesthetic qualities of the movement content the performers had reverted back to a conventional mode of performance preparation resulting in the production of an associated conventional, theatrical performance style. As a consequence of this, the original phenomenological responses and essences of the work became diluted. Once this began to occur the work developed a degree of incongruity, appearing unconnected to the site. This particular site-specific dance performance therefore demanded a different approach to performance in addition to the different approach to movement creation as discussed earlier.

As a choreographer, I became particularly aware of the inappropriateness of any attempt at artifice or acting by the dancers whilst performing the work. This concern operated on two levels, firstly, as the basement site was a relatively small and intimate space the dancers and audience members would be in close proximity thereby lessening the need for any overt acting or projection. Secondly, the movement vocabulary created had successfully managed to capture and develop a sense of connection to the site through both actual movement content and dynamic components. This delicate relationship could have easily been destroyed through the application of an unsympathetic performance persona.

To develop this complete embodiment of the site the dancers were encouraged to re-connect with the site in an attempt to develop a whole-person, thinking-body approach. Once the dance work had been choreographed and established in the dancers' movement memory, each performer was encouraged to spend a period of time remembering and 're-visiting' the site in relation to the movement material and the original motivation behind its creation. The dancers were encouraged to consciously *see* the walls as they brushed past them, *feel* the floor as they touched it and *sense* the site's atmosphere and its affect upon the skin receptors.

Following the rehearsal session the dancers were asked to record their responses to the exercise, the following questionnaire extract provides an insight into the dancer's reflection upon the task:

> I tried to *be* everything I was doing, I had to stay in the 'now' and be true to what I was experiencing.
> (Performer questionnaire response *Beneath*, September 2004)

This process not only influenced the dancers' creation of a performance persona but served to enrich the process of dance embodiment. Through this process the site–performer connection began to operate on two levels as the dancers performed movement material created during the rehearsal process whilst simultaneously constructing and presenting a performance of that material informed by a real-time awareness of the body-self in the site existing in the here and now moment of performance.

Through this process then the dancer experiences an epistemological and ontological interface with the site and its essences occurring through a corporeal interaction with the space manifested through the medium of dance performance.

Receiving the site

If the site-specific dance performance constitutes an embodiment of site through the medium of dance, then could it be suggested that the audience member effectively receives the site through the site-specific dance performance? If so, what does the audience experience and how?

Figure 5.4. Beneath project 2004. Pre-performance installation.
Photography P. Davies

Theories concerning experiencing of space and place are well documented by theorists including Lefebvre (1974), Lawson (2001) and Bachelard (1964) who identify the complexity of this relationship. Sensory, cognitive, spatial, ideological, and psychological factors are amongst those elements that combine to create our perception of space and place and can be seen to explain why space and spaces can be experienced in many different ways.

As previously discussed, the act of simply entering a space engages us in a process of interaction or 'transaction'[16] with our spatial environment during which an inside/outside interface occurs. The site-specific audience member does not approach the performance and the site in an arbitrary, passive manner, arriving instead armed with a wealth of personal and contextual information serving to inform their experiencing of the site and the performance work.[17] Similarly, the audience member does not receive an impartial, neutral experience of the space. In site-specific performance the site is altered by the presence of the performers and the choreographer's intervention in the site and the work itself.

It could be suggested, then, that the audience does not in fact experience the true site but instead experiences the ephemeral *place* of performance. In reference to Massey, this 'place' of performance comprises a number of personal, artistic, social, spatial and contextual 'trajectories' converging 'in the moment' of performance. The degree to which the artistic intervention/interaction with a site occurs can vary dramatically from performance to performance depending upon the production and the choreographic intention. The *Beneath* project, for example utilised lighting, costumes and musical accompaniment to enhance the performance and accentuate particular qualities and elements of the site.

The intention was not to gratuitously impose theatrical convention upon the site but to utilise these components to enhance the choreographic intention thereby revealing those elements of the site that had 'spoken' to me initially. Through highlighting these elements and accentuating their qualities the audience's response to the site and the work was guided by the choreographer. These responses, however, remain connected to the audience's visual and aural perceptions. An analysis of a more fundamental experiencing of the site-specific *place* of performance then, can be achieved through a discussion of the audience in the site and their phenomenological experiencing of the place of performance.

Engaging the audience

By its very definition, site-specific performance challenges accepted codes and conventions pertaining to the presentation and reception of performance work. Through the rejection of the traditional black box theatre, site-specific performance engages the audience in a more immediate manner. The audience member exists in the space with the surrounding work thereby responding and participating in the work and

with the work in an up-close, phenomenological exchange as opposed to 'receiving'[18] the work from a distance.

In the *Beneath* project the potential for this type of phenomenological interaction was facilitated from the outset. Upon entering the subterranean site the 15 audience members stepped into a constructed 'world' comprising a walk-through pre-performance installation situated in a disused laundry room. The room contained a solo chair placed in the corner of the space lit by a single lamp, an old book was placed on the chair suggesting an absent presence (see Figure 5.4). The audience members walked past the installation prior to descending a further staircase which led into the main performance space, whilst a dripping tap situated within the disused laundry space provided the sound accompaniment for this journey.

The intention of this installation was to facilitate the audience's transition from the everyday experience of the outside world to the world of the basement location, thereby assisting a gradual shift in consciousness and awareness. This process of physically moving through the space also allowed the audience time to absorb and experience the space at a corporeal level prior to any experiencing with the dance work itself. Once the performance began however, the audience embarked upon a process of experiencing the ephemeral place of performance. The audience's experiences were captured and recorded through the use of post-performance questionnaires and group interviews and discussions. In addition to responses detailing descriptive recollections and interpretive readings of the work the questionnaires and subsequent audience interviews revealed responses pertaining to less tangible, more illusive experiences of the work. Typical responses included:

> I felt I had gone back in time to another period. I saw beauty in the movement and various energies throughout the piece.

> I felt a desire to be involved – closeness. Changing feelings – empathy, sadness, then surprise.

These types of responses allude to a range of emotional and sensorial reactions to the work serving perhaps to exemplify the 'other-ness' of response elicited through the dance medium.

Many audience members appeared to find these responses difficult to articulate effectively as they struggled to give verbal form to a variety of corporeal, sensory, and kinaesthetic responses. These particular responses then, appeared to co-exist with more formalised interpretations of the work serving to inform a phenomenological experiencing of the work. These descriptions of phenomenological responses appeared to spring from corporeal resonances experienced by the audience member in the moment of performance:

You almost felt yourself moving with them (the dancers) and dancing with them. A real sensory experience.

The sensitivity of the dancers made me sensitive towards them and aware of their actions.

These responses equate to theories of dance phenomenology that propose the audience member receives the dance in a corporeal manner. The performer and audience enter into a bodily 'exchange' based on a shared knowledge of corporeality. Fraleigh refers to the phenomenon thus:

I dance the dance with the dancer, enact it, dissolve it and take it into myself. In this sense, I also embody the dance.

(1987: 62)

Fraleigh proposes here that the audience then embody the dance. If, as previously discussed, the dancer embodies the site through giving form to ideas *of* the site, could it logically follow that the audience's embodiment of the site-specific dance also constitutes an embodiment of site? Is it plausible to suggest that as a bodily art-form site-specific dance performance has the potential to create a more authentic through-line of connectivity between the site phenomenon and the resulting performance work than other site-specific genres which may rely on the aural, verbal and/or visual as their primary mode of expression?

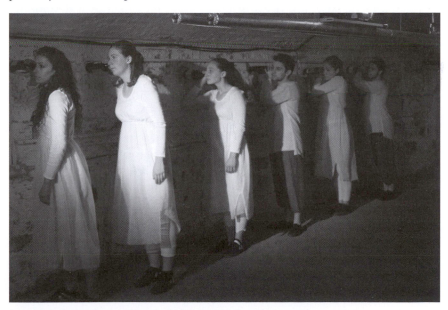

Figure 5.5 Beneath project 2004.
Photography P. Davies

If so, through the dance's embodiment of site the audience member can experience the site/work phenomenon on a fundamental, corporeal level enabling the individual to access a different type of knowing based on whole-body experience. Through an acknowledgement and acceptance of this phenomenological exchange the audience member begins to experience and participate in the site-specific dance responding bodily to the phenomenology contained within the *place* of performance.

Conclusion

Informed by Massey's questioning of the nature of the 'here and now', I have hoped to reveal in this analysis of the *Beneath* project a commonality of concern for an awareness of 'presence' throughout the various stages of the creative process. The creative processes employed when experiencing and interacting with the site and the work itself required the individuals involved to be wholly present in the space, engaged and aware of the transactions occurring in the moment. As identified here, this particular site and location contained a particularly tangible 'spirit of place' or *genius loci* and a wealth of phenomenological energies and resonances. These elements of the site necessitated a very present, open, and aware approach to experiencing and developing site-responses into embodied dance performance.

The concept of the 'here and now' in site-specific dance performance can be explored through the various stages involved in the creation of the work. Throughout, the choreographer's relationship with the site evolves and develops through a process of negotiation informed by a developing sense of familiarity and associated osmosis. From the initial stages of experiencing the space presently, responding to the here and now of the initial moment of interaction through to the creation and formalisation of movement material based upon these responses, the choreographer shifts from a position of 'being in the moment' to re-creating a resonance of the 'there and then'.

At this stage of the process the formalisation of these phenomenological responses into movement material could be viewed as an attempt to objectify the subjective. The dance form in this sense acts as a form of documentation of the body's corporeal, phenomenological interaction with the site. Unlike with literary documents, however, due to the porous nature of this corporeal interaction the dance document remains subject to a continuous process of rewriting informed by the nature of the transaction between individual and site.

Once engaged in the rehearsal process the performers seek to renew and refresh the work and their performance of the work by importing their own 'presentness', stemming from their conscious awareness and actual presence in the space whilst rehearsing. Similarly, the final performance outcome presents a collaboration between the choreographed 'there and then' and the performers' 'here and now' as their actual real-time lived

experience of the site feeds into the performance on a moment by moment basis. The embodied work is then absorbed by the audience member while they are simultaneously engaged in their own corporeal experiencing of the here and now resulting from being in the place of performance.

In accordance with Massey's notion of 'co-evalness' the final resonances of the site, the work and the ephemeral place of performance are internalised and carried with the audience members, consigned to memory and surfacing occasionally as a remembered 'there and then' in a series of future 'here and now' moments.

Notes

1 This chapter was first published in *New Theatre Quarterly* in 2005 and is re-printed (and updated) in this volume with kind permission from the publishers.

2 Norberg-Schulz, C. (1980) *Genius Loci: Towards a Phenomenology of Architecture*, Academy Editions, London.

3 The mansion building dates back to the eighteenth century and housed the University of Leeds School of Performance and Cultural Industries until 2007.

4 This article refers to a devised, collaborative approach to dance making as employed within the creation of *Beneath*, September 2004.

5 Geraldine Pilgrim (Corridor Company) discussed the nature of this type of interaction with site during an address at the SITE/SOURCE/RESOURCE symposium, University of Exeter, September 2004. See also, Eileen Dillon's documentation of her performance work 'Absent Water' in 'Site-Specific: The Quay Thing Documented' Eds, Wrights & Sites, *Studies In Theatre and Performance*, Supplement 5 August 2000.

6 Doreen Massey (2005) Paper presentation at RESCEN Seminar 'Making Space', R.I.B.A. London, 12 January 2005.

7 These theorists examine space and the concept of the production of space from both subjective and objective perspectives.

8 The term here is used in relation to the architectural concept of anthropometry and dynamic 'fit', see Ching, D.K. p. 312 (1996) *Architecture: Form, Space, and Order*, Canada: John Wiley and Sons.

9 See Lefebvre, H. (1974 trans. Nicholson-Smith, 1991) *The Production Of Space*, Blackwell Publishers, Oxford.

10 The use of the term 'genuine' here refers to my own choreographic and artistic value judgement on the emerging work determined by my artistic intention and personal preference.

11 See Ching, D.K. (1996) *Architecture: Form, Space, and Order*, Canada: John Wiley and Sons.

12 See De Certeau, M. (1984) *The Practice Of Everyday Life*, University of California Press.

13 'Theatre dance' is defined here as dance performance created for performance within a conventional theatre setting. This type of dance may employ a codified dance vocabulary and may employ conventional approaches towards issues of projection and presentation to a distanced audience.

14 Preston-Dunlop (2002) *Dance and The Performative: A Choreological Perspective*, London: Verve Publishing.

15 Choreographic devices refer to structuring 'tools' used in the dance-making process such as unison, canon, repetition etc. For a detailed description see Blom, L. and Chaplin, L. (1989) *The Intimate Act Of Choreography*, London: Dance Books.

16 See Hall, M. and Hall, T. (1975) *The Fourth Dimension In Architecture: The impact of building on behaviour*, New Mexico: Sunstone Press.
17 This may perhaps explain why a number of site-specific practitioners choose to create work in derelict sites, the hidden, internal spaces of which may be free from the same degree of prior 'interpretation'.
18 See Bennet, S. (1997) *Theatre Audiences: A theory of production and reception*, London: Routledge.

References

Bachelard, G. (1964) *The Poetics Of Space*, New York: Orion Press.

Blom, L. and Chaplin, L. (1989) *The Intimate Act Of Choreography*, London: Dance Books.

Bloomer, K.C. and Moore, C.W. (1977) *Body, Memory, and Architecture*, Yale: Yale University Press.

Ching, F.D.K. (1996) *Architecture, Form, Space, and Order*, Canada: John Wiley & Sons.

De Certeau, M. (1984) *The Practice Of Everyday Life*, California: University of California Press.

Hall, M. and E.T. (1975) *The Fourth Dimension In Architecture: The impact of building on behavior*, Santa Fe, Mexico: Sunstone Press.

Fraleigh, S. (1987) *Dance and The Lived Body: A descriptive aesthetics*, Pittsburgh: University of Pittsburgh Press.

Kaye, N. (2000) *Site-Specific Art: Performance, place, and documentation*, London: Routledge.

Lawson, B. (2001) *The Language of Space*, Oxford: Architectural Press.

Lefebvre, H. (1974 trans. Nicholson-Smith, 1991) *The Production Of Space*, Oxford: Blackwell Publishers.

Lynne-Hannah, J. (1983) *The Performer-Audience Connection*, Texas: University of Texas Press.

Merleau-Ponty, M. (1962) *The Phenomenology of Perception*, London: Routledge.

Norberg-Schulz, C. (1980) *Genius Loci: Towards a phenomenology of architecture*, London: Academy Editions.

Pearson, M. and Shanks, M. (2001) *Theatre/Archaeology*, London: Routledge.

Persighetti, S. (2000) *Wrights & Sites & Other Regions*. In: Site-Specific: The Quay Thing Documented. *Studies In Theatre and Performance*. (Supplement 5) August 2000, pp. 7–22.

Preston-Dunlop, V. (2002) *Dance and the Performative: A Choreological Perspective – Laban and Beyond*, London: Verve Publishing.

Seager, W. (1999) *Theories Of Consciousness: An introduction and assessment*, London: Routledge.

Sheets-Johnstone, M. (1979) *The Phenomenology of Dance*, London: Dance Books.

Smith-Autard, J. (1976) *Dance Composition*, London: Lepus Books.

Turner, C. 'Palimpsest or Potential Space? Finding a Vocabulary for Site-Specific Performance', *New Theatre Quarterly*, 20(4), November 2004.

Tuan, Y.F. (1974) *Topophilia: A study of environmental perception, attitudes, and values*, New Jersey: Prentice-Hall Inc.

Tuan, Y.F. (1977) *The Perspective Of Experience*, Minnesota: University Of Minnesota Press.

Wrights & Sites (eds) (2000) 'Site-Specific: The Quay Thing Documented', *Studies In Theatre and Performance*, Supplement, 5 August 2000.

Part II

Experiencing site

Locating the experience

Victoria Hunter

This section explores processes of embodiment, bodily knowing and experiencing sites encountered by performers, choreographer and audience members. Throughout this section, notions of location and practices of locating are applied to discussions of 'where' performative encounters take place; for example, where is digital dance and screen dance sited and where am 'I' located in this encounter? The various chapters explore experiences of site and raise questions regarding what the term *site* defines, what it consists of and where and when (physically and conceptually) it might be located. In doing so, this section raises philosophical questions regarding temporality and fixity and, through the inclusion of chapters that explore mobile technologies, screendance and virtual performance, readers are challenged to consider what practices might be included and considered within the scope of site-specific 'dance' performance. Jen Southern and Chris Speed's chapter, for example, provides an account of a family's use of a mobile tracking phone app to chart and observe the virtual movements and the location of family members. The virtual choreography of these relationships provides scope here for choreographers to consider how mobile technologies might contribute to the development of performance work that extends beyond localised time–space constraints. Similarly, Sita Popat's account and analysis of Gibson/Martelli theatre company's work raises questions of location and experiential positioning when encountering this type of performance work. Douglas Rosenberg's re-presentation of his seminal essay on screendance reminds us of issues relating to the 'site' of performance and the representational framing of the dancer's body in dance film works. Camilla Damkjaers's chapter literally turns a discussion of location and spatial relationship on its head as she applies ideas from Deleuze and Guattari regarding spatiality to her own 'academic circus' performance-lecture work in which spatial hierarchies and associated power relations become inverted and re-defined. My essay, *Spatial Translation, Embodiment and the Site-Specific Event*, provides the final chapter in this section and returns the reader perhaps to more familiar territory with a reflective account of the creative process undertaken to produce a site-specific durational work; *Project 3* created in 2007. Informed by phenomenological

theory the reflective account considers how site-dance and intimate performer–audience encounters might bring them closer to an experience of site in the present moment, challenging individuals to be conscious of themselves and their actions facilitated through a located sense of present-ness.

6 Homemade circus

Investigating embodiment in academic spaces

Camilla Damkjaer

In guise of an introduction

> For a moment I imagine seeing myself from the outside – 'I' pass in front of the door to the lecture room, and through the round glass window I see two feet, bony and rough, pointing upwards towards the ceiling. The next instant, I am back in the lecture room focusing on my hands on the hand-balancing blocks, still painfully aware of my feet, and especially what the students might make of them. In this space, the feet appear to be an incredibly private body part.

'Homemade Academic Circus' is a series of lecture performances, mostly performed in academic settings that I have constructed in order to reflect on the embodied knowledge of circus practices. Paradoxically, but not surprisingly, this has led to a continuous reflection on the habits and expectations of embodied practices in academic spaces. In this chapter I consider how performing 'homemade circus' in academic spaces has urged me to reflect on the spatial and embodied practices of academia, the movements and bodily postures in the lecture room, and their consequences for knowledge production and practices of sharing knowledge.

What happens when the spatially upright position of academic lecturing practice is, literally, turned upside down? What happens to the processes of knowledge production when the lecturer stands on her hands or hangs inverted in a rope? What does that tell us about the lecturer standing on her feet? Through these questions, I want to address some of the issues that occur in site-specific performances in academic spaces.

Homemade Academic Circus

Homemade Academic Circus is a performance practice that I have undertaken over the last five years. It consists of a series of lecture-performances in which I simultaneously discuss and perform circus, as a way of bringing this art form into an aesthetic discussion. Each lecture-performance deals with specific research questions and conceptual

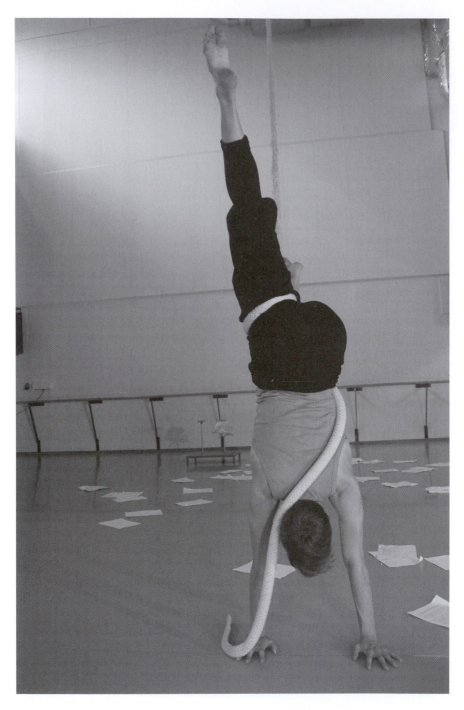

Figure 6.1 'Citournelle for Rope, Podium and boxes' (2011).
Credit: Stacey Sacks

problems related to circus and the performing arts. Therefore the Homemade Circus is an academic practice. Homemade Academic Circus is constructed and performed by myself, and it is made with a minimum of logistics and technical support. Therefore Academic Circus is Homemade.

As Homemade Academic Circus is also performed in conferences, seminars and teaching situations,[1] it has to be sufficiently simple to be performed in almost every space. However, the act of performing circus already means that the spatial expectations of the academic paper are challenged. Some of the lecture-performances have involved vertical rope work and even the most well equipped lecture rooms generally lack rigging points that support the weight of the human body suspended in the air. Homemade Academic Circus has therefore been performed in a variety of spaces with very different functions and associations including entrance halls, where people pass through, gymnasiums, seminar rooms, and also black boxes and small proscenium stages.

What I am concerned with here, however, is not so much these spaces in themselves, though they have given various frames to these experiments and thus highlighted the different expectations connected to performance spaces and academic spaces. What I am particularly interested in is the embodiment of the spatial position of the lecturer, and how that embodiment has been highlighted through literally being turned upside down.

Standing straight – the upright position

> To the story belongs an understanding that research and academic teaching is my profession, and that most of my professional training has consisted of the following set of physical exercises with specific spatial movement patterns: sitting and listening (eyes moving from the person talking to an angle up and to the left, when trying to imagine some abstract term); sitting and reading (head bent slightly forward); sitting watching performances (knees tucked tightly due to the row of chairs in front, leading to painful walking if the position is sustained for more than two hours). As I slowly gained more responsibility as a faculty staff member, these patterns were expanded somewhat: running up and down stairs (filling in papers and leaving them in the correct places), standing in corridors talking (to colleagues also running up and down stairs), standing in lecture rooms or auditoriums talking and gesticulating (often wildly and quite unconsciously, as when teaching or lecturing).

This experience, and some pragmatic observation of academic environments, seems to confirm that the upright but immobile position such as when standing or sitting has a privileged position within the embodied practices carried out in academic spaces. This position also carries with it a specific set of cultural and historical meanings (such as associations of

self-containment, propriety and authority), and has a central position in the disciplining of the European body in pedagogical practices and techniques (Vigarello, 2004). Though we no longer have detailed regulations regarding how to sit or stand, as observed by Foucault in his analysis of the disciplining of the body (Foucault, 1991), we are nevertheless constantly invited to either stand or sit in academic spaces and move only in between these positions; preferably in a straightforward and non-imaginative way.

However, the standing position is not only part of the disciplining of the body. From a phenomenological point of view it can also be seen as a prerequisite for our embodied being, or even our embodied mind. As Gallagher and Zahavi write, the upright position has 'far-reaching consequences with respect to perceptual and action abilities, and by implication, with respect to our entire cognitive life' (Gallagher and Zahavi, 2008: 132). They point to how the upright position makes it possible to 'maintain distance and independence' and shapes our cognitive abilities through influencing the relation between the senses (ibid.).

I do not doubt that this is the case, but it seems to me that within academic life this position in space has become the default mechanism to such an extent that we do not even ask ourselves what this position makes possible or impossible.

The ontology of immobility in academic spaces

André Lepecki observes that dance in modernity 'increasingly turns towards movement to look for its essence' (Lepecki, 2006: 7) and discusses how this imperative to move becomes a part of dance's 'political ontology' (ibid.: 8). He reflects on the manner in which some contemporary choreographers have begun to disrupt this relationship through, amongst other things, the use of stillness. On the other hand, physical and spatial stillness has been an imperative for the embodied practices of academic spaces, an imperative that is increasingly becoming disrupted in recent years due to the growing presence of 'embodied research' (Cooper Albright, 2011: 15), and practice-based and artistic research (Barrett and Bolt, 2010; Biggs and Karlsson, 2011). By inversing Lepecki's terminology, it could be argued that academia's dominant political ontology has been one of immobility, a position that, through developments of more embodied approaches to teaching and learning, is currently under attack.

Here, it is not my intention to simply oppose the spatially upright and static position privileged within academia with different movement practices (such as circus) and their modes of reflection in order to deplore the physically limited practices in academic spaces. Rather, I would like to explore in sensorial details how these spatial positions affect embodied reflection, social interaction and verbal exchange within academic life as it appears to me through the practice of 'homemade academic circus'.

Perhaps the upright and fairly immobile position does in fact allow an embodied and sensorial approach too, one that we tend to be unaware of?

To develop this argument, I would like to explore two different positions (or sets of positions) that I have encountered through performing homemade circus in academic spaces: hanging upside-down (as in vertical rope work) and standing upside-down (as in hand-balancing). Subsequently, I will return to a consideration of the upright and immobile position of the lecturer in order to see how these experiences might enhance or highlight the embodied spatial position of the standing lecturer.

Hanging upside-down

> As I lift my legs above my head, I see some of the observers underneath me. I lock my leg around the rope and feel the rough surface of the cotton even through my clothes. With some difficulty I find the piece of paper with my manuscript that I have kept close to my skin while climbing. I try to recuperate my breath and start talking. But as soon as my breath becomes calmer and disappears from my attention, another part of my body pokes at my consciousness. This time it is my thigh that reacts to the weight of my body held in the knot of the rope, slowing nagging its way into my skin. The longer I speak, the tighter the knot gets, the more it hurts. I read the manuscript as if I did not know the meaning of what I was saying, as if the words were purely a physical, vocal material.

The practice of Homemade Academic Circus has included lecturing while hanging in a rope. In most of the lecture-performances the rope sequences are within the ordinary length of a circus act (around seven minutes) and contain only some talking. However, in a lecture entitled 'The Ropresentation of Space' (NOFOD Conference, Denmark 2011) the challenge I gave to myself was to give a paper presentation whilst up in the rope, which meant climbing and talking for about 20 minutes. However, even when lecturing in the rope for a shorter time, the simple fact of being in or executing rope work has consequences for my embodied experience of lecturing.

As performing vertical rope is a quite strenuous activity, the idea of time changes, as I constantly have to focus on how to manage my energy. I need to be much more economical with text and words, to make sure that I can both climb and talk. (This often means cutting my text to less than a third.) Whereas sitting or standing renders it possible to talk without limits, climbing introduces another limit to the performer's use of breath, and suddenly even talking becomes physically exhausting. The notion of the tongue as a muscle suddenly acquires another meaning, as I struggle to control it and get it around the words.

Even in the rope, I am not always upside down. I often notice that I have choreographed the sequences so that I speak whilst having my head positioned higher than my feet. In the few sequences where I have spoken

whilst having my head down, I have noticed that for some reason it seems even more difficult to speak. Furthermore, it also takes a couple of seconds to find out what it means to address someone while having my head in another direction, particularly when talking about conceptual issues. There is something slightly comical about this, no matter what I say – simply because it inverses our expectations of lecturing and the lecturer's role.

Furthermore, when climbing with a manuscript at hand, I sometimes need my mouth for carrying the paper, as my hands are needed for climbing. When standing or sitting, the hands are liberated for other things (and often we do not pay attention to what they do when lecturing). Now, my attention is constantly directed towards my hands and feet, as my grip (and therefore my safety) totally depends on them. The body parts that are normally at our disposal due to our upright position are suddenly available for no other activity than survival. The relation between different body parts internally is changed for example, when only the mouth is available for carrying objects, it means that it is less available for talking.

For the grip to work there needs to be a certain friction between the rope and the skin, and this also changes the relationship between the senses. Although I am up in the air and thus in a certain sense have an overview of the space, I am also brought into a haptic space where the rope is close both visually and in a tactile way with my skin receptors. Though the audience sees my movement as spatial formations from a distance, I see mostly the space around the rope and my own body. The rest of the space is just part of a dim peripheral sight; despite the fact that I am working at a height I am mostly aware of the space within my own kinesphere.

The element that induces these changes of time and space, the awareness of extremity and core body parts, visual and tactile sensations, is of course not only the rope as such, but what gravity does to a body hanging in a rope. Though the body is subjected to this force all the time in everyday life, it becomes much more evident and palpable when experienced whilst in a string of rope suspended several metres up in the air. In this position I largely depend on the arms to defy gravity and simply holding the upright position is not enough. However, even when I come down, the attention I pay to gravity tends to stay with me for a while.

Whether it is because the attention paid to movement enhances my bodily awareness, or whether it is the sensation of gravity and its affect on the body in the air, I tend (paradoxically) to have an impression of being more *grounded* when coming down from the rope. During the accompanying discussion with students that follows, I tend to be calmer, gesticulate less wildly, master my movements more carefully, and be more aware of the people around me. One could think that through the adoption of a performance persona, I would be more eloigned from the listeners than when embodying my habitual lecturing persona. However, it seems to me that, paradoxically my address tends to become less distanced, even if I am spatially set apart from the listeners while in the rope. Even though I am, or

perhaps because I am hanging several metres up in the air I find that I need to focus on and pay attention to the listeners visually, through sound or through mental pictures in order to share the space with them.

Standing upside-down

When including vertical rope in a lecture-performance, the object of the rope in itself and the way it includes height immediately marks that situation as out of the ordinary compared to an everyday seminar. Simply the fact that the lecturer is hanging five metres up in the air is a statement as is standing on your hands, but in a somewhat less spectacular way. The physical risk may seem less pronounced as I am standing on the floor or quite close to it. However, the risk of failing is much more pronounced as balancing is a tricky thing, and so easily influenced by nervousness and the reactions of the autonomous nervous system to stress. Therefore, hand-balancing and the upside-down position on the floor, highlights other embodied processes at stake in the act of lecturing, for example proprioception and the pre-reflective processes of the body, such as breathing.

The thing that is so striking and fascinating in the practice of hand-balancing is perhaps this: how it can be so entirely different to balance on your hands rather than your feet, even if you are apparently in the same upright position? Due to the human skeletal structure, the required alignment of the body is completely different when standing on your hands, as is the way the muscles need to work together to stabilise the position. When standing on my feet, I generally do not need to focus on my balance, but when practicing to stand on my hands, it becomes obvious that I tend to take this for granted. If lecturing in the vertical rope has made me more aware of intra-bodily and inter-bodily space, then hand-balancing brings my attention towards the body's 'proprioceptive frame of reference' to use the distinction of Gallagher and Zahavi (2008: 144).

When working and lecturing in the rope, there is often confusion between egocentric space (the space relating to the position of my body) and allocentric space (geometric conventions of space, such as directions and relations between geographical points) (ibid.: 141–144). For example, as I am often hanging upside-down, and because I work *around* the rope which furthermore often keeps turning, it becomes confusing to talk about left and right (especially if talking to others who are not upside-down). When working with hand-balancing there is another spatial 'gap' which makes itself felt, namely one between the spatial position that I feel proprioceptively, and the spatial position of my body in the geometrical/allocentric space. Whilst I sense that my right and my left legs are equally close to the floor (when balancing on my hands with the legs in a split position), this might not at all be the case. As one leg is more flexible than the other, it may feel so, however observed from the outside, they are often at different heights. This is just one example of how hand-balancing, even

if it requires a high degree of body control, also confronts us with the fact that we only ever 'master' the body very little. I may think that I know where my legs or shoulders are (through proprioception), but that impression might not be precise enough yet to actually stay in balance on my hands. Through this work therefore, the fact that our bodies are partly out of volitional control becomes obvious. For instance, in hand-balancing there are moments when the (pre-reflective) body-schema and the (reflective) body-image seem to clash. As defined by Gallagher and Zahavi, the body-schema is constituted by the automatic pre-reflective functions of the body and the body-image by reflective and culturally informed bodily practice (2008: 145–146). For instance, the body-schema directs our breathing pre-reflectively, meaning that I do not have to consciously think about breathing, and that breathing happens in ways I do not consciously control. But in hand-balancing breathing operates in a manner that is sometimes counter-productive. For instance, we tend automatically to (temporarily) stop breathing, when something becomes exhausting and difficult, but not breathing when balancing on your hands will eventually make you fall, as you need to breathe as regularly and calmly as possible to maintain the bodily position. In a similar way, the reaction of my autonomous system to stress, might be devastating to my capacity to stay in balance on my hands.

It seems to me that whilst, with time, one controls the exercise more and more precisely, hand-balancing also confronts us with the body as alterity; though the body is mine, my access to knowledge about it is actually quite limited. What can I really know about what goes on within my shoulder joint? To which degree can I actually understand my own process of breathing? Even if my capacity to perceive nuances in the position whilst balanced on my hands grows with time, the body poses itself as an enigma and is no longer 'experientially transparent' (Gallagher and Zahavi, 2008: 144).

Whilst hand-balancing demands a strong focus on the proprioceptive situation of the body, it does not mean that the spatial relation to others disappears. In fact, I tend to be even more aware of the others' gaze than when lecturing in the rope, as I am often at the same height as them. This also makes it all the more revealing, and performing hand-balancing close to others is like inviting someone into a process we as adults rarely share with each other: the simple difficulty of standing and as such it tends to display a certain kind of vulnerability. Even if I cannot actually see the people present in the room (or only through the extreme periphery of my sight) when standing on my hands, I tend to become extremely aware of what I may or may not share with them. As when balancing blind-folded in a lecture-presentation called 'The Teacher as Student: Learning Practice through Theory' (2012):

> I take a firm grip of the blocks – balancing blind-folded is almost like making sure that you will not make it. As balance depends on the interaction between proprioception, the vestibular system and visual

input, taking away your eyesight when standing on your hands throws everything else off balance too (at least until you become a real Master). Imagine that when standing and teaching you would risk falling every time you move your visual focus, for instance to look at one of the listeners or answer a question, or even if you would move your focus ten centimetres from the top of the page to the bottom. Without seeing the audience, I hope that they are looking not only at my legs and their spatially extensive movements, but also at my hands and the tiny movements that to some extent reveal the proprioceptive process which involves my whole body. I know from my own experience as a spectator that it requires a certain proximity to see these details, and in this case some of the audience members are sitting higher than floor level. It is as if the steady and stable position of the standing lecturer is a guarantee of any knowledge proposed, and here I am struggling to stay upright, sharing not abstract thought and complex arguments, but the simple difficulty of dealing with my own balance.

Returning to my feet: clumsily gesticulating while lecturing

By sheer contrast, lecturing when hanging upside-down in a rope has thus made me more aware of the way I use speech, my spatial relation to the listeners (inter-bodily relations), the way my own focus is distributed to different body parts and different senses (intra-bodily relations), and the way I attend to movement (or not) when lecturing. Similarly, lecturing while balancing on my hands, has made me much more aware of the constant work of proprioception and the complex processes of the body at stake even when doing something as simple as standing. But what remains of this when I return to my feet?

Lecturing upside-down has gradually made me more aware of my bodily disposition even when lecturing in less extreme conditions. But how is it that when not having these physical constraints, I frequently tend to be less in control of my movement, less aware of my gesticulation, to the point of being clumsy?

One way to understand this, would be to examine the intentional focus and layers of pre-reflective and reflective consciousness when teaching or lecturing. When lecturing in the rope or while doing a handstand, some part of the movement is of course pre-reflective, but to a higher degree there is a simultaneous reflective focus on movement and balance. When standing and lecturing, I tend to not reflectively address my posture and movement. Of course, being too reflectively focused on your own posture and movement while lecturing might limit the focus on the content. However, when talking after a physical lecture, I tend to be more focused both on my own bodily energy and the people around me as the focus on my body leads me back to the present moment of the situation, and reminds me that talking is also a performance situation.

Whether it is an advantage or not to reflectively focus on the movement or position that one is engaged in, is something that has been discussed within many performance practices. In the chapter 'Body Consciousness and Performance – Somaesthetics East and West', Richard Shusterman (2012: 197–215) proposes that often a reflective approach to the task at hand is necessary in order to continue learning and correct mistakes. Being aware of the standing position of the lecturer may not so much be a question of learning to stand, but of becoming aware of the performative situation.

However, attending to the performative situation when lecturing, is not only about being able to perform smooth and controlled movements and thereby avoiding ridicule. If, for a short moment, I think of myself as a clown rather than a lecturer, then the skill I am supposed to master is not only the content and the delivery, but also the manner and mode of contact with the audience. The technique of the clown as understood in contemporary clowning (based largely on the teachings of Jacques Lecoq and others who have followed him), is based on the capacity to connect to and establish a complicity with the audience, in order to be able to *play* (Lecoq, 2000; Peacock, 2009; Wright, 2006). One way to attune oneself to this play is to direct the attention towards one's own body and its interaction with others. Or, as Stacey Sacks observes, you need to able to be both *in* and *on* the moment (Sacks, 2012), being both pre-reflective and reflectively engaged at the same time. Perhaps then a consideration of the standing position of the lecturer as a form of movement and interaction might help bring this to attention.

Standing: postural balance and alignment – an experience of the unknown?

Even if the standing position may seem to be one of the most banal spatial positions of the human body, this is not actually the case. Fully understanding how we are capable of balancing on our two feet, and how the automatic functions of the body-schema and the reflective layers of body-images interact is far from simple. As Shaun Gallagher writes, the spatiality of body posture is not just 'equivalent to represented positions in objective space; rather it involves a prenoetic spatiality that is never fully represented in consciousness or captured by objective measurement' (2005: 139). What Gallagher is proposing here, is that a neurological understanding of the postural balance is not sufficient, as neurological, spatial and experiential layers overlap.

As a hand-balancing practitioner it is not difficult to relate to this statement. Through the practice it is absolutely clear that the spatial position of the body cannot be reduced to its position in objective space. From my experience I also know that the position of the body often is not really represented in consciousness; the position that I imagine is not the same as the one that I feel, or the one that the body has in allocentric space. Many somatic practitioners working with the body's alignment would also recognize and

confirm the complexity of the simple task of standing. So, what might the consequences be for the lecturer? Might a heightened awareness of this relationship have other consequences than simply rendering the lecturer more aware of the performance situation? How might this understanding relate to or influence other cognitive processes?

If the classical understanding of the cognitive consequences of the upright position tends to be related to visual overview, distance and the execution of tasks (as mentioned above), then a consideration of the upright position as a balancing act could perhaps inform an understanding of related cognitive processes. Rather than looking at the assurance and efficiency of the upright position, this would mean looking at its fragility and probing nature. Balancing is not something you have, but something you constantly search for, something that constantly needs to be readjusted.

In *Difference and Repetition* (2004) Gilles Deleuze describes how certain physical experiences can lead to what he calls the 'transcendental exercise' (2004: 178). By this he understands the process in which one is confronted with something in the world in such a way that it unsettles what we already think we know, through creating a disrupted chain between what we sense, remember, imagine and think. As an example of such a physical experience he refers to the condition of vertigo (2004: 297). I am proposing here that a similar disrupted chain, questioning the knowledge we take for granted, can happen from the simple task of paying attention to alignment and balancing in the upright position.

Thinking of the upright position in this way, would mean undoing the idea that the one standing and talking *contains* a certain knowledge, and instead consider how standing and talking could mean *confronting* the world and our knowledge about it. Such an understanding of the position of the lecturer also looks beyond the status and power apparently *displayed* by position, to consider a position of constant doubt and instability that we can possibly *sense* even when we stand still.

Thinking on the spot

The spatial thinking of Deleuze has mostly been used to argue for a consideration of transversal, continuously spreading and moving spaces (Doal, 2000), as exemplified in the idea of the rhizome which spreads horizontally and exponentially in all directions at the same time (Deleuze and Guattari, 2003). But in his writing he often favours another figure too: the one of standing or travelling on the spot (for a closer analysis see Damkjaer, 2010). Or as he writes with Guattari, 'Voyage in place: that is the name of all intensities, even if they also develop in extension. To think is to voyage' (2003: 482). I believe that he favours this figure as it facilitates an understanding of intensive space, a situation in which quantity and quality are indistinguishable. Intensity is not a difference in quality, and not a difference in quantity, but a relation in which quality and quantity are

reciprocally defined, 'An intensive quantity may be divided, but not without its nature' (Deleuze, 2004: 297).

I propose that even something as simple as the standing position contains the possibility of creating an intensive space. The position of hand-balancing, for example, demonstrates in concrete terms what such an intensive space might consist of. When standing on your hands any change in the extended position of the body simultaneously introduces a qualitative change in muscle tension and energy. And in a reciprocal manner any change in muscle tension will immediately introduce a slight change in the spatial position of the body. The quantitative and qualitative aspects of hand-balancing therefore are reciprocally defined. Just as an intensive space can occur when standing or hanging upside-down, then even standing on your feet can comprise such a situation.

However, what is important is not only the fact that even balancing on your feet is a complex movement task with subtle variations, but how we represent that task to ourselves. In my interpretation of Deleuze's thinking, standing or travelling on the spot can mean several things: the possibility to travel far in imagination or thought as when he writes about his way of working that 'the rare movements that I experience are interior' (Deleuze, 2003: 218, my translation), or the possibility to dig into the sensorial process of knowledge as proposed in the idea of the 'transcendental exercise' (2004: 178) and the manner in which perception is confronted with something which forces us to think. For Deleuze, thinking is an intensive exercise:

> It is true that on the path which leads to that which is to be thought, all begins with sensibility. Between the intensive and thought, it is always by means of an intensity that thought comes to us.
>
> (2004: 182)

Traditionally, we often use the standing position of the lecturer to travel far in terms of examples, fields or abstractions, but we tend to ignore the sensorial aspects of the exercise. It is often used to embody status and authority as opposed to a way of thinking. However, I believe that we could also view the standing position of the lecturer as an opportunity to examine the sensorial aspect of knowledge, starting from where we stand.

Attempts at a conclusion: towards an ethics of posture

Through considering disruptions to academic sites of performance via alternative modes of delivery that challenge spatial and professional conventions, we can begin to uncover some of the implicit expectations concerning the relations between spatial and embodied positions and the presentation and transmission of knowledge leading us to consider these relations differently.

The embodiment of the spatially upright position makes something possible and other things impossible. Due to the quasi monopoly of the upright position within academic situations, we do not know what else might be possible through other embodied spatial positions and relations. As the upright position has become a default mode, even the fact that it is embodied seems to elude us, and thus an important part of the performance situation involved when assuming it is ignored. Artistic or practice-based research and the way in which these practices bring in other spatial designs for exchange of knowledge, is one way of expanding the spatial vocabulary of academic life.

However, even without moving out of the upright position, we can address it as an embodied and perceptual situation and thus begin exploring other possibilities related to it, other understandings of it, and perhaps re-consider the cognitive functions embedded within it. If we move our focus from the upright position as an example of containment, overview and control, to an exercise in which the fragility of our embodied nature and therefore our embodied thinking is at stake, then this simple act of balancing on our two feet takes on other dimensions.

We live in a world in which knowledge production is linked to professionalism, status and authority. However, when we look at the process of knowledge it is filled with insecurity, doubt and stumbling. This is important to remember especially at times when the guarantee of knowledge is supposed to be embodied in the person of the productive, confident, infallible and steadily upright researcher. I would like to imagine, based on my experience of embodying other spatial positions while lecturing, that even standing still is a reminder of this complex confrontation with ourselves and the world that happens through sensibility. Standing still and talking is a moment where complex perceptual layers interact as we negotiate both proprioceptive, egocentric and allocentric space in a manner in which we constantly need to listen and adjust. This conceptual and physical process of re-positioning would, perhaps, posit academic practice not as a spectacular display of skill, but as a perceptive performance of the process of knowledge.

Notes

1 Lecture-performances and presentations in academic spaces that I am referring to in the text: 'The Representation of Gender' – first presented (horizontal version)' at the conference *Women & Circus* within the festival Novog Cirkusa, Zagreb, 2009-11-27, later performed in seminars and courses in Stockholm.
 'Introduction to the complexity of circus through one exercise' – seminar at the Department of Musicology and Performance Studies, Stockholm University, 2012.
 'The Representation of Space' – At: Dancing Space(s) – Spacing Dancing, University of Southern Denmark, Odense, 2011.
 'The Teacher as Student – Learning Practice through Theory' – At Contemporary Dance Didactics, DOCH – University of Dance and Circus, Stockholm, 2012.

References

Barrett, E. and Bolt, B. (eds) (2010) *Towards a Critical Discourse of Practice as Research: Approaches to creative arts enquiry*, London: I.B. Tauris.

Biggs, M. and Karlsson, H. (eds) (2011) *The Routledge Companion to Research in the Arts*, London: Routledge.

Cooper Albright, A. (2011) 'Situated Dancing: Notes from three decades in contact with phenomenology', *Dance Research Journal*, 42(2), December 2011, pp. 5–18.

Damkjaer, C. (2010) *The Aesthetics of Movement: Variations on Gilles Deleuze and Merce Cunningham*, Saarbrücken: Lambert Academic Publishing.

Deleuze, G. (2003) *Deux regimes du fous – textes et entretiens 1975–1995*, Paris: Les Éditions de Minuit.

Deleuze, G. (2004) *Difference and Repetition*, London: Continuum.

Deleuze, G. and Guattari, F. (2003) *A Thousand Plateaus: Capitalism and Schizophrenia*, London: Continuum.

Doal, M.A. (2000) 'Un-glunking geography: Spatial Science after Dr. Seuss and Gilles Deleuze', in: *Thinking Space* (ed. Crang and Thrift), London: Routledge.

Foucault, M. (1991) *Discipline and Punish: The birth of the prison*, Harmondsworth: Penguin.

Gallagher, S. (2005) *How the Body Shapes the Mind*, Oxford: Oxford University Press.

Gallagher, S. and Zahavi, D. (2008) *The Phenomenological Mind – An Introduction to Philosophy of Mind and Cognitive Science*, Oxon: Routledge.

Lecoq, J. (2000) *The Moving Body: Teaching creative theatre*, London: Methuen Drama.

Lepecki, A. (2006) *Exhausting Dance: Performance and the politics of movement*, New York: Routledge.

Peacock, L. (2009) *Serious Play: Modern clown performance*, Bristol: Intellect Books.

Sacks, S. (2012) Master's thesis for 'a year of physical comedy'. Unpublished.

Shusterman, R. (2012) *Thinking through the Body: Essays in Somaesthetics*, Cambridge: Cambridge University Press.

Vigarello, G. (2004), *Le corps redressé, histoire d'un pouvoir pédagogique*, Paris: Armand Collin.

Wright, J. (2006) *Why is that so Funny?* London: Nick Hern Books.

7 Sharing occasions at a distance

The different dimensions of comobility

Jen Southern and Chris Speed

We look on *Comob* and think "where on earth is he now?!"
(Liz, *Comob Net* User)

Global Positioning System (GPS) technologies have become an integral and often invisible part of mobile technologies. We use maps on mobile phones to navigate from A to B on a daily basis without a second thought. The capacities of GPS are, however, greater than "just" navigation, and this chapter explores a speculative art project *Comob*, which has become a widely available mobile phone app.

The *Comob Net* app simply shows the locations of multiple members of a group, and joins together their locations with a line. It was originally built for use in participatory workshop situations, and was used experimentally in live art, performative walks and at a number of conferences in Europe and North America between 2009 and 2013. During these events we observed how it was used, and recorded discussions and conversations about collaborative and collective use of GPS. In analyzing these responses we identified an emerging sense of what we call "comobility," of being mobile with others at a distance. For ease of use in early workshops we submitted the app to Apple's App Store. Subsequently we realized that people worldwide were downloading the app and using it. For some this was just as a one-off experiment, others used *Comob* over several days with a group of friends, over a year with a family, or in some cases on a daily basis over many years.

This chapter describes comobility and explores how one family used the app to enhance their sense of connectedness whilst at a distance, mediating absences and presences in a highly mobile familial group.

While the term comobility is new, it builds upon already established social phenomena, from the "wish you were here" on postcards (Kurti, 2004), the sharing of mobility in travel blogging (Germann Molz, 2012) and the portable personhood of intimately mobile lives (Elliot and Urry, 2010) to a sense of mediated proximity, identified in analysis of the Japanese locative game *Mogi* in which players collect geographically located tokens through their mobile phones, and are able to see and communicate with

other players nearby (Licoppe and Inada, 2010a). In games like *Mogi* or artist's projects like *Can You See Me Now?* (Blast Theory, 2001; Benford *et al.*, 2003), participants can observe that another user is getting closer and thus negotiate meetings and movements en-route (Licoppe, 2009; Licoppe and Inada, 2010b). It is this awareness of the movement of people at a distance through visualized GPS data that we refer to as comobility.

This chapter introduces the term and provides a review of literature and practices that engage with the concept. The chapter also uses an interview with Liz, a member of the public who uses the iPhone app *Comob Net*, to offer a highly personal perspective upon living through comobility.

Distributed copresence

> Virtual travel produces a kind of strange and uncanny life on the screen, a life that is near and far, present and absent, live and dead. The kinds of travel and presencing involved will change the character and experience of "co-presence", since people can feel proximate while still distant.
>
> (Urry, 2002: 267)

The contemporary experience of social interaction is often woven together through complex combinations of mobile technologies and patterns of proximity and distance, absence and presence (Urry, 2002). It is often performed on the move, and can include mobile phone conversations, *skype*, email and text messages as well as face-to-face meetings. Mobile lives and family relationships are being lived out through these technologies and across multiple platforms (Elliot and Urry, 2010). We aim to explore how proximity is entangled with distance in the emerging sense of comobility.

The immediacy of proximate interaction is well documented (Goffman 1983; Boden and Molotch, 1994). When people are physically copresent, non-verbal aspects of interaction such as body talk, line-of-sight, intensity of involvement and levels of engagement in the interaction as well as mood, ease and wariness make the communication rich with additional information (Goffman, 1983). Sociologist Erving Goffman calls this being in each others "response presence" (ibid.: 2), however by being copresent, bodies are also made vulnerable to each other's physical agency, and this double-edged quality both engages and entraps us in proximate interaction. Ole B. Jensen extends Goffman's description of a proximate "interaction order" to include groups that are "mobile with" each other (Jensen, 2010). Comobility captures this sense of being "mobile with" others that are linked-in-motion.

Deirdre Boden and Harvey Molotch (1994) suggested that copresent interaction is often preferable to, or an upgrade from, other forms of interaction such as sending emails or making phone calls. They attribute an often-desirable "thickness" of contextual information that adds detail and

richness (Geertz, 1973) to copresent interactions, created through factors including facial gesture, body talk, turn taking and the commitment of sharing time and location. However, they also suggest that a form of "distributed copresence" may be possible through new technologies, across different locations, people, events and moments (ibid.: 278). Through analysis of empirical data from an interview with a *Comob Net* user, we intend to show how the detail and subtlety of proximate interactions are being stretched and extended by locative mobile social networks.

In the next section we explore how aspects of copresent interaction are retained, transformed and re-invented in comobile interactions and how this can help us to understand distributed interactions.

Presence at a distance

Within the *Comob Net* interface a blue dot superimposed on a map does not simply signify "you are here" but has come to represent three kinds of presence. Firstly, a *locational presence*: the blue dot and username displayed in the on-screen satellite image shows where people are physically present at a distance. Secondly, a *temporal presence*: a moving icon is taken to mean that the person it represents is currently connected to the *Comob* network, creating a sense of a shared "now." Thirdly, a *virtual copresence*: icons share a spatial relationship on screen, which is reinforced by the lines drawn between them.

Figure 7.1 Comob Net iPhone App (2013), Jen Southern and Chris Speed.

These three aspects are not separate, together they contribute to comobile experience as the blue dot that represents "I am here" is joined by the "they are there" of other participants, to produce a sense of copresence (Licoppe and Inada, 2010b; Southern, 2012; Willis, 2012).

Locational presence

In the context of *Comob Net*, *locational presence* is the sense of knowing where someone is at a distance through the location of a blue dot on a map interface, which can be used as a fluid method of micro-coordinating movements and meetings at a distance, and an extension of the reach of copresence.

Aspects of *locational presence* can be found in the use of verbal and textual descriptions of locations in mobile phone calls or text messages. These are familiar methods for the micro-coordination of times and locations of meetings on the move (Laurier, 2001; Ling and Yttri, 2002), when using a locative media interface, however, movements can be followed in real-time without a formal re-making of plans. This could be thought of as the spatial equivalent of the "loose talk" that Boden and Molotch identify in the informal chat of copresent groups, that can "collaboratively and simultaneously mould the ongoing interactions as they change the course and speed of conversational flow" (1994: 268). The "loose mobility" of comobility allows spatial interactions to be collaboratively and simultaneously moulded and negotiated as course, speed and location change they are observed through occasional glances at the blue dot in *Comob Net* and subsequent modifications of route. At its best, comobility offers what Goffman called a "sustained, intimate coordination of action" (1983: 3) through a shared focus of attention previously found in copresent interactions and now extended into distant, comobile, encounters.

However, connecting to someone in a way that constructs a *locational presence* presents both opportunities and risks. To know and track the location of another person can bring with it both the anticipation of meeting a friend but also the fear of being followed by a stranger, an ambivalence that is often present in locative media. As Goffman suggests, proximate interactions always bring bodies and thus instrumentality and vulnerability with them (1983: 4). In comobility vulnerability is experienced because the response presence of participants is extended, making them available for interaction at a distance beyond line of sight. This availability, that people can track each other's movements from a distance, has often been perceived as "creepy" both in previous workshops using the *Comob Net* software and in media representations of location-based services (De Souza e Silva and Frith, 2010). What is missing is an ability to make an assessment of the other person visually through appearance, gesture, intensity of involvement and intent in order to enable quick decisions about whether someone else might be a threat, as was possible in the face-to-face presence

of Goffman's interaction order (1983). When both participants make their location known in software like *Comob Net* or *Mogi*, the mutual availability of comobility allows participants to take evasive action if necessary, by logging out or moving away if something seems risky (Licoppe and Inada, 2010a: 706). If the person who comes into this extended response presence is known, however, even by simple acquaintance, the *virtual copresence* is experienced with anticipation of, or an obligation to upgrade to proximity (Licoppe, 2009). In reference to face-to-face interactions Boden and Molotch say that "[t]his density of interactional detail of proximate encounters thus both engages and entraps us" (Boden and Molotch, 1994: 259). By making individual locations available to others at a distance, comobility engages and entraps them in new ways: participants responded by being engaged and fascinated by the connection but were also aware of the risks in sharing location data to entrap participants into being watched or followed.

Temporal presence

Linked to this spatial sense of "knowing where you are" is a temporal sense of "knowing that you're there," and this is perhaps the strongest feature of comobility. The sense of commitment, of sharing time, place and focused attention found in proximate interaction (Boden and Molotch, 1994: 263), is echoed in comobility, as a distant friend or family member logging in to a shared group demonstrates that they are making themselves, or at least their location, available to others at a distance.

Sharing a location is not limited to a static location marker; the movement of the dot in the interface indicates a "liveness" of the signal and action of the participant. A commitment to sharing time (and location) is enhanced by an awareness of the technology needing significant investment of time, battery life, data connection, signal strength and most of all attention to make it work. Inattention is felt through stillness: a GPS icon that is static for too long suggests disconnection, and is often attributed to a need for privacy, data costs, battery life or loss of signal.

There is a complex set of absences, presences and emplacements here that is mediated by the *Comob Net* interface, and supplemented with satellite images, texts and photographs. The GPS link makes participants *temporally* and *locationally present* through movement and produces a form of imaginative travel through the *virtual copresence* of icons in the map interface. A vivid illustration of this is offered in the interview with a *Comob Net* user later in this chapter who often accompanies her two sons virtually on trips.

Liveness is thus made through both the temporal and locational aspects of movement. The dot has to be both on-the-map (locationally) and also on-the-move (temporally) to indicate presence. Media theorist Philip Auslander suggests that liveness is perceived differently according to available technologies (2008). When compared to a recording a "live"

performance is one that is both physically and temporally copresent. A "live performance" on radio need only be temporally but not spatially copresent. A "live recording" suggests that the presence of an audience in a live setting changes the affective quality of the recording, not that the listener is either temporally or spatially present. In comobility, liveness is shared through spatio-temporal movement but not necessarily in proximity; in order to feel live there needs to be both a visibility of locational presence at a distance, and *temporal copresence.*

Comobility isn't necessarily experienced continuously, smoothly or easily; it is susceptible to error, failure and disconnection. In thinking on paths, Ingold posits that they are to be understood "not as an infinite series of discrete points occupied at successive instants, but as a continuous itinerary of movement" (Ingold, 2000: 226). Sociologist Laura Watts notes that these "continuous itinerar[ies] of movement" have different temporalities, and that travel is often not a continuous flow but a discontinuous series of breaks and pauses, of arrangements made during a busy day, waiting on platforms, phone calls, and imaginings of distant destinations (Watts, 2008: 713). The technical configuration of locative media is reliant on GPS readings at regular intervals, so the blue dots in *Comob Net* jump forward in tiny increments rather than smooth flows. A GPS receiver requires relatively clear "lines of sight" with four satellites in order to work smoothly, so how it is carried can alter the accuracy of its reading; in cities tall buildings can create GPS errors as line of sight to satellites is obscured, and in rural areas there are breaks in the coverage of communications networks that connect the iPhone to other users. Comobility, like travel, is not a smooth ride. Rather, it is co-produced discontinuously with lost connections, breaks in signal and lapses of attention.

By sharing time within *Comob Net* a sense of obligation became important, to not break the connection. During a workshop in Dundee, designed to explore how users experienced the qualitative nature of connections in *Comob Net* through experimental walking exercises, several participants agreed that their availability in the interface meant a stronger obligation to the group task, mirroring Goffman's sense of obligation to pay attention in proximate interactions (1983). On a cold, rainy day when otherwise they might have given up, participants felt that they could not because others were aware of their location. There was nowhere to hide from the group or the rain. Although bodies are in one sense absent in the comobile interface, there is also paradoxically a visibility that is extended beyond line of sight.

There is a perception that using mobile media can create a separation from proximate surroundings (De Souza e Silva and Frith, 2010; Mazmanian *et al.*, 2006), a form of "absent presence," and a removal of people from proximate experiences (Gergen, 2002). *Comob Net*, however, has begun to form part of a network of communication technologies that can do the inverse, make a distant person present despite their physical absence. In

part this is because participants can slip easily between intentional and background synchronous communication. This sense of negotiating attention between absences and presences, between the proximate street and distant participants is a feature of comobility; attention can oscillate between navigation of proximate landscape, use of the satellite or map imagery and attention to the movements of comobile participants.

Virtual copresence

Comobility uses a geographical location and a mutual sense of emplacement to produce a sense of live and imagined connection at a distance, and is related to the traditional postcard in which the image, the postmark and the address indicate the specific locations of sender and receiver, and are used for reciprocal imaging of another person at a distance. In the general "wish you were here" sentiment of the card it conveys "the idea that the people involved actually think of each other sensing both a presence and absence" (Kurti, 2004: 53). This sense of presence that is both real and imagined is a feature of comobility, and of *virtual copresence*, to which we now turn.

At first glance a blue dot on the screen of a mobile phone seems to hold very little information other than location. Through our work with *Comob Net*, however, we would argue that the dots, circles and lines within the interface can communicate a much "thicker" set of information, and can evoke a rich sense of connection that combines both real and imagined activities.

A feature of the thickness of proximate copresence is the ability to read sequential actions, and to anticipate future moves of other people. Without it we would be forever bumping into people on the street instead of skilfully and intuitively sharing the space of the pavement (Ryave and Schenkein, 1974: 266). Boden and Molotch describe features of proximity that give it this thickness that other media do not have, including meaning that is reflexively produced in interaction through context, body talk, commitment of time and turn taking in conversation (Boden and Molotch, 1994). They suggest that the richness of copresent interaction produces a sense of knowing what is going on but that at the same time people are put "on the spot" because their thoughts, intentions and actions are more visible. Locative data initially does not seem to carry any of these thicknesses, but when a location marker regularly updates, movement, route, speed, and direction all become available at a distance, and can be used to imaginatively construct a narrative presence.

As the blue dots and circles move, *Comob Net* data becomes sequential like conversations; one movement implicates another. While face-to-face body talk cannot be detected, movement on a larger scale can be interpreted and it is possible to recognize characteristic forms of movement such as the differences between walking, cycling and driving. In addition, *virtual copresence* in the interface allows some geographic context to be read in the

map or satellite image. Paths can be seen as they are made and future moves anticipated, depending on what happened previously in their trajectory.

Location and trajectory are made visible to other participants as part of a longer sequence of movements. It is not just the detail of face-to-face interactions that both engage and entrap us, the surprising amount of detail that can be read in movement and position data and the distant connections of social media can switch from "intoxicating to threatening" (Elliot and Urry, 2010: 41).

While comobility is an observation of mobile communication, there is, in addition, an aesthetic experience of a network of connection represented in *Comob Net*. The lines that constantly shift as participants move can be interpreted as purely geometric or as full of emotional connection and association, that are co-produced in motion and at a distance, and in the imaginative interpretation of contextual information. The connecting lines, when seen more broadly as drawings, also evoke connections to visible and invisible networks including the infrastructures that make *Comob Net* possible: pylons, satellites and mobile phone networks.

The sense of *virtual copresence* found in comobility creates opportunities for working with others at a distance, through the dual perspectives of the interface and the embodied world. Ethnomethodologist Eric Livingston describes how a view from above has been used to observe patterns of pedestrian movement, but that those patterns are not apparent to the pedestrians themselves, immersed in the work of crossing the road:

> They are engaged in locally building, together, the developing organization of their mutual passage. That organization is, and accommodates itself to, the witnessable structures of accountable action as they develop over the course of their journey. To understand how pedestrians manage their crossing we must, metaphorically, move the camera to eye level.
>
> (Livingston, 1987: 22; in: Ten Have, 2004: 158)

Comob Net makes both the movement pattern as seen from above and the eye-level perspective available simultaneously, thereby combining two methods of looking at and analyzing the world. Participants discover how a view from above accompanies their and their comobile associates' view from the ground, enabling a shared reflection through *virtual copresence*, and collaborative organization based on their augmented capabilities.

The virtual proximity of the interface gives participants enough information to begin to speculate on activity at a distance, but does not give them the detail of what other people are experiencing, the contextual and temporal gaps thus leave space for imagination, speculation, and discussion. This new comobile perspective weaves together distance, proximity, aerial and embodied perspectives with real and imagined absences and presences to generate new forms of being together at a distance.

Interview with *Comob Net* user

Liz is the 75-year-old mother of two sons who together use *Comob Net* to stay in touch and share mobility. What follows is excerpted from an interview conducted with Liz in November 2013. Retired, Liz lives in rural Cornwall next door to her younger son James whose job as a breakdown patrolman takes him all over the county. Peter, the elder son, is an airline pilot who lives in Oxfordshire and works for periods of time across the Middle East flying private planes. When initially asked how she uses the application she described its function as a tool for staying in touch with her two sons, both of whom are involved in travel:

> It's there, and they use it to keep track of each other because of the miles that they live apart. Obviously it reduces those miles between them. They can see what the other's doing and have contact… it's another contact for them.

What becomes clear during the course of the interview is how *Comob Net* has become a compulsive part of her means of connecting with her sons, but perhaps more so, a mechanism to provide companionship:

> I click on every day. I look to see where they are when I get up. It's almost my first mode of contact to see where they are, literally where in the world they are because Peter flies worldwide, James works throughout the county as a roadside patroller and consequently I never know where they might be… it makes me feel comfortable. I feel there's someone else there. Someone I'm close to. And I can see where they are and see how far away they are. That doesn't matter so much somehow; it almost brings them closer to me.

The type of bond that Liz articulates is one that requires reciprocity from her sons to offer a connection. By launching the application, all parties are sharing their location and with it, to an extent, their activity. Familiar with where they live, able to read maps and identify whether the nodes on the *Comob Net* are moving, Liz is able to understand quickly what her sons are doing. This level of regular insight into her family's lives helps her to maintain the ties between herself and her sons. But she also reflects that it initially felt quite invasive:

> I was very aware of being intrusive to start with. I thought I shouldn't be doing this I'm being a nosy old mum. And it did make me feel a little uncomfortable to start with because obviously they've both got their own private lives but we had a chat together at one stage and that was fine, no problem, they didn't mind [being seen] where they were. They had nothing to hide so no problems at all and now I find it a real

comfort to know where they are! It's interesting as well to watch where they are. I mean obviously they don't always speak to me by telephone and tell me what they're doing, where they're going and I can just sort of [say] "oh I saw you so and so".

Liz was very careful to explain the sensitivity that she has developed as she has learnt to use the software that lets her see what her sons want her to see. At times this may be due to the inability to connect *Comob Net* to the internet to relay location details, perhaps when her sons are abroad. On other occasions Liz explains the understanding that has built up between her and her sons that describes personal boundaries, when people don't want to be seen by others:

> Very often I can't see Peter because he's abroad in an area where it's not possible for him to show me where he is. The same with James when he's working. Sometimes I can't see where he is. Whether he's switched it off for whatever reason. I don't ask. I'm not that sort of a nosy person. Not that nosy. I appreciate and accept that they have a need to be private at times. I don't mind that at all. I have my times that I want to be private and don't want anybody to know where I am. So it works in all ways. So it's good in that way that you've got the facility to turn it off.

Throughout the interview Liz talked about being able to "see" her sons. This vision relates initially to the graphic circle that represents somebody's position within the Map View of the application. However, as we explored this insight she appears to have developed an extended vision that encompasses the actions of her sons that equates to "being with them." Introduced as something of a supernatural quality, Liz describes how the software offers her a mental image through which she can see a body:

> When I know where they are with *Comob*, I have this mental image. I can see a body. I have an image of them. Not something that is tangible and you can sort of put your hand out and touch. It's something in the mind. That's kind of spooky!
>
> One of the spookiest was when we saw both Peter and James both going, I think James had a breakdown on the south coast, he was driving down and Peter was going down and I was watching them both and they almost crossed paths. They were within about 10 yards of each other. Incredible that was. They sensed what was happening because they were both on *Comob* at the time as well.

It appears that Liz and her sons have learnt to develop skills in the capability of "being with each other" and have on occasion used the "real-time" feedback that the software and imagery offers to allow Liz to become a co-passenger with her sons. This imaginative travel through copresence is a

key characteristic of *temporal presence* and Liz offered an example of this when Peter let her join him on a cycle trip. Watching from her armchair in Cornwall, Liz describes the form of mobility gained through the observation of Peter's cycle ride:

> I don't know, it was just that it really did make me feel part of his cycle trip. He knew I was watching as well, because you know he gave me details, and told me when he was going and I watched him, and I knew when he'd got back home you know. I felt I was actually there.

On occasions she places herself at the scene of an event and constructs an image, in part based upon her personal experiences, and in part from the information that the app and satellite imagery that the Apple base maps reveal:

> You know he's stuck on the side of the road and I can hear him huffing and puffing. "oooh this blinking rain!" [laughs] head under the bonnet of a car somewhere. I can imagine him, you know, I think he's brilliant with his customers.

For Liz, *Comob Net* seems to be part of a range of practices that help construct images of where her sons are and what they might be experiencing. Complemented by the use of Apple's iMessage software which operates as an instant messaging platform between iPhone and iPad users, the family have developed a sophisticated language for understanding what each other is experiencing on the ground. Peter's job as a pilot for hire, takes him on many diverse journeys and he is likely to be in any one of a few countries during a business trip. Liz described how the family share the excitement of his travels as he posts surprise messages such as: "Can you see us then? We're sitting beside the lake." Suspending her disbelief about the age of the satellite images, Liz clearly relishes these opportunities to follow her sons in real-time as they move around the UK, Europe and the world:

> You tend to forget that the image of the map was there from many moons ago, Peter said "look you can actually see the cars going down the road" and he scrolled right in so that you could actually see the blob that represented, well it was James at the time. And he said you could see his car! Going down the motorway you could almost see how fast he was going.

Liz has learnt to make the most of the comobile perspective that *Comob Net* and the iPhone and iPad can generate. The bird's-eye view that the software gives her of her son's movements encourages her to take screen-captures of particular activities that interest her. She may even share these images with her sons as a form of corroborating her copresence with them:

Peter was going down to the boat and James was working. They were getting closer and closer and I was photographing the images on *Comob* and their actual position. Scrolling out and scrolling in depending on where they were. I was just sort of watching them getting closer and closer. And then I messaged the images to them.

On these occasions the information portrayed as two small circles that represent her sons moving closer to one another, appears to embody the capacity for the software to facilitate a meaningful relationship between a mother and her two sons. Consolidated in the use of the screen shot, the *Comob Net* images seem to act as a form of evidence of family that supersedes the unrelated activities that the members are taking part in on the ground.

Describing how she has "had a few issues with health this year," Liz has been more housebound than she would like, nevertheless the software has offered her a vista on life that she describes has become like "a friend":

Because I can watch it and see life going on. Because we live in the country no one comes past us except from the sheep and the cows. So it is another method of communicating without interfering with anything. They don't mind. They're quite happy about me watching what's going on.

This "armchair mobility" appears to have enabled her to take journeys through her son's travels. Sharing photographs of places that he has been to, as well as his movements on *Comob Net*, Liz describes how Peter is able to construct quite extensive "images" of places that are far beyond her physical reach:

Dubai was just a name on a map as far as I was concerned when he went there. But I could scroll in and see the plaza, where the mall is where he goes shopping. It's that good. I can envisage him. He … sent me back lots of images of Marrakesh as well and it was lovely, it was really good. I think the fact that you can zoom in so close … you can almost imagine it on pictures of Marrakesh, I could imagine the people all milling around all colourful. It was good.

The movement of the dot representing her sons confirmed to her that she was receiving "live data," and was given fuller meaning with the addition of a photograph. They were temporally copresent and thus available for communication, and not unlike Licoppe's (2009) *Mogi* players, felt a pull of obligation from this noticed *temporal copresence* at a great distance, and engaged in further interaction. The spatial distance was bridged by use of the map or satellite image to imagine each other's location and what it was like there. Through text messages and a photograph, detail was added to the shared *virtual copresence*; there was an ability to act at a distance through

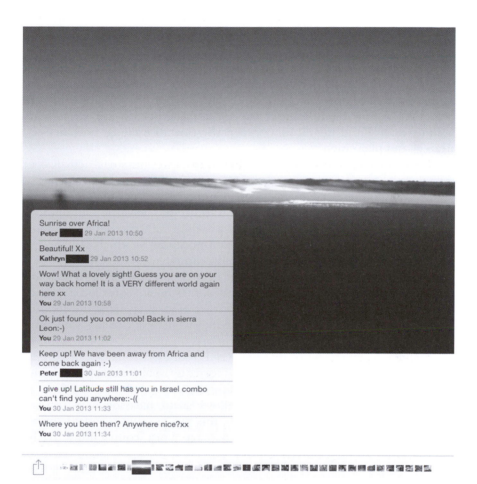

Figure 7.2 Liz and members of her family using photographs, messages and locative media to extend a form of comobility.

the map interface. The combination of *Comob* as a trace of movement and current location, complemented by photographs and text messages constitutes a complex personal environment in which all parties develop a sense of mobility as driver or co-passenger. For Liz, the opportunity to retain connection, to keep checking where her sons are and to join them in

their movements evidently offers a rich form of mobility that at times she feels that she is along for the ride.

Conclusion

Locative media enables new relationships between people, places, objects, networks and environments possible. When using live location data in a map or satellite image, aerial and street-level views are made comobile with each other. The locative media participant has an embodied view of the aerial perspective in situ, they can annotate the map and act on the aerial perspective as they move, and aerial perspectives can encourage conversations between overview and "underview" (Speed, 2010), allowing for new analysis. These views also hold contradictions, between the delight found in seeing from a new vantage point and its use in military reconnaissance and targeting, between the flow of walking, and analysis, strategy and planning.

The distanced perspective that is offered from viewing social activity over digital base maps creates a space for imagination and new forms of sociability, allowing participants to speculate on what might be happening, and to think about the past, present and future of a location and of other participants' movements. The temporal proximity of the other participants allows a comparison to be made between positions in which specific but distant locations are available for communication.

The interview with Liz provided a rare insight into how *Comob Net* extends the experience of comobility. The relay of data from her sons' location back to her iPad clearly offers her a different form of mobility from the comfort of her armchair. The *locational presence* that is achieved as her sons offer their location in exchange for hers supports an intimate coordination of movements: an engagement that involves Liz and her sons in a proximate interaction that holds her attention and forms a visual frame of belonging.

The sense of "liveness" that is offered through the "real-time" feedback of data constructs a *temporal presence* that allows Liz to share journeys with her sons. The family has learnt to negotiate this presence; as it shifts between continuous and discontinuous they manage both connections to the internet but also the information that they want to expose. The clarity of this presence seems stark in Liz's case as she describes how she and her sons have learnt to manage their presence and their absence. Sometimes they use images and text messaging to compliment and fulfil a narrative, but at other times they let imagination fill in the gaps.

Finally the *virtual copresence* that is constructed in this tightly woven relationship is one that is built upon rich contextual and sequential information. The movements of her sons, toward and away from home all offer a real and imagined presence – despite the absence of actual bodies. The knowledge of her sons' jobs and pastimes provides her insight into their routines and activities; an insight that allows her to construct with a

great level of detail, the scenes on the ground that they are engaged in. But this is not one-way, the reciprocity involved in sharing each of their locations constructs a complex multi-perspectival relationship for Liz and her sons, the affect of which can best be described as comobility. This form of mobility is so strong that it compels Liz to become involved as soon as she wakes.

Developed to manifest what the authors tentatively felt might be comobility, *Comob Net* now constitutes a habitual part of Liz's connection with her sons. Tightly bound to their daily routines, the app and its representation of their movements constitute a significant and meaningful aspect of their relationship. Throughout the interview it became clear how important the app has become for the family and the extent of the emotional architecture that it provides. A sentiment encapsulated in Liz's holding request when asked how to improve it, simply "make sure it's always there!".

Acknowledgements

The *Comob Net* iOS application was written by Jochen Ehnes, serverside development by Henrik Ekeus and Chris Blunt and visualization software by Henrik Ekeus and Chris Barker.

References

Auslander, P. (2008) *Liveness: Performance in a mediatized culture*, Abingdon: Routledge.

Benford, S., Anastasi, R., Flintham, M., Drozd, A., Crabtree, A., Greenhalgh, C., Tandavanitj, N., Adams, M. and Row-Farr, J. (2003) "Coping with uncertainty in a location-based game," *IEEE Pervasive Computing*, 2(3) pp. 34–41.

Blast Theory (2001) *Can you see me now?* B.tv festival, Sheffield.

Boden, D. and Molotch, H. L. (1994) "The Compulsion of Proximity," in Fiedland, R. and Boden, D. (eds) *Nowhere: Space, time and modernity*, Berkley: University of California Press, pp. 257–286.

De Souza e Silva, A. and Frith, J. (2010) "Locational privacy in public spaces: Media discourses on location-aware mobile technologies," *Communication, Culture and Critique*, 3(4) pp. 503–525.

Elliot, A. and Urry, J. (2010) *Mobile Lives*, New York and Abingdon: Routledge.

Geertz, C. (1973) *The Interpretation of Cultures*, New York: Basic Books.

Gergen, K. (2002) "The Challenge of Absent Presence," in Katz, J. E. and Aakhus, M. (eds) *Perpetual Contact: Mobile communication, private talk, public performance*, Cambridge: Cambridge University Press, pp. 227–241.

Germann Molz, J. (2012) *Travel Connections: Tourism, technology and togetherness in a mobile world*, Abingdon: Routledge.

Goffman, E. (1983) "The Interaction Order: American sociological association. 1982 presidential address," *American Sociological Review*, 48(1) pp. 1–17.

Ingold, T. (2000) *The Perception of the Environment: Essays on livelihood, dwelling and skill*, London: Routledge.

Jensen, O. B. (2010) "Erving Goffman and Everyday Life Mobility," in Hviid Jacobsen, M. (ed.) *The Contemporary Goffman*, New York: Routledge, pp. 333–351.

Kurti, L. (2004) "Picture Perfect: Community and Commemoration in Postcards," in Pink, S., Kurti, L. and Afonso, A. I. (eds) *Working Images: Visual research and representation in ethnography*, New York: Routledge, pp. 47–71.

Laurier, E. (2001) "Why people say where they are during mobile phone calls," *Environment and Planning D: Society and Space*, 19(4), pp. 485–504.

Licoppe, C. (2009) "Recognizing mutual 'proximity' at a distance: Weaving together mobility, sociality and technology," *Journal of Pragmatics*, 41(10), pp. 1924–1937.

Licoppe, C. and Inada, Y. (2010a) "Locative media and cultures of mediated proximity: The case of the Mogi game location-aware community," *Environment and Planning D: Society and Space*, 28(4), pp. 691–709.

Licoppe, C. and Inada, Y. (2010b) "Shared encounters in a location-aware and proximity aware mobile community: The Mogi case," in Willis, K.S., Roussos, G., Chorianopoulos, K. and Struppek, M. (eds) *Shared Encounters*, London: Springer pp. 105–125.

Ling, R., and Yttri, B. (2002) "Hyper-coordination via mobile phones in Norway," in Katz, J. and Aakhus, M. (eds) *Perpetual Contact: Mobile communication, private talk, public performance*, Cambridge: Cambridge University Press, pp. 139–169.

Mazmanian, M., Orlikowski, W. J. and Yates, J. (2006) "Crackberrys: Exploring the Social Implications of Ubiquitous Wireless Email Devices," *EGOS 2006*, Sub-theme 14. Technology, Organization and Society: Recursive Perspectives.

Ryave, A. L. and Schenkein, J. N. (1974) "Notes on the Art of Walking," in Turner, R. (ed.) *Ethnomethodology: Selected readings*, Harmondsworth: Penguin Education, pp. 265–274.

Southern, J. (2012) "Comobility: How proximity and distance travel together in locative media," *Canadian Journal of Communication*, 37(1), pp. 75–91.

Speed, C. (2010) "Developing a Sense of Place with Locative Media: An 'Underview Effect,'" *Leonardo*, 43(2), pp. 169–174.

Ten Have, P. (2004) *Understanding Qualitative Research and Ethnomethodology*, London: Sage.

Urry, J. (2002) "Mobility and proximity," *Sociology*, 36(2), pp. 255–274.

Watts, L. (2008) "The art and craft of train travel," *Social & Cultural Geography*, 9(6) pp. 711–726.

Willis, K. (2012) "Being in Two Places at Once: The experience of proximity with locative media," in Abend, P., Haupts, T. and Croos-Mueller, C. (eds) *Medialität der Nähe: Situationen – Praktiken – Diskurse*. Bielefeld: Transcript.

8 Video space

A site for choreography

Douglas Rosenberg

(First published in *Leonardo*, Vol. 33, No. 4, August 2000, 275–280.)

Preamble

"Video Space: A Site for Choreography"[1] was first published in 2000 in *Leonardo*, the journal of the International Society for the Arts, Sciences and Technology. The opportunity to re-visit this essay allows for reflection on both the state of the field of screendance at the turn of the new millennium, and also on my own thinking at that time. The original essay laid the foundation for numerous conference papers, workshops, and talks on mediated dance, as well as over a decade of teaching. Ultimately within this essay was the DNA for my subsequent book, *Screendance: Inscribing the ephemeral image* (Oxford, 2012), in addition to theories and arguments that would hold my attention for some time to come.

In retrospect, it is most interesting to see how the concepts of materiality and site-specificity proposed in the essay, were, in 2000, bound to the dominant ideas of the previous historical period, from the birth of cinema through the end of the modernist wave. As the essay was written in the analog era – a pre-digital world that is hard to explain to those who have grown up with the internet, social media, and streaming data – its narrative is tethered to ideas that are closer to the way in which we understand electronic or filmic culture. The cultures of the nineteenth and twentieth centuries were bound up in space, time, and linearity – the physical principles that we took to be the natural order of things and which provided the corpus of cinematic experience as well. Such phenomena were experiential and dependable.[2] In the twentieth century, cinema flourished and in the 1960s video technology came of age, signaling a shift from the alchemy of film to a new electronic (and ultimately digital) frontier. At the cusp of the new millennium, in 2000, YouTube did not exist and "video dance"[3] circulated as if a part of objecthood: recorded on magnetic tape, wound on spools encased in a container, and accessible only through low resolution mechanical playback.

The theory put forth in "Video Space: A Site for Choreography" is that video space is a site and as such has specificities shared by, but differing from, other sites of production and habitation. Video space is complex, contingent on a number of devices and electronic fields; it is both architectural and metaphoric and exerts significant tensions on that which is produced within and of it. The essay further argues that live dance has been inexorably altered by media culture in general. The way in which choreographers compose dances for real time and physical spaces is informed and even altered by our immersion in the temporal rhythms of media and screen technologies. As a result, the viewing and reception of live performance is bothered by the temporal and alogical expectations of mediated dance experiences.

The essay also theorizes contextual or relational specificity. I suggest that a work of art in any medium has references and relationships to other works of art of its own genus and period, but also that it has references and relationships to work of a similar conceptual nature in other disparate mediums both prior to and simultaneous with its own creation.

Finally, the essay proposes a theory of "recorporealization" – the literal re-construction of the body using the techniques and technologies of the screen. Bodies in motion – dancing bodies in real time and real space – are source material for a kind of fabrication process in which an "impossible body" is created for the screen. The impossible body is one that is not encumbered by temporal or physical restraints; it is instead contingent on video space and the method of recording, as well as the method of playback and circulation in its mediated, screenic form.

Preface

Video space as a site for choreography is a malleable space for the exploration of dance as subject, object and metaphor, a meeting place for ideas about time, space and movement. The practice of articulating this site is one in which, through experimentation with camera angles, shot composition, location, and post-production techniques, the very nature of choreography and the action of dance may be questioned, deconstructed, and re-presented as an entirely new and viable construct. The result of this activity is what has come to be known as *video dance*, the practice of creating choreography for the camera, recorded in the medium of videotape.[4] Video dance is a site-specific practice, that site being *video* itself. The term video serves as a kind of shorthand for a much broader system, a spatial construction that includes electronic recording devices, satellite transmission,[5] and reception and viewer decoding. As with any socially constructed site, it is beneficial to begin with an understanding of the language and history common to the form.

The contemporary practice of video dance has as its genesis a short film by Thomas Edison, made as early as 1894–95 and called *Annabelle The*

Dancer. The film, shot in one long take, features a young woman doing a Loïe Fuller impression for the camera, her swirling, flowing dress in constant motion. The arc of dance for the camera continues through Hollywood musicals and the Busby Berkeley spectacles of the 1930s, primarily as a form of escapist, popular entertainment. There are some exceptions to this trajectory, most notably Maya Deren's seminal cine-dance[6] from 1946, *A Study in Choreography For The Camera*, made in collaboration with Talley Beatty, which is the precursor to contemporary video dance. While there was (and continues to be) considerable overlap, the transition in the late 1960s from film (cine dance) to video (video dance) as the common method of fixing autonomous dance images, reflected a rapidly changing culture and concretized Marshall McLuhan's theory of a global village[7] through the application and appropriation of media practices. Choreographers, especially those born in the age of media, and aware of its power, have appropriated the language of media while continuing to create work for the theater.

Contemporary dance has been greatly influenced by the language of video, television and the cinema. This is evident in contemporary choreographic practices that mimic the non-linear deconstructionist tendencies of media and the cinematic jump cut. This is remarkably clear in regard to video dance. There are myriad and distinct differences between dance made or re-made for television and the collaborative work of video artists and choreographers created with other ends in mind. As with any history, there are specific works created for the camera that have come to be regarded as "classics" of the form, such as Merce Cunningham's *Blue Studio*[8] and the aforementioned work by Deren. The importance of these works can be found in their use of the camera in creating an architecturally and/or geographically specific site that contextualizes the choreographer's vision in a way not possible in the theater. There was a flurry of activity in video dance in the United States in the late 1970s through the late 1980s as funding sources like the National Endowment for the Arts, state agencies and PBS affiliates like WNET in New York and KQED in San Francisco, began to recognize dance for the camera. However, that funding (along with much of the funding for the arts in America) has disappeared.

Coincidentally, with the decrease in funding and the increase in cultural media literacy and the availability of consumer format video equipment, the number of artists creating dance for the camera has increased exponentially, giving voice to and empowering dance makers around the globe to participate in defining a site that is particular to dance for the camera. Though this chapter focuses largely on work being made in the United States, it is important to point out that the practice of video dance is an international one. Festivals, television broadcasts and screening opportunities in Europe and Canada far outnumber those in the US.[9]

While "dance for the camera" refers to work made in both film and video, each artist chooses the medium of rendering for reasons that are quite

personal. It is safe to say that prior to the mid-1960s, most dance for the camera was rendered in film (with the exception of dance rendered for television), as video was not yet available to the general public. However, in the mid-1960s, Sony introduced the first portable video equipment. By today's standards, it was cumbersome at best; however, compared to what was available at the time for the recording of real-time activity, it was a revolution. Video technology allowed immediate feedback, it was relatively easy to use, and it required no lab time to "develop." While initially, portable video equipment was seen as an ideal way to document dance, choreographers and video makers recognized the potential for creating dances specifically for the camera. Making dances for the camera quickly became not only a viable alternative to theater dance, but a driving force in how choreographers re-conceived the art of dance for the theater, the impact of which is evident in the cinematic quality of the work of many contemporary dance makers. This oscillation between camera and stage has been articulated by Meredith Monk in speaking about two early works, *Juice* (1969) and *Needle Brain Lloyd* (1970). Monk has stated that while conceiving these pieces, she was interested in creating a "live movie,"[10] and a work that addressed her fascination with cinematic time and space. This fascination of Monk (and others) with cinematic praxis is further articulated by film theorist Noël Carroll in his article *Dancing With The Camera*, he points out that "The other arts also vacillate between regarding cinema as a source of both subject matter and stylistic devices."[11] Carroll goes on to say that, "In the first decades of the cinema especially, filmmakers naturally gravitated toward imitating the other arts." He points out that from the beginning, dance and film had a "natural point of tangency ... both it might be said, were concerned with movement."[12]

Over the years, as cinema and dance have traversed modernism, they have engaged in an almost unbroken courtship, each gazing at the other with a sort of longing and ultimately appropriating both technique and style from the object of its affection. Artists have been quick to recognize the potential of each new technology to come along since the Renaissance, mining it as a forum for artistic expression. Video dance is a product of the current technological revolution (though I prefer the term "technological evolution"). However, all works of art, including video dance, reflect something of the culture out of which they came; no artwork can be created in a vacuum and dance for the camera is no different. As technology has advanced over the past one hundred years, objects, events and screen-based works have reflected those advances. Amy Greenfield's *Earth Trilogy* (1971) and Carolyn Brown's *Dune Dance* (1978) are works that are immediately recognizable as products of the 1970s, reflecting the attitudes and concerns of the era. We can read both works by the signifiers evident in the structural language, film stock, and movement quality, even the duration of the pieces, all of which gives us clues to its era of creation.

Maya Deren's *A Study in Choreography for Camera* (1945) with Talley Beatty finds the filmmaker breaking taboos, transgressing stereotypes, and making

a distinctly political statement by featuring an African-American not as a servant or a butler, as Hollywood did at the time, but rather as a fully formed human being – an elegant and talented dancer. Deren uses the dancer as the constant in a shifting landscape of place and time, the flow of movement unbroken as location changes from scene to scene, questioning our relationship to the logic of chronology. At moments in Deren's silent film, Beatty seems suspended in mid-air for a humanly impossible length of time. At others, an unfolding of the dancer's arm begins in one location and seamlessly ends in another, the choreography literally "moving" the viewer into another place. As we move through radical eras of our history, dance for the camera has mirrored the upheaval in the culture and in fact served as a site for the discussion of issues of gender, race, disability and the very nature of dance itself, even while leaving us with a palimpsest of the concerns of the makers in their time. In choreographer Victoria Marks' video dance work, *Outside In*, directed by Margaret Williams in 1995, the choreographer uses video as a site for exploring gender identity and issues of ability/ disability. Created with dancers from CandoCo, Marks uses video as a site to playfully explore physical identity in a sort of voyage toward the discovery of a new understanding of dance. This work empowers and humanizes dancers of differing abilities, presenting them as sensuous and playful human beings.

The specific site

Dance is, by its very nature, an ephemeral art form. It is also one that is constantly defining and re-defining itself in relation to the culture and to contemporary life. As technology has advanced with increasing rapidity since the late 1960s, dance makers have found new and often ground-breaking methods for using technology to achieve their choreographic visions. Grounded in this marriage of dance and technology is the creation of dances made specifically for the camera. While there are numerous terms used to describe this practice, I will rely on the three that I feel are the most precise. The first, *dance for the camera*, is an inclusive term that refers to any and all dance created specifically for the camera, either in the medium of film or video. The second, *cine dance*, is a term that refers to work made in the medium of film. Lastly, *video dance* refers to work made for the camera using the contemporary medium and practices of video technology. All three terms refer to the art of creating a choreography for the camera, to be viewed as a fully formed, autonomous work of art, ultimately either on a film screen or television. There are numerous approaches to the practice of creating dance for the camera and differences in the histories of film and video; however, there are also similarities that occur in both cine dance and video dance. Both place the choreography within the frame of the camera and offer the makers the opportunity to deconstruct the dance and to alter its form and linearity in post-production. As the quality and resolution of

video has improved in recent years, the boundaries between film and video practice have begun to diminish. Still, each has its own specificity, history, and formal qualities. Video dance, by utilizing contemporary technology, places itself in the discourse of current media practice and therefore in the discourse of popular culture and contemporary media theory as well, while distancing itself from the history of film.

A useful model when articulating these hybrid forms is one in which the camera and method of recording may be thought of as *as the site*, as we might refer to the theater as "site" in the context of concert dance. The site is where the work occurs and it is further the architecture against and through which the audience perceives the work. Site-specificity is how we may contextualize a work of art or for that matter a sporting event, or any number of other organized spectacles. Site provides context. If a dance is created to be viewed only in the medium of film or video, it must be critiqued in terms of the architecture of that particular space. The site or architecture of dance for the camera differs from that of concert dance in a number of ways, some of which are readily apparent, while others are not. First and foremost is the fact that dance for the camera is inherently a mediated experience. That is to say, what we are seeing when we view a dance created for the camera is no longer simply a "dance." Rather, it is first and foremost a film or videotape, the *subject* of which is dance (see Figure 8.1).

The camera and method of recording have rendered the dancing as it has occurred; however, the representation of that dancing is filtered through the compositional and aesthetic strategies of the camera operator or director, and again at a later point in the editing process. It is a work of art we are viewing within which dance is the focus, though the rigors of time, gravity, geography and the performers' physical limitations are suspended in a void or virtual space.

When viewing a dance in a darkened theater we have but one fixed point of view, that of where we sit. The language of cinematography allows us to participate in a work from multiple points of view specifically because the

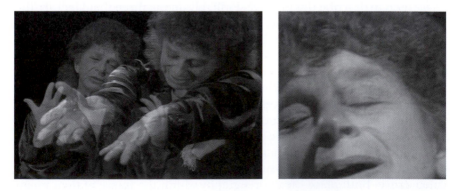

Figure 8.1 My Grandfather Dances, 1999 choreographed/performed by Anna Halprin, directed by Douglas Rosenberg.

camera, while recording an event, may wander at will. That is to say, the camera has the potential to "see" a dance from 360 degrees at any given point. In this case, the term "point of view" may refer to not only a physical location, but a metaphorical one as well. Here, point of view may be a poetic, even abstract representation of place, or a visual reference to a purely emotional state of being. The language of time-based media allows for a constantly shifting, ever-fluid definition of place and time. What is consistent in the genre of work we are addressing here is that dance is the catalyst for each investigation. The very nature of the camera, with its capacity to zoom in and out and to focus tightly in a very small area, invites investigation of movement and its permutations on a very intimate level. The nature of creating dance for the camera at its most experimental, is that the camera operator and the performer are forced to share a very intimate space, a space which in the theater is a safe-zone, protected by the "fourth wall." Dances created for the camera are made with the tacit assumption of Brechtian theatricality. In other words, the presence of the camera is pre-supposed, a given, and as such the camera (or viewer) is invited into that safe-zone (see Figure 8.2) and may participate in the dynamic of the performer's space in a most intimate way. A gesture that on stage may seem small and insignificant may become, when viewed through the lens, grand and poetic, while the dancer's breath and footfalls may become a focal point of the work.

Since its early days, video has come to serve two distinct and singular functions in regard to dance. The first, and still most commonly used, is as a tool for documenting and archiving dance. The second as a site for the creation of unique and singular works of art, or video dance – in essence as a sort of dance-theater for the camera. If one considers the theater with its proscenium arch as a site for the performance of dance, then one might also consider video, with its specific frame size (or aspect ratio, the relationship of width to height) as a sort of architectural space as well. Just as the theater has an architectural specificity, the same can be said of video. However, the theater offers no permanent storage for dance. After a performance one is left with the lingering yet ephemeral image of the dance as it was in the theater. Within the technology of video, the site for storage of the dance becomes the electronically encoded space of the videotape, allowing the audience to view it repeatedly as it is. That is to say, the viewing of the video dance is always in the present, regardless of the passage of time from its creation. The architecture of video, or *video space*, is a construction of transdimensionality, in other words, the simultaneous perception of two time frames (the viewing present and the past/present; the point of creation of the video dance) and the perception of three-dimensional space in a two-dimensional medium. The act of viewing a dance created for the camera in the medium of video requires the viewer to participate in re-imagining the nature of dance itself.

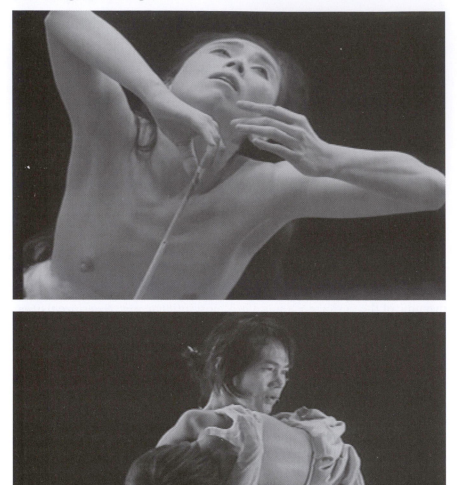

Figure 8.2 Wind, 1996 choreographed and performed by Eiko and Koma, directed by Douglas Rosenberg.

Just as the cinema was the site both literally and figuratively, for the dances of Gene Kelly, Fred Astaire, and Busby Berkeley, and had its own architectural viewing space, so too does video. Movies have historically been viewed in grand palaces, in the dark, surrounded by a number of other viewers. The larger-than-life experience of movie-going contributed greatly to a sense of

spectacle. By contrast, video dance is generally viewed on a television[13] or projected in some cases, but remains a relatively intimate experience. In this regard, the concept of site has multiple meanings.

Merce Cunningham, a pioneer in the field of video dance (who worked extensively in film as well), explored this concept directly in his 1979 work *Locale* (Figure 8.3) directed by Charles Atlas. In fact, the title of the piece refers specifically to the fact that this is not a work for the theater and that the dance exists entirely within the architecture of the camera. David Vaughan states that,

> In the previous pieces, Cunningham and Atlas had dealt principally with movement within the frame rather than movement of the frame – using that is to say, a mostly stationary camera with no fancy editing. Now they were ready to explore the possibilities of a moving camera.[14]

In *Locale*, the camera moves through the space of the dancers at breakneck speed, dancers randomly appearing and disappearing from the frame. The effect is quite the opposite of the entrances and exits one expects in the theater. It feels as if the camera is in a sense "discovering" the movement already in progress. Vaughan goes on to say that Cunningham had an "instinctive understanding" that the language of video was quite different than that of the stage,

> realizing for instance, that time can be treated elliptically because the spectator absorbs information much faster than in the theater, and that space appears to widen out from the small aperture of the screen, giving an illusion of greater depth than in fact exists.[15]

In the videotape *Blue Studio* (1976–77), directed by Charles Atlas, we see Cunningham in the studio, on the road, the point of view constantly shifting, as Cunningham "dances" with dancers videotaped in black and white in another, earlier period of time. It is the collision of images and score (by John Cage), existing in a contingent electronic space that gives the piece both its form and content. The importance of Cunningham's contribution to the development of dance for the camera cannot be overstated. His recognition of the camera as a site for situating choreography and the inherent differences between camera space and theater space has insured Cunningham a prominent position in the history of the medium.

In *Beach Birds For Camera* (1992–93), a 28-minute film directed by Elliot Caplan, we experience the choreography first in studio, with the changing light of the day contributing to a spare, elegant mise-en-scène and later in another location without natural light, but set in proximity to a shimmering blue panel. The film moves from a cool, almost ascetic, black and white to color, and as it does so, the viewer moves both metaphorically and literally to another site, one with a decidedly different emotional range. The

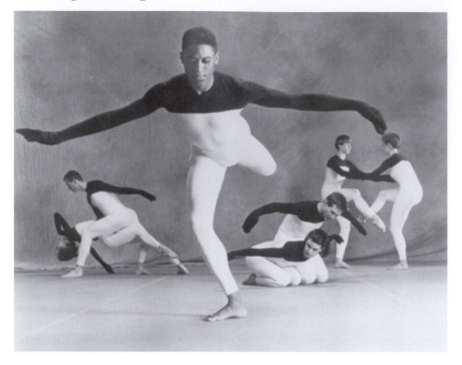

Figure 8.3 Beach Birds, 1991 choreographed by Merce Cunningham, performed by Merce Cunningham Dance Co.
Photo: Michael O'Neill

presence of John Cage's score, Four,[3] at times audible and at times barely so, is embedded in the picture, its source seeming to be the film itself. *Beach Birds* as seen in the theater, though striking, is quite different from the film version. In its theater version, the score is performed at a distance from the stage, the effect being a separation of music and movement, two distinctly different sources. Ironically, the dance itself, lacking in the "close-ups" utilized by Caplan in the film version, seems flat by comparison. There is no shift in site or architectural specificity; we are always aware of the theatricality of both the dance itself and our relationship to it. If one has viewed it prior to seeing the work in the theater, the visceral experience of Caplan's film hovers in the mind like a dream and a longing for the presence of those images while viewing the "live" version is inevitable. This experience reinforces the power of cinematic dance images to replace or serve as a mnemonic marker for the "original" and in some cases to displace the theatrical performance of the same choreography.

While many choreographers initially create a work of choreography for the stage and later adapt it for the camera, Cunningham has reversed the process in works such as *Points In Space*, created for the camera and directed by Elliot Caplan in 1986. According to Caplan, Cunningham is acutely

aware of the contextual differences of camera and stage space and makes precise and numerous adjustments in the choreography for each.[16] In the camera version of *Points In Space*, Cunningham's choreography often unfolds sequentially while entrances and exits are made to and from the specific frame of the camera. In the stage version, the sequential sections of choreography are altered and layered, often overlapping, while entrances and exits are adjusted to stage space and a solo by Cunningham that appears in the camera version, is absent in the stage version. Though the trajectory of camera to theater is unusual, in this particular instance the choreography has two distinct yet intricately related lives.

When we sit in a darkened theater and experience a choreographic work, more often than not our relationship to the work is less than three-dimensional. Though we perceive it to *be* three-dimensional, we make a number of assumptions based on our relationship to the work, which is fixed – as is our relationship to the stage – by our location in the audience and further by the architectural peculiarities of the theater. The choreographer has made certain decisions that present us with a particular view of the movement. We (the audience) experience or perceive the dance in respect to our fixed point of view. The camera has no permanently fixed point of view; rather, the camera in motion has the ability to create a type of intimacy with the dance that can only be imagined by the viewer in the theater. It is an intimacy that comes from both the camera's proximity to the dance and also from the camera operator's hyperactive participation in and fascination with the movement. This fascination with movement has a long tradition in the optical mediums. In fact, the photographic motion studies of Eadweard Muybridge anticipated what we have come to call video dance by some one hundred years. Muybridge, an English-born photographer working in Pennsylvania in the 1870s, invented a system of placing numerous cameras in a line and snapping photographs in rapid succession to capture movement in a way never before possible. What he created was a sort of cinematic unfolding of movement in both human and animal subjects in a way that revolutionized our ability to comprehend movement itself. In 1888 Muybridge had a meeting with Thomas Edison to speak about his idea for a collaboration which would have featured Muybridge's motion studies and Edison's sound recording inventions. Unfortunately, the technology was not yet perfected and the collaboration never occurred. However, as early as 1894, Thomas Edison had begun making silent dance films at his Black Maria Film Studio, including *Annabelle The Dancer*.[17]

It is important here to make a distinction between the documentation of a dance, dance for television, and dance created specifically for the camera. Dance documentation is generally done to preserve a choreography or a performance in its totality. In this example, accuracy is most important, usually ruling out complicated editing. Television dance is generally shot with multiple cameras placed in strategic locations including one wide or

master shot. The resulting footage is subsequently edited together in post-production to give the viewer multiple viewpoints of the dance while still preserving the choreography. Generally, the traditional audience point of view is maintained, that is to say the relationship of the viewer to the stage. Dance for the camera is something entirely different and as such occupies a wholly different space than dance for the theater; one could say that it is a hybrid form, contextualized by the medium and method of recording, that can only exist as film or video. It is not a substitute for, or in conflict with, the live theatrical performance of a dance, but rather a wholly separate yet equally viable way of creating dance-works.

In order to fully appreciate the work we refer to as dance for the camera, we must suspend our expectations of the nature of dance. In fact, dance for the camera has liberated dance from the theater and given it a new and different proscenium – that of the film screen or television monitor. With this liberation comes a new lexicon of terms, with a new and different language necessary to speak of this work. While composition, form, dexterity and command of the medium are critical benchmarks, the language of dance for the camera and specifically video dance is grounded in the language of the media. The representation of dance as a media object puts it firmly in the milieu of other contemporary forms of representation. The site of video dance provides a forum for choreographers to participate in a discourse in the very medium of contemporary discourse, the media itself.

The task of articulating choreography within the site of video is a collaborative process. Unlike cinema, there is often no script, since the tendency in contemporary choreography is toward the non-narrative or abstract. Consequently, fixing an ephemeral art form within the site of video requires not only intimate knowledge of the choreography but a high degree of trust. The camera can be an intrusive presence as it not only records but influences the dance and the dancer as well. When creating dance for the camera, collaborators have a tendency to assume a relationship at odds with the very nature of collaboration, as it is based in a sort of hierarchy that places the camera in service of the choreography. As video art was being invented in the 1960s, there was an effort on the part of those working with this protean form to democratize the practice, making it, at its best, an egalitarian one. The camera tends to exert a sort of authority that shapes a situation it intended to simply reveal or fix and reinforces the hierarchy that early media artists sought to destroy. By allowing the camera to completely dictate form, one compromises the choreography; by ignoring the presence of the camera, one may compromise the video dance. In both situations, the video dance is destined to feel lifeless or empty, occupying a site that is satisfying neither as documentation or video dance.

To supersede this dialectic requires a literal 'recorporealization of the body' via screen techniques. Here, 'recorporealization' is used to describe a literal re-construction of the dancing body via screen techniques; at times it describes the construction of an impossible body, one not encumbered by

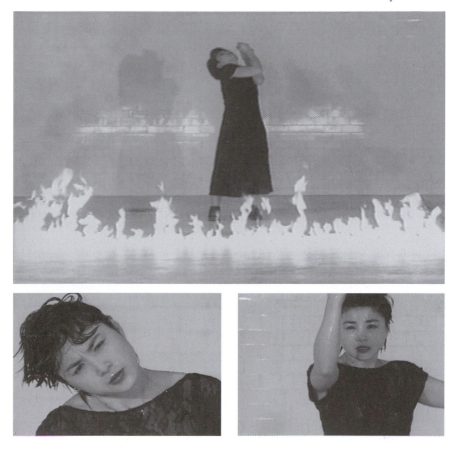

Figure 8.4 De L'Eau, 1996 choreographed by Li Chiao-Ping, performed by Li Chiao-Ping (pictured) and Tim Glenn, directed by Douglas Rosenberg.

gravity, temporal restraints, or even death. Video dance is, in practice, a construction of a choreography that lives only within the site and architectural space of the camera. Neither the dance nor the method of rendering are in service to each other, but are partners or collaborators in the creation of a hybrid form. "Choreography" as such, becomes relevant only as source material for the visualization or recorporealization of the body in the four-dimensional state. In order for the video or cine dance to live, its original (the "choreography") must be effaced or sacrificed in favor of a new creature.

This paradox has occupied the thinking of a number of theorists and critics including Walter Benjamin, who in his seminal essay, "The Work of Art in The Age of Mechanical Reproduction," written in 1936, said, "Even the most perfect reproduction of a work of art is lacking in one element: its presence in time and space, its unique existence at the place where it happens to be."[18] Benjamin explains this presence as the "aura" of a work of

art – in a sense the spirit or texture of a work of art that is lacking in its mechanical representation. Video dance can never be the dance itself, only its other. However, to accept Benjamin's paradigm would be to deny the power of mechanically (or virtually) reproduced works such as Cunningham and Caplan's *Beach Birds For Camera*, the work of Victoria Marks, or numerous others that have successfully challenged Benjamin's assertions and re-inscribed the choreographic aura within the site of video dance.

Notes

1 See *Leonardo* 33, no. 4, August 2000, 275–280.
2 Train travel of the 1870s began the "annihilation of time and space"; however, to shatter such a phenomena is to first acknowledge it.
3 The term "video dance" as it is used in this chapter is specific to both a general usage and to my thinking at that time in 2000. I have subsequently chosen to use the term *screendance* as a general term under which video dance can be included as a sub-category. Video dance is medium-specific while screendance is practice-specific.
4 The term "video dance" as it is used in this chapter is specific to the discussion and to my thinking at that time in 2000. I have subsequently chosen to use the term *screendance* as a general term, of which video dance can be included as a sub-category. Video dance is medium-specific while screendance is practice-specific. See my discussion of this in greater length in *Screendance: Inscribing the Ephemeral Image* (2012: 3).
5 These days, satellite transmission is a misnomer, replaced generally by the internet or other methods of digital/data transport and broadcast.
6 Cine dance was a term used in the pre-video era and continues to be used to describe the material specificity of screendance shot on film.
7 For more on McLuhan's theory of the Global Village, see: Marshall McLuhan, *Understanding Media: The Extensions of Man* (2001).
8 Made in collaboration with video artist/director Charles Atlas, 1975–76. For more see: www.art21.org/images/charles-atlas/blue-studio-five-segments-1975–1976.
9 There has been tremendous institutional support for video dance in England, specifically by the BBC in the form of commissions for broadcast. Additionally, festivals such as Moving Pictures in Canada, DanceScreen (organized by IMZ in Vienna), Mostra Festival in Spain, and Festival Internacional VideoDanzaBA in Buenos Aires, Argentina have succeeded in broadening audience and creating screening opportunities. In the U.S.A the Dance on Camera Festival in New York is the longest running such festival followed by The International Screendance Festival (part of The American Dance Festival) in Durham, North Carolina.
10 Monk made this comment while speaking about her work at the American Dance Festival in 1996 and had previously spoken about the concept of a "live movie" in a videotape interview for the American Dance Festival's *Speaking of Dance* series. Monk had made a film version of *16 Millimeter Earrings* with director Robert Withers in 1966 and had worked with film in her live theater pieces prior to creating *Needle Brain Lloyd* and *Juice*.
11 "Dancing With The Camera," lecture presented at the Museum of Contemporary Art, Santiago de Compostella, Spain, November 30, 1995.
12 Ibid.

13 Since this article was originally written, the tablet, iPad, laptop, hand-held device and computer screen have all become ubiquitous spaces for viewing as well.

14 David Vaughan, "Locale: The Collaboration of Merce Cunningham and Charles Atlas," Millennium Film Journal, No 10/11, 1981–82.

15 Ibid.

16 Personal communication with Caplan on 24 February 1997, regarding his collaboration with Cunningham on the films *Points in Space* and *Beach Birds for Camera*.

17 The Library of Congress, American Memory, History of Edison Motion Pictures: Origins of Motion Pictures–the Kinetoscope. (http://memory.loc.gov/ammem/edhtml/edmvhist.html) accessed, November 20, 2013.

18 From *Illuminations*, Trans. Harry Zohn. New York: Schoken Books, 1969.

References

Benjamin, Walter (1936) "The Work of Art in the Age of Mechanical Reproduction," in Harry Zohn (trans.) *Illuminations* (1969), New York: Schoken Books.

Caplan, Elliot, personal communication with the author, February 24, 1997.

Carroll, Noël (30 November 1995) "Dancing With The Camera," lecture presented at the Museum of Contemporary Art, Santiago de Compostella, Spain.

Vaughan, David (1981–82) "Locale: The Collaboration of Merce Cunningham and Charles Atlas," *Millennium Film Journal*, 10/11: p. 18.

9 Placing the body in mixed reality

Sita Popat

This chapter addresses notions of site and place in site-specific dances that incorporate physical and digital environments. It considers how the site might be defined in such works and explores the implications for site-specific practice.

When I started writing this chapter, I had intended to examine the body in virtual reality, where it is subsumed into a three-dimensional virtual environment or substituted by an avatar in an on-screen virtual world. The separation of body and mind in virtual reality popularized by so much fiction of the 1980s and '90s (e.g. the novel *Neuromancer*, the movies *Bladerunner* and the *Matrix* trilogy) portrayed narratives of bodily displacement and alienation in sites that were defined as unreal. Yet over the past two decades, the practices and study of virtual reality have become increasingly absorbed within wider human–computer interaction perspectives that also address mixed realities, where the physical and the virtual come together to create hybrid experiences, as in mobile systems and ubiquitous computing (Ekman 2013). In these kinds of contexts, new media technologies are incorporated into everyday spaces and activities in such a way that they become a part of the lived environment. This might be as simple as using a sat-nav (satellite navigation system) in your car when driving to an unfamiliar destination, or texting a friend on your mobile phone to enable you to locate each other in a crowded place. It might be the visual augmentation of physical space with digital information or images using the camera and screen on your tablet computer or hand-held gaming console, or playing games on your television by controlling the digital avatar using Kinect body tracking on a Xbox. Or it might be more complex and immersive, as in Gibson/Martelli's installation artwork *VISITOR*, which this chapter will discuss in detail shortly.

These kinds of intersections between the physical and the digital highlight a philosophy of 'embodiment and situated action' (Coyne 2007), raising questions about experiences of both body and site. How does the physical body encounter a mixed reality environment? What is the nature of the digitally augmented or created site? Is there a hierarchy in experiences of physical and virtual? What is the role of movement in such environments?

The moving body lies at the heart of these discussions, and dance has much to offer to other fields on the theorization of the body and location. Consequently my focus in this chapter switched to a discussion of mixed reality, drawing together literature from performance, human-computer interaction and cultural theory to begin to address these questions.

VISITOR

It is difficult to discuss the body and location in any form of reality without an example on which to draw for illustration, and this chapter takes Gibson/Martelli's installation *VISITOR* (2011) as the vehicle for its debate. Gibson/Martelli[1] is a partnership between dancer Ruth Gibson and computer programmer Bruno Martelli. Together they combine movement with digital worlds to create performance/installation works that variously evoke site, space and place. Some of their recent works have been in the form of mixed reality installations in which visitors encounter environments to be experienced and explored. *VISITOR* is a gallery-based piece inspired by the artists' travels in the Canadian Rockies. The installation consists of two separate parts – a film and an interactive environment – exhibited simultaneously but housed in separate spaces in the gallery. The film is monochromatic, depicting glaciers, forests and frozen lakes, and subtitled *where the bears are sleeping*. However, this chapter is most concerned with the interactive environment under the subtitle of *Vermilion Lake.*

In *Vermilion Lake*, the visitor enters through the door of a full-scale replica of a trapper's cabin (see Figure 9.1) and inside she finds the bows of a wooden rowing boat, including rower's bench and oars. The stern of the boat is missing, as if the boat has been cut in half. On the wall of the cabin behind the half-boat is a screen, showing a projected digital animation of the boat's stern floating on a virtual lake. The visitor can sit in the physical boat facing the screen and row the oars in the oarlocks. As she rows, on the screen she can see the virtual stern of the boat moving around the lake and waterways in the virtual landscape, so that it seems as if she is rowing the whole boat within that environment (see Figure 9.1). The scenery is in black and white, although many visitors do not notice this lack of colour since the imagery is of murky water, snowy banks and mountains, dark trees and foliage. Throughout the journey there are traces of human habitation – a single light in a trapper's log cabin, a lighthouse perched on top of dark rocks, the ruins of wooden buildings from long ago – nothing with the sense of a permanent dwelling place (see Figure 9.2). The atmosphere is brooding, with a low soundtrack emphasizing feelings of chill and disquiet. There is a sense of something out there – 'a friendly or malevolent force', the hunter hunted, the tracker tracked, as the publicity describes it.[2]

Whilst inspired by the artists' experiences in the Rockies, *Vermilion Lake* is an imaginary place created as a digitally programmed environment. The visitor is given a map of the waterways on entering the installation to help

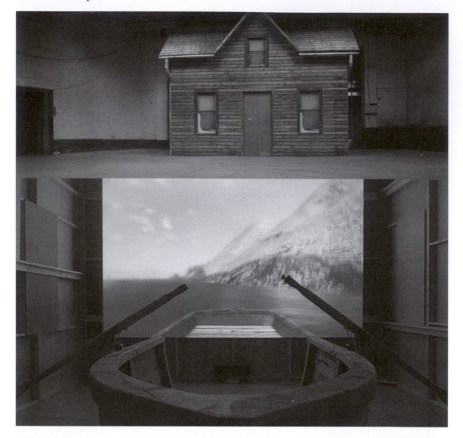

Figure 9.1 Vermilion Lake: Trapper's cabin in gallery (above). Rowing boat and projection screen (below). Copyright: Gibson/Martelli.

her explore the virtual landscape. Rowing requires some effort due to the weight of the oars and the force feedback system, which engages a set of exercise bicycle springs when the oars dip so that the rower feels the sensation of water resistance. The movement of the oars links directly to the computer so that rowing actions result in the motion of the virtual boat on the lake. As the rower rows, the boat moves, with the soundtrack including the noise of the oars and the prow travelling through the water. The visitor cannot get out onto the banks or jump into the water, but the obvious cold and the brooding atmosphere tend to offer discouragement from such actions anyway. There is a gap of a metre or so between where the physical bows end in the room and where the virtual stern begins on the screen, so their connection as one boat is implied rather than literal (see Figure 9.3). Sometimes the bows and the stern slip out of visual alignment when the boat turns, and occasionally the whole boat pivots within the digital world while the physical bows do not move. But always the visual image on the screen locates the viewer's perspective as seated within the boat.

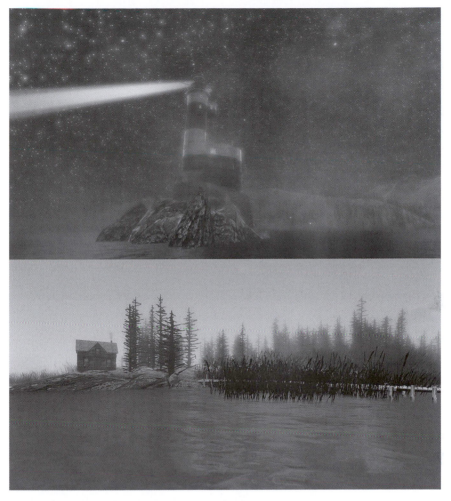

Figure 9.2 Vermilion Lake: Screenshot of lighthouse in the snow (above). Screenshot of lake bank (below). Copyright: Gibson/Martelli.

Multiple visitors can enter the installation and stand or walk around the boat as well as sitting in it. It is possible to fit two people side by side on the rower's bench so that both can row. However, here I am concerned with how the installation might be encountered by a single visitor in order to explore how a series of conceptual frameworks can shed light on issues around site-specificity and movement in mixed reality. I will argue that the piece *Vermilion Lake* inspires a sense of place that is unique and specific to the visitor's encounter with the installation, since it is fundamentally *real*. I explore how the choreography of the encounter with that site is implicit within the design of the virtual environment and within the method of encounter (rowing), and crucially within the connection between these two elements. Firstly I am going to consider some definitions of site-specificity

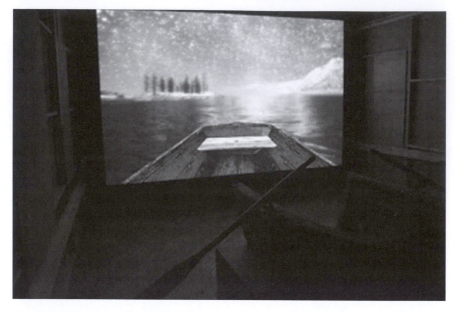

Figure 9.3 Vermilion Lake: Rowing boat and screen (showing separation between physical prow and virtual stern). Copyright: Gibson/Martelli.

in relation to *Vermilion Lake*. Then I will examine notions of mixing realities and address the visitor as an embodied agent within the mixed reality site. Lastly I will offer some thoughts on relationships between the body, the virtual and the real in mixed reality and consider some of the implications for site-specific dance practice.

Defining site-specificity

In *Vermilion Lake*, the physical location is the art gallery while the virtual landscape is a representation of the phenomenological qualia (or essence) of the Canadian Rockies as experienced by the artists. The design of the work draws upon their subjective responses to the physical landscapes that they encountered on their travels. Indeed it is not so much a representation – since there is no specific lake to represent – as a re-presentation of the affective experience of being in that place. The installation aims to capture the pre-cognitive, embodied engagement that the artists felt in the Rockies and present it as a parallel experience for the visitor's sensing body in the virtual environment. Yet can it be defined as site-specific?

In her introduction to *Performing Site-Specific Theatre: Politics, Place, Practice,* Joanne Tompkins (2012) returns to Mike Pearson and Michael Shank's definition of site-specific performance: 'They are inseparable from their sites, the only contexts within which they are intelligible. Performance recontextualises [sic] such sites; it is the latest occupation of a location at which other occupations – their material traces and histories – are still

apparent' (p. 2). This definition assumes fundamentally that site-specific performance re-contextualizes the site *from within that self-same site*, i.e. it inscribes into or over the existing site as a palimpsest. In what way, then, might *Vermilion Lake* be considered site-specific when the visitor encounters the work in an art gallery, and indeed there is no such actual site in the world anyway?

In her book on site-specific art and locational identity, artist and theorist Miwon Kwon (2004) offers a historic overview of the development of site-specificity that updates and broadens the Pearson and Shank definition. She proposes that in contemporary art there are many non-physical things that can be deemed to function as sites: 'cultural debates, a theoretical concept, a social issue, a political problem, an institutional framework (not necessarily an art institution), a neighborhood [sic] or seasonal event, a historical condition, even a particular formation of desire' (pp. 28–9). She exemplifies this through a description of Mark Dion's installation artwork titled *New York State Bureau of Tropical Conservation* (1992), which consists of a neat stack of materials and products from the Orinoco River basin next to a door on which the given title is painted. She explains that the rain forest (the source of material and inspiration for this work) is linked to the projected site of effect (the discourse on nature), 'yet does not sustain an indexical relationship to it' (p. 29). She argues that the site is now 'structured (inter)textually rather than spatially', resulting in the transformation of the operative definition of site 'from a physical location – grounded, fixed, actual – to a discursive vector – ungrounded, fluid, virtual' (pp. 29–30). In *Vermilion Lake*, the primary source of the work is deeply rooted in the site-specific experiences of the artists in the Rockies. The projected site of effect is the affective experience of the visitor, sharing the qualia that the artists felt. The link between the original site and the re-presented virtual environment is not indexical in that there is no direct cognitive mapping between them, since the virtual site is invented. However, there is an underlying phenomenological site-specificity that permeates the work.

Still there is the issue of the multiplicity of this artwork, since there is no original version of the digital landscape (light projection and sound) and it can exist in multiple locations simultaneously with no connection between its manifestations. Kwon can accept this in her flexible definition of site, but it is useful also to consider approaches specific to the particular technology employed in *Vermilion Lake*. Mitchell Whitelaw, writer and new media artist, examines relationships between the digital and the material in new media artworks through his theory of 'transmateriality'. He claims that the immaterial nature of digital information is actually an illusion, since 'the digital is always specific, always subject to the local conditions of its instantiation' (Whitelaw 2013: 230). He explains that this illusion of digital immateriality is propagated by careful programming of 'tolerance and thresholds and the active interventions of error correction. Without these mechanisms, a million entropic, material variations would creep in – dust

motes, temperature variations, mechanical wear' (ibid.). Programmers have to work to eradicate all of the natural interferences of the physical hardware and environment in order to make each projected image, each sound, appear the same every time. In digital image projection sometimes errors can creep in, causing anything from odd little glitches in the image to full-scale computer crashes. So the achievement of identical form in each manifestation (or instantiation) is an engineered feat rather than a feature of the digital per se. The process of converting electrical energy and computer coding into physical arrangements of light projection and sound vibrations is known as 'transduction' – the conversion of energy from one form into another. A specific physical instance of the virtual lake is created for each visitor to each gallery, with electricity and computer coding transduced (converted) into projected images and sounds that this particular visitor sees and hears. These physical lights and sounds are experienced in combination with the other physical elements of the trapper's cabin, the rowing boat and oars. Thus each instantiation of the lake is created physically anew as a specific environment to be encountered by each visitor – a kind of Rockies-inspired Garden of Eden.

Walter Benjamin in his discussion of art in the age of mechanical reproduction attended to the aura of the original artwork and the relationship between it and the individual viewer. He noted the absence of aura from mass-produced work – reproducible in identical form but devoid of the patina of originality in its multiple existences. Yet if we return to Kwon's definition of site-specific work as having a site of effect – in this case the affective experience of the visitor in *Vermilion Lake* – then that site is specific to the visitor's individual engagement with the artwork. More than that, it is specific to the visitor's engagement with that particular physical instantiation of that artwork, with any small anomalies that have arisen during the transduction process in spite of tolerance programming. The work also has physical elements that may be in slightly different relationships to each other depending upon the gallery in which each version is constructed. The piece is not complete until the visitor engages with it and navigates her personal route through the virtual waterways. The presence of the visitor's sensing, moving body in the artwork is the critical factor in its specificity as a site, as I will explain further shortly.

Mixing realities

Firstly it will be helpful to consider in more detail how the visitor engages with mixed reality environments. In 2003, Bolter and Gromala wrote a book called *Windows and Mirrors*, in which they argued that 'every digital artifact [sic] oscillates between being transparent and reflective' (p. 6). By this they meant that every such artefact delivers an experience to the user (a window through which the user can reach something or somewhere else), but inevitably that experience is bound up in the functionality and aesthetic of the interface

(the mirror in which the user is aware both of the processes used to produce the artefact and of herself engaging with those processes). Bolter and Gromala argue that the user should be aware of both the window and the mirror in order to appreciate the experience fully. This argument appears to posit the visual as the primary mode of encountering digital artefacts in an assumption of the desirability of cognitive engagement. The body is relegated to the role of a mechanism via which interaction may be triggered. In the *Wooden Mirror* (Daniel Rozin, 1999) for example, the image of the visitor's body is 'seen' by a camera in the centre of the artwork and processed via a digital interface to be reflected as an image in the angling of the hundreds of small polished wooden facets that make up the 'mirror' face. The *Wooden Mirror* mimics the body's shape, and thus it encourages the visitor to move so that her movement causes the many facets to shift their angles to match her changing profile. However, the movement is simply a means to control the visual interface. I propose that digital artefacts designed as mixed reality environments offer a third mode of engagement – as a door. The door is accessed by the experience of the moving body within the artwork, offering an active counterpart to the otherwise inherently visual/cognitive orientation of the reflective/transparent binary. Through this door, I propose, potentials embedded in the virtual become real and thus the conceptual site is concretized in the visitor's experience of moving within it.

Mixed reality applications are those in which the user 'interacts not only with the computer, but also with other aspects of the physical world' (Bolter *et al.* 2013: 335). In such environments, Bolter *et al.* explain, there is no attempt to conceal the technology. Instead, the graphical and communications interfaces are openly acknowledged and 'typically do not disappear from the user's conscious view' (ibid.). The unconcealed interface highlights the position of the body as a part of the interface and mitigates against the body's own tendency towards absence, as promulgated in Bolter and Gromala's binary of windows and mirrors.

In *Vermilion Lake*, the contrast between the screen-based virtual world and the physical wood of the oars, prow and seat of the rowing boat is not disguised. The completion of the rowing boat in the virtual world is not designed to map directly onto the physical boat, since the first is two-dimensional and the second is three-dimensional. However, Figures 9.1 and 9.3 show that the stern falls within the rower's field of vision in the appropriate direction to construct the concept of a single boat (which might still be defined as a site in Kwon's terms). Bolter *et al.* (2013: 335) propose that 'players' or users of mixed reality environments: 'understand their experience in terms that Auslander defines as the liveness of rock concerts and other mediated productions. Technological mediation does not destroy or invalidate liveness for them; instead, the creative use of the technology contributes to the liveness of the experience.' It is the user's engagement with the physical world in conjunction with the digital that grounds the experience in a particular space.

Mixed reality spaces are often defined as places where data and communications technologies intersect with or overlay physical spaces, highlighting a philosophy of 'embodiment and situated action' according to digital media specialist Richard Coyne (2007). Computer scientist Steve Benford and performance theorist Gabriella Giannachi (2011) maintain that it is the variations in communication that locate the individual in the contingencies of the everyday world. Artist and academic Emily Puthoff disagrees, criticizing what she describes as the 'proliferation of new technologies' in everyday life by claiming that 'the notion of "place" has become so multi-faceted it shimmers' (2006: 76). She argues that the ability to access excessive quantities of information about a place whilst being in that place reduces it to a 'non-place', which she defines by quoting Augé: 'a space which cannot be defined as relational, or historical, or concerned with identity' (ibid.). For Puthoff, the excess of conceptual information overrides and overloads the lived experience, resulting in 'a condition of perpetually scanning the horizon in the distance whilst marooned on the isle of everywhere' (p. 77). Benford and Giannachi appear to be at odds with Puthoff, but these conflicting views do not necessarily arise from a simple split of artists versus computing specialists. Indeed Puthoff's perspective might seem to disagree with the Pearson and Shank definition of site-specificity, which promotes the palimpsestic inscription of the site with 'material traces and histories' to be experienced by the spectator. Perhaps the locus of conflict is the particular ways in which realities are mixed and bodies are engaged.

In Gibson/Martelli's work, physical and digital spaces have a direct relationship, in that they are both encountered and experienced by the visitor's body as a mode of travel in and negotiation of those spaces. The spaces might not blend perhaps as readily as in the overlaying techniques of augmented reality or communications data and physical spaces, since they demand an element of the lived indexical relationship between physical and virtual that is more challenging to both designer and user than the conceptual mapping of information to spatial location or the purely visual perception of augmented reality. However, they promote an experience that equalizes embodied engagement with the physical and the virtual elements through deep interrelationships between the two that are grounded in movement. New media philosophers Jeff Malpas (2009) and Mark Hansen (2006) have both independently proposed that the key factor in defining the 'real' is the lived experience rather than whether the 'reality' in question is physical or virtual. If this is the case, then the representational status of the virtual environment is less critical to the experience of the visitor than the lived experience of mixed reality. The acknowledgement of Bolter and Gromala's window/mirror flickering that was an important aspect of the disinterested viewing of digital visual artworks is overshadowed by the embodied practice of real, lived space. Shall we open the door now?

Opening doors

In *Vermilion Lake*, the visitor enters the life-sized wooden trapper's cabin and takes a seat in the rowing boat. It is a fair-sized boat, and the oars are reasonably weighty. It takes physical effort to row, but that effort is rewarded by the virtual part of the boat travelling smoothly across the surface of the lake. The visitor hears the oars splashing gently and the virtual water swishing audibly past the prow, accompanied by occasional bird song and an atmospheric soundtrack.

In the 1950s, psychologist James J. Gibson was interested in the visual perception of living creatures but he became frustrated with the separation of seeing and acting that was prevalent in his field at the time. He developed a theory that connected the two at a fundamental level, which became known as 'ecological psychology'. Critical to this was Gibson's concept of 'affordances', which are those possibilities for action that are available to the animal (or human) in a particular environment (1986: 127). For example, in order to leave my house, I open the back door but my cat exits via the cat flap. The environment offers those affordances to each of us, but not to the other. (I cannot fit through the cat flap and my cat cannot open the door.) Paul Dourish (2004) explains that Gibson's affordances were taken on board by the human–computer interaction community in the 1990s, as it became apparent that humans using virtual reality responded better when the virtual environment offered similar affordances to the physical environment. A key factor in the experience of *Vermilion Lake* is the mapping of affordances for the visitor. When she rows with the oars, the boat travels through the water and she watches the landscape move past her as she travels.

Cognitive scientist Mel Slater (2009) describes a phenomenon in virtual reality called 'place illusion', where there is 'a strong illusion of being in a place in spite of the sure knowledge that you are not there'. But importantly Slater claims that the experience of place is *further* enhanced by the 'plausibility illusion' brought about by the direct relationship between the user's physical movement and the uncontrolled yet direct responses in the virtual world, i.e. as she rows, the boat appears to move, she hears the sound of the oars and the prow travelling through the water, and she sees the scenery change. Objects that are further away pass behind objects that are closer, giving a sense of perspective and distance that is familiar within our understandings of the physical world. Movement is fundamental to this illusion, as it is only by physically rowing that the correlating responses in that virtual environment can be mapped and evaluated against the physical experience of moving. The particular design of *Vermilion Lake* encourages movement, since the boat is set up to be rowed, and the physical effort of rowing is simple to map to the motion of the boat through the virtual lake. Movement counters the strangeness of the physical/virtual boat, the plywood interior of the cabin, the occasional glitches in the image, as it is

always possible for the visitor to orientate her physical movement within the virtual environment. Gibson and Martelli want to reveal the mixed reality experience to the visitor and to avoid unquestioning immersion – thus foregrounding the mirror as well as the window in Bolter and Gromala's terms. But as Bolter *et al.* explain, this highlighting of technological mediation does not necessarily affect the liveness of the experience. In fact it encourages appreciation of the embodied nature of the engagement, as it highlights the body's movement as a key aspect of the interface in the plausibility illusion – the key to the door by which the visitor enters and negotiates the environment as a mixed reality.

Journeying

In *Vermilion Lake*, the process of negotiating or journeying on the waterways is both a means by which the visitor can engage with the mixed reality environment and a conceptual end in itself. Getting lost and finding one's way in that alien landscape are central to the phenomenological qualia underpinning the site-specificity of the work. De Certeau's (1988 [1984]) discussion of place and space assists in exploring this further. He describes a 'place' as being 'constituted by a system of signs', a conceptual location; whereas a 'space' is constructed in an individual's subjective experience of being in it and moving through it. These two perspectives are not mutually exclusive, as artist and academic Lone Hansen (2009: 7) explains: 'a location can be both an objective or almost factual notion as well as a "container" of subjective and felt experiences.' In *Vermilion Lake*, each visitor's journey is her own, and it is unlikely that anyone else will undertake an identical journey around the lake or through the waterways. In that sense, the computer-coded environment is pregnant with potential pathways (affordances of travel), some of which are actualized in the journeying of the individual visitor. The lake in *Vermilion Lake* is not a physical place – it is a re-presentation of an imaginary place – but it becomes a space in de Certeau's terms through bodily encounter.

Ingold's process of wayfinding is critical to the practice of space as it occurs here. He describes how finding one's way 'is tantamount to one's own movement through the world […] we know *as* we go' (2000: 239). The visitor to *Vermilion Lake* can navigate using the map of the waterways that was handed to her on entry to the installation, or she can find her way by exploring. De Certeau's advice is that navigation without the map enables a 'blind' engagement that embeds the traveller within the environment (1988 [1984]: 93) and allows her to open her 'sensorial apparatus' (Hansen 2009: 20). The map, according to de Certeau, imposes strategies that countermand such situatedness and distance the body from its environment. The process of rowing makes it difficult to look at the map at all times, since it takes both hands and some physical effort to make progress through the water. So the visitor is required to choose either to find her way 'blind' or to switch

between blindness and the map, as it is all but impossible to maintain focus on the map as the primary strategy. Equally the cold beauty of the environment together with the brooding sense of something out there, friendly or otherwise, attracts the eye to the landscape on a regular basis. Inevitably, then, the visitor comes to know the environment by seeing and remembering the contours of the earth, the landmarks, and the unfolding vistas as she travels.

Wayfinding is a process leading towards an immersive experience of a landscape, but it is not a full immersion since we come to know the place as a series of temporal flows, journeys through space and time. The process of journeying is one of familiarization, and the rhythm of rowing – its repetitive movement and the sound of the water – metes out time as the visitor travels through space. The more we engage in finding our way through the environment, the more we are able to orientate ourselves in that environment, building up a series of vistas and transitions that will come to intersect if we travel repeatedly through it. This self-orientation is a subjective experience that develops a sense of space in de Certeau's terms through the practice of being in that place. I noted earlier that Slater's plausibility illusion was dependent upon the environment behaving in a predictable fashion in response to the visitor's movement within it, e.g. landmarks that are further away moving behind those that are closer. This illusion provides the sense of perspective that allows the visitor to feel as if she is located within a three-dimensional (3D) environment. However, what is more important than mere 3D-ness is the depth of potential journeying within the environment, which is not so much an illusion of location as a sense of being present. In *Vermilion Lake*, the particular digital instantiation of the lake is encountered by the visitor, whose bodily presence activates the subjective 'vectors of direction, velocities and time variables' through her movement within it. Her embodied practice of the potentials of that virtual place brings it into focus as a space, the site of a particular set of phenomenological qualia – the site-specificity of this installation.

In reality

Earlier in this chapter I posed the question about whether there is a hierarchy in experiences of physical and virtual elements in a mixed reality site. The discussion so far suggests that the physical engagement of the body is central to the experience of mixed reality environments in site-specific performance. I have explained that mixed reality acknowledges both physical and virtual elements as being present in the same space and makes no attempt to conceal their presence or their differences. However, both Gibson's affordances and Slater's plausibility illusion would seem to imply that the more closely the virtual elements correlate to the physical world, the more the visitor is able to accept those elements into her embodied experience. The visitor's movement highlights that correlation (or

demonstrates it to be missing). Hence it might appear that there is a prioritization of the physical over the virtual in the embodied experience of the site. Yet the argument posited by de Certeau and supported by Ingold is that the matter of the physical mapping of the 'place' is a cognitive process, whereas the subjective and felt experiences of being there are fundamental to the establishment of a sense of 'space'. Those experiences are gathered through embodied practice but they are not dependent upon physical elements necessarily. Instead they are concerned with the unfolding of embodied engagement with virtual and physical elements alike within the environment.

The distinction between physical and virtual needs further unpacking to aid in this discussion. Complications arise in the English language because of a tendency, developed in early discussions of new technologies, to conflate the terms 'physical' and 'real' when talking about the physical/virtual binary. Thus the real is often assumed to be physical, and therefore by extension not virtual. More contemporary philosophers have chosen to confound that assumption, often by divorcing the 'virtual' from the digital. Malpas (2009) has proposed that the virtual is a sub-set of the real, where the real is constructed through embodied experience. Taking this back to the discussion of de Certeau, the visitor's subjective experience of *Vermilion Lake* renders the lake 'real' in her experience through her embodied practice of that space and her sense of the qualia of it, despite the fact that the installation incorporates physical and virtual elements and the lake itself is virtual.

In contrast to this, digital communications theorists Adriana de Souza e Silva and Danield M. Sutko (2011: 31) describe how Deleuze appears to conflate the terminology: '[the Deleuzian] perspective does not oppose virtual and real, for physical spaces become folds within the virtual. If the real can be unfolded into different possible realities, the virtual and the real are actually synonymous and reality, or physicality, becomes one of the faces of virtual.' Deleuze's 'virtual' refers to something that has the potential to become 'real', rather than something that sits in binary opposition to the physical. This argument brings us to the same place as Malpas, but from the other side, so to speak. Effectively the virtual holds the potential for many possible realities. The concept of potentiality negates the difference between physical and virtual because nothing is experienced as real until reality is in the process of becoming through embodied experience. In *Vermilion Lake*, the visitor's experience of the 'real' is fundamentally grounded in the act of rowing on the lake. It is that embodied practice that produces the reality of her experience of that environment, regardless of which elements are physical and which are virtual. The open acknowledgement of the differences between physical and virtual that is typical of mixed reality helps to detract from those differences, as the lack of conceit allows the visitor to focus on her own subjective experience of what she does, sees, feels in that space.

Indeed Gernot Böhme (2013: 462) declares that it does not matter whether a projected space such as the environment in *Vermilion Lake* is 'the product of thought or is derived from reality'. He argues that it is incorrect to call virtual spaces 'virtual' just because they simulate or represent reality. To him it would be of no consequence whether the lake is a representation of a specific lake in the Rockies or an imagined lake. It is only at the point when that representational space entwines with the space of a bodily presence that it becomes truly virtual in the Deleuzian sense, as then the space carries potentials (affordances, perhaps?) to be experienced as real. So the representational space of the virtual lake entwines with the bodily presence of the visitor, providing the potential for the visitor to row on that lake and thus to experience it as 'real'. The three-dimensional illusion of the re-presented lake becomes actualized by the potential for the body to journey on it – to row towards the lighthouse, for example. I propose that this actualization or realization process is the moment at which *Vermilion Lake* is most clearly defined as site-specific, as it is the point of affective experience when a passage materializes between the original Canadian Rockies locations that inspired the artwork and the site of the visitor's embodied engagement.

The visitor

In *Vermilion Lake*, Gibson and Martelli do not wish the visitor to feel at home or to become comfortable in the virtual environment. There is always a brooding sense of something out there. The visitor is constantly reminded that she is just that – a visitor in an alien landscape. The process begins with the title of the overall work, and then continues through entry via the tracker's cabin (a temporary dwelling place), the visual impact of the cold unforgiving landscape of the lake and the uncompromising mix of cheap plywood and digital projection. This is a mixed reality, where physical and virtual elements are openly acknowledged, rather than a cosy immersion in a digital world. But despite the alienation implicit in so much of the design, there is still a strong sense of site underlying the whole installation. The visual representation, the sound and the design of the experience are deeply imbued with the artists' impressions of the Rockies. *Vermilion Lake* becomes a place that the visitor encounters, experiences, however briefly, within her particular instantiation of the installation. It is a space that she remembers traversing and discovering, and there may be a blister on her hand or slightly achy muscles across her shoulders tomorrow to remind her of the physical act of rowing across a lake and her real encounter with that virtual space.

Vermilion Lake enables the visitor to encounter the artwork as a window, a mirror and a door, since it highlights the interface whilst also using the visual aesthetic of the landscape and the centrality of movement to engage the visitor in the experience of the work. Three-dimensionality is not

defined by the illusory depth of the objects on screen but by the depth of potential journeying for the wayfaring visitor. It is the body of the visitor that unlocks the door to these affordances, these potentials in the virtual landscape that become real through her embodied experience in the mixed reality installation.

There is a risk that virtual and mixed realities could be ignored or avoided by site-specific choreographers and artists, as such environments can be seen as essentially disconnected from traditional concepts of 'site' in Pearson and Shank's terms. It is rare also to read about this area critically, except in relation to concerns that site-specificity will be mislaid on 'the island of everywhere' (Puthoff 2006). However, this chapter has shown that mixed and virtual realities are no less able to function as sites if we are willing to accept the definition offered by Miwon Kwon. Indeed it seems that more contemporary definitions are essential now, as previous definitions were devised for a world in which the blending of digital and physical was less possible and less prevalent than it is today.

Particularly in mixed realities, the lack of conceit around the nature of physical and virtual elements not only enables the body to be present but it actually demands that presence, since the body is the experiential interface through which virtual and physical become 'real'. In some ways the body is less able to absent itself in these kinds of environments than it is in those spaces where we are more practised at being and thus we are more at ease. Perhaps the disease of mixed reality is not unlike the experiences of audiences at early 1960s environmental theatre, when their physical bodies were placed for the first time in the same space as the performing (virtual?) bodies of the dancers and actors. In time it is likely that we will become practised at being in mixed and virtual realities, but for the present moment there is much still to be explored and much to be discovered about dancing and choreographing in these new sites.

Acknowledgements

I would like to thank Ruth Gibson and Bruno Martelli for their invaluable input and support in the preparation of this chapter, and for their kind permission to reproduce images of *VISITOR*. My thanks go also to everyone who shared their experiences of *VISITOR* with me in writing or in person.

Notes

1 Gibson/Martelli worked under the name of igloo performance company prior to 2010.
2 See Gibson/Martelli's website at www.gibsonmartelli.com/Visitor.html (accessed 9 February 2015).

References

Benford, S. and Giannachi, G. (2011) *Performing Mixed Reality*, Mass: MIT.

Böhme, G. (2013) 'The Space of Bodily Presence and Space as a Medium of Representation', in U. Ekman (ed.) *Throughout: Art and culture emerging with ubiquitous computing*, Mass: MIT: 457–464.

Bolter, J. D. and Gromala, D. (2003) *Windows and Mirrors: Interaction Design, Digital Art and the Myth of Transparency*, Mass: MIT.

Bolter, J. D., MacIntyre, B., Nitsche, M. and Farley, K. (2013) 'Liveness, Presence, and Performance in Contemporary Digital Media', in U. Ekman (ed.) *Throughout: Art and culture emerging with ubiquitous computing*, Mass: MIT: 323–336.

Coyne, R. (2007) 'Thinking through Virtual Reality: Place, non-place and situated cognition', *Techné: Research in Philosophy and Technology*, 10(3). Online. Available at: http://scholar.lib.vt.edu/ejournals/SPT/v10n3/coyne.html (accessed 17 October 2013).

de Certeau, M. (1988 [1984]) *The Practice of Everyday Life*, Berkeley and Los Angeles: University of California Press.

de Souza e Silva, A. and Sutko, D. M. (2011) 'Theorizing Locative Technologies Through Philosophies of the Virtual', *Communication Theory*, 21: 23–42.

Dourish, P. (2004) *Where the Action Is: The foundation of embodied interaction*, Mass: MIT.

Ekman, U. (ed.) (2013) *Throughout: Art and culture emerging with ubiquitous computing*, Mass: MIT.

Gibson, J. J. (1986) *The Ecological Approach to Visual Perception*, New York: Psychology Press.

Hansen, L. K. (2009) 'Lost in Location – on how (not) to situate aliens', *International Journal of Performance Arts & Digital Media*, 5(1): 3–22.

Hansen, M. (2006) *Bodies in Code*, London and New York: Routledge.

Ingold, T. (2000) *The Perception of the Environment*, London and New York: Routledge.

Kwon, M. (2004) *One Place After Another: Site-specific art and locational identity*, Mass: MIT.

Malpas, J. (2009) 'On the non-autonomy of the virtual', *Convergence: The International Journal of Research into New Media Technologies*, 15(2): 135–139.

Puthoff, E. (2006) 'The Patina of Placelessness', in L. Hill and H. Paris (eds), *Performance and Place*, Basingstoke: Palgrave Macmillan: 75–84.

Slater, M. (2009) 'Place illusion and plausibility can lead to realistic behaviour in immersive virtual environments', *Philosophical Transactions of the Royal Society B*, 364: 3549–3557.

Tompkins, J. (2012) 'The "Place" and practice of Site-Specific Theatre and Performance', in A. Birch and J. Tompkins (eds) *Performing Site-Specific Theatre: Politics, Place, Practice*, Basingstoke: Palgrave Macmillan: 21–36.

Whitelaw, M. (2013) 'Transmateriality: Presence Aesthetics and the Media Arts', in U. Ekman (ed.) *Throughout: Art and culture emerging with ubiquitous computing*, Mass: MIT: 223–236.

10 Spatial translation, embodiment and the site-specific event

Victoria Hunter

This chapter explores the choreographer's facilitation of the performer and audience's lived experience of site through the medium of site-specific dance performance explored through a discussion of my dance installation work entitled *Project 3* (2007). Through this discussion the chapter explores the concepts of spatial translation, 'present-ness' and 'embodied reflexivity' in relation to the individual's experiencing of space and place encountered within the site-specific event. In particular, the practice-led investigation questioned:

> How can site-specific dance performance informed by phenomenological inquiry invoke a 'present' sense of engagement with space and place for both performer and audience?
>
> How can this process 'reveal' the site to the individual and inform their sense of 'being-in-the-world'?
>
> What is the nature of the performer–audience relationship in this context?

Introduction

Project 3 (July 2007) was developed as a site-specific durational dance performance situated in a gallery-esque site (see Figures 10.1a–10.1d). The project's aim was to construct a work that relied upon the choreographer's and performers' corporeal site-responses revealed through phenomeno-logical movement inquiry and to employ this material as the sole form of corporeal and kinaesthetic communication between performer and spectator. The decision to foreground the corporeal and kinaesthetic resulted in a quest to produce a performance experience that encouraged audience members to engage with the site through an experiential encounter with the site phenomenon. Put simply, this project aimed to produce a sense of 'fit' (see Wrights & Sites in Wilkie 2002) in which the final work constituted a performance *of* site in the moment as opposed to a performance *about* the site and its architectural, historical and factual components.

Project 3

Project 3 was situated in the orangery and adjoining conservatory spaces within the Bretton Hall mansion building situated within the Yorkshire Sculpture Park in the North of England (see Figures 10.1a–10.1d):

Figures 10.1a–10.1d Clockwise from top left: Orangery, Orangery terrace, Conservatory, Lavender lawn.

(Photos: by the author)

The project explored the potential for site-specific 'encounters' to increase the audience members' awareness of site through their engagement with the live, real-time performance event, leading to the potential invocation of an increased awareness of *self*. As opposed to feelings of self-consciousness, however, the term is used here to refer to an individual's increased awareness of themselves in the site, in the 'here and now' leading to an increased sense of 'present-ness' (a term which will be discussed and defined later). To this end a creative methodology aimed at producing a work with a congruous sense of fit was developed in order to prioritise the individual's engagement with the site in a very self-aware and present manner. Through the application of an organic form of creative and choreographic process the project explored how the moving, dancing body could be the main facilitator of this process, effectively bringing the individual 'closer' to an embodied experience of the site reliant upon their corporeal and kinaesthetic experience. The purpose of this particular site-specific work then, was to explore a creative, choreographic interaction with the site which would in turn invoke for both performer and audience member, an increased awareness of self; in this place, at this time, in this moment.

The project began by exploring the question of whether the nature of corporeal communication particular to the dance genre could facilitate a unique inter-subjective exchange between performer and audience member through the creation of a performance experience that contained a sense of 'reality' and a lack of deliberate incongruity. During this process of 'exchange' the project aimed to utilise the dancers' skills and spatial 'tuning' to produce a form of site-specific encounter facilitated by the dancers' spatial 'translation', metaphorically transforming the site into movement.

Performed by six dancers, the work was situated in the gallery-esque orangery and adjoining conservatory spaces within the Bretton Hall mansion building. The surrounding lavender-edged lawn was also used as a space for performance and audiences were free to navigate themselves around the site as they wished.

Each space presented the audience member with a distinct installation experience as the orangery space contained three dancers whilst the outside site and the conservatory site contained solo dancers.

The creative methodology and processes employed within the project are discussed here in a chronological format and are explored in relation to the concepts of Present-ness, Exploration and Improvisation, Transcendence, and Co-existence and Translation.

Present-ness, exploration and improvisation

For the purposes of this discussion 'present-ness' is a term designed to describe an active process involving the individual's deliberate focusing of attention on themselves, their environment and their actions and

interactions in the present moment. This is facilitated through a process of phenomenological reduction described by Mickunas and Stewart (1974 in Fraleigh 1987: 6) as 'a narrowing of attention to what is essential in the problem while disregarding the superfluous and accidental', thereby enabling an immediate and direct through-line of connectivity to develop between site, performer and audience. The process of phenomenological reduction referred to here stems from the Husserlian concept of a focusing of attention towards phenomenological essences in an attempt to facilitate the individual's deeper understanding of 'things themselves'. The term is used here to describe a practical form of phenomenological movement enquiry drawing upon Merleau-Ponty's (1962) development of Husserlian phenomenology exploring notions of the whole-self comprising of a synthesised mind and body.

The term present-ness describes an ontological experience perceived by the self, achieved through a process of the individual's 'tuning in' to their experiences of being-in-the-world. Through this process of tuning in to the world the individual's perception of and engagement with the world is transformed from the functional and re-located to the reflexive enabling the individual to acknowledge and engage with phenomena which may frequently be overlooked or taken for granted when experienced solely as functional objects. As such, present-ness can be distinguished from the term 'presence' as it appears within wider contemporary arts discourse often pertaining to a sense of the actor's stage presence as perceived by the audience equitable to a form of 'charisma' (Auslander, 1994: 36), or more recently as a framework for investigations into performance, mediatisation and anthropology as explored by practitioners engaged in Exeter and Stanford Universities' 'Presence Project'.[1]

Present-ness is considered here as an intrinsic component of the site-specific genre; a process through which the individual is afforded the opportunity to connect to the immediate lived-experience of the site-world. Furthermore, I suggest here that this element of 'live-ness' and immediacy may be a key component which attracts audiences to the site-specific genre through providing a performance experience in which the audience member is afforded the opportunity to attend to the moment in both a physical and conceptual sense. Quick (in Heathfield, 2004) explains how the live event compels those engaging with it to attend fully to themselves and their 'being' in a version of the world in a present manner:

> The live troubles because it cannot be completely tied down.
>
> In order to experience its very liveness we are compelled to be open to the moment-by-moment of the live's happening before applying the rules through which we might presume to understand what is taking place around us.
>
> (Quick in Heathfield, 2004: 93)

It is perhaps this live aspect of site-specific work which the dance medium, due to its corporeal nature can facilitate particularly successfully, an observation which is supported here through Tufnell and Crickmay's discussion of bodily engagement with the world:

> It is within our bodies, in our instinctual and sensory responses, that we discover the changing field of what is happening to us. In the rush and pressure of our everyday lives we easily become numbed, cut off from our bodies. Without a sense of the body, of sensation and feeling, we lose connection to what is around and within us, to the immediate and present moment of our lives.
>
> (Tufnell and Crickmay, 2004: 3)

The term present-ness therefore implies an active process experienced by the individual in an attentive manner requiring awareness and receptivity.

To enable the dancers' present-ness to flourish *Project 3* explored and utilised dance improvisation as a choreographic tool which facilitated an exploration of the site during the early stages of the creative process and functioned as a performance structuring device in its own right. This was facilitated by the application of site-based movement 'scores' leading to the presentation of a live 'choreographed' dance improvisation installation. Through the development of dance improvisation arising from embodied phenomenological inquiry, the creative methodology allowed the body to get to know the site world 'well' and enabled the body-self to 'speak' of the site and translate these embodied site-based responses to other moving, living bodies in the space.

In particular, Anna Halprin's notion of movement 'exploration' implying a more focused and 'directed' approach to dance improvisation served to influence the development of tasks aimed at corporeally accessing this particular site. In conversation with Nancy Stark-Smith, Halprin discusses her approach:

> What I called 'dance explorations' was different, because we would take a specific idea – you might take space or you might take time, you might take force and we would work with a very specific focus and then we would explore what are all the possibilities around working with space for example. And in the process of exploration, we would come up with information that then later on I began to call 'resources'.
>
> But 'exploring' was much more focussed and controlled than 'improvising'.
>
> (Halprin, 1995: 191)

Informed by Halprin's approach and the concept of phenomenological reduction I began to develop tasks that equated to a narrowing of the dancer's attention through movement explorations to particular key site

essences. A number of movement explorations were then undertaken by myself and the dancers in order to specifically explore particular essences and aspects of the site through a 'lived-body' (Fraleigh, 1987) approach. The specific spatial or atmospheric aspect explored through each task is summarised below.

Shape
Structure
Textures
Air
Surfaces Experienced through the
Insides body-self.
Outsides
Lines
Angles
Malleability (of skin, limbs, bones, bodies)
Sound
Dimensions and proportions (body>site<body)

Figure 10.2 Project 3 initial site responses.

The dancers' experiences gained whilst exploring these tasks began to form the basis of movement 'scores' that became embodied by the dancers and were played out and explored during the final durational performance event. Improvisation in this instance was employed as a creative tool to facilitate an active form of 'choreography in the moment' occurring during the final installation event. Each dancer embodied four movement scores and each score explored a particular aspect of the site including atmospheric and spatial qualities and site 'essences' as experienced by the performer.[2] The scores encouraged the dancers to listen and respond holistically to the site and to the other bodies in the site and to acknowledge how their interventions in the space impacted upon and altered the site phenomenon. Through this process the dancers began to explore and develop their knowledge of the site corporeally and kinaesthetically and through their enactment of this embodied knowledge began to 'translate' the site into movement.

Transcendence, co-existence and translation

Transcendence and audience

The concept of transcendence is employed here to refer to the opportunity offered to those engaging with the site-specific event to enter into a liminal 'world'. Addressing the phenomenon of site-specific spectatorship and 'hybrid identities' Fiona Wilkie discusses site-specific spectatorship 'as an imaginative experience, which cannot be wholly contained by either space or the performance' (2005: 5). The utilisation of real-world locations inhabited by performance works combined with performance techniques

that (often) blur the boundaries between performer and audience present the site and the individual's encounter with the site as an estranged yet recognisable version of the world in which a range of spectator 'identities' can be encompassed.

The ultimate aim of *Project 3* was to create a work that enabled both the performer and audience member to immerse themselves within a performance experience enabling them to encounter the site in an embodied and immediate manner through the medium of movement. To this end, it was decided that the work should take the form of a durational dance installation in order to allow the individual's experience of the work to evolve over a period of (self-determined) time and that the role of the audience member be defined as a 'witness'. The term witness in the context of performance studies is defined by Tim Etchells (1999):

> To witness an event is to be present at it in some fundamentally ethical way, to feel the weight of things and one's own place in them, even if that place is simply, for the moment as an onlooker.
>
> (Etchells, 1999: 17)

Etchells discusses how, in the case of performance works that challenge conventional modes of theatrical presentation the witness is presented with, 'an invitation to be here and be now, to feel exactly what it is to be in this place and this time' (1999: 18). It is precisely this element of audience 'witnessing' that *Project 3* sought to explore; the witness being 'invited' to participate, react, respond or simply observe as determined by themselves. In the context of this research the term 'witness' is used to describe a process of spectatorship in which the audience member takes responsibility for their actions and responses in order to inform and develop their experiencing and understanding of the work. As opposed to a form of witnessing associated with bearing witness to a crime or injustice in which the witness is required to record and recollect events to impart to others at a later stage, witnessing in this context can be equated to a more immediate form of experiencing as a form of 'coming across' an event as it unfolds before and around them eliciting from the witness an immediate form of response. In this sense, the participatory role offered to the witness in *Project 3* possessed a degree of autonomy requiring them to consciously engage with the work and navigate their journey throughout the installation experience.

I suggest here that the nature of the site-specific event facilitates the development of the individual's present-ness through a process of transcendence. In his discussion of the concept of transcendence, Crowther develops Merleau-Ponty's (1962) notion of the phenomenal body and its engagement with the world:

> The world's transcendence – its refusal to be absolutely fixed by our body's contact with it – obliges the embodied subject to be itself

transcendent: to constantly change its perceptual positioning in relation to the world.

<div align="right">(Crowther, 1993: 104)</div>

I propose that the transcendental world created through the temporary transformation of the site into a place of performance presents the individual with an unquantifiable version of the world in which the rules of engagement and behaviour are momentarily disrupted enabling a freeing-up of behaviours, actions and possible interventions, thereby presenting individuals with choices and associated freedoms to construct their own patterns of behaviour and engagement with the site-world. This process of transcendence creates an environment in which the individual is required to make choices both physically and conceptually regarding their engagement with and navigation through the newly presented landscape of the performance site-world. Essentially, this process of transcendence facilitates the process of present-ness for the audience member by creating the optimum conditions in which present-ness can thrive. Therefore, through the transformation of the site a transcendental world is presented to the individual, effectively creating an environment in which present-ness can be experienced, challenging the individual to engage with themselves in the site, to adapt their 'perceptual positioning' (Crowther 1993: 104) or risk becoming lost or disoriented. Whilst the process of becoming lost affords the individual a self-revelatory experience, in order to avoid drifting off into a self-absorbed reverie, the nature of the work created in *Project 3* challenged the individuals engaging with the work to attend to their experiences of being in this particular world in a present manner.

Audience members were free to choose their level and mode of interaction with the performers whilst the dancers were encouraged to openly acknowledge the audience's presence and to reflect their body language and movement within their own movement explorations. In order to maximise the individual's experience of this transcendental world the work sought to develop in both the audience and the performer a heightened sense of awareness, encouraging encounters between self and site and self and 'the other' in an awakened manner leading to a state of present-ness.

Performing present-ness

As the rehearsal process began to develop it became apparent that, in order to facilitate this process, the dancers' own awareness of themselves in the site and sense of present-ness and engagement with the work required careful development. This stage of the creative process began to develop the performers' sense of performance required for this type of work. As opposed to adopting a form of performance persona derived from character portrayal or narration, the dancers were required to explore and present

their movement explorations to the witness in a naturalistic and present manner with a limited amount of artifice, acting or overt sense of performance. As the aim of the work was to share the dancers' explorations of the site with 'the other' through a form of embodied spatial translation, the dancers' role began to develop in its complexity. In particular, questions began to develop through the practical investigations regarding the dancers' management and manifestation of present-ness. The dancers were required to address questions of how to achieve present-ness and how to maintain a state of present-ness in their own practice whilst acknowledging and responding to the work of others.

In exploring these questions and facilitating the dancers' exploration of present-ness, a number of phenomenological concepts were explored through discussion during the rehearsal process then applied to the dancers' exploration of the movement scores. In focusing the dancers' process of phenomenological reduction further, Parviainen's (1998) discussion of Merleau-Ponty's concept of 'flesh', reversibility, self and other, and Crowther's (1993) notion of 'ontological reciprocity' proved useful in expanding the dancers' conceptual understanding of being-in-the-world.

Parviainen discusses Merleau-Ponty's notion of 'flesh' as a phenomenological concept used to 'convey the notion that the human body and the world originate from the same source' (1998: 62). In a practical sense, this concept aided the dancers' in facilitating a perceptual shift between considerations of the body as a physically limited and bounded entity to developing a consideration of the body-self as a permeable being. Merleau-Ponty in *The Visible and The Invisible* (1964) explains the concept further:

> My body is made of the same flesh as the world, and moreover this flesh of my body is shared by the world, the world reflects it, encroaches upon it and it encroaches upon the world.
>
> (Merleau-Ponty in Parviainen, 2002: 63)

However, Parviainen explains that within this concept the body and the world do not disappear into 'sameness'. The example of breathing is provided to illustrate this point and exemplify the interdependent nature of the body and the world. One dancer explained how the application of this concept within her own dance explorations helped to develop a stronger sense of connection between self and site:

> My body felt open both physically and mentally, I felt a definite exchange between myself and the site informed by the idea of the space moving through the body as the body moved through the space. My movement felt natural but explorative at the same time.
>
> (Performer Diary Extract, July 2007)

This description reveals how the concept helped develop the dancer's sense of engagement with the site in a reciprocal manner, becoming aware of her interventions in the site whilst simultaneously responding to the evolving site phenomenon as it became altered as a result of her movements. In this sense, a process of reversibility is enacted between subject and object and through this process both are defined and re-defined by the other. This does not mean to imply however that inanimate objects become animate through this process. The reciprocal act in this context emerges through the individual's engagement with the phenomenon of the other (the site and other bodies in this context). This is described by Crowther (1993) as a process of 'ontological reciprocity' (p. 2) experienced by the lived-body facilitated by 'our sensori-motor capacities in operation as a unified field' (p. 2). He expands upon the concept thus:

> The unity of this field, and the consciousness of self emerging from it, is both stimulated by, and enables us to organize the spatio-temporal diversity of otherness. We give it contour, direction, and measuring; thus constituting it a *world*. On these terms, the structure of embodied subjectivity and of the world are directly correlated. Each brings forth and defines the other. Their reciprocity is ontological as well as causal.
>
> (Crowther, 1993: 2)

In this sense, the dancer's embodied exploration of the site phenomenon can be seen to operate in a spiralling format equating to a form of 'processing' the space through the dancer's body in a process of 'present-ness'. The process of present-ness is presented here in diagrammatic form and provides an illustration of the dancer's process of experiencing, processing and re-visiting phenomena through the body-self's updated and re-informed knowledge.

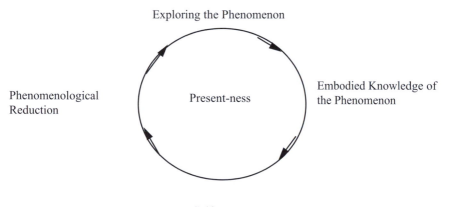

Figure 10.3 Model of embodied reflexivity.
Source: V. Hunter

In this process, the dancer begins by exploring the site phenomenon and, whilst engaged in this exploration the dancer simultaneously creates an embodied sense of how the world of this phenomenon feels through the lived body experience of moving through and engaging with this world. As the dancer's movement exploration develops they begin to respond to their embodied perception of the site world whilst simultaneously creating this world through their bodily, kinaesthetic engagement constituting a relationship that, as Crowther (1993) suggests, is both causal and ontological.

Co-existence

Once the dancers had begun to develop their own sense of present-ness through phenomenological engagement with the site, the phenomenological concept of 'self and otherness' (after Merleau Ponty, 2002) combined with the concept of simultaneity[3] (after Massey, 2005) serving to develop the creative process further. These two concepts were explored and applied firstly to the dancers' simultaneous explorations of the site during the rehearsal process and secondly, the concepts developed to inform and prepare the dancers for the final process of sharing the work with the witness. Throughout these explorations however, the dancers frequently reported a sense of frustration with themselves for 'failing' to achieve a consistent state of 'present-ness' throughout the duration of an improvisation episode. The dancers became concerned that, whilst engaged within a movement exploration they would often find their attention wandering or, would frequently struggle in their attempts to be 'pre-reflective' and effectively quieten their minds sufficiently to 'be in-the-moment'. As the process developed, 'witnesses' were invited to attend rehearsal sessions to enable the dancers to develop their experience of communicating and co-existing with others outside of the rehearsal process. However, the dancers frequently reported a sense of alienation and distance between themselves and the visiting witnesses whilst the witnesses themselves reported a sense of being 'excluded' from the dancers' explorations. During this phase of the investigation the practical explorations revealed a requirement for a re-evaluation of the notion of pre-reflexivity and being in the moment as previously understood through phenomenological dance discourse[4] additionally, the concept of 'communing' with the witness required closer attention.

At this stage of the rehearsal process the concept of 'personhood' proposed by dance anthropologist Brenda Farnell (2007) was introduced. In her conference paper entitled *Choreographic Process as Live Theoretica Practice*,[5] Farnell presented the notion of 'personhood' pertaining to an individual's embodied knowledge informed by their own personal history, identity and cultural make-up. Farnell's discussion of a 'dynamically embodied personhood' seeks to acknowledge the individuality and personal make-up of the dancer acknowledging them as an embodied being and

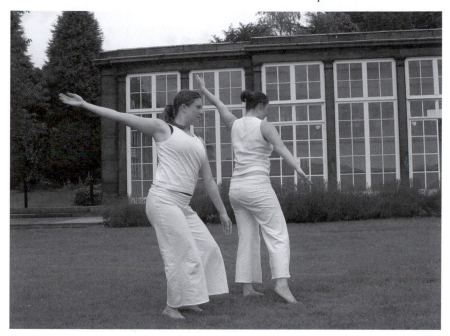

Figure 10.4 Project 3 lavender lawn.
(Photograph V. Hunter)

(using the example of abstract dance) seeks to recover the 'mover from movement for movement's sake' (Farnell, 2007). Farnell's concept of personhood develops Fraleigh's (1987) concept of the lived-body experience by enabling the dancer to bring their whole sense of self to the dance experience enabling them to consider themselves as a 'dancing person' as opposed to a servant of the dance or a supreme dancing being striving to become 'at one' with the dance in a pre-reflective manner. Farnell proposes that the concept of personhood bypasses notions of dualism as it automatically seek to address the individual as a whole person in a holistic sense consisting of mind, body and cultural, social and historical context.

In order to develop the dancers' sense of present-ness, the concept of personhood was explored practically within the various dance exploration tasks. In particular, the concept enabled the dancers to acknowledge and observe themselves and the various states of consciousness experienced throughout the explorations. As opposed to experiencing a constant sense of engagement and immersion within the various tasks suggested by notions of pre-reflexivity, the dancers were able to identify and observe their own individual process of ebb and flow as they experienced moments of immersion, lapses in concentration and moments of re-engagement with the various tasks. This was identified as a significant development in the dancers' exploration and development of their role within this type of

improvisatory process as the dancers became aware not only of *what* they were doing but *how* they were doing it. Through this process the dancers became more aware of their own sense of connection to the site and were able to identify and acknowledge in a honest manner when their movement explorations felt authentic and inauthentic.

Furthermore, it became apparent that this sense of ebb and flow between the dancers' sense of connection and disconnection with the site was an important and significant element of their site exploration as it exemplified the dancer's real-time exploration of the site in the moment and was therefore worth sharing with the other dancers and ultimately the performance witnesses. To facilitate this process the 'pedestrian rule' was introduced. This rule was employed whenever the individual dancer began to feel a sense of disconnection with the movement exploration scores leading to the production of movement content which was inauthentic and aimless. The pedestrian rule enabled the dancers to openly acknowledge their sense of disconnection and to simply walk, pause, observe and take time to reconnect with the site and the other bodies in the site before recommencing the explorations. One dancer explains how this rule enabled her to relax more when engaged in the movement explorations:

> Knowing that I didn't have to force movement when my concentration lapsed enabled me to move more freely, and probably sustained my concentration for longer periods of time as I felt less pressured to achieve a specific aim.
>
> (Performer Diary Extract, July 2007)

The concept of personhood made a significant impact upon the dancers' explorations of present-ness in *Project 3* as they became empowered and enabled to explore the various movement scores as real 'people', individuals who were aware of each other in space, and also moved through stages of consciousness which incorporated moments of total immersion within the movement explorations combined with less 'immersed' explorations which were allowed to evolve albeit in a less connected manner. In this sense the concept of personhood encompassed the essence of a range of complex phenomenological theories presented by Heidegger (1927), Merleau-Ponty (1962), Crowther (1993) and Fraleigh (1987) in a format directly related to the dancers' creative processes of experiencing the site encountered within *Project 3*. The dancers were therefore able to effectively employ the concept within their own movement explorations and engage in dance improvisation episodes in an authentic manner. Their sense of reality was further developed within the final performance installations as they openly acknowledged the witnesses through eye contact, smiling and genuinely acknowledging the presence and proximity of other individuals in the space. From this point onwards, the dancers' movement explorations appeared freer and less constrained as they appeared to engage with the

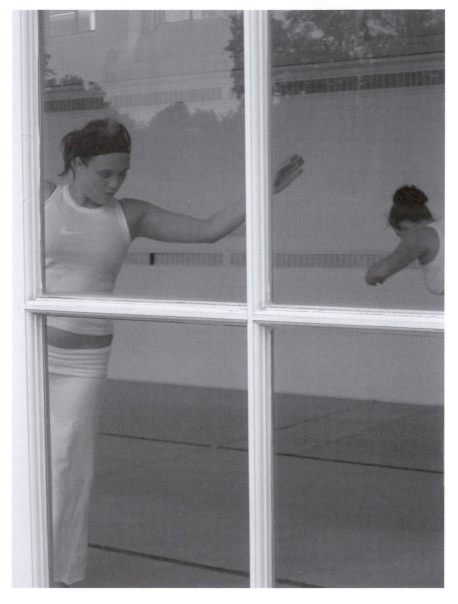

Figure 10.5 Orangery.
(Photograph V. Hunter)

tasks in a more present manner evidencing an increased sense of embodied awareness of themselves and of the other dancers in the site. This subtle development was pleasing to observe as the dancers effectively acknowledged their own present-ness and appeared to understand the work in a holistic manner as opposed to struggling to achieve a (previously misunderstood) pre-reflective state.

Through this development, the dancers appeared to begin dancing simultaneously in response to and *with* the evolving site phenomenon as opposed to attempting to impart a narrative or theme *about* the site. The story of their experience appeared to communicate through their new-found focused sense of engagement with the site and their awareness of themselves *being* in the site. Crucially therefore, the concept of personhood appeared to enable the dancers to be aware of themselves whilst moving as opposed to constantly seeking to 'switch off' and not notice themselves as previously experienced.

As the performers' sense of authenticity and awareness developed it became apparent that the evolving work required a complementary form of performance presentation appropriate to the nature of the improvised organic movement material resulting from the dancers' movement explorations. The concept of personhood then, became a crucial element in the development and facilitation of the final installation performance exchange between the dancers and the witnesses. The notion of personhood enabled the dancers to relate to each other and to the witnesses through a form of address which acknowledged the presence of each other in the site in the 'here and now'. This was achieved by the dancers' open acknowledgement of the witnesses' presence through direct eye contact and bodily acknowledgement as the performers were encouraged to move in close proximity to the witnesses, make eye contact, smile (or not!) and respond to their movement patterns and postures and ultimately engage in movement dialogue and exchange with the witness through dancing with them. One audience response reveals how this approach led to 'a sense of bonding between the audience and performers'.[6] Another response reveals a sense of becoming immersed within the performance world as the boundaries between performer and audience are blurred:

> I enjoyed being gently folded into the performance, being allowed to look closely at the particular spaces – their structure and detail and feel how they work, what they do to bodies.
> I enjoyed the interaction of the dancers and the space and how this gradually came to mean *all* the bodies in the space had a very particular relationship to the space. We were all placed there, part of the picture, not simply dancer and audience.[7]

This response reveals how the witness experienced a sense of blurring boundaries between performer and audience and describes a subsequent

experience of transcendence as they began to feel involved in a group interaction with the site in collaboration with the performers.

The following performer observation reveals how this process of inter-subjective exchange and co-existence between performer and witness resulted in the co-creation of performance experiences and movement 'episodes':

> When witnesses entered the space I felt a discernable shift of atmosphere a 'charging' of intensity as the other person entered the space and moved with me, often requiring from me a new set of rules, points of orientation responding to their interventions whilst offering up some of my own.
>
> (Performer Diary Extract, July 2007)

This example provides an insight into the nature of the dancers' experience of the inter-subjective exchange and illustrates how the exchange provided fresh movement stimuli to explore both in a collaborative and solo manner dependent upon the nature of the performer–witness exchange.

Project 3 therefore sought to break down conventional modes of performer–audience relationship in an attempt to bring the witness 'closer' to the dancer's experience of site, effectively operating as a translator-guide through their corporeal explorations of the site. In this sense, the dancer's exploration of the site was 'offered up' to the witness who may or may not choose to engage the dancer in a new journey or exploration through the site instigated by themselves. In phenomenological terms, this final stage in the creative process constituted a form of inter-subjective exchange between self and other. Merleau-Ponty discusses the concept:

> Between my consciousness and my body as I experience it, between this phenomenal body of mine and that of another as I see it from the outside, there exists an internal relation which causes the other to appear as the completion of the system.
>
> (Merleau-Ponty in Parviainen, 1998: 410)

This 'completion of the system' of perception posited by Merleau-Ponty is exemplified in the performer and witness observations discussed previously and is equitable to the sense of completion of the final performance work achieved via the process of corporeal inter-subjective exchange occurring between performer and witness. Through this final process the work achieves a sense of wholeness and destination as, through the dancer's communion with 'the other', the work secures a degree of completion and purpose.

Conclusion

This discussion of *Project 3* reveals how techniques employed within the creative process contributed towards the production of a work that engaged the audience and performers in an ephemeral place of performance. The discussion identifies how creative techniques combined with a range of presentational methods that situated the work somewhere between conventional theatrical event and reality. Placed within Susan Bennett's (1997) discussion of the 'outer frame', the witnesses were undoubtedly aware of the event as a manufactured 'product' occurring within a specific time and place. However, the inner frame of the work did not attempt to re-create or reference another world but contained instead real-time explorations and choreography-in-the-moment presenting not quite reality in a conventional sense but a form of 'different real' (Schechner, 1977 in Bennett, 1997) thereby constituting a dichotomous relationship between the concrete 'site as venue' and the un-fixed, evolving live performance world.

In order to achieve this an appropriate form of performance product was required which contained a degree of naturalism yet was still able to utilise the abstract medium of dance to achieve this, thereby enabling a simultaneous unfolding of process and product. The durational performance 'event' format provided an optimum environment in which to house the evolving improvisation comprising of a form of 'choreography in the moment'. According to Quick (in Heathfield, 2004), the live event possesses 'a materiality that is also resistant to certain drives to commodify it and make it known' (p. 93). I argue here that this lack of commodification resulting from the 'unknown' improvised content contained within *Project 3* facilitated the witnesses' ability to become immersed within and engaged with the live event.

Whilst this notion of 'live-ness' is not exclusive to the site-specific event, I contest that, as opposed to pre-set, pre-rehearsed forms of choreographic presentation, the improvised nature of the choreography 'in the moment' featured within the *Project 3* performance installation contained an additional element of 'live-ness' making the witnesses' and performers' 'prediction' of the experiential outcome particularly illusive. Furthermore, I suggest that this degree of unpredictability presented a 'freeing-up' of potentiality for the experiencing of place, space, and self experienced by those engaging with the event.

Therefore, the removal of a commodified 'place' situated by conventional temporal, spatial and cultural means became replaced by an experiential place defined by the individual's encounter and engagement with the lived-world as it unfolded before them. In this process of experiencing, through the suspension of conventional systems of understanding, the body-self begins to know and experience the site and themselves in the site-world anew.

Notes

1 See www.presenceproject.com
2 Some of the qualities and 'essences' explored included notions of 'linearity', explorations of the space as a 'malleable' entity and responses to perceptions of the sites 'vectors of direction' experienced corporeally by the dancers.
3 In *For Space* (2005) Massey argues for a re-consideration of space as multiplicitous and 'a simultaneity of stories-so-far' (2005: 9) prioritising an acknowledgement of the simultaneity of experience experienced by individuals in space and places.
4 Both Sheets-Johnstone (1979) and Fraleigh (1987) discuss notions of pre-reflexivity in dance as prerequisites for phenomenological exploration, the practical explorations contained within *Project 3* problematised *how* 'pre-reflexivity' was actually achieved in practice.
5 Presented on 24 June 2007 at 'Re-Thinking Practice and Theory: International Symposium on Dance Research', Centre National de la Danse, Paris.
6 Audience questionnaire response, 4 July 2007.
7 Audience questionnaire response, 4 July 2007.

References

Auslander, P. (1994) *Presence and Resistance: Postmodernism and cultural politics*, US, Ann Arbor: University of Michigan Press.

Bennett, S. (1997) *Theatre Audiences: A theory of production and reception*, London: Routledge.

Crowther, P. (1993) *Art and Embodiment: From aesthetics to self-consciousness*, Oxford: Oxford University Press.

Etchells, T. (1999) *Certain Fragments: Contemporary performance and forced entertainment*, London: Routledge.

Farnell, B. (2007) 'Choreographic Process as Live Theoretical Practice' [Conference presentation] *Re-Thinking Practice and Theory: International Symposium on Dance Research*, Centre National de la Danse, Paris, 21–24 June.

Fraleigh, S. (1987) *Dance and The Lived Body: A descriptive aesthetics*, Pittsburgh: University of Pittsburgh Press.

Halprin, A. (1975) *Second Collected Writings*, San Francisco: San Francisco Dancers Workshop.

Halprin, A. and Kaplan, R. (eds) (1995) *Moving Towards Life: Five decades of transformational dance*, Hanover, New England: Wesleyan University Press.

Heathfield, A. (ed.) (2004) *Live: Art and performance*, London: Tate Publishing.

Heidegger, M. (1927) (trans. Macquire, J. and Robinson, E. [eds] 1962) *Being and Time*, Oxford: Blackwell.

Massey, D. (2005) *For Space*, London: Sage Publishing.

Merleau-Ponty, M. (1962) *The Phenomenology of Perception*, London: Routledge.

Merleau-Ponty, M. (1964) *The Visible and The Invisible*, Northwestern University Press.

Parviainen, J. (1998) *Bodies Moving and Moved: A phenomenological analysis of the dancing subject and the cognitive and ethical values of dance art*, Finland: Tampere University Press.

Sheets-Johnstone, M. (1979) *North Stratford*: Ayer co Publishing.

Smith, P. (2009) 'Actors as Signposts: a Model for Site-based and Ambulatory Performances', *New Theatre Quarterly*, 25(2) (May 2009), pp. 159–171.

Tuffnell, M. and Crickmay, C. (2004) *A Widening Field: Journeys in body and imagination*, London: Dance Books.

Wilkie, F. (2002) 'Mapping the terrain: a survey of site-specific performance in Britain', *New Theatre Quarterly*, Vol. xv 111 (Part 2, May 2002), pp. 140–160.

Wilkie, F. (2005) 'Hybrid Identities? Space and Spectatorship'. [Unpublished symposium paper] *Anywhere But The Stage Symposium.* University of Surrey, January 2005.

Part III

Engaging with the built environment and urban practice

Victoria Hunter

This section offers the reader insight into the work of a number of practitioners who engage with site-dance produced in urban locations. Each chapter provides examples of particular projects, performance work and reflections on audience experiences of this work that engages with the built environment and urban practice in a specific manner. Urban practice is a term applied here in its broadest sense to encompass a range of practices that we employ on an everyday basis to aid us in our navigation of and survival within city and townscapes, domestic dwellings, office and work place encounters, academic environments and constructed places of leisure. These practices are shaped and informed by distinct sets of socio-economic power relations and socially constructed conventions and practices through which our engagement with the urban landscape and built environments are controlled, directed, shaped, informed and normalised. Situated within this theoretical framework, the chapters in this section raise questions regarding the potential for site-dance interaction with the built environment and urban locations to test and disrupt conventions and challenges the reader to consider how site-dance might propose and present alternative modes of engagement. In their exploration of these themes the authors draw on a theoretical framework informed by urban studies, human geography, sociology and psychogeography, feminism and political considerations of power and control and economic dynamics.

Through a discussion of her performance work developed on the Auckland waterfront, choreographer Carol Brown explores her own imperative of paying close attention to a felt sense of history and historicity within a particular location. She presents a reflective account of her creative process informed by a concern for a critical mythologising of place informed by post-colonial theory. Caroline Walthall also explores the political potential for site-dance to amplify and challenge social issues of inequality, freedom and oppression through her discussion of social-historical site-dance produced by choreographers Joanna Haigood, Jo Kreiter, and Ana

Tabor-Smith, who all work in the San Francisco Bay Area in northern California. Notions of mobility, surveillance, permission and control encountered within the super-modern city scape are explored in Melanie Kloetzel's chapter in which she provides a reflective account of her performance work *The Sanitastics* (2011), performed in the Calgary Skywalk System. In her discussion of the process she utilises archaeological examinations, critical commentary, and sensory experiences, and considers how site-specific performance fosters scrutiny of and revelations about human–environment relationships. Kate Lawrence's chapter explores the work of site-dance practitioners Susanne Thomas and Willi Dorner and reflects on their engineering of performer–audience relationships. Through her discussion of particular performance works she considers how, in this type of work, a new set of rules of engagement are employed providing fresh opportunities for artists to engage with the public in different and unconventional ways. In the concluding chapter Katrinka Somdahl-Sands employs a theoretical framework informed by autoethnography and non-representational theory to reflect on the work *Go! Taste the City* by dance artist Olive Bieringa of the BodyCartography Project performed in Minneapolis (2006). Through a reflective account of her own experience as an audience member witnessing the unfolding work she reflects on how this performance proposed a psychogeography of an urban street by transgressing the assumptions about how we move in city spaces.

11 City of lovers

Carol Brown

In Carol Ann Duffy's poem, *The Map-Woman*, a woman's skin is inscribed with a map of the place she grew up (2002: 3). For her, geography is an indelible pattern she cannot escape. In researching urban choreography I was drawn to this poem for its mixture of fact and fantasy in attending to how we are physically inhabited by the places we come from and identify with.

As a dancer and choreographer I am a mover, perpetually interested in and curious about the process of moving through and with space, in and out of time. How we understand and perceive/conceive the space we move through is culturally and psychically specific to the physical environment we inhabit, our memories and associations with that environment and our corporeal potential to be present.

In late 2009, after the arrival of my second child, I shifted my choreographic practice from the transnational potentials of a London art scene and moved 'home' to Aotearoa New Zealand. In the antipodes, my attention has shifted from the specifics of Western European contexts for performance – through touring circuits, festivals, commissions and events – with my company, Carol Brown Dances, to the possibilities for a place responsive critical choreographic practice immanent to the part of the world where I now live.

As choreographer with MAP Movement_Architecture_Performance[1] I have since 2009 been involved in a cycle of works that have been staged on foreshores, on reclaimed land and alongside significant bodies of water where urbanisation and utility infrastructures have redefined the meanings, significance and presence of water. Each of these works involved knowing and accidental audiences participating in ambulatory events through becoming enfolded into the spatial dramaturgy of a performance landscape. All of these works have involved mobile audio-visual technologies that envelop the knowing audience in stories, sounds and images that imaginatively re-tell the (pre)history of each place. Making felt that which is unseen and unspoken, the intention is to reorient the participant towards perceiving their environment differently, in particular by drawing attention to what is hidden, lost and written over by urban development and ecological imperialism.

These projects are part of my research into how choreography can be politically and aesthetically activated in public and civic environments. In this writing I seek to probe the potentials for a practice of charting the contested ground of Auckland, Aotearoa New Zealand, through tracking displacements that open alternative emotional topographies to the dominant narratives of a settler city. In this work, performance echoes pre-colonial, colonial and post- or neo- colonial narratives of encounter.

'Places', as Paul Carter states, 'are made after their stories' (Carter, 2009: 7). The concept of an urban landscape is not just the buildings and infrastructure that compose the city, but the belief systems we invest in it, our evocations of its energies, its flows, its patterns, its life forces, its stories, sedimented histories and invisible subterranean fluids. In acknowledging indigenous Māori understandings of place, or land as whenua (a term meaning ground, country, after-birth and placenta) and in working with local Māori, Pacific Island and Pakeha (European New Zealand) performers, I seek a parallel discourse that invests psychic and spiritual values in place and resists the abstractions of the colonial surveyors' pegs and the settlers' white picket fence (Ryan 1997: 372).

Typically, as Nick Kaye (2000) proposes, site-specific dance is understood as a performance of place, but as I have discovered the Western concept of 'site' is inadequate for opening a dialogue with bicultural practice and indigenous ontologies of place in New Zealand as it undergoes a process of decolonisation. Performance events that are 'site specific', while aesthetically, politically and socially 'framed' by the site, remain primarily architecturally and spatially determined (Gotman, 2012). The cultural, historical and spiritual associations of the location generally perform an accidental rather than central part in the performance. And yet, for indigenous peoples one's body is part of the land rather than on the land, like Duffy's *Map-Woman* (2002), the indigenous body is continuous with place and belongs to it.

In the context of 'site dance' the performance work discussed in this chapter emerged through a recognition of the limitations of postmodern discourses that are bound to Western concepts of space and subjectivity.

The performance cycle, *Tongues of Stone* (developed in collaboration with performance designer Dorita Hannah, sound artist Russell Scoones and dancers from STRUT Dance, Perth) explored place memories as bound to stories that hold a sense of deep time. Fed by the flow of stories that emerge from past events, dialogues with local residents and consultation with indigenous experts, *Tongues of Stone* vocalised (through sound) and embodied (through dance) hidden narratives and spaces (through design). Making urban space speak through performance, it mobilised city architectures constructed by corporate and industrial networks as poetic spaces. Carol Ann Duffy's poem, *The Map-Woman*, was a conceptual trigger. Premiered in April 2011 this work launched Perth as a *Dancing City*, part of the Ciudades que Danzan, an international network of 32 cities that

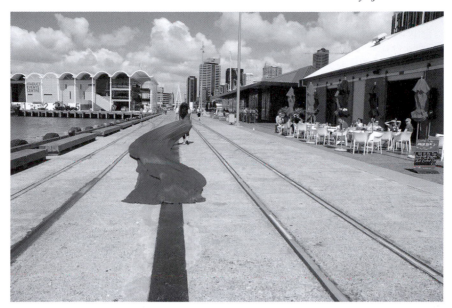

Figure 11.1 Sophie Williams in *1000 Lovers.*
Photo by Carol Brown

Figure 11.2 *Tongues of Stone,* Perth CBD.
Photo by Christophe Canato

promote dance as a vehicle for urban expression and civic and cultural regeneration. Subsequently it has been adapted for Auckland through three events: *Blood of Trees* (World Water Day 2012), *1000 Lovers* (Auckland Arts Festival 2013) and *Tuna Mau* (Oceanic Performance Biennale 2013). Using headphonic sound these performances invited the public to question the role of the past in shaping the present and to envisage in what kind of a city they want to live in the future.

Outside

If theatrical space is a concentration of space, focusing inwards from an outside, site-responsive dance is concerned with a more open relational space that takes us literally outside. Contemporary dance, as an art form is most often practiced in the solipsistic site of the dance studio with its paradigmatic flat floor and bare, empty volume of space. Taking dance outside, into the open air reveals the limitations of a practice detached from a physical world of forces and other species. Outside, we are able to witness the variable rhythms, patterns and vibrations of the natural world.

Working in Auckland in a semi-tropical climate permits working outside on a regular basis encouraging an attunement to the weather and to flows of energy in the environment. Working safely and ethically outdoors, however, requires a lot more than a good nose for rain and a thorough assessment of potential physical risks. For developing a feeling for this place demands also paying attention to its cultural and spiritual associations.

In developing choreography on the Auckland harbourfront we sought to cultivate a reciprocity between colonial settler and indigenous ways of telling place. As a non-Māori working in a place of contested cultural values, I was conscious of the need to listen and to be guided in our performance research by local experts. This required becoming a learner.

The stories, myths, embodied memories, names, histories and spiritual values of places, as held in the bones of the living and the dead, form a resonant affective archive. It is, as Levinas states, the reciprocity of these encounters that sustains us as 'all real [*wirklich*] life is meeting' (Levinas, 1993: 36). Levinas's call for an ethics of encounter that is weighted, rhythmic and culturally positioned could be said to align with indigenous Māori values of reciprocity.

The principle of *ako* meaning to both learn and to teach in te ao Māori, affirms the value of coming to know and understand through a reciprocity of exchange between teacher and learner. It recognises and acknowledges the way that new knowledge and understandings can grow out of shared experiences (Alton-Lee, 2003). Walking and talking with Ngāti Whātua adviser Malcolm Paterson along the waterfront, I came to know something of the pre-colonial history of Tāmaki Makaurau (the Māori name for Auckland) and the Waitemata harbour differently from my first-hand experience. He shared stories of the taniwha (supernatural creatures often

depicted as serpents or dragons), of the meanings of the harbour's name, *Waitemata* as sparkling obsidian and the more than a thousand years of Māori occupation and use.

In this situation I became particularly concerned with how movement can be politically and aesthetically activated in public and civic environments by making visible that which is invisible and making audible that which is no longer heard. In this writing I seek to probe the potentials for a practice of charting the edge of the land, an indeterminate and fluid site and a place of contact at the limits of what is known, through performance. Like the tidal edge of the land where earth and sea meet, these navigations imagine a reciprocity of contact between human and non-human life; between colonial settler and indigenous ways of telling place; between history and the present; and between performers, audience and passers-by.

As 'site dance' this work dances in dialogue with the forces of the world in a sensuous urban terrain and civic site. Whilst it invites multi-sensate experiences of place and an affective attunement to environment, it is also deeply implicated in the embedded stories, stratifications and tensions of history.

Figure 11.3 Blood of Trees, Silo Park.
Photo by James Hutchinson

Moving, placing, storying

> Art… is political insofar as it frames not only works or monuments, but also a specific space-time sensorium, as this sensorium defines ways of being together or being apart, of being inside or outside, in front of or in the middle of, etc.
>
> (Rancière, 2006)

Urban space is in a continual process of production, involving imaginations, embodied memories and narratives of space.

In post-settler cities like Auckland, indigenous understandings of place co-exist with Western conceptions of space and geography although these may be suppressed, under-acknowledged or ignored by the dominant stakeholders in urban development. Alternatively they may be embraced through artistic interventions.

A recent motorway project in Auckland City, one of the largest of its kind in Australasia involved visual artist Lisa Reihana being commissioned to incorporate Māori motifs into the design. She described how this collaboration was part of a wider conversation between the local iwi or tribe, Ngāti Whātua, and the city council to create a deeper understanding of the stories from this place. She described this experience as informing the work she subsequently made:

> It was really great as an artist of Māori descent being able to walk around Auckland today and really get a sense of what it used to be like. I understand what was going on down there before industry developed.
>
> (Reihana, online 2013a)

Walking in the steps of the ancestors is not only to repeat what happened but also to participate in making something new (Carter, 2009: 13). Journeying together, knowledge is discovered in the landscape and one takes up a position in relation to it. Moana Nepia describes the importance of being able to first position oneself in relation to Papatūānuku (the powerful mother earth figure), before one can have a standpoint (2012: 39). In this way knowledge itself emanates from a situated perspective, not in a fixed way but as part of a process that relates to genealogy or what Māori term whakapapa, the primary way that one's rootedness in the world is shaped. Walking the land is a form of sense-making. Heidegger (1993) similarly proposed that by walking we allow the territory traversed to be the guide to both exploration and thought.

In the conditions of settler cities like Auckland undergoing processes of decolonisation, negotiations between the concept of Māori tikanga and Western European notions of site-specific choreography, demand cultural sensitivity and a process that engages with cultural advisors. In these conditions a layered sensibility emerges that can be likened to a palimpsest,

not so much one place after another but one place entangled within another (Kwon, 2004).

During my research for *1000 Lovers*, I was invited to think about the drying of fish at the edge of a park once a beach, the pathway of Tuna Mau a stream plentiful with eels now flowing beneath Freemans Bay suburb, and the presence of waka (traditional Māori canoes) in a city harbour now known as a 'city of sails' as well as a lost namescape that once marked the value of the surrounding environment for Māori but became supplanted by a roll call of colonial patriarchal administrators.

I argue here that this reshaping and renaming of the land through ecological imperialism projects the spatial thought of another part of the world, Western Europe, onto the watery isthmus of Tāmaki Makaurau in the southern Pacific. This spatial lexicon divorced space from time and regulated the fractal geometry of the coastline by cutting straight lines to form harbours and wharves.

Negotiating rights to place

The founding document of New Zealand signed by representatives of the Queen of England and Māori Chiefs in 1840, the Treaty of Waitangi, made a political compact to found a nation state and build a government in New Zealand. However two different versions were signed, Māori understood that they were either retaining the substance of the land in return for the protection of the British crown or they were holding the shadow of the land in exchange for the rights of British citizenship.[2] Either way, the ongoing debate about the significance of the Treaty and its meanings reveals the gap in thinking about space between a nineteenth-century Western European concept of measurable property determined by fixed points and trigonometry, and an indigenous sense of space that is connected with time, journeys, spiritual values and access to resources. Deleuze seemed to recognize this difference when he stated in relation to Oceanic space:

> Does not the East, Oceania in particular, offer something like a rhizomatic model opposed in every respect to the Western model of the tree?
>
> (Deleuze and Guattari, 1987: 18)

Contemporary New Zealanders' understandings of space, place and nation are entangled with post-Treaty political, social and cultural debates. These have brought ongoing contestations of land ownership, debates about rights to resources and compensation claims for stolen land. In the context of site dance this context is important because it means that any discourse of place-making that attends to the right/rite to perform is also involved in a negotiation with the resonances of both a pre-European and colonial past.

Rather than being 'post-colonial', New Zealand is in a process of decolonisation. Māori scholar of indigenous methodologies, Linda Tuhiwai Smith describes five dimensions to this struggle: firstly, awakening critical consciousness of the persistence of hegemonic structures and realising action; secondly, 'reimagining the world' and a Māori sense of the world through creative work; thirdly, a tactical deployment of intersections between disparate ideas, practices and events in the historical moment; fourthly, 'movement or disturbance', destabilising the status quo; and the fifth addressing the underlying code of imperialism, through attending to structures that determine power relations (Tuhiwai Smith, 2012: 201). It is the second of these, 'reimagining the world', that choreographic intuitions can attend to.

> A new thinking (and drawing) practice does not abandon the line but goes inside it. The line is always the trace of earlier lines. However perfectly it copies what went before, the very act of retracing it represents a departure.
>
> (Carter, 2009: 9)

As Paul Carter observes, to reduce the world to an algebra of points and lines opens up 'abysses in both thought and nature' (2009: 8). For the area of Tāmaki Makaurau, the spatial authority of empire deemed the line important because it provided the measure of space and the boundary of site determining the limits of ownership (Tuhiwai Smith, 2012: 55). But what if these lines at the edge of the land are imagined differently through site-dance performance? If they are no longer blunt edges but stages for directed movement that is affectionate, reciprocal, re-routable and mutable. In the performance cycle *Tongues of Stone* we sought to destabilise the geometry of the line, through a spatial dramaturgy that is porous, dispersed and de-centred.

Paths that reach into the past

> It makes you fall in love with your city again.
>> (Michelle Hine, Audience member, *1000 Lovers*)

If the labour of dance involves turning and returning through multiple dimensions and layers of time and space, it is also a practice of reconfiguring space and what is posterior (behind) in relation to what is anterior (in front); in other words it is a continuous process of reconvening the relation of the past, present and future as simultaneous nodes that reconfigure the space–time sensorium.

Tongues of Stone is a project about deep maps, vertical time and the sedimented spatial histories of place. The work interlaces eras, locations and cultures in response to each particular site within which it takes place.

Shuttling back and forth between history, mythology and the lived present, four mytho-poetic figures (Procne, Philomel, Blind Bride and Widow in Perth; Hine, Sloshy Woman, Bride and Tuna in Auckland) and two choruses (five furies and six river runners in Perth; three furies and five elvers in Auckland) perform to a listening public or incidental audience of bystanders, guided on a fragmented journey. The experience is either as a knowing audience immersed in a soundscape (downloaded through soundcloud and received through headphones), or as witness and passer-by to a seemingly spontaneous collision of dance and architecture, where daily distraction is replaced by a spectacle that transforms the particular setting in which it is created and presented.

The event has been accessed by an estimated 10,000 people (Perth CBD 7,600; Auckland CBD 2,400 people) through 19 performances and has involved more than 60 community and professional dancers as performers as well as 44 production and creative collaborators.

In both Perth and Auckland the urban landscape is a protagonist in the work as we attempt to 'make space speak'.[3] In Perth the performance journey charted a pathway between the city and the river that attempted to 'mark' the site of invisible lakes whilst negotiating the laneways, public squares, private corporate buildings and roads and footpaths of a busy metropolitan city. In Auckland the journey moves from Waitemata harbour by Silo Park on Wynyard Quarter re-imagined as a primordial landscape to the industrial North Harbour and finishes with a movement into the urban metropolis at Karanga Plaza.

The long red dress that Nina Svraka (performing with a choreographic score based on *Philomela*) wears is both a *tongue* and a *snake*. Thirty metres long and made of red silk, the dress snakes through the city as she moves and is carried, hauled, hung and flown throughout the route of the performance, its metamorphic properties allow it to be variously seen as a river of red, a spectacular cut through the city, a banner/flag, a monstrous dress, a snake and a tongue.

The emotional topography of an ambulatory performance within the urban terrain might be said to propose an alternative mapping beyond the reduction of 'site' to a quantitatively surveyed plot with fixed dimensions. As Paul Carter states:

> It does not matter how maps are redrawn unless they are drawn differently. Unless they incorporate the movement forms that characterize the primary experiences of meeting and parting…
>
> (Carter, 2009: 7)

As Figure 11.4 reveals (part of the development of *Blood of Trees*, the first iteration of the project in Auckland), the white wriggling line is the shifting line of the pre-settlement coastline in Auckland City. Beyond it is the linear

outline of the wharf structures that have been built and continue to extend into the harbour since the early nineteenth century.

The natural contours of the land's edge are without fixed dimensions and are impossible to quantify accurately as they defy precise measurement and boundary. Standing at this edge we turn and re-turn at a threshold that is porous, changeable, indeterminate and the maps we have are inadequate to describe this experience. As island people in the southern Pacific, space is loosened from terrestrial centric thinking. Surrounded by the Pacific, the ocean becomes a corporeal and psychic relational vehicle for relationships that pivot around the moving body (Teaiwa, 2008). The ocean is Tangaroa, son of Ranginui and Papatūānuku, Sky and Earth. As an urban Pacific city and part of an island, Auckland is as much defined by the surrounding sea as the volcanic plateau on which much of it is built.

Perth as a coastal city in Western Australia offered a different set of challenges. In *Tongues of Stone* we sought to build a spatial dramaturgy that would resonate with the history of a settler city whilst acknowledging indigenous ontologies of place and the unspoken trauma of *ecological imperialism*. In paying attention to the resonances of disappeared wetlands, *Tongues of Stone* became a performance meditation on the invisible stories of place, reconceiving Perth through the unpossessable rhythms of nature; the flows, counterflows and currents of the city's subterranean fluids.

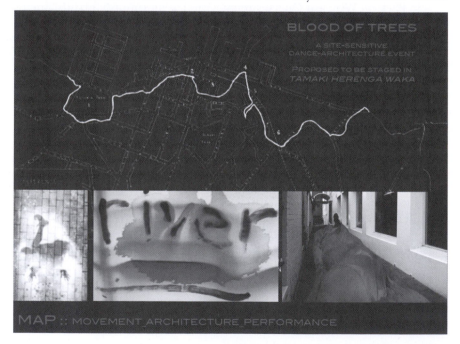

Figure 11.4 The original shoreline of Waitemata Harbour in white and wharves built out into the sea.
Created by Dorita Hannah

Anne Salmond (2012) has written about the challenge to Western conceptions of space through Māori and Pacific life worlds that are highly relational and exist as multi-dimensional webs of reciprocal relations. Like the vitalist tradition within Europe that existed during the Enlightenment, Māori and Pacific ideas of the cosmos see the world as dynamic sets of relations between different life forms expressed through genealogy and connection.

Salmond's thinking chimes with Kélina Gotman's (2012) concept of 'dancing-place', a relational understanding of the term 'site' that shifts it towards a more affective sphere; one where a place of significance becomes a crossroads for a community to reconfigure kinship through the intersection of relationships, histories and cultural memories.

Dancing-places

Gotman adopts the term 'dancing-place' from the work of the late cultural geographer Joël Bonnemaison (2005) who coined the term to describe the choreo-spatial practice of a sacred ritual developed by the Tanna people of Vanuatu in the South West Pacific. According to Bonnemaison the Tanna people liberated themselves by 'de-converting' from the Christian Missionaries who settled on their island from the 1860s. The neo-pagan ritual of *toka* is framed by a 'dancing-place' suggesting it could be a tactic of decolonisation. These ritual places are clearings in the forest at the place where a number of pathways meet. Each 'dancing-place' gathered several hamlets or kinship segments within the same area of social relation, becoming a micro territory for cultural enactment. As Gotman explains, at these sites the 'embedded past' thickly colours the present (Gotman, 2012: 10). Like 'crossroads dancing' in Ireland, the 'dancing-place' is literally an intersection where pathways and peoples meet and dance together. It is a geo-cultural and a geo-historical 'centre of gravity' a place with pull, weight and force and it acts contrapuntally in relation to the present (Gotman, 2012: 8).

In each iteration of the performance cycle *Tongues of Stone* (*Dancing City, 1000 Lovers, Blood of Trees* and *Tuna Mau*) we sought to create a matrixial space that danced place through choreographing relations between the past and the present. In many regards this aligns with Gotman's concept of a 'retro-garde' practice that reaches 'back' to roots and draws attention to their role in the present construction of the event. However, aspects of Gotman's definition of dancing-place don't fully align with practices where spaces and histories of place are contested and unresolved such as in the context of post-colonial Perth and a decolonising Auckland.

In Figure 11.2 a man eating a hamburger pushes into one of the performers in *Tongues of Stone – Perth Dancing City*. Seemingly affronted by the sight of the female performers occupying a public zone outside the Murray Street Underground he attempted to disrupt the performance.

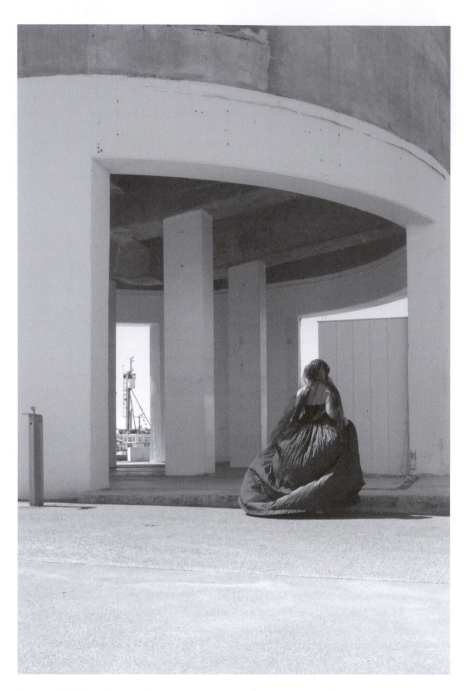

Figure 11.5 Carol Brown in *Tuna Mau.*
Photo by Emily O'Hara

Gotman proposes that through 'dancing-place' the past 'becomes theatrical' but I want to suggest that it can also disrupt the real, creating very real frictions and fissures in the fabric of daily life (Gotman, 2012: 10). In this sense it breaks with the illusion of the theatrical and a sense of gravity as a pull to a renewed sense of centre. Contrary to this, I suggest that ambulatory performances that reimagine the city as a journey through time operate horizontally, crossing boundaries, creating new folds and intersections, making tears and ruptures in the psychogeography of the city and the sense of the real. For real transformations occur through rupture and not just evolutionary change.

If the quality of a 'dancing-place' is historic and relational, performers and audience alike engage in a 'contrapuntal relation' with the past opening the potential for affective resonance. In this way the 'dancing-place' can become a locus for reconfiguring relationships, possibly even for repair of a damaged or alienated relationship to culture and environment. I would like to extend the idea of a 'dancing-place' through consideration of urban waterfronts as places of meeting, parting and historical conflict where Ranciere's call for articulating opposing regimes of historicity (Rancière 2000: 35) might be felt in the performance of diverse spatial orders, species and relations of belonging and difference. Rather than place being defined by fixed points, I would propose that such a topographical mapping is inherently nomadic, and dispersed through rhizomatic pathways.

Wandering and wondering between city and sea

> Choreography is a trace-work of feeling in time. Choreography is that which connects the animate to the inanimate, the air to the ground, the living to the dead.
>
> (Heathfield 2013: online)

1000 Lovers played on the idea of return through a performative re-membering of the relation between the city and the sea: one that does not rely on mastery, control or discipline but on desire, recovery and survival. The title is drawn from Auckland's Māori name *Tāmaki Makau Rau*, which translates not only as 'isthmus of one thousand lovers', but may also be understood as the place of many lovers. *1000 Lovers* took place on a porous site on Auckland's waterfront, where the limits of the body and the contingent edge of the land meet and are negotiated by the shifting volume of the sea. The dramaturgy centred around the central figures of Hine, Tuna, black widow, blind bride and a crew of eel-women or elvers. These composite figures emerged from our research into the pre-European and colonial histories of the waterfront as well as through layers of mythical, genealogical and ecological storytelling acquired through walks with local Māori (Ngāti Whātua) as discussed earlier, waterfront workers, observations and recordings as well as the dancers' own embodied histories and family stories.

Figure 11.6 Carol Brown in *1000 Lovers*.
Photo by Dean Carruthers

What emerged from the research was a pattern of changing values and
purpose attached to the harbour site through its pre-European, colonial
industrial, marine and fishery and contemporary recreational uses. Some of
these historical layers are embedded in the radical reshaping of this edge of
land through the gradual extension of the wharf into the sea, the deep
shafts of toxins beneath the industrial silos, the culverting of buried streams
and the marine life that pushes beneath the wharf to find its instinctual

route.[4] Other layers are to be found in the regular waka ama training that happens on the harbour, in the stories of the Taniwha that is said to swim beneath the harbour bridge and in the cultural memories of a once plentiful shellfish bed at the site of the nearby Victoria Park. Contemporary urban waterfronts are important heritage, industrial and commercial zones and figure prominently in urban planning, however they are also zones of encounter which recall and are embedded with memories of 'first contact' between peoples, between sea and shore and between interior and exterior. Chris Balme (2006) describes the cross-cultural encounter of colonialism in the Pacific as theatrical as much as economic, sexual or political (xii). In this context the body is perhaps the most complex site of exchange as it is the place where the transmission of culture was enabled. Given that the theatricalising of difference was arguably a prerequisite of colonialism, as both Pacific and European peoples used performance as a form of cultural negotiation, the shoreline, the place of first contact becomes a loaded 'site'.

As Paul Carter describes,

> the coastline… is also the place where Western and non-Western people are suddenly exposed to one another. As an imaginary place, quarantined off from the normal comings and goings of social life, it incubates strange, and often fatal, performances.
>
> (Carter 2009: 9)

In *1000 Lovers* as well as *Tuna Mau* I perform the role of the Black Widow. Veiled in black and wearing the silhouette of a colonial mourner I stand on the edge of the harbour and hover, 'like a black-gulled bird' (as fellow performer Moana Nepia described). My movements combine a gliding, skimming action as I move continuously across the surface of the harbour, over the paving stones, bridges, roads and under the silos, with cursive gestures that probe the air as if searching for thoughts that remain unfinished and float off in the wind-swept air. Along the way I meet and encounter other figures – Sophie Williams who performs the role of Hine, a Māori ancestress who is searching for the eel-man; Georgie Goater who defies expectation with her energetic punk moves in a colonial bridal gown; Moana Nepia who emerges from the harbour water to cross through the reedbeds to reach the city as an eel-man (Tuna); and a crew of young women who navigate the harbour, keeping watch on the other performers and moving across its surfaces and structures with strongly rhythmic bursts of action and still witnessing.

Eels formed a central motif within this work as we sought to develop a somatic language that was 'site-specific' without being anthropocentric. The movement patterns of eels as well as their migratory routes in crossing from freshwater to saltwater over vast distances shaped a spatial dramaturgy that involved thinking of the urban habitat as an eely place.

Trained in hip hop, kapa haka, Western contemporary and Tongan dance the performers in *1000 Lovers* possessed protean movement qualities which were well suited to exploring the possibilities of 'becoming eel'. This movement research was not about a mimetic representation of eel but rather an affective resonance *with eel*. Movement research began with a corporeal mapping, starting with the eyes and a sense of a fish spine. What do eels' eyes see? How do they look as they probe the shady banks of the local streams? How might a 'fish swish' pattern on the floor translate into a homolateral sinuous quality of movement? A series of movement motifs emerged including a swishing pattern of hips side to side, a rippling undulating pattern that moved backwards and forwards, and a somatic image of spine as a long tail that could carve through the air initiating from either tailbone or top of the neck. We also developed ensemble material that worked with the tangling and knotting behaviours of eels as they cluster and congregate. Performative hybrids – eel-women and eel-men – emerged from this research to inform the dramaturgy for a crew of elvers (or young eels).

A further layer to the process of the choreography involved working with the pan-Pacific story of Hine and Tuna. The myth tells of how Hine, the wife of Maui (half-man, half-god hero in Polynesian myth), seduces the eel-man, Tuna. After learning of her seduction the avenging god mutilates and dismembers Tuna's body, which forms different species of fish, eel, grass and the blood red stain of the native rimu tree. In our story an eel-man and five elvers (young eel-women) – unable to find their streams – emerge from the sea and intersect with parallel narratives of a colonial bride and widow before leaving the harbour to take on new roles in the city.

In *1000 Lovers* the story of Hine and Tuna forms a compass and architecture through which we navigate the shoreline as a place of strange encounters (Solnit, 2013: 3). For Māori, tuna (eels) are taonga (treasure) a food source and a cultural marker from Tangaroa (god of the sea). Within a Western imagination the sea is a place of passage, journeys, sport and recreation and eels are popularly regarded as slippery, slimy, even abject creatures. However, in working across two different varieties of eel knowledge, a somatic mapping of their movement patterns and a retelling of the story of Hine and Tuna through embodied narratives, we sought to open a dialogue with the shoreline that was layered and non-linear and moved beyond the privileging of the anthropocentric. Architectural and choreographic thinking combined, re-routing urban subjects in alignment with Hine's desire and the imagined movement of eels.

1000 Lovers invited visitors to co-define their relation to the city through participating in a 'lovers discourse' that charts the journey of Hine as she searches for her eel-man (Tuna) (Barthes, 1978). Charting the performance journey through an emotional topography of longing, desire and jouissance we choreographically sought to unsettle and unground the imperial project whose authority names and polices the waterways through extending the

Figure 11.7 Moana Nepia in *1000 Lovers.*
Photo by Dean Carruthers

colonial ground into the sea, cutting the coastline, culverting streams, polluting the harbour and denying a pre-colonial namescape. Through an ambulatory journey that crossed a linear strip of reclaimed harbour and in moving from sea to city, we activate embedded memories and invisible histories, referencing the once abundant kaimoana (seafood) and the now absent Tuna Mau (stream of eel) entangling the subterranean past with the over-written present towards a future that acknowledges the co-existence of primordial states, indigenous genealogies, diverse histories and meanings of place. The contemporary urban shoreline through the flows of bodies, the crossing, swimming, salvaging and surrendering of lovers, provides the place for a strange encounter through which we seek to recover and repair a sense of pastness in present, rather than reclaim or lament a lost pre-colonial landscape.

Ways of love

> To love someone is to put yourself in their place, we say, which is to put yourself in their story, or figure out how to tell yourself their story.
>
> (Solnit, 2013: 3)

The sense of the other's excess, experienced as wonder, is the primary condition of an ethical attitude. An ethical feeling *for* the earth, counters the instrumental view of the world as a resource for extraction. As we have seen, colonialism and global modernity have abstracted the particularities

Figure 11.8 Georgie Goater in *1000 Lovers.*
Photo by Dean Carruthers

and vitality of our geophysical environments, downgrading the history of local and indigenous relationships to the earth and replacing these with an economy of sameness as exemplified by the blandness of the term 'site' (Boetzkes, 2010: 56). As Mick Smith (2009) explains, the power of ethical feelings is found in the excess that transcends self-interest and refuses to force nature to fit into the categories of the symbolic order.

The disruption and de-familiarisation of public expectations about the purpose and function of a location has been an important aspect of my approach to place-responsive choreography. Together with my collaborating artists, including performers, we attempt to generate a *feeling for place* that loosens the coding of the location from its contemporary function and nomenclature.

As Mick Smith makes clear, emotions can be understood as events that 'take place in and through, the real world and real beings' and are amongst the most important ways in which we are both connected and disconnected from our world and mortality (Smith, 2009: 2). Rather than perform the celebrated role of flâneur as a detached observer in the city, this work is closer to Guy Debord's situations or moments of life in which we take an active part and where spectatorship is not an option (1957). Psychogeography becomes a strategy through which the specific effects of the geophysical environment create alternative maps for the unconscious imaginary. Rather than urban choreography expressing an 'intangible point of return' imbued with the imprint of the past as 'dancing-place,' how might a dance create a place for tangled memories that cast lines in different directions, that hold tensions, that tug at memories, that intertwine and bleed? Like Carol Ann Duffy's *Map-Woman*, how might a feeling for place be in our bones and not just written on our skins?

Shore line as continuous line

As a choreographer and performer situated in Aotearoa New Zealand, I am in continuous dialogue with the question of *how not to be imperial.* This task solicits from me the requirement to listen differently, to pay attention and to avoid the projection of a northern hemisphere cosmology onto a southern one.

How we conceive of the land we stand upon, that holds our weight and bearing in the world is historically and culturally determined and defined often in opposition to that which is ungrounded and fluid. If we consider 'land as the bruising medium of life itself' (Somerset, 2013: 34) rather than as a mere setting or backdrop for existence, we enter into a different form of dialogue with it and, potentially, way of performing place. The concept of a liquid ground that resists stability, fixity, centricity and linearity as theorised by Luce Irigaray is appealing in this context especially as it returns us to that place where our feet feel movement, exchange and interaction at the point of contact.

> In me everything is already flowing and you flow along too if you only stop minding such unaccustomed motion, and its song. [...] So remember the liquid ground.
>
> (Irigaray, 1991: 37)

If the West, as Irigaray claims, has taken the 'wrong path', if Western subjects are urged on by something their culture has deprived them of, if they have experienced a loss of sensory intelligence in their relations with nature and the other and are trying to find the *crossroads* again how might indigenous knowledges and practices from the edge of the world speak back to the 'centre'? How might we create a place through performance at the crossroads of cultures and the edge of the town?

Like 'crossroads dancing' in Ireland, the 'dancing place' is literally an intersection where pathways and peoples meet and dance together. It is a geo-cultural and a geo-historical 'centre of gravity' a place with pull, weight and force and it acts contrapuntally in relation to the present (Gotman 2012: 8). Although useful in reconceiving 'site dance' within the condition of a city undergoing decolonization, it is a term that is however locked into a terrestrial consciousness. In reframing 'site dance' for a watery isthmus, perhaps we could adopt Deleuze's term of liquid perception where movement, rather than being from one point to another as it is on land, is always between two movements (Deleuze, 2005: 82).

My interdisciplinary dance practice is concerned with a spatial poetics that *tracks* corporeal knowing through choreography that is intimately located within dynamic compositions of place-making. As interdisciplinary performances that attend to the sensate city this work is a form of creative re-membering, a putting back together of things brought from elsewhere with the multiple layers and specificities of each site (Carter, 2004). It is a choreography written from the perspective of place that folds historical, ancestral and embodied memories through interaction in the local specific context. In this way it releases energy.

This work has evolved in part through conversations with indigenous artists and pacific thinkers whose ways of knowing transcend Western modernity alongside an ongoing preoccupation with choreography that attends to sensate life and the patterns that can be invented when nature and culture are in conversation.

Tuna Mau involved a development of the original production *1000 Lovers* through a more porous spatial dramaturgy that allowed audiences to congregate and cluster across a dispersed performance landscape. Theatre writer Jonathan Marshall described the choreography as a series of pathways defining 'an axial or lineal push or pull' as well as 'coils, spirals and elevations of various degree' as the women performers 'curve around the end of one or more of the lines which are created between them whilst other trajectories cross at right angles or parallel to such virtual corridors stretching from one distant actor to another' (Marshall, 2013). Attention to

the architecture and sight-lines of the site open the potential for connecting diverse zones. The performers draw attention to the long view, turning between what is historically and physically distant and lost and the here and now of the present. Standing on the gantry they peer towards the disappeared stream *Tuna Mau*, navigating the reedbeds they move forward towards the city, standing on the steps of the wharf they strip to their underclothes and face the sea.

Swampy thinking

To think through difference in performance and to site work that has emerged through pacific contexts and practices in a harbour city, is to forge connections and to open a space for re-imaginings of the past and the present. A place perhaps where an 'order of relations' reverberates with the generative force of memories, affects, sensations, ideas and dreams. A place that might include an interweaving, a reconciling and a complicating of the past with the present, the distant and the near, the antipodean and the European, the sea and the land (Salmond, 2012).

But I want to be cautious here. Any understanding of Māori and Pacific concepts should not have as its aim their incorporation into a predominantly Western dance practice. Rather, I would argue that knowledge of these differences carries the potential to open up the possibilities for new crossings, creative methods, collaborations, forms of practice and species of dance. Such practices can be considered localised interventions resistant to neocolonial globalism. As practices of encounter they vibrate at the edges, between inside and outside, performer and audience, releasing the global at the threshold of the local.

The choreography we create in these times of change is filled with intersecting lines and diverging paths that are constantly re-routing. These track messages of our commitments, our corporeal habitations and our positions on the future. Each becomes a figure of possibility rippling concentrically from a drop in the ocean and swelling into the plenitude of energies that surface spectres of the past as well as visions for the future.

Notes

1 Movement_Architecture_Performance was created by performance designer Dorita Hannah, sound designer Russell Scoones and choreographer Carol Brown in 2002.
2 Nōpera Pana-kareao encapsulated Māori understanding of the treaty based on promises from the British that it would control Pākehā settlers and protect Māori lands, saying, 'Ko te atarau o te whenua i riro i a te kuini, ko te tinana o te whenua i waiho ki ngā Māori' (The shadow of the land will go to the Queen [of England], but the substance of the land will remain with us). One year later he reversed his opinion, saying that the substance of the land had gone to the Queen and that Māori retained only the shadow.
3 See Brown and Hannah (2011).

4 Peta Turei described baby sharks and young eels finding their way up the pipes beneath the wharf and reclaimed land mass towards the now buried stream inlet of *Tuna Mau*.

References

Tongues of Stone www.youtube.com/watch?v=F1snTjrlMeM
1000 Lovers www.youtube.com/watch?v=dSMdJ9t4P7Q

Alton-Lee, A. (2003). *Quality teaching for diverse students in schooling: Best evidence synthesis.* Wellington: Ministry of Education.
Balme, C. (2006) *Pacific Performances: Theatricality and cross-cultural encounter in the south seas,* Basingstoke: Palgrave MacMillan.
Barthes, R. (1978) *A Lover's Discourse: Fragments,* (Translated by Richard Howard), New York: Hill and Wang.
Bateson, C.M. (2001) *Composing a Life,* New York: Grove Press.
Bennett, J. (2009) *Vibrant Matter: A political ecology of things,* North Carolina: Duke University.
Boddy, G. 'Mansfield, Katherine', from the Dictionary of New Zealand Biography. *Te Ara – the Encyclopedia of New Zealand,* updated 30 October 2012, www.TeAra.govt.nz/en/biographies/3m42/mansfield-katherine
Boetzkes, A. (2010) *The Ethics of Earth Art,* Minneapolis, London: University of Minnesota Press.
Bonnemaison, J. (2005) *Culture and Space: Conceiving a new geography,* London: I.B. Tauris.
Bottoms, S.J. and Goulish, M. (eds) (2007) *Small Acts of Repair: Performance, Ecology, and Goat Island,* London and New York: Routledge.
Brown, C. (2011) 'Jazyky z kamene: divadlo skrytého městaen— Tongues of Stone: Performing the Hidden City', ERA21, (03), 16–19.
Brown, C. (2011b) 'Rivers of Song, Blood and Memories: Tongues of Stone Perth', BROLGA An Australian Journal about Dance, December, (35), 37–48.
Brown, C. and Hannah, D. (2011c) 'Tongues of Stone: making space speak … again and again', In: Listengarten, J; Van Duyn, M; Alrutz, M. (eds) *Playing with Theory in Theatre Practice,* Houndmills, Basingstoke, Hampshire: Palgrave Macmillan, 261–280.
Carter, P. (1994) 'From Collage to Fold: A Poetics of Place', *Periphery,* no. 20, 3–7.
Carter, P. (2004) *Material Thinking,* Melbourne: Melbourne University Press.
Carter, P. (2009) *Dark Writing: Geography, performance, design,* Honolulu, HI, USA: University of Hawaii Press.
Coole, D. and Frost, S. (eds) (2010) *New Materialisms: Ontology, agency and politics,* North Carolina: Duke University.
Cull, L. (2013) *Theatres of Immanence: Deleuze and the ethics of performance,* London: Palgrave Macmillan.
Derrida, J. (1992) *The Other Heading: Reflections on today's Europe,* Bloomington: Indiana University Press.
Deleuze, G. and Guattari, F. (1987) *A Thousand Plateaus: Capitalism and Schizophrenia,* trans. Brian B. Massumi, Minneapolis, MN: University of Minnesota.
Deleuze, Gilles (2005) Cinema 1: *The Movement-Image,* London: Athlone.
Duffy, C.A. (2002) 'The Map-Woman', *Feminine Gospels,* London: Picador, 3–7.

Gotman, K. (2012) 'The dancing-place: Towards a geocultural and geohistorical theory of performance space', *Choreographic Practices*, 3: 7–23.

Graham, F. (2013) *Catalyst for Change: The dramaturge and performance development in New Zealand from 1974–2012*, University of Auckland PhD.

Grosz, E. (2011) *Becoming Undone: Darwinian reflections on life*, New York: Barnes and Noble.

Heathfield, A. (2013) Choreography Is: A short statement on choreography (Answers 22–28). *What is Choreography?* Online. www.corpusweb.net/answers-2228-2.html, Accessed 15 November 2013.

Heddon, D. (2013) 'New Ecological Perspectives on Performance', 1 November, Central School of Speech and Drama, London www.cssd.ac.uk/sites/default/files/performance_and_the_environment_info_final-1.pdf

Heidegger, Martin (1993) 'Building Dwelling Thinking', translated by A. Hofstadter, in D. F. Krell (ed.) *Martin Heidegger: Basic Writings*, London: Routledge, 217–65.

Irigaray, L. (1991) *Marine Lover of Friedrich Nietzsche*, translated by G. C. Gill. New York: Colombia University Press.

Irigaray, L. (2013) *In the Beginning She Was*, London: Bloomsbury.

Kaye, N. (2000) *Site-Specific Art: Performance, place and documentation*, London: Routledge.

Kwon, M. (2004) *One Place After Another: Site-specific art and locational identity*, Cambridge, Massachusetts: MIT.

Lee, R. and Davies, S. (2011) *Gill Clarke*, www.independentdance.co.uk/author/gill-clarke/ (Accessed 23 November 2013).

Levinas, E. (1993) *Outside the Subject*, Translated by Michael B. Smith (Stanford, California: Stanford University Press).

Longley, A., Fitzpatrick, K., Sunde, C., Ehlers, C., Martin, R., Brown, C., Brierley, G., Waghorn, K. (2013) 'Streams of Writing from a Fluid City', *Qualitative Enquiry*, 19(9), 736–740.

Lonie, I. (2005) 'Proposal at Allans Beach', in Brown, J. (ed.) *The Nature of Things*, Nelson: Craig Poton, 16.

Marshall, J. W. (2013) 'Mobile Sculptural Forms Evoke Local Connections' in Theatreview Online www.theatreview.org.nz/reviews/review.php?id=6550 Accessed 28 January 2015.

Nepia, M. (2012) *Te Kore – Exploring the Māori concept of void*, PhD Auckland University of Technology.

Orange, C. (2012) 'Treaty of Waitangi – Dishonouring the treaty – 1860 to 1880', *Te Ara – the Encyclopedia of New Zealand*, updated 13 July 2012, www.TeAra.govt.nz/en/treaty-of-waitangi/page-4

Phillips, M. (2011) 'dancing city—traceries in stone', Maggi Phillips: Tongues of Stone *RealTime* #103 June, 28.

Rancière, R. (2006) 'The politics of aesthetics', www.16beavergroup.org/mtarchive/archives/001877.php (accessed 28 October 2013).

Rancière, J. (2009) *History, Politics, Aesthetics* Durham: Duke University Press.

Reihana, L. (2013a) Profile www.unitec.ac.nz/advance/index.php/profile-of-lisa-reihana/ (accessed 28 November 2013).

Reihana, L., Raymond, R. and O'Neill, A. (2013b) 'Pacific Sisters Keynote Address' Oceanic Performance Biennale, Auckland Waterfront 24th November. Oral presentation.

Ryan, P.M. (1997) *The Reed Dictionary of Modern Māori*, Auckland: Reed Books.

Salmond, A. (2012) 'Shifting New Zealand's Mindset', *The New Zealand Herald*, 18 August 2012, www.nzherald.co.nz/nz/news/article.cfm?c_id=1&objectid=1082 7658 (accessed 1 December 2012).

Smith, N. Davidson, J. and Cameron, L. (eds) (2009) *Emotion, Place and Culture.* Abingdon, Oxon: Ashgate Publishing.

Solnit, R. (2013) *The Faraway Nearby,* New York: Penguin.

Somerset, G. (2013) *The New Zealand Listener,* November 30, 34.

Teaiwa, K. (2008) 'Salt Water Feet: the flow of dance in Oceania', in *Deep Blue: Reflections on nature, religion and water,* Andrew Francis and Slyvie Shaw eds., London, Equinox Publishing Ltd, pp. 107–125.

Tuhiwai Smith, L. (2012) *Decolonizing Methodologies,* Second edition, London and New York: Zed Books.

12 Dancing the history of urban change in the Bay and beyond

Caroline Walthall

This chapter explores the work of choreographers who are inspired by social activism, community and neighborhood history, and the process of change. The choreographers surveyed include Joanna Haigood, Jo Kreiter, and Ana Tabor-Smith, who all work in the San Francisco Bay Area in northern California. These three women are contemporaries with intertwined histories of their own and with a shared interest in peeling back the layers of public life in San Francisco. This chapter looks closely at a range of choreographic approaches employed within a subgenre of site dance work that is both historically and socially oriented. Like a historical diorama, this subgenre, which I will refer to as "social-historical site dance," (SHSD) takes documentary materials as its starting point. As the layers of stories and movement accumulate, social-historical site dance shares goals of embodying hope, paying tribute, defying limits, and activating critical thought through the audience–performer relationship.

Furthermore, my aim is to survey the methods used by social-historical site choreographers to achieve collisions in our sense of time and activate audience awareness of the processes of migration, displacement, and change. In San Francisco, SHSD work plays out on city streets containing ubiquitous branches of Starbucks and Forever21, and on some of the city's most blighted blocks. In these complex spaces of conflicting socio-economic agendas and experiences, the practice of signing calls people's attention to the deeper struggles beneath our future-oriented experiences of time. Haigood, Kreiter, and Tabor-Smith help peel back the layers of immediacy, commerce, and power which obscure the fact that cities are enormously complex palimpsests of communal history and memory (Lippard, 1997: 196).

Place and community are easily conflated, yet in densely populated environments where hundreds of groupings of like individuals converge, we quickly realize that common geography does not necessarily equate to common social experience. As the blueprint of each global city begins to look more and more like the next, dotted with familiar corporate brands and conveniences, the task of truly understanding the nuances of one's neighborhood history becomes increasingly difficult. Lucy Lippard, author

of *The Lure of the Local: Senses of place in a multicentered society*, aptly explains: "a peopled place is not always a community, but regardless of the bonds formed with it, or not, a common history is being lived out" (1997: 24). Individual stories within larger neighborhood histories are often hidden from public view. Since the 1990s, a handful of American site-specific choreographers have made an artistic point of bringing these partially or wholly obscured personal histories into public space. In taking historical and social activist approaches to making art out of "place," they provide much needed space for audiences and participants to witness the details of our intertwined personal histories by calling purposeful attention to the processes of time, development and change. In doing so, the pioneers of this subgenre have extended site-specific dance practice to: 1) embody or refute American ideals of liberal humanist progress; 2) challenge the limits of socially accepted movement in public environments; and 3) instigate thoughtful discourse surrounding pressing political issues impacting local communities. This subset of choreographers began to develop art works that comment on the ethics of change, i.e. how we remember, how we participate in "urban renewal" or "removal," and how we make sense of our homes and ourselves and in an age of ever-increasing mobility.

Whilst there are a handful of other acclaimed choreographers in New York City, Los Angeles, and beyond who have made site-specific dance works attending to the histories of places, San Francisco's committed community of site artists performs several social-historical site works each year and has demonstrated a substantive commitment to engaging with the transitional identities of urban places. Dance works by Joanna Haigood, Jo Kreiter, and Amara Tabor-Smith, in particular, have invoked the lost cultural heritage and community fabric that is frequently part-and-parcel of urban redevelopment. Using three common approaches and borrowing techniques from one another, these three women have each acted as an artistic "indicator species" (Goldbard, 2013) for social well-being. Like oysters in a marine environment, they serve as monitors to the shifts in local ecosystems and they step forward to share their findings. These approaches include:

1 Multi-sited modern pageants often performed in some kind of period dress depicting a series of personal scenes and vignettes to illustrate a cultural moment along an audience route.
2 Structural recreations from archived photographs or building blueprints, featuring a performed "re-habitation" often with a slow or suspended use of time.
3 Aerial dance on the walls and roofs of iconic city buildings or intersections, often implying the transcendence of phenomenological limitations and establishing a sense of empowerment, enchantment, and individual agency in public space.

Within these large format types, Haigood, Kreiter, and Tabor-Smith may also include documentary film elements, oral histories incorporated in the score, audience participation, historical reenactment, or the use of unconventional materials to ground the story behind each work in our lives in order to make them feel more vivid and to incite dialogue.

Site-choreographer and public historian, goals and impulses

Choreographers of SHSD work may have different goals from traditional academic historians, yet they share many of the same assumptions as professional public historians. In *The Public Historian* David Glassberg (1996: 17–18) lamented the absence of a serious study on the evolution of the American sense of place, concluding that high mobility, centralized economic and political power, and instant architecture "had left Americans with a sense of 'placelessness'." The antidote to this lack of civic and cultural meaning is to orient oneself in relation to local histories. In his essay "Monuments and Memories," Glassberg (1991: 144) calls for an integrated public history that includes and examines "the idiosyncratic versions of the past of artists, writers, and composers… imaginative reconstructions that often bring the prevailing official and commercial versions into sharp relief." Like many San Francisco-based artists who came before them, Haigood, Kreiter, Tabor-Smith, and others provide just that. Beyond asserting that their works constitute a valuable part of public history work in the last three decades (a fact which the San Francisco Historical Society, in some cases, already recognizes), it is important to acknowledge what dance studies has contributed to ways of conceiving historical time and space.

Dance theorist Randy Martin explained that "motional dynamics" of bodies moving in space demonstrate and deepen our understanding of "how a sense of time and space is generated through social life" (1998: 35). Experimentation with contemporary embodiments of historicized narratives in performance can help citizens understand the larger social fabric, economy, and cultural patterns around them. Unlike more institutionalized living history museums, artists are able to abandon traditional concerns of exacting authenticity in favor of creating temporary subversions to our sense of time that allow for provocative statements, the inclusion of many stories, senses, and even historical eras in one place.

The production of difference that occurs by telling obscured stories not only relates to producing a sense of historical agency, but also to securing a sense of identity and integrity that is distinct from the common city zoning plans, architectural tropes, corporate presences, and yuppie trappings we see in countless American metropolises. Identity politics and the social movements of the 1960s and 1970s produced a surge of possible constitutions of sense of identity, but amid the growth of corporate chain stores and overall homogenization of the American landscape, possibilities for the articulation of geographically circumscribed communities have suffered a

loss, even as our online communities have exploded with activity and shared identity.

Additionally, when specific attributes of a historical transition are called to attention, it makes us keener observers and reminds us that our own voices matter. Change is not some monolithic force, but rather the accumulation of an infinite number of small choices. Thus, "time is... an effect of the various densities, aggregations, and mobilizations of human activity" (Martin, 1998). In terms of connecting audiences to an actual living sense of historical agency within their own lives, the acknowledgment of human difference heightens both our sense of empathy and our sense of power. Because this work is so often politically motivated, many social-historical site works aim to highlight the tensions, imbalances of power, and record of treatment of various social groups. This theatrical and dramaturgical element of SHSD work also occurs in traditional theater. The dance element of SHSD work, then, highlights the big picture view of our social systems and migratory patterns, reminding us of our shared experience within a complex social fabric. Instead of hearing one story and empathizing, we step back and recognize that we may play an indirect role in the way such individual stories transpire.

Urban renewal and its invisibility

Dance writer Camille Lefevre considers contemporary site-specific choreography as a process of "de-familiarizing" local environments through the context of performance and by disordering the rhythm of the everyday. In historical site-work, for example, a choreographer might use historical costumes or texts or even aerial work to accomplish this. The next stage, according to Lefevre involves "recontextualizing" those places through the process of gathering a community audience and bringing pertinent subjects to center stage (2005: 148). She asserts that this act of destabilization establishes a new focal lens that allows the audience to peer deeper into the everyday aspects of a neighborhood that may have become invisible over time, "either through day-to-day familiarity, or blight and neglect, or by being physically erased from the urban landscape" (ibid.). Many site choreographers' primary goal is to provoke a shift in perception and consciousness. Like New Genre Public Artists of the 1970s and 1980s, social-historical site choreographers hope to stimulate participatory democracy and create a space for dialogue about local change. For some choreographers, such as Jo Kreiter, historical site-work is about acknowledging our most endangered, recent stories in a place and paying respect to the tension between the under-represented and more dominant social groups. Kreiter offers valuable counter-histories to the dominant patterns, choices, and redevelopments in urban environments. Haigood is concerned with pointing out the systemic injustice that manifests in transient populations as a lack of secure homes. Her work calls this continued pattern to the

surface for her audience to examine. Tabor-Smith, in some of her site-work, calls attention to spaces and communities that supported expression and to the resilience of the artistic spirit.

However, the relationship of artists to urban regeneration is often fraught with competing tensions. Is the practice of placing moving bodies amongst the culturally and economically changing environment speeding up or slowing down the process? In the cases of many of the works selected for review in this chapter, artists have played a small part in gentrification and redevelopment schemes. For as neighborhood "brands" become enhanced through the presence of artists, no performance can be seen as truly ephemeral and without trace.

Randy Martin theorizes that all dancing creates momentum for social movements. Site-specific dance occupies a hybrid role that attracts more individuals from a broader social demographic to socially deprived neighborhoods, thereby pushing the cycle of urban renewal forward, while simultaneously creating opportunities for local human resistance to the government and economy. Often, site artists working at the nexus of all of these cultural and economic forces offer the rare chance to bear witness to the complexity of human patterns, power, and space during the period of greatest tension.

Yet, choreographers who manage to maintain long-lasting relationships with the communities in which they work (by creating works there on a regular basis) increase their impact by orders of magnitude. One's ability to help communities negotiate the processes of gentrification simply increases when one is of the affected community. Jo Kreiter has created work in and around the Mission District of San Francisco for over ten years. Joanna Haigood has created work in San Francisco's Market Street Corridor since the mid-1990s and Kreiter and Haigood taught for years in San Francisco public schools through a non-profit organization called *Performing Arts Workshop*. Since then, both have designed a litany of specialized workshops and programs available to low-income students and professional dancers, alike. Haigood, Kreiter and Tabor-Smith have all developed 20- to 30-year-long teaching practices in sustained local communities in which they work. Kreiter, has worked with a community in Bay View for over 25 years and remarked that community relations take a long time to develop. Sometimes Kreiter finds that people living near her performance sites want gentrification as much as the developers. In one instance, when conducting research for a piece, Kreiter spoke with a man who gives tours around the Tenderloin area of downtown San Francisco and asked him what he wanted to see in the Sixth Street neighborhood of crack addicts and rampant homelessness. He replied, "strollers and Lexuses." After indicating her slight surprise, he simply said, "people who live here don't care about this neighborhood" (Kreiter, 2013). This regard for inclusion, participation, and open communication is evident in that both offer free performances, work with local collaborators, and take steps to include the voices of ordinary people in each of their works.

It is important to note that social-historical site work is also happening outside the Bay Area, in New York, Philadelphia, and even in small towns. Like its artistic and cultural forbearer, the town pageant, SHSD helps communities enact their stories of development and explore the concept of home.

Lippard considers an individual's sense of place as "a kind of intellectual property" that can be developed and even re-ignited with every event that causes a shift in consciousness in one's neighborhood (1997: 33). Site-specific performance events present individuals with an opportunity to reframe and redistribute the "ownership" of the place in question. Ultimately, the goal of SHSD practice is to wake people up to the tensions inherent in transitions and give people a reason to care.

Modern multi-sited pageants: sensory and nonlinear approaches

Often, social-historical site works are inspired by love, empathy, and respect for a particular social group based on their collective resilience in the face of adversity. Premiering in June 2013 in San Francisco's Market and Mission districts, Amara Tabor-Smith's *He Moved Swiftly But Gently Down the Not Too Crowded Street* is one such work. It is also an excellent example of a modern multi-sited pageant or "promenade" performance. The primary intention of *He Moved Swiftly* was to pay tribute to the life and artistic spirit of Ed Mock, a gay, black choreographer who passed away in 1986 as a victim of the AIDS epidemic. Yet the five-hour-long work also included a simultaneous narrative about gentrification in San Francisco. As the work unfolded, Tabor-Smith told the story of lost artistic heritage resulting from the AIDS crisis. While drawing attention to the poignancy of that loss, she also transported the audience on a free-flowing journey back in time to embody a celebratory spirit that harkened back to performance experiments of the 1960s and 1970s. In the middle of the tour, the audience was diverted back to present-day San Francisco. As mentioned earlier, the suspended context of performance, especially in multi-sited pageant style works, enables many overlapping histories and conflicting emotions to hold our attention at once.

To warm the audience up for a five-hour-long walking tour, Tabor-Smith set the scene and tone with short improvisatory dances, which included a man in a tree. The audience witnessed Ed and 15 black men clad in white sitting, standing, and gesturing in a piano store. This section, "Room Full of Black Men," featured subtle gesture and pitched stillness while a blues singer crooned. Slight movements emphasized the feeling of poignancy and loss.

As the emotional weight of the story accumulated, the crowd moved to Josephine Baker Alley and then on to Sparrow Alley. Both are narrow areas off bustling Valencia Street, formerly inhabited by drug addicts and now known for street art. As the audience turned the corner, standing in a long

yellow dress and purple wig, Amara Tabor-Smith, playing an old woman, screamed and muttered about loss. Punctured by sharp and short screams, Tabor-Smith repeated, "She don't live here no more… they took her house… her house is empty but there's people in it." Troubled, the performer asked the nearest audience member, "You got a home? You got a house here?" and replied, "that's good, don't let 'em take it! [scream] [scream]." Moving on to other matters she called for audience participation, asking loudly and indirectly, "Does anybody know a song? I like music." The text of this section suggested themes of displacement, loneliness, and suspicion. This scene is just one layer of many that San Francisco audiences recognize as real in their own lives. This kind of belligerent and distraught character can be jarring in a dance theater work, but equally jarring encounters are daily occurrences in San Francisco life. In this scene, Tabor-Smith represented the dispossessed, often mentally unstable citizens of the streets. When she asked the audience to sing her a song, she offered audience members a choice to freeze up in fear of not knowing how to behave, or to use one's voice to help soothe the pain and manic struggle of this purple-haired woman. When one audience member began to sing "This Little Light of Mine," there was a shift in the performer, who improvized with conviction, singing louder and thereby recognizing the group's shared humanity, rather than continuing to play with the "otherness" or difference of the purple-haired woman.

Almost every stop on the journey (all published on a downloadable pdf map) featured sidewalk dancing, solo improvisations, and gestural theatrical moments of character development. A sense of unease extended through the work, without answers to suggest its underlying source. *He Moved Swiftly* also made frequent use of restaurants, stores, and studios as sites for new scenes and characters. In the section entitled "When they Die, We Eat Chicken," a performer gathered the crowd in Picaro Café (formerly Ed Mock's favorite barbeque joint), and directed the audience to: "write down the name of a landmark you would hate to lose that is already lost and then stick it on me." As the audience rose one by one to place a sticker on his suit, he read the names of the places lost. The social message was not meant to be subtle here: "Even in the face of our landmarks being built over, there is a… muscle memory of where we come from and which way we get home." With the audience back in the present moment, the leading character extended critical commentary to the rapid changes near the 16th Street and Valencia corridor, "your chi-chi restaurants [are] designed to keep hipsters in and gay and brown men out." As audiences, we must ask then, was this a commentary on the present, the past, or both?

After sharing a communal meal mid-performance, the work moved to Abada Capoeira studio. Formerly known as "Footwork," this was Ed Mock's primary rehearsal studio in the 1980s. This section assumed a contemplative tone, with more dancing and short stories from the small cohort of contemporaries who danced with Ed. At the first mention of Ed's illness

and struggle with AIDS, the mood shifted instantaneously. The performers entered a period of stillness and moved through a cycle of tableaux around a mattress on center stage.

Finally, the audience paraded through the streets led by a saxophonist to an indoor rave and a final street performance, reclaiming space to signify and celebrate what was lost. Throughout the work, Tabor-Smith challenged the audience to feel the gravity and seriousness of loss and urban change, while simultaneously giving space for wonder and discovery by celebrating the life of a creative community anchored around the life of one man. Stories were woven together and were made to come alive through color, vocalizations, silent stillness, and exuberant street dancing.

The content of *He Moved Swiftly* is rarely "feel good" in tone. Yet despite its brief three-day run, it won a special *San Francisco Bay Guardian* Best of the Bay 2013 award for "Best Dance Séance" (a specially created tongue-in-cheek category, to be sure) with the following note and nod to history and influence:

> The fact that Mock and his eponymous dance company heavily encouraged, trained, and influenced a generation of young artists surely helped cement his immortality. So much so that former student and UC Berkeley dance instructor Amara Tabor-Smith, who met Mock when she was 14 and joined his company three years later, partnered with several collaborators in June to bring his specter back to the byways of our fair town.
>
> (*San Francisco Bay Guardian*, 2013)

He Moved Swiftly asked its audience to experience many emotions at once. It also induced moments of pause, stillness, and haunting which are also signature characteristics of many works by her friend and contemporary, Joanna Haigood who also danced with Mock, and performed alongside Tabor-Smith as a collaborator in *He Moved Swiftly*. The ongoing exchange and willingness to contribute to one another's creative visions is one reason why the Bay Area so frequently presents new work in this genre. The practical and logistical hurdles for urban-based site work are many, yet this network of contemporaries has been influenced by many similar approaches to history, community, and apparatus-based dance.

Modern multi-sited pageants: linear and historical approaches

Whilst Tabor-Smith has a penchant for sensory experimentation and scrambled narratives, Joanna Haigood's prevailing method is to research and excavate individual stories from documentary materials. In Haigood's repertory is a site work based in downtown San Francisco, which was premiered in 2008 along Market Street and was revived again in 2010 and 2012. *Sailing Away* transported its audience back to 1858 to share the story

of a burgeoning black middle class living in San Francisco. At that time, due to civil injustices, over 50 percent of the black middle class families sailed off to Canada to make a new home. For almost a decade, Haigood has focused her attention on the black American experience.

Similar to *He Moved Swiftly*, Haigood's *Sailing Away* questioned the perpetual transience and lack of safe haven for this marginalized black population. In a talk presented at the California Historical Society Haigood asked: "Why do we have to keep starting over? ... Sometimes one gets tired of living in a place that doesn't want you there." According to Wanda Sabir of the *San Francisco Bay View*, the only problem was that 154 years later, "black people are still unwelcome in San Francisco, which is what *Sailing Away* addresses so eloquently without words" (Sabir, 2012). The conflicts evoked by Haigood's re-stating of history present a challenge to the viewer. Some audience members may already be sympathetic to such tensions, whereas others might not have considered the social impact of their own urban footprints.

Sailing Away was performed by eight dancers, and as with Tabor-Smith's way-finding pdf map, it invited its audience to find the start of the performance by searching for a historical landmark. At the top of each half hour all the characters were scheduled to appear at the northeast corner of Market and Battery streets near Shoreline Plaque, which marks the early San Francisco shoreline. The dancers began with a sequence of gestures that set the scene and the tone, abstractly embodying the exodus of 800 African Americans from downtown San Francisco.

Tabor-Smith demonstrated breadth of relatively unorganized narratives. Haigood, taking a more linear and historical approach, establishes greater depth within a more organized set of personal narratives. Due to her meticulous attention to her documentary sources, Haigood offered the audience a more direct orientation to the characters of *Sailing Away*. These historical figures included:

> **Mary Ellen Pleasant** (AKA "Mammy" Pleasant), an entrepreneur who used her fortune to further the abolitionist movement;

> **Mifflin Wistar Gibbs**, a devoted abolitionist, participant in the Underground Railroad and friend of Frederick Douglass, who made a fortune in the clothing and dry goods trade, real estate speculation, and transportation industries;

> **Archy Lee**, a slave who was the focus of several court cases involving slavery laws and a civil rights movement in 1858; and

> **James Monroe Whitfield**, a barber by trade, a major propagandist for black separatism and racial justice, and a poet of impassioned protest verse.

> (Patterson, 2010)

Through character interactions inspired by documentary traces of the past, such as recitations from diaries and other historical documents, audience members were immersed in a simulation of nineteenth-century commercial life on the city's most important thoroughfare. In case the narrative context established in the performance was not enough, newspapers containing historical information in the form of maps, biographies and significant events were distributed to the public by certain characters.

While *Sailing Away* is more cleanly set in a specific historical moment, it was not just rooted in 1858. It also included a character representing contemporary African Americans living in San Francisco and commented on current trends in black relocation to East Bay communities. According to Haigood: "While creating this work, it was important for me to include a moment to reflect on the invisibility and loss of African American history and to comment on the current out-migration of African Americans."

Haigood saw *Sailing Away* as an opportunity to stretch her audience. The average San Franciscan might not know the names or stories of Mifflin Gibbs or James Whitfield and yet they were national figures, working on behalf of African Americans everywhere. For Haigood: "This piece hopes to illuminate obscured histories and initiate meaningful dialogue around their subsequent legacies" (Patterson, 2010). Using history to comment on the present brings a whole new meaning to the term "living history." Through showing specific stories in SHSD work, audiences see examples of change agents and voices that were under-represented in or even prohibited from public decision-making. From there, dance movement sets the tone, establishing a sense of continuity and reverence for those groups of people and individuals who have been lost. Dance movement phrases suggest empowerment and transcendence. This offering of transcendence, celebration, and "rising above" is also deeply embedded in African American performance traditions.

Re-creations, hauntings, suspension: installations by Joanna Haigood

In the case of Joanna Haigood's recreation of demolished buildings in *Ghost Architecture* (2004), like the eye of a storm, measured slow or still reanimation of the past implicitly calls attention to change around it. *Ghost Architecture* presented historical moments and facts into the present, and placed them on slow, deliberate view, revealing the strata of urban development, as though we joined the choreographer mid-excavation. In her essay *Looking for the Invisible* (2010), Haigood observed:

> I have spent the best of twenty-five years examining places for details that would lead to some sort of story or memory of past lives, a clear picture of the distinct forces that I feel still resonate in the present state of things.

She remarked that the cracks and marks in the landscape or a wall form:

> a tangible and beautifully poetic map of time. Many site-choreographers ask themselves, "What if we really had the capacity of trans-temporal perception? What would it be like to view the intersection of events separated only in time but not in space?"
>
> (Haigood, 2010)

What such excavations create is two fold; firstly, an opportunity to reflect on and mourn the loss of structures and inhabitants passed. Secondly, it draws attention to the current state and speed of change.

In *Ghost Architecture*, Haigood and architect Wayne Campbell aimed to do just that. Their site was the contemporary Yerba Buena Center for the Arts in the downtown Market Street area of San Francisco. But this contemporary art center was also the former location of the West Hotel, the Peerless Movie Theater, and two apartment buildings. Armed with the actual architectural coordinates of those structures, Campbell and Haigood agreed that they would represent whatever had been on that site, and Campbell re-assembled fragments of old buildings: "in a discontinuous way, rather like a partial re-assembly of a crashed airplane during an accident investigation" ("Modeling the Past," 2010). Instead of trying to simulate the architecture of the Peerless and the West Hotel (as seen in museums and theme parks), Campbell said that he: "wanted to express the location of the old structures in an abstract way" (ibid.) and his crafted abstraction of the former site served as the set for Haigood's dance installation.

Ghost Architecture is inextricable from its exact site. The models and stories played out were hyper-local and would lack significant meaning if performed at an alternate site. The West Hotel was home to 122 older men in 1970 just before the redevelopment of the Market Street area. In 1974, the tenants of the hotel were evicted and the building was demolished to make space for the new Yerba Buena Center for the Arts. Haigood maintained that anyone familiar with the area knew at least "something about the battle between the hotel tenants, along with local business owners, and the San Francisco Redevelopment Agency" (2010) during that time. She commented that the story of the West Hotel "reflects our ongoing lack of humane and socially just methods of urban renewal" (ibid.). Her research process became more personal over the months of talking with a photographer named Ira Nowinski. Nowinski's photography series entitled *No Vacancy*, captured the last residents of the West Hotel and captured everyday intimacies of their lives. From these photographs and from stories of the residents and those who fought the forces of redevelopment, Haigood began to generate movement material.

Camille Lefevre described the experience of stepping into the dark forum of the Yerba Buena Arts Center as: "something that's already a place – not only a performance, but perhaps people's lives" (2005: 151). Haigood

had two performers in the space (a series of platforms with steel cables marking where the original coordinates were) enacting sets of actions for half an hour, then switching positions. *Ghost Architecture* was not a traditional dance piece, and as Lefevre noted, it "wasn't for the restless." Lefevre recalled the sense of time in the work and its effects in her essay *Site-Specific Dance, De-familiarization and the Transformation of Place and Community*:

> To underscore the exploration of time and space inherent to the piece, it ran six days a week for two weeks, six hours a day. In order to absorb the pace of this vanished world and recognize the subtleties of variation that occurred within the repeated patterns, the audience was required to slow down and settle in. Despite the fact that the performance was free, many people walked out after fifteen minutes or so. The result of staying with the piece for one hour, or more, was to enter a meditation on time and space, and how humanity is often lost in those continuums.
>
> (Lefevre 2005: 151)

Even if some audience members could not suppress their restlessness, critics for multiple newspapers lauded Haigood's haunting installation.

Ghost Architecture intervened in a neighborhood where gentrification had already done its work and even the Market Street area of San Francisco has become an upward-bound neighborhood, socio-economically speaking (especially with the arrival of the Twitter headquarters in 2012). In order to reveal the layers of change that have hidden the human faces, bodies, and voices that once existed there, Haigood de-familiarized her site by altering the physical environments to create mixed contexts allowing archived moments in time to resonate with traces of the present. The re-contextualization occurred as the audience moved in and around the site. The performers, executing slow, mediated task-like movements, or at times "pitching" stillness, altered the dominant sense of time and pulled audiences into an awareness of history's presence "in the now." Each movement we make up and down stairs, and in and out of rooms, is a new choice that influences and defines our larger patterns. In this way, installations using sustained movement have a ghost-like effect, bringing to light the constancy of urban change that has erased particular social groups from certain neighborhoods, sometimes by less than desirable means.

Flying with the community: aerial dance by Joanna Haigood and Jo Kreiter

Weightless, horizontally floating bodies cut the air 40 feet above the city sidewalk. Dancers glide towards the wall and bounce off and around a fire escape. Aerial, or apparatus-based, dance is an extension of the iconic, thrilling, and yet understated feats of daring explored by Trisha Brown in

Man Walking Down the Side of a Building (1977). Joanna Haigood was an early pioneer of the aerial dance form in city sites in the 1990s. In 2004, she remarked: "I am drawn to aerial work because I am very interested in working the space more sculpturally, using lateral, diagonal, vertical, and horizontal lines as well as perspective and scale as primary choreography tools" (2009: 55). For many years, Kreiter danced and collaborated with Haigood's San Francisco company Zaccho Dance Theater. In 1996, Kreiter started a company of her own called Flyaway Productions to integrate risk, spectacle, and social potency in performance. Kreiter's work tends to be motivated by contemporary political and feminist goals, while Haigood investigates "place memory," often taking her research further back in time and speaking directly to the African American experience. Both choreographers have combined aerial work, community involvement, and reverence of the history of place on several occasions.

In 1997, Kreiter made her first major site-specific work *Sparrow's End* in a drug-infested alley of San Francisco's Mission District. She published her choreographic journal of her time on site (*Site Dance*, 2009: 247). She described a handful of other local encounters with PCP addicts, young children left unsupervised, homeless people, and residents of the hotel. Many of the encounters involved a mix of pain and enchantment. Her final reflection was brutally honest. She wrote that at worst she had: "been accused of cultural imperialism… of dumping my art in someone's backyard" (2009). Her journal reveals the indirect conflicts that help make SHSD work so rich. As dance artists and empaths especially attuned to the subtle and overt rules of public space, Kreiter and Haigood have both noticed the discomfort and anxiety around ownership of space, including the concept of private air space. For Kreiter, regardless of the reception of the work, there is a satisfying power in a group of women working on the streets for long periods of time.

By 2002, Kreiter further developed her skills and artistic methods, and she created a signature work, *Mission Wall Dances*. This piece was inspired by a desire to give voice and visibility to residents of the Mission who had been displaced by arson. In an interview with Carolyn Pavlik (2009: 243) she said that *Mission Wall Dances*: "spoke to a wound in the city's history that is still festering… Many people were thrilled that their own history/pain was being reflected in such a spectacular piece of art." Several additional documentary tactics increased the impact of *Mission Wall Dances*. First, Kreiter interviewed three individuals about their personal experience of arson and displacement and used their voices in the sound score. In the middle of operatic singing and vocal technique in the sound score, different voices echoed:

> The whole row of apartments was catching on fire,
> The whole row of apartments was catching on fire.
> (Nonverbal singing)

This is somebody's home
(Nonverbal singing)
About being in the place you belong
Where is my home?
Home is where your mother is
Where your pillow is
My home, my home, my home.

(*Mission Wall Dances*, 2002)

The echoes of "home" in the score underscore the tragedy of displacement by arson. Hearing the words of the displaced makes them present again – acknowledging their hardships. Secondly, Kreiter commissioned a mural for the building wall on which they performed to provide a more lasting memorial to the displaced occupants. The dancers performed on fire escapes on top of the mural as well as on the edges of the building's roof. As a result, news coverage of *Mission Wall Dances* was more robust than usual and helped the work draw huge audiences (Haigood in Kloetzel and Pavlik, 2009: 243). The element of oral history combined with controlled aerial spectacle and the minor tone vocal score created a hybrid effect of haunting mourning and transcendent hope. The mural captured this duality with its bright colors and sense of peace and renewal on the adjacent face of a wall depicting rows of windows in flames. The mural remains as a reminder and a memory of the performances of *Mission Wall Dances*.

Another of Kreiter's works using this approach, *Niagara Falling* (2012), transposed images of blight and neglect in Niagara Falls (a mid-west town of former glory) onto the wall of the Renior Hotel at Seventh and Market Street. Sixth Street, one of the most blighted blocks in the city, is just around the corner from the Renior Hotel. Oral histories and video footage from the changes that had beset Niagara Falls, New York were a foil for the tensions and human stories at the site in San Francisco. Like *Mission Wall Dances*, *Niagara Falling* made use of a mixed score and plenty of aerial and apparatus-based tricks. The metaphor of the falls was carried through the work with a video projection simulating Niagara Falls on the side of the hotel, with the audience watching from the sidewalks below. After coming down from the roof, the dancers worked in upward patterns with a steel representation of a lifeboat and with their bounding athletic skills to establish the theme of transcendence. How involved does Kreiter find herself in the politics, then, of this socio-economic tension? In her online artist statement she observes:

In the last several years, I have created work from broad notions of art as a catalyst for change. I have tried to bring the beauty of bodies in motion to discarded city streets; I have tried to bring the eye of the city onto an abandoned crane, to help turn it into a labor landmark. I have focused in on the subtlety of human despair. I have honored the power

of dissent as a crucial political and cultural tradition, celebrating the tender underside of Market Street's protest history. I have asked the city of San Francisco to remember its painful history of arson and have offered the body in flight as a hopeful image of transformation. After all these years of dance-making I value both the scale and marvel of site specific work and the intimacy of the theater stage.

(Online, 2013)

Darlene Clover (2007: 519) identified two ways of combating a sense of loss of local identity: reclaiming public space and taking risks. Kreiter integrates both of these practices in each new work she creates. For Kreiter, the site artist needs to grab attention in some way and needs to impress enough to ask people to wonder what the performance is about. Placing high-flying dancers on the sides of buildings is one sure way to do this, but then she must also direct the audience's attention to a real life problem based on local histories and projected plans.

In choosing to think about time and space archaeologically, these three SHSD choreographers open up narratives and opportunities for cultural, economic, and political critique. They have established practices of play within the culturally dominant perceptions of time and place to demonstrate the impact of performance and movement on our notions of "progress." In the mobile age and in a connected metropolis like San Francisco, we can choose to wake up to the shadow side of gentrification and social inequality or anesthetize ourselves to those realities. Artists like Haigood, Tabor-Smith, and Kreiter share the hopes of progressing toward democracy, toward greater empowerment, and greater tolerance. They situate dance in the context of life and the environment, aspiring to reach people not usually touched by art and to help enact change in bodies and minds. Their forays into history are not merely nostalgic yearnings, but draw a larger map of the range of human experience. In the spirit of second wave feminism's decree that "the personal is political" they help audiences wake up to their own roles in larger socio-political narratives, today.

Modern dance has always been a progressive and implicitly feminist movement, and however idiosyncratic choreographic interpretations may be, public history as a whole benefits from alternative narratives that complicate and add dimensionality to our understanding of the societies from which we have risen. Site dance poses new opportunities for activating audiences as well as new approaches to researching and revealing more textured local histories. It activates civic awareness, empowering individuals to incite positive change. Most importantly, site-specific dance events create open spaces for public dialogue about place, change, and identity.

238 *Caroline Walthall*

References

Campbell, W. "Modeling the Past." [Available online] www.zaccho.org/ghost.html (accessed November 10, 2010).

Clover, D. (2007) "Feminist Aesthetic Practice of Community Development: The Case of Myths and Mirrors Community Arts," *Community Development Journal*, 42(4) (October 2007): 512–522.

Glassberg, D. (1991) "Monuments and Memories," *American Quarterly*, 43(1), (March 1991): 143–156.

Glassberg, D. (1996) "Public History and the Study of Memory," *The Public Historian*, 18(2) (Spring, 1996): 7–23.

Goldbard, A. (2013) *The Culture of Possibility, Arts, Artist and the Future*, Waterlight Press.

Haigood, J. (2010) "Looking for the Invisible" [Available Online], www.zaccho.org/ghost.html (accessed November 10, 2010).

Kloetzel, M. and Pavlik, C. (eds) (2009) *Site Dance: Choreographers and the lure of alternative spaces*, Gainesville: University Press of Florida.

Kreiter, J. (1996) "Parallels: Athletics, Power, Feminism," *Contact Quarterly*, 21(2) (Summer/Fall, 1996): 40–43.

Kreiter, J. (2009) "Making 'Sparrow's End'" in Kloetzel, M. and Pavlik, C. (eds) *Site Dance: Choreographers and the lure of alternative spaces*, Gainesville: University of Florida Press, 246–252.

Kreiter, J. Interview by the author. San Francisco, CA, October 19, 2013.

Kreiter, J. "About Flyaway Productions" [Available online] http://flyawayproductions.com/about/, November 15, 2013.

Lefevre, C. (2005) "Site-Specific Dance, De-Familiarization, and the Transformation of Place and Community," *Dance & Community: Congress on Research in Dance* (Spring 2005): 148–151.

Lippard, L. (1997) *The Lure of the Local: Senses of place in a multicentered society*, New York: New Press.

Martin, R. (1998) *Critical Moves: Dance studies in theory and politics*, Durham, NC: Duke University Press.

Mission Wall Dances 2002 (2009) Video. You Tube: Flyaway Productions.

Patterson, K. (August 9, 2010) "Market Street Dance Performance Reveals the Untold Stories of San Francisco's Early African-American Leaders." [Press release] [Available Online]: www.sfartscommission.org.

Sabir, W. (2012) "Joanna Haigood's 'Sailing Away': Black exodus from San Francisco 1858 and 2012," *San Francisco Bay View*, September 21, 2012.

Unknown, "Best of the Bay 2013," *San Francisco Bay Guardian*. October 15, 2013, www.sfbg.com/specials/best-bay-2013-best-dance-séance.

13 Site-specific dance in a corporate landscape

Space, place, and non-place[1]

Melanie Kloetzel

> For me, place contains the entire history of the location we are working
> with, in every sense. The space, however, is the tuning, the key that the
> place is singing in. For us, that is what we tap into.
> (Sara Pearson, 2009: PEARSONWIDRIG DANCETHEATER)

Site-specific performance relies on the terms *space* and *place* as markers for
discussing a performance's engagement with a site. However, practitioners
and researchers are often disgruntled by the limitations such terms impose
upon site-specific performance. In this chapter, I examine how theorists
have defined place and space since the 1970s, and consider how site-specific
scholars have taken up these definitions for their own purposes. Delving
into the divisions that these scholars have used to categorize site-specific art,
I note how perceptions of space and place have shifted over time.
Furthermore, I propose that bringing site-specific performance, and more
particularly site-specific dance, into the discussion triggers another shift as
we are forced to reassess our assumptions about terminology from the
perspective of the body.

In the creation of my site-specific dance film, *The Sanitastics*[2] (2011), I
confronted head-on the restrictions of terminology (as well as those of
security and surveillance) in the Calgary Skywalk System. Begun in 1970 as
a series of pedestrian bridges that pass over busy city streets in the downtown
core of Calgary, the Skywalk System is a dominating feature in Calgary's
downtown public space. To explore this curiosity, I hired American
filmmaker Jeff Curtis to collaborate with my dance company, *kloetzel&co.*, in
the creation of a site-specific, sci-fi spoof that follows four surveillance
superheroes through the Skywalk System. Following the film's completion,
I contemplated site-specific performance's ability to bring space, place, *and*
Marc Augé's (1995) non-place to life. In particular, I discovered that site
performance can highlight all three interpretations of site and, in doing so,
forefront the choices we make with regard to urban planning. By offering
up archaeological examinations, critical commentary, and sensory
experiences, and through exposing our fascination with travel and
consumerism, I consider how site-specific performance fosters scrutiny of

and revelations about the human–environment relationship in sites from the sublime to the mundane.

Setting the stage(space)

When exploring site-specific performances through research and practice, it is difficult to get around the terms *space* and *place*. Indeed, for years, those of us in the site-specific performance field have wrestled with these terms, critical as they are for understanding performance that takes site as the basis of inspiration. Contested among practitioners of site-specific performance, as well as among theorists in fields from geography to architecture, space and place can leave our analytical efforts in a muddle. Of course, we know meanings are slippery, but sprinkling these terms about haphazardly can too often undermine our attempts to examine the goals, actions, feats, and foibles of site-specific performance.

So, is it possible to come to an interpretation of the terms 'space' and 'place' that can enhance our practice and study of site-specific performance? Where, or to whom, should we look for guidance? These were some of the questions that I began to explore as I embarked on a site-specific dance project set in the Calgary Skywalk System. This project, *The Sanitastics*, brought together the dance company *kloetzel&co.* and American filmmaker Jeff Curtis to examine the Skywalk System through the creation of a dance film. By mining the fields of dance, film, and site-specific performance, we reconsidered our assumptions about space and place and, dissatisfied, finally incorporated Marc Augé's theories of *non-place* to help us contend with the homogenized corporate culture we uncovered. Yet, such discoveries did not come lightly, and in order to understand our creative process, it helps to step back and consider the theoretical frame that underpinned our physical and performative adventures.

Many philosophers, geographers, and cultural theorists have contributed to discussions of space and place, and their views have directly impacted and/or been influenced by site-specific art since the 1960s. While site-specific artists have dipped into such theories to situate their work, site-specific choreographers have come to the discussion rather belatedly. Luckily, recent publications have begun to amend this absence (as evidenced by this volume as well as by Kloetzel and Pavlik, 2009) and the choreographic entrance suggests the need for a greater scrutiny of the body and its relationship to space and place, as well as a reassessment of the established trajectory of site-specific art.

From space into place

As performers whose medium is the body, many site-specific choreographers invariably turn to the body as the first arena of analysis. 'As choreographers, perhaps the first "site" is the body,' explains Ann Carlson, a site

choreographer with over 20 years of experience, 'and all the visual, cultural, and behavioural signs ingrained in the body that impact the work. It circles out... from the site of the body to the context of where the body stands' (Carlson, 2009: 140). As we created *The Sanitastics*, we also began with the site of the body and the body in context, a method of analysis that led us to phenomenology and, in particular, to the work of Edward Casey to start our theoretical journey.

Casey (1997) agrees that we must allow the experience of the body to act as a guide. Drawing on the work of Maurice Merleau-Ponty, Casey takes bodily experience back to its fundamentals: if a body exists, then it does so in a *place*. For Casey, body and place are inextricably connected; human sensation and knowledge come from the places we encounter just as places are vivified and acculturated by the human bodies that inhabit them. As Casey states, 'Bodies and places are connatural terms. They interanimate each other' (1997: 24). Casey does not see this intimate connection between humans and *space*, however. Space, along with time, is merely an abstract concept that cannot be embodied. Casey argues that 'the phenomenological fact of the matter is that *space and time come together in place*' (Casey, 1997: 36, italics in original). Space, like time, is only one axis of lived bodily experience and one that cannot be accessed on its own. But place is something with which we directly and intimately engage, something that can be physically experienced and valued.[3]

As site-specific art began to establish itself as a genre in the 1960s, this understanding of place became paramount. Phenomenological priorities stood out as the basis for creating, presenting, and viewing the work. A site's physical realities such as design, dimensions and textures were of utmost import for both artist and viewer. Miwon Kwon, an art historian at UCLA, points to artists like Robert Barry and Richard Serra as visual artists of the 1960s who adopted this stance, and we could include Trisha Brown's performance pieces of the early 1970s (particularly her equipment pieces) as falling into this category for site-specific dance.[4] As Kwon notes, such artists wanted their artwork to move beyond the entrenched Cartesian frame and into a phenomenological one by focusing on the lived bodily experience of place (Kwon, 2002: 12).

But in the 1970s, site-specific artists shifted their attention away from phenomenological experiences of place. Frustrated by what they perceived as analytical limitations inherent in the phenomenological model, site artists began to turn a critical eye on place. Thus, instead of championing the acculturation of place in the manner of Casey, these artists noted (often with dismay) the cultural baggage that weighs upon place.

For Kwon, such site-specific art falls into a new category, one where an art piece critiques its own institutional and cultural framework and where multiple interpretations of the work and its site flourish based on individual viewers and their cultural backgrounds. Kwon sees work by Robert Smithson and others as challenging the 'presumption of a universal viewing subject

(albeit one in possession of a corporeal body) as espoused in the phenomenological model' (Kwon, 2002: 13).[5]

Jeff Kelley, an American art critic, agrees with Kwon that site art in the 1970s offered a new and challenging view of site; yet, he characterizes this development not as a move past phenomenology and into culture, but rather as a trajectory from site to place. 'At some moment in the late seventies, we crossed an important threshold: we moved beyond sites and into places' (1995: 141), claims Kelley in Suzanne Lacy's tome on public art, *Mapping the Terrain*. This shift was noteworthy, asserts Kelley, because it helped place-based public art move past site as an exploitative concept. 'A place is useful, and a site is used,' and he applauds the inclination of such artists to create a true 'art of place' (Kelley, 1995: 141).

Lucy Lippard also contributes to the discussion of space, place, and site in her seminal work, *The Lure of the Local*. For Lippard, place is where culture and space merge (1998: 10), and this demands that art on location needs to be separated into two categories: site-specific and place-specific. Site-specific art is influenced by topography alone, while place-specific art factors in a location's cultural, social, and political dimensions (1998: 274).

This understanding of place-specific art is exemplified in much of the on-site performance work since the 1970s. Site performances have provoked people to experience sites not only sensually, but also as cultural locations that boast wide-ranging personal histories and interpretations. According to Mike Pearson and Michael Shanks' interpretation, such site work offers an 'archaeological' reading of a site, exposing audiences to a rich layering (or 'deep mapping') of cultural knowledge (2001: 159–162).

In the site-specific dance genre, as early as 1967, Meredith Monk was examining archaeological layers on site. In pieces such as *Blueprint* (1967), *Juice* (1969), *Vessel* (1971), and the later *American Archaeology* (1994), Monk investigated such layers through her use of vast distances, disparate scales, and cultural myths; as performers examined sites around New York City from the grandiose to the intimate, they repeatedly questioned a site's frame, rendering any simplistic, perception-based model of place moot (Monk, 2009: 33–40; Kaye, 2000: 203–214).

In the 1990s, site choreographers such as Martha Bowers and Tamar Rogoff continued to explore the historical strata on site. For example, in Bowers' 1993 piece, *On The Waterfront*, presented in Red Hook in Brooklyn, NY, audiences observed different stages in Red Hook history as they traipsed from one shipping warehouse to another along the Red Hook piers; various local community groups inhabited these warehouses depicting the cultural layers on site through movement, text, and song (Bowers, 2009: 280–282). Rogoff's *The Ivye Project* (1994), which was performed in a forest in Belarus, delved into the layers of past and present as she examined the site of a mass grave where the Nazis murdered and buried most of the Jews in the town of Ivye in 1942. In this work, audiences wandered among the trees discovering

scenes of Jewish home life from the 1940s as well as the deep and pointed silence of the grave itself (Rogoff, 2009: 260–267).

Audiences of site work, after witnessing these historical layers, typically note that they feel more deeply connected to the places they see performed. In this interpretation of site work, in other words, performance turns everyday and often overlooked spaces into *places* replete with rich histories and memories.

Turning from place to space

So, has space been relegated to the dustbin of useless abstraction? Has the purview of site work been delineated as either providing a sensory experience of place or offering a lens into the memories and narratives of place? Actually, few scholars and practitioners in the site-specific realm seem satisfied with these fixed objectives. They dislike being pinned down by the implications of site work as simply a sensual partner to place, on the one hand, or a place magnifier, on the other. In the creation of *The Sanitastics*, I too felt fettered by these limited aims and needed to move onto other theoretical ground.

I turned to a different group of theorists who hypothesized new directions for space and place. Writing in 1977, geographer Yi-Fu Tuan, for example, examined the distinctions between space and place in detail and in his analysis, space morphed from a disembodied, abstract term into one of possibility. To condense his findings to a mantra: space is freedom, place is culture. Or, in more detail: 'Space lies open; it suggests the future and invites action', while place is characterized and bounded by fixed definitions, it is a 'calm center of established values' (Tuan, 1977: 54).

Like Tuan, scholars of site-specific and public art Nick Kaye, Jane Rendell, and Miwon Kwon began to regard place as an incomplete concept, one that did not provide the analytical fodder for understanding site art from the mid-1970s to the present. Under these scholars' scrutiny, place became a concept that constrained or confined site art; although place invoked phenomenological possibilities or historical layers, it did not offer the conceptual framework necessary to explicate the variety of site work created after the early 1970s.

In order to discuss such work, these scholars turned to another figure curious about the significance of space and place, namely theorist Michel de Certeau. In *The Practice of Everyday Life* (1980), de Certeau offered such scholars ample reasoning to justify their angst concerning place. Taking Tuan's thoughts a step further, de Certeau depicted place as restrictive, inert, or dead, while space connoted possibility and movement. As de Certeau describes, 'The law of the "proper" rules in the place... [Place] implies an indication of stability' (de Certeau, 1984: 117). This is in contrast to space, which de Certeau characterizes as place transformed by movement. Unlike the limitations of place, space offers endless possibilities based on

the various operations performed within it. To simplify, '*space is a practiced place*' (de Certeau, 1984: 117, italics in original) where practice indicates the physical activities and experiences performed by human bodies in a place.

Nick Kaye finds de Certeau's work promising for analysing the feats of site-specific art, and especially, site-specific performance. Since human action is the basis of performance, performance stands out as one of those transformative practices that turns place into space; thus, Kaye claims, spaces inevitably spring up in the moment of site performance, erasing inert places and leaving only a *representation* of the place in its stead (Kaye, 2000: 6–7). According to Kaye, performers and viewers of site work constantly experience such erasure of places due to the inherent mobility in the performance, and this provides new avenues for the production and characterization of the sites that surround us. Kaye goes on to champion the possibilities that exist in site work's rupture and re-articulation of place:

> Defined in these relationships between spaces and spatial practices, this site-specific work tests the stability and limits of the very places it *acts out*, at once relying on the order of the sites it so frequently seeks to question or disrupt. In this sense, site-specific art is defined precisely in these ellipses, drifts, and leaks of meaning, through which the artwork and its place may be momentarily articulated in one another.
>
> (Kaye, 2000: 57)

Similarly drawn by de Certeau's reading of space and place, Jane Rendell remarks on the possibility for transgression in the move from place to space. Concerned with our tendency to essentialize place as a romantic ideal from which we have become dissociated, Rendell prefers the idea of 'unfixing' a place (that is, turning place into space), as it allows site art not only to access a place's potential for change, but also to cast place into the network of larger social relations (Rendell, 2006: 18–20). From this perspective, Rendell enjoys the vector of place into space because it allows for 'a "space" of critical engagement in the "place" of commodity consumption' (ibid.: 60).

In Kwon's view too, site art from the mid-1970s onward has made greater strides toward space and critical engagement. Such site work, which exists in a third category for Kwon, enters the social realm more actively; it becomes critically engaged in sites that resonate with relevant issues of the day, from global warming to racism to homophobia. 'In this sense,' notes Kwon, 'the chance to conceive the site as something *more than* a place – as repressed ethnic history, a political cause, a disenfranchised social group – is an important conceptual leap in redefining the public role of art and artists' (Kwon, 2002: 30, my emphasis).[6]

Such distinctions hold promise for those of us in the site-specific dance realm. Site choreographers today frequently look to sites that either

promote dialogue for a community or offer the possibility of a larger critical discussion. In much of the work in the past two decades, place becomes a jumping off point for considerations of social economies and relations.

Jo Kreiter, artistic director of Flyaway Productions based in San Francisco, notes that she purposely searches for sites where communities are grappling with larger issues of social or economic inequity (such as an industrial crane that a San Francisco neighbourhood was trying to preserve as a labour landmark). As she explains, 'The site itself lends validity to the artistic inquiry, because the site holds a quandary in its "hands," or in the bricks or steel I-beams or concrete walls, etc.' (Kreiter, 2009: 313). Joanna Haigood, another site choreographer based in San Francisco, claims that she too looks for sites where an issue she is already exploring can resonate (Haigood, 2009: 70). In her work, *Invisible Wings* (1998), for example, Haigood was interested in delving more deeply into the legacy of racism and was able to do so in performance due to her access to a portion of the Underground Railroad in Massachusetts.

By turning to sites that bolster critical discussion, these choreographers are embracing *space* as characterized by Kaye and Rendell. This is particularly true in light of the fact that choreographers, not surprisingly, turn to movement as their discursive medium. In her analysis, Kwon points to the radical potential of site work that employs gesture and movement; she notes that movement-based site work, due to its focus on process and impermanence, can critically engage audiences in ways that question the commodification of art and place (Kwon, 2002: 24). Kwon's understanding of movement as a radical step pairs well with the sentiments of de Certeau and Tuan (and Kaye and Rendell) who look to the freedom of movement to establish space. In this dialogue, in other words, site choreographers and theorists agree: space is invariably linked to action, and the liberty associated with space emanates from active bodies and performing gestures.[7]

Which trajectory and why?

But, for all this theoretical talk, can site work actually invoke this freedom of *space*, even though in so many instances it revels in the history and/or sensual experience of *place*? After all, site work is about being informed by the smallest details of the sites in which it exists; it celebrates, and sometimes interrogates, a site, but it purposefully avoids the decontextualization of a blank theatre space.[8] So, can we really summon the spectre of space while remaining in the realm of the site-specific?

Such issues have not been at the forefront of my own work for very long. I've been content with revelling in the *place*-ness of the old hotels, bridges, or museums that I have explored through site performance. In past papers, I have discussed the depth of understanding of place that site work can provide, commenting on the layers of history that can be accessed through site work and the satisfaction inherent in the dig (Kloetzel, 2005: 130–137).

But a recent move across a national border, inciting a new (and increasingly discouraging) search for sites to perform has jolted my own sensibilities about what site work does or can do.

Relocating to a city such as Calgary in Canada, a city with a history that barely goes back a century, a city that can't keep up with the boom of oil, where workers pour in to snap up oil-related jobs, where new condos and skyscrapers of glass and steel replace lovely brick and sandstone structures every day, raises the question: what can we do in a setting of newness and corporate windfall? Is there still a way to move across the cement perfection and unmarked glass, to explore such a site both physically and performatively? Or, as site performers, do we just bemoan these spots and move on? In cities like Calgary, where homogenization has made its claim and global economic flows have carved precise channels, I begin to understand the angst linked to place; it feels restrictive, *too* calm with its established values and fixed associations. I feel the need to uncover a new relation to site, and I find myself reaching for the *space* of Tuan and de Certeau.

But what kind of site work would allow for that space of invitation, what tactics could incite action and a sense of freedom in a place of restriction? After an initial exploration of sites for performance, I turned to film to facilitate my leap into space. In 2008, I began work on the site film, *The Sanitastics*, set in the Calgary Skywalk System.

Creating *The Sanitastics* in the Calgary Skywalk

The Skywalk System, a dominant and intriguing feature of Calgary's urban plan, consists of a series of pedestrian bridges that pass over busy city streets in the downtown core of Calgary.[9] These Plus 15 bridges, so-called because they hang 15 feet above ground, can be found in many cities in North America, although no Plus 15 system is as extensive as that of Calgary. Since 1970, when the first bridge opened, the Skywalk System has grown to 18 km and 62 pedestrian overpasses. It effectively links much of the downtown. Due to this 'boon' to the city, which was designed by architect Harold Hanen, pedestrians are free to jaunt around downtown with no need to venture outside; today, a person can walk from 10th Avenue to 2nd Avenue or 8th Street SW to MacLeod Trail (2nd Street SE), without ever putting his or her feet on the city streets. Identical signage throughout the system (all with a little white figure in a cowboy hat set against a blue backdrop) directs travellers at every critical juncture, and food courts, nail salons, coffee shops, shoeshine stands, and investment advisers entice pedestrians with their wares. The fluorescent lights that illuminate the endless stream of consumerism and the temperature control throughout the system give an eerie sense that seasons, time of day, or street sounds all belong to some other world, one which is no longer necessary.

The Skywalk has inspired a number of artistic efforts including public art displays, performance walks, installations, and even a film, *Waydowntown*

(2000), by Gary Burns, a Calgary-born filmmaker. This final salute to the Plus 15 system, a cult sleeper, presents a comedic take on corporate culture, which quite effectively jabs at the almost-claustrophobic sensibilities in the Plus 15 walkways.

As I mused over Burns' film as well as the installations and public art offerings erected in the system, I found that while some of them successfully captured the corporate and restrictive nature of the Plus 15s, my own understanding of the Skywalk System as an overly clean, cultivated, and surveilled environment begged for further exploration. Thus began the creation of *The Sanitastics*, a dance film that follows four surveillance superheroes through the Plus 15 system as they attempt to eradicate contamination (in this case, a flower-creature or being of the 'natural' world) that has been mysteriously introduced to the system. Using powerful, angular, travelling movement, cleaning metaphors, and film techniques that vault the plot into the surreal, *The Sanitastics* ironically skewers the underbelly of the Skywalk culture – the oil corporations – in its ridiculous disinfecting feats. The press summary of the film reads as follows:

> A sci-fi dance spoof on the security system of the Calgary Skywalk, *The Sanitastics* scours the system, removing any oddities, invasive species, and problematic beings. With fantastic creatures and hygienic superheroes, *The Sanitastics* offers a site-specific adventure of the endlessly electrifying non-place.

While creating this film, I found myself wondering about space and place and the limitations of these terms. Initially, I was enamoured of the plot line that turned the geometric and heavily mapped grid (place) into a space of

Figure 13.1 The superheroes on the hunt: Deanna Witwer with Caileen Bennett, Naomi Brand, and Kirsten Wiren in *The Sanitastics*.
Photo by author

freedom with room for critical commentary. But I found difficulties with such a trajectory. Place and its historical nuances and archaeological possibilities kept creeping into our thoughts as we passed through the storied Palliser hotel, *circa* 1920, and the decaying sandstone City Hall, *circa* 1911. But how could *place* also fit the much more prevalent existence of gleaming marble corridors, chain stores, and shiny plate-glass windows? Could place aptly characterize the homogenized hallways of corporate consumerism as well as the sites of ghosts and grit? On the other hand, could we discover a freedom within *space* while avoiding that dangerous decontextualization that could vault us out of the site-specific?

Neither place nor space

Disappointed by this lack of clarity within the concepts of both space and place, I turned to Marc Augé and his theories regarding *non-place*. For Augé, a similar quandary led him to split place into two categories: anthropological place and non-place. Anthropological place encompasses those locales where there is an established knowledge of the site, where locals come together in a social network that defines and distinguishes the site. However, instead of looking to *space* to either 'free up' or activate such places as de Certeau might, Augé looks at our obsession with space with a suspicious eye. In contrast to de Certeau, Augé does not see anthropological place as inert or confining. Indeed, he views our obsession with *space* as indicative of the prejudices of supermodernity (Augé, 1995: 30–38).[10] 'The craze for the word "space",' claims Augé, '...expresses not only the themes that haunt the contemporary era (advertising, image, leisure, freedom, travel) but also the abstraction that corrodes and threatens them...' (Augé, 1995: 83).[11]

Disenchanted by what space offers, Augé turns to *non-place* as a more fruitful concept for understanding our current surroundings. Non-places are the architectural realization of supermodernity: they are sites through which the main mode of experience is travel. Airports, shopping malls, hotels, and superhighways (whether for information or vehicles) are the epitome of the non-place, but these sites merely push the travel metaphor into a whole catalogue of sites that we hurry past, allowing signs and tourist guides to tell us the features of the landscape without needing to stop (Augé, 1995: 84–86, 94–98).

Such theories prove ripe for our artistic efforts in the Plus 15s. The Skywalk System is, by definition, a site of travel, a non-place as it were. The bridges exist for pedestrians to pass through on their way to somewhere else, be it their office, a colleague's office, the food court, the bank, and so on. In fact, those who are not travelling are immediately suspect. On our first ventures through the system, we felt the continuous need to move on. Our first pause in the system (merely as investigative spectators) incited three pointed queries about whether we were lost and needed assistance. During filming, other Skywalk travellers would register annoyance or

downright anger at the impediment that we created (even though we were only constricting one 'lane of traffic' on the 'pedestrian highway'). Numerous times per day security personnel would pester us because of our stillness or our unusual movement in the designated walking area. I had to be able to name-drop an entire list of security bigwigs to prove our legitimacy. In one instance, we were strictly prohibited from experimenting on site and were chased out of three consecutive bridges.

Added to the behavioural restrictions and sense of surveillance, this non-place – with its identical signage naming the buildings or 'sights' to be witnessed if we were to turn left or right and head off on another route – brought up multiple questions of identity. Who were we in such a place of conformity? Among the business suits and random shoppers, who stuck out? The 'in-between', travelling nature of the Plus 15 bridges, as well as their position in mid-air, made us ponder our own role in the city. Should we vary our choices about how to present ourselves in these in-between non-places? Could the perception of anonymity in the Skywalk System enable us to try on new personas? Augé sees such questions as part and parcel of the experience of the non-place. As he notes, people using the non-place taste 'the passive joys of identity-loss, and the more active pleasure of role-playing' (Augé, 1995: 103).

Certainly this identity play informed *The Sanitastics* to a large degree. Freed from the need to wrestle with role-playing of a more conventional nature, I wallowed in the possibilities of futurism for both the choreography and the concept. In previous site works, I would have explored who *had* passed through the place, who *might have* lived and loved and died at a particular site. But here, in the anonymity of the non-place, I could fantasize and play with characters and creatures that had no semblance to reality. I could dabble in *what might be* – hence the play with superheroes and a flower-creature to symbolize some era outside of a real time or place. Like our culture's current investment in sci-fi movies and games – an endless list of comic book characters or figures from another world all pieced together with remarkable special effects – we too could find that escape into the *space* of quests and adventures.

Yet, all these attempts to escape to the freedom of space had an ironic foil: the everyday headaches and the subtle policing that curbed our escapist fancies; the checks and double-checks of paperwork and insurance permits; the calls to such-and-such municipal institution; the arguments about the public space of the Skywalk bridges and the discovery of each bridge's private ownership by Shell or Nexen or Husky Oil. Then there were the endless interruptions of filming as we were 'caught on tape' by the surveillance cameras and forced to explain ourselves. Even during our moves from one filming site to another (toting our supplies in plastic bags and looking like an itinerant circus or perhaps a homeless troupe), we received those uncomfortable glances or angry stares, the understated community policing to curb any perceived difference.

For, in reality, we were not really escaping, nor would we be allowed to. While we may have experienced that initial sense of freedom that de Certeau links to space, we quickly discovered the conundrums associated with anonymity in an overly controlled site. As Augé explains of airports, supermarkets, and other non-places, we would always be questioned about our identity in such environs. Although we may have experienced moments of perceived liberation after passing through a checkpoint, these would be fleeting and inevitably marked by another round of authoritative questioning. As Augé warns, 'the user of the non-place is always required to prove his innocence' (Augé, 1995: 102).

Does this mean that we gave in to the sensation of control, that we bowed to the strictures of the non-place? Or were our creative labours able to provide some questioning or critique of the Skywalk System? As our endeavours continued, we realized that for all the playful identities and fantastic narratives we explored, our main role seemed to be 'irritant to the powers that be'. The constant frustration that we brought to the overseers of the system – even when we attained the appropriate permissions – forced our efforts into a realm of critical engagement, planned or otherwise. As the flower-creature tripped her way through overly cultivated planters or scrambled up into the metal rafters of the Plus 15s, the true powers of surveillance chafed at our insolence. The non-place is not a site to be trifled with, they seemed to say, forcing me to make another series of phone calls to the higher-ups.

As the surveilling superheroes mercilessly hunt down the flower-creature, *The Sanitastics* stresses the strategies of authorities – in this case the sovereigns of oil and their municipal partners – to forbid any upset of the system's order. Any provocation of the worker bees must be looked upon as a threat and all semblance of organic matter, unless directly under the control of the authorities, must be immediately eradicated. Both on-screen and off, we upset the balance of the clean, orderly site that exists for the white-collar personnel to sustain their consumer culture throughout the day. By playing in the pseudo-garden spaces, we underscored the separation from the natural elements enforced by the Skywalk. By interrupting the flow of traffic, we highlighted the incessant and uniform movements of the non-place. By introducing bizarre characters and organic detritus as well as by giving the site a performative cleaning, we pointed to the strangely antiseptic, unnatural landscape into which the corporate workers insert themselves daily. And, in the end, we questioned the innocence of our culture's urban planning and how it circumscribes our daily lives.

Mingling trajectories

In these efforts, Augé does see some light in the darkness, and so do we. Augé notes that the non-place can never be absolute, that anthropological place can make inroads into these sites of travel. Non-place 'never exists in

pure form; places reconstitute themselves in it; relations are restored and resumed in it,' he acknowledges. 'Place and non-place are rather like opposed polarities: the first is never completely erased, the second never totally completed' (Augé, 1995: 78–79). In our experience of the non-place, we discover the truth of such a statement. For, while our voyage through the system unearths clear instances of place, non-place, and even the space of de Certeau or Tuan, it also exposes the intermingling of these concepts.

As we travel through the Skywalk System – as well as linger, impede, cajole, and investigate – we see a myriad of small tableaux that check our assumption of the system as merely a non-place. A mother and child dawdle at the window enjoying the warmth of the sun through glass; a woman pushes a cart with all her valuables through the system, food containers and family photos threatening to tumble at any moment; a young couple finds a nook to neck (three whole minutes before someone intervenes). In each of these moments, we witness *place* insert itself into non-place. We observe the efforts to reclaim the traveller's setting for daily activities of enjoyment, relaxation, breakdown, whether by way of phenomenological experience of the place or by adding an archaeological layer.

And, in our small way, we also initiate instances of escape, creative flights of fancy that expose and critique the character of the non-place, operations that turn it into a *space* of freedom as well as of critical engagement. A Brazilian couple tearfully approaches the flower-creature (Chalie Livingston) and tells her how much she reminds them of a journey home; instead of stopping us and asking for paperwork, a security officer (dressed in the identical blue shirt and black tie of the superheroes) mimics a dance movement he witnesses; a businessman hoots in surprise at our off-hand

Figure 13.2 Instigating moments of escape: The flower-creature attempts to break out of the confines of the non-place.

Photo by author

comment that it is casual Friday; a group of teenagers with prohibited skateboards shows off for us and asks to be in the film.

As the experiences add up, I perceive the leakage of place, non-place, and space into and through one another. In our creative work on site, we come across methods and/or events that promote one or another of these conceptions of our environment. I notice the blurred boundaries of the terms, but also the real potential for analysis in these concepts. Site work enables space, place, and non-place to come to life in a way that fosters scrutiny of the human–environment relation. It introduces radical movements and critical commentary that conjures thoughts of *space*, it offers up layers of history as well as sensory experiences of *place*, and it exposes our culture's fascination with the travel and speed of *non-place*. In other words, site-specific performances can spark a fuller dialogue about our terminology for and/or categorization of our surroundings. In doing so, such performances allow us not only to probe the theory and practice of site-specific art, but also to examine our urban planning, cultural mapping, architectural choices, and environmental treatment.

Notes

1 This chapter develops ideas presented in a previous article: 'Site-Specific Dance in a Corporate Landscape', *New Theatre Quarterly*, 26(2), May 2010, pp. 133–144, kindly reproduced here with permission.
2 *The Sanitastics* has been selected by jury for presentation at the 2011 Third Coast Dance Film Festival (Houston, TX), the 2011 Sans Souci Festival of Dance Cinema (Boulder, CO), the 2011 Oklahoma Dance Film Festival (Tulsa, OK), the 2011 Festival Internacional de Videodanza de Uruguay, the 2013 Sans Souci Festival of Dance Cinema on Tour (San Marco, TX), and for a three-month run at the EPCOR Centre in Calgary, AB through the Gallery of Alberta Media Artists. The film is currently available on TenduTV's 'Essential Dance Films' site on YouTube www.youtube.com/watch?v=IZomvuWhDCo&index=13&list=PLUxOzZYi1J1P-4sw2v5aVnfzgNlMTCNGw.
3 In Casey's other texts, he builds at length on this concept, arguing that society needs to reconnect to place for the good of humans and the planet (Casey, 1993, 1998).
4 Trisha Brown's early apparatus work, such as *Man Walking Down the Side of a Building* (1970), exemplifies this understanding of site work. For such pieces, Brown used the physical properties and details of a site to delineate the structure of her pieces. For example, for *Man Walking Down the Side of a Building*, she made sure that the length of the piece would be determined purely by the height of the building and the length of time it took for the performer, rigged in climbing gear, to walk from roof to ground.
5 Kwon's curious parenthetical commentary seems to imply that corporeal bodies, and the phenomenological information that they sense, somehow bring people together under a 'universal' banner. This begs the question: Do corporeal bodies, which clearly do not sense – much less interpret – identically through their corporeal forms, fundamentally undermine the very argument she is trying to make regarding the limits of the phenomenological model?
6 Although Kwon does not consciously employ the term 'space' to characterize this move away from the physical characteristics of a site to larger social

implications, her connotations about 'places' versus 'discursive sites' are akin to the arguments about place and space made by Kaye and Rendell.

7 Interestingly, at the very end of Kwon's text, she puts space and place into a list of oppositions and then ponders the limitations of such oppositional thinking for site-specific art practices. As she states, 'it is not a matter of choosing sides – between models of nomadism and sedentariness, between space and place, between digital interfaces and the handshake. Rather, we need to be able to think the range of the seeming contradictions and our contradictory desires for them together; to understand, in other words, seeming oppositions as sustaining relations' (Kwon, 2002: 166). Kwon's sentiments here, along with the thoughts on mobility by Nick Kaye, foreshadow the direction that the discussion regarding space, place and site work has taken recently. For more on site-specific art/performance and the 'mobility turn', as it has been called, see Fiona Wilkie (2012) and Kloetzel (2013).

8 Note that one would never say 'blank theatre *place*'; rather space is a key indicator of emptiness or *tabula rasa*.

9 The City of Calgary employs the term 'Skywalk' to discuss their +15 system; however, the series of suspended bridges is referred to in various ways throughout North America including the more common term 'skyway' or catwalk, skybridge, or +15 walkway.

10 Augé looks at supermodernity from the viewpoint of anthropological analysis. He defines it as the contemporary era of late capitalism marked by an excess of space, time, and information. Of particular interest to this analysis is Augé's statement: 'Supermodernity, though, makes the old (history) into a specific spectacle, as it does with all exoticism and all local particularity' (Augé 1995: 110).

11 Interestingly, Augé finds that space enters our experience more as a rushing past of a multitude of sites than as a thing unto itself; we are unable to grasp the *place*-ness of place in our overzealous and superficial efforts to see a string of tourist-worthy sites. Instead we register a list of sites barely seen and insufficiently experienced, or, as Augé describes, *space*.

References

Augé, M. (1995) *Non-Places: Introduction to an Anthropology of Supermodernity*, London: Verso.

Bowers, M. (2009) 'Choreography for Uncontrollable Contexts,' in Kloetzel, M. and Pavlik, C. (eds) *Site Dance: Choreographers and the lure of alternative spaces*, Gainesville, FL: University Press of Florida.

Carlson, A. (2009) 'An Interview,' in Kloetzel, M. and Pavlik, C. (eds) *Site Dance: Choreographers and the lure of alternative spaces*, Gainesville, FL: University Press of Florida.

Casey, E. S. (1998) *The Fate of Place: A philosophical history*, Berkeley, CA: University of California Press.

—— (1997) 'How to Get from Space to Place in a Fairly Short Stretch of Time: Phenomenological Prolegomena,' in Steven Feld and Keith R. Basso (eds) *Senses of Place*, Santa Fe: School of American Research Press.

—— (1993) *Getting Back into Place: Toward a renewed understanding of the place-world*, Bloomington, IN: Indiana University Press.

de Certeau, M. (1984) *The Practice of Everyday Life*, trans. by Steven Rendall, Berkeley: University of California Press.

Haigood, J. (2009) 'An Interview,' in Kloetzel, M. and Pavlik, C. (eds) *Site Dance: Choreographers and the lure of alternative spaces*, Gainesville, FL: University Press of Florida.

Kaye, N. (2000) *Site-Specific Art: Performance, place, and documentation*, London: Routledge.

Kelley, J. (1995) 'Common Work,' in Lacy, S. (ed.) *Mapping the Terrain: New genre public art*, Seattle: Bay Press.

Kloetzel, M. (2013) 'Have Site, Will Travel – Container Architecture and Site-Specific Performance', *Conversations Across the Field of Dance Studies*, (Vol. XXXIV).

—— (2005) 'Site Dance: A Deconstruction/Reconstruction of Community and Place,' in Bennahum, N. and Randall, T.M. (eds), *Dance & Community: Congress on research in dance*, Tallahassee: Florida State University, pp. 130–137.

Kloetzel, M. and Pavlik, C. (eds) (2009) *Site Dance: Choreographers and the lure of alternative spaces*, Gainesville, FL: University Press of Florida.

Krieter, J. (2009) 'An Interview,' in Kloetzel, M. and Pavlik, C. (eds) *Site Dance: Choreographers and the lure of alternative spaces*, Gainesville, FL: University Press of Florida.

Kwon, M. (2002) *One Place After Another: Site-specific art and locational identity*, Cambridge: MIT Press.

Lippard, L. (1998) *The Lure of the Local*, New York: The New Press.

Monk, M. (2009) 'An Interview,' in Kloetzel, M. and Pavlik, C. (eds) *Site Dance: Choreographers and the lure of alternative spaces*, Gainesville, FL: University Press of Florida.

Pearson, M. and Shanks, M. (2001) *Theatre/Archaeology: Disciplinary dialogues*, London: Routledge.

Pearson, S. and Widrig, P. (2009) 'An Interview,' in Kloetzel, M. and Pavlik, C. (eds) *Site Dance: Choreographers and the lure of alternative spaces*, Gainesville, FL: University Press of Florida.

Rendell, J. (2006) *Art and Architecture: A place between*, London: I.B.Tauris.

Rogoff, T. (2009) 'Carriers of Consciousness: The Role of the Audience in *The Ivye Project*,' in Kloetzel, M. and Pavlik, C. (eds) *Site Dance: Choreographers and the lure of alternative spaces*, Gainesville, FL: University Press of Florida.

The Sanitastics (2011) video dance, kloetzel&co., Calgary, AB.

Tuan, Yi-Fu (1977) *Space and Place: The Perspective of Experience*, Minneapolis: University of Minnesota Press; reprint (2001) Minneapolis: University of Minnesota Press.

waydowntown (2000) motion picture, Alberta Foundation for the Arts, et al., Calgary, AB.

Wilkie, F. (2012) 'Site-specific Performance and the Mobility Turn', *Contemporary Theatre Review*, 22(2), 203–212.

14 Stop. Look. Listen. What's going on?

Kate Lawrence

This chapter explores relationships between audiences and performers constructed by two site-dance choreographers, Susanne Thomas and Willi Dorner and considers how, in this type of work, a new set of rules of engagement are employed providing fresh opportunities for artists to engage with the public in different and unconventional ways.

Audiences for site-specific performance can range from individuals to small invited groups to the unsuspecting public and many other configurations in between. For example, Fiona Templeton's *YOU – The City* (1988) performed in New York was a performance journey undertaken by one member of the public at a time (see Kaye, 2000: 199–201). The work of performance company Punchdrunk, *The Firebird Ball* (2005), *Faust* (2006–7), and *The Drowned Man* (2013–14) were staged in large disused buildings in London and involved large paying audiences who navigated their own journey through a forest of installations. *Trainstation* (1998) choreographed by British-based dance artist Susanne Thomas, was performed in busy metropolitan rail stations to invited audiences as well as large numbers of unsuspecting travellers. Audience and public engagement can be, and has been viewed as a positive catalyst for social change in the sense that it provides an opportunity to redress a range of balances between performer and audience, such as light/dark, active/passive, moving/static and more. It is certainly something that artists working outside established institutional frameworks of presentation need to attend to, and in so doing, they exert considerable control over the form and conventions of the performance event and also face new challenges beyond the common remit of a choreographer working in a theatre. Inventive new ideas require risk assessments to ensure the safety of performers and audience and complex negotiations to acquire permissions for activities, particularly challenging for performances that occur in city streets.

In this discussion of Thomas' and Dorner's site-dance work, Rancière's notion of the emancipated spectator (2009) is used as a framework for analysis, alongside the ideas of scholars who have considered audience engagement, participation and community in site-specific art (Kwon 2004; Kester 2004; Kaye 2000; Pearson and Shanks 2001; Bishop 2006; and

Bourriaud 1998). The work of Susanne Thomas and her company seven sisters group is briefly traced from their inception in 1994 to the present day, in order to consider the range of methods with which they have chosen to engage with audiences and the public. There follows a close reading of Thomas' work *Boxed* originally created for three shop windows in Oxford Street, which I witnessed in 2006. It is also available on the internet and was reprised in 2012 in New Zealand. Additionally, *Boxed* (2006) will be compared with a description of Willi Dorner's *Bodies in Urban Spaces* (2007) (hereafter referred to as *BIUS*), in order to analyse in detail the different approaches these two choreographers take towards the urban environment and the different experiences they offer to audiences and performers. I analyse *Boxed* from the outside, as a member of the audience, whereas I discuss *BIUS* from the inside, as a performer in the 2013 edition in Bangor, North Wales. Occupying these two subject positions enables me to compare my experiences as a performer and audience member, focusing on the presentation of performers' bodies and their relationships with their audiences and spaces of performance with reference to the theoretical framework provided by Rancière (2009) and other scholars of site-specific performance mentioned above.

One of the most salient characteristics of locational choreographers is their refusal to accept the standard performance conditions of the conventional theatre, preferring instead to construct their own rules of engagement with audiences. For audiences, these rules might include inviting or requiring high levels of physical participation or free access to viewing and a choice of viewing positions. Given the logistical challenges posed by working in non-standard locations it is perhaps surprising that choreographers choose to do so. It could be argued however that site-dance appeals to choreographers because they are able to engage physically, intellectually and politically with the conditions offered by a range of spaces and through doing so, change the rules of engagement with site and (hopefully) influence their audiences and consequently the lives they lead.

Rancière's ideas on aesthetic separation and aesthetic community are outlined in *The Emancipated Spectator* (2009). Starting from the assumption that all people are equally intelligent, he questions the notion that specific authorial intention is readable in the artwork and therefore also challenges the capacity of art to transform social life in specific planned ways (2009: 60). He proposes instead that the artist creates a 'sensorium' that is superimposed or juxtaposed to the sensorium of everyday life creating a 'dissensus' (2009: 58). Site-specific performance practitioners and theorists Pearson and Shanks also use the term sensorium, which they describe as 'culturally and historically located arrays of the senses and sensibility' to account for embodiment and 'social experience' in their discussions of performance and archaeology (2001: 10). According to Rancière the artist 'conflates two regimes of sense – a regime of conjunction and a regime of disjunction' (2009: 58) in order to create a new community of sense by

drawing relationships between the two communities brought together (the everyday and the dissensual, 'as if' worlds). The audience member enters this conflation and constructs their own individual response that cannot be forecast in advance. Changes in the social lives of members of the public as a result of aesthetic experience or 'ruptures' in the everyday fabric of life are certainly possible, but cannot be anticipated by the artist (ibid.: 75).

Rancière's ideas follow a tradition of practice and scholarship which foregrounds a broadly socialist political approach to art. Situationist Guy Debord observed, 'constructed situations' were necessary to rupture the passivity of modern life in capitalist society and 'produce new social relationships and thus new social realities' (Bishop 2006: 13). Brecht, for example, expressly wished to activate the spectator in order to induce critical distance (Benjamin in Bishop 2006: 11) and Artaud's Theatre of Cruelty emphasized physical participation. According to Bishop, these ideas relating to theatre and performance were taken up by visual artists in the 1960s and the physical involvement of the spectator was 'considered an essential precursor to social change' (2006: 11). She goes on to identify three main characteristics of participatory artwork: 'activation; authorship; community' (ibid.: 12). These three factors are featured prominently in Rancière's theory. French art theorist and curator Bourriaud argues that an effect of globalization, increased mobility, increased mechanization of social functions and the proliferation of capitalism has rendered the public at large more and more passive and alienated and has diminished human 'relational space' (ibid.: 162). In response, he says artists have become concerned with 'intersubjectivity' in their work and that 'art is a state of encounter' (ibid.: 161–2). Borrowing Marx's term 'interstice' for trade outside the 'framework of the capitalist economy', he asserts that artworks can exist as 'social interstice' (ibid.: 161). So, an interstice can reside within the overall system, but provides opportunities for operating in other ways that counter the conventional methods, for example bartering within the capitalist system. Thus, as Rancière's 'rupture' suggests, artists can disrupt the common rhythms of everyday life by inserting themselves in this diminishing relational space and create 'tiny revolutions', moments in which this relational space can be expanded, and explored, before disappearing again into the 'superstructure constructed and determined by large-scale exchanges' (Bourriaud in Bishop 2006: 162). According to Bourriaud, these artists work at micro rather than macro levels, with local communities. This is echoed in the work of visual arts scholars and practitioners, such as Kester's (2004) consideration of conversation as arts practice, Kwon's (2004) critical analysis of site-specific art and identity and New Genre Public artists expressly working with socially responsible and responsive practices (see Lacy 1995). Inter-subjectivity and interaction are ever-present as themes in these works and the spaces in which they are displayed are 'devoted entirely to interaction', which Bourriaud calls 'relational space-times... concerned with negotiations, links and

coexistence' (in Bishop 2006: 166). He suggests that a spectator confronted by an artwork should ask the question: 'If there was a corresponding space-time in reality, could I live in it?' (ibid.: 167).

Susanne Thomas

German-born Susanne Thomas studied fashion and visual arts before coming to London to study dance in 1991. She has consistently and almost exclusively made site-specific dance works since 1994 and is strongly influenced by postmodernism, visual art and performance practitioners of the 1960s who 'pay meticulous attention to both the organization of the performance space and the relation between performer and spectator' (von Held 2002: 20). She describes two choreographic approaches she uses in making site dance: the first starts with the site as impulse, such as *Trainstation* (1998); the second starts with an idea that she wants to present in a non-theatre environment 'mainly for reasons of representation and the audience set-up' (in von Held 2002: 22). Typically, she works collaboratively with dancers and artists from other disciplines, notably, the designer Sophie Jump. I would argue that Thomas should be considered as the leading exponent of site-specific dance in the UK (see von Held, 2002: 20), despite the fact that her extensive body of work has received scant scholarly attention and limited financial support. This may be partly attributed to the fact that she has consistently and almost exclusively choreographed in and with unconventional locations. Operating outside the theatre institution brings a range of challenges for dance practitioners, including the lack of a touring circuit for work that disseminates it more widely, and a disruption of familiar practices of theatre attendance (for instance box office, foyer, seating, dimming of lights), and, as the term 'site-specific' suggests, it might be problematic to relocate such works because of their close ties to the spaces in which they are created. Indeed, Thomas was unable to find another location suitable for her 1999 work *Salomé*, yet *Trainstation*, originally made in 1998 for King's Cross and Waterloo stations, toured to several other train stations in Europe.

When Thomas founded seven sisters group, the word 'site-specific' had hardly been uttered on the dance scene despite having currency in theatre and visual arts discourse since the 1960s (see Kaye 2000; Kwon 2002; Pearson and Shanks, 2001; Wilkie 2002; and von Held, 2002). Since 2000, perhaps fuelled partly by the Arts Council Year of the Artist funding programme (see Lawrence 2007 and Wilkie 2002), site-specific dance has flourished in the UK. Dance companies, such as The Cholmondeleys, who operated conventional touring programmes to regional theatres developed site-specific projects, and a few dance companies such as Protein and Motionhouse have combined a focus on site-specific work alongside conventional touring theatre productions. What distinguishes Thomas is her consistent focus on creating work that stands outside the theatre institution. One exception, her

work *On Stage*, performed in The Place Theatre in 2000 'explored the site-specificity in a conventional theatre' (Thomas in von Held 2002: 22).

Thomas' background in visual arts and fashion has influenced her work not least in the cross-disciplinary collaborative approach she has developed with seven sisters group, which she runs with founder member and Associate Director, the designer Sophie Jump. She began her choreographic journey in 1993 as a student at The Place where she was invited by tutor Victoria Marks to make a piece for Vauxhall Spring Gardens in London. Her next major work was *Trainstation* (1998), a work for six dancers originally staged at King's Cross and Waterloo stations in London which then toured to several train stations across Europe until 2004. The work encompasses three different choreographic approaches to space and audience engagement. The first is an overt and operatic scale of performance: three women in very high platform shoes wearing diaphanous draped fabric stand behind the glass above the entrance to the now vacant Eurostar platforms at Waterloo Station: they are displayed to the public. The second is more discreet: a group of harried and hurrying 'commuters/travellers' with suitcases weave their way through the crowds, blurring the edges between performance and everyday life. The third stages a 'street performance': a private emotional moment – a farewell between lovers – is highlighted and the public spontaneously gathers in a circle around them. The performers' bodies are displayed initially, all but disappear as they merge with the public and finally reappear in an apparently impromptu emotional moment of street theatre.

The following year, seven sisters group produced *Salomé* (1999), based on the eponymous biblical character and staged in the decaying St Pancras Chambers as part of London's Spring Loaded festival. Audiences made a solo journey through the building, following a red thread, encountering several different Salomés along the way. This was a very different style of engagement with the audience and thematically much darker in content. Firstly, the event was ticketed, and the audience was given guidance on how to navigate the work: follow the red thread. Furthermore, audience members were captive in the space and their attention was carefully choreographed, whereas in *Trainstation* (1998) the public could choose to ignore the performance and carry on with their daily lives. *Salomé* was designed to address notions of 'abject female sexuality' by casting the audience as voyeurs in a series of encounters with the Salomés. In an interview with von Held, Thomas comments: 'the space opened up a lot of possibilities of how to play with voyeurism, which we couldn't have done in a traditional theatre, because everybody just sits down and looks, which is a voyeurism without consciousness' (2002: 22). Von Held observes that 'Thomas' alertness to the powers of spectatorial self-consciousness has been coupled with a strong interest in social and psychological themes, predominantly viewed through a feminist perspective' (2002: 20). This feminist focus in her work can be seen in the work analysed later in this chapter entitled *Boxed* (2006).

In many of Thomas' works, the audience are taken on a guided journey. This began with the red thread in *Salomé* (1999) and was developed in *The Forbidden* (2001) when the company created a maze in the Clore Studio at the Royal Opera House. In *The Forest* (2004), which took place in woodland at Newlands Corner in Guildford, the audience were guided by sound relayed through headphones. Latterly, she and Jump have developed videowalks, where audience members match filmed images playing on portable devices such as iPhones with the space around them, which often includes live performance. These include *Asterion* (2008–9) at the V&A, *Atalanta* (2010) at the Ashmolean Museum, Oxford and, most recently, *Like a Fish out of Water* (2012) at a series of lidos in London.

In *Boxed* (2006), it is the work, not the audience, that goes on a journey. It was originally performed in the windows of three Oxford Street department stores in London. According to the company's website, 'a woman in a box dances in a display window on London's busiest shopping street'. It asks whether 'the box [is] a place of constraint, a place of privacy, a trap, or a vantage point?' (n.d. accessed 25 November 2013). The following passage captures my first-hand experience of this work:

> 15 July 2006: I hear the noise of the busy street, of conversations and the clicks of camera shutters interspersed with the voices of children. I am standing on the pavement of Oxford Street, outside the John Lewis store, with a group of about 50 people. The only sign that a performance is about to take place is the sign on the window in front of us, which states: 'seven sisters group presents Boxed, a new solo for display'. We are looking at the window. Our bodies and the background of the street are reflected back to us. Inside the window is a young woman inside a life size wooden box, wearing light green shorts and a white Grecian shift. She is staring at us as we stare at her; the moment is uncomfortable. The reflections on the window behind which she stands give the impression that she is a ghost, a palimpsest upon which public desire is constantly expressed and erased. Our spectating bodies merge with her body, fragmenting it. Suddenly she falls forward, catching herself against the glass and coming into sharper view. She pushes back and throws her leg up the wall behind her. Her space for dancing is very narrow – perhaps 1 metre wide. She flings her body around the space, as if she were trying to make it bigger, trying to find the space to express herself more fully. This first section of movement is frantic, and all the while the reflections, particularly of a photographer in the foreground are pasted onto her body. The movements of the observers are pedestrian, small shifts of weight, gestures, a hand passing through hair; all serving to heighten the large, fast movements of the dancer.
>
> Her movements become more controlled, she paces the width of the box that contains her, with swift turns and flicks of her lower legs, interspersed with angrier, more violent movement with which she

Figure 14.1 Boxed by Susanne Thomas. Dancer: Kristin McGuire.
Photo: Kevin Davis

appears to try to break down the walls of the box. She appears to be measuring the box with her body. She reaches up to the ceiling revealing that the box fits her perfectly. As she accommodates herself to the space – or the space forces a constrained physicality on her body, her arms bend and she uses her elbows to push against the walls and the glass.

In the final section she strikes poses reminiscent of fashion models, strutting whilst big red double-decker buses pass behind us, reflected in the window. Buses oblivious to her plight; life goes on. One of the buses remains some time, the film *The Omen* is advertised on its side. She stands and stares out: a stand-off? A police siren adds to the noise of the street. For some time she looks out at the street, motionless; our movements as audience are highlighted by her stillness. She begins to crumple, her back curves, the smile on her face stretches into a grimace of pain. Her legs crumple under her, at impossible angles, she rises again, only to crumble once more to the floor, her face distorted against the glass as she slides down it into a heap on the floor. She looks broken. She twitches one last time, lifting her face to look at us – accusingly?

As audience members we are implicated in this display of the female body and her demise, physical and psychological. We witness the effect of display on the female body; the dancer's last efforts to stand up and conform to the image required of her finally break her; a powerful metaphor for the way in

Figure 14.2 Boxed by Susanne Thomas. Dancer: Kristin McGuire.
Photo: Kevin Davis

which women's lives and bodies are shaped and influenced by mass media representations of women. The shuffling of the audience reflected in the window that merges with the dancer's body emphasizes the uncomfortable statement being made here.

Willi Dorner

Bodies in Urban Spaces is the work of Austrian choreographer Willi Dorner, whose company, Cie Willi Dorner, was founded in 1999. It began as a photographic project at Impulztanz, Vienna in 2004, and was later developed into a performance event, which received its first performance in the Paris Festival Quartier d'été in July 2007. Since then, it has circulated internationally, including performances in London, Philadelphia, Moscow, Montreal and Seoul. According to his website, Dorner's intention in making *BIUS* is 'to point out the urban functional structure and to uncover the restricted movement possibilities and behaviour as well as rules and limitations' (n.d. accessed 3 October 2013). In *BIUS*, Dorner maps a journey through an urban landscape to be undertaken by a guided audience group who witness 'sculptures' along the way, created by single or groups of performers dressed in bright colours holding still positions. The performers are positioned to highlight aspects of the urban space, for example filling gaps or highlighting the rhythm of repeated urban design features. The performers are recruited locally through audition, although performers

from previous events are also invited to apply. The following passage describes my experience as a performer in *BIUS* in Bangor:

27 July 2013: twenty performers were chosen from a three-hour audition, held in the Maes Glas Sports Centre in Bangor, which included running, stopping, falling, jumping, games, following orders and contact work and ended with an endurance exercise holding a handstand position against a wall. The audition and subsequent project were led by choreographic assistant Dolan on behalf of Dorner. The success of the work has meant that Dorner is unable to attend all the editions in different countries; instead he followed the project closely, but at a distance. The initial route was proposed by Dorner from afar. Dolan then visited Bangor in advance of the rehearsals to walk the route and decide which locations would work in practice. The producers, North Wales based Migrations, working with Pontio, Bangor's new arts and innovation centre under construction, pursued permission for all the sites proposed. This was a huge undertaking: some 35 sites were proposed, ranging from the doorways of private residences to municipal benches and street furniture. Dorner and Dolan remained in constant contact via mobile phones throughout the rehearsal process. Dolan would send photographs of dancers in positions in the various locations and Dorner would comment and make suggestions for changes, thus retaining a degree of control of the project.

30 September 2013: nineteen performers gathered at Pagan's Pole (one performer was unable to participate due to illness), a pub/club at the bottom of Bangor High Street currently used to teach pole dancing, for four days of rehearsal culminating in four performances across two days. Performers who have taken part in previous editions of BIUS are often invited to join the group. In Bangor approximately a quarter of the performers were previous participants. According to Dolan, they are looking for performers with an ability to prevail in adverse conditions, a range of body sizes that will fit the urban spaces available, and a range of abilities: some positions require extreme flexibility, others strength and climbing abilities. Approximately two-thirds of the cast were dancers, the rest included aerialists/circus performers, climbers and martial artists.

Dolan introduced the project and plans for the week, stressing the need for fitness and a meditative endurance capacity required for maintaining uncomfortable static positions. In order to build these capabilities we undertook a two-mile run, followed by holding a still position with arms raised for an increasing duration each morning. The first three days consisted of creating the 'sculptures' along the trail. Dolan would often try several different people in a space to discover who fit best. The logistics of organising the group so that there

Figure 14.3 Bodies in Urban Spaces by Willi Dorner.
Photo: Jodie Williams

was enough time for performers to get between locations and set up the next sculpture was complex so there were many substitutions. The fourth day was dedicated to last minute changes and a dress rehearsal.

The audience gathered for the performance outside Penrallt Church on Friday 4 and Saturday 5 October 2013. An introductory talk was given explaining some of the rules of the performance, such as the need to stay with the stewarded group, and to move on when directed. After the talk, following a signal from Dolan, the performers surged from a hiding place, past the audience, running as fast as possible to their designated locations on the trail. The trail consisted of some 28 group, duet and solo 'sculptures' found along a route through Bangor. The sculptures filled their spaces in a range of ways. Some literally filled the space with bodies so that no space was left, for example number eight, which consisted of 11 people squeezed into the space under some stairs outside the main entrance to the university. Others focused more on body design in relation to the space, for example the twenty-fourth sculpture, referred to as chimney, in which five performers were wedged into the space between two buildings, using their legs to span the gap between their backs and feet. They faced alternate directions, creating a pattern in the space. Solos tended to be absurd: performers wedged behind lamp-posts holding plank-like positions at strange angles, as if they had been thrown into place. Other group sculptures were designed to appear like a disorganized heap of bodies piled on top of each other. Throughout there was a strong sense of visual design: all feet were flexed, hands and arms were carefully coordinated, for example, in the final sculpture we were directed to grasp our backsides with our hands. Attention to detail was extended to the simple costumes: jogging bottoms tucked into socks and 'hoodies' in bright contrasting colours. Dolan went through each position to check that the colours were different and complementary. We were asked to be careful not to reveal our flesh when in the static positions.

Performers were instructed to be in position before the audience arrived, to hold the positions until the audience left and then to run through the audience to arrive at the next position. Thus, the aim was for the audience to see only the sculptures and the running. In practice, large audiences on the Saturday performances meant that the performers needed to hold positions for longer and often needed to dissolve the sculpture before the audience had left, and similarly, audience members at the front of the trail were often able to witness a sculpture being formed. This meant that the performance had a fluid quality for the audience who had some agency in constructing their experience. They could decide to stay back to watch a sculpture being dissolved or rush ahead to watch the next one being formed. Audience members were particularly keen to take photographs of the sculptures, which were later circulated widely through social media sites such as Facebook.

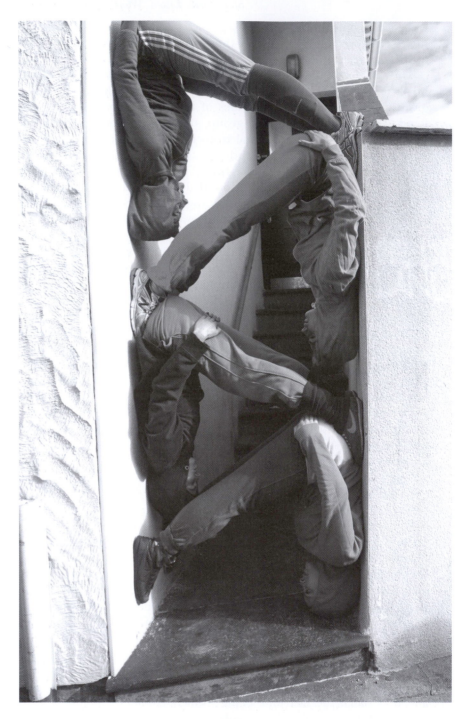

Figure 14.4 Bodies in Urban Spaces by Willi Dorner.
Photo: Jodie Williams

There was a set of rules for us as performers. We were instructed to keep our hoods up when running through the public and to lower them if we needed to walk or stay still (this was often necessary after holding a position for a long time). This was in order for performers to blend with the public when they were not running or holding positions. We were not to speak or engage with the public. We should negotiate between us to decide how small shifts could be made to make things a little more comfortable in the positions and to decide to come out of a position if it becomes unbearable by saying 'out'.

BIUS is a fairly gruelling physical and mental experience for the performer. From a physical perspective, holding quite extreme static positions, often folded in half, and then running to the next 'sculpture' places conflicting demands on muscles, especially hamstrings. Holding the still positions, often supporting the weight of at least one person, demands mental strength. There is also something sinister about lying in a pile of bodies being examined and photographed by the public and trying not to move. On the day of the first performance, listening to the radio, I heard the story of Faith Wambua and her two children Sy and Ty playing dead during the Kenyan Westgate shopping mall attack on 21–24 September 2013 (BBC 2013, accessed 1 December 2013). This played out in my mind as I lay at the bottom of a pile of people, listening to the voices of the public around me, and imagined the terror they must have felt.

Synergies: *Boxed* and *BIUS* compared

I proceed now to compare these two works, focusing on movement of performers, movement and actions of audience, barriers between audience and performers, sound, audience photography and colour. *Boxed* places a woman in a shop window but this body does not take to her situation quietly, she thrashes and swoons in her confined space. Her action perfectly expresses the difficulty of viewing the female body in a space of commodity and commerce. The audience is implicated by watching the action through the reflection of their own image in the glass of the shop window. In *BIUS* there is only stillness and running. Occasionally the audience might accidentally witness a sculpture being constructed or dissipating. Movement is functional, not expressive or abstract. The bodies in Dorner's work are packed into spare spaces in the urban landscape. They fill in gaps in the architecture by squeezing their bodies into confined spaces. Here the physical aspects of bodies in space are pointed out, whereas in Thomas' work, it is the social, political and cultural significance of physical gendered space that we witness. In Dorner's work the gender of the dancers is imperceptible for the most part, indeed it is rare for the audience to catch a glimpse of the faces of the performers.

In *BIUS* the audience struggles to keep up with the performers as they run through the city. They undertake a journey, guided by stewards in high visibility vests who urge them to move on in order to allow the performers to disentangle themselves, stretch and run to their next position. This is a very different journey to those taken in seven sisters group's work described earlier, where the guidance given to audience members is an essential element of the artistic vision of the work, such as the red thread that is followed in *Salomé*. Furthermore, audience members tend to experience the work alone, emphasized by the use of headphones or iPhones to direct them. Dorner's audiences are loud, unpredictable crowds who stop the traffic, take photographs, talk on their phones, and, at times, copy the performers. Unlike many of Thomas' previous works, the audience does not travel whilst they watch *Boxed* (although the piece travels down Oxford Street as it is performed in three separate shop windows). Yet their movement is highlighted and reflected back to them in the window. Their movements join and merge with the movements of the dancer and of the world behind them in the reflective surface of the glass and so they are drawn into the fabric of the choreography and its content. In *BIUS* the audience members are able to get very close to the performers, they go right up to them and take pictures of them; indeed, there is nothing to stop them touching the performers apart from propriety. In this sense the performers are truly vulnerable, often in positions that they cannot get out of without assistance as they are balanced precariously. Some of the positions are also inherently vulnerable – heads down, backsides presented to the public. A push and a poke and the performer/audience divide has been violated. Unlike *Boxed*, there is no sense in which the audience becomes part of the symbolic world of the choreography. In *Boxed* the performer symbolizes the vulnerability of women displayed publicly, but she is in reality protected (although simultaneously imprisoned) by the box and the glass behind which she performs. She cannot be touched, but she cannot escape our gaze. However, she looks back, unlike the performers in *BIUS*, who are instructed not to look at the public, and are usually in positions in which it is impossible for them to do so. In *BIUS* it is the body as object that is on display; in *Boxed*, it is the complex physical and psychological construction of a woman that we are asked to engage with.

In *BIUS* the audience are encouraged to take photographs of the performance unlike conventional theatre performances that often announce that the use of cameras is strictly prohibited. This enables the audience to construct an album of the experience which they can come back to at a later date and which they can share with friends and family via social networking sites. In this sense the audience is enabled to join in with the work and to author their own version of it. The performers are largely unidentifiable and yet I feel slightly awkward when I see yet another picture of my bottom circulating on Facebook. Far fewer audience members took photographs during *Boxed*, however the film on YouTube shows two

photographers with large cameras at the front of the audience, reflected in the window. The noise of the street includes sounds of their camera shutters. Their presence serves to underline the thematic material of the work; the dancer is on display in a shop window, on display as a dancer and on display to the cameramen. Yet the cameramen cannot always fully frame her body as it merges with the reflections of the bodies of the audience members. This is one of the powerful ways in which *Boxed* draws attention to the operation of the male gaze and at the same time subverts it.

The use of colour in these two works is dramatically different. *Boxed* is muted, almost monochrome whereas *BIUS* is vibrant. The former displays the flesh of the dancer, whilst the latter reveals none. The red Oxford Street buses stand out against the creamy white of the dancer's costume; she becomes porous, as if the desires of the watchers and the movement of the city can be projected onto her body, indeed, anything can be projected onto her body. The window behind which she stands provides the illusion that she is a palimpsest upon which the public gaze is constantly written and partly erased. In contrast, it is the performers who stand out against the environment in the streets of Bangor. They provide vigour and surprise in the urban landscape, flashes of brightness under a bench, behind a lamp-post or above a door. *Boxed* is squeezed into the capitalist machine of mass consumption to make an alternative point. *BIUS* operates as a commercial product, circulating in an international marketplace whilst the performers literally squeeze themselves into spaces in the local urban architecture.

Reflection: small revolutions in everyday life

Drawing on his previous work in the fields of politics and aesthetics, Rancière makes three propositions about community and separation. The first is the statement: 'apart, we are together' (2009: 51), suggesting that community is not necessarily about being physically together, but more a sensing of the presence of the other. In *BIUS* there is physical togetherness amongst the public and the performers as groups, but the operation of the gaze is unbalanced: the performers are unable to look back at the audience, they can only sense their presence. In *Boxed*, audience and performer are locked into a world of looking at each other and yet the window of the shop separates them physically. The performer is apart, distant and other-worldly.

The second proposition is that an 'empty place' for solitude and reflection might be required to repair poor community relations (Rancière 2009: 53–55). This is a metaphor that, like the blank page, invites expression. It calls us to make our mark somewhere where it is safe to do so and where the mark will be important and personal because it is apart from everyday life, it is made in emptiness, without witnesses. The performer in *Boxed* behaves as if she is in an empty place and in witnessing her outpouring of expression

we are made to feel uncomfortable: the empty place, which should be private, is on display.

The third proposition draws on Deleuze and Guattari's claim that the task of the artist is to 'twist… seize… rend' language 'in order to wrest the percept from perceptions, the affect from affections, the sensation from opinion' (in Ranciere 2009: 55). Everyday consciousness is thus raised to another level, creating a 'monument' that vibrates with the sensations that have been distilled from everyday experience and have been raised to 'the height of the earth's song and the cry of humanity' (ibid.: 56). 'Seizing' and 'rending' are aggressive, violent terms which feel somewhat appropriate to the process of making *BIUS*: during rehearsals we were shoved, pushed, squeezed and squashed into positions (albeit with good humour). However, what the audience sees is a series of still 'monuments'. In *Boxed* (2009), we witness these violent actions in the dance itself as the dancer is 'seized' and 'rended' before our eyes, echoing the often violent and depersonalizing processes undergone as females are posed and 'air-brushed' for consumption in the media and fashion industries. In *Boxed* the inner world of the woman on show is displayed through her actions, exposing her 'earth's song and the cry of humanity' (ibid.: 56) expressed in a slither of space on the busiest shopping street in the UK. In contrast, *BIUS* does not show the inner life of the performers as characters, rather it is the form of their bodies that is on display. The audience is invited to connect the 'sculptures' with their own experience, whether that is seeing a familiar place in a new light, or by inferring meaning through imaginative connections with their life experience. Either way, they will probably never see the same place again without remembering what they saw during the *BIUS* performance, mentally re-inserting the colourful bodies into spaces in the everyday urban landscape.

Regarding the notion of community, as referred to earlier in this chapter, Rancière proposes that 'a community of sense' has three forms (2009: 57). The first is a 'combination of sense data; forms, words, spaces, rhythms' that constructs a 'sensorium' (ibid.: 58). The second is 'dissensus', comprised of two conflicting sensoriums, the real, everyday and that which is constructed by the artist (ibid.: 58). For example, the placement of the bodies in *BIUS* forms a dissensus amongst the everyday familiar sensorium of Bangor. The single performer in the box in the shop window on Oxford Street is the 'dissensual figure' who interacts with and critiques the everyday shopping sensorium with its attendant globalized institutional structures. Lastly, 'the artistic "proposition" conflates two regimes of sense – a regime of conjunction and a regime of disjunction' in order to construct a new community of sense by drawing relationship between the two communities brought together: the everyday and the aesthetic imagined world (ibid.: 58). The effect of the 'artistic proposition' for the viewer is determined by the onlooker themselves as they enter the realm of conflation created by the artist. In performances in public places, this can range from ignoring

the performance altogether to watching half-heartedly, or seeing it out of the corner of an eye but choosing not to stop and watch. At the other end of the spectrum, audience members might actively participate; some of the young people who came to see *BIUS* copied the performers by squeezing themselves into small urban spaces or climbing on street furniture. According to Rancière (2009: 72):

> aesthetic experience... reframe[s] the relation between bodies, the world they live in and the way in which they are 'equipped' to adapt to it. It is a multiplicity of folds and gaps in the fabric of common experience that changes the cartography of the perceptible, the thinkable and the feasible.

These young people connected with a desire to play in and on the city, fuelled by the example provided by *BIUS* and the opportunities provided by the real folds and gaps, the social interstice revealed in the urban environment, acting on similar impulses to graffiti artists and the exponents of parkour or free-running. Thus they were experimenting with what it would be like to live in the space-time reality (Bourriaud in Bishop, 2006: 167) constructed by Willi Dorner in Bangor in early October 2013. Like Debord, who said 'constructed situations' were necessary to rupture the passivity of modern life in capitalist society (in Bishop 2006: 13), Rancière refers to these moments of participation as 'ruptures', which 'cannot be calculated', they may be triggered by art, or just as easily by any other event (2009: 75). He argues that artists that try to produce a particular social outcome through their work, for example, those who capitalize on the disruption and critique of spectacle, commodity culture and consumerism, simply re-iterate their power and achieve only 'self-cancellation' (2009: 76). They draw our attention to these things, but we already know about them. I believe that what he is suggesting is a more subtle and complex approach in which the sensory worlds of the everyday and the artist's vision are woven together in ways that surprise us and draw us in. Rancière is clearly deeply committed to equality and social justice, but he is equally deeply suspicious of the use of art as a calculated instrument of direct social change. He agrees that art does have the power to 'change lives' but how it does this is slippery and indeterminate and it should not be the job of artists to try to achieve measurable social improvements in the communities that experience their work. We have already seen that Thomas is concerned with spectatorial self-consciousness and psychological issues viewed from a feminist perspective; she does not try to pre-empt audience reaction but provides some rare reflection upon what she was able to observe audiences doing in reaction to her work *Trainstation* (1998):

> What was really nice about *Trainstation* was its humanising effect. People began to step out of their automatism. They started to talk to each

other, trying to work out what the hell was going on. The dancers suddenly seemed less important. Instead people started to wonder who was part of the choreography and who wasn't. They became aware of their unawareness of the space and the people around them, … In *Trainstation*, I understood that I was less interested in audience involvement than audience awareness.

(in von Held 2002: 22)

It seems, based on this reflection that she was entirely successful in activating some members of the public, and in return, the public showed her that she was interested in their heightened awareness of the space around them, facilitated by the performance. The work could therefore be seen to be a catalyst for raising critical consciousness about everyday space and activities and promoting social interaction.

Dorner, on the other hand, describes a direct correlation between his choreographic intention for *BIUS* and the effect he hopes it will have on the spectator:

The intention… is to point out the urban functional structure and to uncover the restricted movement possibilities and behaviour… By placing the bodies in selected spots the interventions provoke a thinking process… Passers by, residents and audience are motivated and prompted to reflect their urban surrounding and there [sic] own movement behaviour and habits. 'Bodies in urban spaces' invites the residents to walk their own city thus establishing a stronger relationship to their neighbourhood, district and town.

(Online, accessed 1 December 2013)

Whatever these two choreographers tell us about the relationship between their intentions and the effects their choreography has on the public, I would argue that by staging dissensual situations that puncture the familiar sensory fabric of everyday life, they provide the potential for small revolutions through these ruptures which open up social interstices previously hidden from view. These interstices invite alternative ways of behaving in everyday life; for example, standing in a group outside a shop window on Oxford Street for much longer than usual and stopping traffic by walking on roads in large groups. They also invite new ways of seeing and being in relation to the urban environment which linger in the memory. Finally, they encourage us to take space and time within quotidian reality and to take stock of political, social and ethical issues.

References

BBC News (4 October 2013) *Kenya's Westgate siege mother and children 'played dead'* [online] Available at: www.bbc.co.uk/news/world-africa-24394966 (Accessed 1 December 2013).

Bishop, C. (ed.) (2006) *Participation*, London: Whitechapel Gallery.

Bourriaud, N. (1998) 'Relational Aesthetics', in Bishop, C. (ed.) (2006) *Participation*, London: Whitechapel Gallery, pp. 160–171.

Cie Willi Dorner (n.d.) *Bodies in Urban Spaces* [online] Available at: www.ciewdorner. at/index.php?page=work&wid=26 (Accessed 15 October 2013).

Cie Willi Dorner (n.d.) *Body Trail* [online] Available at: www.ciewdorner.at/index. php?page=work&wid=27 (Accessed 15 October 2013).

Dance Umbrella (2009) *Cie Willi Dorner* [online] Available at: http://danceumbrella. co.uk/bodies-in-urban-spaces (Accessed 15 October 2013).

Kaye, N. (2000) *Site-specific Art: Performance, place and documentation*, London and New York: Routledge.

Kester, G.H. (2004) *Conversation Pieces: Community + communication in modern art*, Berkeley: University of California Press.

Kwon, M. (2004, 2002) *One Place After Another: Site-specific art and locational identity*, London: MIT Press.

Lacy, S. (ed.) (1995) *Mapping the Terrain: New genre public art*, Seattle: Bay Press.

Lawrence, K. (2007) 'Who makes site-specific dance? The Year of the Artist and the Matrix of Curating', in Rugg, Judith (ed.) *Issues in Curating, Contemporary Art and Performance*, Chicago: Intellect, pp. 163–173.

Pearson, M. and Shanks, M. (2001) *Theatre/Archaeology*, London: Routledge.

Punchdrunk (n.d.) *The Firebird Ball* [online] Available at: http://punchdrunk.com/ past-shows/article/the-firebird-ball (Accessed 1 December 2013).

Punchdrunk (n.d.) *Faust* [online] Available at: http://punchdrunk.com/past-shows/article/faust (Accessed 1 December 2013).

Rancière, J. (2009) *The Emancipated Spectator*, London: Verso.

seven sisters group (n.d.) *Boxed* [online] Available at: www.sevensistersgroup.com/ seven_sisters_group/Projects/Pages/Boxed_%282006,_2012%29.html (Accessed 25 November 2013).

seven sisters group (2006) *Boxed* [video online] Available at: www.youtube.com/ watch?v=ohQ1XI_hriM#t=16 (Accessed 15 October 2013).

seven sisters group (n.d.) *Salomé* [online] Available at: seven sisters group (n.d.) *Site-specific performance* [online] Available at: www.sevensistersgroup.com/ seven_sisters_group/Projects/Pages/Salome_%281999%29.html (Accessed 15 October 2013).

seven sisters group (n.d.) *Site-specific Performance* [online] Available at: www. sevensistersgroup.com/seven_sisters_group/About_us.html (Accessed 15 October 2013).

Seven sisters group (n.d.) *Trainstation* [online] Available at: www.sevensistersgroup. com/seven_sisters_group/Projects/Pages/Trainstation_%281998-2004%29. html (Accessed 15 October 2013).

Von Held, P. (2002) 'Beyond the Black Box' in *Dance Theatre Journal*, vol. 8 mp/4, pp. 20–24.

Wilkie F. (2002) 'Mapping the terrain: a survey of site-specific performance in Britain', *New Theatre Quarterly*, 18, pp. 140–160.

15 Witnessing dance in the streets

Go! Taste the City

Katrinka Somdahl-Sands

According to my analysis of the astrological omens, Pisces, the week ahead will be overflowing with paradox. Lucky danger may be headed your way, or a risky opportunity that will feel like an ordeal even as it brings out the best in you. I also wouldn't be surprised if you had encounters with benevolent trouble, exacting love, and weighty silliness. To thrive in the midst of these rich anomalies, you should suspend any prejudices you might have against puzzling evidence. Don't just tolerate the contradictions – love them.

<div align="right">(Olive Bieringa's horoscope the week of
August 12, 2005; Brezny, 2005a)</div>

There are contradictions in writing about street performances for the academic. How do you write (a representation) about actions and affects that are inherently unable to be represented? Is it possible to use non-representational theory (NRT) to understand a body as both individually performed and transpersonal? Methodologically, is it even possible to *present* events to the reader rather than *represent* them (Dewsbury, 2003)? In this chapter I revel in these contradictions and use autoethnography to 'witness' a performance where the artist, Olive Bieringa of the BodyCartography Project walked/danced/drifted down seven blocks of downtown Minneapolis, MN. I argue here that, in this performance Bieringa exposed her audience to a glimpse of the affect, the psychogeography, of an urban street by transgressing the assumptions about how we move in city spaces.

Dancing in the streets

I came to understand geography through my body. I learned about boundaries, and space, and movement in modern dance classes. It was only in graduate school that this visceral knowledge found an intellectual home in the discipline of geography. And still more years before my academic training in geography really changed my relationship to dance. It began when I responded to an unusual call for performers sent out over the

BodyCartography Project's list serv. I had been writing about this group from afar for my dissertation and this was a chance to meet them and perform with them.

What I knew about them was that the BodyCartography Project began in 1997 in New Zealand as an explicitly political and geographic dance endeavor. The Project has co-directors Olive Bieringa and Otto Ramstad. I knew that Bieringa was a classically trained dancer, while Ramstad's dance background was informed by a diverse set of physical practices, including Butoh and skateboarding. I had been drawn to them because of their stated commitment to use movement practices as a means to investigate and relate to their chosen performance environments. I loved how they spoke of transforming their own bodily spatial knowledge into observable actions for their audiences to reflect upon. I wrote (and published) a collage piece on their ability to actively engage with the sites where they perform and interpret those sites for their audience (Somdahl-Sands, 2003). I quoted Bieringa who said that, "as an artist my role is not to preach dogma, one opinion, but to offer people the choice to be free in how they think and act. As public artists we can offer an alternative range of choices to mainstream culture. Alternative ways of perceiving, responding and existing in the world, in public and with one another" (Bieringa and Ramstad, 2009) but I had little understanding of what that really meant.

And so I return to the story of the "unusual call for performers." The call was to join the BodyCartography Project in a public performance to promote a new tradition "Buy Nothing Day" on the busiest retail day of the year in the United States, the day after Thanksgiving. This was November 2004. The plan involved meeting at a downtown studio to get warmed up and learn some basic choreography, then setting out to dance in the city streets of Minneapolis, MN. After a very brief 40 minutes, we headed out into the stores, skyways and streets of downtown Minneapolis to dance and hand out flyers with information on the unorthodox "holiday."

It quickly became clear that the movement call and response with shopping carts in the aisles of the retailer Target was not particularly subversive. Nor was a slow motion walk through the skyways, or putting on the clothes for sale and then dancing in the department stores. As we performed I repeatedly stopped dancing to approach customers, many of whom believed we had been hired by the stores to entertain the shoppers: "you guys look just like those GAP ads you see on TV!" Despite the seemingly positive response to our antics by their patrons, security guards asked us to leave the various skyways and stores we attempted to use as performance sites. The only place we were left alone to dance and hand out our flyers was on the sidewalks of Nicollet Mall in Minneapolis.

Prior to this performance I had interacted with dance in "appropriate" sites – studios, stages, and while clubbing. This two and a half hour encounter with the dance practice of the BodyCartography Project was radically different from the studio, stage or club experiences of my past. It

was overwhelming. The sites and sounds of the city that I generally barely notice were ever-present as potential inspiration. Prior to this performance I had engaged with the city as a pedestrian, or driver, or most prominently at that point in my life as an academic. What I found was that I experienced the city in an entirely new way when dancing. The material and immaterial surfaces of the city exposed their textures to me; my encounters with others were fluid yet sharp as the disciplining of city spaces was felt on my body as we were forced out into the November cold.

For the first time my intellectual understanding of "[a]lternative ways of perceiving, responding and existing in the world, in public and with one another" became embodied. I actually have few conscious memories of my dancing that day. I was so "in the moment" that it didn't lay down traditional long-term memory. It entered my muscle memory, what Casey (2001) would call a somatic memory of place that fundamentally changed the way I witnessed bodies interacting with cityscapes.

Movement as encounter

Since that time I have been looking for a way to describe that experience and incorporate it into my academic practice. I may have found it in the writings of NRT. NRT is trying to find a way to discuss "the unsettled relationship between what we see and what we know" (Gordon quoted by Dewsbury, 2003: 1909). NRT is a response to the "cultural turn" in human geography. Since the early 1990s much of the writing in cultural geography has focused on representation (Duncan and Ley, 1993; Jones III et. al., 1997), yet not everything that is important is an "it" to be represented. Thrift used the idea of NRT to note all the things that elude representation. Senses, affect, and intuition are all present in our everyday lives and spaces, yet are very difficult to capture and represent. "The question ... is 'how do we witness ... the actualization of life as it happens in all its complexity?'" (Dewsbury, 2003: 1913). Latham argued that non-representational research needed to be reframed as a "creative, performative practice" (2003: 1994), while Dewsbury felt that trying to answer this question was "more an alternative research ethos that touches upon the small intricacies of life" (2003: 1913). In either interpretation, NRT views "the world as an endless set of contingent, practical, incomplete encounters between multiple corporeal and inorganic entities" (Castree and Macmillan, 2004: 473).

Dance is an exciting venue for exploring NRT because, "dance eludes rather than simply confronts or subverts power through its 'capacity to hint at different experiential frames,' different ways of being that cannot be written or spoken" (Nast quoted by Revill, 2004: 201). Within dance "the volume of the body careening through space is a primary source of knowledge" (Somdahl-Sands, 2006: 612). Dance uses the physicality of the body to articulate complex thought and feelings that cannot be easily put into words (represented). This idea was encapsulated by the modern dance

icon, Isadora Duncan, when she stated, "If I could tell you what it means I wouldn't have to dance it" (Lewis, 2010).

Dance creates a kinesthetic response, producing physical consciousness of the liberating potential of bodies in space (Tuan, 2004). Understanding the political implications of bodies in space has been the subject of much geographic writing (Nast and Pile, 1998; Nelson and Seager, 2005). The political possibilities of bodies dancing have been studied by geographers looking at events as varied as American social dance (Nash, 2000), nationalist dances in Northern Ireland (Morrison, 2003), and stripping as a mode of resistance by Filipina women (Law, 1997). Bodies put meanings into motion (Desmond, 1997) and dance is particularly well suited to use the body in motion to convey and disrupt societal norms of the body in space (Cresswell, 2006).

Thrift's NRT focused on bodily practices rather than interpretation (1997; 1996). "The body is not used to solicit telling testimony about people's lives, instead it becomes a device that enables the researcher to reveal the trans-human, the non-cognitive, the inexpressible, that underlies and constitutes social life…" (Pile, 2010: 11). This view of the body is about flows of affect, with bodies being multi-nodal and not passively placed in a single space/time. Nevertheless a NRT of the body should not be *anti* representation because the corporeal body is always mediated through social contexts, including place (Moss and Al-Hindi, 2008; Johnston and Longhurst, 2009).

The city is a crucial milieu for the social production and ordering of corporeality. The built environment conditions our access to points in space. It automatically links otherwise unrelated bodies making "possible different kinds of relations but in turn is transformed according to the subject's affective and instrumental relations with it" (Grosz, 1995: 92). The most common way of being aware of our bodies moving through city spaces is as a pedestrian. The unreflexive and habitual practice of walking unintentionally conveys societal conventions regarding the "appropriateness" of certain bodily actions. This is true to the point that the way one walks can reinforce (or disrupt) cultural practices of racial, ethnic, class, and gender differentiation (Domosh, 1998). The act of walking becomes a kind of performance. While walking is usually an unconscious act, dancing (particularly in the manner undertaken by the BodyCartography Project) actively and consciously manipulates the aspects that make walking an interesting and powerful point of study.

Methodologically, conveying an "event," like an ephemeral dance performance, is very difficult because it is a part of the world "that have little tangible presence in that they are not immediately shared and therefore have to be re-presenced to be communicated" (Dewsbury, 2003: 1907). How to do this is something I have struggled with, especially in the context of NRT, which is consciously "anti-biographical and pre-individual" (Thrift, 2008: 7). In the end, I decided that the only way to be true to the spirit of

NRT was to go against some of its established precepts. This re-presentation of the BodyCartography Project's performance is an autoethnography. It is what I saw, what I thought, and what I want to share. Although autobiography and autoethnography are not standard methodologies within geography, reflexive practices have gained acceptance and I wanted to use "myself as a source of information… I wanted to use my experiences the way I used [others] – to elaborate empirical links with concepts" (Moss, 2001: 3). "Good autoethnography is not simply a confessional tale… it is a provocative weave of story and theory… The researcher and text must make a persuasive argument, tell a good story, be a convincing "I-witness" (Spry, 2001: 713). I am using performance (as what I witness and as a process of exposure) to "turn the internally *somatic* into the externally *semantic*" (Spry, 2001: 721, italics in original).

Go! Taste the City

The performance of *Go! Taste the City* was "60 minutes of live improvised action, interaction and response to several blocks of real estate and real people in downtown Minneapolis" (Bieringa and Ramstad, 2009). The performance took place along a seven-block span of Nicollet Avenue in Minneapolis, MN that connects the downtown portion of the street to a section of Nicollet Avenue known as "Eat Street" because of its concentration of ethnic restaurants. Over the seven blocks "walked" during *Go! Taste the City*, the streetscape goes from "so clean, with corporate types in their suits" to "completely different populations and activities" as you get closer to the I-94 freeway overpass and then cross over it (Bieringa and Beverlin, 2006).

The performance began a few minutes after 5pm on 11 August 2006. There were approximately ten audience members standing near the clock tower at one end of Peavey Plaza on Nicollet Avenue waiting for the performance to begin. Of the many individuals who hang out, pass through or live in this Plaza of downtown Minneapolis, it was obvious who was here for the performance: we were predominantly young (mid-30s or below) and artsy looking, with fashionably scruffy clothes and hair, but the most telling feature was the cameras, not to mention our repeated looks at the clock to see if it was time for the performance to begin. After approximately five minutes, the woman handing out programs came over and let us know the performance had begun. None of us had noticed – we were looking at the clock, not into the plaza. When I first saw Olive Bieringa, she was lying face down in one of the few plots of grass in the plaza about 50 yards from where the audience had gathered (Figure 15.1). Bieringa was wearing a light blue pinstripe suit, running shoes, and had short spiky auburn hair. As she began to move forward with inch-worm-like movements I was able to see the bright orange T-shirt worn under the blue suit coat. Once she came to the edge of the platform she laid her body down and hung over the edge before stretching out to "fly" in the space above the sidewalk below.

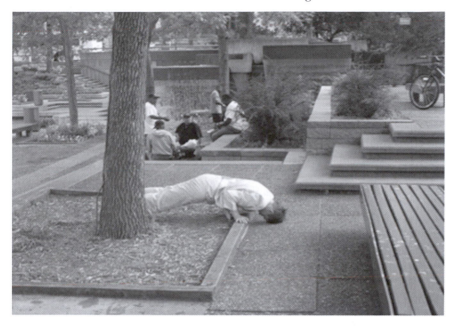

Figure 15.1 Olive Bieringa inching her way through Peavey Plaza, notice the men hanging out in the background.
Photo by author.

During the performance of *Go! Taste the City* I was repeatedly struck by the attention Bieringa paid to the texture of the materials on urban streets. At various points in the dance she swayed in the wind produced by automobiles passing below a freeway overpass, darted in and out of the dappled sunlight produced by the trees that lined the streets, shifted effortlessly between the moments of quiet and bustle of the street, laid in the street until the approach of a bus forced her back to the sidewalk, rolled and slid up and down brick embankments, and danced on the mounds of dirt produced by construction projects (Figure 15.2). At one point in the performance Bieringa entered a waterfall located in the corner of Peavey Plaza. As she stood at the edge of the waterfall, she tilted her face up and stood silently as the water's spray misted her. Appearing to revel in the sensation of the water, her arms slowly rose until they were in the position I have come to associate with evangelical prayer (Figure 15.3). Up until this point, the dozen or so people who were following Bieringa's progress through the plaza had done so from a comfortable distance, not coming too close. Yet after she entered the water, the audience began to tentatively enter the water too. Then, without any warning, Bieringa turned, ran, and left the sunken plaza area. After she left the waterfall one man went to the spot where Bieringa got misted and stood there getting wet. It was as if he wanted to experience for himself the sensation Bieringa had just shown us. At least

half of the audience who had been following Bieringa either joined in or stopped and watched this man playing in the water. After he left the water, I along with the other audience members dawdling by the waterfall followed Bieringa out of the Plaza and onto the street.

Over the course of the performance Bieringa had many encounters with other pedestrians moving along Nicollet Avenue At the very beginning of the performance she interacted with three men sitting on a wall, hanging out inside Peavey Plaza. Bieringa played a kind of "shell game" as she took a baseball hat off one of the men and tried it on the others in turn before returning the hat to its original owner. All the while, the three men were laughing and teasing Bieringa as a "crazy white chick." Further on in the dance, she went into a fashionable hair salon. Megan, a stylist at Olive's Salon told me that it is "fun when Olive [Bieringa] comes into the salon... It scares the clients," but it is "funny and bizarre... it breaks up the day".

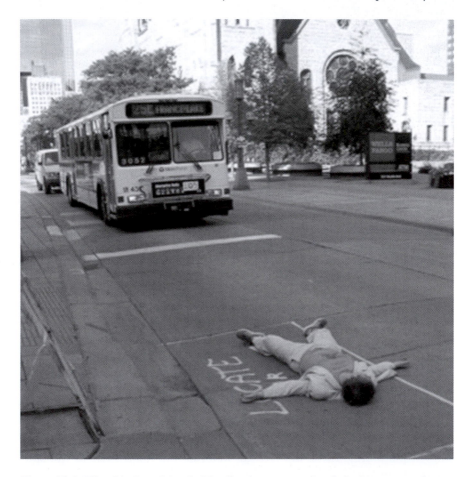

Figure 15.2 Olive Bieringa lying in Nicollet Avenue as a local city bus approaches.
Photo by author.

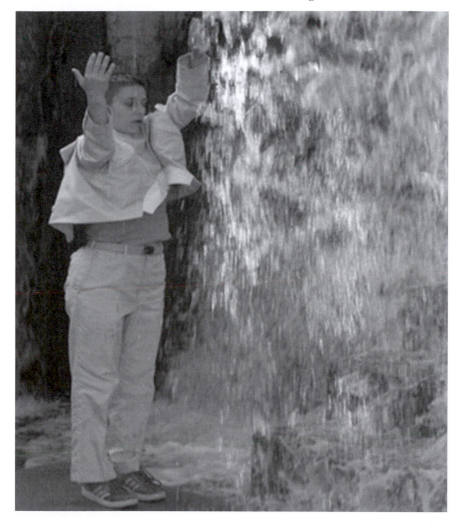

Figure 15.3 Olive Bieringa getting misted by the waterfall in Peavey Plaza.
Photo by author.

Moreover, during the performance she also had an impromptu duet with a patron at the New Dehli restaurant. After being evicted from the premises, a man who was seated at an outdoor table near the door, and who was obviously intoxicated, asked Bieringa what she was doing. She looked at him and said, "I am dancing down the street." The man responded by saying that he loves to dance, and got up out of his seat and began to move. His friends were laughing, the New Delhi employee who had just told Bieringa to leave looked less than happy, and our newest performer flailed around a bit. He was not quite steady on his feet so he kept his stance wide and most of his movements were isolated to his arms. As he moved them up and down

at his sides I was painfully reminded of a child playing a sea monster. Bieringa also took a wide stance and moved her arms creating arcs away from and then towards her own body. The two of them continued this arm duet until they made contact. While continuing to stand they began to turn like two cogs using each other for balance. After two or three rotations, and almost knocking over a parked motorcycle, Bieringa stopped the man by gently holding his shoulders from behind and directing him back to his friends who by then had out their cell phones and were snapping pictures.

However, the instances where members of the public chose to ignore Bieringa were as intriguing to me as when her audience chose to engage and "play with" her. There were three moments when the lack of interaction by her audience was particularly striking. The first was a moment when, while still in the "business-focused" area of Nicollet, Bieringa rolled onto her back and then lifted her feet into a shoulder-stand at a corner where people gather to wait before crossing the street. The passersby at the corner consistently pretended not to see Bieringa. At one point there were three office workers dressed in business casual who stood right next to Bieringa's feet (which were at chest level) and blithely continued their conversation without ever acknowledging her presence by look or action. I briefly followed these three office workers to see if their conversation might shift to what they had just seen once they were farther away from Bieringa. I cannot say that that did not happen eventually, but the conversation did not shift within the quarter block I followed them. Another moment of "invisibility" happened near the abandoned Marker Liquor store when another pedestrian walking towards downtown crossed paths with Bieringa as she tipped her body creating arcs as she walked. He was a tall (over 2 meters tall) man who looked like he might be Hispanic. He was wearing large dark glasses, a two-day-old beard, and wore the jersey of the local football team who had a game that night, the Vikings. He had a cigarette hanging out of his mouth at an improbable angle, but most notably he was wearing a horned helmet complete with long blond braids. As he walked by he avoided even looking towards Bieringa. Perhaps she was too weird. The express lack of attention paid to Bieringa in these two instances was particularly conspicuous in contrast to the dozen or so individuals looking at nothing but Bieringa. As we the "intentional" audience watched, filmed, took pictures and notes, the "accidental" onlookers ignored her.

In contrast to the above, the form of social "invisibility" was very different when Bieringa entered the International Corner Café primarily patronized by Somali immigrants, many of whom own and operate cabs in the area. As she danced in the front window, the men playing pool or checkers and drinking coffee in the shop completely ignored her. What struck me about this moment in the performance was not Bieringa's movements per se, but their context. The gender and ethnic balance of the café was only noticeable to me once it was broken. I had never taken the time to look inside this particular café any of the times I had driven down Nicollet Avenue

Furthermore, despite being ignored by the patrons of the International Corner Café, the dozen or so other audience members who stood outside watching the action through the glass were being watched. A police cruiser with two male officers went by, went around the block and then stopped across the street. They just waited, probably trying to see if we were up to some kind of mischief. After Bieringa emerged from the café and went leaping and turning through the intersection the policemen continued on their way.

We were of interest to the policemen because as a group we were breaking the rules of walking down the street. We were not just walking; we were in fact watching something intently as a group. Olive Bieringa's performance of *Go! Taste the City* transgressed "normal" expectations of how one is to move in public space. She raced a bus, then a bike; once she stopped and put up her dukes challenging a passing car, which she then raced after. She sat and waved at cabbies, swirled in the breeze, and picked up garbage. She did headstands in abandoned lots, baseball slides through intersections, and moved in slow motion for seemingly long periods of time. Yet, the disruptive potential of the piece came to the forefront for me when Bieringa began to walk down the center of Nicollet Avenue along the double yellow lines with a very large red rock she had picked up from the rubble of a construction site. At first, Bieringa walking in the street with a big rock seemed funny; the kind of humor that produces nervous laughter. The rock was so big it made her look like a child. But the humor soon became poignant and then somehow tragic. There was desperation to find one's own path as the cars went by on both sides going 25–40 mph. At one point a man who had been walking in the other direction came out into the road and walked alongside Bieringa for a couple of hundred feet. Eventually, he went back to his side of the street and continued on his way.

Bieringa told me later that the man had thought she might be suicidal and wanted her to come out of the street and let him call someone to come get her. At first, when the man asked what she was doing, Bieringa had just answered "I'm walking in the middle of the street." After it became clear how concerned for her safety he was, she explained it was a part of a performance and that she had no intention of doing herself bodily harm. After this, he wished her well and continued on his way. This passerby was not the only one to try and stop Bieringa – numerous cars honked, slowed down, or tried to switch lanes. Also, as Bieringa passed the Clicque beauty salon the stylists noticed Bieringa and began to bang on the windows, gesturing at her. Some of the audience members waved back at them. We were so secure in our understanding of the event – that it was just a performance – we were unable to see the concern expressed by those who did not know, those who thought that this was *real* and thus had a moral obligation to help Bieringa avoid injury. After the performance when Bieringa told me what the man had wanted, the cars and beauty salon took on a whole new meaning. It made me proud of the care displayed by

strangers, but it also made me question all the people who walked by and did nothing. Did they realize it was a performance, or did they not care? I also began to question the surety of the audience that Bieringa was safe. Did our alienation from the activity lead to complacency of the danger? Eventually Bieringa had returned to the sidewalk with her big rock and handed it to an audience member (who had no idea what to do with it – she eventually put it next to a building) and then Bieringa was off and running again.

Witnessing dance

> [T]he material is something – only it cannot be imposed (known), it can only be exposed (felt); that is why we are called to be its witness. To witness is to be called by an event…. Witnessing such spaces is not easy, it calls us to betray our roots in habitable modes of thinking… shifting the focus over so slightly to keep things alive, to be in tune to the vitality of the world as it unfolds.
>
> (Dewsbury, 2003: 1923)

The BodyCartography Project is able to de-naturalize and reanimate their chosen sites "by moving the dancers and the audience through it during the dance" (LeFevre, 2005: 46). Site-specific art is prized because of its presumed singularity and authenticity (Kwon, 1997). The presence of the artist creates an event, which endows the site with a certain uniqueness that cannot be repeated or even fully described. Art and place both have the power to move us because they each "present to us something other… the intensity of a work of art or the sensations of a dance, communicates its own meaning – it is just that it is on a different register to that which we are used to" (Dewsbury, 2003: 1914). NRT is committed to exploring this different register for knowing, looking for the affect of a space or event (Latham, 2003). However, NRT is not the first to try and understand these relationships (Seamon, 1979; De Certeau, 1984; Lefebvre, 1991; Benjamin, 1999; Routledge, 2005). In fact, there have been many city-based artistic movements in the twentieth century, from the Dada and Surrealists through to Fluxus and the Situationists, who have all used similar modes of traversing the city (Lucas, 2004: 1). All of these movements were using the aesthetic and creative implications of Flânerie as a thinking tool.

The flâneur in Benjamin's writings was an idle wanderer in crowded city streets (1999). The idleness was productive in that it is contemplative and directed by the unconscious (Benjamin, 1999: 453). Thus the flâneur is "writing rather than reading the city. This is an important distinction, as his [sic] spectatorship is an active one… creating a narrative as he goes along" (Lucas, 2004: 3–4). The flâneur was a decidedly masculine figure in the nineteenth and early twentieth centuries (Wolff, 1985). The anonymity of masculinity, the ability to be "invisible" in public space, allowed the flâneur

to observe and not be observed. The notion of the flaneuse remains questionable to this day. "Aimless strolling, 'street walking' per se, still conjures up connotations of prostitution, although it fits the definition of flanerie precisely" (Mouton, 2001: 6). Women have specific roles to play in public space – that of a worker or consumer (Wilson, 1992; Domosh and Seager, 2001). Participating in city life in other ways becomes a fundamentally transgressive and transformative act. "The city... becomes a new structuring presence that enables her and those around her to participate in an alternative model of spectatorship not defined by a strict subject/object dichotomy" (Mouton, 2001: 9).

Of the various artistic movements trying to understand the revolutionary undercurrents in city spaces through Flânerie, the one that speaks most clearly to Bieringa's performance and NRT is the Situationists International's (SI) notion of psychogeography and use of the dérive. Asger Jorn (1958) defined psychogeography as "[t]he study of specific effects of the geographical environment, consciously organized or not, on the emotions and behaviour of individuals."

The Situationists used a practice called dérive [drift] "to explore the hidden, non-physical connections between spaces, as well as to chart the patterns of desire within a space" (Lucas, 2004: 4). During a dérive "[o]ne or more persons during a certain period drop their usual motives for movement and action... and let themselves be drawn by the attractions of the terrain and the encounters they find there" (Plant, 1992: 58). A dérive is intended as a non-verbal discourse on urbanism; a method to *see* the "psychogeographical relief, with constant currents, fixed points and vortexes which strongly discourage entry into or exit from certain zones" (Debord, 1956: 50). Simply walking is not enough; the drifter is mindful, playful, constructive, and actively aware of the psychogeography of the space as she makes her "transient passage through varied ambiences" (Debord, 1956: 22). The feminist drift, like a flaneuse, becomes an act of progressive praxis, a critical device for being in the city.

It is this self-consciously critical lens that links the SI and NRT. Both are approaches that question the rationalist view that dominates much of modern life. They each seek to explore what is left out of the modernist storyline through play and experience. And, while both SI and NRT focus on the material realities, their mutual interest is in the more-than-representational. It is true they take different approaches, one closely linked to the Marxist French tradition, while the other is clearly an Anglo intellectual movement, yet they have similar critiques of what is missing from understandings of society. SI and NRT are both looking for a revolution in everyday life where things like art and life are not separated, and where people are freer to be creative and play. Therefore SI and NRT are referring to similar things in their writings, though with different language and in different contexts. So for instance, in the language of NRT the "varied ambiences" of a city street would be labeled as affect, which "is

spatially and temporally distributed and stretched out into various presences and absences" (Anderson, 2006: 736). Thus, Bieringa was responding to the psychogeography (or affects) of Nicollet Avenue on that sunny afternoon. Bieringa drifted down Nicollet Avenue. She was drawn to certain aspects of the streetscape and allowed her audience to understand the experience of being on a city street in a new way.

Self-propelled movement (like walking or drifting) creates a particular sense of place due to the direct contact with the environment through multi-sensory inputs. The sensing body must acknowledge the material characteristics of the environment, which includes the pyschogeography (the affects). Adams (2001) describes one manner of walking as "light peripatetic." Walking as "light peripatetic" is seen as a kind of ritual where one walks with the conscious intent of "attun[ing] oneself bodily and mentally with the universe and especially with nature" (Adams, 2001: 193). I would argue that the above characterization of walking fits what Olive Bieringa was doing as she walked/danced/drifted the seven blocks of Nicollet Avenue during *Go! Taste the City*. At a public showing of a short film made of the 2006 version of *Go!* that included Olive Bieringa and a second dancer, Bryce Beverlin, the two answered questions that directly address this concept. When asked how they trained for this performance, Bieringa began speaking by describing the difference between dancing in a city street and in a theater environment as:

> the world, literally. In the world [on the street], you can't rely on the reflexes built in traditional dance training. The dance floor is not even and it may start to rain. There is so much material to work from. Once you start making choices and stop just being overwhelmed by the stimulus, you are able to work with your environment.
>
> (Bieringa and Beverlin, 2006)

Beverlin continued, with Bieringa nodding in the background, "before you go you prime your mind, quiet your thoughts. You feel with your senses and become more aware of them. Once you really feel them, you are able to compose from them." Bieringa ended this discussion by stating categorically that, "The world is incredibly inspiring." This statement may sound banal, but in Bieringa's case it is one of the foundations to her dance philosophy. She dances in the public realm because she is inspired by what she finds there.

The performance by Bieringa was very much like a drift (dérive) in that it was meant to expose those edges within cities that lie below the surface of the social consciousness. By making the invisible barriers on city streets visible Bieringa's walk/dance/drift turned reconnaissance into action transforming the environment while observing it. The activity of dancing in a public street is not revolutionary in scale; but it can qualify as a "transgression" of public space (Cresswell, 1996). Site-specific art is able "to

be *out* of place with punctuality and precision… addressing the differences of adjacencies and distances *between* one thing, one person, one place, one thought, one fragment next to another" (Kwon, 1997: 109, 50, italics in original). Thrift describes this as situated creativity, which produces "new variations of actions… [that] generate a new model of human action" (2000: 272). The performance of *Go!* was "at best noticeable… at worst… can cause severe disturbance to… established methods of conduct" (Beverlin, 2008). Tim Cresswell argues that individuals and acts that transgress social expectations of spatial behavior denaturalize dominant norms thereby subverting, and revealing, the power relationships present (1996). The performance of *Go!* consciously used transgression as a form of resistance to the distinction between "acceptable" and "unacceptable" behaviors on public streets. The performances were intended to open new possibilities of playful practice, and consequently encountered strategies for disciplining space.

Bodies are restricted in cities by strategic surveillance, policing techniques, CCTV and aesthetic monitoring (Edensor, 1999; Davis, 2000). There is also the inevitable mixing with various social groups that occurs on city streets. Michel de Certeau describes how walking is tacitly used by urban pedestrians to create spaces of emancipation (1984) by composing a path, a fleeting creative inscription, which attempts to avoid the undesirable encounters and constraints. Yet when one steps beyond simply resisting the disciplining of space, and moves into transgressing those rules, then more concrete disciplining of public actions commences. Despite Trevor Boddy's claims that Minneapolis skyways do not allow for the performance of "a clenched fist, a giddy wink, [or] a fixed-shoulder stride" (1992, 123–4), it was only when dancing (moving in a way that was clearly more than just "a fixed-shoulder stride") in the skyways during the *Buy Nothing* performance in 2004 that Bieringa and her performers, including myself, were told to leave by security guards. Our regular modes of walking in city spaces make the other options of how to move invisible. And yet when the other options are shown, the security guards or police still them again.

Go! Witness! Then what?

It's time to play a game called Do-It-Yourself Horoscope! Here's how it works: I provide a skeleton outline of your fortune, and you fill in the blanks… Ready? Weave the following threads together to create your oracle. (1) The magic toy is within reach. (2) Sexy heresies are risky and wise. (3) It's good to take liberties as long as you do so with gentle sensitivity. (4) Are you smart enough to be pregnant with well-earned hope? (5) A funky asset is 18 percent larger than normal. (6) The sinewy, supple, serpentine approach will require all your concentration and provide all you need.

(Aries horoscope 18 August 2005; Brezny, 2005b)

The BodyCartography Project, and Olive Bieringa as its representative, transgressed the norms of city streets by adding a new practice: dance. Her performance of *Go! Taste the City* consciously resisted those rules which bind us to normalized modes of movement. She *chose* to skip, roll, slide, and swirl down a Minneapolis public street. She spun, raced, did headstands, and rolled around on the ground. Bieringa did not just move along Nicollet Avenue, she offered "[a]lternative ways of perceiving, responding and existing in the world, in public and with one another" (Bieringa and Ramstad, 2009). Her activities were not acceptable behaviors outside of performative experience. Yet despite, and often because of, the fact that her actions broke the rules, her performance was fun. Her dancing absorbed the attention of those who watched her; there was intensity to it. So much so that the people following her began to emulate Bieringa's actions by going into the water, entering an unfamiliar coffee shop, or crossing under fences to get a better view of her dancing. Through interacting with individuals, and with the streetscape, Bieringa used her moving body to reveal the psychogeography that was always already there. The de-familiarization inherent in performance just made it easier to see by directing the audience's intention/attention to the spaces between affect and action. Olive Bieringa was demonstrating a light peripatetic form of being in public. She inspired the adults who saw the performance to heighten their own sensitivity to places.

The particular place for the performance, a seven block section of Nicollet Avenue, was chosen because of the dramatic change that occurs over those blocks as Nicollet Avenue goes from a downtown hub of corporate activity to an ethnic area dominated by restaurants and groceries and the patrons of those establishments. Olive Bieringa engaged with the populations that inhabit Nicollet Avenue on a summer evening and was able to reveal how some bodies are more noticeable than others. When she behaved "normally" she was invisible, yet when she walked in the street she became the object of care and even interference. Bieringa describes her dancing as about "engaging with and revealing the landscape that is already there. It is not about dumping something into the landscape... [the performance] is a negotiation and an interaction with a public space... an opportunity to engage with people" that she would not ordinarily interact with during her day (Bieringa and Beverlin, 2006). Bieringa is very "sensitive to the situation [as she performs]. If someone wants to play with me – I'll play. I'm celebrating life with people" (Bieringa and Beverlin, 2006). She has noted that it is often individuals who have the option of being "invisible" in public space that are the most uncomfortable interacting with her. However it is important to remember that "the choice to 'belong'... does not belong to everyone equally... [T]he ability to deploy multiple, fluid identities in and of itself is a privilege of mobilization that has a specific relationship to power" (Kwon, 1997: 109).

Olive Bieringa's race, gender, and occupational status were explicitly juxtaposed against others she encountered as she moved through

Minneapolis' city streets. Bieringa was not the stereotypical woman in the city. Despite going into restaurants and hair salons she was not a consumer. Nor was she polite as she balanced on her shoulders with her feet in the faces of those who would not acknowledge her. Bieringa slid down embankments, picked up cigarette butts, and generally got very dirty. She used her female body to disrupt (transgress) what women "do" on city streets. "When streets effectively belong to cars, they cease to function as places" where people can gather and interact (Solnit, 1998: 3). Bieringa actively interacted with elements and individuals of the city that most take for granted or try to avoid. Her actions highlighted how different actors within society respond to difference, at least in this one instance. The clientele of the salon were scared of Bieringa's antics, a patron of the New Delhi restaurant joined in even after she had been thrown out of the establishment, and the Somali men at the International Corner Café ignored her completely. Many writers who comment on moving in public space focus on the strategies involving control by means of oversight and systems of surveillance. However, the performance was seen by persons of authority (police officers), by highly transitory individuals (the cabbies), and the general public. The relationship of surveillance in this case was much more nuanced than is generally described.

By engaging audience members both at the level of the mind and the body, Bieringa fostered a new sense of place; the street itself expanded. She asked her audience to consciously consider how meaning was entwined in their urban environment. While many of Bieringa's audience members were probably familiar with Nicollet Avenue they gained a whole new perspective of the radical changes that can occur in urban areas as they followed her explorations of the city street. The disparities between wealth and poverty were stark and tangible. There was no litter to pick off the street near the modern masterpiece of Peavey Plaza, yet the lot next to the abandoned liquor store was strewn with broken glass, plastic wrappers, and odd bits of metal. As Bieringa traversed those seven blocks, the white office workers in loafers and pumps gave way to cabbies, the intoxicated, and individuals like the wayward Viking who was clearly just passing through. Nicollet Avenue took on a whole new meaning for those who saw it under the careful guidance of Olive Bieringa. One does not need to "dance" down a street to become conscious of the "constant currents, fixed points and vortexes which strongly discourage entry into or exit from certain zones" (Debord, 1956: 50), one only needs to *slow down* enough to see them.

I was amazed when I went back to Nicollet Avenue to "map" the performance that she had covered in only seven blocks and that in those seven blocks there was so much to see and experience that I blindly walk by. For instance, despite living blocks off Nicollet Avenue at one point in my life, I had never really noticed the cabs, and their drivers, that this performance made me see as Bieringa raced them, waved to them, or hoped not to be run over by them. Conscious interaction with the city allowed the

invisible to become visible and action to replace reaction. I began to write Nicollet Avenue rather than read it. Thinking about traversing the city from within the framework of SI and NRT created the capacity in me to envision new ways to live and think about a familiar place.

NRT challenges us to recognize the centrality of what cannot be easily represented in everyday social practice and "demands methodological and interpretive strategies that build this recognition into their very core" (Latham, 2003: 1996). Dewsbury believes that "witnessing" an event "represents a genuine and important shift away from thinking life solely in terms of power knowledge... towards apprehending life knowledge, that which speaks to the affirmation of life itself, to our feelings, desires, and beliefs" (2003: 1928). In this performance the audience slowed down and was given the opportunity to see the constant currents of affect swirling in our city streets. Bieringa was not dictating my interpretation of her actions; she offered an alternative way of being in the world and then left it as a "do-it-yourself" performance. The audience was expected to weave together the images and then tell their own story. This is my story of the performance. I don't know if NRT is a magic toy, or my use of it is a sexy heresy, but it certainly feels like a sinewy, supple, serpentine path that hold the promise of hope.

References

Adams, P. C. (2001) Peripatetic imagery and peripatetic sense of place. In: Paul C. Adams, Steven Hoelscher, and Karen Till (eds), *Textures of Place Exploring Humanist Geographies*, Minneapolis: University of Minnesota Press, pp. 186–206.

Anderson, B. (2006) Becoming and being hopeful: Towards a theory of affect, *Environment and Planning D: Society and Space*, 24, 733–752.

Benjamin, W. (1999) *The Arcades Project*, Trans. Howard Eiland and McLaughlin, Cambridge, Massachusetts: The Belknap Press of Harvard University Press.

Beverlin, B. (2008) "Go" Web Page. URL www.insidesmusic.com/bryce/go.html (Accessed March 2008).

Bieringa, O. and Beverlin, B. (2006) "Go! Public Discussion." Minneapolis, MN: Bryant Lake Bowl.

Bieringa, O. and Ramstad, O. (2004) Shifting the territory alters the map, *Contact Quarterly*, 29, 2.

——— (2009) The BodyCartography Project. Web Page. URL: www.bodycartography. org. (Accessed October 2010).

Boddy, T. (1992) Underground and overhead: Building the analogous city. In: Michael Sorkin (ed.), *Variations of a Theme Park*, New York: Hill and Wang, pp. 123–153.

Brezny, R. (2005a) Archive Horoscope Pisces. Online: www.freewillastrology.com/ horoscopes/20050811.html (consulted September 2010).

——— (2005b) Archive Horoscope Aries. Web Page. URL: www.freewillastrology. com/horoscopes/20050818.html. (consulted September 2010).

Casey, E. (2001) Body, self, and landscape: A geophilosophical inquiry into the place-world. In: Paul C. Adams, Steven Hoelscher, and Karen Till (eds), *Textures*

of Place Exploring Humanist Geographies, Minneapolis: University of Minnesota Press, pp. 403–425.

Castree, N. and Macmillan Thomas (2004) Old news: Representation and academic novelty. *Environment and Planning A*, 36(3), 469–480.

Cresswell, T. (1996) *In Place/Out of Place Geography, Ideology, and Transgression*, Minneapolis, MN: University of Minnesota Press.

—— (2006) You cannot shake that shimmie here: Producing mobility on the dance floor, *Cultural Geographies*, 13(1), 55–77.

Davis, M. (2000) Fortress Los Angeles: the militarization of urban space. In: Michael Sorkin (ed.), *Variations on a Theme Park: The New American City and the End of Public Space*, New York: Hill and Wang, pp. 154–80.

Debord, G. (1956) Theory. In: Andreotti, Libero and Xavier Costa (eds), *Theory of the Derive and other Situationist Writings on the City*, Barcelona: Actar, 1996.

De Certeau, M. (1984) *The Practice of Everyday Life*, Berkeley, CA: University of California Press.

Desmond, J. (1997) *Meaning in Motion New Cultural Studies of Dance. Post-Contemporary Interventions*, Durham: Duke University Press.

Dewsbury, J.D. (2003) Witnessing space: "knowledge without contemplation". *Environment and Planning A*, 35, 1907–1932.

Domosh, M. (1998) Those "gorgeous incongruities": Polite politics and public space on the streets of Nineteenth-Century New York City, *Annals of the Association of American Geographers*, 88(2), 209–226.

Domosh, M. and Seager, J. (2001) *Putting Women in Place: Feminist geographers make sense of the world*, New York, NY: Guilford Press.

Duncan, J. and David Ley. (eds) (1993) *Place/Culture/Representation*, London: Routledge.

Edensor, T. (1999) Moving through the city. In: Azzedine Haddour and David Bell (eds), *City Visions*, London: Longman.

Grosz, E. (1995) *Space, Time, Perversion: Essays on the politics of bodies*, Routledge: London.

Johnston, L. and Longhurst, R. (2009) *Space, Place, and Sex: Geographies of Sexualities (Why of Where)*, Lanham, MD: Rowman & Littlefield Publishers, Inc.

Jones III, John Paul, Heidi Nast and Susan Roberts (eds) (1997) *Thresholds in Feminist Geography: Difference, methodology, and representation*, Lanham, MD: Rowman & Littlefield.

Jorn, Asger (1958) Situationniste Internationale No. 1 The Situationists and Automation, http://libcom.org/book/export/html/1843 (accessed 25 August 2010).

Kwon, M. (1997) One place after another: Notes on site specificity. *October 80*, 85–110.

Latham, A. (2003) Research, performance, and doing human geography: Some reflections on the diary-photograph, diary-interview method, *Environment and Planning A*, 35, 1993–2017.

Law, L. (1997) Dancing on the bar: Sex, money and the uneasy politics of third space. In: Steve Pile and Michael Keith (eds.), *Geographies of Resistance*, London, New York: Routledge, pp. 107–123.

Lefebvre, H. (1991) *The Production of Space*. Trans. David Nicholson-Smith. Cambridge, MA: Blackwell.

LeFevre, C. (2005) Riverfront awakenings, *Architecture Minnesota*, July–August, 46.

Lewis, Jone Johnson. 2010. "Isadora Duncan quotes" http://womenshistory.about.com/od/quotes/aisadora_duncan.htm accessed from www.about.com (September 2011).

Lucas, R. (2004) Inscribing the city: a flâneur in Tokyo, *Anthropology Matters Journal*, 6(1), 1–11. Available at www.anthropologymatters.com/journal/2004-1/lucas_2004_inscribing.pdf

Morrison, J.B. (2003) *Mapping Irish Movement: Dance, politics, history.* Ph.D. Thesis, New York University.

Moss, P. (2001) *Placing Autobiography in Geography*, Syracuse, NY: Syracuse University Press.

Moss, P. and Karen Falconer Al-Hindi. (2008) *Feminisms in Geography: Rethinking space, place and knowledges*, Lanham, MD: Rowman and Littlefield Publishers.

Mouton, J. (2001) Feminine masquerade to flaneuse: Agnes Varda's Cleo in the city. *Cinema Journal*, 40(2), 3–16.

Nash, C. (2000) Performativity in practice: Some recent work in cultural geography, *Progress in Human Geography*, 24(4), 653–664.

Nast, H. and Steve Pile (eds) (1998) *Places Through the Body*, London and New York: Routledge.

Nelson, L. and Seager, J. (eds) (2005) *A Companion to Feminist Geography*, New York: Wiley-Blackwell Publishers.

Plant, S. (1992) *The Most Radical Gesture*, London: Routledge.

Pile, S. (2010) Emotions and affect in recent human geography, *Transactions of the Institute of British Geographers*, 35(1), 5–20.

Revill, G. (2004) Performing French folk music: Dance, authenticity and nonrepresentational theory, *Cultural Geographies*, 11(2), 199–209.

Routledge, P. (2005) Reflections on the G8 protests: an Interview with General Unrest of the Clandestine Insurgent Rebel Clown Army (CIRCA). *ACME: An International E-Journal for Critical Geographies*, 3(2), 112–120.

Seamon, D. (1979) *A Geography of the Lifeworld*, New York: St. Martin's Press.

Solnit, R. (1998) The right of the people peaceably to assemble in unusual clothing, *Harvard Design Magazine*, Winter/Spring 4 available at: www.gsd.harvard.edu/research/publications/hdm/back/4solnit.html.

Somdahl-Sands, K. (2003) The BodyCartography Project: an Investigation of space, *Text Practice and Performance*, 4: 39–53.

—— (2006) Triptych: Dancing in thirdspace, *Cultural Geographies*, 13(4), 610–616.

Spry, T. (2001) Performing autoethnography: an Embodied methodological praxis, *Qualitative Inquiry*, 7(6), 706–732.

Thrift, N. (1997) The still point: Resistance, expressive embodiment and dance. In: Steve Pile and Michael Keith (eds), *Geographies of Resistance*, London, New York: Routledge, pp. 124–151.

—— (2000) Entanglements of power: Shadows? In, Joanne Sharp, Paul Routledge, Chris Philo, and Ronan Paddison, (eds), *Entanglements of Power: Geographies of Domination/Resistance*, NY: Routledge, pp. 269–278.

—— (2008) *Non-representational Theory: Space/Politics/Affect*, London: Routledge.

Tuan, Yi-Fu. (2004) *Place, Art, and Self*, Santa Fe, New Mexico: Center for American Places.

Wilson, E. (1992) The invisible flâneur, *New Left Review*, 191, 90–110.

Wolff, J. (1985) The invisible flâneuse: Women and the literature of modernity, *Theory, Culture, & Society*, 2(3), 37–46.

Part IV

Environmental and rural practice

Victoria Hunter

Working with landscape and rural environments presents site-dance practitioners with a particular set of challenges and specific artistic and philosophical considerations.

This section explores how this type of practice can provide distinctive ways of experiencing non-urban environments through corporeal encounters and considers how this work might facilitate the development and articulation of environmental knowledge. If this work presents challenges for site-dance artists, theorising it proves to be equally problematic, terms such as 'landscape', 'environment' and 'rural' and their associated definitions are heavily contested and criticised by academics as concepts loaded with connotations (i.e. romanticism, abandonment, escapism), misconceptions (i.e. wilderness, nature/natural, accessibility) and socio-economic implications. Whilst some of the chapters touch on these debates, an in-depth engagement is beyond the scope of this section. The central theme of these chapters focuses on the body's phenomenological engagement with the natural world emerging from the material and immaterial dimensions of a range of movement practices that share a common interest in somatic and pre-reflective experience.

The section begins with a chapter in which I consider coastally located site-dance practice as a liminal practice located between land, sea, earth and sky. The chapter questions why site-dance practitioners might be drawn to working in coastal locations and is informed by my own beach-site movement explorations. In the second chapter, movement practitioner Sandra Reeve presents a discussion of her systematic application of four dynamics of ecological movement to her developing investigation of site. Notions of an ecological engagement with landscape are further explored by Natalie Garret–Brown in her chapter that articulates her research concerns informing the *Enter&inhabit* series of movement–environment explorations. In the following chapter Malaika Sarco-Thomas applies Felix Guattari's (2000) notion of 'ecology' and transformative practice to her discussion of environmentally-based performance practice produced in Devon and Cornwall. This section concludes with Nigel Stewart's chapter in which he proposes four epistemes or lenses of knowledge through which

environmentally-based site-dance and corporeal-wisdoms can be evaluated. Through the application of phenomenological theory combined with personal reflection on the construction and performance of his site-dance and live artwork *Jack Scout* (2010) he provides the reader with an account from both inside and outside of the practice and challenges us to consider potential ways and means of categorising and evaluating subjective and affective experiences.

16 Dancing the beach

In between land, sea and sky

Victoria Hunter

This chapter[1] explores notions of how borders and boundaries between body and environment are explored by choreographers and movement practitioners engaging with coastally-located site-specific dance performance. The chapter considers the beach and coastal locations as liminal, hybridised sites comprising elements of fluidity and stability, permanence and impermanence, the wild and the urban, and discusses site-dance work located within these sites as a form of hybridised dance practice comprising elements of pedestrianism, dance and extra-daily movement.

In this chapter I explore a form of practice that engages with perhaps the most unpredictable and illusive of environments: the coastal landscape. This particular landscape has appealed to a number of choreographers in recent years including Anna Halprin, Rosemary Lee, Stephan Koplowitz and Lea Anderson all of whom have engaged with coastal locations through a variety of creative approaches. My own interest in this area stems from my experience as a practitioner-researcher exploring relationships between the site and the creative process within site-specific choreography.[2] As I began to move away from working in the built environment and prepared for a site-dance project within a coastal location[3] in Summer 2011, I explored a range of site-dance practice, both live and recorded that engaged with coastal locations.[4] I am personally intrigued by this particular form of 'liminal' dance work, existing physically on the borders between land and sea, comprising artistically hybridised components of pedestrianism, gestural, stylised and non-stylised dance and movement practice, situated on the threshold between choreographed dance performance and environmental movement practice. Some forms of this work markedly shifts towards one form of practice in particular, whilst others navigate a precarious pathway on the limen with occasional stumbles and forays into territories on either side. Both practices share commonalities of choreographic and corporeal curiosity and a fascination with the relationship between body and environment, flesh, sea and sky. The nature of both types of work often involves material being developed *in situ* enabling a significant relationship to develop between choreographer and

site-stimuli. Through this process the site actively informs the form and content of the work in a manner unpredictable prior to the choreographer's engagement with the site. Through working in this manner the choreographer effectively enters into a cyclical form of 'dialogue' with the site as each choreographic development presents an intervention within the site which in turn effects the practitioner's experience of the site, which then informs the following stage of the choreographic process. In this sense the choreographer's relationship with the site develops through a process of constant referral and co-existence through which the emerging work develops.

The beach

Q Why do choreographers choose to engage with this most unpredictable of locations? What appeals?

In order to explore questions regarding the beach's appeal for dance practitioners it is perhaps useful to reflect more broadly on the opportunities and potential for human interaction offered by beach and coastal locations. In his essay *Reading the Beach*, John Fiske (1989: 43) comments on the beach as a signifying 'text':

> The beach is an anomalous category between land and sea that is neither one nor the other but has characteristics of both. This means that it has simply too much meaning, an excess of meaning potential, that derives from its status as anomalous.

Figure 16.1 Site-dance exploration, Flamborough, Yorkshire 2011.
Photo: V. Hunter

It is, perhaps, the anomalous nature of the beach which, when 'read' as an experiential text through the body (as opposed to Fiske's reading of the beach as a social construct) which appeals to the site-specific choreographer and movement practitioner. The prodigious surfeit of sensorial information and corporeal 'meaning' afforded through the body's interaction with coastal locations offers an alternative approach to experiencing this location than proposed in Fiske's reading of the beach. Fiske's essay is pertinent to this discussion, however, as he provides a useful distinction between 'the wild beach and the suburban beach' (p. 57), each of which are governed by their own set of culturally determined codes and conventions. He continues to explore how, despite their (often rural) locations, beaches are subject to processes of control, construction and regulation similar to those employed in urban locations. For example, Fiske observes how, even in rural beach locations individuals are frequently subject to rules governing where and when to swim dependent on sea conditions and often social and cultural norms determine where, when and how individuals behave in this location (i.e. removing clothing and 'covering up').

In her paper *Beaches and Bodies* (2000), creative writer Jen Webb also acknowledges the beach as a cultural construct governed by 'erratically enforced social rules' (p. 1) but, through an exploration of the body as a primary form of experiential navigator in the landscape, she also identifies the beach as 'a place where the body (temporarily) wins the struggle between nature and culture, between social constraints and unspoken desires' (p. 1). Webb explores how the coastal environment invites the individual into an immersive experience not offered by other, everyday interactions with the world. The potential to dig into the landscape, run sand between the fingers, swim and take the site 'in' to the body is an experience not afforded in quite the same physical and experiential way by parks, rural landscapes or cityscapes.

The potential for freedom and the freeing up of habitual behaviours presented by beaches and coastal locations is an aspect also identified by Australian geographers Collins and Kearns (2010: 437) who refer to beaches as: 'places at which it is possible for predominantly urban peoples to experience ("reconnect with") natural elements and processes.'

The dance-film work *Tides*[5] (1982) by film-maker Amy Greenfield provides a useful illustration of this type of bodily interaction and environmental 'reconnection' presented by the beach location. In this work, the performer's body rolls slowly from the shoreline into crashing waves and becomes immersed within the sea-water. The dancer performs a series of rolling and rising actions, and non-stylised movements that appear to parallel the rhythms of the ocean and express the performer's sensual enjoyment of the environment. This sense of re-connecting with 'natural elements' (ibid.) of landscape and environment afforded at the beach potentially reminds us of our own organic relationship to the world and brings us back to more fundamental, bodily processes of engaging with the

world through a range of sensory, visceral and kinaesthetic processes. Jen Webb encapsulates this notion when describing her own experience of the beach: 'Absorbed by salty wind, deafened by the roar of water on rocks, overcome by rolling waves, disturbed by the plangent cry of gulls' (2000: 3).

Here, Webb captures the multi-sensory nature of the body–beach interaction, one in which our bodies are placed alongside expanded planes and horizons, vertiginous cliff edges, undulating sand dunes, topographies created (often) by natural phenomena of wind, rain and tides, occurring in stark contrast to the man-made regulated environments which we inhabit on a daily basis.

The beach as a liminal place of encounter is described by dance theorist Valerie Briginshaw: 'Beaches also exist between land and sea. As shorelines, they form borders and boundaries. They are particular liminoid or in-between spaces' (2001: 60).

A consideration of the beach as an 'in-between', liminal site offers up a degree of uncertainty and opportunity for those engaging with it. The unpredictability and precarious nature of this liminal place holds the potential to present the individual with new ways of experiencing and engaging with the world and, through so doing, invoke new-found experiences of self-awareness and potential ways of being-in-the-world, Webb observes:

> Think, for instance, of the peculiarly evocative relationship between the water and the edge of the land: the uncertainty and indeed the mutability of that edge's location metaphorises the uncertainty about where the body ends and the rest of the world begins.
>
> (2000: 3)

The exploration of this relationship founded the basis for my own, preliminary movement explorations conducted in a coastal location in North Norfolk (May 2010). The movement interactions engaged me in a walking exploration of the water's edge during which the balance point of my body was tested as I fell into and was supported by the stiff coastal wind. Through this exercise I began to physically explore the sensation of being suspended in the air, grounded by gravity whilst moving on the precarious dual limen between sea and shore, land and air. This precarious positioning called into question both physically and conceptually notions of located-ness, problematising where the body was situated in this exchange in a process that constantly shifted and changed with each movement and adjustment of the body.

This level of uncertainty encapsulates and amplifies the uncertainty of location, potentially leading to a questioning of the individual's locational 'fixity' and assuredness of the stability of place. Webb observes how this perceived lack of stability and associated problematising of location 'can be read as a metaphor for the insecurity always attached to ontological

questions – what am I? Who am I?' (2000: 3). Webb's observation helps to position the beach as a contentious and paradoxical place, offering up opportunities for pleasure, danger, escape and disappearance. Through the body's immersion into the sand and sea, rain and wind and, through the projection of oneself imaginatively and viscerally through the landscape into the vistas, planes and horizons beyond, the beach presents the opportunity to metaphorically escape from oneself and, in particular, the form of self practiced and performed (see Goffman, 1959) in everyday life situations. Leading to a sense of absence from the habitual social self and self-norms through entering into a state of limbo where everyday life, behaviours and actions are suspended. Paradoxically, however, when engaging with the beach we are also entering a physically unstable, dangerous place where self-preservation dictates that we *do* attend to ourselves to prevent sinking, drowning, stumbling and colliding with the environment. Through this process we are made very aware of our physical presence and its management within and negotiation of the site-interaction during which, any attempt to escape from attending to our physical self is prevented.

The potentially dangerous and unsettling nature of beaches and coastal locations can, perhaps, be linked to the very nature of their mobility that in turn highlights the impermanence of place. The changing tides and shifting sands of coastal locations embody and exemplify, in a very tangible sense, broader tectonic and environmental shifts. For example, geographer and spatial theorist Doreen Massey observes that the South West corner of England and its coast provide a pertinent example of landscape instability:

> This corner of the country is sinking back down over the millennia since the last ice age. And, bouncing gently a couple of times a day, as the tide goes in and out, Cornwall to the West goes up and down by 10 centimetres with each tide. There is no stable point.
>
> (2005: 138)

This lack of stability within an explicitly kinetic landscape perhaps explains why choreographers and movement practitioners are drawn to explore making work in beach and coastal locations. These liminal sites are themselves unstable in nature therefore offering up a wealth of opportunity for interaction and exchange between body and environment. UK-based movement practitioner Sandra Reeve encapsulates the essence of the site–body relationship encountered within these locations in her description of the 'ecological body', defined as:

> An immanent co-creating body: a body constantly becoming within a changing environment, where the body and the spaces in-between and around bodies are considered equally dynamic.
>
> (www.moveintolife.co.uk)

The dynamic interplay of body and environment as co-creators within the movement exploration and dance-making process is both exciting and challenging for practitioners as they navigate their way through the liminal landscape in which both the body and the art work exist in a process of becoming.

Choreographer Rosemary Lee highlights her own, personal experience of dancing and moving through the liminal beach environment and (referencing Massey, 2005) alludes to a sense of danger elicited by the untamed coastal environment:

> The coastline, for me, is the edge: it is the threshold; it's death; it's ever-changing. So, in terms of the rocks, the sea, every wave, is ever-changing. So, it's something about being at the beach. For me, as a child, that was about instability. There is never a stable point. Maybe dancing gives me a security in a very unstable world and that security is to be present in dancing.
>
> (Online, 2005)

Lee also identifies here a key point regarding the dichotomous relationship between the unstable, ever-changing beach location and the dancer's heightened sense of 'present-ness' elicited through the site–body interaction, expressed as a process of retreating back 'in' to oneself and experiencing a sense of centred-ness with the body-self acting as the central, stable point within this unstable location.

For the choreographer then, this particular site is already densely 'populated' with rhythms and kinetic and organic components with which the emerging choreographed and composed movement material has to relate and merge in order to produce a sense of 'fit' (Wilkie, 2002) between movement and site. The boundaries of the body in this process become fluid and permeable, through processes of engagement and immersion within the beach location and the 'messy materiality' (Longhurst, 2001: 23) of the body and its 'insecure boundaries' (ibid.) become exposed. Human geographer Robyn Longhurst (2001) explores theories of 'corporeo-geography' in considering the body's relationship to the world. In particular, she presents notions of the body's 'fluid boundaries' (2001: 23) as a challenge to ideas of fixity and impermeability between body and world, and through doing so, challenges us to consider the 'runny, gaseous, flowing, watery nature of bodies' (2001: 23). Longhurst's positioning of a porous, open body is exemplified particularly well through dance works that explore the 'messy' materiality of bodies in 'messy' coastal locations in which water, sand, mud and slime become enmeshed, embedded and *sited* within both physical entities of body and environment.[6] Coastal landscapes and, in particular, beaches, may therefore also appeal to choreographers because they provide an opportunity to get 'messy', to break out of the sanitised, enclosed world of the dance studio and engage with untidy

explorations with bodies in real-world locations. In this process, the idealised dancing body is afforded a set of freedoms in the coastal environment which, potentially, enable the body's 'messy materiality' (Longhurst, 2001: 23) to spill forth.

This open-ended liminality of coastal locations combined with an awareness of a porous and open body, pushes choreographers and movement practitioners to explore potential limits, boundaries and possibilities of the body in this particular type of landscape. The range of movement possibilities arising from the beach and coastal landscape interaction can appear endless, freeing up the choreographer from using codified movement vocabulary which may appear inappropriate or redundant in this context. More basic and simplified actions involving whole-body actions and reverting to processes of movement exploration that incorporate basic rolling, running and walking actions (see: *Tides*, Greenfield 1982) might appear most appropriate and relevant in this context. From my own experience of working with movement practitioner Helen Poynor on Charmouth beach, Dorset,[7] processes enabling the body to pause, 'listen' and respond to the environmental rhythms of sand, sea, wind and tides produced a form of 'organic' movement response with simple gestures, shifts of weight, reaching and rolling actions emerging from an internal impetus to move in harmony with the landscape as opposed to imposing oneself and one's actions upon it.

The practice

Q What occurs when, through movement practice, we introduce the body as the primary explorative mediator in this environment? What type of practice emerges?

When considering these questions it is, perhaps, useful to identify two categories or types of site-specific dance practice in order to explore differing site-dance approaches and their implications and effects in this context. Here, I distinguish between work that presents site-dance performance 'about' the place in which it is situated, and work that tells 'of' the site and location. The first type of work perhaps most resembles a 'choreographed' site work resulting from a creative approach in which the choreographer 'excavates' historical, thematic, visual and factual data from the site and feeds this information through a choreographic process and sequenced movement responses occur facilitated by the modified application of choreographic devices. The second type of work engages the choreographer and performer in a more holistic, environmentally responsive dance-movement practice that tends to focus on the exploration of improvised, organic movement responses, resulting in an immediate unfolding of process and product, a form of choreography-in-the-moment. Australian dancer-researcher Gretel Taylor (2010) describes this distinction

from a performer's perspective as: 'dancing in the place' as opposed to 'dancing the place' (p. 72).

Processes inherent in the second category of work may necessarily involve a form of solo practice as an immersive form of site exploration that is never intended for presentation in front of an audience member.[8] Equally, this approach may result in the presentation of a performed, structured improvisation sharing or may contribute towards the generation of movement content which may be formed into a fully performed work at a later stage.

In the first category of work, when creating dances 'about' the site, choreographers engage in a range of creative approaches aimed at amplifying and reflecting the site through the performance work and through the dancer's body and its movement. Approaches to designing and constructing movement material within this process can be defined as 'amplification' techniques, a term which I have applied to my own site-dance work (see Chapter 1). The process involves the devising of creative tasks that require the choreographer to observe and respond to the site's formal features informed by a knowledge and awareness of the site's historical, factual and cultural context. These tasks require the choreographer and performers to respond to the site as seen and to produce material that draws attention to the form and function of the site and the human behaviours existing within it.

Lea Anderson's work *Out on the Windy Beach*, performed in Brighton, UK (1998) provides a pertinent example of the first category of work and is well documented by dance theorist Valerie Briginshaw.[9] In the work, Anderson explored the theme of the beach and the social construct of the English 'seaside' experience and wove the work's content and narrative through a range of associated themes (myth, folklore, eroticism etc.) accordingly. In this work, 'the beach' was explored as a catalyst and a vehicle through which a range of political and artistic issues were explored. The focus of the work therefore, was not solely on the relationship of the body to its environment through processes of immersion, but instead it explored the beach as a backdrop, a scene for action and touched upon notions of liminality present within the location by exposing 'the range of borderlines and boundaries of bodies and space that can be explored in this coastal environment' (Briginshaw, 2001: 68).

Amplified notions of freedom, joy and a return to child-like experiences of play associated with the beach are explored in Rosemary Lee's site-dance film *Boy* (1995). This site-specific dance-film follows the actions of a young boy running on and rolling through sand dunes and captures the essence of child-like joy and 'wild delight' (Webb, 2000) experienced through his interaction with the beach environment of the UK's North Norfolk coast. Stephan Koplowitz's Liquid Landscape Project (Plymouth 2009 and touring) equally amplified and explored notions of playfulness invoked by the individual's encounter with the coastal environment. The project's

work located at the Tinside Lido site[10] presents a playfully choreographed response to the site through movement content that clearly references swimming, diving and water-play actions in a humorous and engaging manner. Busby Barclay-esque movement sequences and group formations reflect the vintage architecture and design of the lido site, creating a spectacle that extended the physical site into group action. Koplowitz's creative process here effectively 'activates' the site, embellishes and adds additional layers of meaning to the site by extracting hidden, dormant themes and making them visible to the audience through choreographed dance material. Themes of play, leisure, decoration and display are amplified and 'played back' to the site through a combination of pedestrian movement, gestural material and codified dance vocabulary.

Whilst this type of work serves to excavate site information, themes and histories and 'amplifies' the many layers of the site to the audience, it is, perhaps, the practice of those choreographers and movement practitioners who explore a phenomenological engagement with the beach and coastal landscapes as their primary source of movement inspiration and generation who can reveal, in more depth, essential processes of being and dwelling specific to this type of location through their practice.

Central to this second category of work are processes of immersion and embodied engagement with the site. This type of work is approached by practitioners in a number of ways, referencing her environmental site-dance practice, Gretel Taylor (2010: 73) discusses her own method of 'locating', stemming from a process of 'multi-sensorial listening' through which movement responses to the landscape begin to emerge: 'The locating dance is the relationship between my body and the place: it is simultaneously the seeking of relationship and the expression, enactment or illustration of it.'

This process of illustration and enactment differs from illustrative processes present within the category of work 'about' the site (discussed here in relation to Koplowitz's and Anderson's work). The 'locating' process described here by Taylor draws parallels with my own definition of site-specific dance 'abstraction' processes where the body's movement gives form to a range of phenomenological responses experienced through an embodied interaction with the environment. Abstraction approaches might involve improvisation or structured tasks that require movement practitioners to immerse themselves within and respond corporeally to the lived-experience of the site and in so doing, give form to those experiences through the creation of abstract movement material. Movement material resulting from abstraction tasks therefore tends to contain a more fluid sense of form unique to each individual dancer emerging from sensation and lived experience and is more personalised and less externally referential than movement resulting from amplification tasks. Barbara Collins, a participant in one of movement practitioner Sandra Reeve's *Move into Life* workshops provides an example of abstraction as she describes her

experiences of exploring the coastal location of Dunmoran Head in County
Sligo, Ireland:

> I could feel my energy rise with the sea. My arms were drawn into the
> movement and at times, it felt as if I was conducting the cacophony of
> sounds and the energy of the sea and the wind. At other times I was
> imitating the movements of the sea. Then I found myself absorbed by
> the sea and also found my breathing was deepening and was in harmony
> with the rhythms of the sea.
>
> (2006: 3)

Nigel Stewart's site-dance work *Jack Scout* situated in Morecambe Bay on the
UK's northwest coast (September 2010) provides a further example of this
type of work[11]. The performance explored a liminal world existing between
beauty and death, the wild and the urban presented through the device of
a narrated 'tour' led by a guide who directed the audience on a journey
through coastal woodland followed by a cliff-top walk during which the
audience encountered moments of solo dance performance.

The initial solos (choreographed and performed by Nigel Stewart)
combined a series of abstract, undulating movements that contracted,
expanded and flowed through the body echoing the performer's
phenomenological processes of encountering and engaging with the
landscape in which he was immersed. The final section of the work was
performed by a female dancer who danced an abstract solo through the
sands and mud flats of the surrounding Morecambe Bay. The solo contained
a series of gestural movements combined with rolling, reaching and sliding
actions that, with each iteration immersed the performer deeper in the
mud and slime and post-tidal residue. As an audience member myself,
resonances of danger and discomfort were immediately experienced
through processes of kinaesthetic and visceral empathy as an affect on my
own body encountered through processes of sensorial communication
transferred from the dancer's body to my own. This particular beach site
movement sequence exemplifies Longhurst's (2001) and Briginshaw's
(2001) observations regarding notions of bodily boundaries and body–
landscape permeability as, with each roll, turn and dive into the muddy and
slimy surface, the viscous and unstable body became enfolded within an
equally unstable and impermanent landscape. In this type of movement
practice and performance work then, notions of the body as a 'container'
are challenged as the 'otherness' of the landscape becomes enfolded within
the body-self, essentially creating a unity of subject/object, body/landscape.

Phenomenological considerations

The site-specific choreographer's process when creating work that immerses
the body within the beach and tells 'of' the site can be equated to human

geographer Christopher Tilley's (2008) discussion of phenomenology and impressionist painting, namely Cezanne's use of colour through which, he observes, the artist presented 'an echo of the world' (p. 24) as experienced through embodied perception. The resulting movement content emerging through phenomenological inquiry is not therefore, empirically representational of the environment but instead, expresses the mover's phenomenological response to the world in abstract form 'coloured' and 'flavoured' by their lived-experience of site.

The process involves an opening up of one's body to the environment, equitable to Tilley's notion of the 'phenomenological walk', described as:

> An attempt to walk from the inside, a participatory understanding produced by taking one's own body into places and landscapes and an opening up of one's perceptual sensibilities and experiences.
>
> (2008: 269)

Our interactions in the landscape therefore, not only leave a physical imprint, but also a perceptual imprint for the experiencer. One way of accessing this type of interaction is through the use of 'scoring', a process employed most notably by the American choreographer and movement artist Anna Halprin. Scores can comprise a simple set of instructions that guide the dancer/mover towards things in particular; in a site-specific context this might involve a focusing of attention and awareness towards particular site elements and components, atmospheres and energies. An example of a score employed during my own site-dance exploration of the Flamborough South Landing site encouraged participants to focus on their body's relationship with the horizon-line perceived through embodied awareness and to engage in an improvised exploration of their response to the phenomena encountered.

Through this type of process, I argue that a form of phenomenological 'reversibility' (Merleau-Ponty, 1968) ensues as, I affect the landscape through my movement interactions and it, in turn affects me, I then return to the interaction with a deepened sense of understanding and 'knowing' and the process of reversibility and reciprocity then deepens and develops in a spiralling format. During this process of experiential spiralling, reversing back and forth between body-self and site, I am proposing here that the experiencer enters into an experiential, interstitial territory in which both body-self and landscape are co-perceived. This territory can be illuminated through the application of Merleau-Ponty's notion of 'Le Chiasme' (1968) as a theoretical lens with which to explore the nature of the site–body-self interaction. Merleau-Ponty's notion of 'Le Chiasme' (1968) enables us to identify, in this context, an intertwining between body and world through an engagement within an interstitial territory in which body-self and site become entwined, overlap and engage in a 'messy' exchange facilitated by a process of reversibility. Merleau-Ponty in *The*

Visible and Invisible (1968: 136) describes this process: 'Once a body–world relationship is recognised, there is a ramification of my body and a ramification of the world and a correspondence between its inside and my outside, between my inside and its outside.'

This mode of movement inquiry, telling 'of' the site, foregrounds the body and the corporeal as the primary mode of engaging with the world and reveals a form of 'being-in-the-world' in which body and world entwine. Choreographer Nigel Stewart describes this as a process of dancing 'the fabric of the world into which I am woven' (2005: 370). This form of practice requires the mover to remain open, present and aware of the body in site and to respond instinctively through a form of pre-reflective practice in which the individual's sense of self is nevertheless present, Taylor observes:

> By becoming grounded and attentive to one's body's perceptual processes one is present in the moment, operating from what may be considered intuition or the instinctual aspects of self, without the need for any violent (or otherwise) abandonment of identity.
>
> (2010: 85)

Here, Taylor acknowledges the need for the practitioner to retain a sense of self within the moment of encounter, equitable to a process of 'embodied reflexivity' (Hunter, 2009) describing an individual's embodied process of noticing, processing and responding to their interaction with phenomena. As such, the subject remains present and aware of themself in the site and encounters an embodied and conscious experience of the world and of themself in the world unique to their body-self. Through this process of embodied reflexivity, the experiencer avoids becoming 'lost' within the interstitial, chiasmic encounter between body-self and environment. The exchange is experienced in the present, in the here-and-now, which, whilst inevitably containing resonances of the previous past moment, exists in a constant process of becoming facilitated by the body's action. Merleau-Ponty observes that, this process of overlapping and over-layering of spatio-temporal action creates: 'a link between a here and a yonder, a now and a future which the remainder of the instants will merely develop' (1968: 162).

This overlapping of past, present and future experienced at the beach and in the coastal site, amplified, abstracted and mobilised through the dancer's engagement and action perhaps illuminates the appeal of these particular sites for choreographers and movement practitioners. The physical act of walking in the sand, for example, is an act that, through the creation of footprints in the sand, at once lays bare evidence of the body's past, present and future actions. In this act, the temporality of action and its impermanence becomes immediately visible as traces of human interaction with the environment appear instantaneously only to crumble, wash away then re-appear moments later in a different yet recognisable form.

In this sense, coastal and beach locations appear as kinetic sites, sites of mobility and motility, paralleling human action whilst simultaneously operating as a metaphor for human processes of presence, absence and being-in-the-world.

Conclusion

Through creating work and dancing in coastal locations, this type of work enables choreographers and movement practitioners to explore and experiment, to escape from habitual creative approaches and to engage with an illusive and challenging stimuli and working environment. The illusive nature of the liminal coastal site can be viewed as a prodigious and liberating opportunity for site-dance practitioners as they are forced to engage with an ill-defined site existing in a constant process of becoming. The opportunities for discovering new creative approaches and working methods within this liminal landscape are, therefore, many and varied as the choreographer's aesthetic and artistic desires combine with some very basic and fundamental approaches to engaging with and surviving in this (often) exposed and wild landscape.

These basic forms of engaging with the beach (falling, slipping, walking, swimming etc.) necessarily require the individual to attend to the functional body in the moment in a manner which (in contrast to 'concert' dance forms) is very basic, unsophisticated and un-modified by outwardly imposed aesthetic or stylistic concerns. This organic form of movement practice therefore holds the potential to free up the individual's self-conscious and self-censoring mechanisms, essentially affording us a 'holiday' from our socially constructed sense of self and instead, enables the body to respond functionally to the demands of the environment and expressively to the corporeal and sensorial affect of the site–body interaction. During this process we effectively become immersed in the encounter with the environment, folding and enfolding into a state of 'being-in-the-beach' (Webb, 2000: 1). In this type of immersive encounter, the individual experiences a temporary cessation of a socially constructed, urban influenced 'self' as we re-engage with precarious terrain and re-connect with a form of self-awareness and self-knowledge encountered whilst being present in the moment of interaction.

This type of work potentially offers up other modes and ways of 'knowing' and experiencing landscape, providing additional layers of information and bodily knowledge with which to consider landscape and 'map' beaches and coastal places. Tilley (2008) explains how the embodied, phenomenological approach challenges representational modes of landscape research mediated by 'various representations and abstracted technologies' such as 'texts, photographs, paintings, sketches, maps, etc.' (p. 266). He observes that these modes of representation essentially remove the subject from the experience of landscape, the knower from the known,

the mover from the moved: 'This is never a lived landscape but it is forever fixed in the words or the images, something that becomes dead, silent, and inert, devoid of love and life' (2008: 266).

Through entering and engaging with landscape, however, we inevitably capture and absorb something of its essence and re-connect with an essential mode of being-in-the-world experienced through the body, a process amplified and abstracted through the creative process.

Site-specific dance practice occurring in coastal locations therefore serves to draw our attention to a familiar landscape and challenges movement practitioners, performers and audiences to engage with the site in an unfamiliar way. Through moving, extending and abstracting our everyday, habitual modes of interacting with the beach and amplifying these actions through extra-daily expressive actions and gestures, the individual learns to experience the site in a new-found manner. This practice then places the familiar alongside the unfamiliar, challenging our pre-conceived notions of the beach as a fixed and familiar entity, presenting new modes of physical and perceptual engagement to individual movement practitioners and audience members.

Furthermore, for the individuals who physically explore and engage with this type of work, the practice holds the potential to invoke a heightened sense of presence as, through the body–site intervention we engage in a process which identifies the body as the centre-point, the stable location from which we can act in this very unstable environment. Whilst this interaction necessarily blurs the boundaries between body and site, requiring a receptive, porous interaction between the two, the individual is still required to be present in the interaction, assured of their body's centrality, stability and sense of gravity. In this sense, the body operates as the site of interaction and the coastal location operates as a catalyst for both physical and self-exploration through which the body itself becomes a site for investigation and new-found discoveries relating to processes of present-ness and modes of being-in-the-world.

Notes

1 Ideas in this chapter are developed further in relation to theories of human geography and non-representational theory in: Hunter, V. 'Dancing-Worlding the Beach: Revealing Connections through Phenomenological Movement Inquiry' in Berberich, C. (2015) *Affective Landscapes in Literature, Art and Everyday Life*, Farnham, Ashgate Press.
2 Productions include work in a disused basement site (*Beneath*, 2004), a public library (*The Library Dances*, 2006) and *Project 3* (2007), a durational dance installation and *x3* (2010) a site-specific dance film.
3 This work took place on the East Yorkshire coast as part of the *Wingbeats* project, an interdisciplinary arts project directed by Adam Strickson, commissioned as part of the Cultural Olympiad.
4 This work includes Nigel Stewart's *Jack Scout* (Morecambe Bay 2010), Stephan Koplowitz's *Liquid Landscapes* project (Plymouth 2009 and touring), Rosemary

Lee's site-dance film, *Boy* (1995), Lea Anderson's *Out on the Windy Beach* (1998) and dance film *Tides* by Amy Greenfield (1982) and the environmental dance practice of Sandra Reeve and Helen Poynor.

5 *Tides* can be viewed at: http://vimeo.com/8371967 and via the Hayward Gallery archive, London.
6 See dance film *Tides* (1982).
7 See Helen Poynor 'Walk of Life' workshops: www.walkoflife.co.uk/helen.htm
8 See movement practitioner Helen Poynor's work (above).
9 See Briginshaw, V. 2001. *Dance, Space and Subjectivity*, London: Palgrave.
10 See: www.youtube.com/watch?v=Nic6dpU0jag
11 A detailed discussion of this work is presented in Chapter 20 of this volume.

References

Briginshaw, V. (2001) *Dance, Space, and Subjectivity*, New York: Palgrave.

Collins, B. (2006) 'Environmental Movement at Dunmoran Head', *Inside Out: The Journal for the Irish Association of Humanistic and Integrative Psychotherapy*, No 48, Spring 2006.

Collins, D. and Kearns, R. (2010) 'It's a Gestalt Experience: Landscape Values and Development Pressure in Hawke's Bay', *Geoforum*, 41(3): May 2010.

Fiske, J. (1989) *Reading the Popular*, Michigan: Unwin Hyman.

Goffman, E. (1959) *The Presentation of Self in Everyday Life*, London: Penguin.

Hunter, V. (2009) *Site-Specific Dance Performance: The investigation of a creative process*. Phd Thesis [unpublished]. University of Leeds.

Lee, R. (2005) *Making Space*, Rescen symposium transcript, RIBA, 12/1/2005 [online] [accessed 10/10/2012]. Available online: www.rescen.net.

Longhurst, R. (2001) *Bodies: Exploring fluid boundaries*, London: Routledge.

Massey, D. (2005) *For Space*, London: Sage Publishing.

Merleau-Ponty, M. (1968) *The Visible and the Invisible* [Trans: Alphonso Lingis]. US: Northwestern University Press.

Reeve, S. *A Sense of Place: Reflections of environment in Dance Movement Therapy* [online] [accessed 1 September 2010]. Available online: www.Moveintolife.co.uk.

Stewart, N. (2005) in Giannachi, G. Stewart, N. (eds), (2005). *Performing Nature: Explorations in Ecology and the Arts*, Bern: Peter Lang Publishers.

Taylor, G. (2010) 'Empty? A critique of the Notion of "Emptiness" in Butoh and Body Weather Training', *Theatre, Dance and Performer Training*, 1:1, February 2010, pp. 72–87.

Tilley, C. (2008) *Body and Image: Explorations in landscape phenomenology 2*, California: Left Coast Press.

Webb, J. (2000) Beaches and Bodies [unpublished conference paper]. 'On the Beach' Conference, Cultural Studies Association of Australia, University of Queensland, Brisbane, December 2000.

Wilkie, F. (2002) 'Mapping the Terrain: a Survey of Site-Specific Performance in Britain', *New Theatre Quarterly*, Vol xv 111 (Part 2, May 2002), pp. 140–160.

17 'Moving beyond inscription to incorporation'

The four dynamics of ecological movement in site-specific performance

Sandra Reeve

The well-rehearsed objection to site-specific dance and movement performance is that it tends to seek to impose a perspective, an interpretation on a landscape, to treat the outdoors as a backdrop to the real performance and to convince an audience of a chosen way of seeing it.

So, within a broader practice called *Move into Life*, my research into site-specific performance has been to develop a somatic, movement-based performance practice that 'incorporates' the site into the performance and its audience, whilst allowing performance and audience to 'dissolve' into the site; to become incorporated into it.

Move into Life is an annual programme of movement workshops that teaches the art of being in movement. Within this practice I move between the various roles of teacher, facilitator/director, movement artist and movement therapist. My approach draws primarily on my 26 years of study and collaboration with Javanese movement artist Suprapto Suryodarmo and his practice of Joged Amerta,[1] on the practice of Satipatthana[2] and on Physical Theatre.

Ecological discourses (including, at times, eco-psychology) urgently advocate changes of attitude towards the environment and the prioritising of ecological literacy within education (Bates, 1962; Sewall, 1995; Goodwin, 2002; Harding, 1997). However, these discourses do not necessarily reflect on how bodies, conditioned by an alienated view of themselves at the centre of the world, or at the pinnacle of a hierarchy of usage, can be trained to reconnect with a corporeal, embodied sense of themselves as part of the environment. This will take time, and embodied time is slower than cognitive time. The question here is how can we re-train ourselves *in body, mind and feeling* to reconnect with a corporeal, embodied sense of ourselves as part of the environment in order to create site-specific performance?

Furthermore, how can site-specific performers shift the audience's habitual expectation and experience of a particular site as a backdrop to activity towards an experience of finding themselves incorporated within the site?

Taking as an example the creation of *Absence* (a site-specific performance, based on ecological movement, West Dorset, UK 2010) I shall begin by defining my use of the terms inscription and incorporation as a useful way of articulating this distinction in relation to site-specific performance. In relation to the performance work, I will consider the role of the four ecological movement dynamics as tools that can facilitate participatory research, rehearsal and performance.

Through this discussion I will demonstrate how working with these movement dynamics challenges the notion that we are independent beings, who can exist separate from our context. I will consider how these approaches can, by contrast, support any environmental or site-specific performer to experience their own 'system' or identity as less fixed than they might have imagined and more an intrinsic part of a wider set of systems. In turn, I propose that this approach can help performers and audience alike to act accordingly, rather than perpetuating an attitude of 'using' towards the environment, akin to self-harm.

Finally, I explore how in *Absence* through production choices, the audience was guided towards a position of immersive participation or involved witnessing, one that I feel is coherent with the idea of incorporation and a first step towards ecological awareness. *Absence* was a site-specific movement-based ecological performance that I created at St. Gabriel's Chapel at the foot of Golden Cap, West Dorset in 2010.

Inscription and incorporation

Embodiment defined as 'incorporation' includes a sense of becoming-through-motion rather than referring to a finite state:

> [...] adopting a helpful distinction from Paul Connerton (1989: 72–3), I regard embodiment as a <u>movement of *incorporation*[3]</u> rather than inscriptions, not a transcribing of form onto material but movement wherein forms themselves are generated.
>
> (Ingold, 1990: 215)

When I first began my research in this area, mindful of Paul Connerton's original distinction between the oral (incorporated) and literary (inscribed) traditions, I considered the notion of 'inscription' as anything that was not embodied or 'live', and 'incorporation' as anything that *was* embodied and live.

However, by paying attention to 'movement as an impulse of life that gives rise to the forms that we see' (Ingold, 2011: 179) my interest in both inscribed and incorporated forms, whether alive in the past (recorded) or vibrant in the present (live) developed through a progression of site-specific work.[4]

As I worked more with video, photos, live and recorded music and text, as well as movement, I realised that the distinctions between inscription and

incorporation were as much about *how* something had been made and the attitude within that process, as about the things themselves. In *Absence*, for example, had the musician working aurally with point, line and angle in her improvised composition, generated by playing within the site of the chapel, also noticed point, line and angle in her finger movements on the violin? If she had, was that music an inscription or an incorporation? And what did it become when recorded onto a soundtrack for the performance? Did it remain capable of connecting viscerally with an audience through headphones?

A hand-written text could be said to be an 'inscription', but once it was recorded and spoken alongside a particular image or movement in performance, rather than remaining an anecdotal 'trace' which is etched onto various surfaces, it could become one of the creative 'threads' (Ingold, 2007: 2), generating new textures as it participated in the weave of an incorporated performance. In this way a trace can become a thread and vice-versa (ibid.: 2).

So, letting go of any distinction between oral and written material or between the live and the recorded, within site-specific performance, I adopted the term 'inscription' to describe a process whereby the individual identifies a concept or feeling to work on through movement or adopts a set of physical actions or gestures using the environment as an imaginative or convenient backdrop. The importance of the visual sense is often prioritised in this approach and the human element is given more value than the environment.

By contrast I use the term 'incorporation' to describe an embodied process where the being-becoming-being (a less fixed identity than the notion of individual) explores their surroundings through movement (as described below) and gradually inhabits the actual environment as well as allowing their imagination and associations to be stimulated by that very place. All the senses are given equal value, challenging the supremacy of sight which has subsequent implications for how the piece is shared with an audience and the environment and other life systems are as important as human life.

Inscription, then, may be seen as informative, intent on creating a context of 'knowing about'. Incorporation is visceral and transformative and encapsulates experiential 'knowing'. The process of 'incorporation' that can include the transformation of body patterns and habits requires practice and operates on a different timescale from theoretical changes or 'inscription'.

I consciously work with the idea that I can layer the live and recorded elements of a performance piece in a way that reflects how each of us incorporates a multiplicity of experiences and memories, occupying a broader, contextual niche.[5] When we dialogue with the other, we inevitably bring all of that multiplicity with us into the present time and space.

Reflecting on notions of 'incorporation', this is what we are doing every day, if we experience our bodies as sites, or 'niches' in their own right. The haunting echo of a memory comes through, for example, a gesture that existed in another place and another time and suddenly this is invoked in us and evoked in our present conversation.

My approach strives to create a performance in which all aspects of the creative/actual environment are incorporations so that the audience can experience themselves as embodied, three dimensional and situated within the site. This preference is in contrast to a performance being an inscription that the audience can read against the backdrop of the landscape. The four ecological movement dynamics serve as tools to facilitate this approach and form part of a coherent methodology of site-specific ecological movement training.

Ecological movement

Creating site-specific performance has evolved for me through environmental movement and ecological movement[6] into what I would call movement-based, site-specific, ecological performance. I am interested in revealing and articulating training 'methods' or 'tools' for performers that shift habitual attitudes of alienation or separation from the environment and that are congruent with notions of ecological performance as much as exploring how the content and means of production of a piece can reflect basic ecological principles. It also seems vital to explore how members of the audience can experience themselves as participating in the place and in creating the moment rather than as outsiders to an event.

Ecological movement allows us to study changes in nature through movement, as a guide to experiencing our bodily selves as a system of shifting patterns within patterns of change. These embodied experiences foster an attitude of biocentric equality. This is the notion that all things have an equal right to live and to fulfil their particular potential.

By rediscovering the flow of environment, rather than the environment as a succession of places, and by challenging our addiction to 'doing' at the expense of our experiencing our 'being' in the world, I maintain that there is a chance that we can give value to ourselves as part of a profoundly interrelated network of beings and that as performers we can transmit this incorporated knowledge to an audience.

Ecological movement dynamics

Absence was a site-specific performance, based on ecological movement which I created in West Dorset in 2010 funded by Activate: Dance and Theatre Development Agency. The key elements supported by the funding were ten days of research, development and rehearsal for myself and a musician, Eleanor Davies; time for historical research; the development of a musical

score and soundtrack; the purchase of MP3 players and the hire of a sculpture, 'Man/Child' by Greta Berlin which was installed temporarily in the performance site. Three performances lasting around 45 minutes each took place on 18 July 2010 and were attended by around 110 people in total, including 15–20 children, some of whom had booked to come and some of whom happened to be walking past or staying at the nearby cottages.[7]

The site was the tranquil but evocative ruins of a chapel set in a field open to cattle and passers-by at the foot of Golden Cap, just off the main South West Coastal Path, a favourite diversion and picnic site a little way inland from the cliffs. It is situated on National Trust land next to the old Stanton St. Gabriel manor house that has now been converted into holiday cottages.

I chose it because it was a local site that I love and that I could walk to each day to prepare the performance. More than that, its intangible atmosphere of calm in a hidden fold in the coastal cliff sat alongside layers of visible history (Neolithic, Roman, Medieval and Napoleonic) that have been interpreted for the visitor by National Trust information boards. I also felt that it would give me a good opportunity to work with notions of immersion and participation both for myself and for an audience. It was my first opportunity to explore using the four ecological movement dynamics that I had identified in my doctoral thesis[8] within the making of a more overtly ecological performance piece. I identified these dynamics as:

- active/passive;
- position/transition;
- point/line/angle; and
- proportion in motion.

I see these movement dynamics as 'etic' skills. Etic, in anthropological literature, refers to a 'wholly neutral, value-free description of the physical world', as opposed to 'emic' (Ingold, 2000: 14) which describes the specific cultural meanings that people place upon their surroundings. As relatively neutral tools, these movement dynamics, applied through non-stylised movement, demand precision but are immediately embedded within the environment as the dynamic principles of active/passive, proportion, transition/position and point, line and angle are apparent everywhere in life. As tools for performance-making they touch certain nodal points, where the flow of human movement interrelates with the changing environment, and stimulates both autobiographical and creative material.

Instead of insisting on a performance that places a single, monolithic meaning or interpretation on an event, they offer a way of describing the multiple perceptions of evolving situations and bodily sensations in terms of change and motion. They do not assume any specific 'a priori' affective relationship between the mover and the environment and they disrupt any predictable descriptive or associative interpretation of the environment,

allowing a multiplicity of unexpectedly selected mosaics of somatic markers[9] to emerge into patterns of significance and meaning.[10] They are movement dynamics but, as described below, they can also be engaged with at a philosophical level. I shall pass through each dynamic in relation to the research and development phase for *Absence* to provide an idea of how they function within the process of creating a site-specific performance.

Proportions in motion

A movement-based exploration of the site for *Absence* inspired by the lens of proportion offered me physical, mental and emotional material that began to open up my relationship with St. Gabriel's chapel. I had no preconceived ideas of what might emerge and at that initial stage very little knowledge about the site itself. Associations, movements and images arose, which I noted down without allowing either my inner editor or my inner critic to exercise their preferences.

What did I do? I crawled, rolled, climbed, ran, walked in all directions, sat on the bench, swung on the gate, landed in the thistles and followed the contours of the field and the meanderings of the stream-bed. I followed the shapes, gestures, breathing patterns, facial expressions and articulations of my moving body, noticing when I was drawn to certain environmental relationships and noticing the places that I never visited. I wrote it all down.

I measured my limbs against the walls of the chapel and found places where my body seemed to fit comfortably as I climbed the ruined walls. I stood at the east end where the altar would have been and felt slightly guilty as I adopted the pose of a crucifix and stood very still for a long time. Memories of my confirmation service, aged 13, crowded in: the solemn figures in the stained glass windows apparently moving as I fainted because the radiator was too hot in church and I was so determined to be visited by the Holy Spirit. Unexpected autobiographical material emerged in the shape of these memories as I stood as still as a crucifix, wondering who St. Gabriel was and whether, like the Buddha, Christian saints had specific hand mudras.[11] So I jotted them down as well.

A little later I noticed the need to stoop as I entered the chapel and observed how the door was so narrow that even a smaller and thinner couple would not have been able to stand side by side in it as they came out of their wedding service. My exploration of proportion had instigated a whole train of thought regarding the ceremonies that might have occurred there. I discovered that to this day, apart from private ceremonies, there is always an Ascension Day Service at the chapel and that it was about to take place. I attended the service with pleasure although I was slightly startled to find that the temporary altar was placed in the west so that the local congregation could enjoy the view of the sea. My imaginative altar was already firmly situated in the east and I felt as if I was the wrong way around in time and place.

I whispered to a thistle, spoke to a cow, sang to a dog and shouted in the wind up to the burial mounds on Golden Cap – different proportions of sound that stimulated my sense of what kinds of sound I might like or might be able to include in my performance. I ran as fast as I could several times up and down the footpath which runs in front of the chapel and I then walked as slowly as I could with very little steps from the bottom gate to the chapel door. I noticed associations that I made between speed and age. I picked up different weights of stone and pebbles and moved with them as I went barefoot in the stream, and created movement installations with twigs, leaves and branches, whatever I found along the way, as part of my movement exploration.

I played around the wooden bench that offered walkers a place to rest for a while and a good view across to Lyme Regis, looking down at the chapel, with Golden Cap at their back. I, instead, walked along it as a child might, tried to fit perfectly under it, tried 'diving' off it and investigated all kinds of shapings that could occur between my shifting body and the static wooden structure. My movements made me feel rather like Alice in Wonderland and from a variety of angles and positions I experienced this 'bench' as a possible gateway or threshold into 'my' magical performance site. It might afford me a change of mode, a way of transforming my sense of being a 'walker passing through' to that of 'performer excavating site for embodied stories to tell'.

Gradually I felt that, rather than being the primary instigator, I was one part of the compositions/installations that I was creating as I moved with an awareness of proportions in motion. This somatic awareness is by definition both sensual and relational and encourages in me a sense of immediate embodied recognition of myself in my particular surroundings at that particular time. If the wind were stronger or the rain more persistent, the sensory, affective and imaginative proportions would inevitably change.

Active/passive

In order to experience myself as inhabiting a place or being embedded within a particular environment, I need to take the time to receive both my surroundings and my inner world without being in a hurry to do something with them or to create something from them. 'Receiving' for me usually means listening, perceiving my environment through the different senses, allowing myself to be just where I am and maintaining a condition of being present in the presence of the place – awake with a soft curiosity, attending to myself, to the place, to a bird, to another performer, alert but without a need to take or to get something from them. This condition encourages a subsequent condition of understanding the place through my felt sense.[12] It is a 'passive' or receptive stance and it is often given less value than the active, initiating position in the achievement-oriented preoccupations of daily life. To all appearances, it is not immediately 'productive' or 'worthwhile'.

However, when I stay present within a receptive stance, an impulse usually presents itself and the skill is to recognise the impulse at the right moment – just as it is in improvisation – and then to follow the movement wholeheartedly. Whereas, if I adopt an active approach and initiate a sequence of actions which pay attention to where I am, this will usually lead me eventually to a quieter position that has more volume, more receptivity and feels more embedded in my surroundings. So, active arrives at passive and passive arrives at active. It is process of deconstruction involved in recognising the starting point that can be useful, because in disrupting my own habits I can allow unexpected material to emerge for performance-making.

For example, I can choose to receive the rhythm of the footsteps of walkers passing by and the soundscape on any particular day: birds, wind, rain, sun, words, tractors, cows, dogs and let that influence my being in motion; or else I can choose to create a movement score for the site, based on my experiences there so far, and start the day's work from that sequence of movements.

The movement dynamics can operate at the level of approach, method or tools.[13] In the case of Stanton St. Gabriel, as an approach, I can choose to explore associations and feelings that emerge whilst moving in the actual site or I can seek to impose interpretations, historical and geological understandings onto the environment and let those narratives stimulate my imagination. The first approach is like the process of reading; the second more like writing. In the former, more passive approach, my experience is that my surroundings incorporate me. I find that I am susceptible to noticing what I notice, what the site 'affords' me at any given moment: the passage of shadows across the field or the times when the sounds of the waves breaking on the shore cannot be heard. In the latter, more active approach, my experience is one of inscribing an account onto the landscape. My body–mind in motion is seeking actual or imaginative correspondences with the narratives that I have brought to the place.

Transition/position

Most days I walked to St. Gabriel's from home following the old farm track, imagining the blue of the hemp fields; noticing the elderflower trees; remembering one of the farmers within this widely spread community who walked two miles to the nearest pub each night and back; wondering what it would have been like to have 27 people living where two of us now lived, all of the adults working on the land. The practice of transition/position was to take me to the heart of this particular site and was reflected in the chosen title of my piece, *Absence*.

Common lore and almost all the local history books maintained that the old village of Stanton St. Gabriel was deserted because the old coach road from London to Exeter was rerouted to the north and so the chapel had

been abandoned when the populace moved inland to Morcombelake in the nineteenth century. This much I knew before I began.

These days, as mentioned previously, St. Gabriel's Chapel is situated on a public footpath that is a short loop off the main South West Coastal Path. Many walkers divert to visit the ruins and nearby there are National Trust holiday cottages. So today, the site has elements of going (footpath and walkers), staying (the chapel) and temporary staying (holiday cottages).

I applied the dynamic of transition/position by identifying and moving with 'going' elements like the signpost and the footpath and with 'staying' elements like the chapel, the bench and various trees. I noticed the elderflower trees and realised that in July we would be able to offer our audience elderflower juice made from the blossoms that were there in the spring, during our rehearsals; I physically explored field gates, stiles and the cattle trough with transition/threshold in mind. I practised different pathways and rhythms of moving through the site and also finding positions and places to stay. I also worked with 'pre-positions' which offer embodied ways of relating differently to the same environment, e.g. *in* the chapel, *through* the chapel, *opposite* the chapel.

As a result, my movement vocabulary began to evoke certain associations and to develop in particular ways. Certain 'modes', or qualities of movement (rather than actual characters), began to emerge as I engaged with the site. My interest became centred around the ruins of the chapel, the footpath passing directly in front of the chapel on its way to Golden Cap and the almost dry stream bed behind it, and a diagonal route directly across the field from the chapel to a separate gate near a cattle trough. The field beyond this trough was overgrown and was the last field before the edge of the cliffs to the sea. It was more difficult to access but it provided an entrance to the site that was more discreet and not on the main thoroughfare.

I felt that it was time to find out more about the transition/position historical narrative of the site to see how this information would influence my movement research.

The subsequent research revealed that the commonly perpetuated belief that the old coach road from London to Exeter, like the Roman road before that, had run through the village of Stanton St. Gabriel was in fact untrue. Most historians also suggested that a cluster of houses had huddled around the village green[14] below the chapel, probably a mill, a manor house and cottages housing some 20–30 families at different times since around 1086. All this, the widely believed mythos of the site, proved to be untrue.

In fact, the old coach road and the Roman road had never passed through Stanton St. Gabriel; old maps revealed that already in the seventeenth century the main road passed one and a half miles to the north of the chapel. It became clear that it was the stream bed at the back of the chapel that marked the old farm track known as Pettycrate Lane and not the current footpath and there had never been a village to be deserted:

The 102 residents of Stanton St. Gabriel in the 1842 census roughly equated to the twenty-three families reported in 1653 – it was simply that they lived then, as now, in the dozen or more farmsteads scattered across the parish rather than in a 'village'. There never had been a village at St. Gabriel's. Just two houses still standing and maybe two or three more.

(Carey, 2010)

So historical research uncovered a logos at odds with the received wisdom and revolving around the theme of transition/position. However, amongst all this confusion some accuracy had emerged from my movement excavation.

In terms of position or 'staying' there had been weddings held at the chapel and this was reflected in a sequence of movements that had emerged from my physical encounter with the chapel, evoking the bride at the chapel door shyly greeting her community – in this case the audience who were provided with MP3 players that included a soundtrack reciting the names of all those who had been married in the parish. From a 'staying' perspective I also felt the need to incorporate the presence of a more resident community to greet the audience and so I decided to bring in the sculpture Man/Child to dialogue with. I situated the sculpture on the ridge against the skyline, where his ambivalent stance could inform the performance from above.

The research also revealed that:

For a considerable time a successful gang of free-traders, under the leadership of a man called the 'Colonel', operated along the coast from Seatown to Charmouth. Their chief landing ground was St. Gabriel's Mouth. Much of the contraband was delivered locally and the Church Tower was used as a hiding place in an emergency.

(Guttridge, R. cited in Carey, 2010)

The diagonal route across the field from cattle trough to chapel, coming from the direction of the sea, evoked a smuggler, who dropped out of hiding in the branches of a tree with a sack of booty on his back – he was using the chapel to hide brandy from the excise men.

A myriad of types or modes of movement also emerged as I continued my rhythmic exploration of the footpath passing the chapel; a furze-carrier, two contemporary tourists deep in conversation, a runner, someone hauling a rope – the fields all around of blue hemp in service of the Bridport rope manufacturers. I decided to have costumes made of hemp… These elements all appeared in the final performance, marking the different layers of time present at this site.

Point, line and angle

Perhaps the most obscure dynamic to articulate, and one that I have thoroughly described elsewhere,[15] is that of point, line and angle. This way of moving (based on the insights of James Gibson's analysis of ecological perception) stimulates fresh perspectives – literally fresh points, lines and angles of view, as well as providing a way of shaping movements directly in relation to the environment thereby offering the opportunity to bypass our habitual descriptive labels:

> The environment, according to Gibson, is both static and improvised, consisting of substances, mediums and surfaces. Surfaces are where substance and medium meet, and the layout of adjoining surfaces can be perceived at corners, edges and angles.
>
> (Reeve, 2014: 13)

As I explored the site for *Absence* through point, line and angle, I observed more closely the particular geological formation of the land behind Golden Cap which gave the impression of the flow of the hills changing direction as if falling back towards the chapel, whilst the front of the sandstone cliff, lying on grey mudrock, was crumbling into the sea. Rhythms of flow and disintegration through time merged with a strong sense of vertical and horizontal lines. I discovered that:

> The very flat top of Golden Cap is actually a remnant of an ancient river terrace that was formed after the Cretaceous. The gravelly deposit was left behind by the river that was eroding the uplifted older rocks. This ancient river terrace can be traced inland forming the flat tops of hills to the north west of Golden Cap.
>
> (www.jurassic coast.org)

The chapel lies on a hillside and the ridge at the top of the field surrounding it offers an apparent 'backdrop' of uninterrupted sky. I loved moving along that ridge – I could become a shadow puppet with an overview of the chapel, the fields and the sea beyond – or hang like a bird against the skyline… Looking up I saw the buzzard hovering above me, a frequent visitor during rehearsals. I began to move in relation to the motion of the bird and to create a score for flight along the ridge.

Working intimately with the chapel ruins through point, line and angle, I became wall, very still, solemn and a mixture of curve, angle and volume in the positions I found to inhabit within their structure. I spotted the expression of a corbel embedded in one corner from a particular angle and worked with that facial expression with no thematic agenda; later these expressions re-presented themselves for the mode of an old woman who

appeared during rehearsals in a headscarf, dragging herself up the hill to lie down and die at the foot of the chapel walls.

'Point' drew my attention to my shifting point of observation in relation to other possible points in the environment; angle made me notice where two surfaces met, the edges, the corners, the angles, the variant and invariant features of the environment (Gibson, 1979: 13) all in different stages of transformation; line seemed to be the 'great connector' and became all the possible pathways of locomotion between two points, or where two surfaces met. There were all kinds of traces and threads to follow, both straight and curved, as well as the swinging lines of my limbs.

While the idea of point, line and angle may appear at first to be inscriptive or existing on or above the surface of the land or body, in fact, by practising point, line and angle I became aware of my position embedded in a kind of environmental geometry; how, as I moved, I changed the overall composition and it changed my movement. I noticed that how I both perceived and engaged with the various surfaces was fundamental to my behaviour and to what the world 'afforded' me. By paying attention to these details I found myself increasingly immersed in the topos.

Taken as a whole, the movement dynamics of proportion, point, line and angle and transition/position all appear as environmental dynamics crucial to ecological perception. Used as elements of movement training, these movement practices encourage movers to perceive the perceptual field from a moving position, whilst perceiving themselves as part of that field. This creates an experience and an attitude of inclusion or incorporation rather than one of measurement or inscription, which tends to define through separating. Nevertheless, inclusion does not remove the uniqueness of a position or pathway within the field at any given moment. From any one position or pathway at any one time, some things are hidden whilst others are revealed.

Ecological literacy

In her exploration of education and perception, Laura Sewall argues convincingly that ecological perception is the perception of dynamic relationships (in Roszak *et al.* 1995: 205). In movement terms, I perceive a dynamic relationship as one that is co-created through both active and passive contributions from each participant in the environment through words, actions or feelings. In order to perceive these relationships, according to Sewall, we need the following skills:

> To attend within the visual domain, to perceive context, relationships and interfaces, to develop perceptual flexibility across spatial and temporal scales, to learn to reperceive depth and to develop an intentional use of the imagination.
>
> (ibid.: 206)

I would argue that a perceptual awareness of these relationships requires attending not only to the visual, but to all the sensory domains. In terms of 'tools', the question arises: how can these skills be taught and developed? I suggest that some of these tools can be found by studying the ecological movement dynamics that I have identified through practice: active/passive, position/transition, point, line and angle and, not least, proportion. A study of proportion includes re-inhabiting a sense of our own 'volume', or 'depth' in space while a contextual study of our rhythm within other rhythms situates us in, what I call, our own volume of time. Point, line and angle facilitate fresh perceptions of Sewall's notion of 'context, relationships and interfaces'. Attention to position/transition develops 'perceptual flexibility across spatial and temporal scales' (p. 206) and ecological movement taught as a creative practice stimulates the imagination. These tools are connected with becoming aware of one's changing creative being in context, in relationship or as part of a pattern, which is one of the primary contributions of ecological movement.

As a performer, each movement dynamic helps me to develop perceptual flexibility and takes me into an experiential perspective of depth and dimensions belonging to both the site and to my moving relationship with it. These may be skills for training ecological perception and literacy (ibid.: 204) but they stimulate both actual and imaginative fresh, incorporated relationships with place. The question remains how to stimulate this kind of ecological perception in an audience.

Creative process

Until now I have given some examples of how the ecological movement dynamics allowed me to connect with my moving self in a specific place, St. Gabriel's, and to begin to collect material for performance. An analysis of the creative process whereby that material crystallised into a performance is beyond the scope of this chapter but I was seeking to create a methodology that was not just theoretically applied to the material I had created but that would emerge and be coherent with ecological principles.

As a brief example: in relation to exploring ecological principles, I was interested in combining tightly scored material (which would follow Grotowski's [1975: 192] notions of a rigorous and detailed scoring of material in order to permit the surrender of a 'total act') and at the same time maintaining parts of a score which were open to changes of action, following impulses and influences of the moment. This approach reflects the improvisational influences from my movement work with contemporary artists in Central Java between 1995 and 1998.

Combined, these two methods create a stochastic process,[16] which is both selective and random, a process reflected in the cycles of creativity in nature. On the one hand, I deepened my associative relationship with one sequence of detailed actions and refused to change the external form (position); on

the other hand, I allowed the external form to change, as I enjoyed the fresh influences of the moment (transition). This combination of scored and improvised components both within the music and movement provided a variety of different textures in the performance.

As an environmental performer, I work with a multi-layered relationship to my movement: I am embodying movements that are connected to specific 'niche' memories, but I am placing them within a themed imaginary environment derived from both inscriptions and incorporations, where the traces and threads take on a new and broader meaning as they interact and weave a tapestry with other elements. They are also placed in a new actual environment so that they co-exist in real time, in performance time and in memory time.

Absence **and audience**

Taking place in and around the chapel at Stanton St. Gabriel with the sculpture of Man/Child[17] situated on the ridge above (providing a symbolic sense of the other members of the community) *Absence* incorporated live movement and live violin/viola playing alongside a recorded soundtrack. This comprised music composed in response to the place, bird song and other natural sounds recorded on site and excerpts from historical and landscape writings about Golden Cap and Stanton St. Gabriel read in multiple voices. These texts often related directly to the various movement sequences taking place then and there, providing another texture to respond to. At other times the dance continued with just the natural ambient sound. Each member of the audience was given a MP3 player on arrival and could move around wherever they wanted to during the performance but knew that their soundtracks were in sync.

Influenced by Gibson, who asserted that perception was not the achievement of a mind in a body, but of the organism as a whole in its environment tantamount to the organism's own exploratory movement through the world, Ingold was intent on looking for a link between the biological animal in its environment and the cultural mind in society (Ingold, 2000: 3). He found this link in an ecological approach to perception.

As I see it, if we go one step further back than Ingold, an ecological approach to movement can be seen as the basis for ecological perception. It is there that I am looking for a similar link, in terms of re-educating how we can feel ourselves, with all our cultural differences, as part of the environment. I believe it involves each person remembering how to discover meaning for themselves, rather than striving to grasp or impose some imagined objective meaning. This means that an audience at an immersive performance can be invited to wander around the site and witness the transformation of that site, seen through a variety of lenses, until meaning begins to emerge for them. Patterns of meaning can be shared between audience members and between audience and performers.

Influenced by outdoor performances in Java,[18] I wanted people to be immersed in an atmosphere and be able to move around and to choose what they watched. This meant that they were active in creating their own pathways, positions and viewpoints throughout the piece and they could select their own proportion, i.e. how near, how far, how fast, how slow based on personal need or preference. They could come and go as they liked, and follow their instincts, which gave them information about themselves as well as the performance. In Gibson's terms, they became more aware of their selection of 'affordances', as they made their choices, and saw that they were indeed co-creating the event through their own particular perceptions. They were seeing, hearing, touching, imagining what they chose to see, hear, touch and imagine. Their role was to follow the piece, but in whatever way they chose.

They were assured from the outset that there would be no invitation to actively participate in the piece. Situating the piece in an outdoor environment, which in itself contained the movement dynamics I had been working with, supported my experience of no fixed sense of self as a performer and the audience's sense of being part of a changing situation.

Baz Kershaw, in his article on 'Radical Energy in the Ecologies of Performance' (2004) uses the trope of 'edge phenomena' where two ecosystems rub up against each other, producing a rich variety of life forms, to explore the actor–audience relationship in ecological performance. He decides that the transformation of the audience into participants is most likely to lead to new ecological forms of performance. In *Absence* I felt that through the development of an integrated role for the audience as active participants they were choosing for themselves how to move through the site. This was helpful in creating a shared ecology of 'being in performance', where each participant, whether performer or audience, could gradually feel that within the totality of the place-in-performance they were one part of each other's stories.

Past, present and future

In *Absence* I attempted to create the conditions for an incorporated moment for the audience. I did this through my choice of movements, arising from the four dynamics; through my ecological approach and methodology, through my choice of content, both live and recorded narratives, through my choice of costume, objects and non-amplified sound and through my decisions around the transition/position of the audience. I wanted the audience, who had either walked half an hour to reach the chapel from the car park or who had stumbled across us, to feel that they were intrinsic to the incorporated weave of the shared moment, remembering the past, inhabiting the present and creating a possible future life for Stanton St. Gabriel – rather than being a temporary inscription on the surface of the place.

My experience is that an attitude towards both the body and the environment as 'objects' persists in daily life. My concern is that these disembodied attitudes are leading us into habits that have dire social and environmental consequences for the future. This explains my interest in investigating the normative attachment to a 'fixed' sense of self through the medium of movement and in communicating alternative embodied attitudes through site-specific performance.

An ecological self,[19] which I define here as a being-becoming-being rests in impermanence and is settled in the unknown. By experiencing my changing body as part of a changing environment, I diminish the sense of a rigid boundary between my experience of 'self', others and the environment. This non-essentialist paradigm presents us with a world that is so intangible, so without us as its focus that it is counter-intuitive and denies our experience of reality. We are just not interested in a view that denies our importance and it is extremely hard for us to face the fact that we are not immortal. Adopting an ecological attitude would mean accepting that notions of transience and impermanence apply to us. We would no longer be 'special' or central to life. We would remember our mortality that we have fought so hard to forget.

In *Absence*, as the audience remove their headphones, and their focused listening to the intimate soundtrack changes to a wider hearing of the ambient sound, accompanied by invisible live viola music drifting out of the ruined chapel, my perception as performer also shifts to my being-in-the-environment and my niche is the present movement. A moment of incorporated presence within the actual site is shared emphasised by the cessation of recorded material. My movements calibrate in response to the atmosphere and I feel appropriate to the moment. The niche of *Absence* itself, including site, performers and audience for a moment becomes situated in time and in the flow of impermanence, rather than fixed within the positions of public event and permanent heritage.

Notes

1 Joged Amerta means 'the moving–dancing elixir of life'.
2 Satipatthana means 'a way of mindfulness'.
3 Author's underlining.
4 *Green Shade*, 2004 / *Being in Between*, 2005 / Ignition Point, 2006/ *Borders of Humility and Humiliation*, 2007.
5 I use niche as a word (describing an ecological habitat) to correspond with a systemic view of autobiographical material (Reeve, 2009: 82).
6 See definitions in Reeve, 2011.
7 http://stantonsaintgabriel.blogspot.co.uk/
8 These dynamics emerged and were investigated and analysed during my practice-based doctoral research. My research included working with the same dynamics to create and perform *Borders of Humility and Humiliation*, a site-specific movement-based performance piece and to co-direct *Being in Between* with Baz Kershaw, a performance project at Bristol Zoo. This project engaged

with place and primates, and I was responsible for developing the movement-based score for the performers, embedded as a system within zoo life.

9 Somatic markers are neurological patterns which link a particular recalled image(s) with particular perceptual images and a particular body feeling… Significantly somatic markers are not static but become re-marked, re-imagined with every re-collection (Riley, 2004: 455 cited in Hunter, K. (2013).

10 The contrast between a single, monolithic meaning or interpretation and multiple perceptions of an event is similar to the distinction between mythogeography and the conventional presentation of 'heritage'. Mythogeography emphasises the multiple nature of places whose multiple meanings have been squeezed into a single and restricted one (for example, heritage, tourist or leisure sites tend to be presented as just that, when they may also have been homes, jam factories, battlegrounds, lovers' lanes, farms, cemeteries and madhouses). See Smith, 2010: 115 and www.mythogeography.com/multiple

11 A mudra is a symbolic or ritual gesture within the Hindu and Buddhist traditions and mostly performed with the hands and fingers.

12 A 'felt sense' is quite different from 'feeling' in the sense of emotions; it is one's bodily awareness of the ongoing life process as defined by Eugene Gendlin, philosopher and psychotherapist.

13 As a family therapist and trainer, John Burnham's systemic approach is inherently curious and self-reflexive, welcoming incoherence as an opportunity for growth, knowledge and transformation. It demands a theoretical and clinical coherence between approach, method and tools and acknowledges that all levels are recursively connected: 'Each level can become the context for understanding the others' (Burnham, 1992: 6). This seemed to me to be a good way of approaching performance practice as research.

14 This 'village green' was in fact a field that had been called Home Cowleaze (cow pasture) for generations.

15 Reeve, 2014.

16 Gregory Bateson proposed that our internal capacity for selection and the way in which we adapt to the external environment were both stochastic systems, combining random components with the selective process.

17 This sculpture of a man holding a small child in his arms leaves it up to you to decide whether the child is asleep or dead – for me, this ambivalence matched the uncertainty of the site's historical facts.

18 Studies in Java with Suprapto Suryodarmo from 1988 until the present day. Resident in Java 1995–1998.

19 A more detailed definition of an ecological self is: *shifting proportional patterns of behaviour and activity, interweaving with other patterns in environmental systems, in a constant state of transformation, whilst individuals nevertheless maintain their own particular integrity* (Reeve, 2009).

References

Bates, M. (1962) 'The Human Environment', The Horace M. Albright Conservation Lectureship II. School of Forestry and Conservation, Univ. of California, Berkeley. Reprinted in: Cloud, P. (ed.) (1970) *Adventures in Earth History*, San Francisco, CA: W. H. Freeman.

Bateson, G. (1972) *Steps to An Ecology of Mind*, London: Intertext Books.

Bateson, G. (1979) *Mind and Nature*, London: Wildwood House Ltd

Burnham, J. (1992) 'Making Distinctions and creating connections in human systems', *The Journal of Systemic Consultation & Management*, 3, pp. 3–26.

Carey, A. (2010) *Absence – An appreciation and some histories about Stanton St. Gabriel* (Online), Available: http://stantonsaintgabriel.blogspot.co.uk/2010/08/new-test.html

Connerton, P. (1989) *How Societies Remember*, Cambridge: Cambridge University Press.

Gendlin, E. (2003) *Focusing*, London: Rider.

Gibson, J. (1979) *The Ecological Approach to Visual Perception*, Boston, MA: Houghton Mifflin Company.

Goodwin, B. (2002) *Diversity, Health and Creativity: Lessons for Living from New Science* (Online), Available: http://tinyurl.com/3kgpvd (18 June 2008).

Grotowski, J. (1975) *Towards a Poor Theatre*, London: Methuen.

Guttridge, R. (1984) *Dorset Smugglers*, Dorset: Dorset Publishing Company.

Harding, S. (1997) 'What is deep ecology? Through deep experience, deep questioning, deep commitment emerges deep ecology', *Resurgence*, no. 185.

Herbst, E. (1990) *Voices, Energies and Perceptions in Balinese Performance*, Hanover, in: Wesleyan University Press. Hughes-Freeland, F. (2008) *Embodied Communities: Dance Traditions and Change in Java*, New York: Berghahn Books.

Hunter, K. (2013) 'The Cognitive Body', in (ed.) Reeve S., *Body and Performance*, Axminster: Triarchy Press.

Ingold, T. (1990) 'An Anthropologist Looks at Biology', *Man*, 25(2): 208–229.

Ingold, T. (2000) *The Perception of the Environment*, London: Routledge.

Ingold, T. (2007) *Lines*, Oxford: Routledge.

Ingold, T. (2011) *Being Alive – Essays on Movement, Knowledge and Description*, Oxford: Routledge.

Jurassic Coast Available at: http://jurassiccoast.org/find-out-about/226-geo-high lights/615-golden-cap-the-highest-view-on-the-south-coast

Kershaw, B. (2004) 'Radical Energies in the Ecologies of Performance', *Frakcija: Performing Arts Magazine*, 2004, p. 14.

Reeve, S. (2009) *The Ecological Body*, PhD thesis, University of Exeter.

Reeve, S. (2011) *Nine Ways of Seeing a Body*, Axminster: Triarchy Press.

Reeve, S. (2014) 'The sacred and the sacrum: Mutual transformation of performer and site through ecological movement in a sacred site', in Williamson, A. (ed.) *Dance, Somatics and Spiritualities*, Oxford: Intellect.

Roszak, T., Gomes, M. and Kanner, A. (eds) (1995) *Ecopsychology*, San Francisco, CA: Sierra Club Books.

Sewall, L. (1995) 'The Skill of Ecological Perception', in Roszak, T., Gomes, M. and Kanner, A. (eds) *Ecopsychology*, San Francisco, CA: Sierra Club Books.

Smith, P. (2010) *Mythogeography – a guide to walking sideways*, Axminster: Triarchy Press.

18 Strategies of interruption

Slowing down and becoming sensate in site-responsive dance

Natalie Garrett Brown

Opening

Exploring how embodied population of sites might invoke new encounters with familiar spaces and places for both mover and audience, this chapter offers a practitioner perspective charting the linage and working processes of *Enter and Inhabit*.[1]

Enter and Inhabit is an ongoing collaborative project which explores the creation of live and mediated events for rural and city spaces. Started by dance practitioners Natalie Garrett Brown and Amy Voris in 2008, principally as a site responsive movement project in the city landscape of Coventry, the project has subsequently evolved to include a photographer, Christian Kipp and, until her recent passing, dancer/writer Niki Pollard. Performance projects are created for a variety of contexts including dance festivals and research-focused symposium and conferences. The wider activities of the *Enter and Inhabit* project include workshop leading, photographic exhibitions and scholarly writing. The artists involved work within the independent dance sector and are also currently affiliated with Coventry and Chichester universities in the UK.

In seeking to reveal the sensorial exploration intrinsic to the collaborative process of *Enter and Inhabit*, this chapter draws on a philosophical perspective to theorize the slow and sensate in embodied encounter within site responsive dance making. Positioning site responsive work as *emergent* through time and collaborative dialogues, the work of *Enter and Inhabit* is considered here as an example of a collaborative practice that moves between the rural and urban, acknowledging that each can co-exist in the same site.

Conversing with the work of performance studies scholar Andre Lepecki (2006, 2007) and others an argument is made here for the quietly political provocation of the slow and sensate in site responsive dance as a means to disrupt the coupling of subjectivity and motility found within a modernist economy of being. Drawing on Lepecki, a re-integration of the slow as an inherent aspect of the dance and creative process is proposed and imagined.

Offering case study examples characteristic of the work of *Enter and Inhabit*, this chapter details how an emphasis on the sensory perceptual cycle as understood by Body-Mind Centering (BMC)®[23] and improvizational practices more widely enables an attentive dialogue between the materiality of site and an attuned body-mind, from which alternate and new perspectives can emerge – including an appreciation for the slow.

The chapter closes by proposing that the slow, more than an act of interruption, can be re-inscribed as an inherent and ever present aspect of the dance and creative process, rather than just an interruption of late capitalist modernity. In doing so the political significance of the slow in site responsive dance is asserted and a claim made for the acceptance of corporeal knowledge as a valuable and necessary epistemological position.

Introduction to an instance of outdoor practice

The *Enter and Inhabit* project explores process-orientated dance making in rural and city landscapes. The first site of the project in 2007/2008 was the underpass system of the Coventry Ring Road in the UK. An intrigue of post-war architecture, the underpass system comprises concrete structures with landscaped gardens, longstanding trees and historic monuments serving to remind us of the possible blur between the rural and urban within the UK landscape where little is truly wild or untended.

In other wooded sites we have worked on (such as a wooded common in Kenilworth, Warwickshire) traces of human population in the form of objects discarded or lost; red plastic sunglasses, fragments of green wool loitering in the mud, a hue which one might guess comes from a manufactured dye, are noted and guest in the photographic image response to site. The presence of such objects offers a reminder of the human intervention that silently resides in much of the UK countryside. Projects created as part of conferences amongst university campuses have also enabled an exploration of the blur and meeting of edges between planted campus gardens and fields and the utilitarian architecture of university buildings. Hayling Island on the south coast of England is a beach site most recently explored as part of the project that similarly offers a landscape of edges where beach and fields meet and merge and the visibility of human occupation through trodden pathways forms part of its identity. The notion of the rural is therefore awake in the work of *Enter and Inhabit* as a question contributing to the artistic play within sites, rather than something fully known.

The practices of the *Enter and Inhabit* project includes durational scored movement-improvization, photography and writing to create scored live (and virtual[4]) installations with an interest to reveal *versions* of the site and the body as always in a process of becoming.[5] When beginning a project the edges of the site are undefined and become so only through the acts of moving, scoring, writing and moving once more. Implicit within this process

Figure 18.1 Enter and Inhabit, Multiples of Two, 2009, Coventry Ring Road, UK.
Photographer: Christian Kipp

is an understanding of site as a material entity, defined in part by its use and population yet in a state of continual transition, renewal and change, however imperceptible or microscopic these shifts might be.

The interest in different modes of perception invoked by BMC® noted above in the introduction, leads to a foregrounding of inter-subjectivity[6] to support this particular understanding of relationship between body and site adhered to in the *Enter and Inhabit* project. From this viewpoint the work seeks to explore how embodied population of sites, real and virtual, can invoke new and the yet-to-be known encounters of familiar space and place, rendering the familiar unfamiliar for both artists and audience. Within this is to be found inquisitiveness around the possibility for kinaesthetic empathy[7] between the project members and audience and performer through a response to site located in the sensate and corporeal.

Broad in its spread of references and lineages, the *Enter and Inhabit* project can be located within contemporary dance practice and specifically the British New Dance tradition. Following the teachings of UK dance artist Helen Poynor,[8] it draws on Anna Halprin's model of collaborative working via the RSVP cycle. Formulated in partnership with Halprin's husband, architect Lawrence Halprin in the late 1970s, the RSVP cycle offers a map or model for collaborative working across disciplines and in site responsive practice. As its title suggests, particular to this process is an inherent acceptance of the cyclical nature of art making, through and across four key stages termed as Resourcing (R), Scoring (S), Valu-action (V) and

Performance (P), whereby the creative act is understood as ongoing and continuing past the moment of a 'first performance'.[9] This formulation is depicted visually, an architectural plan if you will, and thus allows for the articulation of, arguably inherent, characteristics of the creative process, for example the mapping of the inner individual artistic journey in relationship to the collective journey as the project moves through and across the different stages. An example of such a score is presented here:

> *Enter and Inhabit*
> *Hayling Island 2013*
> *Resourcing score*
> *For a full moon and low tide on the East Winner, Hayling Island.*
> *With awareness of ground and constellations of three,*
> *Traveling shoreward, noticing shifting edges and emerging boundaries.*

Implicit within this model is a celebration of collective response and thus too an undoing of hierarchies between art forms and artists. Similarly an investment in reflection as an integral aspect of the creative process is also highlighted in this modelling of collaborative making[10] underpinned by the RSVP process. For instance, movement scores devised and moved in certain sites are collectively revised/re-imaged in the studio or virtual space and then folded back into the live realms of the project which are not bound by project/performance deadlines but rather feed into months or possibly years of movement and photographic practice on a particular site. Images created from inhabiting sites become the slide shows of the website and project installations of live events, but also fuel the resourcing cycle of movement-score writing and project reflection.

As indicated in the discussion so far, central to this practice has always been an interest to develop a collaborative process derived from an engagement with the anatomical structures and systems of the body as conceptualized by BMC®. The anatomical mappings offered by BMC® uphold the possibility of initiating movement from systems of the body other than the musculoskeletal, for example the organ system or awareness of the fluid body. Within the *Enter and Inhabit* project these offer us as movement practitioners a means to extend our improvizational starting points and bodily modes of meeting the environment. Within the practice of BMC® can also be found a valuing of the interrelationship between sensing and action, between rest and activity and between inner and outer awareness. Considered as something inherent to the human organism within the organization of the nervous system, this acceptance of the interrelationship between the sensate and being in the world enables the slow to enter into conceptions of subjectivity.

That is not to say that a slowing to notice sensation is posited as a replacement for action, rather it is recognized as an integral aspect of the sensory perceptual cycle of human movement. More than this its value as

equal to action is upheld and explored as a creative opening. Understood another way, as bodies enter into relationship with the site, through the senses of sight, sound, smell and touch, a balance between activity and receptivity, pause and action, leads the artistic inquiry.

The possibility of the slow is twofold within the *Enter and Inhabit* project and is more than just a literal slow moving through space although this is possible too. Rather it combines a durational approach to making across seasons, one that embraces the slow of the creative process with a delight in the slow of the sensate when practicing and performing. The process of art making is understood to be one of unfolding across time and place through collective activity. Where waves of culmination rather than end points provide the characteristic and shape of public events that find their form through the doing. An inclusion of the slow within the project is traceable in the words of the performance scores. References to dwelling and meandering that invite a stopping, a pausing… a slowing to notice are included as an integral part of the creative strategies. Photographic images wander across the many versions of the site offering figures of stillness alongside sites invigorated by motion. The seeing of the camera slows and pauses to notice detail, alongside movement vocabulary that echoes this mode of attention to detail in equal measure to full bodied frenetic action. And so within the work of *Enter and Inhabit* the slow reasserts itself as valuable collaborator.

> *Enter and Inhabit*
> *2012, Dublin*
> *Virtual Plenary Resourcing Score*
> *Returning to the Arts, Technology, Research Lab Building, Dublin, post-symposium.*
> *Amongst the corridors and designated spaces of the symposium.*
> *Meander*
> *Dwell*
> *Shifting perspectives,*
> *exploring the haptic.*

Becoming conversant with the slow

In the methodology of practice imbued by BMC® the political significance of a 'slowing' and the slow action in site responsive dance has operated as a quiet but consistent interest. The interruption of modernist culture and values enacted via the slow act is not of course unique to the *Enter and Inhabit* project or wider site practices. The political significance of slowness within dance more broadly, for example, is a theme discussed by performance studies scholar Andre Lepecki (2006, 2007). He argues that central to the subject of modernity within the humanist model of subjectivity lies a drive towards mobility, a constant moving on and towards being. In making this

claim, Lepecki draws a correlation between the body of production required in modernity by capitalism and that often locatable within contemporary dance. He also brings attention to the fact that the association of dance with 'uninterrupted flow of movement' (Lepecki, 2006: 3) is not inherent but a historical construct identifiable from the Renaissance time forward. Culminating in the 1930s when the American Modern Dance 'pioneers' were read by influential dance critic and scholar John Martin, as modernist due to their commitment to the autonomy and purity of movement, this historical conflation of motility and dance is, suggests Lepecki, still present today. He draws on critics' distain at dance performance which problematizes this assumption that dance is pure movement to illustrate his point. Having established this interrelation between modernity and dominant understandings of dance he looks to anthropologist Nadia Seremetakis's concept of the 'still-act' and choreographers' use of stillness within dance to argue for its political significance. To frame dance as stillness is, suggests Lepecki, to bring into question the modernist project by disavowing the motility of the modernist subjectivity as a given and constant. As such, Lepecki casts Seremetakis's 'still-act' as 'a corporeally based interruption of modes of imposing flow' that succeeds 'because it interrogates economies of time, because it reveals the possibility of one's agency within controlling regimes of capital, subjectivity, labour and mobility' (Lepecki, 2006: 15). Summing up his thesis he states:

> The undoing of the unquestioned alignment of dance with movement initiated by the still-act refigures the dancer's participation in mobility – it initiates a performative critique of his or her participation in the general economy of mobility that informs, supports, and reproduces the ideological formations of late capitalist modernity.
>
> (Lepecki, 2006: 16)

The critical potential of 'slowness' within Western culture is similarly noted by dance anthropologist Deidre Sklar (2007). Reflecting on her experience of the work of Butoh master Kazuo Ohno, identified as an antithesis to American culture in its slowness, she notes, 'I could not "see" his performance until I stopped looking at it as a visual spectacle and moved into a kinaesthetic mode, joining the rhythm of my attention to that of his movements' (ibid.). In formulating this possibility of audience work relation through the kinaesthetic, Sklar echoes the work of performance studies scholars Holledge and Tompkins (2000) writing at an earlier time on Butoh from an intercultural perspective. Considering in more depth the significance of the slowness of the form they use the metaphor of transformation to characterize that which arises when performers, such as those engaged in Butoh, attend to their corporeality or sensory awareness.

If we are to follow Lepecki, Sklar and Holledge and Tompkins we might begin to understand how sensate bodies moving across a continuum of

stillness and activity, connecting through touch with the materiality of site, illuminate linear logical notions of space and time common to Western frames of understanding as socio-culturally located rather than given and stable. In doing so the possibility of a re-patterned relationship to time and space arises. As dance scholar Erin Manning suggests (drawing on Deleuze and Guattari), recognizing the intersubjective quality of touch in movement leads to a particular concept of space and time. This is one other to that which emanates from delineation of 'self' and 'other', common to a humanist subject position and complicit within the modernist project. Importantly it is one whereby movement pre-exists space and time:

> Whereas in the active–passive commonsense model, time and space are located as stable signifiers into which the body enters, within a relational model, space and time are qualitatively transformed by the movements of the body. The body does not move *into* space and time, it *creates* space and time: there is no space and time before movement.
>
> (Manning, 2007: 27)

The slow of the sensate in practice and performance

> *Enter and Inhabit*
> *Project Website Introductory Text*
> *Ashdon 2012 & ongoing*
> *Weather playing along with us, wind to rainbow mud.*
> *Landing in Christian's stories.*
> *Enjoying the illusion of permanency, amongst pathways which emerge and disappear, fields which thrive and lay fallow. A dialogue between human hand and nature.*
> *A dance with lines on the luminous green strip begins; a dance of furrows, pathways and power-lines.*
> *Looking backwards down a pathway trodden.*

Before further exalting the slow in the work of *Enter and Inhabit* it feels important to restate an interest to acknowledge this in companionship with the kinetic. In acknowledging the moments of attentive stillness integral to the process and practices of *Enter and Inhabit*, the possibility for interaction and movement choices to register as animated, action orientated and therefore shift to a more purposeful play with dynamics rooted in a compositional understanding of time are also remembered.

However, when developing resourcing and event scores from the sensate body, a notion of time derived from the corporeal body is enabled. This can be seen to manifest itself in a play with 'real' or 'lived' time. Rather than time being dictated by the structure of the music or metered 'dancer counts' in which movement sequences follow rhythmic music structures,

Figure 18.2 Enter and Inhabit, 2012 & ongoing, Ashdon Village, UK.
Photographer: Christian Kipp

each moment is allowed to unfold, sometimes in real time as the dancer connects to the inner rhythms and pulsations of the body or with attention to a particular body system or movement pattern. The transition from sensing into moving is a process that can require duration to find form and thus this way of working can have a sense of extended or vortex time more akin to installation art than dance performance whereby the structure and form of the public event embodies alternate relationship to time. Consequently, there is no longer solely a focus on the place of arrival or destination in space within a metered timeframe. Rather an interest in the pause of interruption and moments of transition alongside the flow of movement develops thereby removing a focus on fixed images, positions, lines or forms in space. More than a compositional device this play with alternate timeframes (if we follow Lepecki and others) holds the potential to disrupt the body of production associated with late modernist capitalism through its decoupling of dance with motility.

Within the work of *Enter and Inhabit* there can be seen a play along the continuum of pause, stillness, change and action in which bodies in sites conceive of themselves as consisting of stillness and movement. This is reflected in some of the scores, for example, by the way in which they invite stillness as integral phase of the improvised duet process as evidenced in the score for *Multiples of Two* (2009).

Enter and Inhabit
Multiples of Two (2009)
Event Score Extract

Phase 1: Landing
*With choice to witness and join another's dance and awareness of the spaces between, meeting the environment through the cellular ground, connective tissues, and skin, **settling in stillness until saturation spills into movement**, offering the site that which it invites.*

Phase 2: Bridge
*Bringing that which has come before, becoming attentive to the architecture of the skeleton, meeting the environment with support of the bone layers, compact bone and bone marrow, **remaining available to shared moments of stillness**.*

Other scores such as *River Walking* (2010) share this invitation to stillness while also playing with the expectation to move, claiming it is a possibility rather than a certainty as a compositional strategy.

Enter and Inhabit
River Walking (2010)
Event Score Extract

Part 2 – micro-climate score draft 1 (somatic under-score hands on – separating muscle from bone, and yield and push BNP)
*Establish your own micro-climate, **Remain attentive to the possibility of movement**, Play with the possibility of relating/relationship, a constellation of four and the freedom to witness, move, write, story tell or gift an exchange.*

Repeat until sculptural stillness emerges

This inclusion of stillness, pause, action and change in equal measure extends to the photographic dimensions of the project. Images of still, hovering and paused bodies sitting on bridges, laying in tunnels, amongst tress, on benches and crouching on the sand, are to be found amongst those of running, activated and gesturing forms. Similarly, images of still water, fixed objects, suspended droplets and solo leaves live amidst those of swirling water, dancing kites, and shifting shorelines. In offering the images as part of live or virtual events consideration is given to the mode and duration of their presentation, for example slow paced slideshows as part of the web space invite a slowing down of the nervous system in the looking, a play with multiple scales of image in live exhibitions invite visitors to pause and notice the varying perspectives being offered. Just as the sharing of images might invite visitors and audiences (invited and accidental alike) to momentarily notice the otherwise not seen or acknowledged aspects of a woodland or city underpass site, so too does the act of slow dancing in the environment. Moving and re-appearing repeatedly over time, those populations who are local to the site may indeed literally stop to converse with us about our visits and activities as they pass through on their own

trajectories. Similarly, those invited to or stumbling across a live event momentarily join a process of slowing and appreciation for the pause before action, and the detail in the landscape as modelled in the scored improvization.

The slow unfolding of the creative process

Lepecki's and others theorization of the slow within the performance moment, offers some useful thinking regarding the potential of the slow to interrupt the modernist body of production. However, there are other dimensions of the slow within the *Enter and Inhabit* project[11] that I would argue warrant discussion. Broadly this can be seen in the making process of *Enter and Inhabit* which, characterized by its collaborative nature unfolds through an extended period of time. Rooted in reflection and the RSVP cycle the making timeframe presents an alternative to an approach predicated on a perception of the 'dance work' as product, something that can be constructed to order within a conventional six-week period. Instead there is recognition that through time a dance event will emerge from a process of exploration, negotiation, and sharing of practice across disciplines.

As alluded to in the discussion so far, the *Enter and Inhabit* approach to working on site involves a slowing down to enable the attunement of specific body systems or patterns as an axis point from which movement initiation and relationship with environment can begin. And, while musculoskeletal initiated action and movement through space is perhaps our most familiar territory as dancers, the project proposes that we might also choose to dwell in an alternative body system, for example the organs or fluids as a means to illicit other ways of being and moving in relationship to site. Within BMC® the different tissues of the body are considered to align with variant movement qualities including relationship to time and space which can be accessed via practiced and guided experiential explorations and mined for their creative potential. In exploring this creative potential, we are interested to continually develop the skill to experience anew each time the sensations opened by the improvizational and score structures collaboratively developed during the making process.

Within this approach, improvization is no longer a means to generate movement in 'rehearsal', but rather the extended making period is used as a time for us to explore and develop the skill of staying present with the selected anatomical focus allowing time for movement responses to accumulate beyond the expected. Thus inherent to this way of working is a commitment to the process. Value is given to the returning and repetition of sensate movement explorations fuelled by a belief that new experiences will unfold each time. The skill of connecting with and moving from experientially known body systems and patterns becomes a skill to be honed and developed, a practice that also requires studio time alongside on-site

investigations. As such value is ascribed to a process that extends through time enabling reflection and intuitive unfolding of creative ideas.

Public events are thus not conceived as the work, but rather the first manifestation of an ongoing exploration. And so our engagement with different sites may span months or years, sometimes working in several sites concurrently, as we dwell, meander and resource in the sites to discover what form the public event might take.

To enter into this way of working is to embrace the state of being in the unknown, embarking on a creative journey without a final destination. Such an understanding of the creative process is noted by Crickmay discussing the work of those artists of the British New Dance movement in the early 1980s when he observes:

> these dancers (through their work) are always confronting the unknown. They deliberately seek out situations they themselves do not recognise. The work differs from traditional dance forms in seeking continually to overturn habits of response and perception.
> (Crickmay, 1982: 8)

As such the dance is not conceived as a completed entity but rather as a work in transition. Seemingly rooted in an experiential understanding of subjectivity as an emergent phenomena, the choreographic process becomes one characterized less by a need to construct form and content. Rather, it is replaced by one that delights in the generating of material, the structure of which, to a large degree, is self-defining and resistant to models of capitalist production and consumption.

Closing: integrating acts of interruption

An argument has been made here not for a replacement of action with stillness or the kinetic with slowness but rather to propose an interest to acknowledge the interrelationship of these two habitually diametrically opposed aesthetics; to invite a more easeful move along the continuum and a valuing of the slow in this endeavour. As within BMC® the interest is to balance rest and activity, or to use an anatomical reference point, to balance the parasympathetic and sympathetic nervous system, not merely dwell in the solitude, sensing and contemplation phase of improvization and making. In this we might also want to reclaim the slow as more than an act of resistance through interruption of motility and reassert its always-present presence in the dancing moment and creative process.

In taking this view, a recognition of the cultural and aesthetic situated nature of action and motion is made, or to return to Lepecki, a meditation on the slow in dance is 'to propose how movement is not only a question of kinetics, but also one of intensities, of generating an intensive field of mircroperceptions' (2006: 57). Informed by Deleuze and Guattari, the

proposition here is that slowing to come into relationship with the 'microperceptions' of site can perhaps paradoxically reminds us of its and our continual state of motion or process of *becoming*, and in doing so offers an experiential example of the philosophical notion of intersubjectivity.

Notes

1 See www.enterinhabit.com
2 For an introduction to BMC® see Cohen (1993) or Hartley (1989).
3 The words 'soma' and 'somatics' were first coined by philosopher and somatic practitioner Thomas Hanna (1928–1990) in the late 1970s to speak about the body as experienced from within, as a 'felt, sensed, lived entity'. In using this term he advocated a balancing of first and third person perspective, rather than a replacing of the one with the other.
4 For further discussion of the virtual within the *Enter and Inhabit* project see Garrett Brown, N., Kipp, C., and Voris, A. (Forthcoming).
5 Begun by dance artists Natalie Garrett Brown and Amy Voris in 2008, principally as a site responsive movement project in the city landscape of Coventry, the project has subsequently evolved to work across a range of rural and urban sites and to include a photographer, Christian Kipp and, until her passing, dancer/ writer Niki Pollard.
6 Here I am drawing on a theorization of the term 'intersubjectivity' as offered by dance scholars informed by corporeal feminism. However, this term is used by others working in the fields of Psychoanalysis, Psychology, and Philosophy, specifically Phenomenology when formulating understandings of relationship. For further discussion of this point see Brown, N. G. (2007 and 2011).
7 In introducing the term 'kinesthetic empathy', I acknowledge the research project and resulting collection of essays which speaks to themes of that which we and others have theorized as a corporeal response or bodily transmission. Of particular interest is the cross-art and cross-cultural perspective this brings. See Reynolds, D. and Reason, M. (2012).
8 For further information about Helen Poynor's practice and work see www. walkoflife.co.uk/helen.htm
9 For further discussion of the RSVP process and Halprin's work more generally see Poynor, H. and Worth, L. (2004) and Poynor (2009).
10 As other writing has discussed (Brown, Kipp,. Pollard and Voris [2011] and Brown, Kipp, and Voris [Forthcoming]), the process of art making we are honing within *Enter and Inhabit* resonates with the work of performance studies scholar Professor Susan Melrose (2003), who casts the collaborative process as one of 'chasing angels' and reliant on 'expert intuition'. In developing these metaphors she articulates the significance of artists in relationship when they are making, and also positions intuition as reliant in part on the embodied knowledge of the performer. In doing so she offers a philosophical perspective on the significance of Halprin's RSVP process as a model for collaborative practice operating from an intersubjective position.
11 There are of course many other examples of collaborative and dance practice that might align with this observation. See Garrett Brown (2007) for further discussion of this point in relation to other 'somatically informed' dance artists.

References

Banes, S. and Lepecki, A. (2007) *The Senses in Performance* (London and New York: Routledge).

Brown, N. G. (2007) *Shifting ontology: somatics and the dancing subject, challenging the ocular within conceptions of Western contemporary dance*, PhD Thesis (Roehampton University, University of Surrey) [Unpublished].

Brown, N. G. (2011) 'Disorientation and emergent subjectivity: The political potentiality of embodied encounter', *Journal of Dance & Somatic Practices*, 3(1&2), pp. 61–73.

Brown, N. G. (2012) 'The Inter-subjective Body', in S. Reeve (ed.) *Ways of Seeing a Body: Body & Performance* (UK: Triarchy Press).

Brown, N. G., Kipp, C., Pollard, N. and Voris, A. (2011) 'Everything is at once: Reflections on embodied photography and collaborative process', *Journal of Dance & Somatic Practices*, 3(1&2), pp. 75–84.

Brown, N. G., Kipp, C. and Voris, A. (Forthcoming) 'Dancing with dirt and wires; reconciling the embodied and the digital in site responsive collaborative practice'. In Meehan E. & O'Dwyer, N. (ed.) *Through the Virtual Toward the Real: The Performing Subject in the Spaces of Technology* (UK: Palgrave Publishers).

Cohen, B. B. (1993) *Sensing, Feeling, and Action; The Experiential Anatomy of Body-Mind Centering* (Northampton, MA: Contact Editions).

Crickmay, C. (1982) 'The Apparently Invisible Dances of Miranda Tufnell and Dennis Greenwood', *New Dance*, No. 21 March 1982, pp. 7–8.

Deleuze, G. (1968/1994) *Difference and Repetition*, [translation Paul Pattern], (London: Athlone).

Deleuze, G. and Guattari, F. (1980/1987) *A Thousand Plateaus: Capitalism and Schizophrenia* [translation Brian Massumi], (Minneapolis: University of Minnesota Press).

Hanna, T. (1986) 'What is somatics?' in H. G. Johnson (ed.) (1995) *Bone, Breath & Gesture: Practices of embodiment* (California: North Atlantic Books).

Hartley, L. (1983) 'Body-Mind Centering; an introduction', *New Dance*, No. 27 Winter 1983.

Hartley, L. (1989) *Wisdom of the Body Moving; An Introduction to Body-Mind Centering*, (California: North Atlantic Books).

Holledge, J. and Tompkins, J. (2000) *Women's Intercultural Performance* (London: Routledge).

Johnson, H. G. (ed.), (1995) *Bone, Breath & Gesture: Practices of embodiment*, (California: North Atlantic Books).

Lepecki, A. (2006) *Exhausting Dance, Performance and the Politics of Movement* (New York and Oxon: Routledge).

Manning, E. (2007) *Politics of Touch, Sense, Movement and Sovereignty* (Minneapolis, London: University of Minnesota Press).

Melrose, S. (2003) 'The Eventful Articulation of Singularities – or, "Chasing Angels"' Keynote Address at *New Alignments and Emergent Forms: Dance-making, theory and knowledge*, School of Arts, Froebel College, Roehampton, University of Surrey on 13 December 2003, available at www.sfmelrose.u-net.com

Poynor, H. (2009) 'Anna Halprin and the Sea Ranch Collective, an embodied engagement with place' in *Journal of Dance and Somatic Practices* 1.1. Intellect.

Reynolds, D. and Reason, M. (2012) *Kinesthetic Empathy in Creative and Cultural Practices*, UK: Intellect Publishers.

Sklar, D. (2007) 'Unearthing kinesthesia: groping among cross-cultural models of the senses in performance', in S. Banes and A. Lepecki (ed) *The Senses in Performance* (New York: Routledge).

Worth, L. & Poynor, H. (2004) *Anna Halprin*. UK: Routledge.

19 Diving into the wild

Ecologies of performance in Devon and Cornwall

Malaika Sarco-Thomas

We had a beautiful day at Watergate Bay which was a windy day. Somebody had a kite, and we just used the kite as the point for our bodies to focus. Following the kite with our heads, with our arms, with our whole bodies, it gave us this lovely score to explore. The man with the kite didn't realise there were fifteen people following his kite for about an hour; we were behind him diving to the floor, lurching with the wind, hovering in stillness, poised for the next dart or dive.

(Lois Taylor 2013, workshop facilitator)

Recent initiatives advocating health, fitness and environmental awareness in the UK,[1] raise questions regarding how site-based dance performance[2] can bring people into the outdoors and into a more physical relationship with place. Alongside common knowledge of the benefits of exercise there is mounting evidence regarding the importance of outdoor physical activity to the development of physical resilience, stamina, adaptive skills and sensory awareness (Egoscue 2000) as well as mental health and social development for all ages (Pretty 2004; Pretty *et al.* 2005; Pretty *et al.* 2013; White *et al.* 2013).

With distinctive coastal and moorland features, the rural areas of Devon and Cornwall in the South West of England offer a particular appeal to artists working with landscape, and act as home to a number of practitioners whose performance projects present opportunities for creative engagements with place. In recent years, large-scale site-based productions by dance and theatre companies such as Wildworks, C-Scape and Stephen Koplowitz's Taskforce, and smaller scale performance projects by practitioners such as Niki Pollard, Rosalyn Maynard, Helen Poynor, Rachel Sweeney, Marnie Orr and Sarah Shorten present opportunities for people in the region to engage socially and physically with place.

This chapter explores how this work presents strategies for relating to outdoor environments, and considers how it might contribute to wider discussions regarding the development of ecological interest and action. Using philosopher Felix Guattari's (2000) redefinition of 'ecology' as necessarily including transformative action in three areas of human activity: social, natural and mental spheres. I discuss the potential of site-responsive

choreographic work to develop participants' sensitivity, kinaesthetic imagination and empathy with wild environments.

Performance theorist Dee Reynolds proposes:

> kinesthetic imagination [...] is both a response and an active resistance to constraining patterns of energy usage that are culturally dominant [and] the potential to transform uses of energy in movement places dance at the forefront of culturally significant artistic practice.
>
> (2007: 1)

Where kinaesthetic imagination enables a dancer to transform his or her energies in movement, the process of translating this energy in performance creates the conditions for audiences to experience kinaesthetic empathy with the mover and experience virtual movement sensations within their own body (Reynolds 2007: 14). In her preface to the edited volume *Kinesthetic Empathy*, Amelia Jones comments on Henri Bergson's idea that art, because of its 'empathetic' capacity, is a 'special domain of human production' in which feelings are not only expressed, but *impressed* upon us. Jones proposes that live performance offers 'potential for both performer and viewer to be *changed* through this empathetic relation as they are, presumably, in the same space at the same time' (Jones in Reynolds and Reason 2012: 12–13, emphasis in original). Whilst the ethics of empathy as affect experienced through live performance has been investigated within human-based examples (see Reynolds 2012 and Parekh-Gaihede 2012), scholarship of kinaesthetic empathy specifically toward the non-human in dance performance practice is less prominent.[3]

Realisation of 'ecological' sensitivity and empathy in performance is, I suggest, linked to the ways that an event creates opportunities for responsive, physical and sensory engagement with a site (natural ecology), the conceptual roles afforded to performers, audiences and environments (mental ecology), and the socially responsive nature of the event (social ecology). With this in mind, this chapter surveys a range of recent performances in Devon and Cornwall in terms of how they provoke intersubjective understandings and kinaesthetic imaginings by facilitating walking, dancing or diving into the wild.

In *The Three Ecologies* Guattari emphasizes that the political and environmental significance of ecological praxis occurs via a process of cultivating a kinaesthetic sensitivity which is a:

> 'pre-objectal and pre-personal logic' of the sort that Freud has described as being a 'primary process.' One could call this the logic of the 'included middle', in which black and white are indistinct, where beautiful coexists with the ugly, the inside with the outside, the 'good' object with the 'bad'...
>
> (2000: 54)

For Guattari, eco-art, like the 'ecology of ideas' proposed by Gregory Bateson, 'cannot be contained within the domain of the psychology of the individual, but organizes itself into systems or "minds" the boundaries of which no longer coincide with the participant individuals' (ibid.). Guattari's three ecologies share a common principle of 'a praxic opening-out' through activities which are not 'closed to the possibility of creative proliferation' but are shared as 'a collective and individual subjectivity that completely exceeds the limits of individualization' (2000: 53–68). Such 'ecological' creative practices, in Guattarian terms, can also be discussed in terms of how they disseminate themselves locally through familiar and unfamiliar networks.

For example, where the actions of an audience member of Wildworks' *The Beautiful Journey* might take her on a long walk over hill and dale through rural and industrial landscapes dotted with theatrical events, a moorland resident and village allotment-user takes an opportunity to play with simple partnering games and gardening activities in Niki Pollard's participatory site event *Cartwheeling with Wheelbarrows* (2010). Whereas an audience member of Stephen Koplowitz's Taskforce project, *Liquid Landscapes* (2009) follows dancers who animate architectural icons with musical choreography designed to engage a broad spectrum of onlookers, a mobile audience viewing Impel Dance Company's *MiraMar* (2010) finds a language of surprising movements by otherworldly creatures inhabiting the foliage at

Figure 19.1 Impel Dance Company *Miramar* (2010).
Photo: Minou Tsambika Polleros

Trebah and Dartington Gardens. Meanwhile participants in Helen Poynor's *Walk of Life* workshops create incidental public performances as a by-product of group movement explorations on the beaches of east Devon. Projects like these offer means by which the public can reap some of the many health benefits of being outdoors or in green spaces, whilst simultaneously inviting and requiring creative participation and social interaction.

The participant's kinaesthetic experience of an environmental performance also has the potential to influence their sense of relationship to a place and shift their orientation to the 'more-than-human world' (Abram 1996: 1, 15) and facilitate a transpersonal experience with nature (Fox 1995; Pretty *et al.* 2005: 25).

Choreographer and artistic director of Sap Dance, Nigel Stewart suggests that environmental performance can support the deepening of ecological knowledge. He observes that environmental performance practices invite new ways of experiencing a particular site in its alterity, or 'otherness' (2010: 225). Performance can do this in part by proposing new relationships between bodies and landscapes through performed narratives, creating experiences of altered reality within a site or inviting audiences to witness the results of research into embodying site-textures or qualities. This approach is exemplified in ROCKface by Rachel Sweeney and Marnie Orr (2007) a choreographic collaboration exploring intersections between dance, ecology and geography whose residential research intensives on Dartmoor, *Mapping Project 1 & 2* (2007) and *Adaptation* (2010), as well as other sites across the UK and Australia, prioritize performances of sensation and receptivity in relation to site.

In *Exploring Linkages Between the Environment and Human Health*, Karen Henwood (2002) has suggested that government agencies would do well to promote the health benefits of the amenities the countryside has to offer, and proposes that 'some recognition of the "sensuous pleasures" and "feelings of togetherness at sharing communal spaces, identities and values" can also be used to guide to enhance the effectiveness of open, natural spaces to promote health and well-being' (Morris 2003: 21). Clearly, programmes that provide conceptual and social frameworks for individuals to engage with outdoor environments offer a safe way to 'dive into the wild' as well as the opportunity to generate communal experiences and a sense of identity in relation to places (Pretty *et al.* 2005: 25). Outdoor adventure programmes and sports initiatives provide this for some people, as well as the opportunity to generate skills that an individual can take into his or her own practice of a sport or in life. It is important to recognize the scope for physical and conceptual involvement with nature that such programmes of outdoor experience offer.[4] I argue that performance initiatives such as those described in this chapter offer conceptual and social frameworks for outdoor experiences that provide individuals with health-giving benefits whilst simultaneously proposing ways to think differently about our relationships to wild places.

Table 19.1 Recent site-oriented performance activities in Devon and Cornwall*

Viewing Nature		Incidental Involvement		Purposeful, Somatic Involvement	
Site-Responsive Performance/ Film - Framing Landscapes	Site as key presence/ character	Site as setting for (narrative) performance	Site as starting point for (participatory) choreography	Site/Outdoor involvement as focus for performers	Site/Outdoor involvement as focus for participants
Inner City (film) Kayla Parker and Lois Taylor, Plymouth 2001	Minack Theatre, Penzance, 1932–2014	*Stuff That* Attik Dance and Lois Taylor, Eden Project 2002; *Passion Fruit* 2006; *Clean Sweep* 2007; *Shoppafrolics* 2008, town centres including Bournemouth, Plymouth, Yeovil, Exeter, Teignmouth, Barnstaple	*Liquid Landscapes* Stephen Koplowitz and Taskforce, seven sites in Plymouth, Buckland Abbey and Dartington, 2009	*Road to the Beach* Antony Waller, Motionhouse, C-Scape, Watergate Bay 2004	*An Exeter Mis-Guide*, Wrights & Sites 2003
View from the Shore Jacky Lansley, Hall for Cornwall 2005	*Adder, Hare, Hope, and High Plateau* MED Theatre Company, Dartmoor 2006–2012	*A Very Old Man With Enormous Wings* Kneehigh, Hayle 2004	*Souterrain* Wildworks, Cornwall 2006; *The Beautiful Journey* Devonport 2009	*MiraMar* Impel Dance Company, Trebah Gardens and Dartington Gardens 2009	Lois Taylor and Sally Robbins summer workshops at Watergate Bay and Bodmin 2003–2010
Soliloquy for a Shoreline (dance film installation) Saffy Setohy, Cornwall 2012	Kneehigh's Asylum Theatre, Cornwall 2012	*Venus Flower* C-Scape, Trebah 2009 and Cothele 2013, and *Landings* Trebah 2005	*Polpero Festival* C-Scape 2003	*Twig Dances* Malaika Sarco-Thomas, Dartington Gardens 2010	*ROCKface* Rachel Sweeney & Marnie Orr, Dartmoor 2007, 2010
Kindling (film) Saffy Setohy, Cornwall 2012	*veinglory: fernweh* Alicia Grace, Brewhouse Arts Centre, Taunton 2010	*King Arthur the Wild Hunt, The Dancer and the Devil in the Woods, The Hallowed, The Wild Woodland Summer Ball, Winter Wood* Rogue Theatre, Tehidy Woods, and *The Knockers Easter Trail*, Heartlands 2011–2014	*Imaginers* Antony Waller: Camborne, Pool and Redruth 2008	*River Walking* Enterinhabit, North Bovey 2010	The Blue Gym, European Centre for the Environment and Human Health, Devon and Cornwall 2009–2014
Quercus Malaika Sarco-Thomas Dartington 2011; *Alnus glutinosa* Penryn 2013	*Kneehigh Rambles* Kneehigh, Cornwall 2011–2013	*Facing North* Sarah Shorten, World Dance Day, Clovelly Court, Devon 2011	*Vital Spark Festival*, Liskeard 2009–2013	*From my Doorstep: Riverwaie to Beara Farm* Rosalyn Maynard, Buckfastleigh 2010	Moor to Sea workshop, Katherine Nietrzebka and Niki Pollard, Haytor 2010
		Five Songs on the Rooftops Angela Praed, Truro 2010	*Golowie Donsya* for Big Dance, Saffy Setohy with Caroline Schanche and Emmalena Fredriksson in Marazion, Cornwall; Gemma Kempthorne in St Austell, Cornwall; Carmen Hunt and Lois Taylor in Liskeard 2012	*On the State* James Wilton, Camel Trail 2013	*Cartwheels and Wheelbarrowing* Niki Pollard, North Bovey 2010
		Terrarium Simon Birch, Daymer Bay, Bedruthan Steps 2013	SALT festival of landscape dance, DR2 Cornwall 2013	*She Who Walks* (performance & film) Denise Rowe, Dartmoor 2013	*Unseeable Animal* intensives Rosalyn Maynard and Daisy Martinez, Dartmoor 2011, 2012, 2013
		Young People Dance Dance 2013 Project and schools in mid-Cornwall, Trelissick Gardens 2013	*The Night Ball* Ballet Lorent, Newquay airport 2013	*Storying Futurescapes* Articulating Space Research Group, Falmouth 2013	*Making it Home* intensive: Rosalyn Maynard, Buckfastleigh 2012
			VIA: The Distance that Connects Us Ruth Pethybridge, Penryn 2013		Green Moves dance workshops, Penryn 2012–2013
					Vital Spark Festival walking projects, Liskeard 2013–2014

*This list is not complete or exhaustive but provides a sketch of some of the more visible or well-documented site-based performance events in Devon and Cornwall since 2002.

The kind of experiences afforded parallel the suggested variety of ways in which one can interact beneficially with nature, identified in the *Physical and Mental Health Benefits of Green Exercise* (2005) report. In this report, commissioned by the Countryside Recreation Network, the first suggested way of engaging is by viewing nature, as through a window; the second is interacting with nature in a secondary way, as in experiencing it as an incidental component of some other activity, i.e. talking on a park bench, or walking to work; and the third is a purposeful, premeditated involvement with nature through some physical activity such as gardening, rock climbing, surfing, horseback riding or hiking (Pretty *et al.* 2005: 27). I have used these three frameworks in this chapter to map some approaches to working with landscape employed by choreographers working in Devon and Cornwall in recent years (see Table 19.1). The following sections outline examples of this.

1 Viewing 'the wild'

Framing 'the wild' landscapes of Devon and Cornwall through dance work presented in theatre or gallery venues has often taken the form of documenting experiences of being outdoors. Performances directly dealing with seeing and being in the wild include Jacky Lansley's *View from the Shore* (2005), in which movement sourced on beaches was developed into a proscenium performance at the Hall for Cornwall in Truro. More recently, the screen-based installation *Soliloquy* (2012) by Saffy Setohy and collage

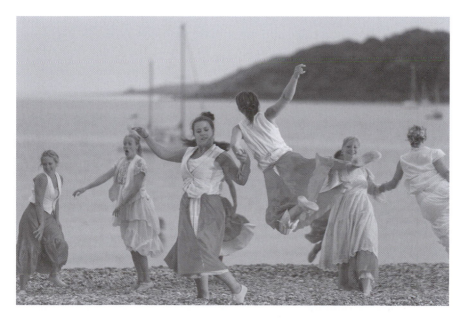

Figure 19.2 Cscape dance company, Venus Flower and Other Stories (2010).
Photo: Steve Tanner.

work by Alicia Grace, documented movement encounters with wild meadow and coastal scenes. Setohy's film *Kindling* (2013) also used rocky moorland landscapes as a playground for the performance of movement games between a mother and teenage son. Helen Poynor has made dance videos *On the Brink* (2001) with Sandra Reeve and *On an Incoming Tide* (2010) with Kyra Norman as a way of framing her work in non-stylized and environmental movement practice. The storytelling outreach project *Kneehigh Rambles* (2013) is an initiative to collect and perform true and fictitious tales of characters' interactions with the Cornish sea and rural countryside. Kneehigh brings these stories to life using puppetry and music, creating animated performances in small and unlikely venues throughout the county. Rosalyn Maynard's solo performance *From my Doorstep: Riverwaie to Beara Farm* (2010) similarly reflects on a year's study of farming via walking practices in the Devon countryside leading to a composed evening of work, and the author's solos *Quercus* (2011) and *Common Alder: Alnus glutinosa* (2013) consist of re-creating for the theatre, time-based moving observations of different specimens of trees, which have been investigated outdoors.

2 Incidental interactions with 'the wild'

Incidental interactions with 'the wild' offer a broad category for site-based work, encompassing approaches that incorporate more and less immersive experiences for audiences and performers. It includes performance in which a location is seen to be a kind of backdrop or setting to activities on view, as well as work that is more deeply rooted in the cultural, social and historical contexts of a place and takes these issues on board as a starting point for devising an event. Much of the more well-known outdoor performance work, e.g. large-scale events by Kneehigh Theatre, Stephen Koplowitz, Antony Waller in collaboration with Motionhouse, C-Scape Dance Company and Wildworks Theatre, from Devon and Cornwall fit into this category, and offer opportunities for participants to engage without having to access traditional theatre spaces. In interviews, choreographers based in the region have echoed how the proliferation of sited dance and theatre work has grown in direct response to the lack of suitable large-scale venues for performance, and an interest to reach out to the region's scattered and often isolated rural communities (Taylor 2013; Waller and Waller 2013).[5] Producers and artists have offered different creative solutions to this problem, with many performances developing or activating networks of Guattarian 'social ecology' across the region. For the purposes of this chapter, three modes of incidental interactions with the wild can be distinguished for works within this category:

- Performance outdoors.
- Landscape as setting for performance.
- Site performances used to build networks of social ecology.

Audiences of **performance outdoors** encounter the elements unavoidably at opera, dance and theatre shows at the Minnack Theatre in Cornwall. This stunning outdoor amphitheatre located on the clifftops near Penzance advises theatre-goers to come with rain gear, hot drinks and a picnic, cheerfully warning that shows are rarely cancelled because of the (often blustery and wet) weather. Similarly, Kneehigh Theatre's purpose built theatre tent, The Asylum, set up in a farmer's field in Cornwall, has brought the company's work closer to the elements and created a space called 'the most inside you can feel outside' (Kneehigh 2013) while still offering a full technical rig and range of comforts within the canvas dome.

Landscape as setting for narrative performance includes a range of dance and theatre work developed recently for larger audiences. Rogue Theatre's popular performances in Tehidy Woods by North Cliffs, Cornwall invite groups to dress for the weather and bring torches for a trip to a forest that becomes animated by lights and colourful visuals. Shows like *King Arthur, the Wild Hunt* (2011) and *The Wild Woodland Summer Ball* (2013) promise a 'theatrical festive woodland adventure' where 'the imaginary comes to life' (Rogue Theatre 2013). Here, audiences are invited to enter the woods as 'a playground of magic' where actors use music, dance and storytelling to animate Celtic-themed myths, folklore and legend. The shows are praised for being accessible and memorable. The company seeks to 'create events that turn our landscapes into imaginative worlds' and 'to gently improve the way we enjoy our environment and local culture' (Rogue Theatre 2013). The 'local culture' featured in these performances depends on the performance, the location, and promotional strategies.[6]

Wildworks theatre company's *The Beautiful Journey* (2009) performed at the Devonport dockyards in Plymouth is an immersive theatre performance that casts the audience as participants in the story. Their approach is termed 'landscape theatre', a process that weaves locally-sourced stories with fictitious narratives in the development of a work that can have incarnations in similar locations (e.g. dockyards) in different regions. *The Beautiful Journey* was performed in Malta as well as Devon, and told a story of characters encountering the end of one world, dealing with rising sea levels, despair, and possibilities of a different future. Wildworks directors Bill Mitchell and Sue Hill state in their project notebook, 'I am trying to make the audience part of the adventure' (2007); the group uses poetic narrative to create a collective experience among actors and participants.

> We are on an enchanted island. The ice has melted and the water level has risen. This is the last island. Something has been found, something that has given the possibility of another island. A doubtful island. Another eden. Together we make a boat and provision it and weave into it ideas of the place we want to create.
>
> (Mitchell and Hill 2007, note capitalisation of 'eden' is kept as originally found in the notebook)

These working notes convey a distinctive approach to finding a sense of 'we' within the sited performance experience. In productions such as *Souterrain* (2006, 2007) which addressed mining histories of Cornwall by taking place in underground tunnels, Wildworks created promenade journeys that were deeply embedded in landscape, demonstrating a choreographic approach to mobilizing both spectators and performers (Cross 2009). Wildworks and Kneehigh Theatre's co-production of *A Very Old Man With Enormous Wings*, developed and performed in the Cornish town of Hayle (2005), devised its story in direct reference to Hayle's history as a once prosperous but now deprived mining port, a town 'with a visible past and a potential future, but still no present' (*This is Cornwall* 2005). Through various storytelling frameworks, these performances build new narratives about the sites they inhabit, often parodying, expanding and drawing on common associations with a place.

Site performances used to build networks of social ecology emerge, in part, from such traditions as the village-based performances of Kneehigh Theatre. Similarly C-Scape dance company's sited performances often address aspects of life in Cornwall and seek to actively incorporate diverse groups of dancers in the performances. Through their work, *Polperro Festival* (2003) C-Scape worked with ten local schools to devise a series of performances around Polperro harbour, highlighting folklore and traditions of this fishing village. In *Venus Flower & other stories* (2010, 2013) a cast of over 100 dancers animated a series of tableaux placed throughout the cultivated landscapes at Trebah gardens. The scenes told a story of the Lobb brothers, Victorian botanists who once travelled the world to collect rare plant species to bring to their garden in Cornwall. The 100 Company project comprised several associate dance artists working with teams of dancers aged 6 to 86 to develop movement material that was woven together to depict the once-in-a-blue-moon bloom of a rare tropical flower. The 100 dancers dressed in shades of white spread over a great sloping lawn and performed movement to an evocative and grandiose piece of music, broadcast over speakers across the valley of Trebah gardens.

Comparable in terms of visibility are the performances curated within the SALT festival of 'Landscape/Dance' in Cornwall. This biannual event seeks to bring audiences together in landscapes across the county by placing highly visible choreographies in 'extraordinary landscapes' (Waller and Waller 2013). In 2013 this involved bringing a number of pre-existing choreographies to new locations to generate the first cycle of the festival. Co-producers Antony and Sarah Waller invited *Terrarium* by Simon Birch, *The Night Ball* by Ballet Lorent and *Venus Flower & other stories* by C-Scape and the 100 Company to be re-performed in eight key locations around the county. As key features of the work, several of these performances culminated in a participatory celebration. *The Night Ball*, performed in an airplane hangar, incorporated social dancing within a performance that dissolved into a party at which audiences sat on tables at the periphery of

the stage and were invited onto the dance floor by professional dancers to join in jitterbug, swing, waltz and foxtrot dances. Tickets to the event included free dance lessons as a preparation to the ball. Producers Dance Republic 2 also commissioned a new work by James Wilton, *On the Slate*, for an old slate quarry along the bicycle-accessible Camel Trail in north Cornwall, offering an un-ticketed event that attracted dance audiences to a cycle trail and surprised the cyclists.

Dance Producer for the SALT festival, Antony Waller moved to Cornwall in the late 1990s and was spurred by statistics that revealed a surprising percentage of young people in Truro had never been to the beach. He set about creating an event that would get children to the coast and involve them creatively in making things happen there. His subsequent projects have creatively imagined performance and participation in sites of natural and cultural significance in Cornwall. Working with Kevin Finnan and Motionhouse dance company he developed a nine-month residency programme with local schools and dance artists. The project, *Road to the Beach* (2002) brought around 1,300 people together as audience, volunteers, performers, stewards and participants on the beach at Watergate Bay in a mile-long promenade event featuring performances from school groups challenging the notion of 'what do you do at the beach' (Waller and Waller 2013) incorporating 'giant windmills and sandcastles, [...] a siren choir on the rocks and the 100 strong sea of boys' (Motionhouse, n.d.). Subsequent projects included *Imagineers* (2007), featured children and professional dancers in a series of performance events that sought to re-tell and re-imagine narratives of engineering and mining within the Camborne area, and *Selling the Wind* (2002) involved over 500 performers in a promenade performance made in collaboration with the National Trust and local artists, an event that led to the creation of C-Scape dance company.

Devon's World Dance Day performance in 2010 choreographed by Sarah Shorten is an example of another approach to innovative large-scale participation. Shorten collaborated with 11 dance artists to create the beginnings of a dance responding to the rugged cliffs of north Devon. Each artist then took their part of the score to develop with dancers and community members in their home area to contribute towards a multi-site performance in which all the dances were performed simultaneously to a piece of music broadcast over BBC Radio Devon. The groups later gathered to share the performances at *Facing North* in Clovelly Gardens in north Devon in a performance that involved a cast of over 70 children, young people, and adults telling stories of the sea.

In each of these examples, audiences see dancers, actors or performers immersed in a set of social and cultural conditions in which they themselves also are caught. Mines, gardens, harbours, dockyards and forest are co-navigated by all, and various narratives substantiate the involvement of these groups. The performers remain the agents investigating the architecture and textures of the site with their bodies, whilst the audience

witness a choreographed representation of this imaginative process. Whilst the outdoor site encompasses the performance, tactile or creative involvements with 'wildness' or the textural elements of a place are, to varying degrees, side effects of the spectacle rather than its main focus.

In these performance examples, networks of social ecology are highlighted as aspects of a narrative that is either part of the performance itself, or by introducing community participants as collaborators/ performers alongside professional dancers. 'Wildness' or the non-human world of the outdoors is often a silent collaborator, an element more easily viewed than dialogued with, particularly in more cultural or historically significant sites.

An example of a dance performance offering another approach to highlighting social ecologies as well as giving attention to the alterity or 'otherness' of wild, natural places in site work is the 2013 production *VIA: The Distance that Connects Us*, a commission for the Penryn Arts Festival sited beneath the viaduct in College Wood and created by choreographer Ruth Pethybridge. This work developed a score that built on creative sensory interactions with the site, and the choreographer chose her setting in part as a contrast to the stunning locations often chosen for site works in Cornwall. She observes:

> It's a strange site: I found it first by walking there with my daughter – it's in the middle of Penryn but mostly only used by dog walkers and people who go there to drink a beer on a bench so it's a bit… seedy… I think we can think that Cornwall is this idyllic location but it can be a bit bleak and Penryn is quite urban most of the time – or it can feel that way. This was a green space that was in the middle of the town but rarely visited, it's not a tourist attraction… I was drawn to the site partially because of its ambiguity, and I had an interest to bring people to a place that isn't often visited, to bring something to and explore this kind of unsung area, or a liminal zone in a town. I was pleased to find out after the performance that most of the audience had never been there before. … I also liked the ambiguity of the tree stumps that lined the space, no-one quite knew what they were or why they were there – so they felt a bit mysterious… the performance was a way to open up what that site could be to people, with people, but also as something that could be discovered, questioned, inhabited.
>
> (Pethybridge 2013a).

Pethybridge invited participants to join the project as 'a diverse group of creative performers'. The callout confirmed that 'this is for people with all levels of dance experience, newcomers and professionals alike' (Pethybridge 2013b), and she describes her interests in 'letting the kids be kids' in the performance by making it quite physically playful in some moments, while also inviting narratives from older members of the group to weave into

references made to the train line running above the city park. By developing the piece in collaboration with the performers and with the site 'as something that could be questioned', Pethybridge acknowledged dialogic routes toward social ecology and creative participation between human and non-human as a focus within the work (Pethybridge 2013a).

She describes a choreographic process in which these various interests were balanced with her wish to bring the audience as well as the acoustic and visual focus of the work both in and out of the woods, the viaduct, and the clearing:

> The piece began with a kind of 'startle' – which I think was inspired by my work with Rosemary Lee. The children run out of the woods and startle, then run back into the woods again. Then they formed a circle in the woods and began a kind of clapping rhythm, drawing the audience in with the sound, and positioned themselves with the musicians in such a way that there was an acoustic effect that the bridge created. This built and then everyone dissipated.
>
> (Pethybridge 2013a)

Pethybridge describes the flows and intensities of the performance evident in devised movement phrases and in sections where performers 'went to a place in the woods or nearby where they were drawn to, with the instructions just to be present there' (ibid.). By playing with acoustics and exploring scores that prioritized participants' intuitive interest in the details of the woods, *VIA* employed a variety of processes to explore sensory and conceptual interactions between performers and site. The ambiguous nature of the site as Pethybridge describes, also provides an example of 'wildness' not found in other examples of outdoor work described here. Pethybridge's process is significant in its willingness to interrogate the sensory qualities of the site as a theme within a participatory choreographic project rather than using a narrative approach to communicate a character or history of the place. Such a process might be said to exemplify a more dialogic engagement with the qualities of wildness or the unknown aspects of a place, proposing a sensitized, responsive and participatory relationship with place.

3 Purposeful interaction with 'the wild'

The premeditated level of interaction with outdoor landscapes is a less frequently cultivated mode of audience engagement as it invites a level of participation that is more subjective, and less straightforward to compose. Dance artists who facilitate interactive outdoor work often do so as part of an improvisational research process. Devon and Cornwall-based practitioners such as Lois Taylor, Helen Poynor, Rosalyn Maynard, Rachel Sweeney, Marnie Orr, Katherine Nietrzebka and Niki Pollard have used different ways of framing their environmental performance practice,

namely as 'intensives', 'workshops' or 'trainings' in order to broaden the possibilities for participant experience. Poynor describes her *Walk of Life* training programme as an experiential approach to movement grounded in 'awareness of the responsive inter-relationship between body, earth, self and environment' (Poynor 2013). Rosalyn Maynard and Daisy Martinez's annual workshop 'Unseeable Animal' (2011, 2012, 2013) enables participants to explore somatic responses to wild areas of Dartmoor and develop creative reflections. In Nietrzebka and Pollard's 'Moor to Sea' workshop offered for free as part of Dance in Devon's World Dance Day in 2010, all ages were invited to an 'outside movement workshop […] inspired by Devon's natural heritage' (Nietrzebka 2010b).

For groups of movers engaging in an improvisational approach to being outdoors, the exploration of an environment within a workshop setting can create a container for impromptu performative moments in public places whilst inviting them to delve into an expanded sensory experience of an outdoor environment that might be different to frames of reference afforded in everyday situations. As a route toward experiencing wildness, some of this 'environmental dance' can be said to offer 'knowledge of environment particular to and registered through bodily experience but beyond bodily control' (Stewart 2010: 223). Such explorations bring one's attention to an experience of movement which is not known only in the body, but through the body in relation to other non-human bodies.

The *She Who Walks* project facilitated by Denise Rowe of Tolo Ko Tolo (2013) featured workshops investigating connections between 'land, women and ancestry' through experiential movement on Dartmoor. Film documentation of the performance includes images of dancers rolling over rocks, taking a somatic imprint of the landscape into the body. Impel Dance Company's performance of *MiraMar* (2010), presented as part of the 2010 Global Gardens Project coordinated by C-Scape, included scenes of white figures exploring alcoves of Trebah and Dartington gardens: through slow motion foraging-esque actions, alien bodies picked their way through dense foliage. Summer intensives facilitated by Lois Taylor and often co-led by Sally Robbins also focused on exploration of landscapes as 'an exercise in responding to change' (Taylor 2013). Taylor, dance artist and director of Attik Dance for 20 years, described her preference for engaging creatively with moorland and coastland sites namely through developing workshop encounters, rather than product-oriented projects. Through a framework of intensives she was able to create space for participants to use movement and improvisational principles to explore the changing qualities of sites such as Watergate Bay or Bodmin Moor (Taylor 2013).

> Working at the beach can be an exercise in responding to change, to finding the moment where the tides come in, offering new pools, new ripples to explore. As a teacher and facilitator I like that the changes are unknown, so we can see what the offers are of the day, alongside the

plans that we've put in place. So being able to wake up and think, 'what are the offers today? What's going to shift our thinking today?'

(Taylor 2013).

Shifts in thinking are key to reconsidering the environment through poststructuralist approaches, according to scholar Verena Andermatt Conley's close reading of Guattari's work in *Ecopolitics: The Environment in Poststructuralist Thought*. Conley wisely asks how one might effect the changes called upon by Guattari:

> The implicit question asks how we might bring about existential mutations that would remedy the situation, how we can be enabled to disengage ourselves from dominant cultural values, and how we can construct another culture. How do we, in Guattari's words, deterritorialize and reterritorialize ourselves?
>
> (Conley 1997: 95)

Shifting thinking regarding human, bodily interaction with landscape offers one possible response, an approach exemplified in Marnie Orr and Rachel Sweeney's research project ROCKface in which an approach to deterritorializing the human body characterizes the work. Exploring Dartmoor through a series of intensives between 2007 and 2010, Orr and Sweeney's work 'prioritises the work of individual receptivity within highly structured improvisational frameworks', offering a frame for choreography and performance that takes as its focal point the 'divergent communication processes of and between dance bodies' and 'the influence of the particular site' rather than 'a unified viewing position that might exist within a conventional black-box performance stage setting' (Orr and Sweeney 2011). Writings and photographic images from these intensives offer documentation of this process, shifting the focus of the performance to the sensory communication processes between dancers' bodies and qualities of a site. Their writing describes a process that explores 'an inclusive and shared set of references that place the body subject in a dynamic and symbiotic relation with its environment, and environment as inseparable from body' (ibid.). In Guattarian terms, such a transpersonal experience of environment equates to a mental and natural ecology where sensory engagement with place enables one to reterritorialize thought processes, by engaging a 'pre-personal logic' (Guattari 2000: 54). Conley explains how Guattari urges people to:

> think less [...] in relation to subjects and objects than to a territory that is more mental than physical in its articulation. Eco-subjects can deterritorialize and reterritorialize themselves continuously.
>
> (Conley 1997: 98).

Such a practice of extending one's mental and sensory frame of reference to include that which is outside familiar ideas of 'the self' could be significant in developing empathy for an environment, and can be seen as a different conceptual route toward engaging with a landscape than simply as a backdrop to human activity.

Personal agency and 'creative autonomy' are characteristics necessary to individuals who wish to bring about an ecological revolution, according to Guattari (2000: 69). He suggests that a key aspect of ecological praxis is the ability to organize activities that prioritize re-sensitizing the body and to galvanize these via new and creative networks:

> It is this praxic opening-out which constitutes the essence of 'eco'-art. It subsumes all existing ways of domesticating existential territories and is concerned with intimate modes of being, the body, the environment or large contextual ensembles relating to ethnic groups, the nation, or even the general rights of humanity.
>
> (2000: 53)

Choreographed with and for neighbours and family in her north Devon village, dance artist Niki Pollard's interactive community-based performance project *Cartwheels and Wheelbarrowing* (2010) is one example of dance practice located firmly within its contextual environment. Structured improvisatory activity constituted the bulk of the performance plan for participants in a score that included ordinary allotment activity and moments of opening the senses to sounds and happenings in the environment. Participants were invited to respond to these sensations through movement 'broadcasted' in time and space with other movers and watchers. Following is an excerpt from the score instructions.

Section 1

At first, doing what you do on an allotment. When the clock strikes 5.30pm and Niall hits spade, come to **stillness, facing south**. Enjoy simply standing. You might, for example, hear bird-calls, notice sensations of air & light on your skin. You might think of your toes spreading & rooting you down, and how this allows a rising through your spine, floating your skull. Noticing your verticality, and verticals in the landscape. You might notice the 'small dance' of balancing over your feet.

The image of our figures – still, vertical – on an earth wheeling through space.

Gradually, **movement begins to happen**, while staying more or less rooted. This could be the set movement phrase, or your own movement – moving as a bird call, or as the clock striking, or as something that

opens up, **broadcasts** a call up through the sky, out to space. [...] We don't have to move together, but we may find we do, and enjoy that.

(Pollard 2010a, emphasis in original)

Pollard's project is innovative in how it invites the public to participate in a site-based performance event. She involves her own community, a small village on Dartmoor, in developing and presenting dance events in a way that is inclusive and accessible to residents, and also open to others as advertised through regional dance networks. By inviting improvisatory responses to a score that includes opening the senses to the wider goings-on of the outdoors, she makes a space for a kinaesthetic reading of site by the performers, and invites this activity to be read by watchers whom receive score-cards and an invitation to join in if they like (Pollard 2010b). Participant Katherine Nietrzebka remarked:

> We were watching each other, within the score. For the last thing, it had evolved into something in which we were both audience and performer, as a group.
>
> (2010a)

This work exemplifies Guatarri's notion of eco-art: natural ecology in the form of gardening and promoting an actively sensory relationship with the local environment. Involving a form of mental ecology inviting 'your own movement' from participants in a way that '**movement begins to happen**' not as directed externally or predetermined. Developing social ecology in the form of organizing participants transversally, working across age groups and skill levels to hatch a project that sits outside familiar channels of arts production and neighbourly communication calling attention to multiple layers of relationship. Pollard's score explains:

> The task is to be aware (receivers!) for our changing constellation as a group in the allotment. We can walk in any direction; the play is in the spatial dynamics of walking towards, alongside, at a distance, and so on. I enjoy the simplicity of the activity – there's a fascination to doing it over a long period in fact. I'd be interested to hear your experiences of it. For me, walking those pathways heightens my sense of the mundane times that I walk them when working on the allotment, and, widening that out, to my paths from there out around the village. Walking as a group focuses me on my relationships with you as other allotment-holders, and beyond into the village and Moreton.
>
> (2010a)

Pollard chose to make environmental performance work in her village, where she felt it possible to generate these events because she lives there. She made dance visible in her community, not as a rarified cultural event,

but what she describes as a 'convivial' activity that sits comfortably alongside normal goings-on of the village:

> In the collaborative improvised outdoor performance *River Walking*, it was our hope that the dance improvisation we did was seen as a part of other things people were doing by the river – that people dancing there could be as accepted as people walking the dog.
>
> (Pollard 2010b)

Asked why she works in North Bovey, Pollard responded:

> ...because I live there; it's my home. And it's a particular challenge and interest there – I couldn't do this work in a place that I didn't know the people. It's about building a relationship of trust and interest. It wouldn't make sense for me to go somewhere I don't know anybody and do this work.
>
> (Pollard 2010b)

As a practice, Guattari's ecology requires a high 'degree of creative autonomy' in order to act as 'catalyst for a gradual re-forging and renewal of humanity's confidence in itself starting at the most minuscule level' (Guattari 2000: 69). Such 'creative autonomy' also translates into the personal agency that is central to a dancer's or an audience member's ability to sense and alter relationships between his/her body, space, time and things. Invitations such as Pollard's in *Cartwheeling* gently challenge both participants and onlookers to use one's personal agency to 'look outside their own artistic sphere', consider new collaborations, and to acknowledge and move in relation to things as simple and accessible as people and trees on a village street, implementing a score to encourage creative autonomy on the most basic level of the individual.

Conclusion

Diving into the outdoors of Devon and Cornwall happens in different ways, with creative and performance practices offering routes toward viewing nature, incidentally engaging with it, or purposeful investigation. According to Pretty *et al.* (2005) each of these three routes of environmental engagement offer measurable health benefits. Beyond their incidental health benefits, outdoor performances also offer ways to change our embodied understanding of 'the wild' and our own place in it.

Both witnessing and being involved in such activities can trigger reflexive responses. As Reynolds and Reason acknowledge, empathic responses associated with mirror neuron activity is often associated with the ability of an audience to empathize with a performer's experience, though 'empathy can also concern relationships to objects rather than exclusively

inter-subjective relationships with other people' (2012: 19).[7] As Reynolds describes, if subjectivity is embodied, then 'changes in embodied experience have the capacity to transform both subjective consciousness and relationships between subjects' (2012: 87). She also proposes that performance experiences create opportunities for kinaesthetic empathy not reliant on emotion (2012: 124).[8] If this is the case then connections between bodies experienced through kinaesthetic imaginations in the outdoors can open up new routes for intersubjective understanding through empathy, or affect, that is not reliant on human experience. For Reynolds, 'kinaesthetic intentionality' describes an interest to produce such affective experiences through choreography (ibid.).

The variety of conceptual and practical approaches to performed outdoor physicality in Devon and Cornwall discussed here encompass diverse acts of kinaesthetic intentionality and creative autonomy. Many projects that encourage kinaesthetic involvement with site might be more readily acknowledged as contributions to a widening scope of 'affective' environmental performance. Guattari's three ecologies offer frames by which to read environmentally-concerned performance practices and present opportunities to consider the effects and affect of such practices on the quality of our interactions in three spheres. By inviting bodies to practice sensitivity in movement through improvised kinaesthetic responses, to question social power relations, and to re-forge affinities with non-human environments in ways not seen as fixed, outdoor performances have the potential to operate as launch pads, not only for diving or dancing into the wild, but for initiating participatory relationships with our environment at natural, mental and social levels.

Notes

1 In the wake of the 2012 London Olympic games UK governmental reports such as 'Moving More, Living More' (2014a) and policies on 'Protecting and Improving People's Access to the Countryside' (2014b) sit alongside dance for health projects including Pavilion Dance Southwest's Breathe initiative (2014), Foundation for Community Dance reports on 'Commissioning Dance for Health and Wellbeing' (Burkhardt and Rhodes 2012) and agendas promoted by earlier documents such as 'Dance and Health' (Arts Council England 2006).

2 See: Anna Halprin's *Returning to Health with Dance, Movement and Imagery* (2002) and Miranda Tufnell's *Dance, Health and Wellbeing: Pathway to Practice for Dance Leaders Working in Health and Care settings* (2010).

3 Exceptions include discussions of empathy within the collections *Nature Performed* which investigates the usefulness of ideas of 'performance' in understanding human–nature relationships (Szerszynski *et al.*, 2003), and *Performing Nature: Explorations in Ecology and the Arts* which offer additional consideration of how art projects can 'reinforce or contest our ideas about nature' (Giannachi and Stewart, 2006), as well as discussions by Natasha Myers (2012) and myself (Sarco-Thomas 2013) about how the activities of physically imitating biological phenomena hold potential for empathic and intersubjective understanding of life science processes.

4 Studies of outdoor and wilderness-based leisure in the UK have shown that participation in such activities is historically a gendered and class-based activity that continues to be largely accessed by privileged, educated and able-bodied people with means of transport (Walker and Kiecolt 1995; Humberstone and Pedersen 2010). Dance artist and scholar Alicia Grace has argued that environmental performance that seeks to be inclusive and participatory must necessarily consider issues of access on physical and socio-economic levels (Grace 2011).

5 In an interview with *Animated*, Antony Waller describes how the challenges of rural isolation he encountered in Cornwall prompted him to work with National Trust sites to curate creative site events at Lanhydrock House with Rambert, at Trerice Manor with composer Graham Fitkin to premier the immortal *Music for 50 Lawnmowers*, and with Bill Mitchell and Sue Hill (then from of Kneehigh Theatre) towards the production of 'Firestorm – a large scale event with 500 young people in Restormel Castle'. Waller recounts a 'five-hour celebratory extravaganza, bringing together 500 local performers in a combination of procession, young people dancing in the garden and the streets, professional dance performances, a burning maze, fireworks and a rather brilliant outdoor dance party to wrap it up'. This performance of *Boz Looan: Selling the Wind*, curated with the National Trust in Boscastle Harbour, was the beginning of C-Scape Dance Company (*Animated* 2006). Lois Taylor articulates in an interview how similar concerns for the remoteness of Devon and Cornwall led her toward a number of creative devising projects that could be recreated for town centres across the southwest. 'Coming from a Lancashire mill town to living near the sea suddenly, the sea was a place I wanted to explore. I was aware that in Cornwall people were doing the same and the lack of small-midscale theatre venues was creating a situation where by default people were finding other places for their work. When we first came to Cornwall there weren't many theatre spaces—Hall for Cornwall wasn't a proper theatre then; there were just little tiny venues and village halls that supported theatre work. I came from a pretty straightforward theatre background, but in Cornwall you went to school venues which were mostly the hosts for touring dance companies. It felt like there was a culture of people who were here and interested in making work in the landscapes and because the venues weren't there they were exploring other environments' (Taylor, 2013). The *Clean Sweep* project by Attik Dance and choreographed by Lois Taylor for example, was celebrated as a 'great opportunity for all sorts of people who may not otherwise have had the opportunity to see dance performances' (Sowden, 2007).

6 Audiences and 'cultures' for site work in Cornwall and Devon vary, and include people who seek out performance in traditional venues as well; see Arts Council England's publication 'Arts Audiences: Insight' (2011) for a broad description of demographics in arts audiences. In response to an email questionnaire asking for practitioners' impressions about the demographics of audiences for recent site work in Cornwall, the following observation was offered by an organizer in the region:

> In Cornwall the audiences at outdoor and sited events seem to me to be mostly local families on the whole, and sometimes tourist families and couples or older/retired tourists (particularly at Summer festivals like SALT or Fal River Festival). At rural sites, I expect that the audiences are mostly those who can afford a car and the petrol to get there as well as being pretty mobile. Combined with the kind of tourism prevalent in Cornwall probably means that most audiences are middle-upper class or at least earning well. When a participatory element is included in an event

this can open up the audience slightly, depending on the content and who is engaged in the participation; outdoor events involving schools for example. The audiences are other school children, teachers, and parents who have volunteered to chaperone and come along on the school coaches.

(Anonymous 2014)

7 The notion of shared affective states is similar to Maurice Merleau-Ponty's notion of the reversible 'flesh' of the world as put forward in *The Visible and the Invisible* (1968). In applying Merleau-Ponty's ideas to our sensuous engagement with the natural world, David Abram describes sentience of another to recognition that that other is made of the same animate flesh which 'is *at once both sensible and sensitive*' (Abram 1996: 67, emphasis in original). Abram extends this logic to animate and inanimate objects, proposing that the notion of reversibility suggests that 'any visible, tangible form that meets my gaze might also be an experiencing subject, sensitive and responsive to the beings around it, and to me' (ibid.)

8 Reynolds suggests that 'affective' choreographic practices are those which 'foreground intermodal sensory perception, which interferes with visual distance and intensifies the spectator's corporeal engagement' (2012: 124).

References

Abram, D. (1996) *The Spell of the Sensuous: Perception and language in a more-than-human world*, New York: Vintage Books.

Animated Magazine (2006) 'Something Always Happens: Antony Waller in interview with Scilla Dyke', Foundation for Community Dance. Winter 2006. Available online: www.communitydance.org.uk/DB/animated-library/something-always-happens.html?ed=14045 (accessed 30 October 2013).

Anonymous (2014) 'Audiences for site dance in the southwest – your impressions' Email (13 May).

Arts Council England (2006) *Dance and Health: The benefits for people of all ages*. Arts Council England in partnership with the Department for Culture, Media and Sport, and the NHS. Available online: www.artscouncil.org.uk (accessed 10 April 2011).

Arts Council England (2011) *Arts Audiences: Insight*. PDF document. Available online at: www.artscouncil.org.uk/advice-and-guidance/browse-advice-and-guidance/arts-audiences-insight-2011. Printed by The Colourhouse, England. (accessed 25 April 2014).

Burkhardt, J. and Rhodes, J. (2012) 'Commissioning Dance for Health and Wellbeing: Guidance and Resources for Commissioners'. Youth Dance England, DanceXchange, Department of Health West Midlands and Physical Activity Network West Midlands. Available online: www.communitydance.org.uk (accessed 10 April 2014).

Conley, V. A. (1997) *Ecopolitics: The Environment in Poststructuralist Thought*, Oxon: Routledge.

Cross, R. (2009) 'Choreographing Landscape Performance: With specific reference to the methodologies employed by landscape theatre company Wildworks.' Dissertation. Falmouth University.

Egoscue, P. (2000) *Pain Free: A revolutionary method for stopping chronic pain*, US: Random House.

Fox, W. (1995) *Toward a Transpersonal Ecology*, New York: SUNY Press.

Giannachi, G. and Stewart, N. (2006) *Performing Nature: Explorations in ecology and the arts*, New York: Peter Lang.

Grace, A. (2011) 'Freaks oN nature: Performing stigma in an ecological paradigm' [conference presentation] Cornwall Disability Network 6th Annual Conference, St Austell College, October.

Guattari, F. (2000) *The Three Ecologies*, London: Continuum.

Henwood, K. (2002) 'Issues in health development: Environment and health: Is there a role for environmental and countryside agencies in promoting benefits to health', Health Development Agency, London.

HM Government (2014a) 'Moving More: Living More; The Physical Activity Olympic and Paralympic Legacy for the Nation.' February 2014. London: Cabinet Office. Available online: www.official-documents.gov.uk (accessed 6 April 2014).

HM Government (2014b) 'Policy: Protecting and Improving People's Enjoyment of the Countryside.' Department of Environment, Food and Rural Affairs. Available online: www.gov.uk/government/policies/protecting-and-improving-people-s-enjoyment-of-the-countryside (accessed 9 April 2014).

Humberstone, B. and Pedersen, K. (2010) 'Gender, Class and Outdoor Traditions in the UK and Norway', *Sport, Education and Society*, 6(1), pp. 23–33.

Kneehigh Theatre. (2013) 'The Asylum'. Available online: www.kneehigh.co.uk/show/the-asylum-trailer.php (accessed 26 October 2013).

Merleau-Ponty, M. (1968) *The Visible and the Invisible*, Translated By Alfonso Lingis, Evanston: Northwestern University Press.

Mitchell, B. and Hill, S. (2007) The Beautiful Journey A3 Design Books, 6 of 10 and 7 of 10. Cornish Performance Archive, Falmouth University. CPA3 Wildworks Archive AC2010-007 (accessed 18 September 2013).

Morris, N. (2003) 'Health, well-being and open space.' *Literature Review*. OPEN space: the research centre for inclusive access to outdoor environments. Edinburgh College of Art and Heriot-Watt University, Edinburgh.

Myers, N. (2012) 'Dance Your PhD: Embodied Animations, Body Experiments, and the Affective Entanglements of Life Science Research', *Body & Society*, 18(1), March, pp. 151–189.

Nietrzebka, K. (2010a) Interview with Malaika Sarco-Thomas. 10 September.

Nietrzebka, K. (2010b) 'Moor to Sea Eflyer' Email (13 April).

Orr, M. and Sweeney, R. (2011) 'Surface Tensions: Land and Body Relationships Through Live Research Enquiry', *Double Dialogues*, 14. Available online: www.doubledialogues.com/issue_fourteen/Orr_Sweeney.html (accessed 25 April 2014).

Parekh-Gaihede, R. (2012) 'Breaking the Distance: Empathy and Ethical Awareness in Performance', in *Kinesthetic Empathy*, Reynolds, D. and Reason, M. (eds) Bristol: Intellect, pp. 175–194.

Pavilion Dance Southwest (2014) 'Breathe Overview.' Available online: www.pdsw.org.uk/dance-development/dance-for-health/breathe/ (accessed 30 April 2014).

Pethybridge, R. (2013a) Interview with Malaika Sarco-Thomas. 20 September. AIR, Falmouth University, Penryn, Cornwall.

Pethybridge, R. (2013b) 'Dance Project Seeking Participants! Invitation to Participate in *VIA*', Email (30 May).

Pollard, N. (2010a) 'Description of the allotment dance', Email sent to allotment movers 27 April 2010; forwarded to the author by Katherine Nietrzebka, 11 September 2010.

Pollard, N. (2010b) Interview with Malaika Sarco-Thomas. 9 April.

Poynor, H. (2013) 'Walk of Life Movement Workshops with Helen Poynor' Available online: www.walkoflife.co.uk/helen.htm (accessed 21 September 2013).

Pretty, J. N. (2004) 'How nature contributes to mental and physical health', *Spirituality & Health Int*, 5(2): 68–78.

Pretty, J., Griffin, M., Peacock, J., Hine, R., Sellens, M. and South, N. (eds) (2005) *A Countryside for Health and Well-Being: The Physical and Mental Health Benefits of Green Exercise*,' Report for the Countryside Recreation Network February 2005 Department of Biological Sciences and Department of Health and Human Sciences, University of Essex, Colchester [Online]. Available at: www.slideshare.net/KlausGroenholm/a-countryside-for-health-and-wellbeing-the-physical-and-mental-health-benefits-of-green-exercise (accessed 30 January 2015).

Pretty, J., Wood, C., Bragg, R. and Barton, J. (2013) 'Nature for rehabilitating offenders and facilitating therapeutic outcomes in youth at risk', in *Routledge International Handbook of Green Criminology*, South, N. and Brisman A. (eds), Routledge.

Reynolds, D. (2007) *Rhythmic Subjects: Uses of energy in the dances of Mary Wigman, Martha Graham and Merce Cunningham*, UK: Dance Books.

Reynolds, D. (2012) 'Kinesthetic Empathy and the Dance's Body: From Emotion to Affect' in *Kinesthetic Empathy in Creative and Cultural Practices*, Reynolds, D. and Reason, M. (eds) Bristol: Intellect, pp. 121–138.

Reynolds, D. and Reason, M. (2012) *Kinesthetic Empathy in Creative and Cultural Practices*, Bristol: Intellect.

Sarco-Thomas, M. (2013) 'Excitable Tissues in Motion-Capture Practices: The Improvising Dancer as Technogenetic Imagist', *Journal of Dance and Somatic Practices*, 5(1), pp. 81–94.

Sowden, S. (2007) 'A "clean sweep" in the Quedam', *This is the West Country.co.uk* Thursday 19 July 2007. Available online: www.thisisthewestcountry.co.uk/news/1556527.print/ (accessed 30 October 2013).

Stewart, N. (2010) 'Dancing the Face of Place: Environmental Dance and Eco-Phenomenology', *Performance Research*, 15(4), pp. 32–39.

Sweeney, R. and Orr, M. (2007) 'ROCKface-body/place/frame research; Mapping project at Dartmoor National Park.' Available online: http://orrandsweeney.blogspot.co.uk/2008/10/rockface-dance-research-collaboration.html (accessed 10 September 2013).

Szerszynski, B., Heim, W. and Waterton, C. (eds) (2003) *Nature Performed: Environment, Culture and Performance*, Oxford: Blackwell.

Taylor, L. (2013) Interview with Malaika Sarco-Thomas. 28 October.

Walker, Gordon J. and Kiecolt, K. Jill (1995) 'Social Class and Wilderness Use', *Leisure Sciences*, 17(4) pp. 295–308.

Waller, S. and Waller, A. (2013) Interview with Malaika Sarco-Thomas. 18 October.

White, M.P., Pahl, S., Ashbullby, K., Herbert, S. and Depledge, M.H. (2013) 'Feelings of restoration from recent nature visits', *Journal of Environmental Psychology*, 35, pp. 40–51.

20 Spectacle, world, environment, void

Understanding nature through rural site-specific dance

Nigel Stewart

This chapter is epistemological: taking heed of Raymond Williams' warning that "nature is perhaps the most complex word in the English language" (1976: 219), I set out four different ways in which we can understand how rural site-specific dance produces knowledge of nature. These expand upon four epistemes of ecological philosophy and art that were first set out in *Performing Nature* (Giannachi and Stewart 2005: 34–62). They are "spectacle", "world", "environment", and "void". In effect, these epistemes exist on a continuum between, at one extreme, aesthetic theories and dance practices that understand "nature" as merely a human construction to, at the other extreme, theories and practices that confront nature's sheer alterity and unmasterable magnitudes.

I define and exemplify each episteme in relation to the natural sciences, the aesthetics and ethics of nature, and the function of language in articulating nature. I also give examples of rural site-specific dance, putting, as I move along the continuum, more emphasis on methods of work than finished site-specific works. For the sake of comparison I refer to works and practices concerned with birds, beaches and grasslands. Finally, I review the four epistemes and demonstrate the ways in which they can overlap through a discussion of *Jack Scout* (Sap Dance and Louise Ann Wilson Company 2010) and *Jack Scout Redux* (2013).

Spectacle

At one end of the continuum, then, is *spectacle*. It is essentially anthropocentric and ocularcentric. Spectacle always sets a premium on a point of view, both in the sense of having a place from which to observe nature and in generating a particular opinion about what is observed. To develop a point of view, an object of nature must be isolated. Spectacle thus encompasses the *object model* of environmental aesthetics in which nature's qualities only come to the fore when an object of nature is "removed, actually or contemplatively, from its surroundings" (Budd 2002: 130; see Rolston 1997: 41).

Spectacle also frames nature: the natural object is placed within a literal or figurative frame that enshrines the system of classification, scheme of

description or method of interpretation through which a detached human observer makes sense of the observed object. The frame enables the same set of classificatory principles to be transposed from one scale or place to another. For instance, the National Vegetation Classification system (NVC), to which I refer below, involves pegging out a 2 × 2 metre "quadrat" over a homogenous patch of vegetation so that the "photosociologist" can first identify, using the Linnaean classification system, all the individual species of plants to be found within that square, and second quantify the percentages of those species so that they can be related to a UK reference system of vegetation communities (Rodwell 1995; Waterton 2003: 116–8).

According to the spectacle episteme, *aesthetic* perceptions of natural objects are predetermined. Perceptions depend on *scientific* systems of classification (Budd 2002: 142). A wide expanse of sand and mud could first be seen to express "wild, glad emptiness", but this might change to a feeling of "disturbing weirdness" if the viewer is then told he or she is looking at a tidal basin (Hepburn 1966: 295). *Artistic* conventions also predetermine aesthetic perceptions of nature. The aesthetic appreciation of a rural site through an academic landscape painting of that site depends upon a tacit knowledge, firstly of the rules of one-point perspective in which the scene recedes to a single vanishing point on the horizon line, and secondly of more specific stylistic conventions and mimetic codes pertaining to the subgenre to which that particular painting conforms. Indeed, the *prospects*, or scenes, that landscape art produces of the natural environment generate the prospect, or expectation, of seeing actual environments according to the compositional conventions of art. This, most famously, was a matter carried to its logical conclusion when landscape architects such as Capability Brown designed the parks of the British Aristocracy according to the conventions of Italian landscape painting those patrons had seen on the Grand Tour (Marshall 2005: 206). For some this tendency is still a virtue. The *landscape model* of environmental aesthetics presupposes that to appreciate nature it is best to divide it into different prospects, each of which is evaluated in compositional terms, for instance, according to the "aesthetic qualities of colour and design [...] seen from a distance" (Carlson 1979: 131). This tendency was alluded to in *Still Life* (2008, rev. 2009), a site-specific dance and live art work created by Sap Dance and Louise Ann Wilson Company at Far Arnside by Morecambe Bay, the largest intertidal area in Britain. At the start of the show audiences with a panoramic cliff-top view of the bay viewed The Woman running along the edges of a sandbar far below. As she did so, The Guide played a recording listing eight "elements of design", namely, line, shape, colour, texture, direction, size, perspective, space (Dunstan 1979). Accordingly, spectators were predisposed to see those *painterly* elements in the wider environment (Stewart 2010a: 217, 220). In fact, many of Wilson's installations for *Still Life* literally framed objects found *in situ* in order to allude to still life painting, and to NVC and other scientific methods of framing natural objects (ibid.:

218–9). I choreographed "Gull", the second solo in the work, from biomechanical studies of bird flight, and the variations I made on that material were directly informed by a Laban movement analysis of the flight patterns of birds I saw through the window frame of a hide at RSPB Leighton Moss Nature Reserve (ibid.: 221).

Ways of framing nature are inseparable from structures of domination. One-point perspective places the viewer in a "position of surveillance" by mimicking a commanding view that a person might have in and of the environment itself (Adams 2005: 86). Examples of how the landscape gaze operates ideologically include eighteenth-century landscape painting's idealisation of wild scenes at a time of widespread deforestation (Thomas 1984: 263–9); the link made between masculine friendship and New World sacred antiquity by landscape photographs and paintings of the Hudson Valley School (Sharma 1995); early twentieth-century wilderness films that justified the westward migration (Adams 2005), and, more generally, the "spectaclisation" of nature in twenty-first century wildlife films and tourism's "visual display of people, places, and things [which] makes them forms of 'spectacle'" (Knudsen *et al.* 2008: 3; see Urry 2002). In *Out on the Windy Beach*, performed at a number of British seaside locations in 1998, choreographer Lea Anderson drew attention to these ways of framing nature, most obviously through the performance space (a two-tiered stage, linked by steps and fringed with fairy lights and cerise flags, with a green beach hut on the higher tier and a jetty-like platform on the lower tier), but also through choreography that toyed with, but never transgressed, the boundaries of that space (amphibian-like entrances and exits, "dive-like poses" on edges, and gestures that reached "towards key borders such as the shoreline and the horizon") (Briginshaw 2001: 62). Her choreography also made reference to codified representations of natural phenomena (costumes that connoted patches of algae when dancers draped themselves over jetty and steps, comic crab walks, and gestures that were a "pastiche of children's drawings of birds"); and music and dance that suggested end-of-the-pier culture (references to Carroll's lobster quadrille, "Wilson, Kepple and Betty's [...] 'Sand Dance' [1934] which [was] itself a parody of Egyptian hieratic poses", music based on sea shanties, and an Amazonian Tea Dance) (ibid.: 68, 61). Finally, the show ironised the ways in which the female body is eroticised at seaside locations. On the one hand, Anderson created choreography deliberately based on 1950's seaside beauty competitions and sailor's tattoos of "bathing belles" (ibid.: 64). On the other hand, she made that choreography "carnivalesque", firstly by giving it to male dancers dressed in cerise skirts and matching boots, and secondly to female dancers who, by virtue of their "reflective, orange, ski goggles and [...] white sun-blocked lips", could "return [the] spectators' gazes" and who also, by virtue of their "luminous, lime green, hooded, figure-hugging body suits, with straight long skirts ending in points like fish", looked like a cross between mermaids and B-movie "web-footed [...] sci-fi, hybrid reptilian aliens" – in

other words, "monstrous, devouring creatures who [in myths and folklore] *eat* sailors" (ibid.: 72, 62, 66, 64). If nature in the form of landscape is "traditionally constructed as a passive female figure [...] 'mapped by a gaze which is eroticised as masculine and heterosexual' (Rose 1993: 96)" (ibid.: 65), and if this show made extensive references to seaside tourism, then *Out on the Windy Beach* revealed a link between the landscape gaze, the "male gaze" (Mulvey 1975) and, I must add, the tourist gaze. Yet for all this the show still stayed within spectacle's realm, offering no knowledge of the tangible natural world other than, to quote Debord from the *Society of the Spectacle*, the "selection of images", or commodified representations, "which exist above it" (1977: 39).

World

World is the tangible natural world. However, it does not involve an unmediated encounter with material nature as such, but rather the creative and collective shaping of human–nature relations. The point is developed through a reappraisal of the term landscape. *Scape* is linked to the English *ship* which in turn stems from the Old English *sceppan* or *scyppan*, meaning to shape (Olwig 1996). *Land* means "a unit of human occupation" and thus an entity identified by law or custom with someone (Sharma 1995: 10). Some scholars have rightly rejected the superficial resemblance between *scape* and *scope* and instead affirmed a "prototypical concept of landscape" in which participants *shape* the land through "multisensory and immersive" activities (Ingold 2011: 136). But since the environment *per se* is a bio-physical totality, prototypical landscape must denote human dwelling *in* the environment and cannot be co-extensive with environment as such. Indeed, for Heidegger the natural environment "does not belong ontologically to the world" since "the world" is no more than humankind's practical knowledge of the world. The farmers of Swabia, for instance, understand the "south wind [...] in its Being" (1962: 112), not by "grasping" it "as it is in itself" but rather "as the herald of rain and good crops" (Dostal 1993: 162). For Gadamer, human language ensures that "world" and "environment" are ontologically different. But here language does not mean *analytical* language in which, as we have seen with spectacle, taxonomies differentiate one aspect of a habitat from another. On the contrary, language here means *hermeneutic* language in which there is a reciprocal and continually-evolving relationship between our lived experience of the environment and our ability through language to develop an "orientation towards" it (Gadamer 1989: 443). Our "world" is the product of this relationship.

Hermeneutic language is a *conversational* language in which an expanding consciousness of the natural world is achieved when *different* "horizons" of understanding of the world are related but never conflated (Gadamer 1989: 302). This is exactly what happened when an encounter was staged between

NVC and dance phenomenology. Claire Waterton, an expert in the sociology of classification with a background in the natural sciences, used NVC to classify the vegetation community of some agricultural grassland in North Yorkshire – and I described the kinaesthetic qualities of that same community according to Sheets-Johnstone's four components of virtual force (1979: 49–58; 1999: 143, 140) noting, for instance, the perceived tensional, projectional, linear and amplitudinal qualities of Sheep's Fescue, Purple Moor Grass, Common Bent and other grasses in that community! Furthermore, we each had to tutor the other in the use of our respective classificatory systems. As Waterton explains (2003: 115–24), by setting up a situation in which, as "first time users" of each other's system, we initially struggled to grasp what the other was saying, ways of seeing and thinking we had taken for granted as "proficient user[s]" of our own descriptive systems were brought to consciousness through verbal explanation and practical demonstration (Suchman 1987: 114–5). I must add that precisely by becoming more conscious of the *differences* between our respective horizons we also created a "point of fusion" that enabled an expanded consciousness of what we were engaged with (Gadamer 1989: 306, 305). Certainly, the time "spent in the grassland, observing, reading texts, writing down notes, interrogating each other, gave [me …] specific descriptors of the movements of plants" that made a distinctive difference at that time to my improvised performances.

Classificatory systems, including those implied by particular understandings of movement, need not dictate a spectacle made in the image of that system (Bell 1998: 209), but rather can be creatively adapted, evolved and contested by human agents in situations that are more like "construction sites" for the production of knowledge of and in the environment (Waterton 2003: 114). In this context "performances [of classificatory systems] are improvisatory, situated, and, importantly, embodied, encompassing much more than cognition and intellect" (ibid.). This is exemplified by the work of US dance artist Jennifer Monson, in particular her *Birdbrain* project. *Birdbrain* was "situated" because, as is the case with NVC and fieldwork practices in Earth sciences (Raab and Frodeman 2002), it depended on tacit knowledge of the material situations in which scientific knowledge was put to the test. Specifically, it aimed to understand the "biophysical and metaphorical relationship" of humans to birds and other animals by not only performing in "parks, urban streets, nature sanctuaries, and arts centres", but doing so by literally following, through a series of annual "tours", the migratory patterns of pigeons (2000), whales (2001), ducks and geese (2004) and northern wheatears (2006) across large tracts of North America.

Birdbrain was "improvisatory" and "embodied", most obviously through Monson's commitment to improvisation as a means of responding openly to the different places to which she travelled, but also in her creative *adaptation* of the scientific knowledge that she acquired along the way. The "observation of animals as well as scientific research into their navigational tools and

perceptual abilities informs [her] own approach to navigation as a dancer" (Monson 2014a), but this led neither to a literal (and potentially risible) interpretation of animal behaviour, nor to an artful stylisation of animal-like movement as in Cunningham's *Beach Birds for Camera* (1991), but rather the development of sensory training exercises and improvisation processes by which that otherwise alien behaviour can be translated into human movement. For instance, the "flocking" exercises on which she focused in *Ducks and Geese Migration* (2004) trained the navigational abilities and spatial awareness of human participants of all ages (from babies to octogenarians) and abilities (from professional dancers to novices in wheel-chairs) by asking them to sense the gravitational pull or push of points in the environment and then to converge upon or disperse from those points in specified ways (e.g. by travelling at different speeds with different facings along straight or curving paths with eyes open or shut). Since all human "perceptual systems are propriosensitive as well as exterosensitive" – enabling awareness of the relationships between one body part and another in kinespheric space and one body and another within environmental space (Gibson 1986: 115) – and since human beings may also have their own magnetic or "sixth sense" (Baker 1981), Monson's dancers and workshop participants do not mimic birds but explore their own very human capabilities.

The inclusion of workshops for all ages and abilities is part of Monson's strategy. In addition to these workshops and free outdoor public performances by Monson's volary of dancers, the *Birdbrain* tours involved panel discussions with artists, scientists and environmental campaigners, and a website that tracked migrating birds and dancers. The accumulative effect was ethical, political and celebratory, "illuminating the importance of sustaining and preserving habitat for migratory species, and deepening [the] dynamic relationship with nature through the kinetic medium of dance" (Monson 2014a). Importantly, then, workshops, discussions and documentation are not merely addendum, but rather integral and equal aspects of an "ethical matrix" (Heim 2005) that "re-negotiate[s] the relationships between art, environment, power and place" (Monson 2014b). Heim argues that ecologically-minded social practice art does not didactically demonstrate predetermined beliefs but instead allows participants to develop their own environmental values in complex and uncertain situations. In that sense, Monson's work is a form of social practice art that develops what Aristotle called *phronesis*, a capacity for moral "reason that shows itself in timeliness, improvisation, and a gift for nuance rather than in the rigorous duplication of [spectacular] results" (Smith 2002: 48, in Heim 2005: 213).

Environment

The environment episteme arises from neither a visual representation *of* nature nor a hermeneutic conversation *about* nature but a heightened

experience of continuity *with* nature. This has been widely explored. Rudolf Laban identified eight basic "efforts" (or permutations of weight, time, space and flow) (1988: 52–84) and "four fundamental trace-forms" (1966: 83) that human beings have in common with all living things, and a "standard scale" of 12 possible points in space from which contrasting clusters of motion can be extracted that, in their alteration between stability and mobility, reflect "binding–loosening processes in nature" (ibid.: 72, 114). Despite its roots in *Ausdruckstanz*, Butoh is not "a dance of 'form' or 'figure'" in the same way that Laban's is, but nonetheless the Butoh "body becomes a tool to feel [the] life forces" of "earth, wind, fire" (Nakajima 1996). To achieve this, Hijikata Tatsumi developed a "double notation system" consisting, firstly, of poetic words that each conjure the kinaesthetic sensation of an individual action, and secondly a poetic title that educes the overarching dynamic quality or "space power" of the phrase into which those individual actions have been sequenced (Stewart 1998: 47). The titles evoke natural objects or elements (e.g. Stuffed Air, the eighth phrase of Hijikata's *Sleep of Stone*, has the actions "Hands and Nail" and "A Hawk"). Poetic language, then, has a part to play in thinking "inside" environment and in bringing kinaesthetic experience of the environment to consciousness. But if the Butoh-ka is to be transformed in this way she must "enter into a special unconscious zone" where she might receive a "special passive power" from the elements into which she is transformed (Nakajima 1996).

In this process of reciprocation, or "chiasmic" intertwining, the sentient self and the sensible environment are reversible, each completing the other "as two segments of one sole circular course […] which is but one sole movement in its two phases" (Merleau-Ponty 1968: 138). This characterised my research for *Be/longings* (Figure Ground 2000–1). By improvising in a barley field, I became aware that how I moved *kinespherically* (exterosensitive trace-forms made with distal body parts in response to the shapes and motion of the barley field) was completed by how I moved *dynamospherically* (proprioceptive "shadow-forms" of the torso and proximal joints). At one point my torso undulated, quivered and wrung itself in completion of my arms as they twisted and contracted, but since that arm motion enabled my index fingers to track the perspectival deformation of tractor paths from the edge of the field to where I stood, it could also be said that those dynamospheric forms completed, or shadowed, the land itself (Stewart 2005). Here the dancing "body is a sort of open circuit that completes itself only […] in the encompassing earth" (Abram 1996: 62).

The notion of an open circuit has also inspired electro-acoustic artists in site-specific dance works. For instance, in *somasonicspirit* (2000), Barnaby Oliver manipulated the sounds of water transmitted to him by Simon Whitehead from the various sources to which Whitehead walked on an upland moor in the Trough of Bowland in Lancashire, England. As visitors stepped up and down a glass-fronted stairwell into which Oliver poured the

sounds, they realised that, due to sensors installed by Oliver, their presence affected the "dowsing and mixing of this material" (Whitehead 2000) and also the movements of dancer Stirling Steward whom they witnessed witnessing them as she moved over different edges and surfaces within, and beyond, the stairwell.

Although this open circuit between body and earth makes landscape spectacle untenable, it also enables a notion of landscape and an ethical relation with the environment that is different from the prototypical landscape of world. Here the edges and surfaces of the environment and the act of bearing witness come to the fore. This can be explained piecemeal through my experience of Authentic Movement on the sands of Morecambe Bay. Authentic Movement is normally a dyadic improvisation form in which a Mover (usually with eyes shut) is watched by a Witness, and then, after some kind of reflection, the Witness becomes the Mover and *vice versa*. I suggest that to enter into this process fully is chiasmic and ethical: the Witness, in giving undivided attention to the Mover, can apperceive what Levinas calls "the face" of the Mover and, *vice versa*, the Mover feels the Witness's face. This special notion of face stems from Levinas's move to locate "[t]he sanction or source of the ethical", not in "the Good, [...] the deep Self" or some other transcendent force, but rather immanently in "the human existent" which one most fully accesses in the actual face of another (Casey 2003: 191). Crucially, the face is exemplary: it extends, says Levinas, to the whole body (1969: 130–4). In this sense, Authentic Movement can involve the *facialisation* – recognition of the alterity or existential otherness – of the other's moving body.

Deleuze and Guattari go further by proposing the facialisation of "the full environment, the landscape in which the body is implaced" (Casey 2003: 202). The result is a "face-landscape". This does not mean that the environment is anthropomorphised (e.g. this hill looks like a breast, that ledge a nose); rather, it means that an encounter takes place between the human body and the non-human "sur-faces" of an environment – surfaces which, in combination, provide affordances for human movement and which *express* a landscape in which the human body can value the alterity of nature *qua* nature. Now, Susan Schell, and then Simon Whitehead and Jennifer Monson, have adapted Authentic Movement so that, instead of witnessing the dance of another person, the Witness witnesses the dance of the environment itself – and then becomes a Mover witnessed *by* the environment in which he or she moves. So, if Authentic Movement exemplifies Levinas's notion of the facialisation of the body, does the application of Authentic Movement to the environment exemplify Deleuze and Guattari's notion of the face-landscape? Certainly, to witness and be witnessed by the environment is to become highly sensitive to a "field of intelligence in which our actions participate" (Abram 1996: 260). To recognise the alterity of the environment is to value it more fully. But, as I will later explain, something else can occur.

Crucially, to experience the environment as a face-landscape is to experience forces of nature that breach the boundaries of the observational rules that frame nature as spectacle. The *natural-environmental model* seeks the aesthetic appreciation of nature in terms of those environmental forces. A rock on a shelf might look reassuringly smooth and solid, but if we return it, literally or meditatively, to the environment from which it was taken we may begin to intuit the forces of weathering, motion and disruption that have eroded that rock through time. Comparably, I "learnt to consider [*Still Life*] not as an *intervention into* a place but a *yielding* to the site's own gravitational force" (Stewart 2010a: 223). Most obviously, as I made my Icarus-like descent down a limestone crag whilst performing the bird material I had choreographed for "Gull", I could not merely impose that material onto the crag; rather "the crag itself was imposing its conditions upon me, [...] sculpting that material to its own peculiarities of footholds and precarious edges as I fought against gravity to prevent myself from falling and injury" (ibid.). To experience nature like this is to approach void.

Void

Here we arrive at the other end of the continuum. In fact, unlike the other three epistemes, void does not, strictly speaking, provide an understanding of nature because it speaks of a speechlessness before a nature beyond human understanding. Nonetheless, we can understand this lack of understanding in several ways. The most well-known is Kant's notion of the sublime in which we experience magnitudes of scale and force far greater than we can sensibly intuit or calculate (Kant 1960; Budd 2002: 66–89; Giannachi and Stewart 2005: 54). Since Kant insists that we nonetheless possess a transcendent supersensible moral worth, Kant's thinking on the sublime is exceeded by more recent and radical views of the incommensurability of nature. In environmental aesthetics, for instance, an *aloofness model* for the appreciation of nature, as developed by Godlovitch (1994), considers nature as a "mystery to which there is no (ultimate) solution", for science will never be able to fully explain nature and so "nature 'as a whole', nature *qua* nature", is finally inaccessible, unknowable, non-moral: aloof (in Budd 2002: 144). This is close to acentric environmentalism in the natural sciences, which sets itself against any of the centricist epistemes I have discussed (i.e. the anthropocentrism of spectacle and world or the biocentrism of environment). Whereas traditional science, as we have seen with NVC, explains nature by transposing the same system of classification from one situation or scale to another, acentric environmentalism claims that there are no fundamentals or transposable principles.

In providing a view of the natural world without any ultimate spatial or temporal measures, acentric environmentalism offers, in effect, a "view

from nowhere" that is uncannily similar to the experience of *groundlessness* recurrent in three examples of site-specific dance that confront void. The first example is my experience of Authentic Movement with Monson near to where the Chinese cocklers drowned far out on the sands of Morecambe Bay. This is a space so porous that anything left on top is sucked under and where I could not stay still for too long; a space so vast that sand, sky and sea merge on the horizon, and where I suffered the cognitive dissonance of knowing that I was far lower than I perceived myself to be against the faraway shoreline; and a space so continuous that only birds, clouds, sheets of rain and other fleeting phenomena provided bearings for my body. As I danced way out there I was:

> pulled [...] beyond my control into a wild whirling around centre-less curves and eventually into a state of collapse. [...] Having lost [my own] place centre, I had a sickening but ultimately joyful experience of abandonment to [...] an alterity grasped as the gravitational power of a place that would, if I were to persist in it, literally engulf me in over 12 feet of water.
>
> (Stewart 2010b: 37–8)

Several Butoh-ka have more deliberately explored death in the sites at which they dance. Takenouchi Atsushi has wandered over the earth, committed to dancing over places where large numbers of people have died, in particular the killing fields of Cambodia, Poland, Japan (Fraleigh 2005: 336):

> I want to feel places where great masses of people have died together [...]. I feel the ground and the clouds. *The killing field is already dancing.* Something happens inside me when I touch death. After that I don't think anymore. I pray and I dance, respecting the meeting of life and death, and how we all connect.
>
> (ibid.)

In 1977, Tanaka Min drove a truck through an iron-net gate to dance, Caliban-like, on a vast rubbish tip floating in Tokyo Bay. He called his dance *Dream Island*:

> Heaves of dumped and rotting materials just lay there, floating above dark water and discharging smelly methane gas. [...] We found ourselves in a world exclusive to abandoned beings. *Endless traces of "present moments" and "actions" were breathing.* Hundreds of bankbooks, hundreds of fabric swatch bundles, and poisonous industrial waste in the process of decomposition and mutation.
>
> (Kobata, in Tanabe 2007)

These sites are voids not because they are too empty but because they are too full. They are unmasterable because they disturb the link between human control of the earth and the body's *spatial* relation to it, between human horizons of understanding of nature and the body's bearing towards the horizon line. They are unmasterable because they have a life of their own: the sands tip and suck, the island of reeking rubbish discharges and breathes, the killing fields dance. They are unmasterable because they are unstable. They offer an experience of groundlessness, an uprooted reality in which bodies struggle to remain upright: the decomposing detritus of commodity culture floating on Tokyo Bay provided fragile support for Tanaka as he quivered over it; and the alterity of the porous sands of Morecambe Bay, registered by a gravitational pull far greater than I could control, took my legs from under me. They are unmasterable because they overwhelm and engulf. They offer sublime magnitudes far greater than the single body can sensibly measure: the vastness and cognitive dissonance of Morecambe Bay; Tokyo Bay's "endless traces" of "rotting materials"; the unimaginable horror of drowning, and murder of innumerable "masses of people" that leaves Takenouchi unable to "think".

These sites are also unmasterable because they refuse time as schematised into past, present, future: by dancing on sands that will be covered in sea water to more than twice my height the possibility of drowning in the future became real to me as a present possibility; for Tanaka the decomposing past is traced as "actions" breathing as "present moments"; Takenouchi senses through ground and clouds the dead "already" dancing now. Indeed, these site-specific dances disclose nature as constituted by an "authentic" temporality that Heidegger qualifies as "being-toward-death" (Hoffman 1993: 196). This is most fully realised when one faces the fact that one is "powerless to escape the *possibility* of dying", a possibility that, if it is to be a *pure* possibility, must be possible *at any time*. As such, linear time gives way to an *ekstatic* time-consciousness. The ecstatic future is "not 'later' than the ecstatic present" for, in dancing in a site that offers few measures for deferring death to a place where one might be "in" the future as such, death is a "live issue" now (ibid.: 208). The ecstatic past has likewise not elapsed into the past as such, because the ecstatic past is one's "thrownness", that is, one's "established preferences, skills, habits" (ibid.), including the stylistic and neuromuscular proclivities of, in my case, contemporary dance and north European physical theatre, in Tanaka's ballet and modern dance, and in Takenouchi's the Butoh of Hijikata. So, if the authentic moment is "magnetised" by death (Rée 1998: 41), and if the unmasterable sites to which these dances were specific made moments of authentic temporality impossible to a-void, then the cultural past which the dancer brings into the present was magnetised by the groundlessness of a futural being-toward-death. Thus each of these site-specific dances of death function as "a kind of inter-face site, a meeting place of human purposes and decisions, and [the] unmasterable, non-human horizon" of nature's space and time (Collins and Selina 1999: 133).

Jack Scout

Time to take stock. We have progressed along a continuum from *spectacle*, the scientific and artistic systems of classification that frame and instrumentalise nature; through *world*, the development of responsibility towards the natural world through the improvisation and meeting of different horizons of understanding in practical situations; and *environment*, the immersive situations in which human bodies learn to value nature as they act within ecological systems of which they are inextricably a part; to, finally, *void*, the discombobulation that occurs within an unmasterable environment of unimaginable scale and force. The themes of this chapter thread throughout. Analytical language is a tool of spectacle, hermeneutic language is necessary to world-making conversation, poetic language deepens a feeling of continuity with environment, and silence is the only option with void. So with the aesthetic appreciation of nature: the landscape and object models of spectacle are tested by world then give way to environment's natural-environmental model which, in turn, is abandoned in favour of void's aloofness model. Competing notions of landscape also crop up: the landscape gaze as scopic regime characterises spectacle, but "prototypical landscape" as human habitation shaped through situated and skilled application qualifies world, whilst the "face-landscape" state of becoming distinguishes environment. Since void's sublime magnitudes, view from nowhere and groundlessness are, by definition, impossible to see, shape or sense, void is a kind of anti-landscape. Finally, although the knowledges yielded by spectacle can lead to the exploitation of natural resources, they can equally inform an ethical engagement with the world typified by *phronesis*. In contrast, the notion of face-landscape attempts to ground environmental ethics in a living sense of the materiality and alterity of the environment's surfaces. Void, however, points to nature's indifference and non-moral value. Some practitioners fit hand-in-glove: Anderson ironises spectacle, Monson develops world, Hijikata and Whitehead practice environment, and Tanaka and Takenouchi confront void. In particular, the compositional processes of *Still Life* typified spectacle, yet depended on on-site conversations with local specialists that characterise world, and gave in to forces of the site itself that pulled the work into environment and gestured towards void.

Still Life was the precursor to *Jack Scout*, a show that can be examined in relation to all four epistemes. Indeed, the final part of this chapter is dedicated to *Jack Scout*, an hour-long walking performance work performed 20 times in September 2010,[1] and *Jack Scout Redux* (2013), the film version of the project.[2] Both explore Jack Scout, a heath in Silverdale, Lancashire, overlooking Morecambe Bay. In the live work audiences of up to 20 at a time were taken through the heath, along the shoreline and over the beach as live music, installations, dance and voice "evoked its land, sands, skies and sea. Woven into those impressions was the story of *The Matchless*, a

pleasure boat shipwrecked in 1895 with the loss of 34 lives" (Sap Dance 2014).

It is first necessary to indicate how the show was made. We set up on-site "Dialogues" with local stakeholders and specialists in order to establish four different worlds: an "Underworld Dialogue" with National Trust wardens and plant ecologists about Jack Scout's unique flora and fauna; an "Overworld Dialogue" with RSPB educators and ornithologists about the behaviour of birds, butterflies and bats on the heath and migratory birds on the beach; an "Innerworld Dialogue" with pupils at a nearby residential special needs school; and a "Waterworld Dialogue" with cross-bay guides, fishermen and local historians concerning fishing traditions and techniques. This generated choreographic, spoken, musical and visual material later montaged into the final live show which, in turn, was abridged and montaged anew for the film. Here I can only discuss the development of some dance and musical material.

As with Monson's *Birdbrain* tours and my fieldwork experiment with Waterton, the four Dialogues promoted an expanded consciousness of Jack Scout through the fusion of different horizons of understanding. As part of the Underworld Dialogue, I traversed the heath with National Trust warden Steve Bradley as he noted the distinguishing features of plant species. Although I later made reference to field guides (e.g. Streeter 2009), this was not book-based instruction, but sited talk coupling concepts and haptics: we were on our bellies, fingering what we debated. Using a chart I developed with Waterton, I then noted the phenomenological qualities I perceived of the same segments of each plant that Bradley had described. With each flower in turn, I improvised according to the data I had noted so as to realise human movement possibilities analogous to those of the flower. This is illustrated by my response to a blackberry bramble at the northern edge of the heath. Learning that this particular deciduous and intensely prickly shrub might run a metre deep, I perceived the relation between, on the one hand, the deeply weighted tension, sustained downward projection, twisting pattern and resilient amplitude of the roots and, on the other hand, the much lighter but contained tension, ballistic then abrupt upward projection, lurching torsion and pliant amplitude of its thin prickly stem, together with the even lighter but resilient expanse and abrupt serrated edges of its palmate leaves. Having improvised from those kinaesthetic qualities, I choreographed the following action: a contraction into a deep squat set against my arms that unfolded from my groin to above my head whilst I imagined my fingers flinching the prickles and stroking the leaves. A second action was inspired by the compact but potentially explosive qualities of the ripe blackberry fruit, qualities that I made sure I experienced in one improvisation by stuffing as many berries as I could into my mouth, then letting them burst before slowly spewing them out. As a result, I set the following: my mouth stretched wide, closed whilst retaining heavily-swollen pouched cheeks, then protruded into a forward-flanged silent shout. A

similar process was followed for all of the other flowers: holly, ivy, hawthorn, dog-rose, autumn hawkbit, red clover, rock rose, hare bell, an oak stump, and a lady's trellis. Likewise, as part of the Waterworld Dialogue I asked dancer Natasha Fewings to work her way along the shoreline and littoral zone to make a movement record of her responses to different sand patterns, water marks, cloud formations and horizon lines, and wind, ducks and gulls.

Other movement material bore a more obvious relation to the social world of Jack Scout. On several occasions we joined conservation work on the heath, an instance, then, of the prototypical landscaping or shaping of a natural habitat. This involved cutting bracken and other ferns dominating the heath so as to ensure the growth of more delicate flora and maintain the heath's remarkable biodiversity. The repetition of beating back bracken with a basher, excising it with shears, and spearing, heaving high, and chucking large heaps of debris with a pitch fork, became so ingrained into my neuromuscular memory that it would have been difficult for those *gesten* (or social gestures) to not find their way into the stash of movement material I was steadily stockpiling. In a parallel process, Fewings developed *gesten* from driving tractors and mending and pulling nets with fishermen out on the Bay.

Comparably, as part of the Overworld Dialogue Matthew Robinson invested much time in notating the songs of robins, chiffchaffs and other often heard but barely seen birds of the heath identified through the Common Bird Census, but his *adaptation* of what he notated was of greater moment. A blackbird song, with its accelerating syncopated wide leaps and trills, was first notated and rendered as accurately as possible on flute, but then transposed down no less than five octaves, slowed down four times and played *tempo rubato* on bass clarinet. Robinson then experimented with different ways in which that transposed music could be played out-of-sight from within thickets and other hidden locations on the heath. In all these cases, then, we had, like Monson, found ways to translate scientific information into artistic material.

If the process of making material shaped a *world*, then the performance work and film put more emphasis on *environment*. Two episodes suggest this. The first is "Tree Tunnel", retained in its entirety for the film. Spectators were led along a path through a dense wood to a clearing where I was discovered, dressed in a mud-splattered tweed suit, straddling a fallen tree. My choreography which ensued was set from my Underworld Dialogue with Bradley. For instance, curling off and lunging away from the fallen tree, I performed my "shears" and "pitch fork" *gesten*, then combined the two "bramble" actions before proceeding with other "plant" material (see Figure 20.1). At the same time, the "mesmerising and haunting" tones of Robinson's blackbird melody for bass clarinet, played from behind some nearby trees, reverberated throughout the wood (Ho 2010: 8).

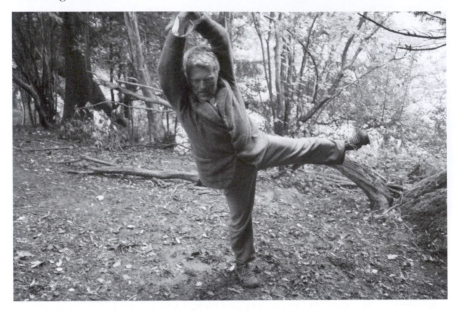

Figure 20.1 "Tree Tunnel" from *Jack Scout* (Sap Dance and Louise Ann Wilson Company 2010).

Photographer: Nicola Tarr. Choreographer and dancer: Nigel Stewart.

A comparable relationship was created between Robinson and Fewings in "Beach", a later episode. Having unravelled herself from a sail, Fewings ran forward in large arcs across the beach, then ran backwards through the audience towards the Cow's Mouth, a gorge and inlet I describe below. Throughout she danced phrases I montaged from the shoreline and littoral material she had logged, and Robinson played a plaintive melody he had abstracted from responses to sea birds as they fled the beach at high tide, slowing down the melody to ensure an open circuit of sound resounding with the cliffs that he faced.

Hardly any of the many written responses collected from audiences immediately after the show or two years later in a follow-up survey make any reference to dance! Yet remarks about those parts that most explicitly used dance typify the environment episteme. They are always written poetically, even rapturously, to stress a continuity between human and other-than-human forms and forces or the audience's heightened sensations of the environment in which they had been immersed. "The man in tweed was the wood and trees", wrote one person, whilst another described "Tree Tunnel" as a "mind blowing [...] wonderful interpretation of trees-growth age" (Ho 2010: 9). Of Fewings someone intoned that the "woman in white was the sea-white horses", another enthused that the "lost soul spirit of woman" and "her sensual experience of wet sand and mud" was "haunting", whilst others appreciated the "exquisite merging of artist with landscape" and how she

"melt[ed] into [and] emerge[d] from the rocks" (ibid.). The same was true of the music played alongside the dance. Several heard how Robinson's clarinet "echo[ed] around the Bay", how it "changed as [he] got closer to the cliffs", and that "the performed sounds made [them] much more aware" of the whole sonic environment, from "the natural sound of birds, wind" to the noise of "sawing [and a] plane" (ibid.: 8). Time and again remarks about the whole show refer to different surfaces – a hallmark, as I have explained, of the facialisation, and thus valuing, of nature. For instance, someone referred to "crossing time, crossing sand, crossing water, crossing […] of nature, music, voice, sounds" and the "crossing of textures – tweed, bark, sail cloth, mud, water, soft moss and grass", whilst another noted "a real sensual awareness – both of the body, its limitations, its fragility" and of an "acuity of perception" of the "environment" (ibid.: 7, 9).

However, the shift from the making of material to the montage of the show was also marked by a haunting of spectacle by void. In keeping with the landscape model we presented the audience with different prospects of the site, and certainly many spectators were "struck" by "the use of perspective", the "ingenious framing of scenes", "the long views" and "the way the production led the eye to embrace the bay" (ibid.: 8, 9). The word "cinematic" is easily the most used adjective. And yet spectacle was disturbed, most notably in the final scene. Spectators were taken inside the Cow's Mouth to a wall fronted by a shallow shingle beach littered with debris. Turning around they were each given a cockle shell by Louise Ann Wilson and then left to look back at the whole picture-postcard scene: a sheer cliff to the south, limestone slabs rising to the north, and in between wet sand widening westward to the Bay beyond. However, they had just discovered Fewings dangling from the top of a cave in the cliff, had watched her descend like a spider, had witnessed her dance right by them on the sand. My choreography for this dance took her repeatedly a short way forwards towards the wall, then much further backwards towards the Bay. As this shuttling pattern continued, all her movements, which were directed to the wall, consisted of fragments from her earlier beach material interlinked with some of her "fishermen's" *gesten* and my "shears" and "pitch fork" *gesten*, so, as can be seen in the film, the increasing difficulty she experienced in dancing over the saturated sand was accentuated by syncopated thrusts and stamps. As she danced, Steve Lewis – a merman reclining on a rock accompanied by Robinson's clarinet – sung "The Matchless", his impassioned out-of-kilter sea shanty about the sinking of the eponymous pleasure ship and the drowning of 34 of its passengers. So by the time spectators had reached the wall Fewings was already far out of the inlet and into the Bay: an ever diminishing figure lurching forwards but tumbling further backwards, slapping the soaking sand and her saturated silted dress (see Figure 20.2) whilst Lewis's voice degraded into inarticulate drones and Robinson's clarinet into honks and scraps of sound bouncing around rock. When rain was heavy and visibility low, as it often was, Fewings was

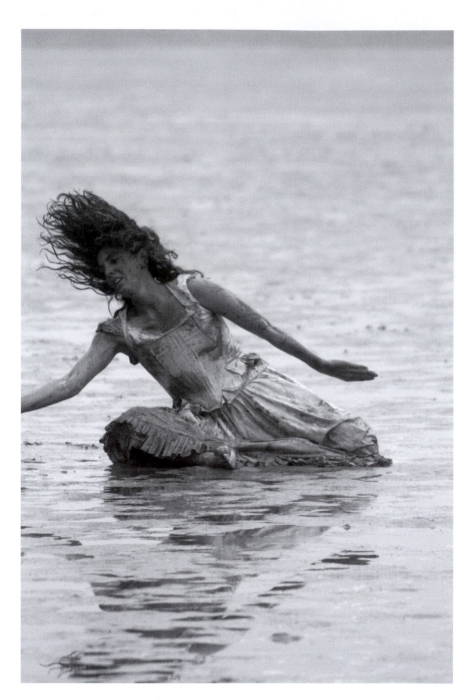

Figure 20.2 "Cow's Mouth" from *Jack Scout.*
Photographer: Nicola Tarr. Choreographer: Nigel Stewart. Dancer: Natasha Fewings.

finally nothing but a flailing thing on the skyline. Then the whole cast, spread around the inlet and together for the first time, turned their attention to the audience. For over two minutes the audience, thumbing their cockle shells, stood still silently witnessing the cast witnessing them.

Many spectators were confident we were "interpreting the shipwreck very well" (ibid.: 9): "the desperation and suffering of the women lingered with me as we walked away", was typical (ibid.: 8). Others, though, were less concerned with the Bay's history of shipwrecks and drownings and more with wider ideas: someone from Mumbai with no necessary knowledge of that history found the end "transcendent", whilst another contemplated a change from the contained to the immeasurable, in particular how the woman "held by the rock" was "then lost in the enormity of the Bay" (ibid.: 9). Indeed, what I have described has much in common with the danced sublime in particular and void in general: the inability to stay upright in an environment that increasingly discloses its unmasterable scale; a perception of alterity felt through the pull of gravity; being-towards-death intuited through the pure possibility of drowning and engulfment; the struggle of the trained body with a porous environment; site-specific dance as a meeting of human endeavour and the unmasterable, non-human horizon of the Bay's aloof and acentric expanse; and, finally, an intuition of nature for which the only appropriate response is neither analysis, nor conversation, nor poetry, but silence.

Notes

1 *Jack Scout* was conceived and co-directed by Nigel Stewart and Louise Ann Wilson as a co-production by Sap Dance and Louise Ann Wilson Company. It was choreographed by Nigel Stewart, danced by Natasha Fewings and Nigel Stewart, and designed and performed by Louise Ann Wilson. Music was composed, and performed live, by Steve Lewis and Matthew Robinson. It was funded by Arts Council England, Arnside and Silverdale Area of Outstanding Natural Beauty, Nuffield Theatre and Lancaster City Council.

 The dedicated project website at www.lancaster.ac.uk/fass/projects/jackscout contains evaluation reports, observations on "four green themes", documentary-style video of excerpts from two live performances, image galleries of the research process and performance, and short sound pieces of the heath and seashore.

2 *Jack Scout Redux* is available for purchase from Sap Dance, LICA Building, Lancaster Institute for the Contemporary Arts, Lancaster University, Lancaster LA1 4WY, UK. This is distinctly different from the website's short documentary film, and presents material cinematically to form an art work in its own right.

References

Abram, D. (1996) *The Spell of the Sensuous: Perception and language in a more-than-human world*, New York: Pantheon Books.

Adams, J. (2005) "Performative Locations: Wilderness Space and Place in Early Film", in Gabriella Giannachi and Nigel Stewart (eds) *Performing Nature: Explorations in ecology and the arts*, Berne: Peter Lang, pp. 85–101.

Baker, R. (1981) *Human Navigation and the Sixth Sense*, London: Hodder & Stoughton.

Bell, C. (1998) "Performance" in Mark C. Taylor (ed.) *Critical Terms for Religious Studies*, Chicago: University of Chicago Press, pp. 205–224.

Briginshaw, V. (2001) *Dance, Space and Subjectivity*, Basingstoke: Palgrave.

Budd, M. (2002) *The Aesthetic Appreciation of Nature: Essays on the aesthetics of nature*, Oxford: Clarendon Press/Oxford University Press.

Carlson, A. (1979) "Appreciation and the Natural Environment", *Journal of Aesthetics and Art Criticism*, 37(3), 267–275.

Casey, E.S. (2003) "Taking a Glance at the Environment: Preliminary Thoughts on a Promising Topic", in Charles S. Brown and Ted Toadvine (eds) *Eco-Phenomenology: Back to the Earth Itself*, New York: State University of New York Press, pp. 187–210.

Collins, J. and Selina, H. (1999) *Introducing Heidegger*, Cambridge: Icon.

Debord, G. (1977 [1967]) *Society of the Spectacle*, Detroit: Red and Black.

Dostal, R.J. (1993) "Time and Phenomenology in Husserl and Heidegger", in C. Guignon (ed.) *The Cambridge Companion to Heidegger*, Cambridge: Cambridge University Press, pp. 141–169.

Dunstan, B. (1979) *Composing Your Paintings*, London: Studio Vista.

Fraleigh, S. (2005) "Spacetime and Mud in Butoh", in *Performing Nature*, pp. 327–344.

Gadamer, H.G. (1989 [1975]) *Truth and Method*, 2nd edn, trans. W. Glen-Doepel, rev. trans. Joel Weinsheimer and Donald G. Marshall, London: Sheed & Ward.

Giannachi, G. and Stewart, N. (2005) "Introduction", in *Performing Nature*, pp. 19–62.

Gibson, James J. (1986) *The Ecological Approach to Visual Perception*, Hillsdale, NJ: Erlbaum.

Godlovitch, S. (1994) "Icebreakers: Environmentalism and Natural Aesthetics", *Journal of Applied Philosophy*, 11(1), 15–30.

Heidegger, M. (1962 [1926]) *Being and Time*, tr. John Macquarrie and Edward Robinson, Oxford: Blackwell.

Heim, W. (2005) "Navigating Voices", in *Performing Nature*, pp. 199–216.

Hepburn, R.W. (1966) "Contemporary Aesthetics and the Neglect of Natural Beauty", in Alan Montefiori and Bernard Williams (eds) *British Analytical Philosophy*, London: Routledge and Kegan Paul, pp. 285–352.

Ho, Y. (2010) "An Audience with Jack Scout: a Quantitative and Qualitative Evaluation of the Audience's Experience of *Jack Scout*", *Jack Scout*. Online. Available: www.lancaster.ac.uk/fass/projects/jackscout/docs/jackscout_evaluation_report.pdf (accessed: 30 July 2014).

Hoffman, P. (1993) "Death, Time, History: Division II of Being and Time", in C. Guignon (ed.) *The Cambridge Companion to Heidegger*, Cambridge: Cambridge University Press, pp. 195–214.

Ingold, T. (2011) *Being Alive: Essays on Movement, Knowledge and Description*, London: Routledge.

Kant, I. (1960) *Observations on the Feeling of the Beautiful and Sublime*, tr. John T. Goldthwait, New York: University of California Press.

Knudsen, D.C., Soper, A.K. and Metro-Roland, M.M. (eds.) (2008) *Landscape, Tourism, and Meaning*, Burlington, VT: Ashgate.

Laban, R. (1966) *Choreutics*, ann. & ed. Lisa Ullmann, London: MacDonald and Evans.

Laban, R. (1988 [1948]) *Modern Educational Dance*, 3rd edn, ed. Lisa Ullmann, Plymouth: Northcote.

Levinas, E. (1969) *Totality and Infinity: An Essay on Exteriority*, tr. Alphonso Lingis, Pittsburgh: Duquesne University Press.

Marshall, D. (2005) *The Frame of Art: Fictions of Aesthetic Experience, 1750–1815*, Baltimore: Johns Hopkins University Press.

Merleau-Ponty, M. (1968 [1964]) *The Visible And The Invisible*, tr. Alphonso Lingis, Evanston, Ill.: Northwestern University Press.

Monson, J. (2002) *Osprey Migration: A Navigational Dance Project*. DVD. New York: Birdbrain Dance.

Monson, J. (2014a) *Birdbraindance: a Navigational Dance Project*. Online. Available: www.birdbraindance.org (accessed: 7 June).

Monson, J. (2014b) "Jennifer Monson", *iLAND*. Online. Available: www.ilandart. org/artist-biography (accessed 01 August).

Mulvey, L. (1975) "Visual Pleasure and Narrative Cinema", *Screen*, 16(3), 6–18.

Nakajima, N. (1996) Untitled Lecture Paper, Copenhagen: International School of Theatre Anthropology.

Olwig K. (1996) "Recovering the Substantive Nature of Landscape", *Annals of the Association of American Geographers*, 86(4), 630–653.

Raab, T. and Frodeman, R. (2002) "What is it Like to be a Geologist? A Phenomenology of Geology and its Epistemological Implications", *Philosophy & Geography*, 5(1), 69–81.

Rée, J. (1998) *Heidegger: History and Truth in Being and Time*, London: Phoenix.

Rodwell, J. (1995) *Handbook for Using the National Vegetation Classification*, Joint Nature Conservation Committee.

Rolston III, Holmes (1997) "Nature for Real: Is Nature a Social Construct?", in Timothy D. J. Chappell (ed.) *The Philosophy of the Environment*, Edinburgh: Edinburgh University Press, pp. 38–64.

Rose, G. (1993) *Feminism and Geography*, Cambridge: Polity Press.

Sap Dance (2014) *Jack Scout*. Online. Available: www.lancaster.ac.uk/fass/projects/ jackscout (accessed: 30 July).

Sharma, S. (1995) *Landscape and Memory*, London: HarperCollins.

Shearing, D. (2014) "Scenographic Landscapes", *Studies in Theatre and Performance*, 34:1, 38–52.

Sheets-Johnstone, M. (1979) *The Phenomenology of Dance*, London: Dance Books.

Sheets-Johnstone, M. (1999) *The Primacy of Movement*, Amsterdam and Philadelphia: John Benjamins.

Smith, P. C. (1998) *The Hermeneutics of Original Argument: Demonstration, Dialectic, Rhetoric*, Evanston, IL.: Northwestern University Press.

Stewart, N. (1998) "Re-languaging the Body: Phenomenological Description and the Dance Image", *Performance Research*, 3(2), 42–53.

Stewart, N. (2005) "Dancing the Time of Space: Fieldwork, Phenomenology and Nature's Choreography", in *Performing Nature*, pp. 363–376.

Stewart, N. (2010a) "The Weathering Body: Composition and Decomposition in Environmental Dance and Site-Specific Live Art", in Lesley Anne Sayers (ed.) *The*

Dynamic Body in Space: Developing Rudolf Laban's Ideas for the 21st Century, London: Dance Books, pp. 217–228.

Stewart, N. (2010b) "Dancing the Face Of Place: Environmental Dance and Eco-Phenomenology", *Performance Research*, 15(4), 32–39.

Streeter, D. (2009) *Collins Flower Guide*, London: HarperCollins.

Suchman, L. (1987) *Plans and Situated Actions: The Problem of Human-Machine Communication*, Cambridge: Cambridge University Press.

Tanabe, S. (ed.) (2007) *Min Tanaka: Between Mountain and Sea*, photos Masato Okada, tr. Jan Fornell and Kazue Kobata, Tokyo: Kosakusha.

Thomas, K. (1984) *Man and the Natural World: Changing Attitudes in England 1500–1800*, Harmondsworth: Penguin.

Urry, J. (2002) *The Tourist Gaze: Leisure and Travel in Contemporary Societies*, 2nd edn., London and New York: Sage.

Waterton, C. (2003) "Performing the Classification of Nature", in Bronislaw Szerszynski, Wallace Heim and Claire Waterton (eds) *Nature Performed: Environment, Culture and Performance*, Oxford: Blackwell, pp. 112–129.

Whitehead, S. (2000) "somasonicspirit", *Between Nature: Explorations in Ecology and the Arts*, Book of Abstracts, Lancaster: Lancaster University, p. 48.

Williams, R. (1976) *Keywords: A vocabulary of culture and society*, Oxford: Oxford University Press.

Williams, R. (1980) "Ideas of Nature", *Problems of Materialism and Culture*, London: Verso, pp. 67–85.

Wood, D. (2003) "What is Eco-Phenomenology", in *Eco-Phenomenology*, pp. 211–233.

Part V

Sharing the site

Community, impact and affect

Victoria Hunter

Placing dance in real-world locations necessitates a relationship of co-existence between the dance practice, site and the community with which it engages. In this section the term 'community' is extended beyond the realm of interventionist and applied practice to include discussions of dance interactions with site that engage a range of 'community' groups including members of the general public, artistic and collaborative practitioner 'communities' engaging with site-dance performance and groups for whom the siting of dance within their community group forms an intrinsic part of social, ritual and celebratory life. This section challenges the reader to consider how performance placed in public spaces or dance that emerges from distinct cultural practices might celebrate or challenge human behaviours and potentially disrupt conventional interactions with particular sites.

In the opening chapter, Cheryl Stock provides an account of a collaborative site-dance work *Naik Naik* (2013) that engaged a community of artists from a range of cultural backgrounds in the development of a performance work at the world heritage site of Melaka in Malaysia. Here she reflects on the group's working methods informed by her own extensive experience making community-based site-work in Australia and Malaysia. In the following chapter dance artist and educator Josie Metal-Corbin reflects on her career as a site-dance artist and provides a practitioner account of her approach to making work with a range of community groups in a number of locations. Ranging from country parks to gallery and civic centres this chapter presents both a pragmatic and a reflective account of the challenges and triumphs of making work in public spaces. Informed by phenomenological theory and notions of inter-subjectivity, April Nunes Tucker provides a reflective account of her site-dance exploration of the prominent tourist site of La Pedrera designed by architect Antoni Gaudi in Barcelona, Spain. In this chapter she discusses her employment of specific techniques designed to activate inter-subjectivites with members of the public and invited audience members who shared the space with her. In the following chapter, Jean Johnson-Jones employs an anthropological approach to her discussion of the Nama Stap Dance performed by the

indigenous Khoisan people of South Africa. She describes the conventions of the performance and its spatial construction around the traditional dwelling hut; the matjieshuis/mat house and addresses key aspects of the Nama Stap Dance that position it as a 'site-specific' dance. This section concludes with a reflective essay that explores the triadic relationship between performer, audience and site encountered within the creation of my own site-specific dance work *The Library Dances* (2006). In this chapter I explore notions of mobility, permanence and fixity in relation to individual perceptions of and constructions of site and question what occurs when dance-makers choose to challenge and disrupt spatial and social norms. This collection of chapters reveal that practices of negotiation are intrinsic to this type of work in which, for example, tensions between artistic/ aesthetic endeavour and the civic remits of public spaces must be brokered and tensions between the preservation of traditional customs are weighed against drives for socio-economic development. The practitioner accounts, reflective discussions and analytical debates featured here provide insights into the nature of such negotiations operating at both a micro/ internalised level for the individual artist and a broader macro-political level for community groups and site-users encountering dance performance sited in real-world locations.

21 From urban cities and the tropics to site-dance in the world heritage setting of Melaka

An Australian practitioner's journey

Cheryl Stock

I use my body to tell the story of the site.

(Rithaudin Abdul Kadir)[1]

As an Australian dance artist for four decades, working in and with sites in various contexts has always been fundamental to my practice, especially at critical turning points in my career in which, paradoxically, theatre productions and extensive touring in urban, outback and international arenas have taken up much of my dancing, choreographic and directing energies. In retrospect, it is those latter touring experiences that have to a large extent shaped my ongoing sensibilities and curiosity around relationship to site. Other seminal influences occurred from the late 1980s when I became deeply involved for 13 years in intercultural dance programs in Vietnam and in the last 14 years as an artist academic collaborating on cultural exchange programs in other parts of Asia; predominantly China, Taiwan, Singapore, Korea and Malaysia.

However, until my most recent site-specific work in Malaysia in 2013, the two driving passions of intercultural and site-specific performance only came together on Australian soil. Australia, vast and diverse, is a country where an amenable climate, clear light, star-filled nights, expansive landscapes and seascapes can provide an idyllic backdrop for externally sited events. It is therefore not surprising that predominantly outdoor site-specific performances have a history and an identifiable lineage. This chapter provides a personal and partial view of that lineage over four decades and through four phases of my site-specific practice. These phases can be summarised as: choreographing cities; working with community; multi-site promenade performances; and finally – the subject of this case study – performative engagement with cultural heritage sites in a festival context. All four phases occurred through evolving collaborations with strong communities of dance-led professional practitioners comprising facilitators, performers, choreographers, visual and media artists, composers and directors.

Choreographing cities – the influence of Marilyn Wood

My initial connection with site-dance was in the 1976 Adelaide Festival of Arts when I was invited by director Marilyn Wood to form and coordinate an interdisciplinary team of eight dancers, musicians, writers and designers who would become the core creative and performing group for a new outdoor program. Wood, an original member of the Merce Cunningham Dance Company, had become renowned for conceptually based site-specific works in New York and internationally. For this Australian festival she was commissioned to oversee a series of performances in key city sites such as the railway station, theatre plaza, stock exchange, museum and a central park in order to animate the city and make contact with its residents and festival visitors. Audiences came upon site performances serendipitously as they went about their daily business. Described by the media at the time as 'a large environmental happening designed to sweep everyone into a Festival fever' (Butler 1976: np), Wood referred to her process as 'choreograph[ing] cities' through 'site-specific and collaborative celebrations' in urban environments to 'revitalize community spirit' and transform 'the familiar into the magical'.[2]

This seminal Adelaide Festival program set the scene for a tradition of outdoor performance programs in every subsequent festival held in the city to the present time. The 1976 festival also spawned *Community Celebrations*; the first ongoing community of site-specific artists making regular work in this context. Key members of this collective who worked with Marilyn Wood and continued pursuing site-specific work through *Community Celebrations* were myself, Tony Strachan, Michael Pearce, Julia Cotton and Paul Adolphus. Arguing for funding support (which was later forthcoming), local media commented on the fledgling group and the 'brief, but nonetheless impressive track record and philosophy of taking their art "to the people"' (Knez, 1976: 38), whilst Atkinson (1976: 54) described the group as 'performing for and with the community in the audience's environment'. Three of the key members later moved from Adelaide and the 'celebrations' legacy extended into groups such as *Chrome* (Melbourne/ Sydney) formed by performers Tony Strachan, Michael Pearce and Paul Adolphus, and *Etcetera*, formed by Julia Cotton, all of whom were active in Australia and overseas in the late 1970s and throughout the 1980s.[3] When we went our independent ways, the pioneering work of Marilyn Wood continued to influence the working processes and artistic approach of these artists and myself. Tony Strachan, in an interview with the author in May 2013, recalls Wood's process as encompassing:

> a good substantial lead in time where we got together, got to know each other and experimented with concepts and working in complementary ways... work that relied on trust which is obviously a common theme through dance, especially improvisational dance... and also taking an

emotional feeling and trying to develop that in a movement sense... She elicited some wonderful things from us I think.

'Scoring the Site'

Arguably the most important and useful legacy of working closely with Marilyn Wood was a thorough preparation for engaging with site and audience in public places; a process called 'Scoring the Site'. In this scoring process we firstly visited each site alone to immerse ourselves in the spatial qualities, energy, sounds, movement and behaviour we noticed as we sensitised ourselves to our surroundings. Reporting back to the group, we shared our experiences and were then ready to explore the evolving work through an improvisational process that Woods saw as the fundamental training ground for site-specific choreography in public environments. Although the performances had structure and continuity, performers were provided with strategies to interact with audience members at opportune times and also respect the shared purpose of the place of temporary performance. Apart from honed improvisational skills, readiness for unexpected intrusions together with subversions and play was required.

Marilyn Wood encouraged us to develop original material derived from the site itself rather than adapt existing material. This illustrates the distinction between what McAuley (2012) terms site-based and site-specific performance. In the former the work takes place in a particular site that is a vehicle and 'venue' for the performance rather than the source of its creation. Site-based dance can therefore be adapted to other sites whereas site-specific dance, as its title denotes, occurs when the site provides the concept and content of the work as well as informs its processes and outcomes, and where immersion in the site at all stages is paramount.

Whilst this theorising of site-specific performance emerged later many of the techniques and concepts now espoused were absorbed by those of us (not only in Australia) influenced by Marilyn Wood in the 1970s. At that time we were also taught 'techniques for moving attention from one aspect of the site to another' (Wood, op. cit.) and thus we became acutely aware of the spectator's role in being able to watch from several vantage points, traverse the site, come and leave at any time and choose whether to observe or participate. These early experiences of creating site-specific works proved to be a crucial training ground for my ongoing and evolving site-dance practice.

Performing for and with community

As in many other parts of the world, the 1980s and 1990s in Australia saw site-specific work predominantly featured in community cultural activities, performatively exploring histories or celebrations of place and social justice issues associated with place (Poyner and Simmonds, 1997). In these events

community groups and individuals were actively engaged in researching, creating and performing the sited work through workshops led by professional dance facilitators and often, probably unknowingly, working through processes similar to those I had learned from Marilyn Wood. In my own practice, two such community-based works *Backtracks* (1982) and *Meet me at Kissing Point* (1994) sited in two very different tropical cities in Northern Australia (Darwin and Townsville), adapted 'Scoring the Site' processes. *Backtracks* took place in a community park where ruins from a devastating cyclone remained, which became the set for a historical pageant-like theatrical performance spanning a 100-year history. *Meet Me at Kissing Point* was set around and in a large rock pool protected by a semi-circular retaining rock wall connected to the sea with a spectacular view of a nearby island. Both drew on historical and contemporary events and included large casts of community members in different parts of a single site, whilst spectators were informally seated and viewed the performances in much the same way as a theatrical production, albeit under the skies with a panoramic view (see Stock, in Poyner and Simmonds, 1997). In both these contexts members of diverse community groups from the town participated fully in the process and the performances, whilst those attending were witnesses to the final event.

Multi-site promenade performances

My dance-site practice in the twenty-first century saw a shift and expansion through the adoption of multi-site, promenade style performances that, unlike the individual site works of Marilyn Wood and subsequent community projects, worked from a unifying concept linking several sites physically and metaphorically. Taking place indoors and/or outdoors, the audience could experience discrete but linked narratives across several sites, and importantly, make their own meaning not only through moving within and around sites but through the pathways between them.

This was explored in an intimate way in *here/there/then/now*, performed inside the Brisbane Powerhouse in 2002. The performance took place across four sites in the nooks and crannies and 'foyers', linking theatrical spaces that had been converted from a former industrial powerhouse (Stock 2005, 2011). This work was interdisciplinary in nature and each of the first three sites was choreographed and performed by a small discrete team of artists. This approach presented a shift in my own practice from choreographer/director to a more conceptual, curatorial and directorial role and marked the beginning of working with independent dance artists to provide a shared collaborative interdisciplinary platform in site-based environments.

The work investigated a theatrical transformation of site through notions of the present and the past dwelling in the fabric of the building. Moving from site to site, audience members chose their point of view – how to see

and from where. *Here* followed the experience of a solo performer exploring the humanity of the body within an industrial space, and the power of fire as light and warmth, hell and depravity. From one end of a large central platform the audience peered through protective railings down into a dimly lit dungeon-like space containing flickering flames and shadows. *There*, occurred in a confined area adjacent to a staircase landing – a deep place of entrapment from which the performers could not escape – to which the audience was attracted by the haunting voice of the Thai performer and her companion dancer. Descending the staircase the audience *then* encountered an open foyer and a solo performer contemplating and interacting with a suspended still life of objects; floating, hovering, inviting an aesthetic gaze rather than emotional involvement. *Now* brought together fragmented histories of the sites left behind to mingle with the histories of the performing bodies, leading the spectators to the final site; a theatre stripped bare to remind them of the architectural site it once was; culminating in *here/there/then/now*.

Festival culture and engaging with heritage sites

The second decade of this century has seen dance artists increasingly exploring immersive and interactive environments (constituting a different kind of 'site').[4] In my own practice, this shift occurred through a two-year process resulting in the work *Accented Body* (2006) for the Brisbane International Festival with six dance-led teams of artists from Australia, the UK, Taiwan, Korea and Japan coming together to create a promenade work of six linked indoor and outdoor sites featuring multiple interactive screens and distributed presences (see M-A Hunter 2006).[5] This project mirrors the concerns of dance and new media artists such as Keith Armstrong and Lisa O'Neill, creating site-work in the first decade of the twenty-first century through their engagement with site via multiple platforms in which real-time and virtual worlds merge.

This period has also seen the revival of a strong festival culture in Australia through major annual international arts festivals all of which strongly feature dance and physical theatre (Perth, Melbourne, Adelaide, Sydney, Brisbane, Darwin). There are also a growing number of niche festivals such as Ten Days on the Island in Tasmania, the bi-annual Ausdance Youth Dance Festival, Dreaming Festival, Short+Sweet dance festival.[6] Parallel to this growth, is an increase in cultural tourism, sometimes connected with world heritage listings of significant sites or towns. Cultural activity at such sites often either feature ethnically based traditional or nationalised music and dance groups, or alternatively, extravagant light and sound spectaculars that cater for the consumer demands of international tourism.

A creative re-connection led me in 2013 to consider making a new work in the Melaka heritage site in Malaysia, providing a platform to re-consider in retrospect many of the evolving processes, practices and environments

that have made up my site-dance practice to date. Long-time colleague Tony Yap, a Melbourne-based artist from Melaka, collaborated with me in 2006 together with his multi-cultural team, to create *Ether*, one of the six site works in *Accented Body*. Subsequently, in 2009 Tony founded and became the director of MAPFest – Melaka Art and Performance Festival encouraging independent Asian, Australian (and to a lesser extent European) artists to perform their predominantly solo work in an Asian context.[7] MAPFest presented an opportunity to deepen my contact with Malaysian art and culture as an artist and to further pursue my long-standing interests in site-specific and Asian performance.

The historic centre of Melaka in Malaysia is a UNESCO (United Nations Educational, Scientific and Cultural Organization) World Heritage Site that is unusual in holding the annual MAPFest (Melaka Art and Performance Festival). The festival performances take place in the ruins of the historic St Paul's church with predominantly existing works adapted for the church setting. In addition to the evening performances, for the duration of the three-day festival, visual and performance art installations called 'mappings' are dotted throughout the old town and areas leading up to the church. These 'mappings' provide spontaneous and short-term collaborations amongst the visiting artists, at times with local participation, and are informed by the spaces, found objects and ideas that arise from traversing and exploring the area.

When attending MAPFest in 2012, on many occasions I walked up the untold number of steep steps via several routes to the church ruins at the top of the hill. Fascinated by the rich history and legends of the hill and its near surrounds (Melaka in its heyday was the centre of the spice trade and considered the Venice of the East), it occurred to me that these steep pathways held enormous potential for a sunset performance; a prelude to the MAPFest evening program. The notion of an ascending procession evoked in me a sense of ritual afforded by the historic fort at the base of the hill and the sacred ruins of the church on the hilltop. The sweeping, steep hillside with a blood-soaked colonial history buried beneath its grassy slopes, is also a place of calm at dusk where, from a certain vantage point, one can discern the blue of the sea meeting the blue of the sky. During the day it is a busy tourist attraction with a market in which hawkers assemble along the steps and around the perimeter of the church ruins. Apart from the call to prayer echoing across the hillside and the sounds of the city below, darkness falls like a silent cloak on the less accessible areas. It becomes a place of meditation and memories – painful, conflicting, yet full of life with the humming of insects and the scores of stray cats emerging to claim their territory. Honouring past and present in this well-known site was what I hoped to achieve, by creating with my fellow artists a poetic journey from dusk to dark, stopping at certain places akin to stations of the cross. This was the site and inspiration for *Naik Naik (Ascent)*. The last half of this chapter maps the research, planning, rehearsal and performance stages of

this new work based on an evocation of place embracing a sense of contemplation and transformation.[8]

Case study of *Naik Naik* – preparatory research

Bukit St Paul – the hill and its surroundings – have a troubled and violent history as well as being the original site for Melaka. Legend has it that Melaka was founded by a Palembang prince, Parameswara, who was driven out of his territory by enemies and after years of wandering was one day resting under a tree near a river when one of his follower's dogs cornered a white mouse deer (*kancil*). In self-defence the tiny mouse deer kicked the dog and pushed it into the river. Impressed by his defiance and courage Parameswara founded Melaka after the name of the tree under which he had been sitting. This was around 1400 and it soon became an international port under a Melakan sultanate. It was colonised by the Portuguese in 1511 when Fort A Famosa was built at the base of the Melaka hill and St Paul's church at the summit, where St Francis Xavier was temporarily buried. The fort was almost entirely destroyed in 1641 by the subsequent Dutch colonisers who also reconsecrated St Paul's church for their use. Controlled by the British from 1824 until the Japanese occupation in 1942, it was not until 1946 that Melaka broke free from colonisation.[9] This history has made Melaka the most culturally diverse city in Malaysia with the famed Peranakan culture and cuisine, predominantly of Malay Chinese ethnicity, typifying its hybridity. Melaka is proud of its tolerance born of this hybridity. In an interview in August 2013 Melakan resident Colin Goh told me:

> I have all these bloods running through my veins… This is what makes me Melakan and Malaysian as well. We experienced that melting pot through community, through friends – that is what is important to me. We are very fond of the word tolerance, but I would go further to say that in Melaka here we have gone to acceptance.

Despite the easy-going nature of the Melakans, in terms of planning a performance work at this historic and cultural site, I was aware of the dangers of appearing to either celebrate its bloody colonial history or to romanticise a well worn and clichéd originary legend. Three months prior to the start of rehearsals I embarked on a reconnaissance visit to Malaysia to immerse myself in the environs and interview three local Melakan residents, two of whom could directly trace their ancestry back 400 years. During that visit, archival research, residents' stories and their lives past and present, informed the beginnings of my exploration to uncover traces of history and narrative hidden in the layers of meaning of the chosen sites. Cultural and personal memories of Melakan-born Tony Yap, Josephine (Jo) Chua and Colin Goh provided an evocative starting point for my background research. Colin and Jo are both retired local residents who have spent their lives in

the area and are very involved in the Melakan Heritage and History Club. Colin in particular is the local history expert and an avid collector of heritage materials. Jo is a respected and well-known Nonya (Peranakan woman). I met both of them during the MAPFest artist forum in 2012 and interviewed them in August 2013.

The power of memory

The power and clarity of their recounting of special memories were palpable; not just sights, sounds and stories, but also smells. MAPFest Director Tony Yap, interviewed in August 2013, described Melaka as a 'port of call for Melakan spirits' and emphasised the 'importance of smell – the earth and incense'. Above all it is the smell of the sea he recalls every time he returns to Melaka: 'the salt – of course you go to many seas but it is not the same – a mixture of the humidity and beach, it has a special combination. Something with the breeze… takes the worry away.' The sea became a significant motif in the work since the sea wall was originally adjacent to Fort A Famosa even though it is now several kilometres away due to the large amount of land reclamation. Such memories reinforced the work as representing a metaphorical 'ascent' from sea to sky, and the symbolic power of both. Blue, always a central design theme for *Naik Naik*, was also privileged because of its spiritual connotations in many cultures and faiths.

Figure 21.1 Tony Yap and Tim Crafti in "remembering" from *Naik Naik* by Cheryl Stock, at Bukit St Paul, Melaka.

The concept of memory itself, triggered by the interviews, became a driving force for *Naik Naik*. Tony spoke of his youth growing up in Melaka 'fishing with a net as a performative act – catching memories with the net – a meditative thing'. Jo in a personal interview August 2013, also mentioned the 'importance of oral history even if it is remembered wrongly' and mused on memory and change: 'memory stays with us for a very long time – these wonderful memories people cannot take them away from you. It is sweet to remember but… a bit bitter that it is not there any more.' Generally, the tone of the interviews with Colin and Jo was infused with a kind of longing and a sadness that Melaka, so vivid in their childhood memories, and their strong sense of connection with the past was being obliterated through greed, corruption and unchecked development, despite the heritage listing of the old town. Later, during the rehearsal period, memory became foregrounded as the principal motif of the work itself.

Collaborative partners

The creative team comprised ten Malaysian and Australian key participants with myself, an Australian director and Suen Kar Nee, a Malaysian producer.[10] Experimental but classically trained composer Ng Chor Guan from Kuala Lumpur (known for his mobile phone orchestra performances) and Australian visual artist Sharon Jewell, with a long-standing practice as a sculptor, provided not only the sound and installation elements crucial to the sites coming alive but also the precious glue linking sites, performers and audience.

Tony Yap, festival director, is both Melakan born and of Peranakan origin. His spiritual practice stems from Malaysian trance dance, a practice which he has shared over several years with close collaborator, Irish-born Brendan O'Connor, whose early training was in contemporary dance. The youngest performing member Tim Crafti is a mentee of Tony although his strong training in classical ballet is still core to his practice. Melakan-born Australian performer WeiZen Ho comes from a musical background with her current practice steeped in voice and text combined with a grounded movement base. Both Malay performers came to dance late and at the time of writing were undertaking their Masters in Dance at the University of Malaya. Azura Abal Abas (Alla) describes her beginnings as 'a very raw dancer from the street', later training in Malayan folk and court dance, then contemporary dance. Rithaudin Abdul Kadir (Din) comes from Sabah with his formative dance knowledge informed by the traditions of his home state. Din began a dance degree in his twenties but had never previously experienced site dance. Common to all the performance artists was improvisational experience, an individual movement identity, strong articulate opinions and a willingness to share ideas and practices. As in all creative teams some members operated through consensus and an open platform, others through challenging ideas and holding strong to practices that informed their artistic identity.

Naik Naik saw my return to once more working creatively with artists in Asia, and also a return to site-specific practice. I was keen to work again with open, natural sites of cultural significance and more importantly with artists whose work encompassed a fluid exchange of cultural ideas and approaches. Australia, as a largely immigrant culture, and Malaysia, with its mix of Malay, Chinese and Indian heritages (and in Melaka Portuguese and Dutch influences), embrace cultural diversity in different ways, but both countries benefit from accommodating a range of cultural perspectives. The emergent possibilities born of a porous sharing between people, places, genres and practices converged in the making of *Naik Naik*. Through this work we sought an illumination and interrogation of place with common and divergent voices juxtaposed side by side; at times separated and at other times hybridised. In this way we attempted to both accept and resist the colonialist effect and affect of site, experience and cultural background. Whilst the Malay, Chinese and European hybrid ethnicity of our cultural and performance backgrounds subtly infused how we worked and what we created, *Naik Naik* primarily explored a creative and personal engagement between the participating artists and the local community. Our working processes focused on the natural setting with minimum intervention, in order to privilege a strong connection to site and importantly, for the first time in the history of MAPFest, local and international professional artists were funded to devise and create in situ a new collaborative work.[11]

Above all, *Naik Naik* aspired to evoke the spirit of place at Bukit St Paul – the hill and its surrounds that are so central to the lives of Melakan residents, as well as a magnet for tourists attracted by the historical significance of the place. Of special interest was Jo's comment on St Paul's church, the final site for the work:

> There are many layers to that church – it plays an important role in the cultural scene in Melaka right from the days of the sultan… And when you enter that place it's like you are in a different space. It feels very clean… as well as being a very good vantage point…

The collaborative creative process

And so it was that this eclectic group gathered by the Melaka river next to my hotel on Friday 8 November 2013 for the beginning of our adventure on the hill. Prior to rehearsals I had shared a basic structure for *Naik Naik* which corresponded to the three original ascending sites referring to 'gathering' – at Fort A Famosa at the very bottom of the hill; 'remembering' – on the sweeping slope of the hill just below the church; and 'becoming' – at the top of the hill and inside the church ruins. The initial meeting was productive with predictably some more engaged than others in sharing ideas – all seemed pleased to have been given the background material that included the Scoring the Site process, reworked and updated from Marilyn

Wood's original document. However, there was opposition by a few who felt they knew the sites well already and did not need to undertake the scoring process. The rehearsal process entailed robust discussions as well as some resistance from a few artists, especially in the first week. However, we gradually moved towards a mutual acceptance of personal professional agendas and of differing expectations. I appreciated the honesty of the performers and eventually it made for a strong and mature team. An experienced member WeiZen encapsulated the creative process for her as:

> creating this opportunity for us to come together, to share, to learn and to re-learn. It gave us space and time to uncover creative and heart connections/experiments that otherwise would have been too fleeting to delve into.

What was quickly established was that we would work on site in the early mornings (7.30 am–11 am) and early evenings (5–8 pm) using the afternoons to meet for discussions, map developing pathways, source props and costumes or simply to rest. The first week began with an hour warm-up that we took turns to lead. This occurred at what we termed the 'red square' – a large terracotta tiled area at the base of the hill that became our gathering place for the performances and where the audience eventually sat to watch much of the performance. Warm-ups provided an enjoyable time to check in and engage with other performers' processes involving movement and sometimes voice. This was followed by a short discussion after which rehearsals were conducted on site by trying out and later consolidating improvisational ideas. Simultaneously Sharon, the Australian visual artist was building and installing wooden organic sculptures of rhyzomic shapes and sizes from branches and debris found on site, as well as constructing a river of sticks across the expanse of the hillside. Each performer at some point of their exploratory journey soon gravitated to one or two of these 'frames' with which they felt a particular affinity. Importantly, Sharon's constant presence on the hill, integrated her into rehearsals allowing ideas and feedback to flow between herself, the ever-changing installations, myself and the performers.

The artists' views on our collaboration and working processes were predictably varied. WeiZen, an experienced performer, who became a mentor and confidante to the less experienced artists, observed how time pressures worked against the kind of collaboration that interdisciplinary approaches encourage noting that:

> at some point you had to cut the collaboration and say we have to make this decision and that decision… the depth of the process still has not been quite revealed but given the amount of time we really did the best… there was a lot of faith that needed to come through.

She also commented on the value of the less tangible aspects of working together:

> giving over to the flow of the process... the organic nature in which the collaboration happened outside of [the] structured time, because in a way we were always working... there were snatches of moments and they are completely non-linear... a lot of that can't be documented, it can't be expressed.

Tim, the youngest performer, felt it was 'all quite intertwined' and that everyone 'was on this very connected trajectory' which he felt made for a blurring of the diverse roles despite artists' different mediums and delegated rolls. However, Alla, a mature Malaysian dance artist, commented:

> at first it was really difficult... I thought, how am I going to deal with these differences and I thought, take your time, go with it, think about it, and just go with the flow and observe the people, observe... you have to feel each other, if not it does not work.

The composer Chor Guan, appeared to relish the collaborative aspects noting:

> a team like this is very important, because every time, every day, every second... you give feedback or comments to each other, giving thoughts to each other, giving ideas to each other... this is how you think... you can always speak out to give a different feeling... so it is like collecting different feedback and to work with it... you must have a healthy argument to get to a better place [and] level.

Discovering connections

Despite the discomfort of working on site for several hours a day, the site itself seeped into our psyche in a way that revealed more to us about the spirit of place than our background research and our conscious creative choices. The hill called to us with its spirits and stories of those who had walked upon it and those buried beneath it. It became a repository of fleeting converging memories across cultures, centuries and present experiences. As a result, *Naik Naik* emerged as a somewhat abstract, poetic work of stillness and alertness, elusive shadows, moving lanterns and lingering moments. The flickering flames from the hundreds of candles along the stepped pathways from Fort A Famosa across the hillside to the church and the individual call of the live wind players placed at different points across the sites saw the audience appear from several vantage points and build like a pilgrimage to settle in the 'red square'. At this point the performers also descended with the audience and on arriving at the square

Figure 21.2 Azura Abal Abas (Alla), WeiZen Ho, Rithaudin Abdul Kadir (Din) in "gathering" from *Naik Naik* by Cheryl Stock, at Bukit St Paul, Melaka.

picked up blue hurricane lamps to traverse the base of the hillside. Here they gathered at the pillared ruins, like settlers from afar at the crossroads of the past to spread across the hill of memories which they must later leave behind as they ascend to a new becoming.

The initial 'gathering' section of *Naik Naik* not only set the scene and ambience but also encapsulated the strong sense of melding past and present which permeated the work. Melakan-born WeiZen spoke of 'calling everyone's ancestral energy' in which 'the spirit and the place come together in a summoning... an invocation'. Composer Chor Guan with his recorded sounds of the Melaka Straits recalled the site when it was connected to the sea and when the sounds of traders filled the air. Din, from the seafaring tradition of his Sabah homeland imagined:

> how people meet with different backgrounds and different languages...
> Malay is a lingua franca at that time, how did they speak Malay... and
> then the memories of course... I try to gather those memories and
> longing to see my father again and at the same time longing to see the
> environment when the traders were here; the same kind of feeling but
> in a different way.

A Kuala Lumpur-born Malay, Alla's experience of 'gathering' was 'a flashback of history from the site itself and the people surrounding you

from the past and the present'. Immersing herself in the site as a place of waiting, she adds: 'I play a dual [role] not only as a local but as a colonial – I play duality gathering memories to connect the past with the present'.

The second week of rehearsals when the individual improvisational journeys came together in architectural paths that both criss-crossed and hugged the contours of the hill, connections began to reveal themselves or were consciously sought and developed. At each rehearsal the performers deepened their sensing of each other's journey in a common goal to ascend and both hold and discard their individual and collective memories on the hill.

Chor Guan, the composer, arrived when the work had been mostly formed and this turned out to be a great advantage. Apart from the concepts he brought with him such as the sounds of the sea in the Melakan Straits, the birds gathering in the trees at dusk and market sounds in the distance, he also worked with the pace and rhythms that the dancers had evolved. He composed a haunting melody that combined Malay, Chinese and Portuguese elements in a pentatonic scale for a section where the young dancer Tim was cradled and rocked by Alla (herself a mother of two) in an intimate memory of past lives. Chor Guan explains his process as observing that everyone is contributing 'some kind of memory and everyone is expressing their memory and I am collecting their memories and make them into a collective memory – it is a memory for the site'.

Figure 21.3 Rithaudin Abdul Kadir in "remembering" from *Naik Naik* by Cheryl Stock, at Bukit St Paul, Melaka.

As the performers' journeys were established connections begin to develop not only through intersecting pathways but also in a symbolic manner. Din, WeiZen and Alla played with shifting between human and animal, embodying the spirit and essence of the *kancil* (mouse deer), which is such a potent symbol of Melaka. Moments of alertness and stillness, combined with moving stealthily along the contours of the hill brought an instinctual animal presence to the site at these points of connection, which WeiZen refers to as 'hiding an eye'; the way an animal rarely totally exposes itself; indeed like the half revelations of history itself.

The tragedies and anguish of the past buried in the site were most keenly expressed through the individual vocal textures of Malaysian born Tony, Din, and WeiZen – described by Chor Guan as 'suffering', 'narrating' and 'entoning'. These qualities were re-captured in a group invocation as the performers reached the top of the hill looking out to sea, before the church bells called them trance-like over the fence at the top of the hill to enter the church forecourt where the wind players gathered and the performers disappeared into the church, leaving the journey of 'remembering' to form new memories in a state of 'becoming'.

(Inter) and (trans) cultural considerations

The cultural sensitivities, knowledge and considerations that informed the creative team's interpretations of *Naik Naik* as described above, were not often discussed explicitly during the creative process, but were nevertheless palpable through the decision making that occurred in each individual. What was more evident was how we all became seeped in the Melakan environment. However, *Naik Naik* did not have an overtly intercultural performance agenda in the sense that it consciously strove to combine culturally specific genres and influences into the creation of the work (for a more specific definition see Fischer-Lichte, 2009), with the exception of Chor Guan's intercultural melody mentioned previously. However, there was mutual valuing and respect for cultural and spiritual aspects and performance traditions of each other's practices, as well as a merging of local and global aspects, which infused the work and were absorbed into it.

Our approach perhaps mirrors more closely what Fischer-Lichte (ibid.: 396) calls 'the shift to transculturalism'. At a meta-level Slimbach (2005: 226) defines transculturalism as the 'growing interrelatedness of life across borders' which is 'rooted in the quest to define shared interests and common values', encompassing a cultural awareness 'that facilitate[s] open and ethical interaction with people across cultures' (ibid.: 206). In the specific context of the arts Fischer-Lichte describes an 'interweaving of cultures in performance', generating 'new forms of [ever-evolving] diversity' and operating in a global environment 'within a framework of transcultural entanglements' that embrace both political and aesthetic dimensions (ibid.: 400). Whilst space prevents this notion being further discussed here the

major premise relating to this project lies in creating 'a "third-space", a state of in-between, by which different identities are possible side by side' (op cit. 398). Indeed, a correlation could be made between the state of in-betweenness that such interweaving cultural performances espouse and the liminal nature of memory at the heart of *Naik Naik*, where past and present were performatively interwoven.

From the artists' point of view the nature and extent of inter/transcultural elements varied. Young Australian dancer Tim expressly felt that 'ethnic culture was secondary... to dance process culture'. Alla commented on what she perceived as the lack of cultural connection, 'frustrated because I think some of the performers don't really allow that to happen... they just block themselves and do not really want to cooperate about the intercultural'. However, in terms of the intercultural nature provided by the site she commented: 'this is a new kind of site-specific work but you are bringing different kinds of ethnicity and identity that match together and try to blend within the site itself.' What soon became clear was that the Malaysian artists strongly connected with the site at an intracultural level, bringing with them their knowledge of differing cultural traditions within Malaysia: the Chinese influence incorporating Buddhist and Taoist philosophies; the predominantly Islamic Malay influence, and animist beliefs from Sabah. Melakan Australian WeiZen connected both transculturally and intraculturally through 'the fact that we have an understanding of our ancestral migrational paths [that] inform us as people and certainly myself who has then chosen to be a migrant somewhere else'.

Challenges and rewards – people and site

Certainly we all inhabited and shared the contemporary cultural milieu of Bukit St Paul which entailed practical hardships, as well as the symbols reflecting more deep-rooted hardships. The logistics of rehearsing on a steep slope in the mosquito-ridden heat with many obstacles on site was challenging. Our working hours also meant adjusting customary eating habits and body-rhythms that, at times affected energy levels. The short time to make such a complex work proved tiring and meant we worked every day for the 18-day period. By the second week the spirit of the site itself seemed to take over our working rhythms and quite magical moments began to emerge. As Din (in an email dated 26 November) wrote to all of us at the end of the season:

> No words could express how appreciative and grateful I am to be in *Naik-naik*. The mosibites, the hot sun, the sickness, the music, the lighting and of course the site; seems to blend with us in the end. For me, it was a magical performance for each day and I'm so happy to share it with all of you.

Figure 21.4 "gathering" from *Naik Naik* by Cheryl Stock, at Bukit St Paul, Melaka.

Despite differing artistic processes and varying skill sets, what was rewarding was the support the artists provided each other and their willingness to commit to the project in its entirety. In the final week we were joined by the composer and six musicians from Pay Fong Middle School Wind Band. In addition, we enlisted the help of around 12 members of the community and some backpacker tourists as volunteer audience guides. We also received generous discounts for items purchased for the performance and enjoyed unstinting hospitality and assistance from local businesses and individuals, including the hawkers on the hill outside the church and the gardeners who maintained the area. Thus the challenges faced were more than compensated through the forging of close interpersonal relationships described above.

Shared experience of site – meanings revealed

Much of the meaning evoked in *Naik Naik* was revealed by the site itself and was different for each performer and each audience member. As I watched the performances over the three nights I was aware of how every artist in the project brought a unique and special gift in evoking the spirit of place on the Melaka hill as I witnessed their journey of creating and discovering the memories connecting their own experiences with the site. Importantly the artists also provided a place for the audience to make their own meanings and connections to the work and to the site.

All of the performers had a strong awareness of their relationship to the audience and the multiple perspectives of both. Alla saw herself as a storyteller whose role it was to 'connect and engage with the audience', while Tim felt that the usual separation of audiences and performers was 'broken down' through walking down to the 'gathering' site together. Chor Guan who was operating his music from a corner of the 'red square' reported he was amazed when he saw people coming from everywhere and not just from the Fort. That part of the hill is rarely populated, indeed it is avoided, and to see it come to life with performers and audience was quite extraordinary. The mesmeric nature of the site was enhanced by the sounds of the horns calling to the audience from different parts of the site as was the timing of the performance – the transitional time of dusk to dark which Chor Guan calls a 'magic moment, a golden hour' and the overlapping of the cycle of life with the sound of birds changing to insects. The site spoke to audience as well as performers of hardships. As Din pointed out, 'it is not an easy site… and we (the audience and performers) can feel that… the hardship of the site itself. And going down the stairs is like a door to another world, to another memory maybe for them, to another history'.

Whilst it was not possible to gather recorded audience feedback of the performances, informal comments used adjectives to describe the effect and affect of the performances as 'magical', 'moving' and 'poetic'. Some commented that they could feel the spirit of the hill come alive through the images created and that the promenade performance journey helped them connect with past sorrows and joys, tribulations and celebrations associated with the sites. Musician Chor Guan observed:

> This kind of artistic work it can be very inspiring to people – the visitors or the locals or even to the site because I always believe that the site itself has its own spirit or the spirit that has been and yet has been de-activated… so when this kind of performance is happening at this kind of site it is not only to activate the site itself, to give new energy to the space but also it gives the people a better understanding.

In the end as we had hoped, *Naik Naik* provided a shared experience of site through its liminal revelation of hidden meanings. In some undefinable way the site was transformed through effective and affective ways of engaging with its realities and possibilities – in a triangulation of creators, performers and audiences. In deference to the site that loaned us its creative platform, the ephemerality of *Naik Naik* allowed the site to return to itself.

Notes

1 *Naik Naik* performer, 14 November 2013, on site in Melaka during a television interview by a Kazakhstan National Television reporter. The group were travelling in the country to make a documentary about Malaysian tourism.

2 Taken from Marilyn Wood's personal archives. Extracts of relevant documents were mailed to me in July 2013.

3 All the artists were of varied backgrounds: Julia Cotton a former member of The Australian Ballet, Michael Pearce a theatre designer and visual artist with a general movement background, Tony Strachan an all round entertainer who could sing, dance, write and act, whilst my career had been predominantly in contemporary dance. We had all worked together previously in different guises and were used to interdisciplinary approaches and collaborations.

4 With the advent of accessible interactive technologies many Australian artists moved towards a more formal yet immersive performance style using screen and sensor based digital and interactive technologies, usually in indoor venues (such as Kim Vincs and the Deakin Motion Capture Lab, Gideon Obarzanek and Chunky Move, Garry Stewart and Australian Dance Theatre, Chrissie Parrott, Jon Burtt, Hellen Sky).

5 For more detail on Accented Body see Stock 2007, 2008a, 2008b, 2011 at http://eprints.qut.edu.au/view/person/Stock,_Cheryl.html

6 (see http://australia.gov.au/about-australia/australian-story/festivals-in-australia).

7 Each year Tony invited me to the festival but it was not until 2012 that I visited as the facilitator for the MAPfest Artist's Forum. I had occasion to visit Malaysia several times since 2003 in my academic and World Dance Alliance roles and had formed a circle of contacts and friends.

8 Besides a creative project *Naik Naik* is also a practice-led research project in which participant observation and artist and stakeholder interviews provide a context for the work itself which was the principal research vehicle and outcome. QUT Ethical Clearance ID: 1300000501

9 For a short history of the area see http://en.wikipedia.org/wiki/Malacca

10 The preliminary visit to Melaka also provided a chance to meet with the Malaysian based artists, three of whom were in Kuala Lumpur, to share my preliminary thoughts and research. I also visited Melbourne where three of the artists were based. As I had only worked with one and met two of the eight artists previously I spent several months seeking out a team of artists. I also set myself the challenge of working with artists of differing artistic practices and cultural backgrounds. Some came through suggestions of Malaysian colleagues and others through Tony Yap and my own networks.

11 Although a funding application to the Australia Malaysia Institute for this project was successful, the reduction in the amount requested meant that the time spent developing and performing the work was cut from four weeks to eighteen days.

References

Atkinson, K. (1976) 'Confident dance into the future', *The News*, Thursday, September 23, p. 54.

Butler, C. (1976) '"Happenings" to enliven our Festival', *The Advertiser*, 26 February 1976, n.p.

Fischer-Lichte, E. (2009) 'Interweaving Cultures in Performance: Different States of Being In-Between', *New Theatre Quarterly*, 25(4), 391–401.

Hunter, M.A. (2006) 'The Body Transported and Transformed', *Realtime and On Screen*, October/November 2006, 75. Available at: www.realtimearts.net/article/issue75/8205 (accessed 25 March 2013).

Knez, T. (1976) 'Full moon frolic will be fun', *The News*, Thursday July 1 1976, p.38.

McAuley, G. (2012) 'Site-specific Performance: Place, Memory and the Creative Agency of the Spectator', *Arts: The Journal of the Sydney University Arts Association*, pp. 2–51. Available http://openjournals.library.usyd.edu.au/index.php/ART/article/viewFile/5667/6340 (accessed 3 January 2014).

Poyner, H. and Simmonds, J. (eds.) (1997) *Dancers and Communities*, Sydney: Ausdance NSW, pp. 121–129.

Slimbach, R. (2005) 'The Transcultural Journey', *Frontiers: The Interdisciplinary Journal of Study Abroad*, 11, pp. 205–230.

Stock, C.F. (2011) 'Creating new narratives through shared time and space: the performer/audience connection in multi-site dance events', in Caldwell, L. (ed.) *In Time Together: Viewing and Reviewing Contemporary Dance Practice: Refereed Proceedings of the World Dance Alliance Global Summit 2010*, World Dance Alliance-Americas under the auspices of the Texas Woman's University Website, New York University, New York. www.twu.edu/dance/world-dance-alliance-proceedings.asp (accessed 23 March 2013).

—— (2005) '*here/there/then/now*: site, collaboration, interdisciplinary performance', in *Dance Rebooted – Initializing the Grid*, Australian National Dance Research Conference, 1–4 July, 2005, Melbourne: Deakin University. Available http://ausdance.org.au/publications/details/dance-rebooted-conference-papers (accessed 24 March 2013).

Personal Interviews (conducted by the author)

Abas, Azura Abul (Alla), Melaka, Saturday 23 November 2013
Abdul Kadir, Rithaudin (Din), Sunday 24 November 2013
Chua, Josephine (Jo), Melaka, Wednesday 28 August 2013
Crafti, Tim, Melaka, Monday 25 November 2013
Goh, Colin, Melaka, Wednesday 28 August 2013
Ho, WeiZen, Melaka, Sunday 24 November 2013
Ngor, Chor Guan, Melaka, Sunday 24 November 2013
Yap, Tony, Wednesday 28 August 2013

22 Dancing in place
Site-specific work

Josie Metal-Corbin

I believe in the accessibility of dance for everyone, everywhere. For decades, I danced in venues ranging from informal spaces such as a school gymnasium in rural Valley, Nebraska, where pivotal irrigation systems are manufactured, to quaint performance spaces such as a Paris attic atelier in the eighteenth arrondissement, where mint tea is popular and outdoor markets abound. Throughout those experiences, I have been guided by the writings of Barry Commoner, a renowned physicist and ecologist, who, in his 1971 work *The closing circle: Nature, man and technology*, proposed a theory of four "Laws of Ecology," in which he discussed the increasing rise of industry and technology and their persistent negative effect on all forms of life. Commoner proposed that the following laws of ecology can inform and sensitize us regarding our connection to the natural world: (1) Everything is Connected to Everything Else; (2) Everything Must Go Somewhere; (3) There Is No Such Thing as a Free Lunch; and (4) Nature Knows Best. I have interpreted them as guidelines for daily living and for my creative pursuits as they provide a deeper understanding of where my niche is as a member of an ecosystem.

The two laws that have made a strong impact on my approach to creating new works are "Everything is Connected to Everything Else" and "There Are No Free Lunches."

I have observed the first law by spending countless hours connecting modern dance to all dimensions of my personal and professional life. Everything in my dance world *is* connected to everything else. Dance is my lifeline: my joy, my work, my passion, and my way of communicating. It is often my way of expressing, as Ruth St. Denis observed, "what is too deep, too fine for words" (Brown et al. 1998: 22). Dance is the common thread woven into all of my scholarly activity and my teaching at the University of Nebraska at Omaha (UNO), where I have explored and investigated the wide horizons of a life in the arts and in academia.

My choreography reflects a collaborative approach that often uses site-specific elements as the catalyst for the movement design. This creative virtual space, as described by the National Dance Association scholar and artist, Theresa Purcell Cone (2007), is a nurturing site where multiple

voices are encouraged and valued. At the core of my own creative process is the compelling desire to make connections with other art forms, social issues, non-dancers, emerging artists, a variety of disciplines, and with the community.

In my drive to establish new alliances, build audiences, and make dance accessible to all I have experienced an impulsive and compulsive drive to find places and spaces for dance to happen, whether it is for advanced-technique dancers, beginners or for persons with disabilities. This is my *modus operandi*, my *raison d'être*, my meaning of life. Everything is connected to every other thing – for me the link is through modern dance. Commoner's (1971) third law, 'There Are No Free Lunches' in essence, is my guiding philosophy for creating work, one of *quid pro quo*. Let me find something in your endeavor that matches, intersects, or connects with my endeavor, and we will both benefit. Once, in Quebec City, I was engaged in a conversation with a hat maker at a millinery store and we arranged a trade. She asked me to create a dance within the store for a discount on a hat that I admired. She locked the front door and for a few minutes I improvised dancing through the aisles and around the displays. She got her dance and I walked out with the hat.

My forays into site-specific work began with dances that I created for neighborhood playmates in Pittsburgh, Pennsylvania, on my terraced backyard. While other kids on the street were selling lemonade, I gave dance lessons and produced shows. Throughout the years, the sites for my dances became more sophisticated and expanded to the concert stage, the kitchen, the hospital room, the entranceway, the stairway, the pathway, the atrium, the amphitheater, the gazebo, the stadium, the escalator, the sidewalk, the polka hall, the clothesline, the rooftop, the neighborhood park, the museum, the garden, and the zoo.

I resonate with Isadora Duncan's essay *I See America Dancing* (Cheney, 1969) in response to Walt Whitman's *I Hear America Singing* (1890). Whitman celebrated the efforts of highly individualistic American laborers envisioning them as a chorus for the nation and Duncan, upon reading his poem, had a vision of America with individuals dancing in broad strides, leaps and bounds and with lifted heads and out-reached arms. As my daily landscape unfolds, I see a mapping of pedestrians, workers, professionals, families, moving in measures, on beats, intersecting and unknowingly creating a choreography in their unique places and spaces. Through many collaborative projects, I have developed a network of support for dance on UNO's campus and in the community that includes, faculty, students, coaches, costumers, musicians, poets, historians, curators, biologists, custodians, elders, videographers, librarians, sculptors, teachers and pedestrians.

The Moving Company

Since 1980 I have taught dance and directed UNO's modern dance company, The Moving Company. Founded in 1935, it is one of the oldest, university-based, modern dance companies in continued existence in the world. I am immersed in an invigorating history of 78 years of dance at UNO, rehearsing in a large studio, the Dance Lab. There is no major or minor in dance, but there is a dance company under the auspices of the College of Education/School of Health, Physical Education and Recreation.

In the 1980s, I started to broaden the audience base for the concerts and showcases so that the company and the audiences would grow to reflect the diversity within the north, south, east, and west populations of Omaha. Over the next two decades, dancers from various genres were invited to dance in performances at the Dance Lab.

As a result of reaching out to the broader Omaha dance community, a *Dance of the People* series was established in 2002. Included in the series were the Omaha International Folk Dancers, African Dance and Drumming, Tribal Style Belly Dancing, Dancing Classrooms (ballroom), and "Reach for It: A Program of Dance for Persons with Parkinson's Disease." In addition, the Omaha Modern Dance Collective, the Dance Department at the Jewish Community Center, and Nebraska Story Arts performed works in the productions. Often, dancers amongst the companies were shared. These new affiliations not only expanded our audiences but also opened up opportunities for more performance venues and emphatically demonstrated that The Moving Company was meeting the mission of the University's community engagement goal within UNO's Strategic Plan. The company became very visible on campus and within greater Omaha. An example of this outreach happened in 1999 when sculptor, John Labja asked me to help him with a commission that would immortalize some of the dancers. He was to create a statue that symbolized the ecstasy and joy of winning in the College World Series, hosted by Omaha since 1950. Labja and a photographer came to the Dance Lab and worked with students from the Dance in the Secondary Schools course. The students performed combinations of running, jumping, and lifting. Labja used these photos for maquettes and, ultimately, some students sat for lost wax casts. The outcome was a 10-foot bronze statue, Road to Omaha, mounted outside of the TD Ameritrade Park. In addition, this sculpture in miniature is the design for the trophies for the next 100 years.

At a time when there is an increasing sense of disconnectedness in civic participation and engagement in community and neighborhood activities, and when Americans experience the phenomena of separateness and isolation, the Dance Lab served as a place, a space, and a site specifically made to showcase a diverse group of artists, dancers, and students. Robert Putnam (2000) addressed this collective decline of association and participation as a loss of social capital in his book, *Bowling Alone.* Dance

educators, artists, and scholars have a prime opportunity to build and enhance social capital in their communities by integrating discourse into dance performance. Using the viewing of dance works as a catalyst for conversation, The Moving Company presented salons in 2003 and 2004 that forged connections between performers and audiences to advance discussions on substantive societal issues such as the environment, prejudice, tolerance, courage, and respect. The Dance Lab was transformed into a salon space that included couches, loveseats, low tables, candlelight, and a string quartet for an evening of dance, discussion, and dessert. These salons were collaborative endeavors cosponsored by the Office of Diversity, the American Multicultural Student Agency, the Omaha Public Library, and the College of Education's Diversity Committee.

An important outcome of networking is to establish a reputation for dance as an effective conduit for communication on and off campus. Dance educator Elizabeth McPherson (2010) has written about building bridges and using dance as a way to connect people in an urban setting. The Moving Company has built bridges to the major art and educational constituencies and, in turn, those institutions have welcomed and introduced the dancers to a broad range of metropolitan culture.

My first on-site work in Omaha was in 1980 at the Paxton Manor Ballroom, where my students and I met for a weekly dance class with older adults (Corbin and Metal-Corbin, 1997). This experience led to a decade of creating dances for or with elders at such venues as lawns, fountains, hallways, and skywalks. It was in this early work of intergenerational dance that I discovered that the element of unpredictability was a constant companion in planning and executing site-specific work.

Museums

Facing and addressing challenges of the unforeseen continued in my work for museums and galleries. My interest for setting pieces in museums began in the third grade in classes at the Carnegie Museum of Art. For seven years I was in an environment surrounded by sculpture, paintings, dioramas, murals, marble columns and brass drinking fountains. This immersion into the arts was my visual awakening and continues to guide me to look at things from different perspectives.

In 1981, I met Carol Mezzacappa, a dancer and choreographer, at The Early Years Festival in Purchase, New York. I saw her dancers perform Weidman's *Brahm's Waltzes* amid the marble columns at the Brooklyn Museum. This was a revelation to me – dancing in a site-specific space and not on a proscenium stage. As I delved into the site-specific dance realm, I discovered that getting permission to dance in a museum is a cautionary, diplomatic adventure. The logistics of acquiring access to photos or slides of the artwork for designing the piece and for rehearsals is often difficult due to liability, copyright, and insurance issues. There is a protocol that

takes time and involves communicating and convincing curators, administrators, and boards.

My first venture dancing in a museum occurred in 1992, when Omaha-based artist/sculptor Catherine Ferguson created an installation entitled *The Peak that Flew from Afar* for the Joslyn Art Museum, Nebraska's largest art

Figure 22.1 Opening dance for a collaboration with artist Jamie Burmeister at Sheldon Art Museum, Nebraska.
Photo by David E. Corbin

museum. I choreographed a circular-design work that integrated a storyteller, percussionist, and two dancers who wove over, under, around, and through the dome-shaped installation of shale, electric flame lights, and wood. The audience was pressed up against the perimeter of the gallery walls in this intimate site. As a result of limited seating space any sweeping upper body movements had to be curtailed because of the audience's proximity. In contrast to working in a limited space, I was provided with an opportunity to create a work in several expansive settings at the Sheldon Art Museum in Lincoln, Nebraska in 2007 as part of a collaboration with visual artist, Jamie Burmeister's kinetic and sculpture installation, *Arrhytmy*. The element of risk and unexpected moments with the audience was woven into the piece as dancers improvised on marble steps and sidewalks and danced through the museum to the second floor. The dancers had to continually adjust their improvisations in response to the flow of patrons moving in and out of the galleries, be peripherally aware of the installation of plastic bottles, tubes, gears, and chairs and spontaneously react to the ever-changing rhythms and sounds produced from the art. These unanticipated moments resulted in a dynamic dialogue of sight, sound, and movement.

In February 2010, the Joslyn Art Museum commissioned me to create a piece for an exhibition titled, *The Human Touch: Selections from the RBC Wealth Management Art Collection*. The art was devoted to the human figure. Alas, there was one caveat from the insuring agent of the collection: the choreography was to be in a *tableau vivant* style, minimizing the amount of movement. The collection ranged from the serious to whimsical and from the realistic to abstract. It included photography, paintings, and sculptures from a diverse group of artists. During the performance, the audience moved amongst the dancers and art collection and inquired, "Are we expected to stand and watch the dance unfold? Are we to interact, move on, or return? Who are the dancers and who are the audience members?" Again, the element of unpredictability prevailed. The curator commented that the presence of the dancers in the space changed the way the audience viewed the art, unexpectedly returning to galleries to confirm what they had seen.

In 2005, I was asked to work with *Latin Jazz: La Combinación Perfecta*, a Smithsonian Institute exhibition at The Durham Museum, a magnificent art deco train station that now serves as an impressive historical museum in Omaha. Specifically, I was appointed as a Scholar in Residence, teaching Latin dance to students after they viewed the exhibition.

Part of my teaching and creative philosophy is based on the slogan, "Nothing about us, without us," a slogan that originally became prominent in the Disabilities Rights Movement meaning that no policy should be decided upon for a group without the full and direct participation of those affected by the policy (Charlton, 1998: 3). This involves groups that are political, social, artistic, or marginalized due to nationality, ethnicity, ability level, or other reasons. It was clear to me that if this exhibition was to honor the heritage of Latin Jazz artists and musicians, then I had to be assertive,

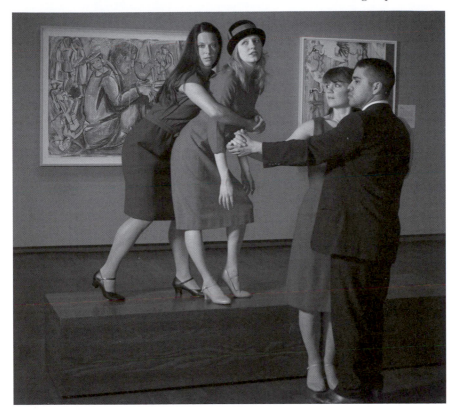

Figure 22.2 Interpreting selections from the The Human Touch art exhibition at Joslyn Art Museum, Nebraska.
Photo by Jim Williams

make my philosophy known, get approval from the museum board and then find a way to include some of the large Latino/a population of Omaha in the endeavor.

I decided to take a risk and request that the scope of the residency be expanded to not only include the teaching component but also a performing opportunity for The Moving Company and the UNO Jazz Ensemble at the opening-night gala event in the Great Hall. The space was defined by marble floors, bronze statues, stain-glassed windows and mosaic ceiling tiles presenting a perfect site for live music and dancing celebrating the influence of Latin Jazz on the American culture.

Underlying the foundation of this endeavor was a concerted effort to be inclusive. I attempted to orchestrate the diversity element of this project by recruiting Latino/a fraternity and sorority members, sending emails to organizations within the Omaha Latino/a community and offering free Latin dance classes in the Dance Lab to the community-at-large in eastern Nebraska and western Iowa. All of these efforts resulted in developing new

audiences for dance and a contract in 2010 and 2012 to tour for the museum's Hispanic Heritage Celebration. Under the auspices of *¡Baila! Dancing with the Durham,* a quartet of Latino/a dancers, a percussionist and I presented workshops to over 5,800 students in six different school districts in Nebraska and Iowa dancing in large gymnasium spaces, on stages, in cafeterias and in courtyards. The one item that was invaluable for all of these site visits was a wireless microphone with adequate amplification to be heard over the pulsing music and the enthusiastic voices of middle school and high school adolescents.

Galleries

The most complex gallery setting for which I have choreographed was in a pagoda-shaped home converted into the UNO Art Gallery. I was asked to collaborate on an exhibition by artist Elizabeth Layton. Her work immediately engaged me. Layton's self-portrait, contour drawings explored social issues such as intolerance, depression, sexuality and compassion from a humanist and feminist perspective. The resulting suite of dances, *Out of the Shadow, Into the Light: A Choreographic Work for Older Women Based on the Drawings of Elizabeth Layton* (1986), was a 30-minute piece and was accompanied by an original violin score by Deborah Greenblatt. The dance happened in the living room, a closet, a bedroom and doorway thresholds. Throughout the spaces, the walls were lined with Layton's artwork. Some of the site-specific considerations included very limited space in all rooms and inconsistent acoustics. An unforeseen disadvantage for the impact of the choreography was a split focus amongst the art, the dancers, the furniture, the movement of the audience, the music and some frustration with sight lines.

Another endeavor that began with rehearsals in UNO's Gallery in 2001 and ultimately traveled to Cesena, Italy for the Dance Grand Prix Festival was a collaboration with New York-based Young Dancers in Repertory under the direction of Carol Mezzacappa and Craig Gabrian. There were 36 dancers ranging in age from 14 to 64 years performing Isadora Duncan's Suite of Schubert Waltzes, set by Mezzacappa. This event entailed three very site-specific challenges that were unforeseen in the planning. In an extravagant fundraiser, held at the Joslyn Art Museum, dancers moved amidst marble columns of the Fountain Court at floor level and high in the surrounding balcony, cautiously dancing around statuary and *objects d'art* under the scrutiny of the museum guards. Upon arrival at the Bonci Theatre in Italy, the dancers were challenged with a raked stage, a demanding surface, especially for chaîné turns and leaps moving upstage. We also had to use our ingenuity to arrange a time and place for rehearsing as the performance space schedule was particularly chaotic. We ended up warming-up on stairwells, landings and hallways and rehearsing the suite of dances on the rooftop of our hotel in the hot, Italian sun. The need to

rehearse took precedent over our bodily needs and we did not think about bringing water, sunscreen, or sunglasses.

This element of unpredictable challenges also occurred more recently in 2012 at the RNG Gallery, a space with a mix of local, national, and international artists housed along with a restaurant in The Hughes-Irons Building in the historic 100 Block of Broadway in downtown Council Bluffs, Iowa. I was commissioned to make a work for the opening night of artist Susan Knight's *Glimpses*, a collection of new work displaying intricately hand-cut layered paper, parchment, and light in Plexiglas, all based on two archetypal shapes found in nature, especially in water. Unexpectedly, an 18-piece work fabricated of Mylar that was sprawled across an expanse of gallery wall and that was only attached at the top became animated as the air currents stirred by the force of the dancer's movements set the bottoms of them in motion. This serendipitous transformation of setting the art piece into motion delighted the artist, curator and audience. Originally, the exhibit was scheduled to open in October of 2011 but due to a delay in the renovation of the building, the premiere didn't happen until June of 2012. This delay presented many challenges including attaining a new rehearsal and performance commitment from the dancer and from the cellist who was accompanying the piece. In addition, the original location for each of Knight's artworks was altered, requiring a new choreographic floor plan. At the first rehearsal in the gallery, a 9 × 5 foot, stuffed squirrel, the mascot of Council Bluffs, randomly was situated in a corner of the

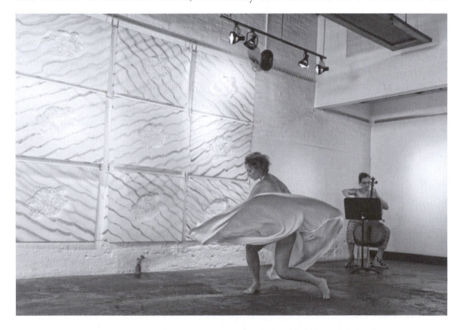

Figure 22.3 Dancing at Susan Knight's art exhibition at RNG Gallery, Iowa.
Photo by Sandy Aquila

gallery that I intended to use as a part of the dance space. I re-designed the dance only to discover the squirrel gone at the next rehearsal. In the middle of the final rehearsal of the dance, working on a very tight time schedule for the videographer, the waling sounds of presidential candidate Mitt Romney's motorcade was intermingled with the poignant sounds of the cellist playing *Serenade* from Stravinsky's *Suite Italienne*. Interruption, whether it is noise, extraneous activity or weather, is a common consequence of making site-specific work. The unpredictable goes hand in hand with meticulously laid plans.

Schools, libraries and zoos

Sprague (2009) acknowledged "the power of dance educators to identify and build partnerships with the larger learning community" (p. 128). She advocated "bringing the 'outside in' and moving dance 'out' into the school and community" (p. 126) in an effort to combat the potential isolation of dance educators. Art agencies and organizations such as the National Dance Education Organization (NDEO) have been tenacious in petitioning the US Department of Education to include the arts in twenty-first-century education reform where the current emphasis is on STEM (Science, Technology, Engineering, and Mathematics). The skills involved in site-specific dance practice and process parallel the proficiencies that have been identified as essential for success in school, work and life by the Partnership for 21st Century Skills (2013) including: Creativity and Innovation, Critical Thinking and Problem Solving, Communication and Collaboration. Integrating dance, specifically site-specific endeavors, into the STEM curricula can create new structures for project-based and student-centered learning. With the inclusion of the arts, STEM transforms into STEAM, developing a more well-rounded student for the future.

For over 20 years, Prairie Visions Institute has been Nebraska and Iowa's leader in comprehensive arts education and interdisciplinary learning. This annual, week-long summer symposium is attended by art educators, classroom teachers, administrators, and program specialists from schools, museums and arts organizations. Participants engage in interactive learning in the visual arts, music, dance/movement, drama and storytelling, using multicultural perspectives, interdisciplinary connections, and thematic curriculum development. Part of the symposium includes traveling to site-specific locations that are historic, political and artistic venues in Nebraska and Iowa. My role within this work is to present methodologies for including dance, introduce dance vocabulary and then have the participants create short dance studies at the various venues. In 2013, the theme was STEAM; integrating Science, Technology, Engineering, Arts and Math into Nature and the sites explored by the group were the Fontenelle Forest Nature Center and the Joslyn Art Museum.

Participants were guided through designing their own short dance studies on the museum's stage and then in the galleries. These brief dance experiences emphasized how physics' principles of energy, flow, weight, time and space are also a part of basic dance elements. The compositions, in addition, were designed to illustrate the parallels present in art, science and dance; specifically, line, shape, direction, size, texture, pattern, balance, symmetry, repetition, contrast, and unity. In the galleries, participants working in small groups observed assigned works of art, then generated and recorded a list of STEAM words. Using a Cinquain Poem Form of five lines, the participants selected an opening noun, two adjectives, three verbs, a four-word sentence or phrase and a closing noun and then ordered them into a poem. The next step involved creating gestures and movements that expressed their poem. At the conclusion of the Prairie Visions Institute, all ten groups traveled throughout the museum galleries to perform in front of their assigned artwork and discuss the overlap of concepts in science, art, and nature.

In 2007, I collaborated with the Omaha Public Library's (OPL), *Omaha Reads: O! What a Book* initiative. Each year, OPL encourages the community to unite in reading one or two books as part of the Omaha Reads Literacy Campaign that provides the city with a common theme to discuss via book talks, author visits and related programs and events. With a focus on E.B. White's *Charlotte's Web* and Timothy Schaffert's *The Singing and Dancing Daughters of God*, I created the kick-off event which was a 30-minute work focusing on themes from both the children's and the adults' book. The dance involved musicians, singers, an intergenerational cast of dancers, and a pick-up truck. It was performed on the street, on the steps and on adjacent sidewalks of the W. Dale Clark Library, Omaha's main downtown library.

I visited the site at various times of day to observe the lighting, sounds and pedestrian traffic. The rehearsals were scrutinized, monitored, and commented on by the homeless persons who regularly gathered on that street to be transported to their meal site. Had I initially possessed the insight to know that libraries in the US, in this case Omaha, are often a day-time sanctuary for underserved citizens, I may have found a way to include them in the opening event.

Rehearsals occurred in the heat of the day, when the iron railings that we were hanging from were too hot to handle, or in the cool of the evening, when library patron traffic was low but the mosquito infestation was high. Permission was gained from the mayor's office to close the street in front of the library on the day of the performance and arrangements were made for amplifying the guitarist, singer and cellist. The piece began with dancers arriving in the old pick-up truck, emerging through the revolving doors of the library lobby, and exiting from the gathered crowd to take their places on the street. The executive director and the staff of the Omaha Public Library discovered that dance could play a powerful role in communicating

their goals and since have included The Moving Company in initiatives that reached out to engage the community.

The Moving Company has performed at zoos, in sculpture gardens and botanical gardens where the dancers are often upstaged by meticulous landscaping, beautiful flowers, exquisite butterflies and buzzing bees. The dance surfaces have ranged from water, to grass, to brick and concrete. *Au Jardin Zoologique* (1983) was a 22-minute work for 30 dancers, seven musicians, and five readers. It was a suite of dances, created on location at the world-class Henry Doorly Zoo, using five habitats with music composed by W. Kenton Bales and based on the novel by Nevil Shute, *A Town Like Alice*. The dancers received training from zoo caretakers on how to walk amongst the flamingos, dance in front of elephants, balance on the edge of the seal pool, step around the flora and fauna of the waterfalls, and move amidst the goats in the petting zoo. Rehearsal and videotaping limitations were from 6 am to 8 am on many cold, October mornings before zoo patrons arrived. The roaring of the lions, tigers, and bears was ever-present, as were the screeching and rhythmic calls of the birds.

Kitchens, clubhouses and serendipity

My husband and I are always dancing in the kitchen. I was curious to investigate whether or not others did this. I was further prompted into this inquiry when a custodian, hearing music emerging from the Dance Lab, stopped me in a hallway to tell me about the spontaneous dancing that he and his wife did in their kitchen. Thus began my pursuit of documenting kitchen dancing in 2000. I involved a filmmaker to go on the road with me to conduct *A Digital Investigation into Dance: Kitchen Dancing and Other Recipes*. We went on location and filmed individuals, couples, and families. The scope of the project included videotaping a woman dancing in front of the produce section with her son at a grocery store, capturing a 10-year-old dancing with a broom as he completed his chore of sweeping the kitchen and witnessing an elder couple reveling in Cuban music in their kitchen. I worked with a communications major's capstone project, and the resulting video was ultimately presented as part of a concert sponsored by the Nebraska Humanities Council.

Sometimes my life is prescient when it comes to making dances. On my way to work one day in 1996, I began humming and somewhat dancing to the Yugoslavian folk song, *Orijent*. Shortly after, a band of refugee musicians and singers from Sarajevo performed that very tune in the Dance Lab as an extra credit project for a UNO student taking the Folk Dance class. They were displaced professionals (an attorney, economist, pro soccer player, marketing manager, and a high school student) who were also vocalists and musicians. Their music inspired me to write two grants and enlist 11 modern dancers and two folk dancers for a work that integrated modern dance with traditional folk forms from Bosnia, Israel, Greece, the Balkan Mountains,

and Hungary. The design for the dance, *Day of Forgiveness*, evolved from a contextual basis surrounding a traditional holiday in May called Djurdjevdan, a day of renewal and forgiveness. The logistics of scheduling and transporting the Bosnians to the university became very complicated so all of the planning and musical rehearsals took place in a clubhouse within a complex where the Bosnians lived. There was a language barrier so the communication was very non-verbal and kinetic. One musician notated all of the score in Bosnian on brown, paper sacks from a local grocery store for their rehearsals and I walked away each time with a cassette recording of what we had accomplished. Although the performance ultimately was on a proscenium stage, the sessions at the clubhouse that were filled with passion and enthusiasm for the music were an influential factor on the design of the choreography.

Parks and prairies

In 2011, *The Perils of Pollen*, was performed on an outdoor stage at Stinson Park in a dance challenge produced by the Omaha Modern Dance Collective. Although I surveyed the grounds at various times of the day and researched the event schedule of this public park with a concrete stage, I invariably encountered everything from spilled chocolate milk and swarming bees, to a full-blown technical soundstage set-up from another event. The humidity was so high at every rehearsal that this dance, when viewed on the video, looks like it was filmed in an impressionistic style because of the constant presence of moisture on the lens. Ultimately, all of the dancers in *45° Celsius: A Movement Festival* enriched and contributed to the fledging history of a new green space in town. This work reflected the assertion by choreographer and writer Arianne MacBean (2004: 97–99) that the opportunity to "bring the community closer to dance and the dance closer to the community" is inherent to site-specific dance.

Recently, I have found myself mesmerized with the Nebraska prairie as a site for dance. In April, 2011, I premiered a work about wind and drought as part of a Green Omaha Panel presentation at the KANEKO art venue in Omaha. A renowned environmentalist and naturalist, Barbi Hayes, was in the audience and envisioned the dance for another site in September 2010, the dedication of some land for the Glacier Creek Prairie Preserve Project. The choreography designed for a quartet was in response to a poem, *Ecology* by Natasha Kessler, with accompaniment by flautist, Beth McAcy. During the reworking of the piece, we rehearsed on tall, fallen, winter grass previously laden down with snow, forming a very sprung dance floor. With sunscreen and insect repellant, we ventured onto the bouncy and uneven terrain of the prairie grass. Crickets and insects flew up at the dancers during rehearsals. On the afternoon of the performance, as if on cue, the sky darkened in the distance, a blackbird flew by, and on an attitude turn, there was a roar of thunder. As American dance critic and author Deborah

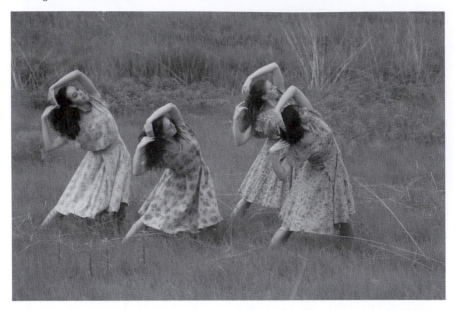

Figure 22.4 Celebrating the acquisition of tallgrass prairie land with poetry by Natasha Kessler at Glacier Creek Preserve, Nebraska.
Photo by David Conway

Jowitt (2009: 27) observed, about site-specific work: "When the sky is the backdrop and the same wind that ruffles the trees and your hair makes the dancers' costumes billow, that fourth wall becomes just a little bit more porous." The response that the audience demonstrated reinforced Jowitt's contention. Even the skeptical biology graduate students realized, to their surprise, that the dance was relevant to the dedication of this treasured land. They were not merely observers but rather were drawn into the meaning of the dance as it unfolded.

I have continued to work with Barbi Hayes on the prairie project. In 2011, an 1890s dairy barn and silo were gifted by Ms Hayes to the Glacier Creek Prairie Preserve. The barn was transformed into a state-of-the-art education and research facility for area schools and scholars to use for further learning about Nebraska's tall grass prairie ecosystem. In 2013, I was invited to create a dance for the dedication ceremony. I selected three sites including the long driveway leading onto the prairie land, the loft of the barn and a prairie lane that led from the barn to a creek. Rivertown String Band and singer/guitarist, David Corbin provided music to accompany the dances. Barn doors and planks from the original structure were woven into the choreography. All of this involved, over a four-month period, the invaluable assistance of the university's Grounds Department to travel to a farm, to the prairie and to the Dance Lab to pick up, deliver and then return all of the props. As a consequence of making a work for a prairie

environment, not only were some of the original choreographic designs modified to accommodate dancing on dried earth ridges in and amongst vegetation but also gloves had to be added to the costuming for dancing with the aged, splintered wood on the planks and barn doors. Vigilance prevailed and dancers were sprayed with repellant for ever-present ticks on the tall grass prairie.

Most helpful was my personal request to be on the planning committee so that there was a voice at the table for dance. As a result of the conversations with the committee, dancers in changing tableaux depicting work on a farm were situated all along the driveway entrance. These welcomed the audience and set the scene for the dedication. After seeing the dance that was set for the prairie lane site, the field manager arranged to trim some of the vegetation so that the audience could better view the dance. One implication of making a dance for the third site, the loft in the renovated barn, was that the rehearsals could not take place on site until the weekend before the dedication. It took that long for the required Occupancy Permits to be acquired. Despite the many deterrents and roadblocks in creating a work for an outdoor environment, nothing exceeds the exhilaration of dancing in a living, breathing natural habitat.

Closing thoughts

Moving dance from the traditional, proscenium stage to site-specific venues has afforded me with decades of working with non-dancers, students and professionals in intimate spaces and expansive sites. The visual impact of non-elitist environments and the kinetic language of dance provide provocative opportunities for collaborations wherein the site provides a common language whether it is on the prairie, in art deco museums, in millinery shops, or in gymnasiums. It has been a particularly rewarding path to follow. I have established new partnerships, gained new audiences and have seen the art of dance embraced by a community of contingencies ranging from environmental biologists to library directors to zoo curators. The ever-present challenge of making on-site, spur of the moment artistic decisions is exciting, hones my resiliency and inspires me to new projects. I am currently working on a dance for National Water Dance Day (2014) that will involve 45 dancers and 15 musicians crossing the 3,000' long Bob Kerrey Pedestrian Bridge that links Nebraska to Iowa over the Missouri River dancing about the issue of drought and the fragility of American waterways. Exploring the endless boundaries of 'dancing in place,' has empowered me to reach my goal of making the art of dance accessible to many and to discover the site-specific framework that is so effective for weaving dance into the fabric of community tradition.

References

Brown, J.M., Mindlin, N. and Woodford, C.H. (eds) (1998) *The vision of modern dance: In the words of its creators.* Hightstown, NJ: Princeton Book Company.

Charlton, J. (1998) *Nothing about us, without us: Disability oppression and empowerment.* Berkeley: University of California Press.

Cheney, S. (1969) *The art of the dance: Isadora Duncan.* New York: Theatre Art Books.

Commoner, B. (1971) *The closing circle: Nature, man and technology.* New York: Alfred Knopf.

Cone, T. P. (2007) In the moment, honoring the teaching and learning lived experience. *Journal of Physical Education, Recreation & Dance,* 78(4), pp. 35–37, pp. 50–54.

Corbin, D. and Metal-Corbin, J. (1997) *Reach for it: A handbook of health, exercise and dance activities for older adults.* Peosta, IA: Eddie Bower.

Enghauser, R. G. (2008) Teaching modern dance: A conceptual approach. *Journal of Physical Education, Recreation & Dance,* 79(8), pp. 36–42.

Jowitt, D. (2009) Dance: No gaze for you! *The Village Voice,* 54(31), p. 27.

MacBean, A. (2004) Site-specific dance: Promoting social awareness in choreography. *Journal of Dance Education,* 4(3), pp. 97–99.

McPherson, E. (2010) Building bridges: Using dance and other arts in an urban initiative. *Journal of Dance Education,* 10(1), pp. 22–24.

Partnership for 21st Century Skills. (2013) *The champion for today's students and tomorrow's workforce.* Available at: www.p21.org/storage/documents/P21_2013_Brochure.pdf (Accessed: November 29, 2013).

Putnam, R. D. (2000) *Bowling Alone: The collapse and revival of American community.* New York: Simon & Schuster.

Sprague, M. (2009) Combating dance educators' isolating: Interacting with the larger learning community. *Journal of Dance Education,* 9(4), pp. 126–128.

23 Activating intersubjectivities in site-specific contemporary dance

April Nunes Tucker

This chapter will explain what phenomenological intersubjectivity is and why it is important to the experience of dancing. It will discuss two of my own practical choreographic processes employed while making the site-specific work *Living La Pedrera* (2006) in the Antoni Gaudi building La Pedrera in Barcelona. These two choreographic processes I have named 'readiness' and 'repetition'. In this chapter I will reference the work of Jonathan Burrows and Atsushi Takenouchi as dance artists who also employ these choreographic tools within their own work.

The chapter will conclude with an explanation of how the process of activating intersubjectivities in performance can reveal the dancer as an individual as opposed to a theatrical representation of something else. I

Figure 23.1 La Pedrera (Casa Milà), Barcelona.

propose here that the process of experiencing the dancer as an individual person brings the dance event into a state of immediacy for the audience member which, in turn, fosters human connection.

Intersubjectivity

The experience of human connection is of upmost importance to me as a dance maker and in order to better understand ways of fostering this feeling of human connectedness I have employed phenomenological theory as a lens through which this feeling can be explored. The French philosopher Maurice Merleau-Ponty spoke frequently about an experience called 'intersubjectivity'. Intersubjectivity could be simply defined as: an experience that occurs when two or more people engage in perceiving one another whilst simultaneously perceiving themselves.

The intersubjective experience also acknowledges the shared nature of our human experience and refuses the option to be a passive recipient of action: 'For a spectator to become thoroughly involved in the lives on stage they must feel that they are sharing in a spontaneous "lived" moment *with* the performers' (Nunes Tucker, A. and Price, A., in McClean, C. and Kelly, R. 2010: 192).

Phenomenologist Edmund Husserl (1859–1938) observed that: 'Intersubjectivity employed a conception of *empathy* with others, [through which] I am able to read into another's actions, as an expression of inner states analogous to my own (in Moran, 2000: 175).

Merleau-Ponty (1908–1961), whose work and theoretical ideas informed the creative process of the work *Living La Pedrera* most significantly, gave an account of intersubjectivity in his unfinished work *Prose of the World*:

> Myself and the other are like *two nearly* concentric circles which can be distinguished only by a slight and mysterious slippage… The mystery of the other is nothing but the mystery of myself… the experience of the other is always that of a replica of myself, of a response to myself. It is because I am a totality that I am capable of giving birth to another and seeing myself limited by him.
>
> (1973: 134–135)

Figure 23.2 Visual representation of 'phenomenological intersubjectivity – our mutual corporeal experiencing' (Sanchez-Colberg, 1999, March 4 [lecture]).

Merleau-Ponty states that the 'totality' of being is what makes us capable of engaging in a process of intersubjectivity. I share Merleau-Ponty's non-dualistic view and agree with his proposition of a condition of totality whereby the body and mind are inseparable. Drawing on my own life experiences and through my experience of dance, I know that my body and mind do not operate as two separate entities, but rather as one ultimate unity. Dancing is not just a physical act; it emerges from the whole being.

The concept of mind–body is evidenced in texts as old as the Upanishads (ancient yogic texts written 800–400 BC) and latterly through the development of the term 'thinking body' (Todd, 1937), now integrated into the vocabulary of the dance world and used by movement practitioners since the early twentieth century. This non-dualist approach concerning the indivisibility of body and mind in relation to intersubjectivities as upheld by Merleau-Ponty, stems from a long-standing strand of reference that aims to examine the amalgamation of being.

It should also be noted that Merleau-Ponty's metaphor of '*two nearly concentric circles*' is not quite adequate for speaking about the intersubjectivities within a contemporary dance event. This is because, unlike Merleau-Ponty's account of intersubjectivity, which aims to speak about interactions between people in the world (i.e. in everyday life situations), the contemporary dance event traditionally sits outside of everyday life situations and is framed by rules and behaviours which are governed by the history of performance.[1] Merleau-Ponty's account of intersubjectivity addresses the mundane experiences of everyday social life. He makes no reference to experiences which magnify the intercorporeal relations between human beings exemplified in performance events where human behaviour is framed for spectatorship and in many cases rehearsed before its presentation to another. However, Merleau-Ponty asserts that a desire for connection with others is a part of our embodied human condition, stating: 'Man is but a network of relationships, and these alone matter to him' (1962: 456).

The innate need to connect with others is why the experience of the contemporary dance event requires a view of intersubjectivity where kinaesthetic empathy is recognised and valued and where performer and audience open themselves to a shared experience through a highly focused state of attention. This view of intersubjectivity, where there is both kinaesthetic empathy[2] and openness to shared experience fulfils a fundamental human desire to connect to another.

I use the term 'openness' to describe a state of willingness that must be present in both myself as a performer and another as witness. Preston-Dunlop and Sanchez-Colberg make reference to this openness to shared experience when they make the distinction between choreographic work that is performative and choreographic work that is performed. They believe that the difference hinges on: 'the level and nature of the engagement of the artists with the spectators and in response, the

engagement of the spectators with them and with the work' (2002: 4). I also share the view that choreographic work that is performative has a deeper level of engagement occurring between the performers and audience and that deep engagement between performer and audience, brought about by focused attention within a shared experience, has the potential to cultivate the sensation of communion with another.

Site-specific dance and intersubjectivity

The title of this chapter reads: *Activating intersubjectivities in site-specific contemporary dance*, indicating that intersubjectivities are something that can be activated or conversely, de-activated. It also asserts that intersubjectivities are already present in site-specific contemporary dance and that there are means by which they can either be drawn out or inhibited. Working site-specifically is a means by which intersubjectivities can be activated. People sharing in a dance event outside the orthodox theatre may foster a sensation of openness to shared experience and kinaesthetic empathy. Turner (1969: 13) observes: 'Spaces, or the different places within space, have meaning and value only because of the different organization and content they contain, which mark them out from one another.' Whilst space and place can never be separated, it is important to distinguish between the two. Space becomes place when we come to know it through lived-experience. We come to associate certain spaces with our reactions to them and they henceforth become places with meaning and familiarity.

Presently, La Pedrera functions as a tourist attraction and as an educational and events facility. There is the hustle and bustle of busy Barcelona all around the exterior of the building with café chatter and non-stop traffic but inside La Pedrera there is a contrasting calm... a cool quiet courtyard, the dark labyrinth-like loft and the undulating rooftop. All of these components contributed to my phenomenological lived-experience of the place that created a response running deeper than the daytime recreational activities.

Living La Pedrera (2006) was made out of a desire to reveal as honestly as I could my real self in an attempt to foster human connection without theatrical representation. The mention of 'real self' undoubtedly raises complex philosophical questions concerning the identity of self.[3] However, I am suggesting that in an attempt to reveal 'real self' a manifestation of yet another guise, a persona of, 'attempting to show my real self' comes into being. If this is true, then when does one ever *not* operate under the assumption of a persona? If, as self-conscious individuals, persona is adopted in any situation, when is the 'real self' ever revealed?

With an awareness of this 'real self'/persona dilemma I nevertheless wanted to strip myself of a 'performance persona' as much as possible in order to show my vulnerability and authenticity. I am defining my own term 'performance persona' as a way of being, developed from a performer's

desire to represent something other than themselves; and that way of being may take the form of a technical virtuoso, portrayal of a character, symbol or otherwise external object: 'Their real self is masked from themselves and others by the compromise of role, speech and gesture' (Priest, 1998: 41–42).

In light of the focus on performance persona therefore, authenticity is a term which articulates an alternative way of being to that of theatrical representation. A definition of the engagement with performance work in an authentic way was offered by Dwight Conquergood as the process in dynamic performance of undergoing 'a shift from mimesis to kinesis' (1989: 83). For the purposes of this discussion I am defining authenticity as 'the moments in which the performer offers a state of being-in-the-moment as themselves in place of a character' (Nunes Tucker and Price, 2010: 188–191). This working definition has been articulated out of the idea in existentialist philosophy whereby, if a person is inauthentic then in a sense that person is not really who they are. The term 'authenticity', therefore, permits a discussion of the individual as dancing human being by focusing on the issue of performance persona.

For example, if the primary concern of the performer is to give the audience an aesthetically pleasing technical performance, then this affects the performer's ability to sense what is going on around them in the moment. Moreover, if in performance the sole aim of the performer is to reach these aesthetic technical ideals then this arguably undermines the activation of intersubjectivities.

Jonathan Burrows, who danced for the Royal Ballet for 13 years, identifies his experience of performance persona where technical precision was the primary focus: 'I have within me still that kind of visceral experience of performing all those ballets which are about giving, giving, giving to the audience' (in Perazzo, 2005: 4). If the sole drive of the performer is to give an aesthetically pleasing performance that has been rehearsed and re-rehearsed and the audience is merely there to receive it then the openness to share an experience together is missing.

Jonathan Burrows, having started his career dancing with the Royal Ballet, now has his own extensive repertoire of choreographic works. His works devised from 2002 onwards feature his friend and composer Matteo Fargion as a co-performer. Burrows believes that in the case of performing with a close friend, with whom there is a long-held, established relationship, it is important to 'keep the reins on it, otherwise there is no room for the audience' (2006). This is because, for Burrows, the relationships between the performers, and between the performers and the audience, are equally important. His latest works have been in the form of duets made for the two friends and demonstrate an intersubjective relationship between them in which we, as the audience, are invited to participate. Unpresuming, open glances at and to one another and at the audience at frequent intervals during the performance create an openness – a human connection between us. The dance critic, Donald Hutera, observes:

I felt they knew that I was there and, projecting into the situation, that my presence was welcome or appreciated. They were doing this not just for them, but for me too, for the entire audience. Without being overt or over-ingratiating about it, I was a welcome observer.

(Hutera, 2006 in discussion with the author)

This sense of inclusion is what Burrows intended and reflects his interest in developing dance works that invite the audience into a connection with those on stage which could otherwise be inaccessible:

[…] although the piece has a certain intimacy, as all the pieces that I make have – it shouldn't exclude other people. So something that's too personal doesn't open a door for an audience to come in. I suppose I would say that we were trying to look at something personal enough that it would still have a door open for somebody else watching from the outside.

(Burrows in Perazzo, 2005: 3)

The movement in Burrows' choreography is set but has the appearance of being flexible. Burrows says: '[…] sometimes a movement in its first raw version can look wonderful, but then when the dancer becomes more familiar with it, it can get smoothed down and begin to disappear' (in Butterworth and Clarke, 1996: 3). I suspect that the 'freshness' with which Burrows and Fargion execute their rehearsed and refined movement material is due to their intention and focused attention to each and every moment of performance. Perhaps it is the repetition of set movement sequences that assists in revealing the intersubjective relationship between them. Burrows says he is interested in 'distracting the performer's mind and body to the degree that something else happens' (2006). This 'something else', I assume, could potentially be the revealing of intersubjectivities that I have experienced as an audience member at Burrows' work. Burrows also reveals that he enjoys 'watching people think' (ibid.) and it is evident that the repetition of movement that he uses is a powerful tool for him in both making and performing.

Repetition

Repetition as a strategy for invoking functional movement responses and distracting the performer away from overtly contrived performance conventions, as evidenced in Burrows' work, appealed to me and significantly informed the creation process of *Living La Pedrera*.

For six months I went regularly to La Pedrera to make movement. In making the work I used two choreographic processes, which I refer to as 'repetition' and 'readiness'. These processes were borne out of my meaningful relationship with La Pedrera as a place and they were designed to activate

intersubjectivites with the human beings (members of the public as visitors to the site and invited audience members) who were sharing the space with me.

Following a line of thinking where I drew upon a connection between Merleau-Ponty's idea of the habit body and the ability to become so engaged in a repetitive movement pattern that my mind was free to follow any other trains of thought, I created a section of *Living La Pedrera* to demonstrate this idea. Merleau-Ponty's concept of the habit body is that the body develops movements that happen without the need for highly focused attention. For example, the movement tasks of driving a car, typing on a keyboard or tying a shoe are habitual. He suggests:

> [...] by becoming involved in the world through stable organs and pre-established circuits man can acquire the mental and practical space which will theoretically free him from his environment and allow him to *see* it.
>
> (Merleau-Ponty, 1962: 87)

For approximately the first 15 minutes of *Living La Pedrera* I stood in the main outdoor courtyard of the building and repeated a slow-motion nodding movement of looking from the tip of my nose up into the sky and back again. The courtyard was enclosed on all sides by Gaudi's strong stone pillars and long rectangular windows spanning nine stories. The slow controlled movement of my eyes and upper body contained a natural sense of expansion and contraction and was coordinated with my breath. I developed this simple movement into one that was habitual. Minimalist in its aesthetic and not dissimilar in its external appearance from tasks set in pedestrian movement that post-modern dance artists such as those in Judson Church would have produced, the repeated movement that I executed had intentions that deviated from minimalist movement explorations alone.

My aim for this section of the work stemmed from a desire to strip my performance persona and reveal *just me, looking up, breathing*. I thought that this was perhaps what Merleau-Ponty was proposing through his explanations around the habit body and I was keen to try something in dance practice. The decision to repeat the movement of looking up in the courtyard was directly taken from my observations made during research visits to La Pedrera, where visitors to the site would regularly walk into the courtyard and immediately look up. During many of my visits to La Pedrera, I often would stand in the courtyard, watch people move into that space, look up and then move on. On every occasion that I worked in the courtyard (with the exception of the day upon which *Living La Pedrera* was performed) the courtyard was a very busy place with people moving around me on all sides. It was for this reason that I chose to stand in the centre of the courtyard where I could be surrounded by other people and experience a wider range of proxemic encounters ranging from intimate to public distances.[4]

Figure 23.3 Living La Pedrera, courtyard section.

The loss of performance persona was a naïve ambition as I certainly never achieved it (not in rehearsal or performance). Upon reflection, this was because I had tried to go against one of the very premises upon which my research was based, namely that the mind and body are not separate. The absolute connectedness of body and mind stared me right in the face for a painful 15 minutes. I found it impossible to dissolve into the mere movement of looking up as my busy mind was unfocused and I refused to give my attention to the moment. Instead, I worried about how I was being perceived.

There were members of the public milling around the space and my invited audience hung back from me with trepidation, watching me as if in a proscenium theatre space as opposed to a site-specific environment.

So, from this exercise my perceived failure in working with the repetitive movement of looking up in the courtyard section of *Living La Pedrera* opened a new avenue of pursuit and with further practical experiments I found mileage in the potential that movement repetition had to offer. Even though repetition of movement was a practical method of pursuit in my research it became evident that repeated movement proved impossible. Movement repeated without change could arguably only be mechanistic since human movement alters continually as a result of our body–mind construct. According to Deane Juhan (2003: 390), a body-worker who promotes the functionally integrated body–mind, it is our corporeality, which dictates our interface with decision-making processes.

Juhan's observation of the link between body and thought further illustrates the indissolubility of body and mind. What Merleau-Ponty advocates is our lived experience of our relations to others, as we inhabit our world as unified beings: body, mind and soul (1962: 88–89). To be clear, this unification does not manifest as some sort of metaphysical power which makes a performer's thoughts visible as they move but rather, that one can see that the performers are in a process of thought:[5]

> In dancing, thought and movement become linked with one another; this turns dancing into the expression of a kind of thinking in which mind and body are no longer opposed but instead seem to coincide; where it is the body that thinks [...] dance is an instance of thinking taking place through the body.
>
> (Ritsema in Bloois, 2004: 121).

Jan Ritsema, theatre director and performer,[6] recognises both the performer's intention to move and the fact that movement is inevitably influenced by thought and vice versa. This looping of movement affecting thought effecting movement can be seen as a circuit of lived consciousness working in conjunction with Merleau-Ponty's view that every moment is enveloped in every other moment. This thought-movement circuit running concurrently within each of us, is revealed in Merleau-Ponty's description of lived consciousness:

> My present draws into itself time past and time to come, it possesses them only in intention, and even if, for example, the consciousness of my past which I now have seems to me to cover exactly the past as it was, the past which I claim to recapture is not the real past, but my past as I now see it, perhaps after altering it. Similarly in the future I may have a mistaken idea about the present which I now experience.
>
> (Merleau-Ponty, 1962: 69–70)

The dynamic flux of this thought-movement circuit that exists within Merleau-Ponty's account of lived consciousness of time[7] is manifested in the moment to moment unfolding of our intersubjective experience within the dance event.

Readiness

As discussed in the previous section on 'repetition' it can be seen that the execution of repeated movement over time reveals variations in movement vocabulary and in the case of set movement material, shifts in the performer's decision-making processes have to manifest within the framework of the movement vocabulary already present. Conversely, an improvised phrase of movement reveals more dramatic shifts in attention as a result of decision-making processes to purposely change the movement vocabulary often occurring in the moment. I found this realisation of great interest and began to work with a butoh dancer named Atsushi Takenouchi whose approach to movement proved highly influential in my choreographic processes of *Living La Pedrera*.

Atsushi Takenouchi works within a hybrid form of contemporary dance and butoh dance. In traditional butoh dance,[8] the dancer begins with an image. Kazuo Ohno, one of the founding fathers of butoh, taught the practice of becoming a 'dead body'. Yet, in the way that Takenouchi approaches image work, the dancer holds the image in their mind and the body follows. This is plausible because of the cyclical nature of the thought-movement circuit. For example, focusing on the image of a dead body may initiate the action of falling to the ground. The lived physical experience of lying on the ground thereby strengthens the image of a dead body. Repetition of image (mentally) breeds repetition of form (physically) and vice versa.[9] However, Takenouchi does not attempt to embody an image for the goal of aesthetic value but rather, Takenouchi focuses his attention to the moment in order to bring immediacy to his work. His approach to image differs from the orthodox butoh dance method in this way, as many butoh practitioners are deeply concerned with the body's external form.

Takenouchi's dances are often wholly improvisational and usually site-specific. He makes his dances in the moment in response to his environment, often in an outdoor setting. His solo improvisational work *Jinen* (1996–1999) was: 'based on [his] impressions of the moment, formulated from the people around him, the space, the air, the climate and energetic mood of the surroundings and spirit of the moment' (Takenouchi, nd). When he dances he is poised with alertness, full of vitality even in stillness and it is this quality in his dancing that draws the audience in to the shared moment of surprise.

Having worked with Takenouchi for several years prior to the making of *Living La Pedrera* this cultivation of 'readiness' was something I felt was vital in harnessing the immediacy of human connection essential to the activation

of intersubjectivities. Throughout the making and performing of *Living La Pedrera* it became evident that 'readiness' is about working with energy as opposed to technique:

> Readiness is a description of both a physical and mental state. It is a state of alertness, likened to that of a cat preparing to pounce. There is an intensifying of mental focus and an opening of sensory awareness. Although the body may be still, it is charged with energy. This sense of engaged presence fosters immediacy by way of harnessing absolute commitment to each moment such that gaps in attention are diminished. Readiness demands cultivating a heightened attention in order to feel the 'right' moments for movement initiation.
>
> (Nunes Tucker in Johns, 2010: 191)

Readiness is achieved through a harnessing and directing of energy in the body and both the disciplines of dance and theatre have within them practical training mechanisms that advance a performer's work with their energy. For example, Tadashi Suzuki, founder of the Suzuki Method (a psychophysical training method predominately used by actors) highlights a key concept in his training called 'animal energy':

> The audience perceives this [animal energy] as an altered mood, a precise external focus and a physical intensity [...] the performer is exposed and vulnerable on stage in this highly charged state. Encouraging animalistic sensitivity shifts the performance away from being an aesthetic entertainment and towards a transgressive interactive event.
>
> (in Allain, 2002: 5)

Like Suzuki's animal energy, it is important to highlight that this state of *readiness* encompasses both openness to shared experience and heightened attention to the moment. As a result, the state of readiness feels vulnerable, uncertain and can be defined as 'authentic'.

Dancing *La Pedrera*

The choreographic process of readiness was my primary navigation tool that led me through the three sections of the 45-minute performance at La Pedrera. The three sections were held together by a spatial pathway that led the audience on a promenade performance through three different spaces within the building. The first space was the main courtyard, enclosed on all sides but open to the sky. Readiness was what guided me out of the courtyard (the first section), up to the rooftop (the second section) and then down a winding staircase, finishing in a once inhabited apartment (final section). Readiness was also how I negotiated my movement material in the last two sections of the work.

The second section unfolded in the form of a structured improvisation on the rooftop of La Pedrera. The rooftop of La Pedrera is a vast place with an undulating surface and surreal structures biting into the skyline. This section was a further experiment towards stripping away performance persona. Here I spoke spontaneously to the invited members of my audience through headsets. This section of the work was devised to establish a connection between performer and audience whereby each audience member could roam the vast space of the rooftop (as could I) whilst remaining connected to each other through the sound of my voice. Headsets are a part of normality at La Pedrera as every visitor to the building is offered one upon their arrival in order to listen to a pre-recorded guided tour as they walk throughout the building. The headsets given to my audience therefore looked nothing out of the ordinary and they served as a way to connect them through shared experience. Instead of listening to a pre-recorded tour guide, they listened to my voice speaking spontaneous thoughts. Because of the vastness of the space of the rooftop and the nature of our connectedness through sound, the audience could only listen and not reply. I worked from both a set series of topics that I wanted to speak about and interspersed these topics with my spontaneous streams of consciousness about them.

Some ideas I mused upon whilst walking the rooftop with my invited audience were:

- *How do we relate to, perceive other people and ourselves – look at all the intersubjectivities that the rooftop allows...*
- *Who do you see? Someone in their house across the road... someone you know nearby?*
- *Touch and experience the space, the undulating surface as you walk, the textures of your surroundings...*
- *Look over the edge...*
- *Sit down and be still for a moment. Notice how the headset gives you freedom...*
- *Look for someone you recognise, make eye contact with them, observe the way they are standing or sitting. Replicate it.*
- *Observe your breath...*

The final section of *Living La Pedrera* was completely improvised combining speech and movement. It took place inside what was once an inhabited apartment. In 2006 it was converted into an education room, complete with a printed carpet map of La Pedrera and the surrounding area and a two-foot high white, wooden model of the building itself. In my previous visits to the room to devise this section the model had not yet existed so much to my surprise, on the morning of the first performance my improvisation had to be adapted to share a dancing space with a number of unexpected boxes:

Figure 23.4 Living La Pedrera, rooftop scene.

> Improvisation presses us to extend into, expand beyond, extricate from
> that which was known. It encourages us or even forces us to be 'taken
> by surprise.' Yet we could never accomplish this encounter with the
> unknown without engaging the known.
>
> (Foster in Cooper Albright and Gere, 2003: 4)

The movement improvisation that took place in this room followed a
familiar process. My intention in this section was to improvise movement,
shift my attention from my movement to the people in the space whilst
simultaneously attempting to keep reins on my performance persona. As a
tactic for this, when I noticed that I was slipping into performance persona,
I stopped the flow of movement and attempted to describe in words my
emotional state to the audience in that moment. Then I waited in stillness
until I felt I could start moving from a more honest place of human
presence. Chris Johns, a specialist in reflective practice, observes:

> The idea of paying attention to self within the unfolding moment
> defines reflection-within-the-moment; the exquisite paying attention to
> the way the self is thinking, feeling and responding within the particular
> moment, and those factors that are influencing the way self is thinking,
> feeling and responding. Such self-awareness moves reflection away
> from techniques to apply to a way of being.
>
> (2004: 2)

Figure 23.5 Living La Pedrera, apartment scene.

It was my hope and aspiration that the way I was being was truer to revealing self than to presenting a technical ideal. I desperately wanted to reveal my inner struggles in a process of negating what was a very deeply embedded performance persona cultivated by years of technical dance training. At times when I felt very uncertain whilst dancing in this final section I gave myself the opportunity to say 'I'm lost' and 'I'm not sure what I'm doing'. This revealed to the audience the uncertainty that developed from my attempt to reveal myself as a 'person' as opposed to a 'dancer'. Playwright and theatre director David Mamet illustrates how revealing one's vulnerability illuminated in moments of uncertainty assist in revealing person:

> [...] bring the truth *of yourself* to the stage. Not the groomed, sure, 'talented,' approved person you are portraying; not the researched, corseted, paint-by-numbers presentation-without-flaws, not the Great Actor, but yourself – as uncertain, as unprepared, as confused as any of us are.
>
> (1997: 124)

Permission to expose uncertainty in this section by voicing my predicament to the audience was liberating. What my efforts to strip away persona in the work *Living La Pedrera* did was to expose the potential for this type of work to inform understandings of intersubjectivity and the 'construction' of personas of everyday person-hood. These constructions of particular roles performed in the site, such as tourist, viewer, curator became disrupted and exposed through the performance event that employed the choreographic

techniques of repetition and readiness to enable experiences of self and authenticity to evolve. Being freed of a traditional theatre space and instead being in the expansive Gaudi building La Pedrera facilitated a rupture in codes of tradition and behaviour when it came to experiencing a dance event. The uniqueness of the site allowed me to come closer to revealing my truer self – not the performer but the person.

Intersubjectivities are activated by people relating to one another; seeing themselves in another person. The La Pedrera site facilitated that feeling of connectedness through a natural progression of shared experiences within space and place. Leaving the traditional theatre space behind and leaping out into the unknown by way of an attempt to shed my performance persona left just me living La Pedrera as honestly as I could.

Notes

1 The codes and behaviours governed by the history of performance overlap with the area of semiotics. Readers may find it useful to refer to Aston and Savona, 1991 and Foster, 1986 if they are interested in this area. In general, however, the codes referred to here are those associated with traditional theatre (i.e. performances which take place in a proscenium arch theatre space whereby the performers and audience are separated and the behaviour of the audience is dictated by the orthodox decorum that has come to be the widely accepted behaviour in these spaces).

2 For the purposes of this chapter the definition of kinaesthetic empathy will be borrowed from Moore (1988: 53) as the 'physical identification with the movement one observes being executed'. The term is also widely used in Dance Movement Therapy to describe a skill that can be honed by the dance movement therapist as a means of developing a trusting relationship with the client/ patient. See Hervey (2000: 18) and Levy (Ed.) (1995: 87). In earlier dance literature, the dance critic John Martin spoke about *kinaesthetic sympathy* (1935: 13) in order to describe the relationship between the performer's intention and the audience's perception of that intention. See Martin (1935: 13) and Maletic (1987: 159).

3 Philosophers have long debated the question of real self and I cannot attempt to unravel it here. If readers are interested it would be useful to have a look at Husserl's work as he provides a summary of the phenomenological account of his ideas on 'reality' and 'nature' in his text *Ideas Pertaining to a Pure Phenomenology and to a Phenomenological Philosophy: Second Book*. See pages 121–150.

4 See Hall (1990) for descriptions of cultural and social implications of proxemics.

5 The phenomenological definition of thought is a complex issue and will not be unpacked in this chapter. However, in the context for which it is used here, it is useful to note that one facet of Merleau-Ponty's central theories on thought is that it is, 'rooted in the historical event' (Moran, 2000: 427). Although, 'rooted in the historical event', it is important to remind the reader that this awareness of the past, according to Merleau-Ponty, is also constituted within our lived consciousness of time. Also see Merleau-Ponty (1962: 410–433) and (1964: 46–59).

6 In 2001 Ritsema collaborated with Jonathan Burrows to make *Weak Dance Strong Questions*.

7 See Merleau-Ponty (1962: 420–433) for further information on his idea of lived consciousness of time.

8 Traditional butoh dance refers to the work of Tatsumi Hijikata and Kazuo Ohno who, in the late 1950s through the 1970s 'played an essential role in the formation of the Butoh aesthetic – to create a specifically Japanese dance form that would transcend the constraints of both Western modern dance and traditional Japanese dance' (Klein, 1988: 1).
9 To keep clarity, the distinction here in language between 'mental' and 'physical' does not imply that I uphold a dualistic stance.

References

Allain, P. (2002) *The Art of Stillness: The Theatre Practice of Tadashi Suzuki.* London: Methuen Publishing Limited.
Aston, E. and Savona, G. (1991) *Theatre as Sign-System.* London, New York: Routledge.
Banes, S. (1994) *Writing Dancing in the Age of Postmodernism.* Hanover, NH: University Press of New England.
Bloois, J., Houppermans, S. and Korsten, F. (Eds). (2004) *Discern(e)ments: Deleuzian Aesthetics.* Amsterdam, New York: Rodopi.
Bremser, M. (Ed.) (1999) *Fifty Contemporary Choreographers.* London: Taylor & Francis Ltd.
Burrows, J. (2004) Choreographers Workshop at Greenwich Dance Agency, London. 19–23 July 2004.
Burrows, J. (2006, February 22) *Process to Product* (Informal lecture given to BA Dance students) London: Roehampton University.
Butterworth, J. and Clarke, G. (Ed.) (1996) *Dancemakers Portfolio: Conversations with Choreographers.* Leeds: Bretton Hall.
Conquergood, D. (1989) 'Poetics, Play, Process, and Power: The Performative Turn in Anthropology.' *Text and Performance Quarterly*, 1, pp. 82–95.
Feuerstein, G. (1998) *The Yoga Tradition: Its History, Literature, Philosophy and Practice.* Arizona: Hohm Press.
Foster, S. (1986) *Reading Dancing: Bodies and Subjects in Contemporary American Dance.* University of California Press.
Foster, S. (2003) Taken By Surprise: Improvisation in Dance and Mind. In Cooper Albright, A. & Gere, D. (Eds.), *Taken By Surprise: A Dance Improvisation Reader.* Connecticut: Wesleyan University Press.
Hall, E. (1990) *The Hidden Dimension.* USA: University of Michigan Press.
Hervey, L. (2000) *Artistic Inquiry in Dance/Movement Therapy: Creative Alternatives for Research.* USA: Charles C. Thomas.
Husserl, E. (1989) *Ideas Pertaining to a Pure Phenomenology and to a Phenomenological Philosophy – Second Book: Studies in the Phenomenology of Constitution*, trans. R. Rojcewicz and A. Schuwer, Dordrecht: Kluwer.
Johns, C. (2004) *Becoming a reflective practitioner.* Oxford: Wiley-Blackwell Publishers.
Juhan, D. (2003) *Job's Body: A Handbook for Bodywork.* New York: Station Hill Press.
Klein, S. (1988). *Ankoku butoh: The premodern and postmodern influences on the dance of utter darkness.* Ithaca: East Asian Series, Cornell University Press.
Levy, F. (Ed.) (1995) *Dance and Other Expressive Art Therapies.* New York and London: Routledge.
Maletic, V. (1987) *Body, Space, Expression: The Development of Rudolf Laban's Movement and Dance Concepts.* Berlin, New York: Walter de Gruyter.

Mamet, D. (1997) *True and False: Heresy and Common Sense for the Actor.* New York: Pantheon Books.

Martin, J. (1935) *The Modern Dance.* New York: Dance Horizons.

Merleau-Ponty, M. (1962) *Phenomenology of Perception.* London, New York: Routledge.

Merleau-Ponty, M. (1964) *Primacy of Perception.* USA: Northwestern University Press.

Merleau-Ponty, M. (1973 [1969]) O'Neill, J. (Trans.) *The Prose of the World.* USA: Northwestern University Press.

Moore, C. (1988) *Beyond Words: Movement Observations and Analysis.* London: Routledge.

Moran, D. (2000) *Introduction to Phenomenology.* London and New York: Routledge.

Nunes Tucker, A. and Price, A. (2010) 'Reflection in Action/Performing Practice'. In McClean, C. and Kelly, R. (Eds.) (2010) *Creative Arts in Interdisciplinary Practice: Inquiries for Hope and Change.* USA: Detselig Enterprises.

Nunes Tucker, A., Price, A. and Diedrich, A. (2010) 'Reflections on Performance'. In Johns, C. (Ed.), *Guided Reflection: A Narrative Approach to Advancing Professional Practice.* UK: Wiley-Blackwell.

Perazzo, D. (2005) 'The Sitting Duo Now Walks or The Piece That Lies Quietly Underneath: Daniela Perazzo Interviews Jonathan Burrows', *Dance Theatre Journal,* 21(2), pp. 2–7.

Preston-Dunlop, V. and Sanchez-Colberg, A. (2002) *Dance and the Performative: A choreological perspective – Laban and beyond.* London: Verve Publishing.

Priest, S. (1998). *Merleau-Ponty.* London: Routledge.

Sanchez-Colberg, A. (1999, January 14 and March 4) *Dance as an Event & Performance Dance* (Lectures given for the MA Choreological Studies module) London: Laban Centre for Movement and Dance.

Takenouchi, A. (1996–1999) *Jinen Butoh.* Retrieved 13 September 2006, from www.jinen-butoh.com/works/jinen_e.html

Todd, M. (1937) *The Thinking Body: A Study of the Balancing Forces of Dynamic Man.* New York: Princeton Book Company.

Tuan, Y. (1977) *Space and Place: The Perspective of Experience.* Minneapolis and London: University of Minnesota Press.

Turner, V. (1969) *The Ritual Process: Structure and Anti-Structure.* Chicago: Illinois: Aldine Publishing Company.

24 Site of the Nama Stap Dance

Jean Johnson-Jones

The Khoisan are the indigenous peoples of southern Africa whose existence can be traced back some 2,000 years to the Cape area of contemporary South Africa. The Nama are the descendants of these original inhabitants and are scattered among five 'coloured-reserve' areas in the north-west area of South Africa known as Namaqualand.

The Nama may be identified with a sequence of movement that is widely recognised throughout South Africa as the Nama Stap (Step); the Nama Stap in turn is the major movement motif of the Nama Stap Dance. The dance has its roots in the historic Nama female puberty ceremony, despite obvious colonial influences (such as clothing, religious practices, and language) within the dances, the Nama have declared these performance artefacts to be symbols of Nama identity. This is in contrast to more classical identifiers such as the matjieshuis (mat house) and the Nama language itself. Equally fascinating in regard to a history of the Nama Stap Dance are the performers who (re-)enact this female rite of passage ceremony today – mature women.

Although this modern-day version incorporates many aspects of the historic ceremony, the traditional ceremony is no longer celebrated. Despite its demise in this form, the Nama have maintained dancing, place, and architecture as part of their contemporary interpretation of the dance. The tenacity of these historical aspects within the ceremony may be indicative of a view of culture that 'stresses its resilience and internal cohesion, rather than the fleeting nature of particular practices' (Barnard, 1992: 177).

This chapter addresses key aspects of the Nama Stap Dance that position it as a 'site-specific' dance. These include the Nama Stap movement pattern/ motif itself, the dance's historical link to the Nama village context (place), and the significance of architecture in the form of the matjieshuis/mat house to Nama women and to the Nama Stap Dance.

The Nama female puberty ceremony

Agnes Hoernlé is often referred to as the 'mother of South African anthropology' (Barnard and Spencer, 2000). During her field research

among the Nama between 1912 and 1913, Hoernlé recorded what is now considered the most comprehensive description of the Nama female puberty ceremony. The Nama Stap Dance (puberty version), the subject of this research, is a contemporary interpretation of this historic Nama ritual. Hoernlé's eminent account of the ceremony is summarised at the outset of this work in order to situate the discussion that follows and to establish the primary data on which the research is based and, as such, is worth quoting at length:

A girl's first period is called *kharú* or */habab*. Young… girls… tell either their girl friends or some older women of the clan, often the father's eldest brother's wife. Through this intermediary the mother is told. The latter gets her married sisters and her brothers' wives to make a little mat enclosure (*kharú óms*), inside at the back of the family hut, on the left hand side. It is a screened off segment… it always has its own little opening leading out behind the hut… the mother goes to fetch a woman, who, though past childbearing now, has been renowned for her former fertility. This woman takes the girl on her back, carries her into the *kharú óms*, and cares for her while she is there. She is called the *abá tarás* (*abá*, to carry a child on one's back; *tarás*, a dignified word for woman). …Once in the *kharú óms*… the girl must not leave the hut except at night, and then it must be by the back opening with one woman behind and one in front of her, to screen here from view…

The time during which the girl must remain in the *kharú óms* …varies from 2 or 3 days to a month… one of the chief things required of a girl in the hut is that she should get fat, with smoothly shining skin… Indeed, immediately she is in the hut, the relatives kill for her, the feast being called *kharú ≠ap*… everything killed must be female, and chief of all must be a heifer…

The *kharú ≠ap* is the great feast for the women, all who have already passed through these ceremonies being able to take part in it. No man or boy is allowed to have any share in it at all… The only exceptions to this rule… are that no menstruating woman must eat of it, 'least the girl's period never stop,'… and no pregnant woman, 'lest the girl's period stop never to return.'

As the time of the girl's seclusion draws to a close, the feasting takes on bigger proportions, regulated always by the relatives. The young people of the village begin practising the reed dance, and the girl's friends, both male and female, play and dance round the hut in which she is confined… the day before she is to come out, a long series of purification rites takes place…

The girl is now ready to receive visits as *õaxais*… a young marriageable woman. All her relatives and friends pour in, each one with some present… She is scented all over with the *sãp* which she and her girl friends have ground. Her face is painted in curious patterns with *!naop*

and *!quasab* ('ground white stone'), and her body is loaded with her presents.

 Towards evening the girl's friends enter the hut to fetch her out. She must leave the hut by the special door that has been made for her at the back. Her friends surround her, and for a time try to keep her from the view of the youth... The youth start the reed dance, and the girls dance round them with the *õaxais* in their midst. Gradually the youths get to the side of the girl and choose her as a partner... In the Hottentot dances the men form the inner ring, the women the outer one, and every now and then there is a change of partners... The dancing lasts often right through the night, and when it is over, the final round of rites begins, reintroducing the girl to her daily tasks, freeing her... from the spell under which she has been living. The *abá tarás* must accompany the *õaxais* in all these rites... Further, the girls who have come of age must after the festival run about in the first thunderstorm quite naked, so that the rain pours down and washes the whole body. The belief is that this causes them to be fruitful and have many children.

(Hoernlé, 1918: 70–74)

Historical overview of the Nama

Due in large part to its harsh, desert-like climate and mountainous terrain, Namaqualand is the least populated region of South Africa. It is one of 20 areas that are known as reserves, coloured reserves, or coloured rural areas. Reserves were officially established in the early part of the 1900s as permanent settlements for the indigenous peoples of South Africa. Namaqualand, the largest reserve, includes Concordia, Komagga, Leliefontein, Richtersveld, and Steinkopf. The Nama live in !Khubus village in the Richtersveld region of Namaqualand near the Orange River.

 In pre-colonial times the Nama were nomadic herdsmen, driving their cattle and sheep between suitable areas of grazing and watering as the seasons dictated. Their possession and maintenance of livestock distinguished them from hunter-gatherers of the region such as the Soaqua or San. Their lifestyle and social organisation were defined by their need to find pasture and water for their herds. The language of the Nama is still spoken by a few thousand inhabitants of the Kalahari along the Orange River. They were once thought to be extinct, but direct descendants of the people who inhabited the Cape for a millennium prior to the arrival of any European still live in the harsh outback which forms South Africa's frontier with Namibia. Two groups of Nama are distinguished: the Great Nama who live in Great Namaqualand in Namibia and Little Nama who reside in Little Namaqualand in South Africa. This research examines the Nama Stap Dance (NS/D), the so-called 'national' dance of the Nama. Based on material collected in conjunction with ethnographic field research carried

out in !Khubus village between 2001 and 2006, the research examines key aspects of the NS/D that position it as a site-specific work.[1]

The Nama Stap Dance

The title 'Nama Stap Dance' is a generic label. When viewed as such, it does not designate a particular version of the dance but refers to the dance itself and its close association with various Nama social events, such as birthdays, funerals, weddings, and tourist activities at which the Nama Stap is performed. On these occasions the Nama Stap motif may be performed informally where the stepping pattern is featured and no other motifs systematically accompany it. At other times its usage is defined by the occasion it is used in conjunction with, such as government-sponsored or educational activities; this kind of multiple usage is not uncommon. In her study of Warlpiri women's dances of Australia, for example, dance ethnographer/notator Megan Jones Morais (1992) noted that similar movement was found in different dances.[2] In much the same manner, the various versions of the NS/D may be organised into groups including: social activities, where the NS/D is performed locally in conjunction with smaller and more intimate activities, tourist activities, that are typically government-sponsored occasions that may be larger affairs; and educational activities, organised in conjunction with the local school.[3]

The Nama Stap

The Nama Stap is the central motif of the different versions of the Nama Stap dances. Due to its prominence in all of these dances the Nama Stap motif may be perceived as a 'movement signature'. Movement signature in this context is used to signify those movement phrases taken collectively to identify the NS as the NS and not, for example, a Xhosa Step or a Pas de Chat.[4] A movement signature is readily recognised by regular users of it, in this case the Nama, and by knowledgeable 'outsiders' (Kaeppler, 1992).[5] A movement signature, like a personal, hand drawn one, is, however, not static but, instead, operates within a dynamic range of possibilities. These deviations do not change the fundamental signature itself but reflect responses to internal and external social, cultural, and political influences. Response to environment allows a movement signature to expand over time outside of a range of understood or agreed possibilities and, ultimately, to develop and to change. The movement signature of the NS described herein should be understood in this light; it is a constructed movement signature of Nama dancing during the period of this research.

The Nama Stap as the chief movement pattern in all versions of the Nama Stap Dance was confirmed by various different sources including indigenous cultural consultants and others in and outside of !Khubus.[6] This culturally informed view of the NS is further substantiated by the fact that,

among other signifiers, such as Nama guitar music, the Nama Stap motif distinguishes Nama groups from each other. Some Nama groups typically slide the feet along the floor, others skim or lift the feet from it, and the youth in !Khubus punch the feet into the ground.

While these stylistic differences in the context of dancing distinguish Nama groups from each other, they also point to similarities between groups and dynamism of the Nama Stap motif itself.[7]

Even though the origins of the NS cannot be confirmed via a Western mode of validation, such as a linear chronology of its development, the Nama acknowledge this motif for what it represents for them – a historical link with Nama pre-colonial history and a bridge that connects the Nama to the future. The Nama Stap is, therefore, a cultural signifier; as such, it serves, at least, a dual role.[8] Firstly, it represents the Nama as descendants of the 'original' people of South Africa; the ideology of these early Nama is embodied most directly in the Nama Stap dances performed by mature women in !Khubus (discussed further below). Secondly, a focus on improvisation exhibited by Nama youth encapsulates contemporary influences and a more recent representation of these descendants of the Khoekhoen.

Various scholars have investigated Khoisan people, of particular interest to this research is the work of Agnes Hoernlé.[9] Hoernlé gathered information concerning 'Hottentot' transition rites over a two-year period as noted above.[10] She conducted field research in three different 'Hottentot' communities including Little Namaqua, the ancestors of the people who are the subject of this research, the ≠Aunin or Topnaars of Walfish Bay, and the /Hei /Khauan in Berseba (German South West Africa, now Namibia). Already at the time of her research Hoernlé found the traditional customs of the 'Hottentots' disappearing. Although Hoernlé did not actually witness female puberty transition rites, she notes that at the time of her research the four 'Hottentot' transition rites that she recorded – puberty ceremonies among women, remarriage ceremonies, treatment of certain diseases, and the purification of the survivors after a death – are 'practiced even now among the people visited, though sometimes in a simplified form owing to the great poverty which prevails' (Hoernlé, 1918: 66). Hoernlé's account of the Nama female puberty ceremony is the most detailed recording of this traditional rite of passage among Nama women; her account of this Nama activity is the foundation on which subsequent research of this topic is based.

The ceremony recorded by Hoernlé no longer exists. Instead, a contemporary rendering of the ceremony, the Nama Stap Dance–Puberty Version (NS/P), is now performed. However, despite its demise in its 'traditional' form, the Nama have maintained particular aspects of this rite of passage of Nama women. These include: the powerful role of women in Nama society, the connection of the dance to its 'home village' context, the traditional Nama home, the matjieshuis, as central to the dance, dancing as

part of the contemporary interpretation of the ceremony,[11] and a theme of female unity; these all remain prominent markers in the contemporary version. The next part of this chapter will examine these Nama markers and will demonstrate how they continue to provide the foundation for the contemporary version of this dance of solidarity between Nama women.

Nama women

The female puberty ceremony was a major rite of passage for young Nama females, and it marked not only the transition from childhood to full adult membership, but also the division between males and females. Nama females had considerable power as adult members of the Nama community, and this influence may be observed through an examination of a woman's role within the family. Women in pre-colonial Nama society had supreme authority, for instance, within the homestead. Anthropologist Theophilus Hahn explains:

> In every Khoikhoi's house the woman… is the *supreme ruler*; the husband has nothing at all to say. While in public the men take the prominent part, at home they have not so much power even as to take a mouthful of sour milk out of the tub, without the wife's permission. If a man should try to do it, his nearest *female* relations will put a fine on him, consisting in cows and sheep, which are added to the stock of the wife.
>
> (in Barnard, 1992: 185, italics author's own)

During the course of this field research, male consultants in !Khubus confirmed that, 'women had privileges above men; women, for example, could not be punished; a husband or father was punished; women were not held accountable'.[12] In contrast to the position of women in the *ou-ou dae* (olden days), Vedder notes the changed status of present-day Nama women:

> The position of the woman among the Nama is by no means that of the devoted servant of the man. According to old custom *the hut belongs to her* [italics added] and she disposes of everything within it. When in need of something the man has to approach his wife entreatingly and not imperiously. But since the old-fashioned huts [matjieshuis] which was covered with rushes by the women have more and more been displaced by the modern houses, which the man builds with material for which he has laboured, the woman is being pushed into the background. The abode now becomes the property of the man and there is danger that the consequence will be ill treatment of the women.
>
> (Vedder, 1928: 135)

Prior to the arrival of Europeans, wealth was calculated in terms of how many cattle and sheep one owned and stock could be accumulated through

service to others, raids, marriage, purchase, or inheritance. Various levels of governance of Nama communities were based on the accumulation of wealth so that large stockholders, for example, were regents. Nama women could inherit stock in their own right and maintain these distinct from male relations even after marriage. Through this system, women gained considerable power (and independence) and in *ou-ou dae*, some women even became regents or temporary chiefs (Vedder, cited in Barnard, 1992: 185; Carstens, 2007).[13] Marriage, linked to direct authority of the household, could provide women with another avenue of financial independence via the acquisition of stock by means of the 'fine' system as described by Hahn above. Equally notable is the fact that it was not the wife who levied such a fine, but the 'nearest female relative of the husband' (Hahn in Barnard, 1992: 185). This necessitated good relationships between female family members and between women in general. In !Khubus, for example, I noted that despite the opposition of some members of the community, older females supported younger women in the opening of a Gastehuis (Guest House) and café in the central portion of the village. Further, Maria Farmer and other mature women not only maintain and perform the NS/P but also oversee the development of the NS/D performed by village youth.

The home village

According to anthropologist Judith Brown (1963), female rite of passage ceremonies were celebrated in those societies where matrilocal residency was practiced – after marriage a woman will continue to live in the same village/location of her mother; this is typically the village/location where she grew up. Within this system, the puberty ceremony serves to notify members of the community of her change of status from that of a girl child to adult woman. On the other hand, Brown notes that those societies in which patrilocal residency is the norm – after marriage a woman leaves her childhood home and resides in the location of her husband – a rite of passage ceremony may not be celebrated. Such an activity is not necessary as the new wife has not grown up in the community of the husband and therefore a 'notice of change of status' is not needed; the new community welcomes the new wife as an adult member from the outset (Brown, 1963: 841). The crucial point here is residency after marriage. However, residency after marriage in the case of the Nama is ambiguous. Nama literature suggests that matrilocal residency was practiced. Carstens notes that, uxorilocal residence – temporary residence in the village/location of the new wife – was typical among Nama people and residency in the village of the wife was often continued indefinitely (Carstens, 1982: 512).

Indefinite uxorilocal residency may, therefore, be seen to: strengthen the continuation of the female puberty ceremony itself, to reinforce the fundamental purpose of the ceremony, and to secure the ceremony to

matrilocal residency. Furthermore, this Nama rite of passage acknowledged the economic contribution of Nama women to family and community:

> …only when women have real importance in the subsistence activities of society will female initiation rites be celebrated…This is because within such societies women make a substantial contribution to subsistence activities.
>
> (Brown, 1963: 849)

From this economic point of view, the ceremony also serves to ensure that a young woman understands her role as *manager* of the household, its significance in the Nama community, and to assure her of the support of her *Ouma* and other women of the community in this role.[14]

As noted previously, the position of women in Nama society was high, and this standing was not dependent upon that of a man in the form of a husband or male relative. When a woman married, for example, she brought to the marriage her own possessions in the form of cooking utensils and even the 'house' itself, which was constructed for her by other women, and an inheritance in her own right on the death of her parents (Carstens, 1983).[15] In Nama society there was a separation of the sexes in which each operated independently of the other and neither dominated the other (Carstens, 2007).

This 'coming of age' ceremony was also a proclamation of a young woman's readiness for marriage; the role of 'married woman' was a further elevation of her standing within Nama society. The status of 'married woman' was tied to the fact that as such, she had complete authority in all domestic spheres; this included control of the milk supply. The management of milk and milk products was significant as milk was a staple food of the Nama, and it could be bought, sold, or traded; milk was highly valued by Nama people and its use controlled by women.

The demise of the historic female puberty ceremony in !Khubus (and other Nama communities) may be linked to economic pressures especially as they apply to women. Carstens (1982) noted that due to the loss of large portions of their herds, for example, Nama women sought employment as domestic servants, while men took jobs as migrant workers in the mines and on the farms of Europeans. Even within this European economic system, however, women continued to manage the resources of the household. Carstens explains,

> When husbands and sons went out as migrant workers, it was the women who insisted on receiving the remittances in the old roles as 'supreme rulers' of the home… when Nama men went to work, they did so for women who controlled the purse strings in much the same way as they had controlled the milk supply in the traditional society.
>
> (Carstens, 1982: 517)

This would seem to suggest that Nama women, despite a change in the 'object' of value from 'milk' to 'currency', maintained their status as 'rulers' of the household.[16]

The Matjieshuis

The Nama sanction the Nama Stap Dance as one of their cultural signifiers and, as noted by Sharp and Boonzaier (1994), it is used to identify the Nama as the descendants of the 'first owners of the land'. This view presents a traditional portrayal of the Nama as hunters and/or herders who live in a traditional manner in matjieshuis, moving from place to place, and living more or less off the *veld* (countryside). This perspective would not be entirely inaccurate as, during the course of my field research, I met some Nama who continue to live semi-nomadically. This way of life, however, is no longer the norm in the twenty-first century since 'the people of the Richtersveld have no desire to dwell in matjieshuis, which in the context of everyday life, they associate with poverty and the inability to afford modern housing' (Sharp and Boonzaier, 1994: 409).[17] The matjieshuis, however, remains an essential artefact of the Nama Stap Dance–Puberty Version that connects it to the Nama female puberty ceremony.

The matjieshuis or mat house is a unique form of Nama vernacular architecture. The dynamism and tenacity of this cultural artefact remains an obvious facet of contemporary Nama life. While maintaining its traditional function, the matjieshuis has, like the Nama Stap Dance, evolved to signify both traditional and contemporary Nama values. The conventional style matjieshuis is readily seen punctuating the landscape of the Richtersveld area in the northern part of South Africa where Nama coloured-reserves are situated.

The need for a continuous supply of vegetation and water for their herds necessitated a nomadic way of life for the early Khoekhoen. The architectural design of the matjieshuis, like designer recreational vehicles today, enhanced this itinerant lifestyle. This moveable house was planned for portability, maximum function, and comfort. The matjieshuis is a basic, floorless, dome-like structure made of woven reeds and branches. Portable and easily constructed and repaired from available materials, the matjieshuis has, since the Stone Age, ideally met the needs of nomadic hunter-gatherers roaming the sparse and rugged environs of southern Africa. Even now when many of the Nama are settled into permanent communities, a matjieshuis make the perfect temporary accommodation for short-term visitors. It provides protection from the sun and the wind and keeps out the heat of day and the cold of night.

As in the past, women are the architects of these traditional family homes, and they continue to engineer their construction. In !Khubus, they are built in the traditional manner to traditional standards; this method makes their

construction, from a contemporary point of view, an extremely time-consuming activity.

The building of a matjieshuis is a multi-layered process that requires, at a minimum: the collection and preparation of thorn trees needed for the scaffold, the gathering and preparation of reeds for the outer matting, the weaving of the mats, preparation of the ground, the construction of the frame and, finally, attaching the outer covering.[18] Noteworthy in this process are the mats that form the walls of the matjieshuis.

The traditional matjieshuis was constructed of 11 mats. Since the mats were made by different women, they were of 'different sizes and shapes, and each mat [had] a special female name. Every mat is a different "woman"… [the mats are placed on the frame] in an established and particular order' (Carstens, 2007: 130–131). Further, the pattern woven into the mat would have been distinctive of the group of women or clan who produced them. This was yet another distinguishing feature between Nama groups.

The matjieshuis is 'considered to be rare' today. Rare, in this sense, means that the traditional mat house, that is constructed of traditional materials, using traditional processes, and to traditional standards is not often seen. To say that the traditional matjieshuis is uncommon is perhaps an accurate statement statistically speaking. However, as this research demonstrates, and more importantly, as I have experienced, the traditional matjieshuis is not uncommon in the Richtersveld region.

It has, in fact, been targeted as one of a number of traditional crafts that has been re-established as a result of government funding.[19] It is also evident that cultural processes, organic as well as forced external influences, have affected nearly every feature of the matjieshuis:

> change in size and materials used; have produced new patterns of material culture and social organisation among the descendants of 19th c. Nama herders… variants using hessian, plastic and corrugated iron can be seen side by side with European-style houses in parts of Namaqualand.[20]

Both types of matjieshuis are familiar structures in !Khubus; here it continues to be utilised in a traditional manner where it provides accommodation for visitors, researchers, and is home to many of the inhabitants of the community. However, its role today, as well as its status, in !Khubus, and in Nama society generally, is much greater. The function of the matjieshuis has expanded from that of providing basic shelter to one in which it is an essential part of the economic system of the Nama. This expansion is a direct result of South Africa's cultural revitalisation programme. The growth of purpose of the matjieshuis has had the added effect of reinforcing it as one of a number of cultural symbols that identify the Nama worldwide.[21] After the initiate herself, the matjieshuis is the focal point of the Nama Stap Dance–Puberty Version.

This section has discussed three aspects of Nama ideology as it relates to Nama women and as they are embedded in the Nama female puberty ceremony. The final portion of the chapter will examine how these have been reconfigured in what I have labelled the Nama Stap Dance–Puberty Version, a twenty-first-century version of the historic Nama female puberty ceremony.

Themed versions of the Nama Stap Dance such as the puberty ceremony are performed in association with the occasions they mark, by request, or for organised community tourist activities. The puberty ceremony described here, for example, was performed in association with a twenty-first birthday celebration and also as part of the village's tourist programme. These activities are planned and rehearsed in advance. The distinction between these two categories, tourist and community-based dance activities, is that themed activities are organised by community members and *take place in the village*. The NS and the NS/D performed for larger occasions and/or performed outside of the village offer insight into traditional Nama ideology, post-colonial, and contemporary influences. The NS/P version, however, offers a view of a particular aspect of Nama culture, Nama women and must also feature the matjieshuis.

Evolved traditional dance

Although the NS/P is often referred to as 'traditional', 'traditional dance' typically refers to dances as they were performed prior to the arrival of Europeans. Evolved traditional dance, on the other hand, can be used to refer to dances that are based on traditional ideas but have also developed new movement vocabulary that reflects new ideas (see Kaeppler, 1992: 155; Welsh Asante, 2000: 14).

Early descriptions of the Nama female puberty ceremony on which the current NS/P is based (as noted at the opening of this chapter) do not refer to the 'Nama Stap' as part of the ritual. The inclusion of the NS appears to be a later development and may have evolved from the reed-dance. Historical aspects as described in the various accounts of the ceremony (Hoernlé, 1918; Carstens, 2007; Vedder, 1928) such as face painting, the dressing of an initiate in fine clothes, the slaughter of a goat in a prescribed manner, and senior female(s) in attendance to the initiate remain relatively intact. Other features noted in early records, such as the taboo in respect of cold water and the cleansing of the initiate in cow dung, were not part of the version observed during this research. These accounts indicate that the rite of passage activity maintains its basic theme and many of the elements documented as early as 1912 by Hoernlé, but it has also adopted new movement elements. Kaeppler's evolved traditional dance grouping, therefore, is an appropriate category through which to translate the traditional and contemporary themes symbolised and recorded in the NS/P.

The Nama Stap Dance – puberty version

The central focus of the NS/P is the matjieshuis that is located in the up-stage right corner of the performance area. The paired dancers are situated in the centre of a well-defined space the shape of which is marked out by the audience–participants that enclose it on nearly all sides. The dance is constructed of two main parts that are further divided and subdivided into sections linked together by means of the Nama Stap. Attention in part one is directed to the dancers situated in the middle of the performance space while consideration in part two is centred on the matjieshuis. The entire dance is organised in canon and unison forms, performed on a counter-clockwise circular-type path, and facilitated by a dance leader who takes decisions on the progression of the dance through time and space. This section comprises the dance material and is detailed further below.

The opening portion of the dance activity is similar to that of a prologue found in some Western theatre forms. In this introductory section, audience–participants, community members, performers, and visitors socialise and dance together. Here, residents of !Khubus, including performers, interact with and guide children and visitors through the movement vocabulary of the NS. A story of the dance, the context, in this case the Nama female puberty ceremony, symbols used, and an introduction of the performers, all form part of this portion of the dance. The overall atmosphere is overwhelmingly communal. Efforts are made to ensure everyone, especially visitors, feels included and a necessary part of the activities. There is also a sense of pride in being of Nama heritage. This part of the event is designed to impart 'the dreams of the group' (Moore and Yamamoto, 1988: 70) to its children through knowledge of the NS, NS/D, and its historical and cultural significance to Nama people.

Part One of the dance commences with a statement of the Nama that is in response to colonisation. Western-style dance vocabulary (such as turning patterns and arm gestures), spatial formation (dancers in pairs), and patchwork costume have been incorporated over time and point to an acceptance or incorporation of rather than conformity to colonial authority. This merger is even more apparent when juxtaposed with part two of the dance, where more traditional Nama values are displayed. The Nama Stap motif is used repeatedly throughout this portion of the dance and traditional Nama guitar music accompanies the movement. Most noteworthy as signifiers of the tradition are the performers themselves since mature Nama women, rather than young females, perform the dance.[22] This first part of the dance presents the thematic movement: the NS, turning sequences, and arm patterns. The first part of this section also introduces the leader of the group. This person directs the dancing and makes decisions, in situ, concerning the dance's progression. The leader is someone who is considered by community members to be a good Nama Stap dancer, is

experienced, and knows the dance well. This may well be someone who has earned this distinction in her youth.

Part two of the dance is a re-enactment that relates directly to the traditional puberty ceremony itself. The Nama Stap motif, turning patterns, and arm movements comprise the full movement vocabulary. This limited vocabulary is of little consequence as the dancing is, to a degree, secondary. The focus is on the performers themselves, especially the initiate, and the embodiment of the theme of the ritual. This section of the dance is directed towards the matjieshuis and its content, the initiate; it extends the ongoing theme of relationship introduced in the first part by establishing a connection with the matjieshuis and the initiate. It is intertwined with symbolic aspects of the traditional Nama female puberty ceremony such as the presence of the *abá tarás*, the matjieshuis, painting the initate with *!naop* and *!quasab* (ground white stone), and, of course, dancing.[23]

While 'an elderly woman who had borne many children' would once have attended the initiate, in the version I observed, six mature women attend her. The dance leader can be seen to represent the elderly attendant, the *abá tarás*, and the other women the senior female(s) in attendance to the initiate recorded in the historic version. The point of this united, female presence is to demonstrate that adult women had rights, power, and influence and they could also accumulate wealth within Nama society. These rights could be exercised directly and indirectly through the female line. Women, therefore, were reliant on each other. At the end of this section each performer dances with the initiate first, and then other members of the community are invited to join in. This portion of the dance demonstrates the acceptance of the initiate not only into the community as a whole but also into full partnership with Nama women.

The final stage of the dance is similar to an epilogue or closing statement. Here, a review of what has taken place is examined. Audience–participants are encouraged to ask questions and to make comments about the performance or other aspects of Nama culture. This is not unlike the question/answer secessions that proceed or conclude dance performances in England in recent years. Unlike a Western context, however, a period of dancing and interaction with performers, community members, and other visitors follows this verbal exchange thus offering yet another opportunity to be guided through the detail of the NS, to engage with the culture in which it lives, to dialogue with members of the community and other guests, and to complete the historic puberty ceremony in which members of the Nama community are encouraged to dance with the 'new woman'.

This view of the dance favours an interpretation in which it is used to symbolise a re-validation of traditional Nama values and integration of colonial mores especially in regard to Nama women. The story of the Nama women is told through dancing. While the NS motif may stand as a symbol of the Nama people more generally, the NS/P may be viewed as a symbol of Nama women and womanhood.

Although a few families still perform the NS/P as a kind of rite of passage for young women, nowadays the ceremony is (primarily) a re-enactment. Only mature women enact the ceremony (in !Khubus) and in this respect they are sentinels or guardians of it. These women, aged approximately sixty years or more, carry certain responsibilities in regard to the dance. They must maintain the ceremony in historical and performance order, clarify its codes, and interpret its significance for Nama women in the present day. Crucially, they have a duty to pass this embodied knowledge on to the next generation of Nama women.

Conclusion

This work has examined two of the more prominent of Nama signifiers, the Nama Stap and the Nama Stap Dance. The Nama Stap is performed frequently in social, formal and informal settings; the Nama Stap Dance is displayed at various select contexts. This research has considered the Nama Stap Dance in the context of the Nama female puberty ceremony.

Historically, it would seem that both the Nama Stap and the Nama Stap Dance are products of the twentieth century. The dance embodies and is used to exhibit traditional and contemporary Nama experience. This is clearly demonstrated in the !Khubus interpretation of the traditional Nama female puberty ceremony noted by Hoernlé and others. The Nama Stap is a motif in its own right; it is also an integral aspect of the Nama Stap Dance(s). In both contexts, it is seen as a movement signature both physically and ideologically.

Even though the Nama female puberty rite is no longer celebrated as described in literature, and the fact that there are only a few mature Nama women in !Khubus who have experienced some version of it, the NS/P dance, a contemporary re-enactment of the ceremony, continues the theme of the traditional ceremony: the public declaration of power, unity and cooperation between Nama women. In spite of the gradual decline of the participation of younger women in the dance ceremony in more recent times, this theme remains a hallmark of the dance. *Ouma* clarifies the continuity of the ceremony as well as the Nama people:

> We are all part of the past, as much as we are caught up in the present and as much as the future also depends on past and present. To say that authentic Nama no longer exist… is very wrongheaded. And I wonder whether this is what they teach in… school, as a way of believing that all the Nama and other Khoi ceased to exist by a certain date because they were not the same as they were before the terrible battles with the first duismanne at the Cape. On the other hand, would you deny that we no longer exist because we are different now from what we used to be?
>
> (Carstens, 2007: 169)

Returning to the opening consideration of this dance form in relation to the notion of 'site-specific' dance performance it can be observed that the significance of the site and its structures in which this performance takes place form an integral part of the dance experience. The Nama Stap Dance illustrates a form of culturally informed ceremonial site-dance that employs the matjieshuis structure as a transformational device through which the initiate's passage from girlhood to womanhood is reinforced.

Notes

1 This work is informed by my field research in !Khubus village, Little Namaqualand. The field research, carried out at various periods between 2001–2006, involved my living in !Khubus as a participant-observer. As a temporary member of the community I learned the dances, participated in day-to-day activities in the village (such as building a matjieshuis), and conducted interviews. As part of the research, I also investigated different versions of the Nama Stap Dance in two other Nama communities including: Lekkersing and Nababeep.
2 In documenting Warlpiri dance, Morais distinguished three broad categories of movement: 1) movements which occur in almost every dreaming complex, and which have a general meaning; 2) movements which occur in many, but not all, dreaming complexes and which have a general meaning as well as a specific meaning; 3) movements which occur in only one dreaming complex and which have a specific meaning (Morais, 1992: 140).
3 I developed this classification of the dances for the purpose of this research.
4 In reference to Xhosa dances see Honoré 1994.
5 'Knowledgeable outsider' refers to those who have more than a passing knowledge of the dance. In reference to this work, this would include people such as teachers in the local school who are not Nama or members of the !Khubus community but are exposed to, learn, and/or study the dances. This would also include researchers who conduct in-depth research related to the dances. See also Mauss (1973) concerning actions and gestures and how these are determined, integrated, and changed within different social groups.
6 The major cultural consultant for this research was Maria Farmer. Maria Farmer is a mature Nama woman and resident of !Khubus. She is director of the Nama Stap Dance youth group in !Khubus; she is also director of the group of women who perform the Nama Stap Dance–Puberty Version.
7 This study investigated the Nama Stap in three different villages and across generations. These include the villages of: !Khubus, Lekkersing, and Nababeep.
8 Sharp and Boonzaier (1994) note the following in reference to Nama cultural symbols: 'Outsiders… were confronted with a range of clear symbols of Nama ethnicity, the presence of a Nama choir, the singing of Nama songs, the construction of a traditional Nama matjieshuis, staging of the marriage ritual for a Nama bride… The symbols gave… a glimpse of their heritage, an indication of who they were, and an insight into the responsibility they believe they bear as intermediaries between past and future generations… The signing ceremony [itself] was designed to highlight the inhabitants' ethnic identity. By emphasising their Nama identity at a public ceremony the people of the N.R. reserve stressed their conviction that there was continuity between themselves and the 'first owners' of the land (Sharp and Boonzaier, 1994: 406).
9 See also Barnard 1992; Boonzaier *et al.* 1996; Brown 1962; Carstens 1982, 2007; Jules-Rosette 1980.

10 Carstens also conducted research among the Nama between 1952–62. See also Carstens 1982 and 2007.

11 The various descriptions of the Nama female puberty ceremony note the 'reed-flute dance' rather than the 'Nama Stap Dance'. For a fuller discussion of reed-flute dances, see Kirby 1933.

12 This statement was made by Petrus Josop, one of my cultural informants in !Khubus, during an interview that took place in !Khubus in June 2003.

13 Carstens (2007) notes, for example, that 'Mrs. Swartbooi [a political leader in !Khubus] was once a chief in her own right, but she was never able to exercise her authority because the white man's law prevented it' (Carstens, 2007: 116).

14 *Ouma is* a Nama word meaning grandmother; also a form of respect for an old woman (Carstens, 2007).

15 In reference to the construction of the house, Carstens notes the following: Closer to the wedding day, the girl's mother and a team of women helpers began the construction of the bridal hut. But there were times when the man's mother and her team built the hut for her son to give to his wife (Carstens, 2007: 139). Carstens also notes that the house itself may be thought of as 'female' (Carstens, 2007: 130–131).

16 According to Carstens, cross-sex descent may be seen to weaken patrilineality; this system highlights, once again, the strong position of women in Nama society. As part of 'old' Nama customs, male children took the 'great name' [similar to a surname] of their mother while female children took the 'great name' of their father. Carstens (2007) suggests that this system 'must be seen as weakening patrilineality on the grounds that sons become identified in a very real sense with their mothers and all the other people who share the same great name. These include mother, mother's sisters, mother's father and his full brothers, mother's father's mother, etc. A girl takes her father's great name, but this is also her father's mother's name, and not a *lineage* name (Carstens, 2007: 137).

17 Sharp and Boonzaier, for example, note that 'the people of the Richtersveld have no desire to dwell in matjieshuise, which in the context of everyday life, they associate with poverty and the inability to afford modern housing' (Sharp and Boonzaier, 1994: 409); my fieldwork in !Khubus would support this position.

18 Although a simple structure, the matjieshuise was efficient… the aerodynamic dome shape enclosed maximum volume with a minimum of surface area… The circular plan and upward curving roof gave the interior a spacious feeling although the actual space inside was restricted. The sedge mats fastened over the framework in a particular pattern regulated atmospheric conditions within. In dry weather, air could pass through the mats to cool the interior but when it rained the sedge expanded to provide a water-tight roof. Two mat doors at the front and back could be rolled up to increase ventilation and augment the diffuse light that filtered through the mat walls (Archaeology and Anthropology Resources Index, www.museums.org.za/sam/resources/arch/mathuis.htm, 2006).

19 The South African government has a policy of encouraging indigenous populations to develop their potential to attract tourists. This is, in part, a means of recognising and honouring a part of the country's heritage that has been suppressed since the arrival of Europeans in the seventeenth century. But it is also an attempt to foster the development of economic independence among local groupings. In 1999, an Act passed through the South African parliament that formed the South African Heritage Resources Agency (SAHRA). SAHRA created responsibility for the 'identification, conservation, protection and promotion of heritage resources at a national level' (Sofeleng,

2008: 1). With the aim of preserving the intangible cultural heritage, the Act identifies as worthy of protection: 'places or objects to which oral traditions are attached or which are associated with living heritage' (Sofeleng, 2008: 1). Living heritage, according to the National Heritage Resources Agency, refers to Cultural Tradition, Oral History, Performance, Rituals, Popular Memory, Skills and Techniques, Indigenous Knowledge Systems and the Holistic approach to Nature, Society and Social Relationships. The revival of the skills and techniques needed to construct a traditional matjieshuis has been targeted (and funded) by SAHRA.

20 See www.museums.org.za/sam/resources/arch/mathuis.htm.

21 For a fuller discussion of 'symbols of Nama ethnicity', see Sharp and Boonzaier (1994); see also note 12 above.

22 !Khubus is sometimes labelled a sleeping town. This identifies a locale as well as a condition in which there is no paid work in the immediate vicinity. Residents must seek employment outside of the community and, where practical, return home to rest only. I have labelled this absent group 'lost generation'. I use this phrase to identify a generation of women and men who are roughly between the ages of thirty to fifty and who are not visible in the community. The lost generation calls into question the future of the NS/P as without a generation of women to pass the dance to, it will surely cease to exist. The gradual demise of the ceremony in !Khubus however, is not an isolated occurrence; other groups of indigenous people have experienced similar erosion in reference to rite of passage ceremonies.

23 For a full account of the Nama female puberty ceremony, see Hoernlé 1925 and 1918.

References

Barnard, A. (1992) *Hunters and herders of Southern Africa: a comparative Ethnography of the Khoisan peoples.* New York: Cambridge University Press.

Barnard, A. and Spencer, J. (eds) (2000) *Encyclopaedia of social and cultural anthropology.* London: Routledge.

Bhabha, H. (1994) *The location of culture.* London: Routledge.

Boonzaier, E., Berens, P., Malherbe, C. and Smith, A. (1996) *The cape herders: a history of the Khoikhoi of Southern Africa.* Cape Town: David Philip.

Brown, J. (1963) 'A cross-cultural study of female initiation rites.' *American Anthropologist,* 65.4: 837–853.

Carstens, P. (2007) *Always here, even tomorrow. The enduring spirit of the South African Nama in the modern world.* USA: Xlibris Corporation.

—— (1983) 'The inheritance of private property among the Nama of Southern Africa reconsidered.' *Africa: Journal of the International African Institute,* 53.2: 58–70.

—— (1982) 'The socio-economic context of initiation ceremonies among two Southern African peoples.' *Canadian Journal of African Studies,* 16.3: 505–522.

Davenport, R. and Saunders, C. (2000) *South Africa: a modern history.* 5th edition, London: Macmillan Press, Ltd.

Gall, S. (2002) *The Bushman of Southern Africa: slaughter of the innocent.* London: Pimlico.

Gandhi, L. (1998) *Postcolonical theory: a critical introduction.* Edinburgh: Edinburgh University Press.

Gennep, A.V. (1963) *The rites of passage.* London: Routledge.

Gilbert, N. (ed.) (2001) *Researching social life*. 2nd edition, London: Sage Publications.

Harding, F. (ed.) (2002) *The performance arts in Africa: a reader*. London: Routledge.

Hewitt, R. (1986) *Structure, meaning and ritual in the narratives of the Southern San.* Hamburg: Helmut Buske Verlag.

Hoernlé, A. (1925) 'The social organisation of the Nama Hottentots of Southwest Africa.' *American Anthropologist*, 27.1: 1–24.

—— (1918) 'Certain rites of transition and the conception of !Nau among the Hottentots.' *Harvard African Studies*, 1: 65–82.

Honoré, J. (1994) *The Xhosa dances*. Unpublished manuscript. University of Cape Town Library.

Hunt, J. (2005) *Dutch South Africa: early settlers at the cape 1652–1708*. Leicester: Matador.

James, D. (1999) *Songs of the women migrants: performance and identity in South Africa*. Witwatersrand University Press.

Jules-Rosette, B. (1980) 'Changing aspects of women's initiation in Southern Africa.' *Canadian Journal of African Studies*, 13.3: 389–405.

Kaeppler, A. (1992) 'Theoretical and methodological considerations for anthropological studies of dance and human movement systems.' *Ethnographica*, 8: 151–157.

Kirby, P. (1933) 'The reed-flute ensembles of South Africa: a study in South African native music.' *The Journal of the Royal Anthropological Institute of Great Britain and Ireland*, 63: 313–388.

Lane, P. (2002) 'Tourism and Social Change among the Dogon.' *The performance arts in Africa: a reader* by Frances Harding (ed.), 304–310. London: Routledge.

Mauss, M. (1973) 'Techniques of the Body', in Crary, J. and Kwinter, S. (eds) *Zone 6: Incorporations*. New York: Urzone, Inc. The MIT Press, 1992, pp. 454–477.

Moore, C. and Yamamotao, K. (1988) *Beyond words: movement observation and analysis*. New York: Routledge.

Morais, M. (1992) 'Documenting dance: Benesh movement notation and the Warlpiri of central Australia.' *Oceania Monograph*, 41: 130–153.

Penn, N. (2005) *The forgotten frontier: colonists and Khoisan on the Cape's northern Frontier in the 18th century*. Ohio: Ohio University Press.

Radcliffe-Brown, A.R. (1963) 'The Mother's Brother in South Africa.' *Structure and function in primitive society* by A.R. Radcliffe-Brown, pp. 15–31. London: Cohen & West.

Sharp, J. (1994) 'Land claims in Namaqualand: the Komaggas reserve.' *Review of African Political Economy*, 21.61: 403–414.

Sharp, J. and Boonzaier, E. (1994) 'Ethnic identity as performance: lessons from Namaqualand.' *Journal of Southern African Studies, Special Issue: Ethnicity and Identity in Southern Africa*, 20.3: 405–415.

Sofeleng, K. (2008) 'Country report: South Africa safeguarding of intangible cultural heritage in South Africa.' *International partnership programme for safeguarding of intangible cultural heritage*. Asia/Pacific Cultural Centre for UNESCO (ACCU), www.unesco.org pp.1–4 (2008) (Accessed July 2008).

Van Gennep, A. (2004) *The rites of passage*. London: Routledge.

Vedder, H. (1928) 'The Nama.' *The native tribes of Africa* by C. Hahn, H. Vedder and L. Fourie (eds), 109–145. Cape Town: Cape Times.

Welsh Asante, K. (2000) *The Zimbabwe dance rhythmic forces, ancestral voices – an aesthetic analysis*. New Jersey: Africa World Press.

Wilmsen, E., Dubow, S. and Sharp, J. (1994) 'Introduction: ethnicity, identity and nationalism in Southern Africa.' *Journal of Southern African Studies, Special Issue: Ethnicity and Identity in Southern Africa*, 20.3: 347–353.

Witz, L., Rassool, C. and Minkley, G. (2001) 'Repackaging the past for South African tourism.' *Daedalus*, 130.1: 277–296.

Electronic sources

Archaeology and Anthropology Resources Index, www.museums.org.za/sam/resources/arch/mathuis.htm (2006) (Accessed: 12 July 2006).

UNESCO: United Nations Education, Scientific and Cultural Organization, www.unesco.org (2008) (Accessed: 18 September 2008).

UNESCO: Convention on the Promotion of the Diversity of Cultural Expression www.portal.unesco.org/culture/en/ev.php-URL_ID=35510&URL_DO=DO_TOPIC&URL_SECTION=201.html (2008) (Accessed: 25 September 2008).

25 Moving sites

Transformation and re-location in site-specific dance performance

Victoria Hunter

This chapter explores the concepts of mobility, transformation and re-location in the creation, production and experiencing of site-specific dance performance. Processes and practices of mobility are explored here through a consideration of the triadic relationship between performer, audience and site encountered within the creation of my site-specific dance work *The Library Dances* (2006). Through a discussion of a creative process which explored the potential for the site-specific event to challenge an individual's sense of located-ness, the chapter explores how the mobile, experiential interplay between performer, audience and site problematised subjective notions of 'located-ness', fixity and 'place identity'.

Introduction

> We are here
> Here we are
> Here is where
> Where are we?[1]

Site-specific performance events can often reveal something new and unknown about site, location and the surrounding world. This work holds the potential to both locate and *re-locate* the individual, drawing their attention to the site whilst simultaneously challenging pre-conceived notions of the site as the real world is shifted momentarily 'out of focus'. The creative potential afforded to the individual within this moment of shift and its ability to instigate an individual questioning of location, located-ness and identity founded the basis for *The Library Dances* project. The work was created and performed in Leeds Central Library in September 2006. Performed by five dancers, the event engaged eight audience members in a promenade journey through the site where they encountered moments of performance in key locations. Each performance episode aimed to 'reveal' the site to the audience in a new light, experienced through a combination of performed dance movement, performance soundtrack (relayed through

headsets) and through their own, physical experience of journeying through and 'being' in the site.

A conceptual framework informed by environmental psychology (Proshansky *et al.*, 1983), spatial theory (Lefebvre, 1974) and human geography (Massey, 2005 and La Cecla, in Read, 2000) informed the creative process which became shaped and directed by a desire to challenge the audience to experience the site anew through the transformative medium of site-specific dance performance.

The term mobility is applied here to a personal practice comprising an individualised movement process and is considered in relation to the highly stylised, honed mobility of the dancer/performer and in relation to the more functional, attentive mobility and journeying experienced and 'performed' by the audience member. This chapter therefore, is not concerned with 'meta-mobilities' of travel and distance, but instead considers individualised 'micro-mobilities' and personal 'journeys' consisting of subjective perceptions and experiences encountered within the site-specific performance event. It places the practices of mobility encountered within the creative process and final performance outcome on a progressive continuum comprising: the dancers' mobility, exploring new pathways through and new ways of moving in and around the site, the audience's mobility, following the performers' journeys and actions, moving through the site and performance, and finally, a 'mobility' of the site itself, as its fixity becomes destabilised by the performance event through the revelation of multiple readings, identities and reference points.

To illustrate the engineering of this process and its practical and theoretical implications, the discussion of *The Library Dances* follows a chronological format addressing key themes and concepts revealed throughout the practical investigations. These themes are identified here as Location and Identity, Transformation, Getting Lost and Re-location.

Location and identity

Topographic systems locate us in the world through the processes of mapping, charting and tracking our whereabouts; an individual's location becomes pin-pointed, identified and fixed so that we are located in a particular place at a particular time. Our sense of located-ness becomes defined by a degree of certainty that we are 'here', we know that a particular location is here because, in addition to our physical presence in a particular place, we can locate ourselves on a map, register a grid location and direct ourselves towards and within it. In a conventional sense, 'located-ness', to be *in* place implies a degree of fixity, rooted-ness and assuredness. Site-specific performance troubles this understanding through the transformation of everyday places into places of performance.

Proshansky *et al.* (1983) discuss 'place-identity' as a 'cognitive sub-structure of self-identity' (p. 61) involving both a conscious and sub-conscious

experience of place comprising an enmeshment of physical and conceptual experiences encountered in the moment. These experiences combine with personal memories and associations informed by an individual's personal make-up and by their cultural and social context. The concept explores how notions of stability and implied permanence associated with place and location provide an individual with 'affirmation of the belief that the properties of his or her day-to-day physical world are unchanging', a position which, over time 'gives credence to and support for his or her self identity' (Proshansky *et al.*, 1983: 66).

Comprising of 'a pot-pourri of memories, conceptions, interpretations, ideas and related feelings about specific physical settings as well as types of settings' (Proshansky *et al.*, 1983: 60) the concept of place-identity can be viewed as a holistic process engaging the whole self in the experiencing of and identification with places and location. Through the creation and presentation of a site-specific dance work within a library building, however, *The Library Dances* challenged the acquired habitus and the conventional 'narratives of use' habitually enacted within the site through the creation of performance material that amplified and abstracted existing behavioural norms practised within the library site.

The initial planning stages for the work were informed and influenced by an awareness of a culturally influenced concept of place-identity and the associated responsibility on behalf of the site-specific practitioner to approach any intervention within a public site with sensitivity and care, particularly as the performances were scheduled to take place in the early evening when the site was open to the general public. The act of interrupting and by association, disrupting the *habitus* of a particular place could potentially equate to a colonisation of the site by the artist. However, in this project the intention was to work with the site and its community in an attempt to create a performance that worked with the site as opposed to imposing itself upon it.[2]

The Leeds Central Library building dates back to 1883 and represents a prominent architectural feature in the city of Leeds in the north of England. It houses a range of books and reference materials over four floors and is a very open site holding regular workshops and classes, art exhibitions, talks and reading groups. As such, the library is an active site with a wide range of site users, staff and visitors all of whom experience and interact with the site in a variety of ways. To acknowledge and draw upon the site's 'shared ownership' in this sense, site users were provided with the opportunity to contribute towards the development of the creative process through the completion of pre-production questionnaires. These questionnaires invited site users to reflect upon their experiences, associations with and responses to the site in order to explore the nature of their relationship with the library and subsequently inform and enrich the creative process.

Upon analysing these responses a number of common themes began to emerge regarding the site users' perceptions of and associations with the

site. Many responses explored an embodied sense of place and described the site as a place of refuge, for example, 'I feel relaxed and protected here' whilst another described the library as 'a place of refuge when in town'. For many users the perception of the site as a place of refuge appeared to be associated with a sense of escapism into a 'timeless' world often associated with libraries;[3] one participant explains, 'I feel as if time has stopped in here', whilst another response describes how, 'this place allows you the freedom to chase your own knowledge and dreams'. This sense of a pursuit of knowledge was shared by other users and appeared for many to equate to a process of empowerment, as one response explains:

> The library represents a gateway to other things –
> knowledge, freedom.

For others, the historic nature of the building appeared to invoke a process of reminiscence pertaining to their own past and personal histories:

> It [the library] invokes lots of good memories, of books
> and childhood.[4]

Towards the end of the questionnaires the site users were invited to complete a free-writing exercise placing themselves in a favourite location within the library to record their thoughts, feelings and responses to the site in the moment of experiencing. One such response is described here:

> A journey around the world, universe, anywhere, you just have it.
> Whatever you feel like reading.
> Peaceful, the world at our fingertips.
> The books are the tools. They make me feel powerful.[5]

The responses to the writing task were perhaps (in some instances) the most interesting and intriguing as the individuals attempted to articulate their personal relationship with the site in all its intricate complexity. These responses provided an insight into numerous 'versions' of the site as seen, perceived and experienced by each individual. In this sense, each response to the writing task effectively provided a 'snapshot' of the individual's 'site-reality';[6] an impression of how the site phenomenon appeared to the individual through their lived-experience. These site-responses and site-realities were read and absorbed at the start of the devising process by the creative team, comprising myself (as choreographer/director), a creative writer, sound designer, scenographer and five dancers. Through this process the responses combined with the team's own site experiences and a range of creative themes or 'strands' began to emerge as stimuli for further exploration, identified as:

Time / Passage of Time / Timelessness
Perspective / Playing with Perspective
Inside / Outside
Boundaries / Blurring boundaries (physically and conceptually)

In addition to the gathering of site user responses my own process of site exploration began to develop both physically and experientially; firstly, through an analysis of my own phenomenological process of 'being' in the site and secondly, through an exploration of the site's architectural features and history. Through these factual and historical excavations the site became revealed as the past life of the site as a former museum, public offices and former C.I.D. headquarters was unearthed. It became apparent from reading the site users' responses that few had any notion of this past life or any knowledge of the site beyond their immediate experiencing. In addition, the site as experienced differed between users, between employees and between the regular and the irregular visitor. The range of responses revealed a multiplicity of site realities, meanings, uses and associations connected with the library, all of which combined to create an impression of a site that evaded categorisation and demarcation. The site as a 'given', as known, as a definable entity became subject to a process of slippage as inconsistencies in its public and private (determined by the individual) identities began to emerge. Through this process, the potential mobility of the site began to emerge; if the site was no longer what it had first seemed then where is 'here' and what are the associated implications for the construction of a subjective 'place-identity'?

These initial attempts at identifying the site users' responses revealed that they were engaged with a number of individually perceived sites existing within one physical location at a particular time. In this sense the physical site remained located in its geographical position, however, through the individual's lived experience the site also became located in and defined at the nexus of interaction between individual and site. Informed by Doreen Massey's consideration of space and place both as fluid and indeterminate entities containing a multitude of 'coeval trajectories' (2005: 114) determined by the individual, the co-existence yet separate-ness of these sole-authored perceptions of the site began to interest me greatly. This led to the formulation of a creative process concerned with exploring the potential for a site-specific performance to reveal and celebrate the co-existence of site realities (and to suggest some alternatives along the way) in order to invoke an individual questioning of location, located-ness and place-identity.[7]

Transformation

To facilitate this subjective questioning process the emerging work formulated a series of performance installations often referred to as

'episodes' or 'encounters' during the devising process. The aim of each episode was to create a subtle disruption of and interruption to the everyday place-world of the library site and the associated habitus in order to encourage the audience members to question assumptions and reassess their surroundings and perceptions. Seven key locations within the library building were selected as micro sites for dance performance installations moving from the ground floor upwards, these performance encounters were visited in sequence by the eight audience members en masse (see floor plan below).

The locations were selected for their potential to facilitate an exploration or explication of the work's themes (identified earlier) resulting from the location's architectural make-up or through the nature of the 'thematic' content provided by the library material housed within the particular corridor, room or landing. For example, the 'Country Life' corridor (location 4) housed a collection of the magazine's back copies, many of which were bound in leather and gold embossed volumes lining the corridor's floor to ceiling shelving. The apparent incongruity of attempts to house and contain 'Country Life' in such a bound and ordered manner within an urban location provided the inspiration for a series of improvisation tasks which explored notions of inside/outside, bound/free dichotomies in relation to the symbolic 'capturing' and 'ordering' of the countryside encapsulated within the corridor location. The resulting performance episode featured the five dancers moving through the corridor performing individual phrases which explored their abstract responses to notions of 'nature' and countryside imagery resulting in a fluid, languid movement quality combined with movement tasks which engaged them in a more dynamic and literal 'search' through the archived material as they effectively sought to reveal the 'Country Life' contained within the walls of the building.

The performance soundtrack comprising original composition, devised and found sound accompanied these moments and provided the audience with verbal information (a combination of fact and fiction) regarding the

Figure 25.1 Cross-section plan of the Leeds Central Library building (not to scale).

library as they moved between performance episodes. The conceit of the guided tour format served a number of functions: firstly, as a practical means of navigating the audience around the site in a safe and comfortable manner; secondly, the format facilitated the questioning of location and located-ness in a very overt and simple manner through the auditory juxtaposition of sound accompaniment and verbal oratory comprising a combination of truths and untruths and overt questions (see opening reference). Thirdly, the use of headsets as a transformative device allowed the individual audience members to experience the library in a new way, accompanied by a soundtrack which only they could hear allowing them access to the full performance event whilst simultaneously creating the potential for self-consciousness as they adopted a form of costuming which demarcated their status as belonging *to* the event.

Informed by the site users' questionnaire responses, the generation of movement material followed a devised approach. The movement devising tasks explored the site through two related yet distinct processes identified here as the processes of *amplification* and *abstraction*.

Amplification tasks required the dancers to respond to the site as seen and to produce material that drew attention to the form and function of the site and the human behaviours existing within it. Through these tasks movement material was produced which served to amplify and develop those behaviours, drawing attention to often overlooked formal and architectural features through the creation of pedestrian and gestural material. A description of one such task exploring the library's main entrance foyer and information area is described here:

> The dancers entered the space and were instructed to observe the flow, gestures and mannerisms of the pedestrian 'traffic' moving in, out and around the space. In addition, the dancers were asked to really look and regard the architectural design and features of the space, touch and feel the site's surfaces and textures.
>
> Gradually, they began traversing the space, moving in and out of doorways, through the space, touching, experiencing and seeing the space, its height, depth, dimensions. The pace and dynamic qualities of the walking began to vary and develop in relation to each other and the members of the public.[8]

This task developed over the course of the rehearsal period resulting in the creation of movement motifs, gestures and phrases representing the architectural lines, dimensions and forms of the site.

Abstraction tasks required the dancers to immerse themselves within the experiential, phenomenological world of the library site in an attempt to respond corporeally to the lived-experience of the site and in so doing give form to those experiences through the creation of abstract movement material. A description of one of these tasks is provided here:

We began by simply 'being' in the space, taking the time to explore the site and surroundings with the senses – what is contained within the site?

The space is a corridor therefore perspective is a major theme – we stood as individuals at the top end of the corridor and stared down to the end of the corridor – a large wooden door stands at the bottom shrinking and diminishing the rest of the site as it engulfs the site – a real focal point of the corridor.

In our own time we took a walk down the corridor – when I walked down the corridor I could sense my pace picking up as I ventured closer to the door – excitement and urgency took hold of my walk – a few of the dancers had the same experience whilst others progressed leisurely.

Whilst staring to the other end of the corridor a heat radiated from the door which was felt by us all instantly – for me it was at the lower part of my back. A warmth possibly refuge, or safety meant it was increasingly difficult to draw myself away from the door as it was so comforting – I had to make a conscious decision; this time to part – as a consequence my walk was a slower procession and I did not feel the draw/pull in this direction – mid way down the corridor warmth left me and I started to notice bookcases were barren and a cold landscape beckoned.

Based on the information we had gathered the dancers took up a space of their choosing in the site and closed their eyes – this closed the need to constantly seek the visual element and really attune to the felt experience of the site – so often neglected.

We began a breathing exercise on the spot and began to sway. We let the sway be informed by the pull of the door – this became the inroad to inform the pattern and dynamic of the movement material.[9]

From this phenomenological movement task a simple sequence developed involving the dancers' journeying through the corridor, walking, turning, pausing and swaying. This was combined with movement responses and reactions to the presence and movement of the audience members and site users who passed through the corridor during the moment of performance. The performers were required to be present in the moment, responding to the energies of the site and its users as the performance unfolded. The aim of the performance episode developed from this exercise was to provide the audience with another form of experiencing the site by entering into a phenomenological exchange with the performer positioning them in a perceptively active and viscerally 'mobile' role.

Getting lost

In his essay 'Getting Lost and the Localized Mind', La Cecla discusses various forms and degrees of getting lost as a condition of humankind's negotiation and interaction with the physical and cultural environment:

Figure 25.2 The Library Dances (2007).
Image: V. Hunter

It can happen on the freeway, in a city that we do not know or even on the way home. It is a frustrating, embarrassing and at the same time ridiculous experience. We are put in a position of being displaced, misplaced. It shows an ambiguous, vaguely defined, confused relationship with the environment in which we get lost. We suddenly find ourselves without sense of direction, without reference points.

We are 'here', but 'here' doesn't correspond to a 'where' we would like to be.

(La Cecla in Read 2000: 31)

The above passage encapsulates the type of 'getting lost' which *The Library Dances* aimed to invoke through the audience's total immersion in the event and the associated new-found place-world, equitable to La Cecla's description of getting lost as a form of 'immersion into the unknown' (2000: 33). The type of experience offered to the audience member did not seek to alarm or alienate them however, but instead invoked a gentle sense of estrangement through a combination of three key elements: firstly, through the overlapping and layering of performance themes and concepts; secondly, through the direct choreographing of the audience experience; and thirdly, through the use of a naturalistic and 'direct' style of performance adopted by the dancers. To illustrate this point a description of one section of the work is provided here. The section described was performed within the library's business library on the third floor of the building.

The audience travel towards the room accompanied by the sound of choral music performed by female voices, turning a corner the space is revealed. As the audience enter the site the sound track echoes the cathedral-esque quality of the imposing space, the carved ceilings, marble columns and intricate stone-work.

Four dancers dressed in white sit at a long table alternating between looking at the audience, encouraging them to follow their gaze drawing their eyes upwards and around the site itself whilst challenging their presence within the site and their own act of looking and observing. Other site users glance at the audience members and the dancers, others immersed in their work remain oblivious to the event unfolding around them.

Slowly the dancer at the far end of the table reaches down to a box on the floor and places a small white box on the table. As she observes the box and moves it around, it is revealed to be a small model of a building, or part of a building.

The box is passed on down the line of dancers at the table, more boxes are slowly unpacked and revealed. The buildings vary in size and shape, some are recognisable as local architectural landmarks, others remain anonymous. As the dancers receive the boxes, they place them, re-arrange and observe them as a miniature model city begins to reveal itself, its skyline stretching across the table.

The dancers perform functional, pedestrian actions necessary for the construction and arrangement of the model city, more abstracted movements also emerge and recede as they respond to the unfolding city before them.

As the scene develops the fifth dancer on the far balcony above moves unnoticed or observed by the dancers and site users below. She travels slowly across the balcony performing gentle, undulating arm gestures and high-arch body actions mirroring the architecture and expansive qualities of the site's form and design.

Mid-way through her journey, the four dancers below complete their task and exit one by one. As they pass the audience they regard them, acknowledging their presence once again before exiting the room. The solo dancer continues her trance-like journey across the balcony and exits out of sight. The sound-score changes and the audience file out to follow the four dancers out of the room.

The section described here in detail exemplifies how the work explored various themes and concepts through a combination of movement, scenographic and aural content. For example, the concepts of time and the passage of time were explored through the variation and juxtaposition of tempo and dynamic qualities present within the movement content. The slow-motion abstracted actions and travelling performed by the dancer on the balcony contrasted with the functional amplified movements performed by the four dancers at the table and with the real-time actions of the site users engaged in their everyday activities below.

The theme of perspective and playing with perspective was explored through the placement of the four dancers in close proximity to the audience juxtaposed with the positioning of the fifth dancer on the far galleried landing above the main floor. This served to create a dialectic between the near and the far requiring the audience to actively engage in a process of focusing and re-focusing from one area to another. The disproportionate scale of the model buildings unpacked and re-arranged by the dancers also served to embellish and develop the notions of perspective explored within this section and in addition, overlapped and contributed towards the exploration of the concept of inside/outside.[10]

Underscored by found sound and traffic noises collected from outside the library building itself, the sound-score text explored the concept of inside/outside through references to the city of Leeds' commercial past and contemporary development, serving to remind the audience of the site's wider context and the simultaneity of city life surrounding the library building and the unfolding performance event housed within. This was mirrored by the dancers' manipulation of the cardboard buildings as the outside world was symbolically transported inside. In addition, the audience themselves throughout the work were engaged consciously and subconsciously in their own subjective exploration of the concept of inside/outside through the use of headsets which simultaneously placed the individual both inside and outside of the library site-world, engaged and complicit in the frame of play yet removed from other site users. In turn, this creation of difference carried with it the potential to attract attention thereby identifying the audience member as someone to be looked at, facilitating a process of subtle estrangement.

This blurring of boundaries between performer and audience was further enhanced by the direction of the performers' gaze back to the audience as they regarded their mutual presence in the space. Furthermore, this device actively directed the audience's gaze around the site in order to highlight certain architectural and spatial features thereby encouraging the individual to acknowledge the site's detail and expansive proportions. One audience response gathered from post-performance questionnaires describes how this technique increased her awareness of the site and invoked a sense of 'present-ness':

> My senses were heightened in the moment and I felt present both physically and mentally in a now that was a web of past and present events and experiences.[11]

This deliberate manipulation of perspective and gaze carried with it the potential to disorientate the audience member physically and experientially. During this process of disorientation the individual becomes 'lost' as they search to conceptually re-orientate themselves in relation to the performance work, their position and role as an audience member and in relation to the world as presented to them through the performance event. A further audience response describes how they became 'lost' within the performance world and distanced from the 'real' world outside of the library site:

> It made me feel very relaxed and lost in the moment. Everything from the outside world was forgotten about, it felt quite liberating.[12]

The audience responses featured here appear to reveal two distinct yet interrelated types of 'getting lost' described by a number of audience members pertaining to both a conceptual and phenomenological process. Conceptually, the audience members were presented with a number of elements to engage with on a cognitive level, all of which were intended to reveal the site in a different light and disorient and 'unfix' the individual. Phenomenologically, the audience members were presented with an opportunity to immerse themselves within a performance world through their engagement with a range of less tangible performance elements experienced subjectively. Through this process the intention was to invoke a re-examination and subsequent re-engagement with the site informed by new-found site experiences leading to a subjective questioning of located-ness and place-identity. This process required a willingness on the individual's behalf to be present in the moment and respond in a holistic and corporeal manner to the event and was facilitated by the performers' ability to totally immerse themselves within the work in order to invoke a phenomenological exchange between performer and audience as discussed previously.

Re-location

What are the implications for this process of transformation?

What happens to our located identity when a place becomes 'mobile', transformed by the site-specific performance event, when 'here' becomes (momentarily) somewhere else?

Through this discussion of *The Library Dances* project the concept of transformation can be applied not only to the deliberate artistic transformation of the site through performance but also to a physical, psychological and experiential process undertaken by the individual audience member. In order to fully experience this phenomenon, the individual immerses themself within the performance event, essentially becoming 'lost' and divorced from the real site-world as previously perceived and defined. Through this process, according to Miwon Kwon's (2004) discussion of site-specific art and locational identity an actual place becomes a 'phantom' (p. 165) as the site-specific event invokes a liberating 'deterritorialisation' (p. 165) of site:

> Displacing the strictures of place-bound identities with the fluidity of a migratory model, introducing possibilities for the production of multiple identities, allegiances, and meanings based not on normative conformities but on the non rational convergences forged by chance encounters and circumstances.

The final performance work, whilst comprising an artistic response to the site, could also be considered as an 'offering up' of the site as an incomplete space, evading categorisation or definitive description, available for the audience to explore and construct according to their own imaginative and subjective wanderings. Many of these explorations are evidenced through responses gathered from post-performance questionnaires concerning the individual's experiences and feelings encountered during the performance event:

> I felt like a child in an old house... curious, calm. I became nostalgic for my grand parents' old library.
> It felt like I was witnessing a secret, something hidden and old that was exposed and integrated with the now.[13]

A number of these responses referred to a sense of peace and calm experienced during the performance event; inevitably informed by the wearing of audio headsets which served to distance the audience members further from the everyday site world. Connected to this sense of calm and tranquillity, however, appeared to be an associated facilitation of personal self-reflection referred to by a number of audience responses, an exemplar is provided here:

> I felt very calm and peaceful, floating through experiences of history both personal and learnt.[14]

This quotation evidences a sense of personal reflection and 'journeying' through past memories and experiences invoked by the performance event. This sense of self-reflection and memory invocation was echoed in a number of other post-performance responses, suggesting a personal process of re-assessment and re-evaluation associated with the transformative process of 'getting lost' within the performance event. This process parallels Proshansky's observation regarding 'dysfunctional' settings:

> It is, generally speaking, only when a physical setting becomes dysfunctional that a person becomes aware of his or her expectations for that setting.
>
> (1983: 75)

Through the individual's engagement with this 'dysfunctional' performance world they were afforded an opportunity to embark on a process of questioning not only of where they were but *who* they were and how they should act in relation to an ever-shifting world which, through the performance event, was revealed to be unfixed, fluid and open to interpretation and re-definition.

The result of this self-reflective journeying can be equated to a process of subjective 're-location' invoked by the challenging of assumptions and pre-conceptions surrounding our site-reality and our located place-identity. This process effectively represents a conceptual 'in-between-space' (Briginshaw, 2001), the limits and parameters of which are fluid and permeable allowing the individual to explore the liberating potential of being lost and un-fixed. This un-fixing of a located place-identity, itself a constituent component of self-identity, carries with it the potential for a re-defining of self. If here is no longer 'here', then the potential for re-orientation and re-invention in an ever-changing, fluid construction of 'heres' can be considered prodigious and liberating.

The concept of re-location can also be applied to the site itself as, through its own process of metaphorical 'mobility', it effectively becomes re-inscribed[15] with meaning both during and following the performance event itself, as the palimpsestic nature of the site is written-over with new meaning arising from the individual's interaction with the performance event. This process is exemplified here through responses gathered from post-performance questionnaires completed by library staff. Comments included:

> I think it was the first time I had thought about the library in a personal context, rather than historical/literary.

All the corridors which normally appear quite gloomy had life and beauty. Apart from the architecture I hadn't noticed or felt much towards the library until now.

Memories of this performance will stay with me and be evoked when I walk around.[16]

For the library staff then, the performance work presented the library building and its environment in a new and unfamiliar light facilitating a different mode of experiencing and engaging with the site. The resonance of this performance experience remains with the individual informing and colouring their future interactions with the site as they remember and re-collectively experience fragments and memories of the performance event. The evidence suggests, however, that the processes of transformation and re-location as encountered by the library staff members were experienced on a deeper level with a greater degree of significance from those audience members less familiar with the site.

Conclusion

In light of this discussion, the concept of located-ness in site-specific performance describes an active interaction with space and place comprising both a physical and conceptual orienting of the body informed by phenomenological exchanges between the holistic self and the site. In this sense, located-ness is a fluid process as the individual becomes open to the potential of place whilst simultaneously grounded in its physical location. Considered here as an experiential phenomenon, located-ness is used to describe a mobile process of locating the self in relation to an ever-shifting notion of the here and now challenging notions of 'rooted-ness' and fixity commonly associated with definitions of place. The potential transformational experience offered by the site-specific event to the audience member requires a degree of bravery, confidence and willingness on behalf of the individual to participate in this process of re-evaluating their own located-ness and associated sense of self informed by their subjective place-identity. In this sense the role of the audience member in the site-specific performance event involves a greater degree of interaction and involvement both physically and personally than in conventional proscenium arch theatre practices. The degree to which this form of participation and interaction occurs varies from individual to individual, in turn serving to shape and determine each individual's perception and reception of the performance work and the site in which it is located. As a result, the final performance event in a sense becomes fragmented in its definition and meaning as the locus of creativity shifts from choreographer, to performer, to audience member, as each individual interacts with and

responds to the work in their own subjective manner, creating in effect a myriad of performance outcomes personal to each individual.

Due to the varied nature of the event, however, the roles and definitions of the audience experience become mobile, fluid and ever-changing. Through their willingness to 'unfix', become 'lost' and engage with the work, the individual is presented with the opportunity to locate themselves on a sliding scale between 'viewer' and 'participant', effectively negotiating their role within the performance event as it unfolds. The negotiation of and journeying between a range of roles from navigator, to explorer, to interpreter and back again enables them to engage with the work and the site-world in a number of ways dependent upon personal preference and need as they encounter the site work through their own mobility and simultaneous, personal processes of transformation, re-orientation and re-location.

The site-specific dance performance event therefore holds the potential to abstract, amplify and highlight some of the (often overlooked) everyday interconnected practices and processes of mobility experienced by the individual. This discussion of *The Library Dances* reveals how this type of performance encounter encourages the individual to become self-aware and present in their engagement with space, place and environment and exposes the ever-shifting, ever-mobile nature of these very individual physical and experiential processes. These processes become heightened during the moment of performance as the individual is challenged to navigate their own 'journey' through the performance event reliant upon a deeply personal form of conceptual and phenomenological engagement.

Notes

1 Soundscore excerpt *The Library Dances*, 2006.
2 Issues of power and control regarding the making of performance work in public spaces are discussed further in Hunter, V. 'Public space and site specific dance performance: negotiating the relationship', *Research in Drama Education*, 12(1), February 2007, pp. 112–115.
3 See Hartman (2000), Cart (1992), and Ligget (1995).
4 Extracts from audience questionnaire, *The Library Dances* project, September 2006.
5 Extracts from audience questionnaire, *The Library Dances* project, September 2006.
6 The term 'site-reality' was developed throughout the devising process to describe the individual's immediate lived-experience of the site. The concept of the 'lived experience' in dance draws upon phenomenological philosophy and focuses on perceiving and experiencing the world in a pre-reflective manner, responding in the moment through the lived experience of the body. See Fraleigh, S. (1987) *Dance and The Lived Body: A Descriptive Aesthetics*, USA: University of Pittsburgh Press.
7 This concern for exploring 'co-existence' can also be evidenced in Shobana Jeyasingh's site-specific dance work [h]Interland (2002) performed in the Borough Hall, Greenwich. This work explored issues of specificity and

simultaneity across time and space through the exploration of 'different presences overlapping in the same arena' Roy, S. (2002) www.rescen.net/Shobana-Jeyasingh/hinterland.

8 V. Hunter, Choreographic Process Diary abstract *The Library Dances* project (September 2006).
9 Louise McDowall, assistant choreographer (journal entry) *The Library Dances* project, September 2006.
10 See Lefebvre, H. (1974) *The Production of Space*.
11 Extracts from audience questionnaire, *The Library Dances* project, September 2006.
12 Extracts from audience questionnaire, *The Library Dances* project, September 2006.
13 Extracts from audience questionnaires, *The Library Dances* project, September 2006.
14 Extracts from audience questionnaire, *The Library Dances* project, September 2006.
15 For a discussion of site-specific dance performance and re-inscription see Briginshaw, V. (2001) *Dance, Space and Subjectivity*, London: Palgrave.
16 Extracts from audience questionnaires (library staff), *The Library Dances* project, September 2006.

References

Briginshaw,V. (2001) *Dance, Space, and Subjectivity*. New York: Palgrave.

Cart, M. (1992) 'Here there be Sanctuary; the Public Library as Refuge and Retreat'. *Public Library Quarterly*, 12(4): 5–23.

La Cecla (2000) 'Getting Lost and the Localized Mind', in Read, A., *Architecturally Speaking: Practices of Art, Architecture and the Everyday*. London: Routledge.

De Certeau, M. (1984) *The Practice of Everyday Life*. US: University Of California Press.

Hartman, C.W. (2000) 'Memory Palace, Place of Refuge, Coney Island of the Mind'. *Research Strategies*, No 17: 107–121.

Hunter, V. (2007) 'Public Space and Site-Specific Dance Performance: Negotiating the Relationship'. *Research in Drama Education*, 12(1): 112–115.

Krupat, E. (1983) 'A Place For Place-Identity'. *Journal of Environmental Psychology*. 3: 343–344.

Kwon, M. (2004) *One Place After Another: Site-Specific Art and Locational Identity*. US: MIT Press.

Lefebvre, H. (1974) (trans. Nicholson-Smith, 1991) *The Production Of Space*. Oxford: Blackwell.

Ligget, H. (1995) 'City sights/Sites of Memories and Dreams.' In Ligget, H. and Perry, D. (eds). *Spatial practices*. Thousand Oaks: Sage Publications: 243–272.

Massey, D. (2005) *For Space*. London: Sage Publishing.

Merleau-Ponty, M. (1962) *The Phenomenology of Perception*. London: Routledge.

Proshansky, H. M., Fabian, A. K. and Kaminoff, R. (1983) 'Place-Identity: Physical World Socialization of the Self'. *Journal of Environmental Psychology*. 3: 57–83.

Index